Perspectives on Habermas

Perspectives on Habermas

EDITED BY

LEWIS EDWIN HAHN

OPEN COURT
Chicago and La Salle, Illinois

To order books from Open Court, call toll free
1-800-815-2280.

Front cover photo: AKG London

Open Court Publishing Company is a division of Carus Publishing Company.

Copyright © 2000

First printing 2000

Library of Congress Cataloging-in-Publication Data

Perspectives on Habermas / edited by Lewis Edwin Hahn.
 p. cm.
 Includes bibliographical references and index.
 ISBN 0-8126-9426-0 (cloth : alk. paper) — ISBN 0-8126-9427-9
 1. Habermas, Jürgen. I. Hahn, Lewis Edwin, 1908–

B3258.H324 P47 2000
193—dc21

00–056961

TABLE OF CONTENTS

PREFACE

This volume has been in the making for eight years. Professor Jürgen Habermas was to be the subject of a volume of the Library of Living Philosophers. Over the years we collected many fine essays written by the best scholars we could find and they worked hard and fruitfully to complete these essays.

In 1999, Professor Habermas wrote to tell me that because of other events in his life he could no longer participate in this project. Because of the high quality of the essays we received, it was decided to publish this book as a scholarly monograph to honor the life work of Professor Habermas and to give full recognition to those contributors who worked so hard to complete this volume. We are extremely grateful to them for their efforts.

I am happy to acknowledge the warm support, encouragement, and cooperation of Open Court Publishing Company, especially M. Blouke Carus, David R. Steele, Kerri Mommer, Jeanne Kerl, and Jennifer Asmuth. And I also very much appreciate continued support, understanding, and encouragement from the administration of Southern Illinois University. Moreover, I am grateful for the invaluable and unfailing assistance of the staff of Morris Library. My warm gratitude goes to Christina Martin and the Philosophy Department secretariat for help with numerous projects, as well as to my colleagues who from diverse perspectives make common cause for philosophy and a better university. My thanks also go to Lucian W. Stone, Jr. and Darrell J. Russell for the careful work they did on the manuscripts and proofs, and to Kevin Thompson for the Introduction in which he very ably introduces the reader to the wide-ranging essays in this collection. Finally, I am most grateful to Frances Stanley for her unfailing support and ingenuity, as well as her excellent work in typesetting the volume. Without her, this volume simply could not have been produced.

LEWIS EDWIN HAHN
EDITOR

SOUTHERN ILLINOIS UNIVERSITY AT CARBONDALE
JULY 2000

INTRODUCTION

The thought of Jürgen Habermas represents today one of the most significant contributions to the development of Western thought in the twentieth century. Such judgments have perhaps become rather commonplace in the wake both of his astoundingly diverse body of work and his vast influence in so many fields of academic interest and beyond. Nevertheless, his thought has initiated some of the most important philosophical debates and shaped many of the defining trends of the intellectual landscape of the postwar era. As a result, Habermas's work has generated a wealth of critical discussion over the last several decades. Yet, a rather striking and persistent divide has often characterized these investigations. They consist largely, on the one hand, of works of careful exposition and sympathetic development or, on the other, of general critiques and strident polemics. All too often the fundamental systematic character of Habermas's thought has been lost in the work of interpretation or rendered a mere cliché in vague denunciations.

The aim of the present volume is to begin to bridge this divide. It seeks to do so by bringing together a collection of new essays that critically evaluate the various facets of Habermas's work in terms of the whole of his thought. The hope is that in this light a better understanding and exploration of the set of systematic problems that provide this work with its inner coherence will become possible and, as a result, that the question of the future of Critical Theory itself can once again be opened.

The organization of the volume reflects the systematic character of Habermas's project. At the core of this work, of course, stands Habermas's attempt to develop a communicative conception of human rationality. Habermas continues to share the belief, following the early work of Horkheimer and Adorno, that the creation of a genuinely rational social order is deeply bound up with the formulation of a more expansive conception of reason than that which came to dominance in the Western intellectual climate of the postwar period. The development of the theory of the norms of communicative competence and the defense of the emancipatory ideal of modernity that derives from this, which Habermas was able

to achieve in the late seventies and early eighties, thus forms the theoretical basis for the rest of his work. But it is his fundamental commitment to the practical import of theory that has subsequently led him to explore the ramifications of communicative rationality in the fields of ethics and political theory, and its significance for debates concerning the proper roles of science and technology. It has also forced him to reconsider his own intellectual roots in Historical Materialism and the Frankfurt School, as well as the contributions of such other traditions as Analytic Philosophy, Hermeneutics, and American Pragmatism. The division of the essays presented here seeks to facilitate examination of each of these aspects of Habermas's work.

Part I considers the basic elements of Habermas's theory of communicative rationality. The essays fall into three basic groups. James Bohman, Lenore Langsdorf, and Carlos Pereda examine Habermas's theory of universal pragmatics, demonstrating its centrality to his project and considering both its possible efficacy and inherent limitations. These are followed by a set of essays that investigate various aspects of Habermas's defense of modernity. Alexander Bertland, Paget Henry, Garth Gillan, and Eduardo Mendieta explore Habermas's attempt to distinguish modern rationality from what he considers pre-Enlightenment forms of thought, principally mythology and religion. Thelma Z. Lavine concludes this discussion with a comparison of Habermas to several of the most important historical figures in the debate over the project of rehabilitating the Enlightenment. The section closes with Beth J. Singer's innovative extension of Habermasian pragmatics to a field that has thus far been rather neglected, artistic creation.

Part II considers Habermas's theory of communicative ethics. W. S. K. Cameron's essay combines careful exposition of Habermas's discourse ethics with a critical examination of the relationship between the universalistic elements of Habermas's account and the significance of social and historical context. The essays by Chung-ying Cheng and Enrique Dussel bring important non-European perspectives to bear on Habermas's moral theory, considering its unacknowledged assumptions as well as its relevance and applicability outside the Western European traditions from which it emerged.

Part III explores Habermas's theory of communicative politics. The essays here again fall into three natural groups. Douglas M. Kellner, David Ingram, and Paul G. Chevigny discuss the central tenets of the deliberative model of legitimacy that underpin Habermas's account of political and legal authority. The next set considers the relationship between Habermas's defense of political democracy and various pressing social and political

issues. Lorenzo C. Simpson and Martin Beck Matuštík explore the questions of cultural diversity, identity, and responsibility that seem to present some of the most substantive challenges to Habermas's views, while Scott Bartlett and Max Oelschlaeger discuss the significance of a democratic way of life and a sustained environment as prerequisites for the kind of institutional democracy Habermas defends. Finally, Bill Martin examines the limitations of the ethical-political universalism at the center of Habermas's political project in terms of several of the stances he has adopted on matters of global concern.

Part IV moves beyond the various elements of Habermas's project proper to its immediate roots and the traditions with which it has entered into conversation, as well as its relevance for matters of practical concern. William L. McBride and Marie Fleming take up the question of Habermas's relationship to Historical Materialism, examining in particular his own reconstruction of this tradition and whether this provides an adequate account of some of the most basic problems that have played such a central role in this tradition. G. B. Madison and Richard E. Palmer return to the set of issues that first arose in the encounter between Habermas and Gadamer and assess the opposing positions. Finally, Larry A. Hickman and David Detmer consider Habermas's analyses of the role of science and technology in modern society, while Robert Young probes Habermas's work in search of its relevance for education.

Part V closes the volume by looking to the future. James L. Marsh's work, *Critique, Action, and Liberation*, represents an attempt to engage with Habermas's thought in a way that advances its fundamental concern with emancipation and social transformation. The essay included here is an elaboration of the basic claims of that work, but now with an eye to specifying precisely where Marsh believes Habermas fails to hold true to the task of liberation. Marsh does this by identifying those features of Habermas's view that he believes lead him into conflict with his own earliest concerns with the pathological and conservative tendencies supported by contemporary forms of capitalism. This piece thus brings the volume full circle. It assesses Habermas's project of communicative rationality in terms of its own underlying motive and in doing so points towards at least one way of thinking about what the future of Critical Theory might be.

Together, then, the essays collected here afford a uniquely comprehensive view of Habermas's thought, one that attends to its systematic coherence without losing its critical perspective. The essays thus provide a rich resource for further development of the various facets of Habermas's work and of the project that that work embodies. However, what is of the

utmost importance is that the depth and breadth of Habermas's theory provides an unparalleled opportunity to consider the fundamental problems of our time. The contributors to this collection have sought to take up this challenge. The hope is that their work will prepare the soil for further exploration.

KEVIN THOMPSON

SOUTHERN ILLINOIS UNIVERSITY AT CARBONDALE
JULY 2000

PART ONE

COMMUNICATIVE RATIONALITY

1

James Bohman

Distorted Communication: Formal Pragmatics as a Critical Theory

When water chokes, what is one to wash it down with?
Aristotle, Book VII.2, 1146a

Like many other theories of rationality, the theory of communicative action offers its own distinctive definition. In good pragmatist fashion, Habermas's definition is epistemic, practical, and intersubjective. For Habermas, rationality consists in neither the possession of knowledge nor the consistency and content of one's beliefs, but rather in "how speaking and acting subjects acquire and use knowledge."[1] Such a broad definition suggests that the theory could be developed through explicating the formal conditions of rationality in knowing and reaching understanding through language, and this task falls primarily on "formal pragmatics." The positive goal of such a theory is not only to provide a rich enough account of the structure of communicative action needed for a "comprehensive" theory of rationality, it must also be normative enough to be able to clarify the necessary conditions for its employment. Suppose such a theory exists. A problem arises: what if communication itself becomes so restricted that it is no longer cognitively reliable or normatively appropriate? What if it is "distorted" to such an extent that it is no longer the intersubjective medium by which agents could reflect upon how they use their rational capacities? Here we seem to have reached a paradox, a paradox that has been noted in most accounts of irrationality since Aristotle. If communication is the medium of self-reflection, it may well be that such free self-reflection cannot take place under the certain conditions of communication. What does the critic do when communicative rationality fails?

Habermas solves the paradox of communicative irrationality in an

account of "distorted communication," a problem for speech that is anal-
ogous to Aristotle's diagnosis of the problems of curing akrasia in action:
what to do "when water chokes," when the medium of reflection and testing
also is so restricted as to frustrate any self-correction.[2] While Aristotle can
appeal to cultivating those virtuous dispositions through habit in order to
make rational persuasion effective, the problem of a cure is particularly acute
for Habermas's account. If "the public use of reason" is the location both for
social criticism and for political decision making, then it seems that there is
nothing outside of communication itself that could administer the proper
corrective. While Habermas has so far limited the use of his formal
pragmatics to developing theories of normative justification for various
domains, his own attempts to extend such an analysis from discourse to
practices and institutions such as law and democracy requires considering
the ways in which actual relations of power and other social asymmetries
undermine the conditions of successful discourse and communication. Such
a normative and critical use of formal pragmatics is also consistent with
Habermas's initially strong claims that the philosophy of language could
provide the "foundation" for a broadly based empirical research program for
studying the normative basis for social order.[3]

Lying at the intersection of the philosophy of language and social theory,
the theory of "distorted communication" is the critical dimension of formal
pragmatics, a theory that can perform at least some of the functions
traditionally in the domain of the theory of ideology. "Formal pragmatics"
is Habermas's term for a general account of the capacity of a speaker to use
and understand speech acts correctly. It analyzes the general and necessary
conditions for the use of valid symbolic expression and thus uncovers their
basic and implicit normative structure. Although it may be assigned a
foundational role in the social scientific analysis of rationality (due to the
special status of language use and argumentation), it is one of many
"reconstructive sciences." While empirically informed, such a reconstruction
of speech is inherently normative, in the sense that it is one of the disciplines
that reconstruct a common domain: "the know-how of subjects who are
capable of speech and action, who are attributed the capacity to produce
valid utterances, and who consider themselves capable of distinguishing (at
least intuitively) between valid and invalid expressions."[4] This domain is
rather large, including the capacities to produce and evaluate correct
inferences, grammatically correct sentences, effective instrumental actions,
and so on. The focus of formal pragmatics is on the know-how necessary for
producing and evaluating correct and incorrect expression or valid and
invalid utterances, or for producing well-formed utterances that meet the
implicit conditions of successful communication. The guiding assumption
of a "formal" pragmatics is that these conditions can be explicated from the

"internal organization of speech," represented in the "standard" or "normal" form of complete speech acts.

More than just reconstructing an implicitly normative know-how, Habermas is clear that such reconstructive sciences obtain a "quasi-transcendental" status by specifying very general and formal conditions of successful communication. In this way, their concern with normativity and with the abilities needed for rationality in Habermas's practical and social sense permits them to acquire a critical role. Certainly, the goal of the reconstructive sciences is theoretical knowledge: they make such practical know-how explicit. But insofar as they are capable of explicating the conditions for valid or correct utterances, they also explain why some utterances are invalid, some speech acts unsuccessful, and some argumentation inadequate. Thus, such sciences "also explain deviant cases and through this indirect authority acquire a *critical* function as well."[5] Such performances are "deviant" not simply due to the fact that a speaker makes a false assertion or makes an invalid claim, but at a deeper normative level: in their failure to meet certain necessary conditions for successful communication. Unlike linguistic or communicative incompetence, severe brain injury, developmental disability, or inadequate knowledge of a second language, these performances do not simply fail to achieve their aims. Nor are they the result of merely ambiguous expression, ordinary miscommunication, or common misunderstandings; those cases of pragmatic failure are not "systematically distorted" and thus can be corrected by the means of normal communication. Rather, a theory of distorted communication examines the range of cases between error and incompetence, cases which are also "systematic" in the sense that their success violates the normative conditions that make communication possible. By making the implicit conditions of communicative success explicit, the theory of distorted communication explains such communicative actions as "deviant" to the extent that they always involve the violations of norms which make utterances correct or incorrect.

In what follows, I modify Habermas's account of distorted communication to make it more consistent with his more fully developed view of formal pragmatic norms and their critical role. This reconstruction has three steps. I first develop the account of the implicit normative structure of speech acts developed in Habermas's discussion of explicit norms of acceptability through the orientation of utterances to particular validity claims. I then turn to Habermas's own discussion of distorted communication, which does not adequately describe the paradoxical condition of distorted communication as communication that violates its own conditions of success. Rather, Habermas prefers to explain distorted communication causally as "latent strategic action." While such actions do indeed violate the explicit norm of sincerity, this description does not show how they systematically distort

communication. Third, I argue for an alternative and more general account of distorted communication as violating norms already implicit in what we do in communication rather than explicit norms, counterfactual idealizations, or regulative ideals. That Habermas himself already uses formal pragmatics in this way can be seen in his claim that "cultural traditions have to exhibit certain formal properties if rational action orientations are to be possible."[6] The theory of distorted communication adds a dimension to normative theories of institutions such as democracy and science: it shows that they promote rationality through their implicit communicative infrastructure rather than their defective forms of explicit justification. Most of all, formal pragmatics thereby becomes a critical theory in the fullest sense. It shows how the norms operative in ordinary communicative practice provide a sufficient basis for speakers to analyze and criticize the communicative medium. Aristotle's problem can be solved by going beyond the explicit level of norms of justification to the implicit practical norms of communicative success. Indeed, the fact that these norm violations are implicit explains what seems paradoxical at the explicit level: how it is that such irrationality persists and how distortions may restrict communication practices and institutions which make these very norms explicit.

FORMAL PRAGMATICS: IMPLICIT NORMS OF COMMUNICATIVE SUCCESS

Before turning to the way that formal pragmatics makes norms of communication explicit, let me begin with some general remarks on Habermas's theory of meaning. Habermas's philosophy of language combines two of Wittgenstein's slogans about the social and practical character of meaning: "meaning as use," as it has been developed in John Searle's speech act theory; and "meaning is justification," as it has been developed by Michael Dummett's anti-realist interpretation of truth conditional semantics. On the one hand, Dummett's verificationism does not do full justice to Wittgenstein's idea of meanings as justification and must be expanded to the notion of "acceptability conditions" for a broad spectrum of speech acts. However narrowly it conceives of such conditions, the program is based on the "internal connection" between meaning and validity. On the other hand, Searle's contribution is to make utterance meaning central and thus pragmatics prior to semantics. Nonetheless, his speech act theory fails to provide a sufficient analysis of the distinctiveness of illocutionary force of different types of speech acts.

Combining the strengths of both of these theories of meaning, Habermas argues that the proper understanding of the meaning-conferring properties of validity claims (truth, correctness, and truthfulness) simultaneously

classifies utterances into types and gives them their illocutionary force. The acceptance of such a claim provides the utterance its intersubjective "binding and bonding force." While validity claims may remain implicit so long as communication is unproblematic and ongoing, competent speakers may also demand the implied warrant be redeemed and demand explicit justification in second-order communication (or "discourse") in order to reach an understanding. Habermas locates the rational potential of communication in discourse, in the explicit and second-order capacities of acts to produce reasons for their own claims and evaluate the reasons offered by others; they thereby engage in argumentation, through which the implicit basis of ongoing communication (accepted "until further notice" in Garfinkel's phrase) is suspended and made the basis of explicit testing, judgment, and assent.

Illocutionary force may be examined by considering "standard" or "typical" cases of utterances that represent pure types, oriented to a specific validity claim, such as the assertion of a fact as true. Such claims may be implicit in the utterance, so that a warrant is attributed to the speaker that he or she could "redeem" these claims when asked for reasons. This activity of giving and asking for reasons is made possible by the implicit structure of utterances, in virtue of which they are able to make claims at all. The structure can be exhibited in the internal organization of utterances, a norm-bearing structure that can be made explicit in any attempt to understand them. Comprehensible utterances exhibit this structure in the form of a completed speech act: they "say something to someone about something." To put it more formally: S (speaker) says (illocutionary verb) that p (propositional content) to H (hearer).[7] This structure requires that the production of a well-formed utterance have a particular internal organization if it is to be accepted or rejected by a hearer at all. Just as Frege thought that the component words together make up the truth conditions of the sentence, Habermas thinks that the component parts of an utterance taken together constitute its acceptability conditions. The basic structure requires that speakers connect three implicit component parts in order to complete any successful utterance: the intentional, illocutionary, and propositional components join together to form a complete and interpretable utterance.

The role of each component may be explicated in terms of the force of the utterance as a whole. The propositional content is explicated in a meaning-preserving assertoric sentence. The intentional component of an utterance has two possible explications: if it is an illocution, then speaker's meaning and linguistic meaning are identical; if it is a perlocution, then the utterances must be put in terms of some first person sentence describing the aim of the speaker. Finally, the illocutionary verb specifies the type of speech act that it is and the sort of acceptability conditions associated with

it. While all three components may be explicated independently and thus be seen as performing different tasks in communication, they are all present in any complete utterance and thus form necessary conditions for reaching understanding.

When "someone says something to someone about something" success-fully, these component parts of utterances form a complete speech act. Its success can be measured in terms of its uptake in the hearer in a "yes/no attitude" towards the claim that the speaker has offered. Different functions of communication emphasize different aspects of the internal structure of an utterance, so that each type of speech act represents different possibilities inherent in the competent production of a meaningful utterance. Habermas identifies three such general or pure types corresponding to different functions of communication, and I shall use the internal structure of such utterances as the guiding thread for such a classification in place of Habermas's own use of validity claims.[8] As I will show, this alternative classification permits a fuller account of the deviations from the necessary conditions of successful utterances than simply their implied claim. The basic idea is this: the component parts of a successful utterance form an internally connected and coherent whole; in an unsuccessful utterance, these connections are not made even though the utterance appears to be well-formed.

In cases of ordinary unsuccessful utterances, speakers fail to contract utterances with sufficient structure to communicate a claim. In distorted communication, speakers construct utterances that violate conditions of successful communication and nonetheless receive uptake. In such cases, the use of an utterance is problematic in ways that miscommunication and misunderstanding that is corrected by meta-communication are not. Rather than simple failure or error, distorted communication involves a pragmatic paradox of some sort or another: it resembles successful communication but at the same time does not have all the consequences and obligations for speakers and hearers that such communication ought to have. Here "double binds" (such as paradoxical commands that make uptake by the hearer impossible) and "disqualification" of an utterance by the speaker or hearer (such as the myriad ways of "saying something without really saying it") represent pure types of distorted communication whose logical structure is a pragmatic paradox.[9] Empirical research has shown that such apparently well-formed yet implicitly incorrect utterances are found in a variety of asymmetrical contexts, including some interactions between parents and children, or native and non-native speakers, and in many situations of conflict.[10]

If this implicit normative structure properly characterizes and makes manifest the conditions of communicative success for any speech act, the

analysis of such distorted communication proceeds in three steps. First, it shows how the internal structure of successful communication exhibited in complete speech acts may be violated. These violations occur in all utterance types and undermine what it is that they are supposed to do: how they raise claims, constitute social relationships, or express intentions. Second, it shows that such apparently successful communication does not produce the usual speech-act immanent consequences and obligations demanded in subsequent communication. This means that such distortions are neither simple errors in communication nor violations of explicit rules. Rather than operating within the implicit normative structure and suppositions of ordinary communication, the success of such utterances depends upon asymmetries in communication produced by social relations of power between speakers and hearers. In bypassing communicative constraints, their success can only be maintained by restrictions and barriers on communication. Third, any theory of distorted communication must also specify how such paradoxical restrictions are overcome and the conditions of communicative success transformed. The speech of social critics attempts to unblock communication by making distortions explicit, thus initiating acts of reflection that aim at restoring the conditions of genuine communicative success. They do this by employing the resources of undistorted domains of communication and then attempting to build these norms into expanded or novel social practices. In this way, formal pragmatics may take on the theoretical role of traditional ideology critique, without the usual claims to epistemic superiority and the attendant problems of performative contradictions in acts of criticism.

THE PRAGMATICS OF DISTORTED COMMUNICATION: VIOLATING IMPLICIT NORMS OF COMMUNICATIVE SUCCESS

In the three general types of speech acts identified by Habermas, meaning accrues by its connection to a particular sort of content that an utterance makes manifest: meaning and validity, meaning and action, and meaning and intention, corresponding to the cognitive, regulative or coordinating, and the expressive functions of communication.[11] Here the pragmatic violations of norms of communicative success works much the way that Marx thought ideology produced representational failure: for Marx, ideology "represents something without representing something real."[12] In each case of distorted communication as "disqualified" speech, a speaker "says something to someone without really saying it." A well-formed utterance of each type thus fails to accomplish its communicative function, whether it be an assertoric, regulative, or expressive utterance.

Assertions play a particular semantic role by virtue of their capacity to make explicit the connection between meaning and validity especially prominent in cognitive language use and in justification.[13] Their manifest relation between *meaning* and *validity* makes possible the "exacting form of communication" peculiar to argumentation, which under normal circumstances allows us to learn from our mistakes and biases.[14] By failing to make the relation of meaning and validity manifest in the utterance, distortions of communication of this sort inhibit rational testing and argumentation. Speakers may, for example, answer different and less fundamental criticisms, say in the case of the confirmation bias of a research program in decline.

In the communicative function of regulative utterances such as promises, something different is at stake: they coordinate action and establish a relationship between speaker and hearer through creating obligations to each other for subsequent interaction. Distortions of communication of this type inhibit the formation of common obligations that result from the mutual acceptance involved in successful utterances of this sort. They connect *meaning* and *action* in successful utterances by setting out the performance of conditions that speakers will make true as actors. Such a failure may mean that only one speaker is obligated in subsequent performances.

Finally, expressive utterances make manifest the relation of *meaning* and *intention*. This connection is successfully made only if the speaker commits himself to act in particular ways in the future. Distortions in communication of this type emerge when utterances of this type fail to bind the speaker to the obligations that are entailed by the expression. In each case of distortions, asymmetries of power make it such that the normative obligations of communicative success are not self-binding upon some of the participants in communication: they can ignore their obligation to provide justifications to other interlocutors when challenged, to bind themselves with others, and to commit themselves to particular sorts of actions without injuring their chances of success.

While this conception of distorted communication is consistent with his formal pragmatics, Habermas does not develop his own account of distorted communication in these terms. Rather, Habermas considers distorted communication to be a form of "latent strategic action" operating undetected in communication.[15] While such a description emphasizes the use of non-communicative means to achieve success, it has limited empirical scope and is best suited to distortions in regulative speech acts. However, in other writings, Habermas offers other descriptions that depend upon a broader definition of distorted communication and are related to his effort to integrate a normative account of communicative action into a broader social theory. Such a theory would also have to incorporate a positive conception

of what Habermas calls "communicative power," or power generated by the self-binding of speakers in the commitments and obligations inherent in their speech; such power is not instrumental, and hence neither coercive nor linked to domination. Rather, it is the power that results from mutual cooperation, from agents "acting in concert."

Habermas has two more directly pragmatic ways of talking about distorted communication that link it to power and domination without only taking it to be a form of strategic action. The first concerns the ways in which social conflicts, inequalities, and roles affect the normative conditions of successful communication or "the internal organization of speech."[16] When this structure is understood not merely as well-formedness of utterance but as the successful linkages of meaning to validity, action, and intention, then we can see the ways in which such "external organization of speech" might overburden its internal structure and thus undermine the capacity of participants to create and enforce the normative obligations inherent in their utterances. The other description that goes beyond latent strategic action sees distorted communication functionally, in terms of "structural restrictions on communication" that constitute and express relations of domination of power.[17] Restrictions on communication undermine communicative success, allowing acts and expression and understanding to be limited in such a way that consensual means may be used to establish, justify, and reproduce conflicts and inequalities.

Examples of this sort of restriction are imposed on topics and themes of political discussion and decision making, so that fundamental concerns of certain groups are never expressed or incorporated into the decision-making process. Such restrictions may create informal mechanisms of political exclusion. While it is true that ideologies no longer supply the semantic resources for the justification of relations of power and domination, they now take the form of restrictions on public communication and testing of communicative success. Far from coming to an end, as some have asserted, ideologies now have taken a different form. The critique of ideology is now pragmatic rather than semantic, the object of which is now those restrictions operative on the implicit level of communication rather than the explicit level of justification.[18] Such implicit restrictions emerge in two distinct situations. The first is found in long-term and trusting interpersonal relations (such as in the family) where conflicts remain hidden for the sake of the maintenance of trust and the lack of practical credibility of any alternatives.[19] The other situation is found in institutions which make the conditions of communication explicit in publicly recognized and legally enforced norms. Such institutions are governed by the explicit norms that determine the conditions of communication within them: specifically, freedom, equality, and publicity. In permitting many correct performances, these open textured

norms are not sufficient to make violations of implicit norms of communicative success impossible and thus leave open possibilities of communication distorted by power. In the next section, I show that their critical power depends on seeing how implicit conditions of communication undermine the use of explicit institutional norms, particularly in the political domain where the distribution and generation of power is at issue.

DISTORTED COMMUNICATION IN INSTITUTIONS: DEMOCRACY AS MAKING EXPLICIT NORMATIVE EXPECTATIONS OF COMMUNICATIVE SUCCESS

Democracy traditionally refers to a specific set of institutions which assure citizens' self-rule via procedural mechanisms that, at the very least, permit equal access to political influence. For example, making decisions according to voting rules such as the formal principle "one person, one vote" also attempts to assure such equality by distributing political power widely. Other decision rules would require different forms of equality: in Habermas's notion of "deliberative politics" in the constitutional state, equal chances to participate in deliberation might be conjoined with mechanisms of decision making by majority rule.[20] In this case, a conception of justification grounded in the formal pragmatic conception of justification would inform the design of such institutions. However important they may be, the necessary conditions for democracy are not exhausted by explicit rules of justification or the distribution of power in decision making. Besides the background of common knowledge of such rules and of a shared political culture, democracy in general and deliberative democracy in particular requires a particular communicative infrastructure. Without the effective operation of implicit norms of communicative success as a resource available to all, formal procedures and institutions, no matter how well designed, will not succeed in distributing power in accordance with explicit norms of political freedom, equality, and publicity.[21] Such norms must also be implicit in communicative practices, even if they are governed by discursive modes of justification. The lack of consideration of the relation between implicit norms of communicative success and explicit norms for the distribution of power has led to practical deficits in how Habermas thinks of implementing deliberative politics.

Rather than only being a set of explicit principles of justification and institutional decision rules, *democracy* is also a particular structure of communication. It is a structure of communication among free and equal citizens. By contrast, *ideology* restricts or limits such processes of communication and the conditions of success within them. Ideology as distorted communication affects both the social conditions in which

democratic discussion takes place (what Habermas calls its "external organization") and the processes of communication that go on within them (their "internal" structure). The theory of ideology, therefore, analyzes the ways in which linguistic-symbolic meanings are used to encode, produce, and reproduce relations of power and domination, even within institutional spheres of communication and interaction governed by norms which make democratic ideals explicit in normative procedures and constraints. As a reconstruction of the correct insights of the Marxian critique of liberal ideology, the theory of distorted communication is therefore especially suited to the ways in which meanings are used to reproduce power even under explicit rules of equality and freedom. This is not to say that explicit rules are unimportant: they make it possible for overt forms of coercion and power to be constrained, the illegitimacy of which requires no appeal to norms implicit in practices.

Democratic norms of freedom can be made explicit in various rights, including civil rights of participation and free expression. Such norms are often violated explicitly in exercises of power for various ends, such as wealth, security, or cultural survival. Besides these explicit rights, such coercion also violates the communicative freedom expressed in ignoring the need to pass decisions through the taking of yes/no attitudes by participants in communication. But such communicative freedom may also be violated implicitly, whenever the discrepancies in the scope of agency freedom in a polity are sufficiently large that more powerful groups may reach their goals without the need of exercising their own communicative freedom. Violations of communicative freedom may remain implicit: the success of a deliberation may simply not be a matter of putting one's reasons up for evaluation by others when one avoids communication altogether. Contested topics may simply be avoided. For example, large advantages in the agency freedom of one group over all others may be due to the possession of vastly greater resources or other forms of social power; the achievement of their goals may not depend upon the consensual resolution of a conflict with groups with less social power. If Przeworski and Wallerstein are right, powerful economic groups have historically been able to attain their agency goals without explicitly excluding topics from democratic discussion but by implied threats and other nondeliberative means.[22] Threats of declining investments block redistributive schemes, such as those that would burden such groups with higher tax rates; such credible threats circumvent the need to convince others of the reasons for such policies or to put some issue under democratic control. The excessive agency freedom of some and the lack of social power of others means that some dissenting reasons will not become topics to be recognized or respected. Similarly, the mobilization of bias in large organizations through the agenda setting process is also due to the social

power of persons of particular organization statuses to define the scope of deliberation and restrict political communication by defining those topics that can be successfully introduced and made to become the subject of public agreement.[23] Such distortions often lead to cognitive distortions, such as ineffective policies and inefficient means to achieve them. In all such cases, the lack of communicative freedom of some speakers makes it such that on-going communication need not make connections between meaning and validity explicit.

Another such example of distorted communication has to do with the entry requirements for *public* speech and hence violations of publicity. These barriers are not always the result of the unequal distribution of resources and powers which restrict the value of communicative freedom. Rather, the problem is that some speakers experience difficulty in receiving uptake from others, so much so that they do not have the reasonable expectation of communicative success. Certainly, communicative interaction is marked by uncertainty, especially in situations of initial communication.[24] But repeated interaction that would be typical among free and equal citizens in a polity would decrease such uncertainty over time, so that conditions of relatively unrestricted communication would lead citizens to have the reasonable expectation of influencing decisions in their favor. In situations of distorted communication such an expectation is not formed, and repeated interaction does not decrease uncertainty. This effect is the result of implicit restrictions on public expression, whether due to inadequate development of public capacities and powers or to the lack of social recognition of one's reasons or the way in which one makes one's claims. A speaker capable of full public functioning need not expect to be able to determine the outcome of deliberation. However, all must successfully be able to initiate communi-cation about interests and needs. Such expressive restrictions are typical in cases of inequalities of status, race, and gender and lead to the often implicit and publicly unrecognized exclusion of participants in public life dependent on receiving uptake from others, affecting opportunities to speak in implicit norms of turn-taking, interruptions, and topic changes. Such distortions of interaction may be analyzed in terms of "gender codes" that operate on an implicit level and undermine conditions of communicative success even as they maintain social interaction. In all such cases, some dominant group's control over "the means of interpretation" restricts the socially acceptable possibilities of expression and uptake needed to create mutual obligations.

As a restriction in communication, any systematically distorted com-munication is a violation of the norms of openness essential to publicity. But publicity also marks a particular form of communication directed to an indefinite audience, and such communication becomes systematically dis-torted when it violates the conditions for successful communication to such

an audience. For example, such communication becomes distorted when an indefinite audience is confused with a specific audience, as when speakers presuppose particular communication styles or cultural assumptions. Dominant social groups see their own characteristics as invisible or "unmarked," leading to implicit definitions of an indefinite audience that undermine the conditions of successful public communication. Such assumptions may include the definition of public communication itself, so that the communication styles of some groups are interpreted as "restricted linguistic codes."[25] Here what speakers do is not connected with the regulative norms that they give themselves explicitly. Even as they fail to connect meaning and action within the constraints of publicity, such speakers may succeed nonetheless due to current definitions of the norm in use. Other such violations of the conditions of successful communication empty public speech, making it repetitive and inauthentic. For example, the repeated use of promises that do not result in appropriate actions make such speech acts meaningless and empty gestures that require no discussion or real uptake by portions of the public who lack the ability to withdraw from the normative obligations and consequences of such incomplete speech acts.

Besides such an account of power and domination, any account of ideology must also give an account of what it is that critics do to overcome it. Given that distorted communication can be described both functionally as restrictions in communication and normatively as communication that violates conditions of communicative success, correcting and overcoming distortion must take a variety of forms depending on the sort of violation of implicit and explicit norms of communicative success. Violations of implicit norms can sometimes be overcome by instituting the constraint of explicit norms when none exist; basic civil rights may need to be interpreted so as to establish and guarantee a minimum threshold and the fair value of communicative liberties. Such addition of new norms or the reinterpretation of old ones may require a period of what Ackerman calls "constitutional politics" within an existing democracy.[26] Analogous processes of change may occur in other discursive institutions such as science. Because of their implicitness, the violation of such norms may require special forms of communication to overcome them: critics may first have to bring about a communicatively shared experience sufficient to disclose the limitations of forms of public discourse and thereby transform the current social conditions of communicative success. Limitations on expression may demand the formation of alternative public spheres, whose developed forms of expression expand the pool of reasons and styles of acceptable public communication in the larger public sphere. In all of these cases, the critic is a participant in a communicative process governed by norms of communicative success. This makes criticism always symmetrical. Indeed, it is ultimately the bootstrapping affair

described by Aristotle's cure for incontinence. But in this case, circularity is avoided because the critic does not have to start from scratch: bootstrapping begins with the ability to participate in those areas of everyday communication, no matter how small, which are not distorted by power. So long as there exists such a domain in which implicit norms still operate correctly, critics may attempt to initiate acts of reflection on the conditions of communication themselves, thereby using communication to overcome its own internal restrictions and create a new and more inclusive public. At the very least, such reflection produces gains in freedom by permitting speakers to become aware of the ways in which implicit violations of norms limit public functioning and inhibit those very corrective and transformative performances that might change the conditions of communication.

CONCLUSION: HOW TO USE FORMAL PRAGMATIC NORMS

As Habermas conceives of it, formal pragmatics is a reconstructive theory: that is, a theory that is empirical, normative, and practical all at the same time. These are precisely the characteristics that Horkheimer identifies as distinguishing a "critical" from a "traditional" theory. Although it is clearly empirical and normative in Habermas's hands, I have shown that it is also a practical theory that aids in the diagnosis and transformation of restrictions of communication. It can be used for the goal of participatory, symmetrical, and reflective social criticism. It is thus practical in the special sense of a critical theory. It puts forth criticisms to an indefinite audience for their free acceptance, and such verification is to be found in enabling participants to understand their practices and institutions in a new and better way.

This significantly enriched analysis of distorted communication shows the limits of Habermas's own conception of formal pragmatics. He has thought of its theoretical reconstructions as making explicit the know-how needed for raising and redeeming of the validity claims that guide our speech and communicative interaction. His approach uses formal pragmatics philosophically to reflect upon norms and practices that are already explicit in justifications in various sorts of argumentation or second-order communication. Such reflection has genuine practical significance in yielding explicit rules governing discursive communication (such as Alexy's rules of argumentation), which in turn can be used for the purpose of designing and reforming of deliberative and discursive institutions.[27] It is easily overlooked that such rules are only part of the story; they make explicit and institutionalize norms that are already operative in correct language use. Such implicit norms of well-formed and communicatively successful utterances are not identical with the explicit rules of argumentation. Here Habermas has been

misled by modeling formal pragmatics on Chomsky's reconstruction of linguistic competence in a generative grammar of explicit rules governing how we actually use language. Besides the problem of the regress of rules which Wittgenstein and Brandom have shown to be unavoidable for the intellectualism of Kantian explicit rules, such an approach is insufficient to see how norms are operating in practice, whatever their rational status. If such explicit rules are said to guide practices in light of the rational reconstruction of speaker's knowledge, it is impossible to avoid a vicious regress of rules; other rules would then have to be shown to be part of a speaker's knowledge necessary to apply them.[28] Habermas's own admission that formal pragmatics is only "indirectly legislative" already takes us away from Kant's jurisprudential analogy between the necessary conditions of rationality and explicit rules. The theory of distorted communication makes no sense without rejecting this analogy: its norms are implicit in what we do in practice, not just in a speaker's general know-how.

While such implicit norms expressed in practices are open to the cognitive revision that could result from making them explicit, they are not the same as such explicit rules, nor are they captured in a normative account of explicit or discursive justification. Such norms are implicit in conditions for communicative success and discovered by explicating how complete utterances are formed and receive uptake from others. Formal pragmatic analysis does not only move upwards from intuitive know-how to explicit norms that might guide our discursive practices; it also moves downward in reflection to the implicit normative conditions of communicative success. Such a downward reconstruction proves its critical and practical significance in showing how power and other asymmetries operate to distort communication and violate the implicit norms of everyday communicative practice. Such a reconstructive science is thus not only critical; it also provides a way to explicate the implicit understandings on which explicit interpretations and justifications are based. In this way the two directions of analysis are interrelated. As the examples of democratic norms indicated, the institutionalization of explicit rules demands reflection on the conditions implicit in linguistic and communicative practices which promote or inhibit their operation in everyday life practice. Reconstructing such implicit norms is thus also the main task of the social scientist who interprets the norms implicit in practices; the task of the participant-critic in the democratic public sphere is to change them.

JAMES BOHMAN

DEPARTMENT OF PHILOSOPHY
ST. LOUIS UNIVERSITY
DECEMBER 1997

NOTES

1. Jürgen Habermas, *Theory of Communicative Action*, volume I (Boston: Beacon Press, 1984), p. 11. Hereafter *TCA*.

2. As Aristotle puts it: "To the incontinent man may be applied the proverb 'when water chokes, what is one to wash it down with?' If he had been persuaded of the rightness of what he does, he would have desisted when he was persuaded to change his mind; but now he acts in spite of being persuaded of something different; the proverb in *Nicomachean Ethics* in *The Basic Works of Aristotle*, ed. R. McKeon (New York: Random House, 1941), p. 1039. It seems that for Aristotle the already incontinent person may not be able to be cured. His appeal to habits as a means to develop the disposition to act rationally is ultimately circular: the truly incontinent individual would no more be able to act on the habit than the virtuous disposition. By contrast, Habermas is able to develop a non-circular solution, particularly since it cannot be the case that all communication in a society is distorted at the same time.

3. Habermas, "Vorlesung zur einer sprachtheoretischen Grundlegung der Soziologie," *Vorstudien und Ergänzungen zur Theorie des kommunikativen Handelns* (Frankfurt: Suhrkamp Verlag: 1984), p. 11ff.

4. Habermas, *Moral Consciousness and Communicative Action* (Cambridge: MIT Press, 1990), p. 31.

5. Ibid., p. 32.

6. *TCA*, vol. I, p. 71.

7. *TCA*, vol. I, pp. 298–99.

8. *TCA*, vol. I, p. 439. For an argument detailing the weaknesses of Habermas's method of incorporating empirical data, see my "Theoretical Strengths and Empirical Weakness," *Pragmatics and Cognition* 3 (1995): 299–316.

9. On the notion of a double bind (such as the command "Don't read this sentence!"), see P. Watzlawick, J. Beavin and D. D. Jackson, *Pragmatics of Human Communication* (New York: Norton, 1967); on disqualifications as "saying something without really saying it," see Janet Beavin Bavelas and Nicole Chovil, "How People Disqualify," *Communications Monographs* 53 (1986): 70–74. Whereas double binds occur in rigid and recurrent conflicts, disqualifications are a strategy used to avoid them (as when one wants to avoid lying *and* telling or hearing the truth). Disqualification is the broader category, since it does not require that communication be explicitly paradoxical.

10. For an excellent discussion of the widely divergent definitions of "miscommunication," see *Problematic Talk*, ed. N. Coupland, H. Giles, and J. Wieman (Newbury Park: Sage, 1991). Problematic talk is the better category than miscommunication: it encompasses any communication in which normatively appropriate expectations are violated by either speaker or hearer. See Allen Grimshaw, "Mishearings, Misunderstandings, and Other Nonsuccesses in Talk: A Plea for Redress of Speaker-Oriented Bias," *Sociological Inquiry* 50 (1980): 35ff. The conception of distorted communication as latent strategic action has this speaker bias.

11. For a fuller development of this analysis of distorted communication, see my

"Critiques of Ideology," in *The Philosophy of Language: An International Handbook*, ed. M. Dascal, D. Gerhardus, K. Lorenz, and G. Meggle (Berlin: de Gruyter, 1992); also my "Formal Pragmatics and Social Criticism: The Philosophy of Language and the Critique of Ideology in Habermas's Theory of Communicative Action," *Philosophy and Social Criticism* 12 (1986): 332–52.

12. Marx, *The German Ideology* (New York: International Publishers, 1970), p. 33.

13. For a clear analysis of the special status of assertions, see Robert Brandom, *Making It Explicit* (Cambridge: Harvard University Press, 1994), p. 156.

14. Habermas, *TCA*, vol. I, p. 22. Habermas has argued that there is no violation of truth claims that is typical of distorted communication, since these only involve mistakes or errors. But the violation of the validity claim in distorted communication is in every case implicit and therefore misstates what an account of distorted communication is supposed to analyze.

15. Habermas, "On Systematically Distorted Communication," *Inquiry* 13 (1970); this same definition continues to guide Habermas's discussion in *TCA*, vol. I, p. 278.

16. Habermas, "Über Kommunikationspathologien," in *Vorstudien und Ergänzungen zur Theorie des kommunikativen Handelns*, p. 244.

17. Habermas, *TCA*, vol. II, p. 194.

18. Habermas comes very close to an "end of ideology thesis," declaring that cultural traditions in modernity are now sufficiently rationalized so as not to be able to hide their forms of domination from critical examination within the religious and metaphysical world views. See *TCA*, vol. II, pp. 353ff.

19. Terrence Kelly, "Rationality, Reflexivity and Agency in the Critique of Everyday Life," Ph.D. Dissertation, St. Louis University, 1998.

20. For this discursive account of democracy on a "two-track model," see Habermas, *Between Facts and Norms* (Cambridge: MIT Press, 1996), chapters 7 and 8.

21. For an argument that procedures supply necessary but not sufficient conditions for successful deliberation, see my *Public Deliberation* (Cambridge: MIT Press, 1996), chapter 3.

22. See James Bohman, "Deliberative Democracy and Effective Social Freedom," in *Deliberative Democracy: Essays on Reason and Politics*, ed. J. Bohman and W. Rehg (Cambridge: MIT Press, 1997), pp. 338–39.

23. See James Bohman, "Communication, Ideology and Democratic Theory," *American Political Science Review* 84 (1990): 94–109.

24. On this sort of analysis, see Frank Sunnafrank, "Predicted Outcome Value During Initial Interactions: A Reformulation of Uncertainty Reduction Theory," *Human Communication Research* 13 (1986): 3–33. Different events can reintroduce uncertainty, something that may be desirable in periods of change.

25. On the contrast between "elaborated" and "restricted" linguistic codes in social classes, see Basil Bernstein, *Class, Codes, Control* (London: Routledge, 1967); this kind of developmental deficit provides a flavored example in Habermas's discussion of communicative competence in *Kultur und Kritik* (Frankfurt: Suhrkamp Verlag, 1973).

26. On the political process of constitutional change, see Bruce Ackerman, *We the People*, volume I (Cambridge: Harvard University Press, 1991), pp. 6–7 and 266–94.

27. Habermas, *Between Facts and Norms*, p. 230; Alexy's rules of argumentation include the following: "speakers may not contradict themselves"; "different speakers may not use the same expression with different meanings"; "every speaker must assert what he believes"; "every competent speaker may participate in the discourse"; "Everyone is permitted to express their attitudes, question any assertion, etc."; "no speaker may be prevented from speaking due to internal or external coercion." Similarly, Habermas claims that accepting such procedural conditions for discourse "is tantamount to implicitly acknowledging U" (his explicit principle of moral justification that "all those affected" must be able to accept a norm). See Habermas, "Discourse Ethics: Notes on a Program of Philosophical Justification," in *Moral Consciousness and Communicative Action*, p. 93. What we implicitly acknowledge in practice is not some explicit rule, although it could be made explicit as a practical norm. On an attempt to see legal argumentation in terms of explicit rules of justification, see Robert Alexy, *A Theory of Legal Argumentation: The Theory of Rational Discourse as a Theory of Legal Justification* (Oxford: Oxford University Press, 1989). This approach succumbs to the regress of rules argument discussed below.

28. For a thorough discussion of "the regress of rules argument," see Brandom, *Making It Explicit*, pp. 18–30. Brandom shows that the Kantian conception of norms treats them as explicit rules: "On this account, acts are liable to normative assessments insofar as they are governed by propositionally explicit prescriptions, prohibition and permission" (p. 19). Habermas succumbs to this Kantian temptation in discussing the usefulness of formal pragmatics and in this way sees them as modeled on explicit principles. I have shown here how implicit norms can be used critically, albeit indirectly. Explicit norms developed from formal pragmatics could become the basis for a normative moral or political theory in wide reflective equilibrium; the analysis of implicit norms could form the basis for critical social inquiry into normative practices.

2

Lenore Langsdorf

The Real Conditions for the Possibility of Communicative Action

. . . philosophies of the past remain open to reinterpretations and reappropriations, thanks to a meaning potential left unexploited, even repressed, by the very process of systematization. . . .

(Paul Ricoeur, 1970: 299)

. . . at least in one sense Habermas is the true heir of Husserl in late 20th century philosophy. Like Husserl he seeks to maintain the universality of reason against a conception of the world which, as lifeworld, is always particular and limited. . . . [To do that] he must part company with Husserl and much of the tradition in a decisive respect: the paradigm of consciousness, based on the subject-object relation, must be . . . replaced by the subject-subject relation of communication.

(David Carr, 1987: 20)

This is an appreciative critique of Jürgen Habermas's philosophy of communication. I speak of it as "appreciative" in light of the remarks given above as epigraphs, although I here apply Paul Ricoeur's insight to a philosophy that is quite present, rather than one of the past: Habermas's conception of formal pragmatics. The endeavor is inspired by David Carr's assessment of Habermas as heir to the Husserlian defense of reason. Carr suggests that Habermas could only accept that heritage by (so to speak) rebuilding the ancestral home—founded, Carr notes, on the "paradigm of consciousness, based on the subject-object relation"—on a new foundation: "the subject-subject relation of communication." There is ample evidence that Husserl, in his later work, also sought an alternative to the "paradigm of

consciousness." But it's all too evident that he did not accomplish the thoroughgoing revision of that foundation of phenomenology that is needed. Habermas has been far more successful in avoiding the "paradigm of consciousness, based on the subject-object relation." I argue here, however, that he has not realized his reconstruction project—an expanded conception of rationality, founded on "the subject-subject relation of communication"—because of a scarcity of building materials. His lack of success, in less figurative terms, is a result of making choices that were almost inevitable, given the intellectual context in which he developed his theory of communicative action.

With considerable hindsight—it is now thirty years since Habermas's "linguistic turn"—we can reconstruct his philosophy of communication by making other choices.[1] The reconstruction that I propose here relies upon a phenomenological concept, the lifeworld, but also accomplishes a reconstruction of that concept by understanding it as thoroughly communicative, rather than grounded in a Cartesian paradigm. In brief, I propose that Habermas's conception of communicative rationality must be liberated from its linguistic basis and epistemological focus, in order to provide a concept of human being that is useful for actual analysis of sociopolitical life. From that basis, we're also able to further phenomenology's efforts to overcome Husserl's initial egoic (consciousness-based) starting point. More specifically, the reconstruction I propose uses Husserl's "way into phenomenological transcendental philosophy by inquiring back from the pregiven lifeworld" to inquire forward, as well as back: to investigate the sociopolitical lifeworld in ways that Husserl—burdened with the vestiges of "the paradigm of consciousness"—could not.[2] The vestiges of that same paradigm in Habermas's theory, I propose, supported his turn to linguistics for a foundation for the theory of communicative action. That foundation, in turn, results in a theory that has little application to analysis of actual communicative activity in everyday sociopolitical experience.

The importance of this reconstruction for Habermas's overall project cannot be minimized. As Thomas McCarthy notes, "Habermas' entire project, from the critique of scientism to the reconstruction of historical materialism, rests on the possibility of providing an account of communication that is both theoretical and normative" and which, by virtue of that account's "theory of communicative competence," can "articulate and ground an expanded conception of rationality" (1978: 272). The potential strength of this theory remains unfulfilled in Habermas's conception of communicative competence, I propose, because of assumptions built into his starting point. When we dissolve the limitations imposed by those assumptions, we can reconstruct his theory so that it relies not just upon language—a part of communicative action—but upon the whole of communicative activity. We can then identify

multiple goals furthered by a plurality of means, rather than the single goal of understanding linked to the use of language to reach agreement (consensus). A philosophy of communication that is grounded in this broader analysis can account for phenomena—such as the actual emergence and dissipation of critical potential in social life—that are, at best, problematically theorized in Habermas's present account.

In the first of the three parts that follow these introductory comments, I sketch Habermas's reliance upon four sources for his theory of communicative action.[3] This leads (in the second part) to focusing on certain aspects of the theory which, I argue, work to suppress its effectiveness for analyzing social life. In the third part I propose an alternate mode of investigating communicative activity that begins from a characteristic of social science that is usually considered problematic: reflexivity. The result is a reconstructed formal pragmatics that has direct application to sociopolitical research in general, and communication research in particular. By proposing that reasoning norms are embedded in communicative facts, rather than derived from an ideal conception of communication, it offers a response to criticism of Habermas's theory as utopian and of Husserlian phenomenology as logocentric. Thus, I hope that this critique contributes to further development of both Habermas's theory of communicative rationality, and Husserl's project of phenomenology as based in the lifeworld.

I. An Idealized Formal Pragmatics

What raises us out of nature is the only thing whose nature we can know: language. Through its structure, autonomy and responsibility are posited for us. Our first sentence expresses unequivocally the intention of universal and unconstrained consensus.

(Jürgen Habermas, 1971: 314)

Today the problem of language has replaced the traditional problem of consciousness; the transcendental critique of language supersedes that of consciousness.

(Jürgen Habermas, 1988: 20)

Habermas's early work can be recognized as a continuation of themes that preoccupied Frankfurt School Critical Theory from its beginnings in the decade of his birth. The first mentions of communication in the titles of a speech or publication come eighteen years after the earliest entries in Rene Goertzen and Frederik van Gelder's "Bibliography of Works by Habermas" (1978: 455). Habermas, at that point, identified the goal of what came to be recognized as a "linguistic turn" in his work as "a revision of role-theory as it

is presently common in sociology" and went on to say that this "presupposes the elaboration of a theory of communicative competence" (1970c: 116). He notes that his "starting point is Chomsky's concept of a general theory of language," as based in "four basic assumptions of generative grammar" and "central arguments" from "general semantics" (1970c: 116). He also identifies a second theoretical base in speech act theory, as developed by John L. Austin and John Searle. The result, as Habermas recognizes, is "a first attempt to grasp communicative competence in terms of linguistic theory" (1970c: 145). His "linguistic turn" thus broadens the theoretical basis of critical theory from its initial dependence on the work of Marx and Freud by extending its interdisciplinary dependence from political-economic and psychological theory into linguistics and philosophy of language.

The history of Marxian theory itself, as well as in correlation with political action undertaken in the name of that theory, provides ample motivation for rethinking Marx's analysis. Habermas's contribution to that ongoing endeavor is rooted in his recognition that "Marx does not actually explicate the interrelationship of interaction and labor, but . . . reduces the one to the other, namely, communicative action to instrumental action" (1973: 168–69). Thus, Habermas returns to Marx's critical appropriation of Hegel in order to develop a non-reductive alternative understanding of communicative in contrast to productive activity, as the basis for his conception of communicative in contrast to instrumental reason. In contrast to Marx's claim that Hegel "had comprehended labor as the essence of man" (1973: 168), Habermas argues that Hegel formulated a "distinctive, systematic basis . . . which he later abandoned. The categories language, tools, and family designated three equally significant patterns of dialectical relation: symbolic representation, the labor process, and interaction on the basis of reciprocity" (1973: 142). Habermas's extended discussion of that tripartite scheme provides support for his contention that the "dialectics of language, of labor, and of moral relations" constitute "basic patterns of heterogeneous experience" that do not allow of reduction (1973: 143). "Liberation from hunger and misery" through labor/instrumental action, he concludes, "does not necessarily converge with liberation from servitude and degradation, for there is no automatic relation between labor [production] and interaction [communication]. Still, there is a connection between the two dimensions" (1973: 169).

Habermas's "linguistic turn" is an extended effort to discern that connection through a theory that delineates the correlations among, but distinctive characteristics of, these three categories: "language" (communicative action), "labor" (instrumental action), and "moral relations" (less explicitly glossed as emancipatory critical reflection).[4] His emphasis is as much on the first category (language) as Marx's was on the second (labor), and his appropriation of Chomsky's theory of language and Searle's (dependent upon Austin's)

theory of language use in speech acts raises some issues parallel to those associated with Marx's reliance upon Hegel. In the remainder of this section, I summarize those contributions. In the following section, I argue that they work against Habermas's efforts to develop a formal pragmatics that provides the structure of communicative competence and a theory of communicative rationality that parallels instrumental rationality. Before turning to those themes, however, a brief comment on Habermas's use of Freudian theory is needed.

In contrast to his extensive revision of Marxian theory, Habermas's use of critical theory's second theoretical basis, Freudian theory, is relatively straightforward. Significantly, it is marked by an alignment of Freud with linguistic theory.[5] He considers "psychoanalysis as a kind of linguistic analysis pertaining to systematically distorted communication"—speech which is "deformed" because its content is "isolated," and thus, its speaker has been "excommunicated" from the social environment because he or she does not follow "the rules of public communication" (1970c: 118). A particular mode of interpretation is required for understanding the "semantic content" of "distorted communication": the "physician . . . can construct a dictionary for the hidden idiosyncratic meanings" of the patient's speech by analyzing it as the result of "transference" rooted in "repetition of early childhood experience" (1970c: 119). The physician/analyst's task, then, is "reconstruction" of what is, for others in the relevant community, "deviant" communication (1970c: 129). Reconstruction seeks "scenic understanding" that contrasts with "hermeneutic understanding or ordinary semantic analysis" in that it requires "theoretical guidance"—such as supplied by Freudian theory—rather than relying on the "communicative competence of a native speaker" (1970c: 120–21, 128, 130). Insofar as the speaker/client accepts the analyst/physician's reconstruction, a way is opened toward reconciliation of the "excommunicated" member of the community. Habermas uses this analysis to develop an implicit analogy between "clearly pathological speech disturbances such as is observed among psychotics" (1970c: 117) and "deviance from the model of pure communicative action" that increases "correspondingly to the varying degrees of repression" characteristic of a particular "developmental stage . . . of the institutionalization of political and economic power" (1970: 146). In the second part of this chapter, I propose that this analogy is problematic in relation to theorizing actual communicative activity.

Habermas's appropriation of Chomsky's theory is modified by his understanding of "communicative action" as "interactive" or "dialogical," in contrast to Chomsky's "monological" understanding of linguistic competence. Habermas recognizes that there are "immanent difficulties which result from this [Chomsky's] model" (1970c: 132), and identifies the sources of those difficulties in certain "basic assumptions of generative grammar" (1970c:

116). These assumptions propose that the creativity of speakers, despite their limited knowledge of the "finite number of elements" comprising "every natural language," is best explained through the "postulate of an abstract linguistic system . . . of 'generative rules'" that provide "an innate language apparatus" that is "monological"; that is, "founded in the species specific equipment of the solitary human organism" (1970c: 131). This "apparatus" is present as innate "deep structures" underlying the "surface structures" of linguistic performance. It is accessible through "transformation" of those of finite elements (deep structures) into the (potentially) infinite formations (surface structures) of actual speech (1970c: 131, 133). Habermas objects that these assumptions ("monologism," "apriorism," and "elementarism") continue a tradition of theorizing syntactics and semantics "independently of the pragmatic dimensions of language performance" (1970c: 132–33). In effect, these assumptions continue the history of neglect of interaction (the pragmatic dimension) which Habermas would remedy with his theory of formal (universal) pragmatics.

The extensive criticism of Chomsky's theory that Habermas develops in arguments against these assumptions, which he identifies as basic to generative grammar, leads him to a conception of communicative competence that is "in addition to" linguistic competence, rather than simply an "application—limited by empirical conditions" (1970c: 138). The "basic qualifications of speech and symbolic interaction," he holds, are at the "disposal" of speakers by virtue of their "mastery of an ideal speech situation" (1970c: 138). This "mastery" is displayed at the level of "'doing something in saying something'," that is, in the "illocutionary level" of utterances, in which "a meaning . . . is linked to the speech situation as such" (1970c: 138). In other words, communicative competence is a characteristic of any possible speech event, as well as being displayed in particular (actual) events. Habermas thus links speech act theory's contrast between the illocutionary (performative) level and the "locutionary level" of an utterance's "propositional content" (1970c: 138) with Chomsky's proposal that performance is generated from competence, by way of rules that generate the observable (empirically analyzable) "surface structure" of utterances from a hypothesized "deep structure" of language. "Communicative competence," Habermas emphasizes in a footnote, "should be related to a system of rules generating an ideal speech situation" (1970c: 147). In another footnote, he aligns these rules with Searle's concept of "'constitutive rules' [that] do not merely regulate, they create or obtain new forms of behavior" (1970c: 147). In sum, the "elementarism" which limits semantic creativity, as well as "apriorism" and "monologism"—all of which separate syntactical and semantical aspects of language from pragmatics—are rejected through arguments that locate communication's creative potential in the "structures of culturally and historically changing world views" (1970c: 137).

Despite his extensive critique of Chomsky's generative grammar, Habermas's theory of communicative competence retains many features of Chomsky's theory. In effect, Habermas develops a "generative pragmatics" (his term is "universal" or "formal" pragmatics) that relies upon "dialogue-constitutive universals" embedded in the forms of language as well as ethnologically discovered "cultural universals" (1970c: 134–35). These two sorts of universals "enable us to generate the structure of potential speech" (1970c: 140). The communicative rules that are "mastered" by competent speakers are comparable to Chomsky's linguistic rules, but are reconstructed (by analogy to the Freudian analyst's reconstruction of "distorted communication") from the "illocutionary force" that gives utterances their "pragmatic power" (1970c: 139). In other words, communicative rules are to be reconstructed by analyzing the "performative force" of (actual) utterances—rather than sentences or propositions (theoretical entities)—and so can claim a basis in interaction (dialogue). But the reference to "potential speech" reminds us (and Habermas emphasizes) that the result is to be a general theory—such as the Freudian analyst requires—and not a mere articulation of ethnological observations of a native speaker's intuitions; that is, not "sociolinguistically limited" (1970c: 147) to particular communicative situations. Communicative competence "relates to an ideal speech situation in the same way that linguistic competence relates to the abstract system of ideal rules"; it "is defined by the ideal speaker's mastery of the dialogue constitutive universals irrespective of the actual restrictions under empirical conditions" (1970c: 140–41). In other words, the "ideal speech situation" is an "idealization" which "exists in the fact that we suppose an exclusively linguistic orientation of speech and interaction" (1970c: 144, 141). We need to look more closely, now, at how this idealization is accomplished.

In "What is Universal Pragmatics?" Habermas both develops this idealization of speech and proposes connections between idealized and empirical speech.[6] In general, idealization requires abstracting certain features of a phenomenon from our experience and constructing a concept that includes only those selected features. Thus, one could say that Marx abstracted the productive aspects of human existence from the whole of human activity in order to construct an idealization, species being, in which labor is privileged at the expense of other features of human being such as contemplative spirituality, aesthetic pleasure, or communicative interaction. Correlatively, Habermas's theory requires three cumulative abstractions. He abstracts one type of communicative action—"the type of action aimed at reaching understanding"—from the multitude of forms of human action (1976: 1). Although "understanding" can be as minimal a goal as achieving comprehensibility, it ultimately includes reaching agreement on the basis of discursively justified validity claims. This epistemic focus is joined to the "assumption that

other forms of social action . . . are derivatives of action oriented to reaching understanding" (1976: 1). The second abstraction valorizes a particular form of communicative activity: "language is the specific medium of understanding at the sociocultural stage of evolution" (1976: 1). The third abstraction "go[es] a step further" to "single out explicit speech actions" and "ignore nonverbalized actions and bodily expressions" (1976: 1; cf. 66–67). The result is a "preliminary delineation of the object domain" of formal pragmatics that accords with the specification given in "Toward a Theory of Communicative Competence": "the idealization exists in the fact that we suppose an exclusively linguistic organization of speech and interaction" (1970c: 141). The pragmatic dimension, in other words, is assumed to be congruent with, and even modeled on, the syntactic dimension that predominates in linguistic theory.

This conceptualization of idealized speech is crucial to formal (universal) pragmatics' task, which "is to identify and reconstruct universal conditions of possible understanding" (1976:1). These conditions are "general presuppositions of communicative action" which are neither physiological (for example, those relevant to phonology) nor mental (for example, those relevant to linguistics).[7] Since they are conditions for an idealization, they are not amenable to empirical inquiry that begins in "sensory experience or observation . . . directed to perceptible things or events" and seeks to "develop nomological hypotheses about domains of observable events" (1976: 9). Rather, discerning these conditions of ideal speech requires a reasoning process that begins in "communicative experience or understanding . . . directed to the meaning of utterances" and seeks to "systematically reconstruct the intuitive knowledge of competent subjects" (1976: 9). Habermas is at pains to align this reconstructive process with, but also distinguish it from, the Kantian program of transcendental analysis which seeks "a priori concepts of objects in general" (1976: 21). "Rational reconstruction" seeks instead "the basic concepts of situations of understanding" and ultimately, "the conditions for argumentatively redeeming validity claims" (1976: 23).

One abstraction that Habermas does not wish to make in this idealization is identified by Karl-Otto Apel as an "abstractive fallacy" that leads to a "logical analysis of language" which "focuses primarily on syntactic and semantic properties of linguistic formations" (1976: 5). This research tradition "delimits its object domain by first abstracting from the pragmatic properties of language" with the result that "the constitutive connection between the generative accomplishments of speaking and acting subjects . . . and the general structures of speech cannot come into view" (1976: 5). Chomsky's theory provides a clear illustration of this process. He abstracts "the underlying competence of the speaker-hearer" from "the variety of factors" involved in "actual linguistic performance" (Chomsky, 1965: 4). The idealization at the

heart of generative grammar thus requires a rather complex series of abstractions, as Chomsky moves

(a) from explicit use in actual performance, to "tacit knowledge [that] may very well not be available to the user" (1965: 21);
(b) from actual performance in concrete instances, to "a mental reality underlying actual behavior" (1965: 4); and
(c) from "the generative accomplishments of speaking and acting subjects" (in Apel's words), to the hypothesized competence of "an ideal speaker-listener, in a completely homogeneous speech-community, who knows its language perfectly and is unaffected by . . . grammatically irrelevant conditions . . . in applying his knowledge of the language in actual performance" (1965: 1).

This series of abstractions results in a conception of language in which, as Apel says, how actual human subjects constitute the connection between what they evidently do ("speaking and acting"), and what they purportedly know ("general structures"), remains outside of consideration: "If one abstracts from the pragmatic sign-dimension, then there is no human subject of argumentation. As a result, there is no possibility of reflection upon the preconditions for the possibility of argumentation that we always presuppose" (Apel, 1980: 263).

Apel's remarks on the crucial need for the pragmatic dimension if analysis is to retain its connection to the subject who engages in argumentation applies as well to any other form of communication: idealization cannot go so far as to abstract away from the subject who participates in communication. Thus, although Habermas affirms that it is "the great merit of Chomsky" to have "developed this idea" of reconstructing the "pretheoretical knowledge of a general sort" (1976: 14), the pretheoretical knowledge that Habermas seeks is quite different from Chomsky's reconstruction of syntactical rules (the grammatical deep structure) on the basis of the organizational patterns (surface structure) of language use. Habermas's project of reconstructing not simply the particular conditions of communicative activity, but the universal conditions for any communicative activity—on the basis of the participants' communicative competence—must be a pragmatics.

Pragmatics involves the relation of language (signs) to participants in communicative experience—in contrast to the relations within language (among signs) that are the domain of syntactics, and the relations of language (signs) to objects (referents) that are the domain of semantics. However, linguists seem reluctant to name the extra-linguistic term in the pragmatic relation.[8] We have formulations that refer to "interpreters" and to "the origin, uses, and effects of signs within the behavior in which they occur" (Lyons,

1977: 115, quoting Morris, 1938: 6 and 1946: 218–19). Carnap (1942: 9; quoted by Lyons, 1977: 115) edges closer: "If in an investigation explicit reference is made to the speaker, or to put it in more general terms, the user of the language, then we assign it to the field of pragmatics." Yet, bluntly speaking, pragmatics involves people, and any theory of communicative action which would be useful for analyzing actual communicative activity surely involves people—variously called actors, agents, or even, subjects. Thus we need to question whether a conception of communicative competence which "suppose[s] an exclusively linguistic organization of speech and interaction" (1970c: 141)—even one which follows from pragmatic features of linguistic organization—can be the ground for the expanded conception of reason which Habermas calls communicative rationality. We can now consider that question, in the second part of this paper, as one of three aspects of Habermas's theory that I would reconstruct.

II. THE FORMAL PRAGMATICS OF SUBJECT-SUBJECT RELATIONS

The social sciences take human and nonhuman nature in its entirety as given and are concerned only with how relationships are established between man and nature and between man and man. However, an awareness of this relation . . . is not enough to bring the concept of theory to a new stage of development. What is needed is a radical reconsideration . . . of the knowing individual as such.
(Max Horkheimer, 1972: 199)

If we surrender the concept of the transcendental subject . . . this does not mean that we have to renounce universal-pragmatic analysis of the application of our concepts of objects of possible experience, that is, investigation of the constitution of experience.
(Jürgen Habermas, 1976: 22)

There are three closely related aspects of the foundation of Habermas's theory of communicative rationality which, I would argue, frustrate that theory's ability to engage in the "radical reconsideration" for which Horkheimer called. The first aspect is Habermas's adoption of views of human being that are presupposed in the work of those theorists who provide the foundation of his theory: Marx, Freud, and Chomsky. Insofar as he accepts these presuppositions, he relies on three reductive portrayals: Marx's reduction to labor that reproduces the material environment, Freud's reduction to "isolated" speech that causes the "excommunication" of individuals from their social environment, and Chomsky's reduction of

language to the interplay of "deep" and "surface" structures.[9] The conception of human being derived from these reductive presuppositions is one which limits Habermas to a theory of communication that focuses on the nature of linguistic relationships between participants. Thus, investigation of the conditions for human relationships—and, in particular, the conditions for the constitution of the participants in relationships—is excluded from his domain of research. If we can think of the multiplicity of factors and stages that enter into communicative experience as a communicative chain—by analogy to the food chain—I would argue that Habermas's analysis begins too high up on the communicative chain.

The second aspect of Habermas's theory that limits its applicability to actual communicative activity is his reliance upon a conception of communication that is modeled on the traditional (rather than critical) social-scientific orientation of Chomsky's linguistics together with the traditional (rather than critical) philosophy of language embedded in Austin's and Searle's speech act theory. Since communication includes more than language, so we need to question whether a conception of communicative competence which "suppose[s] an exclusively linguistic organization of speech and interaction" (1970c: 141) can be the ground for the expanded conception of reason which Habermas calls communicative rationality. In effect, Chomsky's, Austin's, and Searle's non-critical theories of language use magnify the problem raised by the first problematic aspect—the failure to engage a "radical reconsideration . . . of the knowing individual as such" (Horkheimer, 1972: 199)—by bypassing that individual in order to focus on one technology, alphabetic language. By appropriating that model, Habermas has appropriated reductive conceptions of communicative activity that are appropriate for the purpose of delineating object domains within particular academic fields (linguistics and philosophy). Although his aim is to reverse earlier Critical Theory's reliance on two other reductive conceptions (by Marx and Freud), he has not provided any justification for adopting this third reduction—of communicative activity to language—in their stead.

The third aspect of Habermas's theory that limits its applicability follows from this focus on language. Along with unexamined presuppositions as to the nature of human being, and taking language as the model of communication, Habermas takes one goal that is closely tied to particular ways of using language, and posits that as the goal of all communication. That goal is understanding, which covers a spectrum ranging from mere comprehension of the syntactical and semantic features of language, to the unconstrained consensus characteristic of the ideal speech situation. There is a triple valorization here: first, language is the privileged aspect of communication. Also, discourse (an argumentive form of language that requires giving good reasons as justification for claims) is the privileged form of language use.

Finally, the epistemic goal of discourse (consensual understanding appropriate to a pragmatic conception of truth, expanded to include correctness in regard to the moral and legal domains and sincerity in regard to the personal domain) is privileged as the telos of all communication. I believe that we need to heed Ricoeur's warning here: "the process of systematization" can leave "unexploited, even repressed" a "meaning potential" (Ricoeur, 1970: 299). In this case, repression is accomplished through valorization, and the result disables the usefulness of Habermas's theory for theorizing actual communicative activity in its own right (so to speak), rather than as equated with language use for epistemic goals.

Counter-arguments can be given in relation to each of these disabling steps in Habermas's systematization. However, my purpose is not to argue against these reductions, but to release his theory from the constraints inherited from linguistics and the philosophy of language—constraints which limit its effectiveness for analyzing the sociopolitical lifeworld. In the concluding part of the chapter, I propose an alternate mode of investigating communicative activity that begins from a characteristic of social science that is usually considered problematic: reflexivity. The result is a conception of communicative rationality that supports David Carr's recognition of Habermas as the "true heir" of Husserl, insofar as he is able to replace the "paradigm of consciousness, based on the subject-object relation" with a reconception of rationality based in "the subject-subject relation of communication" (1987: 20; quoted in context at the start of this chapter). It's in keeping with that aim that I advocate reconstructing Habermas's theory on a communicative, rather than linguistic, basis. Doing that will, in effect, reverse the reductive valorizations that he inherited from the linguistic and philosophical traditions.

What's needed here is the taking of a communicative turn in formal pragmatics. We can do this by beginning with Carr's "subject-subject relation" in contrast to the "subject-object relation"—whether that be one of consciousness-world, or user-language. One difference between language and communication is that language provides relatively stable objects that can be used in a variety of contexts. Thus, language is amenable to study as an object—a status that has been exploited by a number of philosophers and linguists. Von Humboldt and de Saussure may be the most influential in relation to the models that Habermas uses. Chomsky's reference to both is indicative of the importance of their approaches. He stipulates

a fundamental distinction between *competence* (the speaker-hearer's knowledge of his language) and *performance* (the actual use of language in concrete situations). . . . The distinction I am noting here is related to the *langue-parole* distinction of Saussure; but it is necessary to reject his concept of *langue* as merely a systematic inventory of items and to return rather to the Humboldtian conception of underlying competence as a system of generative processes. (1965: 4)

For Humboldt, as Chomsky goes on to say, linguistic processes "make infinite use of finite means" (1965: 8). Chomsky understands those "finite means" as "the form of a language, the schema for its grammar, [which] is to a large extent given, though it will not be available for use without appropriate experience to set the language-forming processes into operation" (1965: 51). The Platonic undertone of this conception—which Chomsky acknowledges—reminds us of a basic presupposition of inquiry in Euroamerican scholarship: relatively static substances or concepts, in contrast to fluid processes or events, are valorized as fitting objects of investigation.

This preference for pregiven objects is evident in Saussure's lament in regard to delineating a proper object domain for linguistics. Given the importance of his decisions for the research traditions which Habermas adopts, I need to quote the relevant passages at some length.[10] Saussure begins with the observation that "other sciences work with objects that are given in advance and then can be considered from different viewpoints; but not linguistics. . . .it would seem that it is the viewpoint that creates the object" (1959: 8). "Moreover," he continues, "the linguistic phenomenon always has two related sides": sound is "the instrument of thought," and "has no existence" by itself, but "combines with an idea to form a complex physiological-psychological unit" (1959: 8). Speech (*le langage*) is the other side of the phenomenon, yet it also is characterized by multiplicity:

> Speech [*le langage*] has both an individual and a social side . . . at every moment it is an existing institution and a product of the past. . . . From whatever direction we approach the question, nowhere do we find the integral object of linguistics . . . the object of linguistic appears to us as a confused mass of heterogeneous and unrelated things. . . . [This heterogeneity] opens the door to several sciences . . . which might claim speech [*le langage*], in view of the faulty method of linguistics, as one of their objects. . . . There is only one solution: from the outset we must put both feet on the ground of language [*la langue*] and use language as the norm of all other manifestations of speech [*manifestations du langage*]. (1959: 8–9)

In the course of this delineation, language is (so to speak) purified by transferring the dreaded heterogeneity to speech. Language (*la langue*), Saussure goes on to emphasize,

> is not to be confused with human speech [*le langage*] of which it is only a definite part. . . . [Speech (*le langage*)] is both a social product of the faculty of speech [*faculté du langage*] and a collection of necessary conventions that have been adopted by a social body to permit individuals to exercise that faculty . . . speech is many-sided and heterogeneous . . . we cannot put it into any category . . . we cannot discover its unity. . . . Language [*la langue*], on the contrary, is a self-contained whole and a principle of classification. As soon as we give language first place among the facts of speech, we introduce a natural order into a mass that lends itself to no other classification. (1959: 9)

Saussure makes one further classificatory decision that is important in relation to the scarcity of building materials that I mentioned, at the start of this paper, as accounting for Habermas's turn to language in order to theorize communication. In a brief foray into the "heterogeneous . . . mass" that is speech (*le langage*), Saussure distinguishes

> an active and a passive part: everything that goes from the associative center of the speaker to the ear of the listener is active; and everything that goes from the ear of the listener to his associative center is passive; . . . everything that is active . . . is executive . . . everything that is passive is receptive. . . . Execution is always individual, and the individual is its master: I shall call the executive side speaking [*la parole*]. (1959: 13–14)

He concludes this delineation of the object domain of linguistics by emphasizing the differences among these three aspects of language use:

> In separating language from speaking [*la langue de la parole*] . . . we are separating (1) what is social from what is individual; and (2) what is essential from what is accessory and more or less accidental. Language [*la langue*] is not a function of the speaker; it is a product that is passively assimilated by the individual. . . . Speaking [*la parole*], on the contrary, is an individual act. (1959: 14)

There are two morals of this story: (1) Saussure was at pains to delineate an object domain that could be protected from colonization (so to speak) by other disciplines. (2) The hierarchy of object domains that resulted from Saussure's endeavor has survived in present day academic study of language, language use, and communication. Linguistics and philosophy departments study "language" (*la langue*) and have built substantial bodies of theory and research; communication departments study "human speech" (*le langage*) as well as "speaking" (*la parole*). Communication scholars have only recently begun to develop theory and research that does not depend heavily on the other sciences (for example, psychology) that Saussure mentioned, and are only beginning to explore their conceptual differences from the very linguistics that Saussure founded. Typically, a hierarchy among these disciplines exists by virtue of linguistics' valorized status as "science," in contrast to communication study's ambivalent placement between the human/social sciences and the humanities and its association with technique, that is, with the arts of oratory and rhetoric.[11]

This closer look at the object domain of linguistics confirms, then, that we need to go beyond a conception of communicative competence which "suppose[s] an exclusively linguistic organization of speech and interaction" (1970c: 141) if we are to reconstruct a conception of communicative rationality. For communication includes more than language. At the very least, this "more" involves the many individually and socially sedimented ways of

using language that Habermas seeks to identify in a formal pragmatics. But this "more" also requires an understanding of pragmatics that diverges from its linguistic heritage. Linguistically-based models of inquiry simply cannot accommodate investigation that takes the whole of communicative experience as its domain. Habermas himself suggests that supplementation, through speech act theory, is needed. However, I would argue that Austin and Searle retained the essential features of the linguistic tradition. As Habermas notes,

> speech-act theory thematizes the elementary units of speech (utterances) in an attitude similar to that in which linguistics does the units of language (sentences). The goal of reconstructive language analysis is an explicit description of the rules that a competent speaker must master in order to form grammatical sentences and utter them in an acceptable way. (1976: 26)

Although speech act theory does make a decisive move away from Saussure's avoidance of the heterogeneity intrinsic to speech and speaking, it accommodates communicative activity within its expanded domain to the categories of more traditional study of language. Thus, it continues traditional theory's presupposition in regard to the humans who perform speech acts: in Horkheimer's words, speech act theory takes "human . . . nature as given" and is concerned solely with the relationships that are established within the categories of speech acts. In other words, speech act theory incorporates a conception of individuals as users of language for diverse purposes, and then inquires into the nature of the relationships established by, for example, illocutionary in contrast to locutionary usage. But speech act theory does not reflect on what it takes "as given"; does not inquire into the constitutive conditions for the very being of speakers who both shape their environments by using language, and are themselves shaped by that usage.

How, then, can we investigate actual communicative activity, including the nature of those subjects who come into relation in that activity, without relying on inappropriate (to the phenomena) delineations and concepts borrowed from linguistics? One way of responding to that question begins with consideration of the first problematic aspect of Habermas's theory: his adoption of views of human nature that are presupposed in the work of Marx, Freud, and Chomsky—to which we may now add, the Saussurean view that underlies Chomsky's work. None of the models that Habermas adopted show any promise of contributing to Horkheimer's requirement that critical theory must go beyond social-scientific and philosophical examination of "relationships" that are already "established" among human beings, and engage in "a radical reconsideration . . . of the knowing individual as such" (1972: 199). One model that does respond to that requirement is the Husserlian one explicated most thoroughly in *The Crisis of European Sciences and Transcendental Phenomenology*, although it is at least hinted at by virtue of the conflict

between the Cartesian and lifeworld approaches that we can discern in most of his work.

In taking this Husserlian path, I do not intend to minimize the extent to which earlier critical theory held itself apart from phenomenology (for example, Adorno 1982) or the extent of Habermas's criticisms of Husserl's work in itself and as it influenced phenomenological sociology through the work of Alfred Schutz (for example, 1987: 129–30; 1988: 106–13). I would argue, however, that synechdoche can be seductive as well as creative. There is a general tendency, in contemporary scholarship, to take part of Husserl's phenomenology for the whole. Evidence for this tendency can be supplied by playing a word-association game, as we sometimes do for therapeutic or entertainment purposes: mention "Husserl" and the auditor produces "consciousness." The argument of the first two sections of this chapter has been concerned to undo the effects of an equally prevalent synechdoche in Habermas's work, namely, the taking of a technology, alphabetic language, for the whole of communicative activity. In the last section, I move from both of those "parts" (more precisely: products) to the whole for which they often stand: from language and consciousness to communicative activity.

III. A RECONSTRUCTED FORMAL PRAGMATICS

> . . . the concept of communicative action has to be completed through a concept of the lifeworld.
>
> (Jürgen Habermas, 1984a: 279)

> From the idea that the self is not given to us, I think there is only one practical consequence: we have to create ourselves as a work of art.
>
> (Michel Foucault, 1997: 261)

Traditional social sciences, Horkheimer objects, "take human and nonhuman nature in its entirety as given"; critical theory, in contrast, must engage in "radical reconsideration" of the given (1972: 199; quoted in context at the start of section II of this chapter). This is the meeting point of critical theory and phenomenology, for as Husserl notes, the phenomenologist also "lives in the paradox of having to look upon the obvious as questionable" (1970: 180). Husserl goes on to emphasize the radical demand of this calling: "what is peculiarly proper to . . . this phenomenological-transcendental radicalism is that . . . rather than having a ground of things taken for granted and ready in advance, as does any objective philosophy, it excludes in principle . . . any underlying ground" (1970: 181). For Habermas, the "underlying ground" discovered in his "linguistic turn" was language. For Husserl, it was consciousness. Both direct us, as Carr notes, to "subject-object relations": of

subjects to linguistic objects, or of a subject to itself as "ego-pole . . . directed toward the particular object-pole and its pole-horizon, the world" (1970: 183). However, the "concept of the lifeworld" that both Habermas and Carr recognize as needed for a non-Cartesian conception of rationality is a "subject-subject relation of communication" (Carr 1987: 20; quoted in context at the start of this chapter). In order to fulfill that need in the context of Habermas's formal pragmatics—his inquiry into the conditions for communicative activity—we need to take up the task posed by Horkheimer as well as Husserl and Habermas: the task that Husserl called "asking after the how of the world's pregivenness" (1970: 154).

The all-too-obvious answer is that the world is pregiven in communicative activity. Habermas recognizes this:

> I never say that people want to act communicatively, but that they have to. When parents bring up their children, when the living appropriate the transmitted wisdom of preceding generations, when individuals and groups cooperate, that is, when they work to get along with one another without the costly recourse to violence, they all have to act communicatively. . . . Communicative action normally takes place in a common language and in a linguistically developed, preinterpreted world, in shared cultural forms of life, normative contexts, handed-down traditions, customs, routines, and so forth. . . . (1994: 111)

This is to say that what is pregiven are the "subject-subject relations" in which we obviously take part in going about mundane life. We need to make a great intellectual effort—Husserl calls it the "universal epoche"—if we are to avoid taking the subject-subject relation as an "underlying ground," and then slip easily into objectivating that relation as either language or consciousness in semiotic or referential relations. The model for doing so is a powerful one in Euroamerican intellectual history, which has as one of its "handed-down traditions" the story of Descartes discovering the self-ratifying activity of thinking, and immediately conceptualizing that activity as the object of a thinking subject.

The intellectual effort I'm advocating adheres to critical theory's task as specified by Horkheimer: "a radical consideration . . . of the knowing individual as such" (1972: 199), and phenomenology's task as specified by Husserl (when he was not traveling a Cartesian path): an "ontology of the lifeworld purely as experiential world" (1970: 173). For Habermas, the task is the "investigation of the constitution of experience" (1976: 22; quoted in context at the start of section II of this chapter). Perhaps the most helpful clue is Habermas's reminder that acting communicatively is not a matter of what "people want," but of what "they have to" do. We leave both volition and epistemic goals aside, then, when we focus on that doing—on the activity of communicating—and seek to discern, in that "Heraclitean flux" (Husserl 1970: 156, 177), both the real and ideal conditions for its possibility.

This is a shift from epistemology (subjects engaged in knowing objects, with a concern for accuracy) to ontology (doing and affect—in the sense of constitutive, rather than causal, influence). In other words, it is a shift of interest from representations of what has been done, to how the sense of any doing emerges in communicative activity. In phenomenological terms, that shift in interest is called the "epoche": attending to the development of sense (the aiming-at or directedness-toward the environment that Husserl calls intentionality) rather than to (epistemically-oriented) accounts of what is constituted and so presents itself as "given." A phenomenologically-informed critical theory accomplishes this "radical consideration . . . of the knowing individual as such" (Horkheimer 1972: 199) by virtue of a characteristic of inquiry that is typically considered a disadvantage: reflexivity.

The history of the social sciences is burdened by the presumption that social scientists, unlike colleagues in the physical ("natural") sciences, are inevitably involved in the very objects of their investigation and thus are at risk of conflating themselves with their subject matter. Here again, we need to look more closely at what is obvious: this presumption takes it that humans are social, but—somehow—not physical; alternatively, that physical constituents of a "cultural scene" are "natural," but social constituents (including human beings, and thus the investigators under suspicion) are not.[12] Once that presumption is undone, the fact that reflexivity obliges us, as inquirers, to consider our participation in any constituting process, and thus the ultimately tentative (because intrinsically incomplete) nature of any analysis, need not be a barrier for inquiry.[13] Habermas's analysis of knowledge as infused with human interests (1965) certainly undoes that presumption, which is not to say that it ceases to inform both mundane and academic beliefs. Phenomenological analysis (by virtue of the methodological step called variation) reinforces that recognition of the persistent presence of interests by requiring ongoing attention to how else the cultural scene might be; that is, what other meaning might be actualized in any situation.[14] When analysis is of a physical phenomenon (for example, air quality; gravitational pull), it is relatively easy to suspend interest in the fact that humans participate in physical phenomena as much as in social phenomena.[15] Phenomenological method reminds us, however, of the basic requirement of all inquiry, regardless of subject matter: persistent reflexivity is needed to identify and account for that activity's constitutive effect on its context, content, and participants.

In awareness of the reflexivity inherent to any inquiry, then, we can engage in "explicating intentional life, through the epoche, as accomplishing life . . . an aiming . . . that is realized in the harmoniousness of ever new ontic validities . . . variatiational forms of accomplishments which are ultimately those of the ego" (1970: 177). The obvious danger here is presuming that this "ego" is a substance, and thus, can be investigated in terms of its relations with

other substances. There are two crucial methodological steps for avoiding that danger. The first is to resist reification; that is, to persist in investigating processes (the "accomplishing"), rather than abstracting their results ("accomplishments") as the proper focus of inquiry. Husserl's references to "Heraclitean flux" (for example, 1970: 156, 177) remind us that process thinking is a less-traveled path of inquiry in Euroamerican intellectual life; yet, it is an available option. The second step is to follow Habermas's distinction between "formal" (or, universal) and "empirical" pragmatics: the former seeks the conditions for any communicative activity whatsoever, rather than (as in the latter) for any particular instance of communication. These processual conditions are neither subjects nor objects.

The conditions of particular interest in formal pragmatics are the conditions for (in Horkheimer's terms) the "individual as such" rather than for any particular empirically existing individual (or ego).[16] Certainly, there are powerful currents that force inquiry into what are ratified as "empirical" methods and topics; yet there is an available option. Habermas chooses that option when he undertakes a "universal-pragmatic analysis of the application of our concepts of objects of possible experience" (1976: 22; quoted in context at the start of section II of this chapter). Making that choice here underlines (so to speak) the pervasiveness of constitutive activity as accomplishing ego (subject) as well as objects (subject matter). In other words: taking up the task of "explicating intentional life, through the epoche, as accomplishing life . . . an aiming . . . that is realized in the harmoniousness of ever new ontic validities . . . variatiational forms of accomplishments which are ultimately those of the ego" (1970: 177) can indeed mean that all that is, is dependent upon consciousness. But that way of making sense, when subjected to variation, uncovers another possibility for understanding the relation between ego and accomplishments: they constitute ego even as ego is accomplishing them. Their relation is an intentional one of reciprocal directedness, rather than causal efficacy.[17]

Care in taking both of these steps allows us to respond to the paradox of reflexive inquiry, which Husserl articulates as the "paradox of human subjectivity: being a subject for the world and at the same time being an object in the world" (1970: 178). The "subject for" aspect is Horkheimer's "individual as such" or Habermas's "possible experience"; that is, the conditions for communicative activity summarized in the phrase "formal pragmatics." The "object in" aspect is a particular, empirically existing individual. Thus when Husserl asks: "How can a component part of the world, its human subjectivity, constitute the whole world?" we need not be led into the "absurdity" of holding that "the subjective part of the world swallows up, so to speak, the whole world and thus itself too" (1970: 179–80). Rather, we reflexively access our own experience and discover that it is embedded in

cultural scenes which provide a multiplicity of possible conditions for constituting actualities.

Ontological clarity in regard to these conditions is vital: they are processes, rather than any sort of objects. That is to say that they are not Platonic Forms or even Habermas's "concepts of objects" (1976: 22, quoted in context at the start of section II of this chapter)—both of which veer from aspects of an ontology into elements of an epistemology. More specifically, they are practices: the "shared cultural forms of life, normative contexts, handed-down traditions, customs, routines, and so forth" that Habermas (1994: 111) identifies as the environment in which communicative action happens, and which academic wisdom typically relegates to "beliefs" in contrast to "knowledge."[18] These provide a multiplicity of possibilities at any particular spatiotemporal locus; a matrix not yet delineated into "physical" (material, natural) or "social" (historical, economic) aspects, within which subjects and objects continually form and reform.[19] In more phenomenological terms, what there is when inquiry refocuses on the conditions for the "underlying ground of things taken for granted and ready in advance" (1970: 181) is a constitutive process of actualizing certain possibilities. In and through that activity, subjects and objects are co-constituted. Nothing more is meant by "subject" here than a locus of constitutive agency, directed at (and thus giving sense to) particular aspects of a cultural scene even while those cultural forms give sense to the locus. The social praxis which is communicative activity does not wait (so to speak) for items to transmit. Rather, it transforms possibilities into actualities, and so, develops particular forms of life (in Wittgenstein's sense) or domains of the lifeworld (in Husserl's terms).

Our habits of attending to what is given, rather than to the how of that givenness, typically work to conceal communicative activity's transformation of possibilities into the actualities that we call subjects and objects. David Carr's (1997: 189–91) remark about phenomenological method is applicable specifically to this process of attending to the possibilities that are conditions for what exists: this is "not a matter of looking harder but of looking differently"; of "having a new way of looking." To take but two examples from United States history: President Truman's executive order that integrated the armed services can be looked at as actualizing possibilities that were available to him in that cultural scene (multiracial rather than segregated units; change through executive order rather than through happenstance or refusal to comply with existent practices and regulations). Likewise, extending the franchise to women can be looked at as actualizing culturally-available possibilities (irrelevance of gender in relation to voting qualifications; constitutional amendment as a way of enabling broader rather than narrower participation in the electoral process). It's important to recognize that actualizing possibilities is an intentional, rather than causal, process: possibilities are diverse ways of

making sense (instituting meaning) but do not, in themselves, cause things to happen in the world. In other words, ideas do not cause things; the intentional (sense-giving) dependence of objects upon possibilities accessible at a particular locus (moment in history and culture) is not a causal dependence upon mental processes.

Humans do cause things to happen, but here again a different way of looking is needed to dissolve the conceptual difficulties articulated by David Hume in regard to causality.[20] One way to do so is through recognizing that communicative activity functions rhetorically—or, in Husserl's terms: through the sense-giving directedness called intentionality—rather than as mental or material production. In other words, participants in communicative activity identify with particular possibilities, and so incorporate particular meanings into the matrix of actions, beliefs, and values that together may be called a form of life or lifeworld.[21] Certainly, much of human activity is a matter of the species' physical requirements (for example, breathing, eating, locomotion). But even these necessary activities, along with the vast proportion of human activity that is optional, are performed with particular meanings rather than others (which remain possible). We have a convenient name—culture—for the totality of possible meanings actualized at a particular geographical and historical moment. Language and other codes that have become sedimented in a particular cultural scene provide—as Humboldt recognized—only a finite supply of already articulated actualities. Identification with some of these, rather than others, inspires what may well be an infinity of actual cultural forms. What phenomenology does for us is impel us toward looking differently at these actualities, so that they appear as both spatiotemporally real things and as possibilities that can be actualized at any time and place that presents appropriate conditions.[22] This doubling of sense enables new questions: What other possibilities might be suppressed under current conditions? How might those be actualized?

Understanding communicative activity as constitutive is recognizing how diverse technologies (for example, alphabetic language, gesture, kinesthes-thesia, tactility, tonal variation) evoke particular actualities in a multiplicity of combinations, and so make diverse possibilities present. Novelty—that is, the incorporation, or making present, of possibilities in unique actualities—occurs even when past actuality is re-presented in a present cultural scene, since that scene inevitably is different from previous incorporations of those possibilities into other cultural scenes. Often, looking differently at the obvious enables seeing more; in this case, however, it means dissolving the obvious understanding of communication as using language to report (preferably, accurately) what is the case. Instead, we recognize that even in its representational aspirations, communicative action constitutes its context, content, and participants, even as it purports to simply tell about any or all of

those domains. The double sense of the subject in "formal" and "empirical" pragmatics is evident here also: communication is both a condition for cultural scenes and an activity in those scenes. Thus the telling in any cultural scene is, simultaneously, the making of that scene.[23]

Although much more could be said about the constitutive efficacy of communicative activity, I'll mention only two aspects of that story which are crucial for reconstructing Habermas's theory on a truly communication-theoretical, rather than linguistic, basis—and thus making the norms it proposes (in the ideal speech situation) applicable to analysis of actual communicative activity. The first is how this alternative philosophy of communication speaks to undoing the separation that Habermas makes between communicative and strategic action. The second is why this alternative philosophy of communication makes a difference for critical theory, and especially, for critical analysis of actual communicative activity in sociopolitical contexts that are arguably oppressive.

Habermas's formal pragmatics—the theory of the conditions for communicative activity—is restricted to a class of speech acts that is delineated by separating communicative action from strategic action. The difference is between communicative activity that is "oriented to reaching understanding," and that in which "validity claims are suspended" in favor of activity that is "oriented toward the actor's success," understood in "purposive-rational" terms (1970c: 35, 41). Implicit in this delineation is a transmission theory that understands communication as oriented toward the epistemic goal of accurately representing how things are, so that participants can reach consensus about those states of affairs. In contrast, a constitutive theory of communication recognizes that actual communicative activity incorporates both perlocutionary and illocutionary goals—which is to say that its goals are both constitutive and representational. In other words, the telos of communicative activity is both ontic and epistemic.

In practice, this means that participants are at least as much engaged in constituting what Foucault (1972: 37) calls "discursive formations" or "systems of dispersion" as in reaching understanding. What is "dispersed" as aspects of a cultural scene are differentially interpreted by its inhabitants as meaning. This dispersal has perlocutionary effect—including, the ongoing constitution of participants who are "actors" seeking "success." Particularly in oppressive sociopolitical contexts, when a non-engaged observer (analyst or critic) may see no means for altering the cultural scene, the "looking differently" that is phenomenology can discern participants engaged in strategic communicative action that realigns their identifications with aspects of their cultural scene. In doing that, they actualize their identities differently—and so, succeed in constituting themselves differently. Often, given the recalcitrant power of oppressive cultural forms, they are careful to conceal that success.

Paolo Freire (1970) describes this process as "conscientization."[24] Dwight Conquergood (1992) identifies it as ongoing in the lives of those who are assumed to be passive victims swept up into outbreaks of violence such as slave uprisings. On a more mundane scale, it can be discerned when substance-abusers or battered spouses "become different people," as we commonly say. Most often, these changes are ascribed to alterations in consciousness, with the implication that the strategies of social movements provide (in effect) objects with which subjects must come into relation, if change is to occur. A constitutive philosophy of communication, however, engaged for critical analysis of actual communicative activity in sociopolitical contexts that are arguably oppressive, can discern that the process may not be a matter of external forces causing (or failing to cause) internal change. Rather than Marx's analysis of political action as stumbling on the obstacle of who would educate the educators, the situation may be theorized along the line identified by Foucault (1997: 261): "From the idea that the self is not given to us, I think there is only one practical consequence: we have to create ourselves as a work of art." I have argued here against understanding that creativity in linguistic or epistemic terms. Rather, it is a matter of actual communicative activity constituting, and being constituted by, the cultural forms that are the real conditions for the possibility of communicative action.

LENORE LANGSDORF

DEPARTMENT OF SPEECH COMMUNICATION
SOUTHERN ILLINOIS UNIVERSITY AT CARBONDALE
JANUARY 1999

NOTES

1. I take 1970 as the appropriate date for Habermas's "linguistic turn." By invitation of Peter Winch, Habermas gave two lectures in London that year which were published (in their original English form) as (1970a) and (1970b). A revised version that combined the two lectures appeared as (1970c). He also gave a course of lectures during the 1969/70 Winter Semester in Frankfurt entitled "Probleme der Sprachsoziologie" (partially published in an unauthorized version as 1970d; more completely as 1971b).

This is not to say that there were no prior indications for this shift in his thinking. Preparation for those London and Frankfurt lectures, as well as the six lectures in Berlin in 1970 and those at Princeton University early in 1971 (published in [1984b]), clearly is rooted in Habermas's Inaugural Lecture at Frankfurt in 1965, which was published as an appendix in (1971). He notes there that "the human interests that have emerged in man's natural history . . . derive both from nature and from the cultural break with nature," and goes on to assert: "What raises us out of

nature is the only thing whose nature we can know: language" (1971: 312, 314). By 1968, he had formulated the distinctions between communicative and strategic action which are crucial in the theory. These are incorporated in (1973; original publication 1968) and (1970d; original publication 1968).

This line of thinking was explicitly based in works published during the decade during which the "turn" took form; for example, Apel (1963), Austin (1962), Chomsky (1965, 1968), Hymes (1967), Kamlah and Lorenzen (1967), Lyons (1968), Searle (1969), Watzlawick, Beavin, and Jackson (1967).

Correlations between Habermas's and Foucault's work that I note here and discuss elsewhere (Langsdorf 1997a) prompt me to mention that the latter's "The Discourse on Language," published as an appendix in (1972), was originally presented as a lecture in 1970.

2. The quoted phrase is the title of Section IIA of Husserl (1970).

3. Although the foundations of the theory of communication that I sketch here are venerable—when viewed in relation to the ongoing development of Habermas's work during these past decades—the factors that I identify as damaging to that theory's capacity for theorizing everyday communicative activity remain efficacious in his later work. Criticism of Habermas's theory typically focuses on his reliance upon ideality (that is, the "ideal speech situation" as a condition for the communicative activity). However, once that concept is elucidated (in terms of counterfactuals and the dual sense of "ideal" as both formal principle and maximum efficacy for a specified goal), the theory still needs attention to the real (actual) conditions for communicative activity. These real conditions are quite different if communication is understood as constitutive of participants, context, and content—rather than as a means of transmission of messages, which takes those three dimensions as given. Habermas's adoption of a linguistics model leads him to theorize communication as transmission; the phenomenological analysis I propose theorizes communication as constitutive.

4. The later, and perhaps less fully developed, consideration of the third category has often been remarked upon. The term I use here (emancipatory critical reflection) relies on the discussion in the Appendix to *Knowledge and Human Interests* (1971: 301–17), which Habermas identifies as the basis of his inaugural lecture at the University of Frankfurt in 1965 (1971: 348).

5. This alignment may have been intended as an alternative to the "scientific self-misunderstanding of psychoanalysis inaugurated by Freud himself . . . [which] is not entirely unfounded" (1971: 215). Habermas goes on (1971: 246ff.) to extend his relatively descriptive consideration of Freud's theory (now, under the term "scientistic") into a more negative assessment: Freud, he maintains, "succumbed to an objectivism that regresses immediately from the level of self-reflection to contemporary positivism . . ." (1971: 252).

6. Thomas McCarthy notes in his "Translator's Introduction" that this essay was "translated and somewhat revised" for this volume" (1976: xviii). One element of that revision is footnote 1, which does not appear in the original German version (in Apel, 1976), and was not added to the reprinted version (in Habermas 1984b). In the English version, Habermas added an initial footnote saying that he "is no longer happy" with "'universal' pragmatics" as the term that marks the "reconstruction of universal features of using language" in contrast to "analysis of particular contexts

of language use," which he called "empirical" (1976: 208). He continues: "the term 'formal pragmatics'—as an extension of 'formal semantics'—would serve better." Since I share that conviction, I use the term "formal pragmatics" except when citing his (translated) text, which retains "universal pragmatics."

7. Chomsky notes that "linguistic theory is mentalistic, since it is concerned with discovering a mental reality underlying actual behavior. Observed use of language. . . may provide evidence as to the nature of this mental reality, but surely cannot constitute the actual subject matter of linguistics, if this is to be a serious discipline" (1965: 4). He goes on to relate this delineation of his object domain with Saussure's distinction between *langue* and *parole*, but with the correction of understanding language (in contrast to speaking) as a competence, rather than a code.

8. To the best of my knowledge, Lyons (1968), which provides "a relatively self-contained introduction to the most important trends in contemporary linguistic theory" and which the author "hope[s] . . . will prove useful" to students in the social sciences and humanities, never mentions the term "pragmatics" (1968: ix). Lyons does note that he "provides more space to semantics than most other textbooks of linguistics," but "nothing about . . . the role of language in society" (1968: x).

9. Habermas's reliance upon Freudian theory raises questions as to whether he developed a theory of communicative competence on the model of (so to speak) communicative incompetence. To the extent that he did so, he is open to criticism analogous to that directed at much conventional medical practice that conceives of health on the model of (at best) lack of sickness. In other words, to the extent that Habermas based his theory of communicative interaction on a theory of "distorted" and "isolated"—and thus, non-interactive—communication, his claim that "the special type of semantic analysis, which deals with systematically distorted communication and enables an explanatory understanding, presupposes a theory of communicative competence" may be undermined by a reversal in presuppositions: rather than explaining distortion on the basis of competence, Habermas may be offering an explanation of interactive competence that is based in isolated distortion. If that is so, Habermas's criticism of Chomsky's theory as "monologic" would apply also to his own theory, by virtue of its basis in monologic ("isolated") premises.

10. Saussure's work is a compilation of students' notes gathered from the three occasions on which he gave the course (1906–1907, 1908–1909, 1910–1911). There are several English translations taken from diverse French editions, and each gives variations in the passages I quote. However, the French terms I render as "language," "speech," and "speaking" are consistent.

11. This is a simplified mapping of the academic terrain. Communicative phenomena are also studied in anthropology, psychology, and sociology—as well as English, pedagogy, political science and so on. To some extent, linguistic anthropology, psycholinguistics, and sociolinguistics, and so on, also contend with a hierarchy that valorizes the "pure" study of language above approaches that focus on language as situated in various domains of human activity.

12. I borrow the phrase "cultural scene" from Donal Carbaugh: "The concept of scene . . . draws attention to actual social settings, the communicative practices being used in those settings (an order of enactment), and the participants' senses of

the communicative practices that are being used there (an order of reports about enactment)" (1996: 15). He goes on to note "a second sense of cultural scene": "Whether participants say it is relevant or not, one would want to know the history of the community, its social demography, economic composition, political structures, occupations, educational system, legal processes, objects of art, and so on. . . . This 'cultural knowledge' then becomes a general resource with which to describe and interpret, to account for, the communication in any one particular scene" (1996: 16).

13. For a careful discussion of these linked factors, see Bohman (1991).

14. Husserl's term for this step in phenomenological method is "free phantasy variation"; Don Ihde (1977: 40) speaks of "possibilizing." For phenomenological analysis that emphasizes variation, see Langsdorf (1994, 1995b).

15. Failing to acknowledge that human activity is prior to delineation into the categories of social and physical is the focus of Marx's rejection of the prevailing anti-Cartesian theory of his day in the First of his Theses on Feuerbach: "The chief defect of all materialism up to now . . . is that the object, reality, what we apprehend through our senses, is understood in the form of the object of contemplation; but not as sensuous human activity, as practice; not subjectively. Hence in opposition to materialism the active side was developed abstractly by idealism—which of course does not know real sensuous activity as such. Feuerbach wants sensuous objects, really distinguished from the objects of thought: but he does not understand human activity as itself objective activity" (1947: 197).

16. The difference here is that between transcendental and empirical inquiries. Habermas gives considerable thought (for example, 1970c: 21–25) to why he resists the term "transcendental," as in Apel's "transcendental hermeneutics" or "transcendental pragmatics" (1970c: 23). I follow his avoidance. (Cf. 1988: 20).

17. Although we usually think only of subjects as being attracted to (directed toward) objects, Husserl discerns a reciprocal relation that resists awareness. See his *Analyses of Passive Synthesis* (forthcoming), especially Section 32.

18. Understanding constitutive activity may well be a matter of rhetorical rather than philosophical inquiry; that is, of discerning how particular deeds and ways of doing motivate identification with particular actualities and inspire further activity—rather than of articulating what is known, with some defensible degree of accuracy, and arguing for plausible explanations of why things are as they are.

19. In Husserl's terms, subjects and objects are co-constituted as "an ego-pole" of "acts, habitualities, and capacities" are "directed toward . . . the particular object-pole and its pole-horizon, the world" (1970: 183).

20. In other words: both agents and the results of agency are continually re-constituted within evolving cultural scenes; constitutive activity changes its subjects along with its objects.

21. I am indebted throughout to Kenneth Burke's philosophy of rhetoric. See, especially, Burke (1950). For discussion of rhetorical activity as "poiesis," in contrast to mental or material production as "praxis," see Langsdorf (1995a).

22. These non-spatiotemporally-situated possibilities are thus ideal rather than real, although Husserl's term, "irreal," avoids the double sense of "ideal" as both non-situated and perfect, that is, as ideas and Platonic Forms.

23. For an extended example of this simultaneity, see Wieder (1974), which gives an account of the author's fieldwork in a residence for ex-offenders. He discovered that residents cited a "convict code" to justify various actions, beliefs, and values—and in so doing, formed the code that they were citing. Similar recognition of the double effect of communicative activity is present in many ethnomethodological accounts; see, for example, Douglas (1970), McHoul (1982), and (especially) Garfinkel's proposal that we "drop the . . . theory of signs, according to which a 'sign' and 'referent' are respectively properties of something said and something talked about" as a step toward recognizing that "what the parties talked about could not be distinguished from how the parties were speaking" (1967: 28).

24. Freire's conception of coming to critical consciousness of one's situation and potential alternatives to it relies upon conceiving communicative activity as constitutive: "Within a word we find two dimensions, reflection and action in . . . radical interaction. . . . An inauthentic word, one which is unable to transform reality, results when dichotomy is imposed upon its constitutive elements. When a word is deprived of its dimension of action [constitution; actualization of possibilities]. . . the word is changed into idle chatter, into verbalism. . . . On the other hand, if action is emphasized exclusively, to the detriment of reflection [representation; recognition of what is the case] . . . the word is converted into activism . . . [to] action for action's sake . . . [which] makes dialogue impossible" (1970: 75–76; see also 105–106, 112).

REFERENCES

Adorno, Theodor W. (1982). *Against Epistemology*, trans. Willis Domingo. Cambridge, Mass.: MIT Press. Original German publication 1975.

Apel, Karl-Otto (1963). *Die Idea der Sprache in der Tradition des Humanismus von Dante bis Vico*. Bonn, Archiv fur Begriffsgeschichte.

——— (1980). *Towards a Transformation of Philosophy*, trans. Glyn Adey and David Frisby. London: Routledge and Kegan Paul. Original German publication 1972.

Austin, J. L. (1962). *How To Do Things With Words*. Oxford: Oxford University Press.

Bowman, James (1991). *New Philosophy of Social Science: Problems of Indeterminacy*. Cambridge, Mass.: MIT Press.

Burke, Kenneth (1950). *A Rhetoric of Motives*. Berkeley: University of California Press.

Carbaugh, Donal (1996). *Situating Selves: The Communication of Social Identities in American Scenes*. Albany, N.Y.: SUNY Press.

Carr, David (1987). *Interpreting Husserl: Critical and Comparative Studies*. Dordrecht: Martinus Nijhoff.

——— (1997). "On the Difference Between Transcendental and Empirical Subjectivity." In *To Work at the Foundations*, ed. J. C. Evans and R. W. Stufflebeam. Dordrecht: Kluwer.

Chomsky, Noam (1965). *Aspects of the Theory of Syntax.* Cambridge, Mass.: MIT Press.

——— (1968). *Language and Mind.* Cambridge, Mass.: MIT Press.

Conquergood, Dwight (1992). "Ethnography, Rhetoric, and Performance." *Quarterly Journal of Speech* 78: 80–123.

Douglas, Jack (1970). *Understanding Everyday Life.* Chicago: Aldine.

Foucault, Michel (1972). *The Archaeology of Knowledge,* trans. A. M. Sheridan Smith. New York: Harper and Row. Original French publication 1969 (main text), 1971 (appendix).

——— (1997). "Ethics: Subjectivity and Truth." In *The Essential Works of Michel Foucault, 1954–1984,* ed. Paul Rabinow. New York: The Free Press.

Freire, Paolo (1970). *Pedagogy of the Oppressed.* New York: Seabury.

Gadamer, Hans-Georg (1975). "Truth and Method." New York: Crossroads. Original German publication 1960.

Garfinkel, Harold (1967). *Studies in Ethnomethodology.* Englewood Cliffs, N.J.: Prentice-Hall.

Goertzen, Rene and Frederik van Gelder (1978). "A Bibliography of Works by Habermas, with Translations and Reviews." In Thomas McCarthy, *The Critical Theory of Jürgen Habermas.* Cambridge, Mass.: MIT Press, pp. 442–64.

Habermas, Jürgen (1970a). "On Systematically Distorted Communication." *Inquiry* 13 (3): 205–18.

——— (1970b). "Towards a Theory of Communicative Competence." *Inquiry* 13 (4): 360–76.

——— (1970c). "Toward a Theory of Communicative Competence." In *Recent Sociology No. 2,* ed. Hans Peter Dreitzel. New York: Macmillan, pp. 114–48.

——— (1970d). *Uber Sprachtheorie: Einfuhrende Bemerkungen zu einer Theorie der kommunikativen Kompetenz.* Wein: Hundsblume.

——— (1970e). "Technology and Science as 'Ideology'." In *Toward a Rational Society.* Boston: Beacon Press, pp. 81–122. Original German publication 1968, 1969.

——— (1971a). *Knowledge and Human Interests,* trans. Jeremy J. Shapiro. Boston: Beacon Press. Original German publication 1968 (main text), 1965 (appendix).

——— (1971b). "Vorbereitende Bermerkungen zu einer Theorie der kommunikativen Kompetenz." In Jürgen Habermas and Nicholas Luhman, *Theorie der Gesellschaft oder Sozialtechnologie.* Frankfurt: Suhrkamp Verlag.

——— (1973). "Labor and Interaction: Remarks on Hegel's Jena *Philosophy of Mind.*" In *Theory and Practice,* trans. John Viertel. Boston: Beacon Press, pp. 142–69. Original German publication 1968.

——— (1976). "What is Universal Pragmatics?" In *Communication and the Evolution of Society,* trans. Thomas McCarthy. Boston: Beacon Press, pp. 1–68. Original German publication, "Was heisst Universalpragmatik?" in *Sprachpragmatik und Philosophie,* ed. Karl-Otto Apel (Frankfurt: Suhrkamp Verlag, 1976), pp. 174–272; reprinted in *Vorstudien und Erganzungen zur Theorie des kommunikativen Handels* (Frankfurt: Suhrkamp Verlag, 1984), pp. 353–440.

——— (1984a). *The Theory of Communicative Action.* Vol. 1, *Reason and the*

Rationalization of Society, trans. Thomas McCarthy. Boston: Beacon Press. Original German publication 1981.

——— (1984b). "Vorlesungen zu einer sprachtheoretischen Grundlegung der Soziologie." In *Vorstudien und Erganzungen zur Theorie des kommunikativen Handelns*. Frankfurt: Suhrkamp Verlag, 1984, pp. 11–126.

——— (1987). *The Theory of Communicative Action*. Vol. 2, *Lifeworld and System: A Critique of Functionalist Reason*, trans. Thomas McCarthy. Boston: Beacon Press. Original German publication 1981.

——— (1988). *On the Logic of the Social Sciences*, trans. Shierry Weber Nicholsen and Jerry A. Stark. Cambridge, Mass.: MIT Press. Original German publication 1970.

——— (1991). *Between Facts and Norms: Contributions to a Discourse Theory of Law and Democracy*, trans. William Rehg. Cambridge, Mass.: MIT Press)

——— (1994). *The Past As Future: Jürgen Habermas Interviewed by Michael Haller*, trans. and ed. Max Pensky. Lincoln, Nebr.: University of Nebraska Press.

Horkheimer, Max (1972). "Traditional and Critical Theory." In *Critical Theory: Selected Essays*, trans. Matthew J. O'Connell et al. New York: Seabury. Original German publication 1937.

Husserl, Edmund (1970). *The Crisis of European Sciences and Transcendental Phenomenology*, trans. David Carr. Evanston, Ill.: Northwestern University Press. Original German publication 1954.

——— (Forthcoming). *Analyses Concerning Passive Synthesis*, trans. Anthony Steinbock. Dordrecht: Kluwer.

Hymes, Dell (1967). "Models of the Interaction of Language and Social Setting." *Journal of Social Issues* 23: 8–28.

Ihde, Don (1977). *Experimental Phenomenology*. New York: G. P. Putnam's Sons.

Kamlah, Wilhelm, and Paul Lorenzen (1967). *Logische Propadeutic: Vorshule des vernunftigen Redens*. Mannheim: Hochschultaschenbucher Verlag.

Langsdorf, Lenore (1993). "Words of Others and Sightings/Citings/Sitings of Self." In *The Critical Turn: Rhetoric and Philosophy in Postmodern Discourse*, ed. Ian Angus and Lenore Langsdorf. Carbondale: Southern Illinois University Press.

——— (1994). "'I Like to Watch': Analyzing a Participation-and-Denial Phenomenon." *Human Studies* 17: 81–108.

——— (1995a). "Philosophy of Language and Philosophy of Communication: Poiesis and Praxis in Classical Pragmatism." In *Recovering Pragmatism's Voice: The Classical Tradition, Rorty, and the Philosophy of Communication*," ed. Lenore Langsdorf and Andrew R. Smith. Albany, N.Y.: SUNY Press.

——— (1995b). "Argument as Inquiry in a Postmodern Context." In *Perspectives and Approaches: Proceedings of the Third ISSA Conference on Argumentation*. Amsterdam: International Society for the Study of Argumentation, pp. 452–63. Reprinted in *Argumentation* 11 (1997): 315–27.

——— (1997a). "Refusing Individuality: How Human Beings are Made into Subjects." *Communication Theory* 7: 321–42.

——— (1997b). "Unheard Voices from Unknown Places: Saving the Subject for Science." In *Transgressing Discourses: Communication and the Voice of*

Other, ed. Michael Huspek and Gary P. Radford. Albany, N.Y.: SUNY Press, pp. 73–94.

Lyons, John (1968). *Introduction to Theoretical Linguistics*. Cambridge: Cambridge University Press.

———— (1977). *Linguistics*. Vol. I. Cambridge: Cambridge University Press.

Marx, Karl (1947). "Theses on Feuerbach." In *The German Ideology* by Karl Marx and Friedrich Engels, ed. R. Pascal. New York: International Publishers. Original German publication 1932.

McCarthy, Thomas (1978). *The Critical Theory of Jürgen Habermas*. Cambridge, Mass.: MIT Press.

McHoul, A. W. (1982). *Telling How Texts Talk*. London: Routledge and Kegan Paul.

Ricouer, Paul (1992). *Oneself As Another*, trans. Kathleen Blamey. Chicago: University of Chicago Press. Original French publication 1990.

Saussure, Ferdinand de (1959). *Course in General Linguistics*, ed. Charles Bally and Albert Sechehaye; trans. Wade Baskin. New York: McGraw-Hill. Original French publication 1915.

———— (1960). *Cours de Linguistique Generale*, ed. Charles Bally, Albert Sechehaye, and Albert Riedlinger. Paris: Payot. Original French publication 1915.

Searle, John (1969). *Speech Acts: An Essay in the Philosophy of Language*. Cambridge: Cambridge University Press.

Thompson, John B. (1978). "Universal Pragmatics." In *Habermas: Critical Debates*, ed. John B. Thompson and David Held. Cambridge, Mass.: MIT Press, pp. 116–33.

Watzlawick, Paul, Janet H. Beavin, and Don Jackson (1967). *Pragmatics of Human Communication*. New York: W. W. Norton.

Wieder, D. Lawrence (1974). *Language and Social Reality*. The Hague: Mouton.

3

Carlos Pereda

Assertions, Truth, and Argumentation

If I say:

(1) Snow is white

my assertion, like *any* speech act, implies certain obligations deriving from the very speech act I perform. In other words, in communication (for example, in a conversation) speakers and their audiences coordinate their communicative actions, for instance, by means of certain commitments the speaker formulates to his or her audience. Thus, anyone in the audience has the right to complain if he or she considers that one of those commitments has not been fulfilled. I shall start by examining how these commitments have led Jürgen Habermas to defend an ideal speech situation, a consensual theory of truth, and a concept of truth as a validity claim which defines assertions. Although mistaken, these are all very attractive and important proposals. So, whether Habermas still defends these theories or not, I think that both of them have their own life and frequently provoke a certain dangerous fascination which we must dissolve.

I

Let us consider the case of an assertion such as (1). According to Habermas, by asserting (1) I claim that the validity conditions for (1) are fulfilled. That means that I co-assert or implicitly affirm, or am forced to commitments (implicit or not) such as the following:

(1.1) Assertion (1) is intelligible.

(1.2) Assertion (1) is sincere.

(1.3) Assertion (1) is true.

(1.4) Assertion (1) is normatively correct.

(1.1), (1.2), (1.3), and (1.4) are necessary formal presuppositions for the communicative use of any language in which assertions are involved. (Could a language be possible without assertions? Certainly not.) We are not dealing then with material presuppositions, conditions dependent on a context, a society, or a tradition, but with, as Habermas points out, *universal claims of validity* of language itself, claims which are the subject matter of a "formal pragmatics".

It is worthwhile to examine some of the properties of these claims. (1.1) is both an actual pre-condition of communication and a validity claim we must observe; for, in order to engage in communication, speakers must presuppose that they follow the same code, for instance, that they share the same language (*pace* Davidson[1]). Once communication takes place, they must secure themselves time after time against a number of misunderstandings. On the other hand, (1.4) seems to me ambiguous. As far as assertions are concerned, it amounts above all to communicative relevance; whereas, in relation to norms, (1.4) perhaps commits us to the rightness of norms.

In any case, (1.1), (1.2), and (1.4) are general claims of any speech act. (1.3), in its turn, seems to be a claim *directly* implied in particular by speech acts such as assertions. Here, the "specific difference"—the properly defining rule of assertion—would seem to be:

(1.3.1) P can assert A if and only if A is true.

"P can assert A" is used in this context as meaning "P is entitled to assert A"; "When P asserts A, P is not misusing A"; or "If P asserts A and A is not true, we must criticize both A and P".

But am I really committed when I assert (1) to assuming or co-asserting (1.1), (1.2), (1.3), and (1.4)? Let us suppose that this were not the case, and that while confronting certain doubts from my audience about (1) I answered: "Why, don't you understand the sentence 'snow is white'? Neither do I"; or, "So you say I am lying? So what, I like to lie"; or, "I really didn't mean to refer to snow, I just happen to like the words 'snow' and 'white' and I put them together, don't you think it's a remarkable piece of word-play?" Perhaps also: "You ask me why or for what purpose I asserted (1). Well, I just felt like doing so".

After considering such clarifications, my interlocutor may perhaps complain, quite reasonably: "Well fine, but in that case you are *not* asserting anything in saying that you are only playing with words". In relation to (1.1): "You are only playing with noises you don't understand";

in relation to (1.2): "Why do you lie and then say that you're lying?" Something similar could be said with respect to (1.3): suppose that a friend of mine doubted (1), and proposed a very strong counterexample to the assertion "snow is white". Suppose that I answered: "I don't care if there's black and violet-colored snow in China, I shall say what I please". In this case, in accordance with (1.4) my friend might reply, again reasonably: "But then you're trying to fool me or fool yourself; or what in the world are you trying to do with your so-called 'assertion'?"

Generally speaking, we suppose that when a speaker makes an assertion, he or she necessarily implies that that assertion can be understood, that it is a sincere expression, that it is true and relevant for the purposes of communication. (Being unaware of all this is presumably like being unaware that we actually breath all the time.) (1.1) through (1.4) constitute, for those reasons, universal validity claims, rules for the use of assertions. If one of these claims is frustrated, the speaker finds himself forced to clarify his or her assertion, to apologize or to defend with arguments the truth or relevance of the assertion. Thus, the obligation to justify oneself with arguments underlies communication itself.

What do we mean by "to justify oneself with arguments"? What is implied in offering justification through arguments? Habermas's answer: all specific rational disputes entail inevitable presuppositions, certain universal rules that tell us how to resolve a conflict through the force of the best arguments alone. Therefore, if we reconstruct those rules we realize that all rational disputes presuppose a model which can be defined in formal terms: in terms of certain presuppositions defining what is a good argument and a good exchange of reasons. That is to say, any actual argument and any actual exchange of reasons is governed by a set of counterfactual rules which constitute an "ideal speech situation".

Some of these rules—those which state the reciprocal acknowledgement that each participant is an autonomous person—are:

> Each subject who is capable of speech and action is allowed to partici-
> pate in discourses:
> a) Each is allowed to call into question any proposal
> b) Each is allowed to introduce any proposal into the discourse
> c) Each is allowed to express his attitudes, desires, and needs.
> No speaker ought to be hindered by compulsion—whether arising from
> inside the discourse or outside of it.[2]

Turning back to an assertion like (1), let us remember that whoever asserts that sentence claims, merely for the reason that he or she asserts it, that the sentence is true and that he is, therefore, in a position to defend it in a concrete rational dispute. This rational dispute, according to Habermas,

presupposes and is governed by the rules of an ideal speech situation. In other words, the predicate "true" is a validity claim we link to sentences when we assert them:

> A sentence is true when the claim of validity of the speech act by which we assert that sentence is justified.[3]

Therefore, the truth of a sentence such as "snow is white" consists in the potential assent to (1) by any speaker in an ideal speech situation, for

> The truth of a proposition means the promise to reach a rational consensus about what has been asserted.[4]

So we have here, in a very sketchy form—and which does not take into account the theory of communicative action in which this philosophy of language is embedded—*one* way of construing Habermas's proposal about what is implied in the speech act of affirming or denying sentences. (I wish to emphasize that this is only *one* possible interpretation since one finds in the writings of Habermas many hesitations with respect to this topic, surely an indication of the complexity of the issues under discussion and of Habermas's sensitivity in not avoiding the problems he runs into.)

What shall we say about the different steps in *this* line of thought? Well, in the first place, perhaps we have here something more than just more or less intertwined steps in a general line of thought. Perhaps we are dealing with an argument. In what follows I intend to reconstruct Habermas's remarks in the following transcendental argument (or, as Habermas might put it, "quasi-transcendental argument"):

Premise 1: There are different communicative actions.
Premise 2: Different communicative actions presuppose certain universal validity claims.
Premise 3: A communicative action such as an assertion entails truth as its typical validity claim.
Premise 4: If validity claims are called into question, one must defend them in rational disputes.
Premise 5: The defense of validity claims in rational disputes presupposes a consensus in an ideal speech situation.

Conclusion: The truth of assertions construed as the satisfaction of certain validity claims is the outcome of a rational dispute that reaches a consensus in an ideal speech situation.

This argument takes into account the characteristic know-how involved in communicative competence. In this case, it deals with the conditions that

make possible an assertoric speech act. By exploring its validity claims it uncovers certain necessary presuppositions of those acts, such as truth. The concept of truth in its turn is construed by means of the consensual theory of truth.

However, when I confidently assert such an ordinary sentence as "snow is white", am I in some sense *necessarily* presupposing, directly or indirectly, such strange constructs as an ideal speech situation and a consensual theory of truth? In what follows I investigate this incredulity.

I think that premises 1, 2, and 4 are promising. They allow us to catch a glimpse of interesting perspectives on assertion and its relations to other speech acts. This perspective, if I am right, may be generalized to the whole language and is worth considering. On the other hand, premise 3, and notably 5, and therefore the conclusion, contain, I am afraid, some errors.

I shall continue my discussion by sketching some criticisms of the notion of the ideal speech situation and of the consensual theory of truth.

II

Does not any argument and argumentation necessarily presuppose certain "counterfactual" models? Does not every concrete argument and particular argumentation necessarily presuppose a norm for good arguments by which we can evaluate them? Certainly. Thus, I would like to make clear that it is not my intention to cast doubt upon the usefulness of normative idealizations in general, including ideal patterns of argumentation. Therefore, I will not try to defend some of the absurd empiricist theories of argumentation which confound the psychology of argumentation with its logic. I wish only to distinguish between effective idealizations and useless idealizations. Let me explain myself.

In the first place, keeping in mind the radical variety of arguments and kinds of rational disputes—as well as their contextual character—it does not seem plausible at first glance that the model for our arguments and rational disputes needs to be homogeneous. Maybe we do not need a "single logic" of rational dispute governed by some kind of "ideal speech situation": a common, immutable, and sole foundation for all arguments and all rational disputes. Against this "single logic" for rational disputes one can claim that the "counterfactual model", both of arguments and rational disputes, consists in a heterogeneous, and non-converging set of argumentative patterns that we acquire by empirical means in the different learning situations of our lives. I dub this position "multifoundationalism".

Let us begin by taking into account the fact that there are many kinds of arguments. For instance, if one advances a particular argument, say a deduction, one implies the claim that that deduction is correct according to

certain patterns, which have been systematically studied by classical logic. Thus, when we try to correct someone's wrong deduction—as typically when somebody commits the fallacy of asserting the consequent—we tend to invoke, implicitly or explicitly, those principles which constitute a part of classical logic.

However, as soon as the concept of relevance appears, difficulties arise. Maybe there could be a "logic of internal relevance", of the relevance of the premises of an argument with respect to its conclusion. But surely there cannot be something like a "logic of external relevance", of the relevance of an argument with respect to the problem it is supposed to solve. Here—as in many other places—perhaps we need not a "theory", but "phenomenologies" of rational dispute.

Difficulties of this kind increase in number and seriousness as we move to the different kinds of underdetermined arguments, such as inductions and analogies. We normally distinguish between well-supported inductions and those which are unlikely to have or even have no support at all. We also distinguish between reasonable analogies and wild analogies. How are such distinctions possible? Among other kinds of support, one often appeals to what one has learned in a tradition of inductions and analogies, in our everyday lives as well as in the sciences; for instance, one often appeals to the epistemic virtues one has learned through such inductions and analogies. An induction or an analogy may be evaluated on the basis of such epistemic virtues as systematicity, empirical testability, predictive power, and explanatory power.

For example, once a piece of relevant evidence is given, an induction I_1, will prove preferable to its alternative, induction I_2, if with I_1 it is possible to establish systematic relations with other information and arguments in the corresponding field of those data, if it predicts and explains what I_2 cannot predict and explain; and all this must be carried out from case to case. Something similar can be said if we turn from kinds of arguments to their parts, the different kinds of sentences. In consequence, it seems necessary to conclude: we find argumentation patterns in classical logic as well as in its further developments, but we find nothing like a "single logic" of rational dispute.

Nevertheless, if such a "logic" were possible, it would be useless to try to reconstruct it by appealing to an "ideal speech situation". Moreover, it would seem that, in the face of any sentence or argument, perhaps we are really in a situation which is the opposite of the one Habermas proposes: it is not by means of the formal attributes of consensus in an ideal speech situation that we evaluate (or explain, or clarify . . .) the truth of *all* of my sentences or the soundness of *all* of my arguments. It is rather the concrete truth of those sentences and the concrete soundness of those particular arguments (deductions, inductions, analogies . . .), and consequently their

rationality—a rationality that derives from patterns "entrenched" in various traditions (logic, the different sciences, everyday life . . .)—that allow us to evaluate the rationality of a consensus, and eventually to imagine "models" such as the ideal speech situation.

I shall proceed a step further. *Even if the ideal speech situation were an intelligible and effective device* in relation to all the dimensions of an argument (including its external relevance) and to all kinds of arguments (including underdetermined arguments), I would still defend the claim that arguments are not sound arguments only because a rational consensus recognizes them as such. Rather we deem a consensus to be rational *if,* *because* they are sound arguments, the consensus recognizes them as sound. Thus, making use of a familiar distinction in the Wittgensteinian tradition, the difference between "symptoms" and "criteria", it is possible to defend the position that the rationality of a consensus is revealed through the "symptom" consisting in its respect for sound arguments, but never gives us a "criterion" (or explanation) of the soundness of those arguments. (To claim otherwise is to try to elucidate a fairly clear notion with an obscure one). In connection with this, it would be useful to remember the lesson of the *Euthyphro,* to which I shall turn later.

Maybe we can concede all these remarks but add the following: of course, it would be absurd to suppose that in our use of the ideal speech *situation* we intended to evaluate (explain, elucidate . . .) something other than certain *situations,* namely, argumentative contexts. Nevertheless, I fear that with argumentative contexts there will be difficulties to some extent analogous to those posed to us by arguments.

Despite this, we have been talking, for the sake of argument, *as if* the ideal speech situation were an intelligible and effective device. But this is not so. Once again, we come across with the double uselessness of all utopias and analogous devices. We are talking about, so to say, idealizations which are both too elaborate and too ideal: very precise concepts, but disconnected from any particular application. In this case, we confront the double uselessness of what we might call the "strong version" of the notion of an ideal speech situation:

(a) the ideal speech situation is useless because it is such an abstract device that nobody has any idea about how to use it in concrete cases. That is to say, we cannot find in it a set of fixed, general, and precise criteria—nor even any underdetermined patterns to guide us in our evaluations of real rational disputes—or

(b) it is useless because, as soon as we intend to abandon that level of abstraction and specify what it means to realize such an "ideal situa-tion", most people will surely not agree as to what this "realization"

means—as has happened so many times when people have tried to implement a utopia. Indeed, we might find attempts to specify it as ridiculous or terrifying; or, in the case of the ideal speech situation, in some sense subject to error.

In order to save such attempts at specification from the risk of failure, and if we want the ideal speech situation to *define* truth for sentences and soundness for arguments, surely we would have to concede logical and empirical omnipotence to the participants in that situation. (However, do we really understand the word "omnipotence"?)

I would like to examine further some of the propposed rules of the ideal speech situation: it does not seem evident that we should permit the introduction of *any* proposal in *any* discourse. For example, in a discussion of physicists, politicians, or lovers, one should only permit the participants to advance *relevant* proposals. But what do we mean in this context by "relevant"? As with the use of the word "relevant" when dealing with arguments, we mean nothing, I believe, invariable in relation to the various situations: nothing that we can regulate by a formal procedure, independent of the context. That is the reason why the rule that requires that *anybody in any* rational dispute should be able to express his or her attitudes, needs, and desires, evokes the nightmare in which any kind of exchange of reasons becomes a collective therapy. (Such a situation reminds me, for example, of those irritating colleagues who, in the middle of a discussion about matters of curricula, wish to express their innermost feelings on the subject.) You might reply: we should not understand those conditions proposed by Habermas in such a strict empiricist fashion. The difficulty with this reply is that if we do not interpret Habermas's conditions concretely, the expression "ideal speech situation" becomes totally devoid of content.

Nevertheless, it is also possible to defend the thesis that, although Habermas's rules do not pick out sufficient conditions for a good argumentative context, they formulate, or at least some of them formulate, some necessary conditions. Of course they do. In that case, they are clearly vague constitutive rules, and understood in this way they form what we might call a "modest version" of the ideal speech situation.

Let us examine now this "modest version" of the ideal speech situation and compare it with the rules, also modest in their pretensions, which constitute the medieval model of rational dispute, the *disputatio*. The *disputatio* involves two main components, a *proponens* and an *opponens*; a proponent whose role is to advance proposals and defend them and an opponent who must attack them. In this sense, the rule saying that anybody can introduce any proposal and call it into question is just another way of stating the fact that no rational dispute can be implemented if the roles of the proponent and the opponent cannot be fulfilled. The rest of the rules may

perhaps all be construed in terms of the concept of autonomy: the complete fulfillment of the roles of the opponent and the proponent presupposes that the participants in the rational dispute are autonomous persons.

Yet this "modest version" of the ideal speech situation does not offer sufficient conditions for judging argumentations. It proposes a normative heuristics, *a starting point for the elaboration of a phenomenology of rational dispute.* It tells us what are, in general, the necessary components of a rational dispute. But it leaves us the task of specifying from case to case, exploiting our empirical training in actual rational disputes, just how those components are to be realized—for instance, which are the different obligations involved in being a proponent and an opponent in a discussion among physicists, politicians, or lovers.

Of course, I have no objections against this "modest version" of the ideal speech situation. Moreover, I think that much of what has been said about the ideal speech situation has, in *this* sense, a great normative importance both for the understanding of the obstacles and misunderstandings produced in communication as well as for the advancement of better forms of communication. However, this "modest version" of the ideal speech situation is much too weak to be a yardstick to define (or even to evaluate, or explain . . .) truth or argumentative soundness.

On the other hand, I think that if we direct our attention to another line of thought of Habermas (which is probably more interesting to Habermas himself), the line that runs from norms to their justification, perhaps we can make similar remarks (as, if I am right, Habermas himself suggests when dealing in *Between Facts and Norms*[5] with the specific processes of justification of concrete norms in the law codes of democratic regimes). But let us turn to the line we are interested in exploring here.

What is important is to realize that what we mean by "learning to argue" is to learn *phenomenologically* (in a manifold and never-ending process) to recognize many kinds of arguments and their respectively different virtues. I am not aware of any good reason for thinking that if we lack what the foundationalist asks of us, "*the* formal Pattern for all arguments and all rational disputes" or, more specifically, if we do not have "a logic of rational dispute generated from an ideal speech situation", we are thereby in need of something we should have and, thus, something we should seek for. Of course this does not prevent us from considering that the norms proposed by Habermas in relation to the ideal speech situation understood in terms of its "modest version"—more or less abstract norms which need to be specified from case to case—might be very useful as a starting point for reflection, when we are dealing with specific argumentative contexts.

However, if we preserve the "modest version" while rejecting the "strong version" of the ideal speech situation, aren't we denying the

possibility of developing a consensual theory of truth? How are we supposed to characterize such a "consensus" in the absence of those formal features which could only be provided by the strong version of the ideal speech situation? Time and again we find out that the very same premise that occurs in one debate as a *modus ponens* functions as a *modus tollens* in other debates. So those very questions which are intended as a defense of the strong version of the ideal speech situation as a foundation for the consensual theory of truth, may also be construed as something close to a *reductio ad absurdum* of that theory of truth. There are, however, more specific objections against such a theory. Let us turn to them now.

III

Habermas holds that an empirical sentence is true when a validity claim is justified, and defends the thesis that the attribution of the predicate "empirical truth" *means* to hold open the promise of reaching a rational consensus. But doesn't this seem to leave behind the *elementary* meaning of empirical truth? Moreover, can't we say we are taking an effect of a certain phenomenon for the phenomenon itself? If I am right, this elementary meaning consists in the pre-theoretical thought that when a sentence is empirically true, it is true because language and the world are arranged in a certain manner: the sentence we use is true—partly—due to circumstances *external* to the sentence. This elementary meaning is correlative with the so-called "minimum realist intuition".[6]

I suspect that the equivalence formulated by Tarski[7]—"convention T"—may be understood as beginning to capture the "minimal realist intuition".

By (1), and convention T, we arrive at:

(2) The sentence "snow is white" is true if and only if snow is white.

Why should we say that (2) may be considered as "beginning to capture" the pre-theoretical thought appropriate to the minimal realist intuition? Let us consider above all what it means to say that a sentence with an empirical content has certain truth conditions. To say that a sentence with empirical content has certain truth conditions is just another way of saying that the truth of the sentence depends on certain conditions which do not belong to the sentence itself, that is to say, on circumstances external to the sentence we mean that that sentence is true *because* certain empirical conditions—some circumstances—make that sentence true.

What are these empirical circumstances which render true the sentence "snow is white"? In conformity with the remark on (2) (to say that a sentence

with empirical content has certain truth conditions is to say that the truth of the sentence depends on certain empirical circumstances) we may suggest that "the best possible explanation, as well as the most elementary explanation" of (2) is:

(2.1) The sentence "snow is white" is true *because* some words have a certain meaning in English and snow is white.

The assertion performed by a speaker of the well-formed sentence "snow is white" is a fact. The reference of the disquoted sentence is another fact, the fact that snow is white. Thus, from (2.1) we can also affirm:

(2.2) The fact that the sentence "snow is white" is true
is coherent with . . .
can be explained in the best possible way by . . .
can be verified by . . .
the fact that certain words mean what they mean in English and the fact that snow is white.

So, the "because" of the minimal realist intuition of (2.1) can be captured in (2.2) as the most epistemically virtuous way—most coherent, with the greatest explanatory power, most verifiable, and so on—of understanding the truth of (1).

Let us examine two consequences of this proposal.

In the first place, let us situate the minimal realist intuition as resting between the—too robust—correspondence theory of truth and the—too uninformative—deflationist theories. *Grosso modo* a correspondence theory holds the following:

Language provides us with a more or less exact representation of reality, and this representation will be as accurate as language can be.[8]

In its turn, a deflationist theory would maintain:

There is nothing interesting to say about the nature of truth, for there is no common attribution shared by all true empirical sentences.[9]

The "because" figuring in the minimal realist intuition is not committed to postulating any isomorphism between language and the world, nor by the same reason does it have to investigate what elements of language are supposed to correspond with certain elements in the world. Nevertheless, in contrast with deflationism it does commit itself to the fact that the truth of sentences depends on language and the world.[10]

In the second place, I hold that all theories of truth not generated from assertions such as (2), (2.l), and (2.2)—all the theories that fail to capture the minimal realist intuition—will be parasitic on these assertions.

These remarks are just another way of emphasizing, in relation to the consensual theory of truth, that the rationality of a rational consensus —including a rational consensus in an ideal speech situation—which arrives at the conclusion "snow is white" depends on the fact that snow *is* white.

Let us suppose that this argument is rejected. We are immediately forced to ask: What are the disadvantages and advantages of attributing (contrary to the customary uses based on the minimal realist intuition) to the concept of rational justification in an ideal speech situation the properties commonly attributed to the concept of truth?

Let us first see what is lost. Above all, there are good reasons to accept that we have no criteria to judge truths apart from our criteria to judge justifications: indeed, there is no procedure to capture true beliefs different from our best criteria of justification. However, it is a fact that the predicates "true" and "rationally justified" function in different ways in our communication: they correspond to different *interests*.

First, consider the fixed character of truth. If (1) is a true assertion, it cannot turn into a false assertion (unless we add temporal indexes to it). On the other hand, notice the variable character of justifications (a belief is justified for a subject in a given argumentative context with certain epistemic conditions).

Second, since truth is something fixed, it has an incorrigible character, while justifications posses a corrigible character. This is what makes intelligible adversative clauses of the kind "although assertion *A* was well justified, *A* is, notwithstanding, false". To take only one example, in the history of science one is frequently forced to formulate such adversative clauses.

Therefore, by identifying truth with a rationally justified sentence—for instance, justified in an ideal speech situation—we lose the important oppositions which revolve around the contrast between two categories. Roughly stated, these are the categories of *what is the case,* and of *what people believe,* including what people believe in an ideal speech situation. Turning back to Plato's dialogue, let us call this contrast the "Euthyphro contrast".

If I am right, the "Euthyphro contrast" highlights the idea that truth is *external* in relation to contexts and traditions—nobody can eliminate the possibility that a certain true belief may come from the most unsuspected places and procedures. On the other hand, justifications are necessarily *internal* to contexts and traditions; a justification totally detached from the rest of the web of beliefs and desires of a tradition is not even intelligible.

The "Euthyphro contrast"—if legitimate at all—emphasizes once more

the parasitic character of any theory of truth which neglects the minimal realist intuition. If justified, this "contrast" also explains the irreducibility of the following two uses of the predicate "true" to the predicate "rationally justified", or even "justified in an ideal speech situation":

(a) the teleological use of truth. This use indicates the purpose of this predicate in the following sense: people pursue justified beliefs in *order to* achieve true beliefs, or even in order to reach the truth; understanding "truth" in accordance with the minimal realist intuition. In other words, people want to have justified beliefs in order to reach beliefs "firmly bound" to reality. Thus, most epistemic theories of truth (as in Habermas or Putnam) cannot understand why the "game of justification" is played, insofar as they are unable to grasp the purpose of such a "game".

(b) the critically regulative use of truth. This use makes possible adversative clauses which postulate the contrast between plausible beliefs —even wonderfully justified scientific theories—and what is plainly the case.

Let us explore now the apparent advantages of the consensual theory of truth. Here's a proposal: the consensual theory of truth, the concept of rational acceptability in ideal conditions, connects the concept of truth with the human practices in which this concept plays an important role. It directly—or internally—binds truth to the routines of justification of beliefs and knowledge. Unfortunately, it is, in various respects, an anti-intuitive and even muddled connection. On the one hand, as I have already indicated, the connection is hard to understand or even to imagine (the notion of the ideal speech situation, in its strong version as the source of a definition of truth, must involve the assumption that its participants possess logical and empirical omnipotence). (This reminds me of some difficulties in Descartes's notion of God.) On the other hand, this connection leads to confusion or else combines in an illegitimate way such different questions as:

(a) what is truth?

(b) how do we qualify truths? by what criteria?

(c) what role does truth play in a language?

(d) what role does truth play, generally speaking, in our lives?

By combining questions such as (a) and (b) we begin to lose sight of the fact that assertions like (2), (2.1), and (2.2) *define* what truth is according to

what seems to be the elementary and primordial way of understanding that notion. On the contrary, a belief may be justified rationally in many different ways, by appeal, for instance, to the different epistemic virtues. (It might be added that the other kind of traditional theories of truth, coherentist theories, are also, just as much as consensual theories, wrong in their reductionism—they reduce all epistemic virtues to coherence, as if one could not justify a belief by reference to its predictive power, or explanatory power, or empirical testability, and so on. In the long run, I believe that they too turn out to be parasitic on the definition of truth captured by the minimal realist intuition. But developing an argument in this direction would lead us too far.)

Regarding questions such as (c) and (d), we must not forget that truth plays *several* roles as much in language as, generally speaking, in our lives. Certainly *one* of those roles is to provide a rational basis for a consensus. (Once again, the degree of concreteness with which we speak is important, for with a sufficient amount of abstraction and a few logical maneuvers it is almost impossible not to reach irrelevant consensus.) But sometimes we also make use of the notion of truth in order to highlight quite focal kinds of rational disagreement. With respect to this, remember the different accounts of the processes of enlightenment which show that what matters for rationality is not consensus or dissent, but the properties which make this or that agreement or disagreement a rational affair. Anyway, what the predicate "true" means cannot be settled by any rational consensus or dissent, for while words like "justification" and "consensus" are words we use to speak about what people believe, "true" is a word we use to talk about what is the case.

Let us be careful: we must not confuse a rational consensus, a consensus which *results* from good arguments, a consenus produced *after* argumentation, with a partial and precarious (but relatively firm) consensus that to some degree is necessarily presupposed by any use of language, any tradition, and any rational agreement or disagreement, *before* any argumentation. This kind of consensus is not rational but a mere matter of fact. In order to explain it we certainly don't need to appeal, at least not in the first instance, to something like a theory of argumentation. We need a more powerful tool, namely, the theory of evolution: the survival of our species depends upon such consensus.

IV

But isn't there a contradiction between the criticism carried out in section II (against a foundationalist ideal shared pattern for judging arguments and rational disputes, as well as the very possibility of building a "logic" of

argumentation), and the defense of the minimal realist intuition developed in section III? Let us look at this objection more closely. If we hold that there are different kinds of arguments (deductions, inductions, analogies, and so on) with different standards of correctness and, above all, if we hold that there are different kinds of argumentative contexts, how can all this be compatible with the antirelativistic defense of the minimal realist intuition of truth?

Let us imagine that two lovers, natives of the tropics who have never traveled abroad, are discussing assertion (1). And let us imagine a Swedish physicist visiting the tropics as a tourist who overhears the discussion between the two natives and decides to take part in it. Consider the following two conversations:

Conversation A:

SWEDISH PHYSICIST: Look, I've got a video from my country in winter, and you can see that snow is really white.
TROPICAL LOVERS: Who are you to stick your nose into a private conversation? Mind your own business.

Conversation B:

SWEDISH PHYSICIST: Look, I've got a video from my country in winter, and you can see that snow is really white.
TROPICAL LOVERS: What is a video? What is your country? Why should we believe you and what you call your "video" if we have never seen such a thing before?

The first reaction to be avoided is trying to defend the assumption that:

(a) in Conversation B, the agents are discussing the same validity claim as in conversation A.

Proposal (a) is false. In Conversation A, the lovers question the physicist's "normative correctness" validity claim in the sense that, although his remark is relevant, it may not be proper of him to make it. On the contrary, in Conversation B it is the argument of the Swedish physicist, and not his right to speak, that is being questioned.

Doesn't Conversation B show the context-dependency of arguments which justify the truth of an assertion? But—let us imagine—perhaps our Swedish physicist is rich and stubborn enough to invite his interlocutors from the tropics to Sweden during the winter season and, once they arrive, gives them an ostensive definition of snow. Nevertheless—as Wittgenstein and Quine have both argued in different ways—anybody can offer reasons

to reject an ostensive definition. Perhaps our lovers wonder whether the plane trip was a magic trick, or whether they are only dreaming, or whether the Swedish physicist—with all the money he seems to have—is only trying to deceive them and has shown to them an artificial scenery in which snow looks white while it is really multicolored, or just purple.

Faced with the latter remarks on Conversation B, we must try to resist two new different sorts of reaction:

(b) The reaction of opposing the realist intuition and eliminating the universality of truth on the basis of the necessarily contextual character of arguments and rational disputes.

(c) The reaction of defending something more than an elementary theory of truth and, consequently, defending the view that the uses of truth are not always indirect. (And, in this sense, that there might be more direct uses of the concept of truth than those established by the teleological and critical-regulative uses.)

However, proposals (a), (b), and (c) are not the only alternatives at hand to discuss Conversation B. Let us consider a further option (d), generated by the "Euthyphro contrast": what people believe is necessarily internal to contexts and traditions; generally speaking, it depends on a shared knowledge, on an actual consensus. Those beliefs may not be criticized directly, by introducing a self-authenticative, fulminating truth, but only by using other justified beliefs. In their turn, these justified beliefs will claim to be true—here we encounter the teleological use of truth—but will also be open in the future to adversative clauses which, even recognizing that they are well-justified beliefs, can reject them as false. This is the critical-regulative use of truth.

Thus, the contradiction postulated between what is being attacked in section I and what is being defended in section II evaporates on option (d): arguments and justifications are *internal* to contexts and traditions. But truth *is external* to any tradition: it is noncontextual or, more precisely, it is universal.

V

Let us examine quickly premise 3 of our initial transcendental argument. Is rule (1.3.1) a correct rule? Let us compare the following rules, all of which are traditional candidates for the role of specific constitutive rules of assertion:

(1.3.1) P can assert A if and only if A is true

(1.3.2) P can assert A if and only if A is a completely justified belief for P

(1.3.3) P can assert A if and only if P knows that A.

The characteristic validity claim for assertions, or, if you wish, the specific constitutive rule of assertions will be that rule the satisfaction of which prevents any criticism of an assertion *as* an assertion (of course, one also can criticize an assertion for being rude, silly, unpleasant . . .).

If P guesses right that A, (for example, if a fortuneteller hits upon the winning number in a lottery contest) P would satisfy rule (1.3.1). But, in this case, wouldn't we criticize A and P for not being well-justified? Similarly, if rule (1.3.2) is satisfied, it could still be the case that we could use one of those adversative clauses which indicates that, even if A is completely justified, it is nonetheless false. So, if I am correct, (1.3.3) *is* the constitutive rule of assertion: the specific validity claim of assertions is not truth, as Habermas proposes, but knowledge (what we commonly understand in the sciences and in our everyday life as knowledge, a notion which includes, among other necessary conditions, the condition of being a justified true belief).

Confronted with this objection, the champion of the consensual theory of truth may immediately reply: "You can develop that criticism because you have surreptitiously substituted the consensual concept of truth for a realist concept. However, there is no room in an ideal speech situation for a lucky guess, for the concept of truth provided by the consensual theory of truth assimilates the concept of truth to the concept of completely justified belief, blocking the road for the kind of counterexamples you have introduced in order to replace the validity claim of truth with the validity claim of knowledge".

The problem with this objection is, I believe, that it may be just another piece of evidence for the minimal realist intuition. The notion of a lucky guess, the notion of a true belief without the support of good reasons—the notion of an unjustified but true assertion—is something not only intelligible, but also an accepted and common fact in many popular practices (such as, for instance, games of chance). However, I think that this fact can only be accepted and understood from the standpoint of the "Euthyphro contrast", between what is the case and what people believe.

My point is that the notion of a lucky guess is another telling "symptom" of the minimal realist intuition. For such intuition is the only principle capable of explaining how there can be an important distinction between a true belief and a justified belief, a distinction which results from the possibility of an external—yet indirect—use of the predicate "true" in opposition to the necessarily internal use of justifications.

Nevertheless, don't we manifest a horrible arrogance in the latter remarks? If one defends (1.3.3) as the constitutive rule of assertion (if one holds that the speech act of assertion institutionally presupposes the claim of knowledge), we are "misusing" an assertion each time we assert something without knowing what is the case. But if this is right, don't we "misuse" most of the assertions we make? When confronting these doubts it's good to remember Habermas's rule in relation to the various validity claims: if one of those claims is not fulfilled by the speaker, the hearer can protest. Moreover, notice that we often wish to weaken such validity claims, so we add before the assertion such expressions as "I think that . . .", "I suspect that . . .", "I guess that . . .", or, if we are obliged to, we excuse ourselves or justify ourselves for having made this or that mistake. But these very activities—weakening assertions, the "games" of excuses and justifications—would not be intelligible if (1.3.3) were not the specific rule of assertion.

VI

I wish to stress, once again, that the attacks on premise 5, on the conclusion of the argument and on premise 3—the opposition to a "strong version" of the ideal speech situation, to the consensual theory of truth, and to the concept of truth as a validity claim which defines assertions—do not render invalid at all the most decisive steps of the argument in question, premises 1, 2, and 4. So it must not be surprising to find that these steps are taken up in many proposals different from Habermas's, for instance, in the assertion model developed by Robert Brandom in his *Making it Explicit*.[11]

According to this model, to treat a performance as an assertion is to treat it as recognizing a certain kind of doxastic commitment. Doxastic commitments are normative: they are the kind of commitments about which a question may emerge on the authority or entitlement of the person who makes the assertion.

The inferential articulation that gives content to each expression is constituted by the relations between commitments and authorizations by which one claim might commit to or authorize other claims. Thus, speakers follow a "scorekeeper" of commitments and authorizations, both their own and the others'. The participants in argumentation change the scorekeeper by modifying the commitments and entitlements which are appropriate to attribute. This is precisely what argumentation is about. Brandom writes:

> Logicians typically think of inference as involving only relations among
> different propositional contents, not as also potentially involving relations
> among different interlocutors. However, discursive practice, the giving

and asking for reasons, from which inferential relations are abstracted, involves both inter*content* and inter*personal* dimensions.[12]

Thus, the idea is to begin our reflections on language by taking into account the fact that the various contentful activities—and, in particular, the many sorts of communicative actions—contain commitments governing the correct use of expressions and the duties they yield. This *knowing how* to fulfill the constitutive norms of such expressions makes up a part of our judgment. Such norms are often formulated as validity claims and are institutionalized by means of social activity.

This is the reason for thinking that such rules and claims are irreducible to any kind of "naturalization" other than "socialization" in those institutions. For in the natural world of events we find regularities but not rules specifying how to use correctly different sentences. So the natural world cannot contain something like the concept of the authority of a speaker, including its preconditions, the validity claims, and the corresponding commitments she has to tackle with arguments.

We are just the class of animals whose members are compelled to answer for their actions, as well as for what they say. We are also the class of animals which tend to obey the strange "force" of good arguments and even—sometimes—try to make real the promise of "symmetries" among the diverse participants which underlie every rational dispute.

Carlos Pereda

Instituto de Investigaciones Filosóficas
UNAM-Mexico

NOTES

1. Cf. Carlos Pereda, "Is There Such a Thing as a Language?" *Critica, Revista Hispanoamericana de Filosofia* 30, no. 88 (April 1998): 73–91.

2. *Moral Bewusstein und Kommunikatives Handeln* (Frankfurt: Suhrkamp, 1983). English translation: *Moral Consciousness and Communicatve Action*, trans. Christian Lenhardt and Shierry Weber Nicholsen, Cambridge, Mass.: MIT Press, 1990, p. 99.

3. Jürgen Habermas, "Wahrheitstheorien", in H. Fahrenbach, ed., *Wirklichkeit und Reflexion* (Pfallingen: Neske 1973), p. 135. (Translation is my own.)

4. Op. cit., p. 137.

5. Jürgen Habermas, *Faktizität und Geltung. Beiträge zur Diskurstheorie des Rechts und demokratischen Rechtstaates* (Frankfurt: Suhrkamp, 1992); English translation: *Between Facts and Norms*, trans. William Rehg (Cambridge, Mass.: MIT Press, 1996).

6. Sometimes it seems that Habermas also tries to defend such a "realist intuition". But, in that case, why does he think that he also needs the concept of the ideal speech situation—in its strong version—and the consensual theory of truth?

7. A. Tarski, "The Concept of Truth in Formalized Languages" and "The Establishment of Scientific Semantics" in *Logic, Semantics and Metamathematics*, 2nd ed. (Oxford: Oxford University Press, 1990).

8. The correspondence theory of truth is as old as Plato and Aristotle and is usually condensed in St. Thomas's formula: *Veritas est adecuatio rei et intellectus.* In our days this theory is defended among others by W. Alston, *A Realist Conception of Truth* (Ithaca: Cornell University Press, 1996); M. David, *Correspondence and Disquotation* (New York: Oxford University Press, 1994); M. Devitt, *Realism and Truth* (Princeton University Press, 1984); R. Kirkham, *Theories of Truth* (Cambridge, Mass.: MIT Press, 1995).

9. In the past this thesis was defended by F. Ramsey, *On Truth*, original manuscript materials, 1927–1929 (Dordrecht: Kluwer, 1991). Nowadays we can include among its sympathizers Eduardo Alejandro Barrio, *La verdad desestructurada* (Buenos Aires: Eudeba, 1998); M. Brandom, "Pragmatism, Phenomenalism and Truth Talk," in P. French, Th. Uehling and H. Wettstein, eds., *Midwest Studies in Philosophy*, vol. 12, Minneapolis: University of Minnesota Press, 1988; A. Fine, "Unnatural Attitudes: Realist and Instrumentalist Attachment to Science", *Mind* 90, 1986; P. Horwich, *Truth* (Cambridge, Mass.: Basil Blackwell, 1990); R. Rorty, *Philosophy and the Mirror of Nature* (Princeton: Princeton University Press, 1979) and *Objectivity, Relativism and Truth*, Phil. Paper I (Cambridge University Press, 1991); D. Stoljar, "Emotivism and Truth Conditions" (1993), *Phil. Studies*, LXX and "Deflationary Theory of Truth", *Stanford Encyclopedia of Philosophy* (1997).

10. A. Moretti formulates the correspondence theory of truth as follows: "The traditional idea of correspondence consists of either an isomorphy between sentences and external entities or, at least, a global association between these objects. But it is also a relation of fundamentation of sentences in different aspects of the world (or in the world as a whole) and not the other way around", in *Concepciones tarskianas de la verdad*, U.B.A., 1996. I think that whoever defends the last idea—the minimal realist intuition—does not need to commit herself to a correspondence theory of truth.

11. Robert Brandom, *Making it Explicit* (Cambridge, Mass.: Harvard University Press, 1994).

12. Op. cit., p. 497.

4

Alexander Bertland

Habermas and Vico on
Mythical Thought

Within the philosophy of Jürgen Habermas is the recognition that mythical thought threatens the theory of communicative ethics. Habermas argues that ethics should be grounded in reflective reason developed through open communicative action. Mythical thought presents a distinctively undemocratic yet coherent alternative to an ethics based on reflection. One could argue that ethics should be grounded either wholly or partially on myth because of its power to motivate and its foundation in cultural tradition. In *The Theory of Communicative Action*, Habermas attempts to refute these arguments by presenting an account of the rationalization of society which demonstrates that myth and tradition are not essential for proper ethical activity.

As background for this argument, Habermas uses communicative theory to draw a distinction between mythical thought and instrumental thought. Habermas describes mythical thought as closed because it does not allow for critique. Mythical thinkers are grounded in tradition such that they cannot question its authority or develop radically new approaches to practical or political problems. Instrumental thinkers, on the other hand, are free to discuss and develop useful techniques and fairer political systems. This distinction is communicative because it is based on differences in social interaction rather than on epistemological differences in the structure of thought.

The eighteenth-century Neapolitan philosopher Giambattista Vico would question the way Habermas draws the distinction. In the *New Science*, he claims that for philosophy to comprehend mythical thought, it must be respected as a distinct form of non-reflective thought. It must further be understood as having a unique poetic logic which is grounded in mimesis. Vico draws the distinction epistemologically and would claim that the communicative distinction follows from it.

In this paper, I will ask which philosopher better characterizes mythical thought? This is a difficult question because it is a debate between two interpretations of the same set of facts. It asks one of the two sides to engage in a paradigm shift. It is unclear whether a definitive argument can be given in debates such as these. However, I hope that this paper will show that Vico's new science presents Habermas with a number of important criticisms that critical theory needs to take seriously.

I will begin by looking at Habermas's own discussion of Vico. This discussion will culminate in Habermas's rejection of mimetic hermeneutics which excludes him from Vico's mimetic interpretation of myth. I will then turn to Habermas's argument for the communicative distinction between mythical and instrumental thought. I will explore Vico's critique of this distinction through his concept of the conceit of scholars. Finally, I will compare Habermas's account of myth to Vico's. This will reveal that Habermas cannot adequately explain how mythical thought generates the cultural tradition. Habermas emphasizes the innovative power of instrumental thought and the ability of mythical thought to restrain that power by shutting off open discourse. Vico would suggest that it is only when mythical thought is respected as a mimetic form of thought that its innovative power to create ideas can be recognized. Habermas, because he brackets mimesis from philosophy, cannot recognize this power and so cannot recognize the true significance of the presence of mythical thought.

Before I begin, I must make a few qualifications. By the term mythical thought, I am referring to the very primordial and imaginative form of autochthonous thought found in primitive tribes.[1] I am not concerned here with any possible metaphysical or spiritual content that these myths might have.[2]

I will use the term instrumental thought as the alternative to mythical thought. There are many different terms that may be used for it including discursive thought and reflective thought. At times, I will bracket the important distinction in the development of rationality between instrumental thought and communicative action. Since both are opposed to mythical thought, I will refer to both the lower level of instrumental thought and the higher level of communicative action it allows as instrumental thought. I am simplifying this notion merely so that I can focus more directly on mythical thought.

This paper will also distinguish understanding thought communicatively from understanding thought through a theory of consciousness. Philosophy has generally understood thought through a theory of consciousness; that is, it has concentrated on the subjective thought processes of individuals. One of Habermas's main contributions to philosophy is his argument that thought should be understood as part of a communicative process; that is,

thought should be understood by examining the structure of communication. I will use this distinction in an attempt to give Habermas's project as fair a reading as possible; however, I will not delve too deeply into the foundations of this distinction.

I would also like to mention that both Vico and Habermas present very subtle and detailed accounts of the development of reason. I cannot hope to do full justice to either account here. Furthermore, I am limiting myself almost exclusively to Habermas's *Theory of Communicative Action* and the third edition of Vico's *New Science* even though both thinkers discuss myth in other works. I am also trying to give the *New Science* as charitable an interpretation as possible given both its baroque nature and Vico's odd selection of evidence. I hope that I present the essence of the two accounts fairly and in a way that reveals the basic conceptual differences between the two thinkers. I will now begin with a discussion of the traditional view of Vico and Habermas's reading of him.

As Donald Phillip Verene has suggested, Vico's true originality lies in his explanation of mythical thought as grounded in his notion of the imaginative universal.[3] However, Vico's reputation has been based largely on his other ideas. Vincenzo Cuoco, the first Vico scholar, presented Vico as essentially a communitarian whose defense of rhetoric indicates an argument for a culturally grounded ethics. One of Vico's most famous ideas is his cyclical view of history in which societies rise through the development of mythical thought and then fall because of the inability of rational thought to keep society from collapsing into civil war (NS:240–41). These ideas represent strong differences between Vico and Habermas, but Vico does not have as many original ideas to contribute to these debates as some of Habermas's other interlocutors.

Habermas discussed Vico a number of times early in his career. This is not surprising since Vico was studied by Horkheimer and other members of the Frankfurt school.[4] Habermas, like many others, praised Vico for being the first philosopher of history. Habermas saw that Vico's cyclical history contained some of the primary elements of Hegelian dialectic.[5] However, Habermas criticizes Vico's account because it ultimately sees history as a divine rather than a human process.[6] Habermas regards Vico only as a starting point from which the philosophy of history could further develop.

Habermas gets closest to Vico's view of myth when he discusses Vico's famous *verum-factum* principle. This principle states that what can be known is what is made. Vico originally presented this principle as an argument against skepticism; since humanity has made the world, humanity may know its truth.[7] However, by the time Vico wrote the *New Science* it had become a hermeneutic principle. Vico writes, "history cannot be more certain when he who creates the things also narrates them" (NS: 349).[8] Vico

argues that to understand his new science of history, one has to remake history and present it in narrative form. This implies the need for a mimetic recreation of mythical thought.

In *Knowledge and Human Interests*, Habermas recognized this hermeneutic reading of Vico's *verum-factum* principle as presented by Wilhelm Dilthey.[9] However, Habermas rejects Dilthey's use of the principle. He faults Dilthey for using the *verum-factum* principle as a justification for finding universality through hermeneutics without justifying the principle itself.

Although Habermas has only mentioned Vico briefly in his more recent works, he has continued to argue against the use of mimesis in hermeneutic investigation. In *The Theory of Communicative Action*, Habermas sharply criticizes Horkheimer and Adorno for their reliance on mimesis because they too cannot provide an abstract account which explains the universality of mimesis from within itself.[10] Once they oppose mimesis to instrumental thought they lose the ability to ground mimesis in anything significant.

Habermas does not reject the use of mimesis entirely, but he claims that it must be understood in a communicative framework (I:390). Yet Habermas does not explore further the role mimesis would play in such a framework. Instead, he stresses that hermeneutics should be based on the recognition of the differences in the contexts of the hermeneuticist and the authors of the previous era (I:131). Philosophy can best use the evidence presented by previous thinkers by clearly recognizing these differences. This suits Habermas's depiction of philosophy in general as based on reflection, since reflection is the faculty of the mind that both critiques and creates categorical differences (I:8).

Vico, conversely, asserts that mythical thought is fundamentally mimetic and non-reflective. Mythical thought is grounded on powerful acts of the imagination. Specifically, the imaginative activity of *fantasia*, or the mythic activity of making things familiar, as opposed to the act of *imaginare* in which the thinker remains distinct from the object imagined.[11] A modern thinker can only grasp the mythical acts of *fantasia* by engaging in them. Because Habermas has bracketed mimesis, the mythic activity of *fantasia* is foreign to him. This forces him to give a reflective account of mythical thought.

Habermas may argue that Vico has the same difficulty justifying mimesis as did Dilthey and the others. However, Vico is attempting something different. He is not trying to use mimesis to recreate any particular historical era. His goal is to use mimesis to reveal a unique form of thought that is fundamentally non-reflective. Habermas's arguments against mimesis do not appear to be designed to deal with this possibility. Rather than trying to construct an argument for Habermas on this score, I

will now turn to an investigation of the communicative distinction Habermas draws between mythical and instrumental thought.

In *The Theory of Communicative Action*, Habermas defines the difference between mythical thought and instrumental thought in the context of a discussion of the debate between Peter Winch and E. E. Evans-Pritchard among others (I:45). Winch uses Wittgenstein to argue that languages categorize reality in radically different ways. For Winch, the lifeworlds of different cultures are fundamentally different and are irreducible. Thus, Winch argues for cultural relativism (I:56–57). Conversely, Evans-Pritchard argues that instrumentality is a universal concept and that all languages can be measured pragmatically. Thus, anthropologists may use scientific concepts to understand mythic thinkers (I:60). So, Evans-Pritchard argues for the universality of the scientific method.

Habermas argues that both positions fail because they understand rationality in terms of a theory of consciousness (I:66). Habermas defends the need for a communicative account by qualifying both positions. Habermas agrees with Winch that mythical thought is radically different from discursive thought. He claims that Evans-Pritchard's account of mythical thought is too scientific and assumes too much about the universality of the scientific method (I:60). Habermas makes this claim because he wants to argue that the difference between the two forms of thought is great enough that philosophy can learn both by contrasting the two. Thus, to an extent Habermas agrees with Winch that the difference between mythical and instrumental thought must be respected.

However, Habermas does not want to go so far as Winch and say there are many incommensurate forms of rationality (I:66). Habermas agrees with a fundamental claim of Evans-Pritchard. Habermas writes, "The well-known investigations of Evans-Pritchard concerning the belief in witchcraft among the African Azande confirmed the view that the differences between mythical and modern thought do not lie at the level of logical operations" (I:44). Habermas uses this claim to demonstrate the failure of Winch's Wittgensteinian argument. Cognitive adequacy, the pragmatic ability to accomplish acts in the world, is fundamentally a universal method for comparing different types of thought. However, Habermas has to qualify this because if he applies cognitive adequacy as a criterion too strongly he will reduce all thought back to the scientific method (I:60–61).

Habermas has in essence uncovered an antinomy between Winch's and Evans-Pritchard's positions. To avoid this antinomy, Habermas moves beyond the philosophy of consciousness to a philosophy of communicative thought. He reinforces the notion of cognitive adequacy with Robin Horton's argument which uses Popper's notion of the openness and closedness of societies. Mythical thought is rooted profoundly in traditions that prevent its

people from engaging in productive discussions that generate better solutions to practical problems (I:61–63). Thus, for Habermas, if a tribal language seems confused and contradictory, it is not because its speakers have a different way of thinking but it is because the closedness of their society prevents them from rectifying the deficiencies in their language and achieving greater cognitive adequacy (I:63).

This conclusion allows Habermas to do two things. First, it allows Habermas to continue to define the extent to which modern thought may be considered universal. It is universal in the sense that it is part of the movement of thought toward communicative universality. This is his primary objective for this section (I:63).

Second, and more significant from a Vichian perspective, it allows Habermas to reduce other possible distinctions to the communicative distinction of openness versus closedness. He writes, "the contrast of 'unreflective vs. reflective thinking' refers to those 'second-order intellectual activities' that make possible not only formal scientific disciplines . . . but also the systematic treatment and formal construction of symbol systems in general" (I:64). The first order distinction is the social one, all the other distinctions are secondary. Thus, Habermas does not have to worry about any logical difference between the two forms of thought and can simply focus on the primary communicative difference between the two.

A Vichian critique of this argument would start by questioning whether Habermas avoids the conceit of scholars. This conceit is the tendency of scholars to assume that all people think in the same basic fashion that scholars do (NS: 122–24, 127–28). Because of this conceit, scholars have failed to understand mythical thought because they have assumed that it was a weak form of modern thought.

Habermas recognizes the basic nature of this conceit although he does not use Vico's term. He praises Winch for recognizing that the Victorian anthropologists Frazer and Tyler made the error of "simply imposing the supposedly universal rationality standards of one's own culture upon alien cultures" (I:55). Yet, Habermas sees the danger of this conceit differently than Vico does. He thinks the danger rests in underestimating the power of mythical thought and making the error of Claude Lévy-Bruhl, who argued that mythical thought only existed as a form of pre-rationality that was not itself rational (I:44). Habermas acknowledges, with Winch, that mythic societies are complex and that it is incorrect to assume that because mythic thinkers do not think as clearly as moderns that they are simply irrational. Habermas believes that this is enough to avoid the problems of Victorian anthropology.

Vico would contend that Habermas has not identified the true danger of the conceit. The real danger is believing that mythical thinkers think the

same way as moderns. Because Habermas states that mythical thought has the same basic logical structure as modern thought, Habermas cannot recognize mythical thought's unique power. Instead, Habermas essentially reduces mythical thought to nothing more than an inferior form of instrumental thought since the closed nature of mythical thought prevents it from having the same cognitive adequacy as instrumental thought. Habermas does not recognize the possibility of a unique criterion for mythical thought from which it may be judged on its own terms.

Vico would suggest another way out of the antinomy. Instead of arguing for many forms of thought, as Winch does, or one form of thought, as Evans-Pritchard does, Vico argues simply for the existence of two forms of thought. Winch tried to make the negative argument that modern thought could not comprehend other forms of thought. Vico, instead, tries to demonstrate the existence of mythical thought positively by outlining its structure.[12] He tries to do this directly by showing the unique coherence and criteria of mythical thought rather than trying to demonstrate that instrumental thought cannot comprehend it.

From a Vichian perspective, Habermas can refute Winch because he was making too big a claim. For Habermas to refute Vico, he would have to show that the particular form of thought Vico depicts either does not exist or that the differences Vico describes result from the closedness of mythical thought. Habermas, to my knowledge, does not try to do this. Instead of trying to construct this argument for Habermas, however, I will turn directly to the contrary depictions of mythical thought suggested by Habermas and Vico.

To be fair, Habermas's text is not primarily about mythical thought. He admits he does not want to discuss the nature of primitive methods of symbolization or try to find the exact line between human thought and instinct.[13] When he does discuss mythical thought, it is usually in the context of an argument concerning either his ethical theory or his account of the rationalization of society.

Nevertheless, it is frustrating that Habermas does not make a definitive statement about the nature of mythical thought. He uses the notion that mythical thought is closed fairly consistently. However, he stops using the term closed, and he does not show how the other characteristics of mythical thought follow from the closed nature of mythical thought. The above argument tries to justify the need for a communicative distinction, but it does not appear to justify this particular basis for the distinction.

I shall discuss two main aspects of the writings in *The Theory of Communicative Action* where Habermas does talk about mythical thought. First, I shall discuss the admittedly rough empirical presentation of mythical thought that Habermas gives early in the first volume. Then, I shall discuss

the more communicatively based discussions of mythical thought that come later in the text. I intend to show that Habermas emphasizes the manner in which mythical thought prevents innovation while affirming the power of tradition.

Habermas admits that his first characterization of mythical thought is a "rough" one (I:45). He writes, "The deeper one penetrates into the network of a mythical interpretation of the world, the more strongly the totalizing power of the 'savage mind' stands out" (I:45). Habermas's point is that mythical thought through ritual penetrates all aspects of the life of the mythical thinker. It presents a comprehensive world view that does not clearly distinguish elements into any sort of classification system.

Because mythical thought is totalizing and cannot classify, it has to rely on comparison in order to make judgments (I:45–46). Further, because mythical thought can only compare elements and not classify them, mythical thought can only understand the world in a concretistic way that does not go beyond surface level analogies and contrasts (I:46).

From the concretistic nature of myth, Habermas recognizes that mythical thinkers view nature and culture as being on the same plane. This is the reason why mythical thinkers anthropomorphize nature; they can compare themselves to nature but cannot make a clear distinction between themselves and nature (I:47). Even further, Habermas writes, "Myths do not present a clear, basic, conceptual differentiation between things and persons, between objects that can be manipulated and agents—subjects capable of speaking and acting to whom we attribute linguistic utterances" (I:48). Mythical thought equates moral failure and physical failure; since mythical thinkers do not separate culture from nature, they also fail to separate sickness from evil.

Habermas concludes that the totalizing power of the mythical lifeworld prevents mythical thinkers from engaging in moral criticism. Habermas writes, "mythical worldviews prevent us from categorically uncoupling nature and culture. . . . As a result the concept of the world is dogmatically invested with a specific content that is withdrawn from rational discussion and thus from criticism" (I:51). It is only as reflection gains power and language develops more fully that individuals can ground their society on a rational understanding of cooperation.

It has been helpful to portray this account of Habermas's because it will make the rest of the following discussion of mythical thought clearer. Much of what Vico says about mythical thought agrees with this basic characterization. Further, this account is in accord with Habermas's communicative distinction between mythical and instrumental thought because it does not suggest that mythical thought has a unique criterion other than cognitive adequacy.

However, it is important to note that this account cannot be seen as fundamental to the communicative distinction Habermas wants to make between the instrumental and the mythical. This account is grounded on the epistemological fact that mythical thought totalizes but cannot categorize. If this were the key difference, then Habermas would be undercutting the notion that thought has to be understood communicatively. By calling it a rough characterization, it is clear Habermas did not intend it as a justification for his later account. I now turn to the rest of *The Theory of Communicative Action* where Habermas portrays mythical thought in its communicative aspect.

In the first volume of *The Theory of Communicative Action*, Habermas makes an important point in the midst of a discussion of Max Weber. Habermas claims that mythical thought does not distinguish between the needs of the individual and the community. It is only concerned with the good of the collective; he writes, "tribal cults were tailored to dealing with collective exigencies and not with the fates of the individuals" (I:201). This is in accord with the fact that mythical thought is closed. Since the needs of the group are the only needs considered by mythical thought, it does not present individuals with a way of making their personal desires heard, thereby shutting off communication. Presumably, Habermas understands the good of the collective pragmatically since he does not deny this criterion as a way of understanding mythical thought.

Habermas claims that the totalizing nature of mythical thought is its own undoing. As knowledge expands the range of human interests, an individual will come to desire a justification for his or her personal sacrifice. As this happens, religion develops as an abstraction from myth that is designed to cope with unjust suffering (I:201). This allows religion to become more objective and more abstract, thereby overcoming the closed nature of mythical thought (I:213).

The collective nature of mythical thought is a recurring theme throughout the second volume of *The Theory of Communicative Action*. Habermas, at one point, engages in a thought experiment in which he examines a mythical language with no critical power at all. A society that used this language would be totally integrated. Without the power of critique, there would be no way for any individual to distinguish himself or herself from the group. In such a society, Habermas writes, "the religious cult is something like a total institution that encompasses and normatively integrates all action . . . to such a degree that every transgression of a norm has the significance of a sacrilege" (II:87). There would be language, but the language in this society would consist of totally binding norms that could not be questioned at all.

Practically speaking, when mythical thought is called upon to give a

justification, the only justification it can give is tradition itself. Habermas writes, "In societies organized through kinship [mythical societies], the institutional system is anchored ritually, that is, in a practice that is interpreted by mythical narratives and that stabilizes its normative validity all by itself" (II:188). Mythical narratives state that the community has always acted in a particular fashion and this is enough to justify a course of action.

Mythical societies are grounded in kinship because tradition dictates it. There is no need for the leader to justify his or her rule (II:157). Further, there is no need in such a society for a rational articulation of justice since the word of the ruler, grounded in tradition, is enough to justify any norm (II:175). Again, since there is no room for individuality, there is no reason for open discussion.

These characterizations of mythical thought are communicative in that they show how mythical thought operates differently in society than instrumental thought. Indeed, Habermas's purpose in making such a distinction is to demonstrate that instrumental thought has to fight to establish itself in the face of the mythical power structure. According to him, as societies develop, they encounter complicated situations that mythical thought cannot handle. Practically speaking, societies come to undertake complicated tasks such as fighting wars and building canoes that will cause them to start using instrumental thought and ignoring mythical thought (II:160). Politically speaking, societies will begin to break down the traditional kinship system by intermarrying. This too will call on instrumental thought to develop new ways of stratifying society and new rules for the exchange of goods (II:161). These problems lead to the outdating of mythical thought and its replacement by instrumental thought.

This is significant because it allows Habermas to reveal another communicative function for mythical thought. For Habermas, the distinction between instrumental and mythical thought is fundamental and even prelinguistic (II:46). Since the two forms of thought are fundamentally different, Habermas does not think one developed from the other. Rather, Habermas can portray continual conflict and communication between the two forms of thought throughout the development of society.

This becomes the basis for Habermas's account of the nature of mythical ritual. He discusses ritual in the context of a moral debate over the conclusion that Emile Durkheim draws from the nature of the sacred and the profane (II:47–55). I do not want to get into this argument here, but I want to examine their views on ritual since it will make an important contrast with Vico.

Habermas and Durkheim basically agree on the nature of mythical rituals. They contain sacred norms but do not represent anything other than the

collective consciousness. Habermas writes of Durkheim's view, "Nothing is depicted in ceremonies of this kind; they are rather the exemplary, repeated putting into effect of a consensus that is thereby renewed" (II:53). For Durkheim the individual understands himself or herself through ritual as a member of a collective identity and so obeys the norms of that entity. This is in accord with Habermas's claim that mythical thought only needs tradition as justification; mythical thought presents the tradition through ritualized activity.

The disagreement begins when Durkheim draws the moral conclusion that ritual and myth are needed even in contemporary society to motivate people to act morally and maintain the integrity of society. Durkheim believes that since proper moral norms should not operate on the basis of sanction, these moral norms ought to be reinforced in modern society by ritual (II:48–49). Habermas needs to refute this argument as part of his program of separating tradition from morality. He does so by showing that the fundamental separation between instrumental and mythical thought implies that instrumental thought and ultimately communicative action has no need for mythical thought.

Habermas attacks Durkheim for placing ritual at too fundamental a level of communication. For Habermas, ritual cannot be seen as a primordial act of symbolism since it operates at too high a level of linguistic development. Language must begin through very basic signals (II:22–23). These signals must be developed through a process of trial and error and are grounded in the cognitive and instrumental, which are fundamentally separate from the expressive and mythical. Ritual can only begin once the more basic activity of communicatively agreeing on a set of signals is met (II:55).

From this, Habermas sees a role for ritual that is radically different from Durkheim's. Ritual is not a primordial activity that holds society together, but the more advanced activity that only holds mythical thought itself together in the face of the development of more advanced forms of instrumental thought. He writes that in a mythic society all elements of social structure are integrated into the totalizing worldview. However, "Myth binds the critical potential of communicative action, stops up, so to speak, the source of inner contingencies springing from communication itself" (II:159). Communicative action continually looks for ways to solve new problems, but the totalizing power of myth and ritual prevent that from happening.

Put more strongly, instrumental thought wants to break down the totality of mythical thought. Habermas writes, "mythical thought shields ritual practice from the tendencies of decomposition that appear at the level of language. . . . Myth holds the same aspects together on the plane of interpretation that are fused together in ritual on the plane of practice" (II:193). Ritual is an advanced form of thought that prevents people from

getting enough distance to question the efficacy of their actions. Ritual reinforces the idea that the only justification necessary is that of tradition.

What is striking about Habermas's account of myth is the emphasis he places on the ability of mythical thought to prevent innovation. Mythical thought's primary communicative ability is, in a sense, to stop communication or at least to stop any communication that might interfere with the power of tradition. Habermas understands mythical thought negatively as a destructive force, while emphasizing that the positive development of society comes primarily, if not entirely, from instrumental thought.

Vico would criticize Habermas for not explaining the way that mythical thought generates tradition in the first place. It seems that the strongest explanation Habermas could give for the origin of tradition is that it is actually based in instrumental thought. Mythical thought would come later, such that the leadership, who presumably benefited from the original results of instrumental thought, could prevent anyone from developing more effective techniques which would lead to a shift in power. This does not seem satisfying, though, because it fails to explain why the leaders would turn to myth to secure their power.

Vico would agree with Habermas that mythical thought works to impede instrumental thought. He would also agree that mythical thought does this by reinforcing tradition and ritual. Moreover, Vico never questions the significance of memory for understanding mythical thought. However, Vico would suggest that myth is not understood until the productive aspect of the imagination is disclosed.

A starting point for Vico's critique of Habermas might be found in his early work, *The Study Methods*. There he suggests that the problem with modern philosophy and society is that it recognizes the scientific problem solving ability of critique but does not recognize the inventive power of rhetoric. Rhetoric does not solve problems by generating a method as instrumental thought does. Rather, rhetoric generates ideas by locating the middle term between disparate objects. These middle terms can be between ideas in an argument or between the speaker and the audience.[14] Nothing new is being created, but ideas are found that connect other ideas. This brings the speaker and the audience together and makes ideas intelligible.

Mythical thought can be seen as a radical form of rhetoric. A mythical thinker needs to find the rituals or traditions that will connect the speaker with the rest of the tribe. This is a difficult task and one which requires a powerful imagination on the part of the mythical leaders. Habermas does not recognize this. He is satisfied to say that mythic rule is legitimized only by the influence and prestige of the tribal leader (II:179). He does not explain what sort of work needs to be done to gain that influence and prestige. Vico might respond that while kinship is obviously an important part of the power structure of mythical societies, mythical leaders must still use their powerful

imaginations to create commonplaces that will hold the tribe together.

To make this point complete, Vico would show that mythical thought has its own set of criteria. As a starting point for explaining these criteria, he would suggest that Habermas was correct to emphasize the fact that mythical thought is grounded in comparison rather than categorization. Yet, he would say that Habermas did not take that idea far enough. The imagination—in this case fantasia which is a more powerful form of imagination but one that fulfills the same role as the art of topics—creates through finding similarities. Mythical thought is a powerful act of the imagination rather than categorization.

Vico claims that people have a natural tendency to understand what is unknown by comparing it with what is known (NS:122). The first people must have had powerful imaginations, so the comparison the first people must have made was between the only thing they knew, their bodies, and a powerful experience they could not understand (NS:377). Further, this comparison cannot be grounded in reflection since that faculty is weak at the origin of consciousness. Rather, the comparison occurs as the primitive makes use of his or her body to imitate the external event (NS:401). This act of imitation is itself what Vico calls the imaginative universal.

The most detailed example Vico gives of this is the imaginative universal Jove. Vico may have intended this example as a literal fact of history, but here I am assuming it is just a paradigm for Vico's account of mythical thought. The first mythic thought, according to Vico, is the memory of a profound experience of thunder. He writes because of the thunder, "a few giants . . . were frightened and astonished by the great effect whose cause they did not know, and raised their eyes and became aware of the sky" (NS:377). However, because they could not reflect, they could not remember the sky and the thunder by naming it. They could only remember the thunder by shaking their bodies in imitation of the sky (NS: 379). The mythical thought of Jove is both a powerful act of imagination and a physical imitation of the past experience. Every time a mythical thinker thinks of Jove, the thinker must engage in the shaking again.[15]

Starting from this mimetic non-reflective logic of mythical thought, Vico can explain the nature of mythical innovation. Vico says that every time a powerful experience occurred, the mythical thinkers generate a new imaginative universal. While Habermas is correct to say that mythical thought focuses on the past as its justification, he underestimates how difficult and complex that activity is. In order for someone to rule, he or she must either imagine new and persuasive imaginative universals or at least be able to associate the right universal with the particular circumstance. This requires an ingenuity that needs to be understood if a complete account of mythical thought is to be given.

From here, it is possible to use Vichian ideas to account for many of the

characteristics of myth Habermas describes. Habermas derives the importance of comparison in myth from its totalizing power. From a Vichian perspective, mythical thought is totalizing because it is constituted by the experience of possession. Every primordial mythical thought is totalizing because it is passionate and requires full bodily activity to perform it. When a mythical thinker recreates Jove, he or she becomes the experience again in its entirety. When a mythical thinker recreates one thought, he or she does so at the expense of all other thought. Mythical thinkers move from one act of possession to another as various events cause various emotions to manifest themselves.[16] Each thought is totalizing, but mythical thought as a whole is not so totalizing that it cannot create.

Vico would also claim that Durkheim is correct in saying that ritual is primordial. Reading into Vico's text, his argument is that because mythical thinkers have no ability to abstract, they must think with physical gestures that imitate previous events. The imaginative universals can be understood as basic primitive rituals that become formalized and regimented over time.

Habermas argued that ritual can be developed only after signals have been established through a very basic process of trial and error. Vico would respond that Habermas makes this claim only because he does not respect the ability of the imagination to invent. Mythical thought has the potential to create, but its success is measured by the quality of the comparison and not by the success or failure of an instrumental act. In other words, the success of mythical thought rests in its ability to persuade others and not by its ability to accomplish a specific feat.

The irony developing here is that even though Vico starts from an epistemological fact, mythical thought's inability to reflect, he ends up describing mythical thought in a communicative fashion. The criterion of mythical thought, for Vico, is its ability to persuade by creating an effective common ground in which the members of the tribe can live. One can think of an individual engaging in instrumental thought to solve a particular problem, but according to Vico's view, mythical thought must always operate in a social situation.

This leads to the reason why Vico's account is of interest for critical theorists. Vico's *New Science* is difficult to read. This is partly because it is not a straightforward presentation of mythical thought through a philosophy of consciousness as given by a thinker like Ernst Cassirer. Vico recognizes that mythical thought must be understood in a social and communal fashion. Instead of presenting mythical thought in a Cartesian fashion, he presents it in the context of an account of a history of mythical society.

Since the imaginative universals need to be presented persuasively in order to be recognized as universal, they are fundamentally communicative. Imaginative universals must come from events that are either unnatural or at least are experienced as unnatural like the thunder. Thus, the imaginative

universals do not come from nature, since this is understood instinctively, but from human acts. The primary uniquely human act is the control the rulers develop over the slaves beneath them (NS:389, 524).

Thus, the imaginative universals are actually political institutions representing the control of the strong mythical thinkers over the weak instrumental thinkers: Jove gave the rulers power, Juno is the institution of marriage, Apollo contains all the acts of nobility of the rulers, Venus is the beauty of the order provided by the rulers (NS:503, 504, 533, 565). Habermas is correct to say that ritual tries to prevent the development of instrumental thought. However, there is much to be learned by how mythical thought does this. The history Vico presents in the *New Science* is one understood through the relationship between the two classes of people; this appears to be an unpolished but basic communicative understanding of myth.

This brief sketch of the Vichian mimetic view of mythical thought is intended to show some of the ways Vico's account is superior to Habermas's and to show how Vico's account is interesting because it appears to be more communicative than epistemological. It is doubtful that any thoroughly discursive argument could demonstrate the superiority of Vico's view to Habermas's. It is unclear whether a reflective argument can justify the need for a non-reflective reading of a non-reflective form of thought. All that Vico suggests is that the reader narrate the science to himself or herself in the hope of understanding this very foreign way of thinking.

Nevertheless, it seems that Vico would have a number of serious charges to level against Habermas. Habermas's depiction of mythical thought appears to be incomplete since he cannot adequately answer the critical question of where tradition comes from. Vico's mimetic account of mythical thought, based on the notion of the imaginative universal, can describe the origin of tradition. Habermas cannot fully explain the power structure of mythical societies. Vico's fuller account of the political conflict between mythical and instrumental thought can. Further, Habermas tries to dismiss many of his opponents by presenting mythical thought in a communicative fashion rather than on the basis of a theory of consciousness. It seems that Vico's account could avoid this charge since it presents mythical thought as occurring in a social context while avoiding the charge of radical cultural relativism. Ultimately, Habermas claims to respect the power of mythical thought but uses the criteria of instrumental thought to condemn mythical thought for preventing open communication. Vico suggests that mythical thought may only be respected when its own mimetic criteria are examined.

If the charges are correct, there may be some serious problems with the theory of communicative action. Habermas suggests that there is a conflict in the rationalization of society between mythical thought and instrumental thought. However, he cannot fully portray this conflict, because he does not

appear to understand the weapons of mythical thought. Further, because he does not understand the innovative power of mythical thought, he cannot explain any positive role that mythical thought might have to play in philosophy or in society. More deeply, Vico would suggest that Habermas must question the assumption that philosophy should be grounded entirely on reflective critique. Vico suggests that Habermas should allow mimesis back into philosophical activity in order to understand the power of mythical thought.

These last statements are important but should not be misread. The debate between these two thinkers should not be seen simply as a debate over first principles. The debate is also part of the search for a complete account of human understanding. There is enough similarity in their positions that a dialogue between the two could lead to a greater comprehension of human understanding in its entirety. I hope that such a dialogue will be undertaken.

ALEXANDER BERTLAND

DEPARTMENT OF PHILOSOPHY
UNIVERSITY OF SCRANTON
SEPTEMBER 1999

NOTES

1. There are many accounts of this anthropological investigation of myth. One example is Claude Lévi-Strauss, *The Savage Mind* (Chicago: University of Chicago Press, 1966).

2. Vico's text often implies such readings but I am bracketing them here to concentrate on his political understanding of mythical thought. See Giambattista Vico, *The New Science of Giambattista Vico* (1744 edition), trans. Thomas Goddard Bergin and Max Harold Fisch (Ithaca, N.Y.: Cornell University Press, 1984), paragraph 345. Hereafter cited in the text as (NS: with the paragraph number).

3. Donald Phillip Verene, *Vico's Science of Imagination* (Ithaca, N.Y.: Cornell University Press, 1981), pp. 29–30, 66–67.

4. See Max Horkheimer, "Vico and Mythology," trans. Fred Dallmayr. *New Vico Studies* 5 (1987), pp. 63–78.

5. Jürgen Habermas, *Theory and Practice*, trans. John Viertel (Boston: Beacon Press, 1973), pp. 242–45.

6. J. G. Merquior, *Vico and Marx: Affinities and Contrasts*, ed. Giorgio Tagliacozzo (Atlantic Highlands, N.J.: Humanities Press, 1983), pp. 401–26, esp 405–7.

7. Giambattista Vico, *On the Most Ancient Wisdom of the Italians Unearthed from the Origins of the Latin Language*, trans. L. M. Palmer (Ithaca, N.Y.: Cornell University Press, 1988), pp. 45–47, 56–57.

8. See also Vico, *New Science*, p. 331.

9. Jürgen Habermas, *Knowledge and Human Interests*, trans. Jeremy J. Shapiro (Boston: Beacon Press, 1971), pp. 148–49.

10. Jürgen Habermas, *The Theory of Communicative Action*, vol. I: *Reason and the Rationalization of Society*, trans. Thomas McCarthy (Boston: Beacon Press, 1984), p. 391. This will be hereafter cited parenthetically in the text as (I: page number).

11. *New Science* 700. Vico states, "we . . . cannot at all imagine how the first men thought." Here the word imagine is a translation of *imaginare*. This implies the need for the other type of imagination, *fantasia*. Donald Phillip Verene, *Vico's Science of Imagination* (Ithaca, N.Y.: Cornell University Press, 1981), pp. 101–6.

12. Karl Otto-Apel tries to bring Vico into the debate between Winch and critical theory, but he does not recognize that Vico's approach to the problem is different. Karl Otto-Apel, *Towards a Transformation of Philosophy*, trans. Glyn Adey and David Frisby (London: Routledge & Kegan Paul, 1980), pp. 163–67.

13. Jürgen Habermas, *The Theory of Communicative Action*, vol. II: *Lifeworld and System: A Critique of Functionalist Reason*, trans. Thomas McCarthy (Boston: Beacon Press, 1987), p. 22. This will be hereafter cited parenthetically in the text as (II: page number).

14. Giambattista Vico, *On the Study Methods of Our Time*, trans. Elio Gianturco (Ithaca, N.Y.: Cornell University Press, 1990), pp. 14–15.

15. For a fuller explanation of the imaginative universals see Verene, *Vico's Science*, pp. 65–95.

16. For a good account of the importance of possession in mythical thought, see Ernst Cassirer, *The Philosophy of Symbolic Forms*, vol. 2: *Mythical Thought*, trans. Ralph Manheim (New Haven: Yale University Press, 1955), pp. 73–74.

5

Paget Henry

Myth, Language, and Habermasian Rationality: Another Africana Contribution

INTRODUCTION

In an earlier work,[1] I examined the nature of Habermasian rationality in the light of the analysis of myth offered in the first volume of *The Theory of Communicative Action*. There I argued that in spite of its continuously changing nature, Habermasian rationality has been inscribed in a binary that it has not been able to adequately thematize and satisfactorily transcend. This binary derives from the fact that like earlier conceptions of Western rationality, Habermasian rationality requires a conceptual other. I've argued that this conceptual other is myth and its associated discursive and institutional practices. In positive terms, Habermasian rationality understands and defines itself in terms of structures of argumentation. However, equally important to its self-understanding is that it is the negation of myth. Hence, in the contrasting discursive practices of myth it sees very clearly its own rationality. Using the case of African mythic discourses, I tried to show that the persistence of this binary not only distorts the nature of myth and contradicts the ideals of communicative action, but also that its removal will require the contributions of the distinctive rationality of myth.

In this paper, I will again take up this theme of the binary or dualistic nature of Habermasian reason. This time I will focus on the treatment of myth in the second volume of *The Theory of Communicative Action*, in particular the sections that treat "the linguistification of the sacred." Again, with the aid of African myth, my argument here will be that while the treatment of myth has improved significantly, it is still severely hampered on three grounds: first, the persistence of the binary oppositional structure in Habermasian rationality

that requires myth as its conceptual other. Second, because of the built-in bias of this binary there is an over-investment in the explanatory and behavior-coordinating powers of language. Third, a corresponding under-emphasis or devaluation of the explanatory and behavior-coordinating powers of the ego/spirit relationship, which is central to myth, accompanies the above over-investment. I will show that an alternative conception of myth that is free of these problems is implicit in Habermas's work but was never developed. This alternative could have been thematized through a reading of myth in terms of the Habermasian notions of knowledge constitutive interests and general interpretations.

The first of these two positions on myth have in turn affected Habermas's reading of African societies, which provide many of his examples of myth. Within the Africana tradition of thought, myth has not been "othered" in quite the same way that it has been in Habermas's work. This has resulted in a very different view of myth. Second, within this tradition, patterns of discursive and institutional differentiation have not autonomized language in the way Habermas sees it. Third and finally, the importance of poeticist traditions of writing and the birth of new religions such as the Rastafarians point to the presence of an active world-constituting ego/spirit relationship. Consequently, from the perspective of key positions within the Africana tradition, the roles of myth and language in the modernizing of social practices and institutions appear to be quite different from the Habermasian view. It is these differences in perspective and their implications for myth, language, and philosophical rationality that will also be the focus of this paper.

HABERMAS AND THE BINARY STRUCTURES OF WESTERN RATIONALITY

In spite of his critiques of Marx, Weber, Husserl, Adorno, Horkheimer, and the post-structuralists, Habermas has certainly not been able to lay to rest the spectre of a non-rational shadow haunting Western rationality. In the views of these theorists, the incorporating of the sciences into the productive and administrative regimes of the Western societies produced surprisingly ambivalent outcomes. On the one hand, these rationalizing practices resulted in new orders of freedom and inclusion. On the other, they also produced new orders of domination and exclusion.[2] The former brought with them unimagined increases in efficiency of output and in technological mastery over the natural and social environments. The latter were accompanied by equally unimagined increases in the scope and efficiency of systems of domination, the fragmenting of everyday experience, and the separating of these fragments from any concrete sense of a larger whole. The vacuum created by these separations has been filled by a continuous set of hegemonic struggles between these fragments which are carriers of the binary codes that help to produce the

patterns of exclusion, "othering," and domination that ground so much of modern thought. In other words, the process of Western rationalization was seen as locked in struggle with a shadow that it has not been able to decisively grasp or jettison.

These ambivalences that have relentlessly pursued Western rationality become even clearer when we take into account the latter's global impact, particularly in the societies colonized by the West. Here the gaps between the rational ideals of the Enlightenment and social orders of domination that came with them were even wider: slavery, racial apartheid, colonial authoritarianism, and ethnic manipulation were some of the major elements in the peripheral shadow of Western rationality. These elements Enrique Dussel has labeled "the underside" of Western modernity.[3] In short, when viewed comprehensively the concrete practice of Western rationality has been a very ambivalent experience. It was this ambivalence that prompted the dark pronouncement from Adorno and Horkheimer that "the fully enlightened earth radiates disaster triumphant."[4]

Indeed, it was Habermas's responses to some of these ambivalences that provided many of the keys to his early thought. Situated in the discursive field defined by the works of Husserl, Adorno, and Horkheimer, Habermas's point of entry into this conversation was a focus on the tendencies of Western scientific rationality to eclipse the self-reflective rationality of philosophical reason. This concern placed him on the frontlines of the defense of a subject-centered philosophical reason over which the dark shadow of scientific rationalism had descended. Thus Habermas's engagement with the binary structures of Western rationality was a limited one that focused on strategies of techno-scientific othering and exclusion.

In spite of this limitation, Habermas clearly inherited and engaged this particular set of oppositions that earlier theorists had identified in the structure of Western rationality. His first response was to join the fight to save self-reflective rationality from technocratic eclipse. Although Habermas had his own ideas about how this should be done, these need not concern us at this moment. What is important for us to note is his engagement in the rescue of a philosophical practice from unwarranted discursive suppression at the hands of the enlightened rationality of science and technology. It is the nature of this discursive or epistemic violence that arises within the fragments of rationalized discourses that is of interest here. Without a clear grasp of this violence, we will not be able to understand why Habermas was on this rescue mission or why he remains locked in battle with myth.

The domination and eclipse of philosophical reason that the early Habermas fought was a classic case of the othering practices that continue to cling to the differentiated and rationalized fragments that constitute the modern discourses of the West. Ironically, so also is Habermas's devaluation of myth in relation to the differentiated Western versions of both language and

philosophy as theoretical discourses. In the case of the domination of philosophical reason, Habermas has been able to show that the othering practices of scientific and technocratic discourses were systematically related to their attempts to become self-legitimating.[5] As a consequence, discourses that could not be easily absorbed had to be systematically devalued or negated. This repressive devaluing was effected through a concealing of the shared transcendental domain within which the categories, schemas, and presuppositions of both scientific and non-scientific discourses arose. These knowledge-constitutive activities and their independence of scientific knowledge production were ignored in favor of a strong emphasis on the superiority, if not universality, of the scientific method of knowing. However, from the transcendental point of view of the knowledge-constitutive processes that support both types of discourses, these devaluations and negations appeared excessive and unwarranted. I will argue that Habermas's devaluation of myth has been of a similar nature.

The Jamaican novelist and literary critic, Sylvia Wynter, has made a strong case for the liminal nature of these processes of discursive othering and excluding.[6] In conceptualizing this discursive violence as liminal, Wynter is suggesting that othered discourses have been analogically linked to what represents chaos or anti-structure for both the functioning and sovereignty of hegemonic discourses. In Habermas's case, myth would represent the antithesis of both scientific and philosophical rationality, something they cannot and should not be associated with. If this liminal thesis is valid, it gives us a clearer idea of the shadow that Habermas was resisting on his rescue mission and the one he is pursuing in his battles against myth.

With the global expansion of Western capitalism and the increased differentiation and rationalization of its discourses, binary tensions such as these have only increased. This increase in the number of differentiated and well-articulated discourses has given rise to what Weber saw as a modern polytheism.[7] This multiplying of quasi-autonomous but liminally marked discourses has given rise to a pattern of continuous hegemonic struggles. These in turn have produced in the West very distinctive discursive patterns of rise and fall that go beyond a particular theory being confirmed or disconfirmed by evidence. The Nigerian writer Wole Soyinka has very artfully captured these peculiar rhythms of Western discursive economies. His portrayal is constructed around a train metaphor that is worth quoting in full:

> You must picture a steam engine which shunts itself between rather closely spaced suburban stations. At the first station it picks up a ballast of allegory, puffs into the next emitting a smokescreen on the eternal landscape of nature truths. At the next, it loads up with a different species of logs which we shall call naturalist timber, puffs into a half-way stop where it fills up with the synthetic fuel of surrealism, from which point yet another holistic world-view is glimpsed and asserted through

psychedelic smoke. A new consignment of absurdist coke lures it into the next station from which it departs giving off no smoke at all, and no fire, until it derails briefly along constructivist tracks and is towed back to the starting point by a neo-classic engine.[8]

This pattern of rapidly shifting positions described by Soyinka points very clearly to the hegemonic struggles that we have identified. However, it also goes on to hint that this train of ideas is on a fast track the switches of which its conductors, engineers, grammarians, and scholars do not fully control. It is a shadowy image of reality repeatedly escaping the Western grasp that is very reminiscent of Weber's own train metaphor in which the dynamic movement of world images are the switchmen that determine the tracks along which the train of human action will travel.[9] Habermas has been on the Soyinkan train, switching between the tracks of technocratic, self-reflective, and communica-tive rationalities.

Myth and Language in Habermasian Rationality

Habermas's conception of rationality has not been a static one. On the contrary, it has been in continuous motion, moving along self-reflective, pragmatic, and finally communicative tracks. On the way, Habermas engaged in debates with a wide variety of hermeneutic and empirical/instrumental forms of rationality that emerged in philosophy and the social sciences.[10] When this gradual shift to communicative rationality is surveyed from the point of view of the binary structures of Western rationality, at least four important tendencies standout: first, the persistence of specific exclusionary categories and practices as integral parts of the structure of Habermasian reason; second, the persistence of myth and it's associated practices as the primary objects of these liminal exclusions; third, the tendency over time for self-reflective rationality to be moved closer to the excluded domains; fourth and finally, a failure to engage the racial othering that Western rationality produced in its peripheral areas. Here, my focus will be on the second of these, the othering and excluding of myth.

The othered status of myth in Habermas's work gets its most systematic treatment in the opening chapter of the first volume of *The Theory of Communicative Action*. Here Western rationality and particularly communica-tive rationality are defined in terms of their structures of argumentation. Habermas reserves the term argumentation for "that type of speech in which participants thematize contested validity claims and attempt to vindicate or criticize them through arguments."[11] This portrayal is complemented by a discussion of the self-understanding of communicative rationality. It is here that the opposition to myth emerges most explicitly, giving rise to a binary

analysis of the self-understanding of communicative rationality. The analysis is carried out within a polarized we/they framework in which all the negatives are attributed to myth and all the positives to communicative rationality. In these comparisons, Western rationality often becomes scientific and techno-cratic, assuming the narrow presentation of self that the early Habermas had resisted so effectively. This polarization is compounded by the fact that these comparisons are made with non-Western mythic discourses as opposed to Western ones.

In the second volume of *The Theory of Communicative Action*, the immediate setting for the discussion of myth is not the internal structure and self-understanding of Western rationality, but the quiet, ongoing differentiation of language in the context of the modernization of Western capitalist societies. This process of linguistic specification and autonomization has reached the point where it is now possible to see quite clearly the properties of language that were formerly suppressed by their integration within pre-modern discursive totalities. Within the framework of these totalities, it was language as a medium of everyday communication that was most visible. In addition to this interactive dimension, the semiotic and the pragmatic aspects of language have now emerged more explicitly. Habermas's primary interests are in the latter aspect, which for him reveals the structures by which language makes it possible for speakers to achieve a consensus. Through these interests in the pragmatics of language, Habermas makes the linguistic turn that has left such a definite mark on twentieth-century Western philosophy. It is in the context of retracing this once hidden but now visible process of linguistic differentia-tion that Habermas returns to the problem of myth.

The major difference with the earlier treatment is that mythic discourses now have positive and indispensable properties that are necessary for understanding the trajectory of this process of linguistic differentiation. The positive properties follow from the fact that myth carries within its "structure of argumentation" the authority of the sacred. The sacred is of interest to Habermas because it is the source of the social consensus that shaped group identities and sustained the institutional orders of pre-modern societies. This is the task that Habermas sees language taking over from the sacred as societies modernize, hence the interest in reconstructing this evolutionary transfer of functions.

Following Durkheim, Habermas sees the sacred as the power behind the obligatory character of the social norms, moral rules, religious practices, and institutional orders of pre-modern societies. The sacred has the power to elicit acts of obedience, devotion, and self-renunciation from human beings. Working through the symbols, discourses, and rituals of the mythic/religious consciousness, imparting to them its authority and charismatic powers, the sacred succeeded in creating the normative orders of the earliest human societies. Habermas agrees with Durkheim that the social consensus that

supported these social orders, their ability to define collective identities and shape institutions were primarily the work of ritual practices that included the acting out of mythic narratives. Consequently, the starting points from which the evolutionary differentiation of language set out are the sacred consensi that are discursively thematized in myth and dramatically expressed through ritual. In societies organized around such consensi, the formal/pragmatic aspects of language remain deeply enmeshed in the consensus creating activities of mythic and ritual practices. In these discursive orders, language remained highly undifferentiated and could only be recognized as the medium of everyday communication. The wider range of its capabilities, including its consensus forming abilities, remained deeply concealed. It is the story of language's liberation from its early captivity in the frameworks of myth and ritual that Habermas will attempt to reconstruct.

Although drawing extensively on Durkheim, Habermas argues that this concealment of language in the discursive orders of the archaic societies misled Durkheim and many other earlier theorists. Still too undifferentiated, they did not see the distinctive contribution of language to societal modernization. For example, he criticizes Durkheim for not distinguishing "adequately between the commonality of ritual practice established via religious symbolism and the intersubjectivity produced by language."[12] Even the early Habermas did not see quite as clearly the distinctness of the intersubjective consensus-forming capabilities of language. Thus, in *Towards a Rational Society*, the process of cultural rationalization was driven by the autonomization and rationalization of systems of economic production and instrumental action that were the outcomes of feedback relations with science and technology. The resulting increases in the autonomy of these productive activities from the legitimating powers of traditional world views, and their abilities to create alternatives to these views, was the framework within which cultural modernization was analyzed.[13] In this early work, the originality of the thesis of the linguistification of the sacred and its explicit thematizing of the distinct contributions of language are strikingly absent.

Although indexed by changes in the nature of law, Durkheim's theory of cultural and institutional differentiation rests ultimately on the struggle of human subjects for greater autonomy from the sacred powers of the collective consciousness. The struggles between these two sites of creative agency framed the cultural transformations that made modernity possible, and not the creative agency of language. In contrast to this position, which is rooted in the paradigm of the subject, Habermas will attempt to reconstruct the emergence of modernity from the point of view of the creative agency of language. This he will do in formal/pragmatic terms as opposed to causal/empirical ones.

From this pragmatic perspective, the key question that Habermas must ask is: what was the impact of the formal properties of language on the sacred and the normative orders it produced in the archaic societies? In answering this

question, Habermas's starting point is a hypothetical and ideal typical construction of the archaic societies. These are social orders that are totally integrated around sacred consensi that are thematized in myth and dramatized through ritual. In such societies, the constitutive and developmental powers of language are suppressed, and, hence, have only minimal significance for the social order. The consensi upon which these orders rest are of an imposed rather than an achieved nature. Consequently, these are societies in which language is "on holiday."[14] As societies develop, the power that the sacred exercises over their discursive orders declines, allowing for limited increases in the autonomy and differentiation of these orders. As this occurs, the process of cultural modernization can be linguistically channeled, thus allowing the creative powers of language greater scope for social organization.

As a distinct symbolic medium, language, like other discourses, has the power to decode and recode the mythic/religious frameworks in which the sacred embeds social orders and collective identities. The symbolic order of language arranges the persons, objects, and events to be represented in ways that are quite different from the arrangements of myth. Also, its mode of consensus formation is very different from that of the sacred. In Habermas's view, language organizes its contents in three basic forms: the propositional, illocutionary, and expressive. However, these distinct categories are form ʻly linked through rules of transformation. Thus, what can be said in all three modes can be recast in the assertoric form of the propositional mode. These formal categories and rules of transformation give language its distinct manner of recoding the mythic and religious orders of the sacred. Along with these recoding capabilities, the propositional, illocutionary, and expressive categories of language are all embedded in structures for contesting and redeeming validity claims. It is these structures that give language its unique capability for establishing alternative consensi to those of the sacred. All of the above powers of language are linked by Habermas to the evolutionary processes of the rationalization of world views, the differentiation of institutions, and the individuation of human subjects.

The impact of language on the sacred construction of these three aspects of pre-modern cultures can be summarized as a recoding of their mythic organization that opens these aspects of cultural life to higher levels of institutional and discursive differentiation as well as ego individuation. This recoding and differentiating power is "inherent in the structures of linguistic communication, but it takes effect only to the extent communicative action has its own weight in the functions of mutual understanding, social integration, and personality formation, and dissolves the symbiotic relation in which religion and society stands."[15] In other words, as societies develop, the re-symbolizing powers of language are released. With this release, they reinforce and eventually lead the discursive overthrowing of the sacred that grounds modern processes of differentiation and secularization. For Habermas, this particular

impact of language really begins to make itself felt when the authority of the sacred has declined to the point where the production of social consensi requires that participants engage in exercises that are oriented toward reaching an understanding. From this point on, the linguistification of the sacred determines the logic of the formal/pragmatic changes in discursive orders that make possible processes of cultural modernization.

In Habermas's view, language overshadows other discourses in this regard because it alone has the power to replace the socially necessary consensus that was supplied by the sacred. For example, he notes that "inasmuch as the sacred domain was constitutive for society, neither science nor art can inherit the mantle of religion; only a morality, set communicatively aflow and developed into a discourse ethics, can replace the authority of the sacred *in this respect*"[16] (emphasis in the original). In short, the results of Habermas's pragmatic analysis suggest that the observed "disempowering of the domain of the sacred takes place by way of the linguistification of the ritually secured basic normative agreement; going along with this is the release of the rationality potential in communicative action."[17] This trajectory suggests that "the aura of rapture and terror that emanates from the sacred, the spellbinding power of the holy, is sublimated into the binding/bonding force of criticizable validity claims and at the same time turned into an everyday occurrence."[18]

MYTH, LANGUAGE, AND DISCURSIVE VIOLENCE

In the above pragmatic analysis of the linguistification of the sacred, myth is constructed very differently from the way in which it was done in volume one of *The Theory of Communicative Action*. Here myth is constructed from the point of view of the evolutionary differentiation of language and not the self-understanding of Western rationality. This shift in focus brings with it significant changes in both the tone and nature of the discursive violence directed at myth. In this volume, violence results not so much from the systematic devaluing of myth as from the tendencies of its ideal typifications to change into reified categories. These categories consistently imprison myth and reduce it to its binary differences with the discourses of the modern West.

These ideal typifications are constructions of myth whose primary purpose is to reveal the constitutive powers of language rather than those of myth or the sacred. Myth is here cast in the role of mirror to language in its process of differentiation. Consequently, there is little reciprocal role reversal in these analyses of myth and language. Language never really becomes a mirror to the development of myth as in the case of Levi-Strauss. It is never really constructed from the point of view of myth and the impact of the formal pragmatic categories of myth on language are never examined in detail. The closest we come to such a reversal of positions is the ideal typical case in

which the sacred authority of myth blocks and contains the constitutive powers of language. Besides this property of sacred authority, no other formal/ pragmatic features of myth are examined. However, there are references to features of myth that were systematically devalued in volume one, such as myth's tendencies to blur categorical distinctions between the objective, social, and subjective worlds. As a result, the overall portrait of myth is one that defines it in terms of two pragmatic negatives: the initial inability of language to resist the sacred authority of myth; and myth's inability to maintain clear analytic distinctions. As a discourse with such formal properties it was fated to be surpassed by language.

This is clearly a rather restrictive portrayal of myth, which may be fine from the point of view of the differentiation of language, but not for myth itself. At some point, myth needs to be freed from this linguistic space and returned to its own terrain. To freeze it as Habermas does between the needs of language and the self-understanding of Western rationality is to suppress and conceal many important pragmatic features of myth. These suppressions parallel the concealment of transcendental interests by the sciences referred to earlier. As such, they point to the problems that continue to plague the treatment of myth in volume two. To develop more fully the nature and significance of these problems, the remainder of this paper is devoted to two crucial issues: (1) a closer look at important pragmatic features of myth concealed by Habermasian typification and othering; and (2) the implications of these suppressions for African myths.

MYTH AND THE PRAGMATICS OF GENERAL INTERPRETATIONS

The suppressing of important features of myth in Habermas's ideal typifications is a form of discursive violence that we all engage in quite often. We do whenever we construct objects from specific points of view. In these constructions, reductive strategies often become necessary if we are to magnify and see more clearly the contributions of a specific viewpoint. However, provisions must be made to return reduced aspects or dimensions to their right sizes. The early Habermas not only recognized these forms of "specialized narrow-mindedness,"[19] but proposed a solution to the reductionist and exclusionary problems that they generated. This solution entailed the practicing of a distinct type of self-reflective philosophy in which specialists learned to reflect on categorically or methodologically driven strategies of suppression in their knowledge producing practices. In this regard, the early Habermas considered it "philosophical enlightenment when sociologists, directed by professional historians, apply some of their general hypotheses to historical materials and thereby become aware of the forced nature of their generalizations."[20] In this way provisions are made for returning particulars to their right

size, after being reduced by sociological generalizations. Exercises of this type are clearly needed in this second treatment of myth.

Such self-reflection on knowledge-generating practices was an integral part of the philosophy of the early Habermas. With the rejection of the paradigm of the subject, it is not clear where the later Habermas stands on the above solution to the problems of discursive violence under consideration. However, I would like to suggest its continuing relevance for dealing with the suppressions and forced typifications in Habermas's treatment of myth. This use of Habermas against Habermas suggests itself in the case of myth because of a number of striking inconsistencies between its treatment and the broader framework of Habermas's philosophy. This strategy will be a major part of our discussion of the pragmatics of myth.

To grasp the knowledge-constitutive forces shaping Habermas's suppression of key aspects of myth, we must begin with some reflections on the fundamental analogies, assumptions, categories, and schemas that inform his analysis. First, Habermas's primary orientation to the world is cognitive as opposed to ethical or existential. His interests are in knowledge production and the categories and rules that make it possible. Second, within this cognitive orientation the objective sciences have progressively emerged as a founding analogy for all other forms of knowledge production. This has resulted in a marked eclipsing of self-reflective modes of cognition. Third, among the three basic categories into which language divides its contents, it is clear that propositional speech acts serve as an analogy for the analysis of the other two categories. Thus, in volume two of *The Theory of Communicative Action*, Habermas suggests that, "when participants in communication utter or understand experiential sentences or normative sentences, they have to be able to relate something in a subjective world or in their common social world in a way similar to that in which they relate to something in the objective world with their constative speech acts."[21] Fourth, we have already seen how important it is for Habermas, that expressive and normative speech acts are translatable into the assertoric form of propositional or constative speech acts. Fifth and finally, the social worlds that correspond to these linguistic divisions—the cognitive/instrumental, the moral/practical, and aesthetic/expressive worlds—are marked by a similar analogical relationship.[22] These facts point to Habermas's strong cognitive orientation and the exemplary role of the empirical sciences in it. Given this objectivist cognitive orientation and the strategy of casting myth in the role of mirror, we begin to get some idea of the transcendental/categorical dynamics that have shaped the horizon within which Habermas has viewed myth.

However, an objectivist reification of myth was not an absolute necessity in Habermas's case. Alternative portrayals were possible because of other transcendental dynamics operative in the work of the early Habermas. Particularly important in this regard were the transcendental analyses with

which self-reflective rationality was rescued from the tightening grip of objectivistic/technocratic rationality. Suppose for a moment that Habermas had seen this technocratic narrowing of Western rationality as impacting on myth in ways that were similar to its impact on self-reflective rationality. Grasped within the categories and schemas of that transcendental horizon, a very different picture of myth would have emerged. This is what I showed in my first critique of Habermasian rationality.

Regarding the epistemic foundations and rationality of mythic knowledge, I argued that the cognitive core of myth was not object-oriented but subject-oriented. Its primary orientation to the world was existential and not cognitive. At the heart of its knowledge production lies a discourse of the human self and the problems inherent in its genesis. Because the mythic theory of ego-genesis consistently involved the category of spirit, I argued that it rested on a mode of knowledge production that could not be subsumed under any of Habermas's three knowledge constitutive interests. However, I insisted that myth's epistemic practices could be formulated in terms of the general Habermasian notion of knowledge constitutive interests, even though it had not been done. Consequently, I proceeded to show that the knowledge and rationality of myth could be formulated around an interest in reconciliation and harmony—particularly ego/spirit reconciliation.

In spite of drawing on Levi-Strauss, Habermas misses these reconciliatory interests of myth. Levi-Strauss breaks down mythic narratives into opposing constitutive themes that have to be balanced. In the case of the Oedipus myth, its many variations are broken down into binary themes such as the overrating of blood relations versus the underrating of blood relations. The results of his analysis are summed up in a correlation that must be kept in balance: "the overrating of blood relations is to the underrating of blood relations as the attempt to escape autochthony is to the impossibility to succeed in it."[23] In other words, myth provides "a kind of logical tool,"[24] for thematizing such issues and keeping them in balance. Levi-Strauss's emphasis on balancing and reconciliation finds important echoes among the Anufo of Northern Ghana. For this ethnic group, the central "life-predicament" is balancing oppositions such as "kinship-based values" (respect for elders) versus "estate-based values" (entrepreneurial spirit). These are the reconciliatory dynamics that structure the production of mythic knowledge. Such a transcendental treatment of the nature of mythic knowledge was a definite possibility within the self-reflective domains of Habermasian philosophy. Unfortunately, it was overshadowed by a sociologically reductionist treatment that arose within the transcendental horizons that framed the self-understanding of Western rationality.

In a similar fashion, the cognitive and objectivist horizons described above have eclipsed a different reading of the pragmatics of myth that has been a very

definite possibility within the self-reflective horizons of Habermas's philosophy. Although quite visible within this horizon, it is very likely to be missed in the cognitive/objectivist framework that informs the analysis of language. This alternative reading of mythic discourses sees them as describing human ego genesis as a self-formative process that is subject to spiritual interruptions. As such, this feature of myth can be pragmatically reconstructed under the category Habermas refers to as a general interpretation.

General interpretations are epistemic formations whose distinctly self-reflective strategies of explanation Habermas has formulated in contrast to the object-oriented strategies of general theories. As epistemic formations, their primary focus is the human self and the problems of its development. Like general theories, general interpretations have an inventory of basic concepts. However, what makes their internal structure different is the fact these concepts are organized around a systematically generalized narrative of the intentional structures of an individual, ego-organized life history. This generalized narrative is not the history of a particular individual, but a narrative of ego-organized development that has been drawn from many cases and from which the particulars have been removed. Such generalized narratives of development contain stadial reconstructions of human self-formative processes that can be used to restart interrupted processes of self-development. In other words, they can be "represented schematically as a self-formative process that goes through various stages of self-objectivation, and that has its telos in the self-consciousness of a reflectively appropriated life history."[25]

This narrative dimension of general interpretations makes for two important differences with general theories. The first difference is that the application of a general interpretation must be a self-application. The application of a general theory to an object of study takes the form of an external imposition or subsumption that is significant only for the theorist or researcher. The theory is of no significance to the object. With general interpretations, there should be no external impositions on the "object" (that is, the self-in-formation) or any subsuming of it. Application is conditional upon individual recognition of his or her case in the insights and potential for self-transformation contained in the generalized interpretation. With this recognition, the individual then applies the theory to him or herself usually with the aid of a specialist. Hence, application becomes self-application in the case of general interpretations. As Habermas points out, "it is we ourselves who undertake the application, abstract the comparable from the differences, and concretize the derived model under the specific life circumstances of our case."[26]

The second important difference with general theories is that from this self-application the individual must achieve a "conscious appropriation of a suppressed fragment of life history."[27] In other words, it must lead to a process of therapeutic remembering in which the individual has insight into or

becomes conscious of a formative complex of processes of which he or she had been unaware. Such insights initiate "the reorganization of the action-orienting self-understanding of socialized individuals, which is structured in ordinary language."[28] The new awareness that comes from this remembering can resolve stadial conflicts or remove blockages that have slowed or halted the process of self-development. However, to be effective these insights must be recovered and reconstructed by the individual, and not through any form of external manipulation that operates above or below the consciousness of the individual. In short, self-application and the conscious recovery of lost fragments excluded by an ego-unified life history are vital features of general interpretations.

Habermas's primary example of a general interpretation is psychoanalysis. It certainly has its systematically generalized narratives of human life histories. One such narrative takes the individual through the oral, anal, and genital phases, with stadial conflicts such as the Oedipus complex that must be overcome. Application is indeed self-application as therapists offer the above narratives to patients as discourses in which they could possibly recognize themselves. In psychoanalysis, this self-application works only to the extent that patients consciously recover lost fragments of earlier phases of their lives, particularly those concerning relations with their parents.

If Habermas had released myth from its confinement between the needs of language and the self-understanding of Western rationality, its self-reflective dimensions would have become more visible and hence the possibility of pragmatically viewing it as a general interpretation. As already noted, at the core of myth is a discourse of human self-formation. This genesis is usually portrayed as a process of stadial development that is marked by crucial conflicts to be overcome at critical stages of the process. What is distinctive about mythic conceptions of human self-formations is that the life histories and stadial conflicts emphasized are spiritual in origin. In other words, they are not rooted in the family as suggested by psychoanalysis, or in social orders of domination as suggested by many sociological theories. Rather, these life histories and stadial conflicts are rooted in the complex relations of formation and rebellion between the ego that is organizing the self-formative process and its unconscious ground that supplies the intentional resources with which the ego executes its projects of selfhood. Hence the possibility of representing the mythic view of human development as a self-formative process that is subject to spiritual interruptions.

The spiritual framing of life histories are usually thematized through notions such as fate, destiny, or divine plan, which echo Habermas's concept of "causality of fate."[29] In these thematizations, spirit often emerges as a very active site of creative agency whose originary designs are seen as both foundational and determinate for the human self. In spite of this ontological primacy of spirit, it is the ego and will of the individual, as alternative sites of

agency, that take the lead in the organization of the self. This ego leadership sets the stage for the dramatic tensions in mythic life histories, as it is quite possible that the ego will carry out projects of self-hood that are at odds with the destinal or originary designs of spirit. Indeed, the systematically generalized narratives of myth make this possibility into an actuality. Consequently, they usually take the form of narratives in which the steering of self-development by a spiritually blind ego results in crises or impasses that the latter is unable to resolve.

In these life histories, the endemic problem of ego-leadership is that of hubris, or an overestimating of the self-creative powers of the ego. As the organizer of spiritually supplied intentional raw materials, the ego imposes its own categorical and symbolic constructions on these materials. Thus, some are marked good and separated from the bad, others male and separated from female, and still others are identified with the ego, marked egological and separated from spirit. As a result, the ego is confronted with the challenge of getting all of the oppositionally marked elements that constitute the self-formative process together in a genuine whole. As Levi-Strauss suggests, the mythic view is that the ego usually fails in this task as its unities always produce remainders that are either totally excluded or insufficiently included. In spite of these failures, the ego establishes what Wilson Harris has called "an ontic tautology"[30] around these problematic or premature totalizations. This ontic closure elicits opposition and destabilization from excluded intentional formations. Consequently, ego unity is often an unstable one because of its internal imbalances, hence the views of both Levi-Strauss and Jung, which see myth as a discursive practice that seeks to correct imbalances in ego-organized worlds.

For myth, the central imbalance is clearly that between ego and spirit as sites of creative, self-forming agency. This, of course, is not to say that other imbalances of ego constructed worlds have not been the focus of myth. As self-development proceeds, the ego's capacity for agency increases, changing its relations with spirit and with its discursive and social environments. These increases are often inflated to the point where the ego, eclipsing spirit, comes to see itself as autonomous and pursues its choices and its hegemony in opposition to or with disregard of spirit. A battle ensues as spirit resists this displacement by withdrawing its intention resources from the ego, leaving it partially immobilized or negated in some fashion. These negations expose the ego to possibilities of not being able to be, and hence to what modern philosophers have called existential anxiety. The primary goal of these negations is a correcting or re-balancing one, to open or awaken the ontically closed ego to suppressed spiritual fragments in its life history that need to be revalorized against ego autonomy. As we will see in the case of the Tallensi, spiritual forces are "continuously involved in the affairs of the living; but they

manifest their powers and interest characteristically in the unforseeable occurrences which upset normal expectations and routines; and they do so in order to make some demand or elicit submission."[31] In other words, the generalized narrative of myth recounts a stadial process of ego-directed development that will be spiritually interrupted because of its systemic tendencies to devalue and eclipse the agency of spirit.

As in the case of psychoanalysis, the practical application of this mythic narrative is a self-application. The individual making the self-application becomes an initiate rather than a patient. The assisting professional is a priest or priestess and not a psychoanalyst. However, the roles of initiate and patient do overlap as both include identities of sickness that are not biological in nature, even though they may have bodily manifestations. Rather, these notions of sickness are linked to the intentional conflicts of a human subject. Thus, among the Anufo of Northern Ghana, "sickness is more often considered the superabundance of uncontrolled vitality than the lack of it."[32] As a result, people are seen as being "born with sickness within them, and one has strength and fertility to the extent that one has sickness."[33] This comes very close to the concept of sickness found in Kierkegaard.[34] Another area of significant overlap between mythic and psychoanalytic general interpretations is the importance of dreams to the two different types of therapeutic remembering that each requires. However, in addition to dreams, myths also employ ritual practices and ego displacing techniques.

With such an intentional view of sickness, the priest uses the generalized narrative as a framework around which to organize the fragmentary bits of information supplied by the initiate, and "to reconstruct gaps of memory and hypothetically anticipate the experience of reflection of which the patient [initiate] is at first incapable."[35] If the initiate recognizes his or her case in the suggestions of the priest, the self-application can proceed and the specific crisis of the self-formative process analyzed. Successful outcomes will be achieved to the extent that initiates consciously integrate into their self-understanding progressively more comprehensive accounts of their suppressed hegemonic struggles between ego and spirit.

In short, mythic discourses on human self-formation have all the major pragmatic features of a Habermasian general interpretation. They often contain systematically generalized life histories, their mode of application is self-application, and successful outcomes require a therapeutic remembering in which the initiate recovers lost fragments of his or her spiritual life. In the case of psychoanalysis, Habermas argued that if a discourse pre-supposes the recovery and interpretation of lost fragments of a life history, then it is embedded in the categorical framework of self-reflection and therefore can only be removed from it at the risk of misunderstanding its nature. Yet in spite of mythic discourses having these features, Habermas does in fact remove

them from this transcendental horizon and by locating them in the more objectivist framework described above, misunderstands them and fails to see them as general interpretations. To underscore this point let us look more specifically at African myths as general interpretations.

AFRICAN MYTHS AS GENERAL INTERPRETATIONS

Although not thematized in Habermas's discussions of the Nuer, the Azande, and the Tallensi, the general interpretive nature of many African mythic discourses on human self-formation can be easily demonstrated, particularly in the case of the Tallensi. For the most part, the African setting for this discourse on the self-in-formation is a broader cosmogonic ontology in which existence is seen as the creative work of spirit, which is conceptualized as a pantheon of deities, ancestors, and spirits. Consequently, existence (including the human self) as we know it in the everyday world is neither self-creating or self-sustaining. On the contrary, at originary levels existence depends on spirit, which is also thought of as a boundless ocean of energy into which all created life must remain plugged. Thus, the deities and ancestors were seen as the originary and often unconscious ground of the self as well as the rest of creation. As such, they remained for the most part implicit and unmanifest, but very active in the life of the created world.

Although usually in this unmanifested state, the deities and ancestors or spirit as impersonal energy had the capacity to make themselves manifest, and their presence or intentions known. Any object, process, or person could potentially be the locus through which they made themselves manifest. Such revelations of their existence Mircea Eliade has referred to as hierophanies.[36] In African myth, the human self was a primary site for the hierophanies of spirit. Further, African religions have developed ego-displacing techniques such as dance-induced trances, which allow capable individuals to experience more directly the creative powers of the deities and ancestors. Thus, between ego and spirit there is a lot of back and forth movement. As we will see in the case of the Tallensi, these movements are tension-ridden with the deities and ancestors constantly restraining, vetoing, counteracting, or compensating for the actions of a hubristic and recalcitrant ego, which sets the stage for the generalized narratives of African myths. These narratives are often framed in terms of predestinarian relationships between the deities and ancestors on the one hand, and the ego and the self on the other.

The Tallensi are a small ethnic group of northern Ghana. As the work of Meyer Fortes has shown, their myths contain one of the classic expressions of African predestinarian beliefs. The systematically generalized narrative of Tallensi myths describe a life cycle that begins with birth, which is conceived

as an emergence out of the spiritual realm of the unborn, moves through adulthood, parenthood, and grandparenthood, and ends with ancestorhood, which returns one to the spiritual world after death. However, it is particularly in the middle phases of this cycle, which requires success in parenthood and careers like farming, drumming, or divining, that the predestinarian relationships between spirit and ego really emerge.

In the middle phases of the life cycle, the Tallensi individual must choose a path to social success which usually means having a large family that is well cared for. As individuals pursue these goals, they experience varying degrees of success. Quite often "the illness" that starts the process of self-reflection is the emergence of an unbridgeable gap between the efforts towards this goal and success. This gap that refuses to close threatens to bring the individual's efforts to naught and to expose him or her to social failure. Consequently, movement along the important life cycle is suspended, further increasing the anxieties of the aspirant to parenthood and social success. Like the members of Dante's purgatory, the Tallensi aspirant is here suspended in a state of existential limbo, unable to move forward or backward. It was the bite of these states of ego negation that led Fortes to compare them to the situations of both Oedipus and Job. These anxieties over one's fate produced by "unforeseeable occurrences which upset normal expectations" often drove Tallensi individuals to make use of the frameworks for self-reflection available in their mythic discourses.

With the aid of a diviner they will begin a process of self-reflection that is guided by the generalized narrative of the complex relationship between ego and spirit. In addition to ego agency, this narrative will situate the details of their failed efforts in a self-reflective framework that includes the determinate powers of three other sets of forces: the spiritual guardian, the prebirth pact with God, the creator, and the concerns of the nature deities and the ancestors. In other words, it is past or forgotten fragments of relations with their spiritual families as opposed to the biological ones that Tallensi individuals will seek to recover. Fortes refers to this important group as the "Destiny ancestors."[37]

The spiritual guardian is the ancestor who elects to guide the life of a newly born baby, "to watch over and try to preserve his ward's life itself."[38] The identity of this guardian must be secured by the father with the aid of a diviner. Once identified a Yin (Destiny) shrine must be built in acknowledgment and recognition of this guardian. If ignored, the spiritual guardian will interrupt, block, or negate the projects of his ward.

The centerpiece of these destinal configurations affecting the life cycle of Tallensi individuals is the prebirth conversation with God. In this heavenly conversation which occurs before the assumption of a bodily form, this spiritual individual must declare to God its wishes and plans for its earthly sojourn. It can declare strong likes or dislikes for ordinary human living, but

it cannot refuse to be born. Whatever the declaration, it becomes a pact or a contract outlining the destiny of the individual, even though the latter has little or no memory of this conversation after material birth. He or she is inscribed in it and will be pushed, pulled, or restrained by it. A declaration of strong likes leads to good "Prenatal Destiny" while a declaration of strong dislikes leads to bad Prenatal Destiny. These are the important spiritual forces shaping the earthly life of the Tallensi individual.

Finally, in this destinal family are the nature deities and the ancestors. They all have determinate power over the individual's prospects for successfully completing the life cycle and achieving ancestorhood. As in the case of the spiritual guardian, the deities and ancestors insist on being properly recognized through shrines and rituals. When they are not, they too block or interrupt the completion of the life cycle.

It is toward this complex economy of destinal forces that Tallensi self-reflection is oriented, particularly the impact of individual life choices and individual agency on this economy of forces. The problem created by individual agency is that it is often exercised in ignorance of Prenatal Destinies, pre-birth conversations, the concerns and interests of spiritual guardians, deities, and ancestors. The result is often the eclipsing of these spiritual agents or imbalances in the creative authority exercised by the ego on the one hand and this configuration of spiritual forces on the other. These are the forgotten fragments that Tallensi self-reflection seeks to recover. Externalized in rituals, this self-reflective dimension can be easily missed. Nonetheless it is there and it constitutes the basis for suggesting that Tallensi myths can be viewed as general interpretations.

Since the work of Fortes, many changes have taken place in Tallensi society. Among the most important of these are urbanization, political modernization, scientization, Christianization, and Islamization. The first two have incorporated the Tallensi into a national system of cities, towns and urbanizing sites, as well as a national political system. The last three have become major sources of competition for Tallensi mythic belief. The Protestant churches in particular have been very critical of Tallensi notions of fate and their belief in the nature deities and ancestors. In spite of the changes that have taken place in Tallensi society since the work Fortes, these self-reflective dimensions of its cultural life are still very much alive. On a field trip to the Tallensi community in 1995, I discussed some of these issues quite extensively with a number of religious leaders. In one of these interviews, I asked the question: "do people still use these (predestinarian) beliefs to justify patterns in their lives?" One replied, "it is a major factor. Some people even name their children in relation to destiny. We have names such as Naumphal . . . which means what God has said you have come on earth to do, or what you told God you are coming on earth to do. . . . Most people believe in destiny, apart from

those who have gone into Christianity. All those who have gone into teaching and may have done psychology or biology may say that 'this destiny may not be true.' But, immediately that they have not succeeded, they say 'that is my destiny.'"

John Kirby's recent ethnographic study of the Anufo, whose beliefs are quite similar to those of the Tallensi, strongly supports the claim that these practices have persisted into the present. According to Kirby, the Anufo conceive of themselves as being in a state continuous tension which must be constantly rebalanced. These tensions give rise to what is called their "life-predicament," which threatens the completion of the life cycle. This often motivates the decision to seek professional help. Among the Anufo, "the professional healer treats illness as part of a more general approach to problem-solving, but his interest is not so much the treatment of the illness itself (or its outward symptoms) as it is the deactivation of its cause."[39] This attempt at deactivation leads to a process of self-reflection that is quite similar to the case of Tallensi. Thus, our case for a general interpretive reading of African myths could also be made on the basis of more contemporary ethnographic data.

CONCLUSION

The major thrust of my argument has been to show that an alternative conception of myth was possible within the framework of Habermas's philosophy. This conception was a path not taken because of the discursive roles of other to Western rationality and mirror to the differentiation of language into which myth was cast. Restricted by the conceptual needs of these discursive undertakings, a systematically distorted picture of myth emerged that Habermas left without compensatory self-reflective correction. As a result, the primary suggestion of this paper can be summed up as follows: if myth had been released from this double confinement and reinscribed in its self-reflective transcendental horizon, then at least three important points can be made about the nature of this alternative conception.

First, within the self-reflective framework of Habermas's philosophy, the epistemic practices of myth could have been analyzed in terms of the general notion of knowledge-constitutive interests. In these terms, they would have required Habermas to establish a fourth set of knowledge-constitutive interests: a set concerned with harmony and reconciliation between ego-unified worlds and the larger cosmic order. The result would have been the thematizing of another distinct set of knowledge-producing practices, whose rationality was being eclipsed in the modern period.

Second, along with these distinct knowledge-constitutive interests, the epistemic practices of myth could have been further developed by analyzing

their pragmatic features in terms of the category of general interpretations. Such an analysis would have established myth's subject-oriented nature, it's reliance on therapeutic remembering, and, hence, its transcendental roots in paradigms of self-reflection.

Third and finally, these two features of this alternative conception would have required Habermas to rethink the creative agency of the sacred, at least on the model of the unconscious in psychoanalysis. Such a rethinking would have given the sacred a more active and continuing role in the production of modernity, and so problematize the rather easy and final transfer of consensus forming responsibilities described by Habermas. Such an overall conception of myth would have been very different from the ones we find in both volumes of *The Theory of Communicative Action*, and would have had very different consequences for Habermas's analysis of Western rationality.

From the African mythic perspective, the current Western discursive economy is a cultural formation that is accelerating out of control in search of a unifying center and epistemic guarantees that it rejected with its extreme othering of myth. In Levi-Straussian language, we have here a discursive order that has been disequilibrated by major imbalances in the binary, overrating ego agency versus underrating spiritual agency. This in turn has produced other imbalances in the larger system of binaries in which the Western life cycle is inscribed. At the same time, there are no mythic discourses to facilitate rebalancing and the restoration of equilibrium. Many contenders have arisen to take this place left by the decline of myth in the modern West. Levi-Strauss saw politics as taking the place of myth; for Habermas, it is language, and for others it is science or art. However, the fact that the cultural rationalization of the West finds itself on the Soyinkan train points to the inability of these alternatives to substitute for the unifying, grounding, and integrating powers of myth. As the West continues to ride this train and to globalize its tracks, it will continue to make great scientific discoveries and unprecedented conquests. However, these will continue to be haunted by that shadow of which Adorno and Horkheimer wrote, and with which Habermas is still wrestling.

PAGET HENRY

ASSOCIATE PROFESSOR
SOCIOLOGY AND AFRO-AMERICAN STUDIES
BROWN UNIVERSITY
NOVEMBER 1999

NOTES

1. Paget Henry, *Caliban's Reason: Introducing Afro-Caribbean Philosophy* (New York: Routledge, 2000), pp. 149–76.

2. Theodor Adorno and Max Horkheimer, *Dialectic of Enlightenment* (New York: Seabury Press, 1972).

3. Enrique Dussel, *The Underside of Modernity* (Atlantic Highlands, N.J.: Humanities Press, 1996).

4. Adorno and Horkheimer, *Dialectic of Enlightenment*, p. 3.

5. Jürgen Habermas, *Toward a Rational Society* (Boston: Beacon Press, 1970), pp. 81–122.

6. Sylvia Wynter, "The Ceremony Must be Found: After Humanism," *Boundary* 2, no. 12 (Spring 1984): 26–32.

7. H. Gerth and C. Mills, eds., *From Max Weber* (New York: Oxford University Press, 1958), pp. 146–49.

8. Wole Soyinka, *Myth, Literature and the African World* (Cambridge, Cambridge University Press, 1990), pp. 37–38.

9. H. Gerth and C. Mills, eds., *From Max Weber*, p. 328.

10. Jürgen Habermas, *On the Logic of the Social Sciences* (Cambridge, Mass.: MIT Press, 1988).

11. Jürgen Habermas, *The Theory of Communicative Action*, vol. I (Boston: Beacon Press, 1984), p. 18.

12. Jürgen Habermas, *The Theory of Communicative Action,* vol. II (Boston: Beacon Press, 1987), p. 46.

13. Jürgen Habermas, *Towards a Rational Soceity*, pp. 81–122.

14. Jürgen Habermas, *The Theory of Communicative Action*, vol. II, p. 87.

15. Ibid., p. 88.

16. Ibid., p. 92.

17. Ibid., p. 77.

18. Ibid., p. 77.

19. Jürgen Habermas, *Towards a Rational Society*, p. 8.

20. Ibid., p. 8.

21. Jürgen Habermas, *The Theory of Communicative Action*, vol. II, p. 27.

22. Jürgen Habermas, *The Theory of Communicative Action*, vol. I, p. 3.

23. Claude Levi-Strauss, *Structural Anthropology* (New York: Basic Books, 1963), p. 216.

24. Ibid., p. 216.

25. Jürgen Habermas, *Knowledge and Human Interests* (Boston: Beacon Press, 1971), p. 259.

26. Ibid., p. 263.

27. Ibid., p. 251.

28. Ibid., p. 247.

29. Ibid., p. 271.

30. Wilson Harris, *Explorations: A Selection of Talks and Articles* (Aarhus: Dangaroo Press, 1981), p. 16.

31. Meyer Fortes, *Oedipus and Job in West African Religion* (Cambridge: Cambridge University Press, 1959), p. 35.

32. Jon Kirby, *God, Shrines and Problem-solving Among the Anufo of Northern Ghana* (Berlin: D. Reimer, 1986), p. 88.

33. Ibid., p. 88.

34. Søren Kierkegaard, *Fear and Trembling and The Sickness Unto Death* (Princeton: Princeton University Press, 1970), pp. 144–61.

35. Jürgen Habermas, *Knowledge and Human Interest*, p. 260.

36. Mircea Eliade, *The Sacred and the Profane* (New York: Harcourt Brace and World, 1959), p. 21.

37. Meyer Fortes, *Oedipus and Job in West African Religion*, p. 44.

38. Ibid., p. 34.

39. John Kirby, *God, Shrines and Problem-solving Among the Anufo of Northern Ghana*, p. 90.

6

Garth Gillan

Communicative Action Theory and the Possibility of Theology

A theological reading of Jürgen Habermas's theory of communicative action must always conduct itself according to a studied ambivalence. On the one hand, the theory of communicative action stands at the center of a tradition of political criticism that is focused upon emancipation and justice. This movement not only encompasses the Frankfurt school, but also classical political theory from Plato and Aristotle to Marx. On the other hand, the theory of communicative action carves out a specific field of discourse, action tending toward mutual understanding, as the focus for the elaboration of the issues raised by classical and modern political theory. It therefore has its own relationship to modernity and its socio-economic context. It is important to preserve the progressive significance of the theory of communicative action in modern political theory while developing a reading of that theory that points out its boundaries, intrinsic limitations, and relationship to the truth.

Without an eye to both sides of such an ambivalent reading, any interpretation would indirectly and unconsciously pursue goals that would undermine critical thinking about the issues that the theory of communicative actions raises: emancipation and justice. Ideology critique requires a hyper-reflection that is attentive to the multiple determinants and varied directions that ideas can take in any historical setting. Habermas has pointed out this issue in his reading of *The Dialectic of Enlightenment*.[1]

The reading of the theory of communicative action in the view of the question of the possibility of theology is no exception to the above strictures. The significance of those strictures are all the more important since at first sight raising the question of the possibility of theology would seem to be, from the perspective of the theory of communicative action, a regressive, pre-critical move on the part of philosophical reflection. Raising the possibility of theology on the part of philosophical reflection in more than

a negative way does not mean, however, that the point is to identify philosophy with theology or to establish rationality on the basis of religious assumptions. Religious faith cannot be identified with reason. The differentiation is structurally intrinsic to the elaboration of the nature of Christian faith from the New Testament to the present. But the move is not then made from that differentiation to a denial of any relationship. Belief in the identity of Jesus as Son of God and his salvific mission is not a priori irrational, nor, on the other hand, is it based upon reasons established through argumentation.[2] It cannot be assumed out of hand, then, that the articulation of a positive relationship between rationality as articulated in philosophy and the sciences is incompatible with affirmations of religious faith. Raising the question of the possibility of theology on the part of philosophy from the perspective of rationality is not, then, a priori a regressive position.

That observation brings us face to face with a fundamental posture of the theory of communicative action. From a number of different points of view Habermas sees the question of theology as impossible within the modern shape of rationality. First of all, "postmetaphysical thought does not dispute determinate theological affirmations, instead it asserts their meaningless. It means to prove that in the system of basic terms in which the Judeo-Christian tradition has been dogmatized (and hence rationalized) theologically meaningful affirmations cannot be set forth at all."[3] On this point, Habermas's commitment to modernity is unequivocal. It is supported by his analyses of *The Theory of Communicative Action*[4]: the linguistification of the content of the sacred into secular morality and the modern rationality differentiated into knowledge, ethics, and aesthetics. From the perspective of modern rationality the sacred is no longer an object of objective knowledge in the modern sense of the term, one in which its validity claims could be expressed in propositional forms and resolvable through argumentation. Faith, from that point of view, as an assent to and trust in what cannot be rendered in principle objective without losing its metaphysical nature cannot be included in that definition of rationality.

Habermas's retrieval of the concept of rationality from Weber's discussion of formal and substantial reason makes his position very clear. The concept of rationality operative in the theory of communicative action is a "procedural rationality."[5] Habermas makes a distinction between the particular value contents of the spheres of cognition, ethics, and aesthetics and the universal, formal standards according to which those particular contents are judged in argumentation about their validity claims. Particular values cannot substantiate their claims to validity by means of their intrinsic content, but only by means of their satisfying the logical standards by which validity claims can be affirmed.

The rationalization of particular value contents, then, arises not from the rationality of their contents, but from their extrinsic acceptance by logical

argumentation. Rationality lies on the side of the formal standards of argumentation and not on the part of values themselves: "the unity of rationality in the multiplicity of value spheres rationalized according to their inner logics is secured precisely at the formal level of the argumentative redemption of validity claims."[6]

This is a very telling passage, for it contains most of the concepts that are operative in our initial question. The establishment of the unity of rationality by means of the logic of argumentation running through the different value spheres on the basis of their formal similarities retains for the theory of communicative action a strong theory of rationality. A strong theory of rationality states that the rationality to be found in the different spheres of cognition, ethics, and aesthetics is not rationality particular to each and incommensurate with one another. Relativism lies at the end of that road and a political theory that cannot deal with substantive value issues. The core of communicative action, the achievement of mutual understanding, requires that particular values be rendered rational, that is, open to the acceptance of others on the basis of their validity claims. But that process of rationalization is anchored, not in the substantive claims of particular positions on values, but upon the rationality of the process of coming to a mutual understanding: argumentation. The unity of rationality is procedural and not substantive.

Habermas is not claiming to have put into place a theory of rationality that actually secures the unity of reason. But it is an idea that structurally belongs to the theory of communicative action: "even today we lack a pragmatic logic of argumentation that satisfactorily captures the internal connections between forms of speech acts. Only such a theory of discourse could explicitly state wherein the unity of argumentation consists and what we mean by procedural rationality after all substantial concepts of reason have been critically dissolved."[7] The emphatic concept of rationality, while yet to be explicitly theoretically articulated, nonetheless, arises out of the force of argumentation in rationalizing particular values. As particular they do not call for any acceptance in terms of cooperation. Rational beings do not cooperate or come to a mutual understanding on the sole basis of taking over the values of others. Force or imposition are always involved in submission. Mutual understanding rests upon the dissolution of the force of "substantial concepts of reason," that is arguments based on concepts of the universal good or universal truth that arise out of particular cultures, religions or ethnic groups. The idea of mutual understanding based on substantive concepts of reason in Habermas's view is self-contradictory. Historically such attempts have always accompanied conquest, colonialism, and terror.

The dissolution of substantive concepts of rationality are, then, intrinsic to the theory of communicative action as a theory of procedural rationality. This displacement of the theoretical burdens of substantive rationality to

procedural rationality signals a decisive shift in focus and grounding for political theory. Habermas aligns the theory of communicative action with the developmental direction of social theory in the modern period and with the goals of modernity as it is formed in the crucible of the Enlightenment. This is intentional and forms part of the major argument in *The Theory of Communicative Action*. Habermas follows that development from Durkheim through Weber to Mead and Parsons to show the progressive acquisitions of the basic concepts of the theory of communicative action: the differentiation of the three spheres of action (Weber), the linguistification of originally sacred norms into socially based norms (Durkheim), and the social subject as inter-subjective in its structure (Mead). For Habermas this history is the charting of the growing realization of the foundations of modernity.

The ultimate foundation for the theory of communicative action for Habermas lies not in the search of substantive reason for the good, but in the evolution of the dynamics of language as social communication. Procedural rationality is the acquisition based upon the social consciousness embedded in that progressive dynamics: the consciousness of objectivity, moral norms and expressive values incorporated in mutual understanding and arrived at through argumentation. The Platonic question of the nature of justice and the good which drives the dialectic of *The Republic* or the priority of goods, which the highest good through the virtue of justice orders in Aristotelian politics, are dissolved into norms guiding the use of language in communication. Through the acquisition of logical criteria and moral norms in argumentation the experience of the sacred is assimilated to sacred world views. A site of discourse is created from which the good, justice, and the sacred can be viewed as relative to the discourse about norms for validity. And that site, in turn, is identified with the historical viewpoint of modernity.[8] Rationalization becomes identified with secularization.

Taking this historical, evolutionary view of rationality to its corresponding basis in the inner logic and dynamics of language, Habermas finds that inner logic in the propositional nature of language or the dependence of knowledge upon the representational function of propositions. "When we use the expression 'rational' we suppose that there is a close relation between rationality and knowledge. Our knowledge has a propositional structure; beliefs can be represented in the form of statements. I shall presuppose this concept of knowledge without further clarification, for rationality has less to do with the possession of knowledge than with how speaking and acting subjects acquire and use knowledge."[9] In this conception critical reflection as it works in cognition, ethics, and aesthetics is reframed as a metalinguistic of language or metalanguage of acting and speaking subjects. It is not tied to any particular historical movement (Marx) or place in social codes (Barthes), but upon the use of language apart from any expressive content derived from social analysis. In classical Marxism

that place was occupied by the proletariat as an exploited class. Later critical theory ties that content to a theory of substantive reason (Horkheimer) or to the subjective and objective possibilities of truth in the material world (Adorno).

Habermas makes not only a further move away from the articulation of a material, critical perspective, but divorces the roots of critical rationality from any concrete social, political position in society and from any concrete analysis of systemic relations in society or the natural world: "Philosophy can no longer refer to the whole of the world, of nature, of history, of society, in the sense of a totalizing knowledge. Theoretical surrogates for worldviews have been devalued, not only by the factual advance of empirical science but even more by the reflective consciousness accompanying it."[10] The conclusion must be that any religious discourse or representation of a sacred world view as the expression of a particular community and of a totalizing knowledge stating the conditions for the existence of the world is meaningless.

There is a role for philosophy, however, although it is not one that carries with it its own object domain and methodology. The foreclosure of any relationship to totality and the modern differentiation of the inner logics of cognition, ethics, and aesthetics restrict the role of philosophy to one of mediation between the exact sciences and the life world:

> Today, philosophy could establish its own distinct criteria of validity—in the name of genealogy, of recollection (Andenken), of elucidating Existenz, of philosophical faith, of deconstruction, etc.—only at the price of falling short of a level of differentiation and justification that has already been reached, that is, at the price of surrendering its own plausibility. What remains for philosophy, and what is within its capabilities, is to mediate interpretively between expert knowledge and an everyday practice in need of orientation. What remains for philosophy is an illuminating furtherance of lifeworld processes of achieving self-understanding, processes that are related to totality. For the lifeworld must be defended against extreme alienation at the hands of the objectivating, the moralizing, and the aestheticising interventions of expert cultures.[11]

All that is left of the historical tasks of philosophy in Habermas's compromise with positivism is a relationship to the lifeworld. Philosophy in its title as wisdom took as one of its main tasks to undertake the search for *archai* or the principles underlying the order of the world. It was and is clear that pragmatic competence in human language and experience depends intrinsically on the adaptation of human actions to the "real" world. And, at the same time, the temporal character of human actions makes it clear that the same competence is made possible by time consciousness and that the rationality of human actions involves the retention of the past and the motivating anticipation of the future. The order of the world (cosmos),

temporal, cognitive, and sensory, elicits the attitude that issues into the hold that transcendence has upon human behavior and consciousness.

The dissolution of the concept transcendence into a relationship to the lifeworld narrows the scope of political critique to the point where philosophy must put aside the question of concrete possibilities and strategy to solely comment upon distortive intrusions into the social and cultural background for human actions. A remnant of critical social theory remains in the issue of the preservation of the lifeworld against colonialization by expert cultures. But what is really at issue is what differentiating rationality has eclipsed: the social, material objectivity of the world. It is in the cultural use of things, the aberrant forms of human actions, and the terror of evil that the fissure between actuality and real possibilities occurs. The vulnerability of things and bodies, minds, and souls to distortion is the mark of their real possibilities and presents us with the glimmer of an intent or purpose imbedded in them.

In moving from a theory of knowledge that would provide the grounds for a critique of systematically distorted communication to a theory of communicative competence, *From Knowledge and Human Interests* to *The Theory of Communicative Competence*, Habermas has eliminated the recognition of the unavoidable role that evil plays in the dialectic of truth. Systematic distortion of communication as exemplified in the National Socialist renaming of political activities suppressing free information, political opposition and obscuring genocidal programs requires that the formation of concepts in social and political theory follow a reflective path of emancipation. Social theory then must be consciously anti-ideological in the sense that to conceptualize the material process in society it is necessary to reflect upon those real processes masked by class consciousness and political propaganda.

In that reflective reappropriation of the materiality of the social object across its ideological distortions, there lies an awareness of the roots of distortive consciousness in social evil: class prestige, economic exploitation, racial extermination, and the elimination of surplus age or gender groups. The move from a social critique based upon a theory of substantive human interests to one based on the procedural rationality of communicative competence signifies a real change in direction for Habermas and at the same time an improvishment of the scope of critical political theory.

In taking up the question of the possibility of theology within the limits of the theory of communicative competence, then, we must address issues that are not only anti-theological, but also anti-philosophical in the sense of a discourse that eliminates from critical rationality any relation to metaphysics and, by inclusion, to theology. The exclusion from rationality of any particular set of values and the content of any particular world view, sacred or not, excludes the possibility of theology, but it also narrows the concep-

tion of philosophy into the channels already prepared for it by Comtean positivism. In this respect the fate of theology is tied to that of philosophy in a manner not unlike its pre-Christian and Christian historical relationship. The grounding of justice in *The Republic* in a metaphysics of the good and the explication of politics through an ethical conception of the good in Aristotle's *Politics*, and the development of an economic point of view through the historical demand for freedom on the part of the proletariat demonstrate a necessary connection between metaphysics, ethics, and political theory not envisaged in the theory of communicative competence. In theology and in philosophy there is a regulative relationship to a world view based upon a metaphysical or ontological conception of the good. This is not Husserl's *Weltanschuaung* or world view, the summation of a cultural period in its ideological components. It is rather an awareness that the boundary conditions of the world and universe as we experience it are not conditions internal to the world/universe itself. It is also a recognition of the limits of human subjectivity which are drawn by an insatiable thirst or desire for fulfillment in what is beyond it and completed by what exceeds it.

Rationality is, as Habermas has noted, a question, not of the possession of knowledge, but of the way in which language is used; rationality is procedural. It is not only theology that is at stake at this point, but any concrete interpretation of history, society, or politics. The dissolution of substantive concepts and concrete world views into the subject matter of argumentation makes them, from the viewpoint of procedural rationality, only matters of fact. They themselves in their self-understanding or in the process of cultural assimilation do not contribute to the process of the rationalization of society or cultural formations. The theory of communicative competence is free, then, from any of the methodological problems associated with a critical social theory involved in the critique of political and economic structures such as Marxism. Indifferent to any attempt to understand the rationality of economic or political structures, it is also innocent of any knowledge of evil. Procedural rationality escapes the never-ending entanglements haunting efforts to conceptualize social structures and movements that fundamentally distort and twist almost beyond recognition authentic human possibilities.

The ease with which Habermas dissolves the content of the sacred in *The Theory of Communicative Competence* may lie in his dependence upon Durkheim's interpretation of religion as rite or ritual.[12] The collective morality involved in the enforcement of the religious world view is easily rephrased into inter-subjectively affirmed communal norms. While Habermas recognizes the difference between rite, sacramental practice and contemplation, all of those can be subsumed under purposive, as opposed to communicative, activity. The logical development from religion to argumentation lies along the axis of purpose activity to communication. Religious

activities cannot be differentiated in terms of purposive and communicative. None of them are communicative. And not being involved in the process of reaching mutual understanding in action, none of them have any cognitive content.

What cognitive or communicative content could be attributed to theology's reflection upon the nature of religious faith? That the history of theology is one of argumentation according to different philosophical models may not be close to the issue. One does not arrive at a theological understanding of faith by argumentation with God over commonly agreed norms for action and belief. But theology does argue with itself over specifying the content of its original intent or its basic affirmation of the Word of God. In Christian theology the essence of faith is a response to an original communication of God to humanity. It involves an attitude of trust in the person of God and a language determining the implications of that communication for the nature of the world and human actions. In the history of Catholic and Orthodox Christianity that language has not been the result of a logical, monothetic development, but philosophical, political and cultural struggles. The clarification of theological truth has evolved through argumentation based on the requirement of mutual understanding. As historians have often pointed out the real issue in such argumentation is not only orthodoxy, but orthopraxis. Theological agreement defines the correct attitude that maintains communion and moral discipline.

However, such argumentation directed toward communion and moral discipline does not necessarily carry with it a cognitive value. In its historical development it clearly shows that Habermas's treatment of the communicative nature of Christianity is deficient, but it does not indicate the cognitive import of its affirmations. Prior to the seventeenth century that cognitive import was not seriously in question. The European Enlightenment is evidence of a drastic change in the epistemological status of theology as it was also a fundamental change in the political and cultural position of Christianity as a whole. Habermas and others understand those changes under the rubric of secularization. Secularization dissolves the attempt on the part of religious ritual and rite to act upon the world into the chain secondary causes that incorporate nature forces into implements of change: technology and science. Religion as an action on the world becomes impotent. And with that impotence the entire cognitive structure of its worldviews falls. The rationality of religious faith was purpose and not communicative. With communicative rationality emerges a procedural rationality in which knowledge, values, and art works are subject to argumentation and the rational assessment of their validity.

But at the same time, historically and socially, secularization has its limits. It characterizes the institutions that produce knowledge, the political and social centers that debate public policy and the corporations that direct

investment and manufacture. But it does not exclusively direct communica-
tion at the level of labor, family life, and the relation of self to self. And for
that reason, while antiquated in terms of secular rationality, religious faith
has remained socially and politically imbedded in world cultures. And for
good reasons, since Judaism, Christianity, and Islam are expressions of the
cognitive, ethical, and affective effects of the experience of alterity which
permanently opens up human social existence to the risk of a communication
it cannot control, nor for which it can determine the logical criteria for its
validity. The rationality of consensual norms is radically dependent upon the
rationality of a history at risk. The rationality of human social existence is
always the rationality of possibilities that hold the promise of the fulfillment
of the good.

For that historical discernment, the rationalizing force of tradition creates
a necessary institutional context and enabling factor. This thesis runs counter
to the basic foundation for Habermas's affirmation of secularized procedural
rationality and its differentiation into the spheres of cognition, ethics, and
aesthetic values. The processes involved in preserving community bonds and
identity across historical periods involve a discernment of fundamental
cognitive, ethical, and aesthetic issues in their relationship to politics,
history, and the natural world that escape the encapsulization of the
processes of reasoning in the present. Traditional rationality, of course, also
involves the redemption of validity claims through argumentation, but it also
institutionalizes the awareness of those values and cognitive orientations that
are basic to action within a history at risk. The thesis of secular modernity
is based upon the affirmation of a radical break with pre-modern cultures
and institutions from which no rational contribution can be sought for
modern social or political questions. For secular modernity and for
Habermas there is no communal subject of history that would span the gulf
created by the advent of the Enlightment. Such a subject or subjects can only
remain as remnants of a pre-enlighted period. Knowledge, values, and modes
of expression must be recast as a result of the logic of history into the shape
of modernity.

The question of the possibility of theology within the multiple perspec-
tives of Habermas's theory of communicative competence raises questions
that transcend the boundaries of Habermas's theoretical concerns.
Habermas's passionate commitment to the agenda of the Enlightenment, to a
rationality that arises through its own resources, also entails a corresponding
commitment to many of the flaws in the shape of rationality in secular
modernity. But what is not in doubt is the contribution of the theory of
communicative competence to our understanding of the rational formation
of the modern political will. Habermas has seen very clearly that in a world
economy political decisions require a commitment to that rational
communication that arises from mutual understanding. But there are more

questions that arise from the modern shape of politics than those answered by a theory of rational argumentation.

GARTH GILLAN

PROFESSOR EMERITUS
DEPARTMENT OF PHILOSOPHY
SOUTHERN ILLINOIS UNIVERSITY AT CARBONDALE
JANUARY 2000

NOTES

1. Jürgen Habermas, *The Philosophical Discourse of Modernity*, trans. Frederick Lawrence (Cambridge: MIT Press, 1987), 119–20.
2. Nancey Murphy and George F.R. Ellis, *On the Moral Nature of the Universe* (Minneapolis: Fortress Press, 1996), 19–38.
3. Jürgen Habermas, *Philosophical-Political Profiles*, trans. Frederick Lawrence (Cambridge: MIT Press, 1985), 12.
4. Jürgen Habermas, *The Theory of Communicative Action*, vols. 1 and 2, trans. Thomas McCarthy (Boston: Beacon Press, 1989).
5. *The Theory of Communicative Action*, vol. 1, 249.
6. Ibid.
7. Ibid.
8. Ibid., 229.
9. Ibid., vol. 1, 8.
10. Ibid., 1.
11. Jürgen Habermas, *Postmetaphysical Thinking: Philosophical Essays*, trans. William Mark Hohengarten (Cambridge: MIT Press, 1992), 17.
12. *The Theory of Communicative Action*, vol. 2, 190–91.

7

Eduardo Mendieta

Modernity's Religion: Habermas and the Linguistification of the Sacred

INTRODUCTION

One of the most fundamental aspects of the project of modernity is its avowed rejection of religion. At times this rejection has turned into either a commitment to its marginalization through interiorization, or elimination through the so-called secularization of society and mental outlooks. At times, this rejection has turned into declared war: pogroms, witchhunts, even genocides, have all been undertaken under the modern quest for purity from religion.[1] Yet, such explicit rejections conceal a deeper ambivalence towards religion. Modernity itself, as both a project and a mental orientation, has been made possible by religion. Religion continues to haunt modernity; not just because the latter has not been finally accomplished and fulfilled, nor just because the latter perdures as an indigestible or insoluble detritus from an archaic stage of societal development. Instead, there is an unequivocal sense in which modernity has spawned its own religion, as every age has given birth to its own "religion." This new "religion of modernity" has come to operate within modernity as a litmus test of modernity's own commitment to its avowed de-sacralization of the world and deflation of all transcendental and mystical claims of a situated and linguistified reason. The other side of modernity's atheism is the criticism of all claims to absoluteness performed by an "enlightened" religion which refutes and rejects all fetishisms and fetishes.[2] Modernity, despite its superficial disavowal of religion, has opened up a horizon in which, as Bloch put it, a conversation "between believers purged of ideology and unbelievers purged of taboo" can be established.[3]

Notwithstanding all appearances, Jürgen Habermas has made an

important and enduring contribution to the disentangling and drawing out of this ambivalence and duplicitious internal relationship between religion and modernity. While the reception of Habermas by theologians and sociologists of religion continues to gain momentum,[4] his reception as a philosopher of religion by philosophers remains incipient.[5] Philosophers and social theorists in general have taken Habermas's pronouncements on religion in his *Theory of Communicative Action*, especially in volume two,[6] and his sporadic and pointed criticisms against mysticism and messianism in *The Philosophical Discourse of Modernity*,[7] as definitive and representative of his general outlook. It would seem, from a quick and superficial reading of passages in these two works, that Habermas has put religion to rest and has pronounced its theoretical and social-developmental death. In fact, a consensus has developed around the notion that Habermas's theory of the "linguistification of the sacred" entails the sublimation or *Aufhebung* of religion *tout court*. This misleading representation and conclusion about Habermas's positions on religion has made it unlikely and undesirable to engage him any further.[8] This is most unfortunate, for if anything, Habermas has opened up a path for a renewed dialogue with religion, whether as a source of concepts or lived experience. He has neither unequivocally rejected nor half-heartedly accepted calls for a turn to religion in an age of catastrophe. The point, as he writes, is ". . . not to overcome modernity by having recourse to archaic sources, but to take specific account of the conditions of modern postmetaphysical thought, under which an ontotheologically insulated discourse with God cannot be continued."[9] The term "postmetaphysical" here carries conceptual weight, and it is not an empty rhetorical gesture. Postmetaphysical refers not just to a condition of philosophy, but also of religion. As Habermas makes explicit:

> I do not believe that we, as Europeans, can seriously understand concepts like morality and ethical life, persons and individuality, or freedom and emancipation, without appropriating the substance of the Judeo-Christian understanding of history in terms of salvation. And these concepts are, perhaps, nearer to our hearts than the conceptual resources of Platonic thought, centering on order and revolving around the cathartic intuition of ideas. . . . *But* without the transmission through socialization and the transformation through philosophy of *any one* of the great world religions, this semantic potential could one day become inaccessible.[10]

Another factor that may have contributed to forestalling a reception of Habermas as a philosopher who has contributed to our understanding of religion is certainly the very epochal and pointed character of his contributions. Every major work by Habermas has acted as a catalyst but also as a barometer of the *Zeitgeist*, registering its deepest fears and most cherished hopes.[11] Indeed the polemical and innovative character of Habermas's works

over the last forty years militates against trying to link Habermas's position with established and old-fashioned questions like: what about religion? Further, the skewed reception of Habermas's work, especially in the United States, which sometimes and detrimentally echoes and telescopes throughout the world, has also prevented a cross-textual, cross-disciplinary reading of his work. This last factor is particularly surprising given the theoretical claims of Habermas's own research agenda. He has without equivocation continued the interdisciplinary research agenda that informed the Frankfurt School's critical theory.

Insofar as he has been engaged by theologians, these have been mostly political theologians, or theologians in the tradition that harkens back to Bloch, Moltmann, Metz, Sölle, and more recently, Helmut Peukert and Edmund Arens. This has created the impression that only a certain type of theological reflection, and even more specifically, a particular tradition, has any use for Habermas the philosopher of religion.

In the following I will not seek to refute those readings of Habermas that proclaim his rejection of religion, nor will I attempt to formulate a better critique of Habermas's putative failure to give religion its due. I do not seek, either, to establish whether a thoughtful, honest, appropriate treatment of religion is possible at all on the grounds of Habermas's theory of communicative action, and that what remains to be done is to draw it out explicitly. Something much more limited, but perhaps for that very reason much more useful, is what I seek to present. In the following I will offer a reconstruction of those types of formulations and pronouncements made by Habermas that trace out a historical-developmental, quasi-functionalist, or in short, phylogenetic, story of the rise and transformation, but not demise, of religion. This type of exegesis and reconstruction is necessary to dispel the misconception that there is an unambiguous Habermasian rejection of religion. I want to illustrate first that there have been modifications in Habermas's views on religion. Such variations have to do with the increasing nuancing and sophistication of his theoretical model. At the same time, I would like to illustrate the extent to which Habermas has also continued to maintain questions concerning religion close to the center of his thought.

A fuller, more appropriate treatment of Habermas's treatment of religion would have to complement the work here undertaken with what I would call its dialectical complement, namely Habermas's philosophical treatment of religion. Indeed, a parallel reconstruction and exegesis would need to be undertaken which trace those formulations and pronouncements made by Habermas that explicitly articulate how the semantic contents of religion (as well as its institutional dimension, I would say) remain both inextinguishable and always still-to-be non-instrumentally appropriated. While the work I undertake here deals with Habermas the sociologist of religion, the dialectical complement missing here would be the one that deals with Habermas

the philosopher of religion, in whose hands the philosophy of religion turns into the critique of religion.[12]

HOW RELIGION MADE US MODERN

In the widely read and still classic text of 1968, written on the occasion of Herbert Marcuse's seventieth birthday, Habermas already approaches the question of religion. It is to be noted that this is a very important text for at least two reasons. First, because here Habermas, vis-à-vis the work of Marcuse, seeks to further elaborate a critical theoretical approach to the question of technology in particular, and the growth of rationalization of society in general. Second, because here is made explicit, if not for the first time, at least in an extended and elaborated fashion, Habermas's own dissastisfaction with the Frankfurt School's traditional approach to the question of the rationalization of society. In this text, in fact, Habermas elaborates more extensively on the distinction between work and interaction, which he had announced in an essay from the same period: "Labor and Interaction: Remarks on Hegel's Jena *Philosophy of Mind*."[13] In this latter essay, Habermas pursues the missed opportunities in Hegel's early work and how such a failure impacted the development of Marx's own work. In the Marcuse essay, Habermas takes up his philosophical reflections from the angle of social theory. The intent behind the introduction of this distinction is dual. On the one hand, Habermas was to disentangle Marcuse's critical theory of technology and societal development from a host of aporias and self-contradictions which nullified some worthy insights. On the other hand, Habermas wanted to rescue Weber's and Parson's analysis from their subjectivistic and monological perspectives. Still, the unifying thrust of this distinction is to allow for an appropriate understanding of the logics that inform the rationalization of different modes of action. In this early sketch, "labor" refers to purposive action which brings together instrumental and/or rational choice. Such forms of action are guided by technical rules, or strategies of either maximization of benefits or minimization of costs. By "interaction," Habermas understands what he already called in the late sixties *communicative action*, that is, that type of action that is guided by binding *consensual norms*. Succinctly, as Habermas put it: "While the validity of technical rules and strategies depends on that of empirically true or analytically correct propositions, the validity of social norms is ground only in the intersubjectivity of the mutual understanding of intentions and secured by the general recognition of obligations."[14] This analytical distinction actually corresponds to different social systems. Social systems, or societal contexts for interaction, differ and are differentiated by whether they are the locus for the predominance of one or the other mode of action.

This mapping of modes of action to social systems allowed Habermas to distinguish between (1) the institutional framework of society or what he calls the "lifeworld," and (2) the subsystems of purposive-rational, or instrumental, action. With this distinction on hand, Habermas proceeds to reconstruct Weber's theory of the rationalization of society, with an eye, as well, to correcting the misguided appropriation of Weber by the first generation of critical theorists.

Max Weber's social theory is above all a theory of the phylogenesis of social systems and their corresponding forms of rationality. Weber's theory, as Habermas is going to make explicit in his *Theory of Communicative Action*, is a theory of society as a theory of rationality, which in turn must be specified as the theory of the differentiation of types of rationality, or typology of rationality. This much was already clear to the young Habermas in this early incursion into the reconstruction of historical materialism. In this early essay from 1968, thus, Habermas will offer a sketch of a succession of different developmental stages of human societies to match his analytical distinction between lifeworld and systems level. Habermas distinguishes between archaic, or primitive, traditional, and modern societies. The second differ from the first in that traditional societies: (1) have developed centralized ruling power, (2) society has divided vertically into socio-economic casts or groups, (3) centralized world views have developed to legitimate centralized power and the distribution of social goods. But what is true about the distinction between archaic and traditional societies is also true of the distinction between traditional and modern societies. Their differences can be gauged by the level of the harnessing of productive forces in accordance with the dictates of a legitimation strategy of force and coercion, and how the latter are overtaken by the former. Differences in societal development are partly determined by the gap that develops between the extension and levels of sophistication in subsystems of purposive-instrumental action and the legitimation of power.[15] Indeed, the triumph of capitalism within modern societies has to do with its relative success at harmonizing and bringing into equilibrium the divergent trends of the expansion of subsystems of instrumental action and the legitimation of coercion. This is what Weber called the rationalization of the forms of interaction. In Habermas's view, however, it has to be made explicit that this rationalization is executed or brought about from "above" and "below." From below, by the very success of the subsystems of instrumental action that, with each gain, continue to expand vertically, taking over more and more subsystems of purposive, or instrumental, action. Progressively and ineluctably every major, and minor, structure of traditional society is brought under the logic of instrumental or strategic rationality. Simultaneously, but now as if from "above," world views, whether mythological or religious, lose their power and "cogency."[16] This rationalization from above is what Weber

called secularization. This is made up of two aspects. On the one hand, traditional world views lose their power and status as myths, ritual, justifying metaphysic, and immutable tradition, as they are interiorized. In this view, secularization means subjectivification, or subjective relativization. On the other hand, secularization also means that such traditions, world views, rituals, legitimating metaphysics, and so on are transformed "into constructions that do both at once: criticize tradition and reorganize the released material of tradition according to the principles of formal law and the exchange of equivalents (rationalist natural law.).[17] This is a pregnant formulation. Rationalization as secularization means that traditions, or world outlooks, themselves became the locus of contestation and innovation as well as the site for the preservation and transmittal of tradition. There are no longer "traditional" world views that lag behind, as archaic undertow, which are not submitted to the court of rational self-justification. Tradition itself, be it religious or metaphysical, must be rationally justified. Hence the long history of theologizing and metaphysical speculation that accompanies the modernization of world religions. Secularization, in short, means that religious as well as metaphysical outlooks became the site of their own delegitimation and relegitimation. Tradition is discovered as such at the very instant that it becomes open to re-configuration and rational analysis. For this reason, Habermas notes "ideologies are coeval with the critique of ideology."[18] Or, formulated in slightly different terms: the tradition of modernity is the critique of tradition for the sake of tradition.[19]

A slightly different version of such orientation towards the modernity of religion is voiced in Habermas's 1973 work *Legitimation Crisis*.[20] Summarily put, the goal of this work was to translate the discourse about the contradictions of capitalism, as it was articulated by historical materialism, into a discourse about the crises and deficits of rational legitimation of modernized, secularized, rationalized systems of interaction and increasingly weakened and demystified world outlooks. In this work, Habermas sought to offer his complement to a critique of Marxism, and classical Frankfurt School critical theory, but in terms of politics and economics. How do we understand the "contradictions" of a social totality when this has been now conceptually dissected into two distinct levels: the lifeworld and the systems level? Both operate according to their own logics. Their development is dictated by their respective corporealizations of forms of reason or modes of action. Further, if we understand society diachronically as a differentiated arrangement of types of rationality, then contradictions must now be rethought as crises or pathologies in the forms of rational abjudication and justification—either insufficient rationalization, or pathological rationalization. It is against this background of the systematic reformulation of the Marxist project of the critique of political economy into a critique of failed or pathological rationalizations of society that Habermas once again

broaches the question of religion and, now explicitly, of God.

In part three, chapter four, entitled "The End of the Individual?" Habermas discusses the shipwrecking of world views on the shoals of the disjunction between the cognitive and social integrative of functions of traditional world views. Indeed, at the most minimum, one of the fundamental functions of religious and metaphysical world views was to integrate individuals to society, by offering bridges between individual and group identity, while offering a cognitive handle on the natural world.[21] With the rationalization of world views, from above, to use the language of his *Festschrift* essay for Marcuse, personal identity is now separated from group identity, and these in turn are made distinct from any cognitive management of the natural world. In this view, the rationalization of metaphysical and religious world views means that we must face our subjectivities and group alliances as contingent, for neither entails the other. At the same time, the intractability and impertuability of the natural world before our own wills means that we must face our individual existence in the world as entirely contingent. We must face the world *disconsolately*, without warrants or guarantees. In this desolate world, bereft of unifying and meaning-granting mental or religious pictures, does it mean that we must surrender to technocracy, disavowing the links between truth and justice, and that a universalist morality must be reduced to its empty self-affirmation before the scientistic and objectifying self-understanding of contemporary humanity?[22]

Habermas speculates that an affirmative answer is not yet forthcoming, if at least because the "repoliticization" of the biblical tradition, as was particularly observable in the then-emerging theological formulations of political theologians.[23] Such repoliticization, which entailed a leveling of the immanent/transcendent dichotomy, was not supposed to be read as an atheism. Instead, such "religious" revivals, and modern reappropriations of the traditions, formulated from within but also heeding the calling of the times, are to be understood as modern reformulations of the very concept of God. Habermas writes, "The idea of God is transformed [*aufgehoben*] into a concept of a *Logos* that determines the community of believers and the real life-context of a self-emancipating society. 'God' becomes the name for a communicative structure that forces men, on pain of a loss of their humanity, to go beyond their accidental, empirical nature to encounter one another *indirectly*, that is, across an objective something that they themselves are not."[24] Evidently, it would be anachronistic, although not illegitimate, to reread this incredible formulation in the language of the *Theory of Communicative Action*. God is the name for that substance that gives coherence, unity, and thickness to the lifeworld wherein humans dwell seeking to acknowledge each other as meaning-giving creatures. One may ask, paralleling this reinscription: Is this God as the *Logos* of a community of "believers" (who are always believers only insofar as they speak, confess,

and witness in a community of communication of biblical texts and truths), the same God as the communicative rationality of a community of arguers and vulnerable corporealities? God has always been the cipher of humanity's unactualized potentials. God is the name for a negative fiction of what humans should but are always hindered from becoming by their own corporeality and finitude.

Another key textual point of reference that should be visited before we turn to the pivotal *The Theory of Communicative Action*, is Habermas's synthesizing and synoptic 1976 introduction to this *Zur Rekonstruktion des Historischen Materialismus*,[25] "Historical Materialism and the Development of Normative Structures."[26] This introduction offers a map of Habermas's efforts to reconstruct historical materialism. The text it introduces is itself divided into four major sections: philosophical perspectives, identity, evolution, and legitimation. The introduction, therefore, undertakes the task of unifying what Habermas had been trying to accomplish over the first part of the seventies, which succinctly and pointedly is summarized by him in the following way: To spell out the ways in which communication theory can contribute to understanding the learning processes that humanity has undergone not just in the dimension of objectivating and instrumentalizing thought, but also in the different dimensions of: moral insight, practical knowledge, consensual arbitration of social interaction. In short, Habermas sought to preserve the critical impetus of historical materialism by rearticulating its analysis of human history in terms of a theory of the acquisition of communicative competencies the developmental logic of which can be analyzed as a process of rationalization, formalization, universalization, and abstraction. The idea, therefore, is to reconstruct the developmental logics of those processes of rationalization that have guided the internal differentiation of processes of identity constitution, social differentiation, and political legitimation. To accomplish this, Habermas draws out what he calls "homologies" between ontogenetic and phylogenetic developmental logics. Such homologies are to be traced by comparing the developmental logics of the domains of ego and world views, on the one hand, and ego and group identities, on the other.[27]

Habermas is quick to qualify the conditions under which these homologies, or parallelisms, can be drawn. He spells out a long and detailed list of the kinds of reservations that must be heeded and specious parallelisms that might be illegitimately drawn. Nonetheless, Habermas proceeds, certain homologies can be made explicit. Thus, we are able to discern within the ontogenesis of the cognitive capacities of individuals the following: the differentiation of temporal horizons, namely the differentiation between natural and subjective time; the articulation of the concepts of causality and substance. Similarly, mythological and religious world views admit of an analysis that makes explicit the development and acquisition of conceptual

and logical differentiations. Myth, which corresponds to an early stage of human evolution, is incorporate within traditional societies in a functional manner. Myths are now supposed to legitimate the authority of the ruling structures. But at the very instant, myth turns into tradition by being assimilated within a temporal horizon. In other words, the very incorporation of myth within the social fabric of a differentiated social system leads to the catalyzation of myth into tradition, which in turn is going to transform into abstract principles upon which argumentative orders are grounded. In the parallel unfolding of logical structures, cognitive competencies, and ego and group identities, myth and tradition never remain the same, and are simply ossified. Just as the cognitive competencies and faculties of a human being can be understood as the acquisition of more decentered and self-reflexive learning abilities, world view and religious and metapysical systems are also caught in the flow of processes of de-substantialization, de-centering, and self-reflexivity. At the very moment that universalistic forms of interaction are being established through the triumph of capitalism and the bourgeois political revolutions of the eighteenth century, religious and metaphysical world views are simultaneously introjected and rendered reflexive.[28] The parallelism, however, is not simply a homology. There is a fundamental link. Ontogenesis must be understood as the unfolding of cognitive capacities which in fact are also learning abilities [*Lernfähigkeiten*]. A cognitive capacity is above all a way of learning. But such learning abilities must be, as Habermas notes, "latently" available in world views before they may be utilized socially, that is, be "transposed into societal learning processes."[29] Enlightened subjects are not possible without enlightened world views, like those of the classical monotheistic religions of the Axial Age.[30]

Our chronological analysis of some key sections in Habermas's texts from the late sixties through the seventies should have left the clear impression that his project of a reconstruction of historical materialism entailed the salvaging of all kinds of insights from different fields. Looked at in this perspective, Habermas has remained true to the interdisciplinary project of the Frankfurt School. Practically, this has meant that Habermas has taken recourse to what *prima facie* seem antithetical approaches: Hegel, Marx, Gadamer, Adorno, Marcuse, Blumenberg, Koselleck, but also Piaget, Kohlberg, Luhmann, Weber, Durkheim, and Mead. Here we must recall that many of Habermas's books began as *Literaturbereichten* (reports on the literature of a particular debate or field).[31] This approach should not be understood at all as a type of eclecticism or theoretical promiscuity. Instead, as we have noted thus far, Habermas wants to preserve Marx's insights into history and the pathogenesis of capitalism by translating them into the language of developmental logics and rationalization processes. The point was not to dissolve Marx into Weber and historical materialism into systems theory, but rather to see whether both could be measured by the same

standard: namely, the question of humanity's differentiated unfolding. To this extent, Habermas's theoretical appropriations should be seen as *litmus tests* of the theories themselves. In Habermas's case theoretical reconstructions have a systematic intent in such a way that ". . . for any social theory, linking up with the history of theory is also a kind of test; the more freely it can take up, explain, criticize, and carry on the intentions of earlier theory traditions, the more impervious it is to the danger that particular interests are being brought to bear unnoticed in its own theoretical perspective."[32]

Staying focused on the question of Habermas's relationship to religion, we note that his analysis remains basically the same, albeit now formulated in terms of a detailed theory of communicative competencies and the symbolic acquisition of identity. Whereas in his earlier writings Habermas approached the question of the secularization (that is, rationalization) of religious and metaphysical world views through the lens of Weber, Hegel, and his colleagues at Stanberg, Klaus Eder and Rainer Döbert, in his *Theory of Communicative Action* Habermas approaches this question through the lenses of Mead's and Durkheim's complementary theoretical models. Just as Habermas had found Hegel, Marx, and Marcuse wanting because of their failure to address the differentiated modes of action, namely, instrumental and communicative, now Habermas finds Weber, Adorno, Parsons, and Luhmann wanting because of their failure to address the question of the unfolding of modes of interaction, their corresponding domains of embodiment, and the acquisition of cognitive capacities in terms of a symbolic, communicative, linguistic understanding of reason and agency. The failures of these great thinkers, suggests Habermas, were to be remedied from within, namely, by making explicit what they already presupposed tacitly. Here, again, Habermas has also remained faithful to the critical orientation of the Frankfurt School, that is, to think from within the very theoretical assumptions of a given analysis or conceptual orientation about its own inadequacies.

More concretely, the fundamental question for Habermas in the late seventies became how can we explain the development of universal and normative structures as the development of linguistic and symbolic competencies. This is where Mead and Durkheim are introduced in order to play a pivotal role. The former allows Habermas to reconstruct his theory of individuation as a theory of language acquisition, which yields that subjectivity is posterior to an intersubjectivity that is co-originary with the acquisition of language. Mead turns into the Hegel and Kierkegaard of Habermas's new theory of subjectivity, or more accurately, of communicative agency. Durkheim, on the other hand, allows Habermas to reconstruct the development of normative social order as the process of symbolic integration that is matched by social solidarity. Durkheim allows Habermas to translate Weber's and Parsons's question about order into a question

about the symbolic constitution of social solidarity, and the symbolic integration of individuals into social groups. In tandem, Habermas must discuss the way in which world views, whether metaphysical or religious, are linguistified, that is, rendered accessible to symbolically constituted agents through their being opened up to discursive or linguistic treatment. Thus, in this expanded theoretical orientation, the separation between the profane and sacred corresponds to a split in the medium of communication, namely, the slip that takes place between the propositional, expressive, and normative uses of language that correspond to objective nature, the social, and subjective worlds respectively.[33]

In order to accomplish his theoretical aims, Habermas must explain how religious and metaphysical world views, which at early or so-called archaic stages provided an analogical coordination between nature, humanity, and society, became a "drive belt that transforms the basic religious consensus into the energy of social solidarity and passes it onto social institutions, thus giving them a moral authority."[34] Religious world views, in fact, hasten the process of the sublimation of the compulsive power of terrifying divine power into the normative binding power of social norms. It is not that political or social power compels religion to surrender its grip over the cowered masses; rather, in as much as religion itself is ritualized and then made part of a tradition, which then is reflexively appropriated and rendered accessible to criticism, religion itself compels subjects to adopt universalizing and critical attitudes towards its own myths and theologemes. Habermas makes this explicit when he writes (and I must quote at length):

> The core of collective consciousness is a normative consensus established and regenerated in the ritual practices of a community of believers. Members thereby orient themselves to religious symbols; the intersubjective unity of the collective presents itself to them in concepts of the holy. This collective identity defines the circle of those who understand themselves as members of the same social group and can speak of themselves in the first-person plural. The symbolic actions of the rites can be comprehended as residues of a stage of communication that has already been gone beyond in domains of profane social cooperation.[35]

Through a religious symbol, or a theologeme, a community of believers, which is also a ritual community, constitutes itself as a group. This clears up the linguistic space for the first person plural of pronouncements. Simultaneously, this linguistic circumscription initiates the separation of the sacred from the profane. Everyday practice is de-sacralized. Religion, as belief and ritual (that is, practice) inaugurates a particular syntactical relation that in turn overtakes it.[36] *Religion linguistifies the world, catalyzing the very dichotomies that in turn linguistify the sacred.* The power exercised by myth over humans is transformed into the non-coercive coercion of moral norms.

The religious is not so much disposed and left behind, but rather internalized in society; it allows for society to take place. The normative power harbored and protected within religious contexts is released through communicative action. "Only in and through communicative action can the energies of social solidarity attached to religious symbolism branch out and be imparted, in the form of moral authority, both to institutions and to persons."[37]

Only the disenchantment and disempowerment of the sacred domain through its linguistification leads to the release of the binding, normative power stored in its ritualistically accomplished normative agreements.[38] This also releases the rational potential implied in communicative action. For, the "aura of rapture and terror that emanates from the sacred, the *spellbinding* power of the holy, is sublimated into the *binding/bonding* force of criticizable validity claims and at the same time turned into an everyday occurrence."[39] The linguistification of the sacred leads to its dialectical assimilation and transformation. The compulsion exercised by the "wholly Other" turns into an everyday occurence which we must live by in terms of our respect for the binding force of norms of action, and moral maxims. Indeed, only a universalistic, deontic, moral outlook that corresponds to a post-conventional moral outlook can appropriate the normative contents of religion: "neither science nor art can inherit the mantle of religion; only a morality, set communicatively aflow and developed into a discourse ethics, can replace the authority of the sacred. . . "[40]

CONCLUSION

After almost half a century of public intellectual and scientific work, Habermas's contribution is both impressive and humbling. Habermas has remained vital, creative, engaged, and most importantly, attuned to the *Zeitgeist* without sacrificing intellectual honesty and rigour. There is no field that he has left untouched, and this includes religion, even if in this his reception has been mixed and skewed. As questions of pluralism, cross-cultural dialogue, fundamentalisms, re-assessments of notions of inalienable rights and sacredness of life, and religiously fueled conflicts continue to press upon contemporary life, Habermas's insights into religion can offer a guide and point of debate. In an age of so-called globalization, the "West" itself has been provincialized, rendered local and historically contingent. Globalization has meant that the "West" now has to give an account of itself to others as well as to itself. Giving such an account must begin, above all, with a discussion of the West's relationship to its religious identity.[41] It is against this background that Habermas's wide-ranging, systematic, sociologically and philosophically informed analyses of religion commend themselves. In the brief and focused reconstruction executed above, traces

and points of entry for a thoughtful engagement were offered. At the very least, this reconstruction should make it more difficult to accept quick dismissals of Habermas's insights into religion. Habermas is certainly a secularist, but he is no anti-religion *philosophe*. "As long as no better words for what religion can say are found in the medium of rational discourse, it [communicative reason] will even coexist abstemiously with the former, neither supporting it nor combatting it."[42]

<div align="right">EDUARDO MENDIETA</div>

UNIVERSITY OF SAN FRANCISCO
JANUARY 2000

<div align="center">NOTES</div>

1. Zygmut Bauman, *Modernity and the Holocaust* (Ithaca, N.Y.: Cornell University Press, 1989).

2. See the wonderful essay by Russell A. Berman, "From Brecht to Schleiermacher: Religion and Critical Theory" in *Telos*, no. 115 (Spring 1999): 36–48.

3. Ernst Bloch, *Atheism in Christianity: The Religion of the Exodus and the Kingdom*, trans. J. T. Swann (New York: Herder and Herder, 1972), 62–63.

4. See Edmund Arens, ed., *Habermas und die Theologie: Beiträge zur theologischen Rezeption, Diskussion und Kritik der Theorie kommunkativen Handelns* (Düsseldorf: Patmos Verlag, 1989); Edmund Arens, Ottmar John, Peter Rottländer, *Erinnerung, Befriung, Solidarität: Benjamin, Marcuse, Habermas und die politische Theologie* (Düsseldorf: Patmos, 1991); Helmut Peukert, *Science, Action, and Fundamental Theology*, trans. James Bohman (Cambridge, Mass.: MIT Press, 1984); Don S. Browning and Francis Schüssler Fiorenza, eds., *Habermas, Modernity, and Public Theology* (New York: Crossroad, 1992). See the following works for extended applications of Habermas's theories to theology: Paul Lakeland, *Theology and Critical Theory: The Discourse of the Church* (Nashville: Abingdon Press, 1990), and Jens Glebe-Moller, *A Political Dogmatic* (Philadelphia: Fortress Press, 1987).

5. See the works by Rudolf Siebert, which unfortunately remain hardly accessible.

6. See, for instance, the essays gathered in *Habermas, Modernity, and Public Theology*, already cited above. See also Donald Jay Rothberg, "Rationality and Religion in Habermas's Recent Work: Some Remarks on the Relation between Critical Theory and the Phenomenology of Religion" in *Philosophy and Social Criticism* 11 (1986): 221–46; Klaus-M Kodalle, "Zur religionsphilosophischen Auseinandersetzung mit Jürgen Habermas's 'Theorie des kommunikativen Handelns'" in *Allgemeine Zeitschrift für Philosophie* 12 (1987): 39–66; Ludwig Nagl, "Aufhebung der Theologie in der Diskurstheorie? Kritische Anmmerkungen

zur Religionskritik von Jürgen Habermas" in Herta Nagl-Doceckal, ed. *Ueberlieferung und Aufgabe. Festschrift für Erich Heintel* (Wien: Wilhelm Braumüller Verlag, 1982), 197–213; Anne Fortin-Melkevik, "The Reciprocal Exclusiveness of Modernity and Religion among Contemporary Thinkers: Jürgen Habermas and Marcel Gauchet" in Claude Geffré, and Jean-Pierre Jossua, eds., *The Debate on Modernity*. Special issue of *Concilium* 6 (1992) (London: SCM Press, 1992), 57–66.

7. I am referring to Habermas's statements of criticism against Jacques Derrida. See Jürgen Habermas, *The Philosophical Discourse of Modernity: Twelve Lectures*, trans. Frederick Lawrence (Cambridge, Mass.: MIT Press, 1987), 183–84, see also footnote 46, pages 406–7.

8. While it is neither necessary nor desirable that everyone who writes on contemporary philosophy write something that in one way or another faces up to the challenges of Habermas, it is indeed unfortunate that in otherwise superlative works like those of John D. Caputo and Hent de Vries, no attempt was made to directly address Habermas's criticisms of Derrida's "atheistic messianism and mysticism." See John D. Caputo, *The Prayers and Tears of Jacques Derrida: Religion without Religion* (Bloomington and Indianapolis: Indiana University Press, 1997), and Hent de Vries, *Philosophy and the Turn to Religion* (Baltimore and London: Johns Hopkins University Press, 1999).

9. Habermas, *The Philosophical Discourse of Modernity*, 406–7, note 46, last sentence.

10. Jürgen Habermas, *Postmetaphysical Thinking: Philosophical Essays*, trans. William Mark Hohengarten (Cambridge, Mass.: MIT Press, 1992), 15. Bold added, italics in original. Compare with what Habermas says in "The Unity of Reason in the Diversity of Voices" later in the same book, especially page 145.

11. See Robert C. Holub, *Jürgen Habermas: Critic in the Public Sphere* (London and New York: Routledge, 1991), see also Max Pensky, "Universalism and the Situated Critic" in Stephen K. White, ed. *The Cambridge Companion to Habermas* (Cambridge: Cambridge University Press, 1995), 67–94.

12. This dialectical complement, Habermas the philosopher of religion, I elaborate in my introduction to the collection of essays on religion and theology by Habermas that I have edited with Polity (forthcoming shortly). In that introduction I discuss essays from *Philosophical-Political Profiles*, trans. Frederick G. Lawrence (Cambridge, Mass.: MIT Press, 1983), *Postmetaphysical Thinking*, and his most recent collection of essays, *Vom sinnlichen Eindruck zum symbolischen Ausdruck* (Frankfurt am Main: Suhrkamp, 1997).

13. Jürgen Habermas, *Theory and Practice*, trans. John Viertel (Boston: Beacon Press, 1973), 142–69.

14. Jürgen Habermas, *Toward a Rational Society: Student Protest, Science, and Politics* (Boston: Beacon Press, 1970), 92.

15. Habermas, *Toward a Rational Society*, 97.

16. Ibid., 98.

17. Ibid., 99.

18. Ibid., 99.

19. See the excellent work by Juan Luis Segundo, *The Liberation of Dogma: Faith, Revelation, and Dogmatic Teaching Authority*, trans. Phillip Berryman (Maryknoll, N.Y.: Orbis Books, 1992). The original title *El Dogma Que Libera* was lost in translation, but the entire book is precisely about a tradition that instigates criticism in its very process of transmission.

20. Jürgen Habermas, *Legitimation Crisis*, trans. Thomas McCarthy (Boston: Beacon Press, 1975).

21. Ibid., 118.

22. Ibid., 120.

23. Habermas mentions Pannenberg, Metz, Moltmann, Sölle, but one should also add Bloch, and Benjamin, who influenced directly and deeply this first generation of political theologians. See *Legitimation Crisis*, 121.

24. Ibid., 121. Italics in original. Compare with the following statement from Habermas's 1974 speech on the occasion of his receiving the Hegel Preis, which is granted by the city of Stuttgart. "Gott kennzeichnet fast nur noch eine Kommunikationsstruktur, die die Teilnehmer nötig, sich auf der Grundlage der gegenseitigen Anerkennung iherer Identität über die Zufälligket einer bloß äußeren Existenz zu erheben." *Zur Rekonstruktion des Historischen Materialismus*, 101. This speech was partly translated as "On Social Identity," *Telos*, no. 19 (Spring 1974): 91–103.

25. Frankfurt am Main: Suhrkamp Verlag, 1976.

26. Published in English in Jürgen Habermas, *Communication and the Evolution of Society*, trans. Thomas McCarthy (Boston: Beacon Press, 1979), 95–129.

27. Ibid., 99.

28. Habermas, *Communication and the Evolution of Society*, 105.

29. Ibid., 121.

30. This is Karl Jasper's term, see his *The Origin and Goal of History* (New Haven, Conn.: Yale University Press, 1957).

31. See in particular Jürgen Habermas, *Zur Logik der Sozialwissenschaften*. Erweiterte Ausgabe (Frankfurt am Main: 1985). This book originally appeared in 1970, but was later expanded in 1982. The English translation omits much of this text and focuses only on the second section of the German version, namely, the section on hermeneutics.

32. Jürgen Habermas, *The Theory of Communicative Action*, vol. 1: *Reason and the Reationalization of Society*, trans. Thomas McCarthy (Boston: Beacon Press, 1984), 140.

33. See Jürgen Habermas, *The Theory of Communicative Action*, vol. 2:. *Lifeworld and System: A Critique of Functionalist Reason*, trans. Thomas McCarthy (Boston: Beacon Press, 1987), 54. Note that this conceptualization of the differentiation of religious outlooks in terms of a differentiation of linguistic and verbal modes was already elaborated by Döbert in the early seventies. What differs, now, in Habermas's treatment is that this "linguistic" understanding is backed by a full-fledged "universal pragmatics," that is, a theory that describes language and reason in terms of validity claims, domains of action, and forms of rationality.

34. Ibid., 56.

35. Ibid., 60.

36. Readers of Habermas might be unfamiliar with the voluminous literature that makes these claims plausible and credible. For a point of entry to the idea that the religious linguistifies and it is linguistified, see John Dominic Crossan's numerous books, in particular *In Parables: The Challenge of the Historical Jesus* (New York: Harper & Row, 1973), *The Dark Interval: Towards a Theology of Story* (Niles, Ill.: Argus, 1975), *The Cross That Spoke: The Origins of the Passion Narrative* (San Francisco: Harper & Row, 1988). For a comprehensive and systematic overview of the impact of the "linguistic turn" on Bible studies and religion in general, see *The Bible and Culture Collective, The Postmodern Bible* (New Have, Conn.: Yale University Press, 1995).

37. Ibid., 61.

38. Ibid., 77. This is paraphrasing of the original German, see Jürgen Habermas, *Theorie des kommunikativen Handels. Band 2. Zur Kritik der funktionalistischen Vernunft* (Frankfurt am Main: Suhrkamp Verlag, 1981), 119.

39. Ibid., 77. Translation slightly altered. The original reads: "Die Aura des Entzückens und Erschrechkens, die vom Sakralen ausstrahlt, die *bannende* Kraft des Heiligen wird zum *bindenden* Kraft kritisierbaren Geltungsansprüchen zugleich sublimiert und veralltäglicht" (119).

40. Ibid., 92. Compare with Marcel Gauchet, *The Disenchantment of the World: A Political History of Religion*, trans. Oscar Burge (Princeton: Princeton University Press, 1997). For Gauchet, the departure of the gods from the world means the turn inward. The otherness of the gods is replaced by the otherness that the aesthetic experience grants us. Religion is replaced by Art, the prophet by the artist, the priest by the cultural critic.

41. See Jacques Derrida, "Faith and Knowledge: the Two Sources of 'Religion' at the Limits of Reason Alone" in Jacques Derrida and Gianni Vattimo, eds. *Religion* (Stanford: Stanford University Press, 1998), 1–78.

42. Habermas, *Postmetaphysical Thinking*, 145.

8

Thelma Z. Lavine

Philosophy and the Dialectic of Modernity

I

The social philosophy of Jürgen Habermas, outstanding philosopher and master dialectician of our time, has an immediate appeal to American philosophers, educated in the history of the Protestant migrations to the New World in search of religious freedom early in the seventeenth century; educated also in the Founding Fathers who drew up a constitution for a modern republic heralded by Thomas Jefferson's Declaration of Independence proclaiming the universality of human equality and the natural rights of individuals by which their political freedom from despotism is secured.

The appeal of Habermas to American philosophers acculturated in these Enlightenment principles is that of a voice speaking for reason and justice; he stands forth philosophically on behalf of "rehabilitating the Enlightenment" in the face of various current modes of thought engaged in its undermining. Habermas has been widely commended for his strong unequivocal stand as a German intellectual against the Nazi movement and the Holocaust it produced, and against any revisionist circumlocutions seeking to obscure those atrocities. In this connection he has received intellectual approbation for his famous altercation with Hans-Georg Gadamer in whose *Truth and Method* Habermas notes, "Gadamer's prejudice for the rights of prejudices" is "certified by tradition" and denied "the power of reflection." Habermas has also won approval for his strong stand against anti-Semitism, in Germany as well as in its worldwide manifestations. From the Enlightenment perspective pervading much of American thought, Habermas is commended for his repudiation of Martin Heidegger's complicity with Nazism and his retreat to linguistic mysticism. He is commended as well for his strenuous criticism of postmodernism's

drive to bring philosophy to an end. Of crucial philosophical significance is the appreciation of Habermas's recent struggle to rehabilitate the Enlightenment by securing it, however unfashionably, upon a firm foundation by a democratic politics of deliberative discussion.

In the face of the multi-dimensionality of Habermas's perceived accord with American philosophers, understood to be culture carriers of principles from the Founders and from classical American pragmatism, there comes the shocking realization that the Habermas appeal has been falsely construed. The shock occurs with the discovery that Habermas's account of philosophy in *The Philosophical Discourse of Modernity* begins the discussion of philosophy in the modern era with Hegel and finds no place for the tradition of Enlightenment philosophy. How was it possible for Habermas to erase the Enlightenment tradition from his text of the philosophical discussion of the modern era? How, in view of this erasure of Enlightenment thought, was it possible for American philosophers so seriously to misinterpret Habermas's project for "rehabilitating the Enlightenment," with its Jeffersonian subtext of universal reason and with its Deweyan promotion of communicative democracy? How, then, was it possible for Habermas, after omitting the Enlightenment from his overview of modern philosophy, to appeal nevertheless to the Enlightenment language of reason, communication, universalism, and democracy?

The search for some answers to these questions cannot, of course, rest with the Habermas who in 1987 in *The Philosophical Discourse of Modernity* presents his interpretation of modern philosophy as beginning with Hegel, but must discover the young Habermas emerging from the recent Nazi past, finding his way from the horrors of World War II disclosures to the socialist vision of the Frankfurt School with its potent mix of Marx, Freud, and Weber. Especially significant was Horkheimer and Adorno's *Dialectic of Enlightenment*, which mythically portrayed the Enlightenment's capitalist domination of nature as the source of Nazism; the domination of nature turns into the domination and repression of human beings, eventually into their self-repression and into their political and social domination by the Fascist regime. Horkheimer and Adorno returned to Germany from their refuge in capitalist America only to confront the postwar hopelessness of their political vision. It is possible to see the subsequent developmental line of Habermas's career as the philosophical search for a restored rationality for society in the form of a non-repressive democratic consensus; he retains from the Frankfurt School the logic of the *Dialectic of Enlightenment*, that Enlightenment economic and political freedom turns into Fascist domination while also retaining a saving remnant of the Frankfurt School's socialist hope.[1]

The pursuit of Habermas's intertwined goals of a restored societal rationality and a sustained socialist ideal is visible in the venture of *Knowledge and Human Interests* into establishing a foundation for the natural and social

sciences, which are in turn subjected to psychoanalytic and ideological critique. These epistemological goals along with the focus on science are, however, set aside with the resumption of a political focus in *Legitimation Crisis* with its foreboding impending crises of the liberal democracies, which could be forestalled only by an unspecified socialist radicalization of their democratic institutions.

Responding to the widespread philosophic interest in language and its entrance into German intellectual circles, Habermas moves forward in his quest for a rational grounding of society with the breakthrough discovery that in language itself there is the ground he needs. This is Habermas's well known discovery that in speech there is "always already," pre-theoretically, four validity-claims which are to be "redeemed" in human exchange of language which seeks to "come to an understanding." These claims, "comprehensibility," "truth," "truthfulness," and "normative correctness," are modeled upon Kant's transcendental categories, and are intended to provide a Kantian-type a priori certainty as a foundation for rationality.

Habermas's linguistic "turn" enables him to identify a new mode of rationality, communicative rationality, in distinction from the instrumental purposive rationality which Max Weber had seen as unopposed in pervading and culturally impoverishing the modern world. Weber's "iron cage" metaphor for the modern world had been central to the Frankfurt School's despair. Habermas's breakthrough discovery of a new form of rationality liberates him from the pessimism of Weber's exclusive monological instrumental rationality and from the darker pessimism of Horkheimer and Adorno. And in the massive, two-volume *The Theory of Communicative Action*, Habermas's trademark intricacy of argumentation is perceptibly en route by way of the language of intersubjectivity, and the idea of coming to an understanding through the redemption of validity claims, to a language expressive of the Enlightenment ideal of liberation. He now begins to build upon his newly formed distinction between instrumental and communicative language to develop his newly formed concept of society as consisting of the prevailing Western economic and governmental systems, employing the language of Enlightenment purposive, instrumental rationality, and the lifeworld of civil society, which is expressed in the intersubjective language of mutual understanding and fosters communities of free and open democratic discourse. It is significant to observe that the philosophic interpretation of the natural sciences (now in an era of unprecedented development) falls characteristically outside Habermas's counter-Enlightenment purview. [2]

It was 1981 when *The Theory of Communicative Action* appeared in Germany. The onset of the collapse of the Soviet Union was only eight years away. But Habermas cannot be charged with an accommodationist shift in his philosophy in response to the Soviet crash. Habermas had already begun to divest himself of hopes for the continued stability of the Soviet Union in the

light of the movement of social and political change in Germany and in the West. By the end of *The Theory of Communicative Action* he has constructed a philosophy of society which borrows much of his concept of "system" from the "functionalist" sociologists Talcott Parsons in America and Nicholas Luhmann in Germany.

How far has Habermas come in *The Theory of Communicative Action* toward affirming the Enlightenment tradition of the rationality of constitutional democracy, the natural and social sciences, and civil society? In evidence there is the statement of Stephen K. White in his introduction to *The Cambridge Companion to Habermas* on Habermas's "strong universalist position on rationality and morality and the claim that the modern West—for all its problems—best embodies these values." But is this a fair assessment of Habermas's views? White goes on to say that the position he has attributed to Habermas "has, not surprisingly, run into intense opposition from a broad array of poststructuralist, postmodern, and feminist thinkers." But White seems to take no notice of Habermas's dialectical model of society in which opposition comes not from an outside "broad array" of "thinkers," but from within Habermas's own model. The dialectical logic of Habermas's model conveys his view of the modern society as one in which the power of the ever-expanding economic and governmental systems is in a position to infiltrate and overwhelm the everyday lifeworld and the forms of civil society. Habermas expresses this danger in his ideologically charged concept of the "colonization of the lifeworld." Marx's socio-economic conflict theory of base and superstructure, of submerged proletarian truth and regnant bourgeois ideology, having been conceptually reinterpreted by Horkheimer and Adorno's *Dialectic of Enlightenment* as the Weberian dominance of unopposed purposive rationality, is now linguistically reinterpreted by Habermas as the conflict between instrumental and communicative rationality, between system and lifeworld. The emotional power of this unfolding portentous historical dialectic resonates in *The Theory of Communicative Action*. Habermas has remained faithful, in his own way, to the *Dialectic of Enlightenment*.

It is not surprising but nonetheless noteworthy that insofar as Habermas has found his way to accepting in his recent model of society the economic and political systems of the West, he has done so without acknowledgement of the historical reality of the Enlightenment tradition from which these systems have been derived. Here we have come upon an astonishing, deadly erasure. In his text, Habermas has erased from historical consciousness the philosophic vision of liberal democracy, fought for in the Enlightenment transformative revolutions of 1688, 1776, 1789 in England, America, and France.

The intellectual violence of such an erasure calls out for explanation and interpretation. The erasure of the Enlightenment philosophic tradition, only to incorporate without identification key elements of that tradition (the foundational project for philosophy and society, the cognitive function of validity

claims, the pursuit of the ideal of democracy and democratic procedures, the Lockean-like distinction between scientific and intuitive truth), would appear to be a gratuitous intellectual endeavor. This gratuitous strategy of incorporating, without identification, key Enlightenment elements while disdaining the option of identification with modification can only derive from important determining interests. The rewriting of Western political philosophy is at stake. Is it to be rewritten to reflect anti-Enlightenment socialist political thought? Or to reflect postwar interests of Germany in sugarcoating its philosophical past and assuring its place in history? Or to affirm with Heidegger, "When [others] want to philosophize they speak German"?[3]

What, then, of philosophic thinking in the modern era? How has it engaged the Enlightenment tradition in relationship to the philosophy of modernity? In the preface to *The Philosophical Discourse of Modernity*, Habermas refers to "Modernity—An Unfinished Project," the title of his speech upon accepting the Adorno Prize in 1980. "This theme," he says, "never lost its hold on me. Its philosophic aspects have moved ever more starkly into public consciousness in the wake of the reception of French neostructuralism. . . ." To meet the challenge of poststructuralism Habermas undertakes "to reconstruct here, step by step, the philosophical discourse of modernity."

It is astonishing to discover immediately that this step-by-step reconstruction of the philosophical thought of modernity begins with Hegel. The obliteration of the prior Enlightenment philosophic tradition with its deep historical roots in the Magna Carta and voicing itself after the Renaissance and the Reformation in Bacon, Locke, and Newton, Berkeley, Hume, and Kant, and moving to the French enculturation of Enlightenment thought in the *philosophes* Diderot, D'Alembert, La Mettrie, Helvetius, Holbach—this vast obliteration of Enlightenment philosophers is an expectable outcome of Habermas's philosophical and political strategy.

Prior to the pivotal philosophy of Hegel in the German philosophical scene are Kant, Fichte, and the German romantics. Kant plays no important role in the philosophical overview although in other Habermasian texts he appears as a vestibule to Hegel, problematic, however, concerning the issue of his prioritization of individual mind over collective mind and of moral freedom over political freedom. Fichte, the fickle, flattering follower of Kant, is discreetly erased because of his sudden turn in response to the Napoleonic threat, to a non-Kantian primacy of the will of the community over individual rights, to proclaiming the superiority of the German people over the other peoples of Europe, and to celebrating in advance of later Nazi accolades, the rootedness of the Volk in their blood and soil.

Romanticism appears as the rise of the aesthetic "modernist temper," subverting everything normative, and thus heralding the extremism of the French postmodernists in their revolt against the "normalizing" functions of tradition. It is, however, Baudelaire rather than a German romantic writer who

is selected by Habermas to exemplify this trend. On behalf of Baudelaire and other literary and philosophical romantics, Habermas points out, however, that there is merit in opposing false normativity, and that a serious problem has been opened up by the romantics' questionings: how, in the presence of continuing conflict with regard to the traditions of the past and the uncertainties of the present, can any ground be found for the modern age?

The stage has now been set for Hegel and the beginning of modern philosophy: "Hegel was the first philosopher to develop a clear concept of modernity." Again, Habermas announces: "Hegel was the first to raise to the level of a philosophic problem . . . detaching modernity from the suggestion of norms lying outside of itself in the past." Hegel's famous insight that "philosophy is only its own time reflected in thought" is interpreted by Habermas to convey Hegel's view of modernity: "Modernity can and will no longer borrow the criteria by which it takes its orientation from the models supplied by another epoch; *it has to create its normativity out of itself*" (*The Philosophical Discourse of Modernity*, Lecture I).

Habermas's Hegel is, however, not recognizable in the role of disconnecting philosophy from the norms of past philosophies or in the role of bringing about the end of philosophy. Nor is Habermas's Hegel recognizable as the Hegel whose philosophy of history culminates with German philosophy and culture triumphant in the history of the world; the Hegel whose philosophy assigns to Germany the reconciliation of the conflicts brought about by the decline of religion and the advent of Enlightenment philosophy and social structures; the Hegel who elevates the truth of idealist "philosophy" over Enlightenment scientific and political "understanding"; the Hegel whose texts, empowered by the conception of dialectical conflict, are overflowing with ideas of the spirit of different historical peoples, the concept of culture, historicism, the master-slave concept, formal ethics and the ethics of *Sittlichkeit*, alienation, leadership, formal and substantive freedom, and the unintended consequences of human action—ideas which are the substance of much of twentieth-century social philosophy and social sciences. Habermas erases both Hegel's political authoritarianism and the richness of his cultural bequests in order to focus upon the Hegel who, as the first to open the philosophic problem of modernity, and the first to question whether the conflicts of modernity have any possibility of a reconciling normativity, can appropriately be seen as marking the beginning of modern philosophy.

But Habermas bestows upon Hegel yet another distinction. In the writings of the young Hegel, Habermas discovers a path to communicative action and intersubjectivity and a democratic self-organization of society within the living spirit of the early Christian community. "Hegel did not take this path," Habermas concedes, because he was "forced" in "the modern age" to part with this recourse to religion, and because "he had to see that the capitalist form of economic commerce had produced a modern society. . . ." But was this ever

a meaningful option for Hegel? How could this elusive reconstruction of an archaic path to a Habermasian intersubjective radical democracy be imputed to the Hegel for whom the true path leads precisely away from radical democracy, the Hegel who writes, "If people means a section of the citizens, it is precisely that section which does not know what it wills. To know what one wills, and still more, to know what the absolute wills, is the fruit of profound knowledge and insight, precisely the things which the public does not know" (*Phenomenology of Spirit*). Nevertheless, "the path not taken" runs like a leitmotif throughout *The Philosophical Discourse of Modernity* sounding the note that the path is not lost but is yet to be taken, a path to a society which organizes itself by the uncoerced intersubjectivity of radical democracy.

The third distinction which Habermas confers on Hegel is the discovery of normativity within modernity. Despite Habermas's stark portrait of modernity (attributed to Hegel) as banishing all past philosophies as inadequate to deal with the problems of modernity ("Modernity can and will no longer borrow . . .") and despite the categorical imperative that modernity "has to create its normativity out of itself," Habermas does discover normativity within the modern era: "The only source of normativity that presents itself is the principle of subjectivity . . ."; and Habermas draws directly upon Hegel: "The principle of the modern world is freedom of subjectivity, the principle that all the essential factors present in the intellectual whole are now coming into their right in the course of their development" (*Philosophy of Right*).

How, then, is the principle of subjectivity, the key to the modern world, to be understood? For Hegel, Habermas suggests, "the term 'subjectivity' carries primarily four connotations." These connotations are: *individualism* ("singularity without limit can make good its pretensions"); *the right to criticism* ("what anyone is to recognize should reveal itself to him as something entitled to recognition"); *autonomy of action* ("our responsibility for what we do"); and "*idealistic philosophy itself.*"

The scope of these connotations of subjectivity implicitly encompasses the gamut of modern Western philosophy, from the "individualism" of Enlightenment social philosophy to its dialectical opposite in the "idealism" of modern counter-Enlightenment philosophy. "Subjectivism," Habermas says, "is a one-sided term." It is also pejorative, and he skillfully develops the concept of "subject-centered philosophy" and "philosophy of consciousness" with the provocative connotations of limitation, prejudice, personal bias, isolation, and exclusiveness. Singled out, remarkably, as exemplifying subject-centered philosophy, are Descartes and Kant, key figures of the Enlightenment whose philosophies were engaged in establishing foundations for the *objectivity* of the rapidly developing new sciences. Hegel himself does not escape the ignominy of subjectivism, despite Hegel's having pioneered in introducing the concept of culture as formative and prior to individual "subjectivity." For Habermas,

the very acuteness of Hegel's subjective mediation of modernity's conflicts leads him on to the idea of the fulfillment of subjective mind in the Absolute, and thus to a rational redemption of all evils and the forfeiting of criticism.

Habermas has tried to lead us to see that modern philosophies from the Cartesian Enlightenment to the Hegelian Idealist counter-Enlightenment and their philosophical offspring are trapped by subjectivity, which is reflected in the subject-object conception of knowledge, and which in turn pursues a purposive, instrumental mode of relationship to things and which in turn expresses itself in the language of instrumental rationality. Habermas's principle of subjectivity may now be seen to have swept before it and devastated the whole of classical Enlightenment philosophy from Descartes to Kant, and the whole of "idealistic philosophy itself," including Hegel. How to explain the devastating sweep of the principle of subjectivity with which Habermas discredits the philosophies of the modern world? The remarkable answer appears to be their failure to address and engage the principle of intersubjectivity and its language of communicative action. More significant is his intention to deny priority to the Enlightenment.

But Habermas has devised the principle of subjectivity to sweep up and devastate the twentieth-century rise of poststructuralism, which he is alarmed to find menacing his effort to find a ground for philosophy with which to "rehabilitate the Enlightenment." *The Philosophical Discourse of Modernity* is devoted to fighting off the poststructuralist threat.

Habermas begins the historical discussion by moving beyond the left and right immediate disciples of Hegel to Nietzsche,[4] whom he sets aside as not in a direct line of succession from Hegel. Habermas's strategy of separation appears designed to establish Nietzsche as the source of postmodernism and to disconnect Nietzsche from the Hegelian tradition which is freed of the burden of postmodernism and presented now by Habermas in a significant new formulation:

> Neither Hegel nor his direct disciples on the Left or Right ever wanted to call into question the achievements of modernity from which the modern age drew its pride and self-consciousness. This was realized in society as the space secured by civil law for the rational pursuit of one's own interests; in the state as the in principle equal rights to participation in the formation of political will; in the private sphere, as ethical autonomy and self-realization. . . . (p. 83)

This introductory statement to Lecture IV is astonishing both for its inconsistency with Habermas's earlier assignment of "individualism" (and its Enlightenment context) to the ignominy of subjectivism and for the boldness with which the achievements of modernity are acknowledged, but their Enlightenment source is obliterated. Habermas's strategy not only absolves the counter-Enlightenment tradition from involvement in the emergence of

postmodernism, but it presents its prideful acceptance of Enlightenment accomplishments as an admonition to the postmodernists for their anti-Enlightenment normlessness. And contrary to Habermas, Nietzsche is no renegade source of postmodernism. Nietzsche is a rightful heir to the Hegelian line of succession and to the earlier anomic German romanticism from which Hegel, too, responsively derived.

As Habermas's remarkable, if unidentified, tribute to the Enlightenment and his attempt to separate Nietzsche from the German idealist tradition reveal, the project of constructing *The Philosophical Discourse of Modernity* was delicate and placed severe demands upon his enormous dialectical skill. On the one hand, Habermas characteristically denounces the Enlightenment: "Agreement . . . exists about the fact that the authoritarian traits of a narrow-minded enlightenment are embedded in the principle of self-consciousness or of subjectivity" (p. 55). Habermas goes on to express the scope and strength of the philosophical repudiation of the Enlightenment:

> In the discourse of modernity, the accusers raise an objection that has not substantially changed from Hegel and Marx down to Nietzsche and Heidegger, from Bataille and Lacan to Foucault and Derrida. The accusation is aimed against a reason grounded in the principle of subjectivity. And it states that this reason denounces and undermines all unconcealed forms of suppression and exploitation . . . only to set up in their place the unassailable domination . . . into just so many instruments of objectification and control. . . . (pp. 55–56)

On the other hand, Habermas has written *The Philosophical Discourse of Modernity* specifically to denounce the postmodernist opponents of the Enlightenment who pursue subversive modes of philosophy aimed at the total undermining of reason and the very possibility of philosophy itself. How can he denounce the postmodernist denouncers of the Enlightenment? And if he can, can he do so while shielding the romantic-idealist counter-Enlightenment from indictment as the cultural and philosophic source of the postmodernist's subversions? Neither the Hegelian tribute to the Enlightenment, which was intended to free the Hegelian tradition from the burden of postmodernism, nor the separation of Nietzsche from the Hegelian tradition, which was intended to place this burden squarely upon him, can be regarded as successful. It may already be seen, however, that the threat of postmodernism confronting Habermas is that despite its opposition to Enlightenment norms and values, it proceeds to a selective decomposition of the structures of the counter-Enlightenment tradition. The danger presented by postmodernism is that it undermines the intellectual cogency and philosophical integrity of the idealist counter-Enlightenment in its historic role of arising to combat and fend off the Enlightenment, a role which Habermas is committed to defend.[5] The postmodernist decomposing of the thought structure of the idealist tradition is

accomplished by the fixation upon certain of its themes, by isolating them, by pursuing their implications *ad extremis*, and by exploiting the tragic or comic possibilities of the outcome. With this, the meaningfulness of the historic idealist structure which provided its anti-Enlightenment mission and its philosophic stability is lost. Postmodernists' project of selective decomposition effectively destroys the political significance of the counter-Enlightenment tradition for the philosophy of the historic past; and its normless exploitation of isolated, detached themes bestows upon the intellectual culture of the present a defenseless vulnerability to potential social and political disaster.

II

In Lecture IV, "The Entry into Postmodernity: Nietzsche as a Turning Point," Habermas begins to build his case against postmodernism by affirming it to be philosophically derivative from Nietzsche. "With Nietzsche's entrance into the discourse of modernity," Habermas notes, he confronted a philosophical impasse in which Hegel, and the Hegelian Left and Right, had attempted to validate reason "as the equivalent for the unifying power of religion"; they devised a Hegelian reconciliation conferred by absolute spirit, a Marxist liberation through revolutionary appropriation and a right-wing compensation for the pains of conflict through understanding the cunning of history.

> Three times this attempt to tailor the concept of reason to the program of an intrinsic dialectic of enlightenment miscarried. In the context of this constellation, Nietzsche had no choice but to submit subject-centered reason yet again to an immanent critique—or to give up the program entirely. Nietzsche opts for the second alternative: He renounces a renewed revision of the concept of reason and *bids farewell* to the dialectic of enlightenment. (pp. 85–86)

But did Nietzsche's philosophic excursions into the will to power and perspectivism bid farewell to the Hegelian counter-Enlightenment tradition or do they instead signify that Nietzsche carries heavy historical and philosophical baggage from that tradition which he can cope with only by a process of internal dialogue, by the self-interrogation of "working through" philosophically? The same task of reflectively working through and assessing the counter-Enlightenment heritage confronts the postmodernists who follow the alternative lines of speculation opened by Nietzsche.

The intellectual richness and emotional power which constitute the heritage of the counter-Enlightenment reflects a long German cultural and philosophic tradition of opposition to the dominance of Western rationalism in the domains of science and technology and the politics of individualism and constitutional democracy. Early German literary and intellectual romanticism offered a

break-out, a new way of looking at the world, with the idea of the inward path to truth, the will replacing reason as the supreme reality of the self and of the group, the symbolic spiritualization of nature, and the ironic dialectic of the polarities of thought and history. The romantic celebration of human passion and of intuitively grasped truths was captured and magnified by Fichte into the maniacally wishful vision of the supremacy of the Germans as the Ur people, destined by the power of their will to overcome oppressors and to gain spiritual and political leadership of the West. After Fichte and the romantics, a counter-Enlightenment idealist thought-style emerged which rested upon oppositional conceptual structures: opposing the primacy of universal reason with the primacy of will, spirit, imagination, creativity; opposing the objectivity of science with the subjectivity of the arts and traditional cultural modes as paths to truth; opposing the politics of the autonomous rational individual, natural rights, constitutional democracy, and a free-market economy with a collectivist politics of left or right, a statist government and a command economy; opposing the priority of the individual with the priority of the needs and aspirations of the community.

The counter-Enlightenment movement explored and penetrated the largely unknown territory of the inner world, the variety of possible relations of self to society and government, and the master-slave dialectic with its utopian, mystical, or mundane modes of overcoming. But the new philosophical territory is purchased at a high price: it divorces itself from the stability of the structures and principles which provide for the possibility of objectivity, validity, and normativity for philosophic thought and its practical conse-quences. These are the costs of what Foucault calls "the blackmail of the Enlightenment." But on the other side are the Enlightenment rationalization processes and their power to organize and systematize the affairs of the world: in the establishment of universal human rights; constitutional democracy; the advance of science, technology, and communication; and the improvement of living conditions. But the costs of organization and systemization carry the potentiality for coercion domestically and internationally and the public sense of the loss of meaning and freedom and the disenchantment of the world.

With the political rise and fall of Germany in World War I came a bitter re-activation of the cultural syndrome of the archaic and unique German people which served to fuel the oratorical power of Hitler's National Socialism and its fervent embrace by Germany's leading philosopher.

With regard to Heidegger's relation to National Socialism, Habermas offers a complexly differentiated interpretation. Habermas cautions against moral judgments by a later generation "who cannot know how we would have acted under conditions of a political dictatorship." Habermas argues that "what is irritating is the inability of this philosopher, after the end of the Nazi regime, to admit his error" (p. 155). Instead, Heidegger holds history

itself responsible for withholding the truth of National Socialism. In this way, the reputation of Heidegger's *Being and Time* and the *Dasein* of the individual could be salvaged from the *Dasein* of the Volk of his Rektor's address. "Thus," says Habermas scathingly, "was born the concept of the history of Being."

On the issue of the internal relationship of Heidegger's philosophy to National Socialism, Habermas offers a variety of interpretations, which in effect assert that there is no connection, but if there is, it does not impugn the greatness of Heidegger's contribution to philosophy: (1) Heidegger's focus on the invariant structures of *Dasein* "cuts off the road from historicity to real history"; thus, Heidegger's text had no connection with prevailing beliefs. (2) Heidegger absorbed impulses from the ideology of his epoch, which pervade the German Gymnasium, and "has affected entire generations—on the Left as well as the Right . . . all these themes are unreflectively perpetuated by Heidegger." (3) "The pathbreaking achievement of *Being and Time* . . . may be *illuminated* by the motivational background of a personal life crisis, but is not *impeached* by it." (4) "[F]rom around 1929 on, Heidegger's thought exhibits a *conflation* of philosophical theory with ideological motifs . . . [which] enter into the heart of Heidegger's philosophy itself. . . . The defects that immanent textual criticism can detect in *Being and Time* could not be seen *as* deficits by Heidegger because he shared the widespread anti-Western sentiments of his intellectual environment and held metaphysical thinking to be more primordial than the vapid universalism of the Enlightenment." (5) "Heidegger's philosophical work owes its autonomy, as does every other such work, to the strength of its arguments. But then a productive relation to his thinking can be gained only when one engages those arguments—and *takes them out* of their ideological context. The farther the argumentative substance sinks into the unchallengeable morass of ideology, the greater is the demand on the critical force of an alert and perceptive appropriation."[6]

After the euphoria of early conquests, the Holocaust, deterioration, and a second defeat in 1945, came the genocide trials and the peace settlement in which the Allied Western governments imposed upon Germany a Western-style liberal democratic government.

In the 1980s, Habermas looks back during a period of internal political conflict upon this world-historical traumatic reversal with the revelation that only after the first postwar decades did the German political culture begin to understand and to assimilate the political theory of the Enlightenment.

> The political culture of the Federal Republic would be in worse condition today if it had not adopted and assimilated ideas from American political culture during the first decades after the war. For the first time, the Federal Republic opened itself without reservation to the West; at that time we adopted the political theory of the Enlightenment . . .[7]

But Habermas finds the political climate worsening with the spreading of pessimism and negativity, especially in the form of postmodernism, which directly threatens his ("Never again") commitment to ground social philosophy and society. Habermas subjects six exemplary texts to exhaustively detailed examination only to reveal, unwittingly, that postmodernism is not a Nietzschean splinter-group but comes from within the counter-Enlightenment tradition itself. The postmodernist writers seize upon ideas and images from the counter-Enlightenment corpus: the elevation of will, spirit, imagination, creativity over reason; the romantic search for the self and the group in an archaic past and a mystical hereafter; the anti-Enlightenment contempt for rationalistic universalism, for the rationally autonomous individual, and for the regularities of public law and scientific objectivity. Exploiting these features of the counter-enlightenment, the postmodernists threaten to leave no ground upon which Habermas can build a social philosophy. The counter-Enlightenment chickens have come home to roost.

Yet Habermas attacks the postmodernists for mounting a radical critique of reason, although "they can and want to give no account of their own position." Their "self-referential critique of reason is located everywhere and nowhere," and leads to a leveling of distinctions between philosophy and literature, between reason and instrumentalism. They fail to distinguish between the "emancipatory-reconciling" aspects of social rationalization and the "repressive-alienating" aspects; the line between these is blurred. In their unmediated rejection of reason they are "insensitive" to the ambivalent contents of cultural and social modernity (*Philosophical Discourse of Modernity*, pp. 332–38).

These formal deficiencies are identified by Habermas's masterful elucidation of the texts. The power of postmodernism must, however, be seen in the Nietzschean appeal of the will to power before which truth and morality become merely perspectival, with overtones of Dionysian frenzy; in the romantic cultural despair of Heidegger's destruction of the history of metaphysics, guilty of the forgetting of Being which in turn withdraws, to be revealed only by the language of poets; in Derrida's playful antinomianism in which he can "romp" in the deconstruction of the history of "logocentric" philosophy through the revelation that any philosophic meaning is riddled with multiple differences, supplementations, disseminations, undecidabilities, and metaphoricities; thus the distinction between philosophy and literature is levelled (with the concurrence of Richard Rorty); in the negativity of Horkheimer and Adorno's *Dialectic of Enlightenment*, their "blackest book" ("How can these two men of the Enlightenment be so unappreciative . . . of the [to put it in the form of a slogan] achievements of Occidental rationalism?" [p. 121]); in the elation of Battaille's unbounding subjectivity, in his exploration of anthropological studies of sadism, his revelations of "limit experiences" of

sexual frenzy, and his reconstruction of a Marxism which would provide for the sovereignty of the individual; in Foucault's assault upon the human sciences as "congealed" into the disciplinary violence of therapies, expert opinions, technologies, and research reports. Habermas finds himself attacking postmodernists for their totalizing critique of reason, but also defending the Enlightenment against postmodernists' failure to acknowledge the empirical and institutional reality of Enlightenment achievements.

Habermas has faced "risks" on two fronts in constructing the argumentation of *The Philosophical Discourse of Modernity*: how to attack the postmodernists without implicating the counter-Enlightenment tradition of Hegel and Marx which arose to tame the power of the Enlightenment; on the other side, how to criticize the postmodernists for erasing such Enlightenment achievement as democratic forms of political organization and scientific technologies benefitting the living conditions of the "masses," without giving aid and comfort to Enlightenment ascendancy.

The outcome of Habermas's strenuous campaign against postmodernist rootlessness and normlessness strengthens his acknowledgement that Enlightenment universal moral and legal principles have led to democracy in human affairs. The structure of lifeworld and system is on the road to being solidified in *Between Facts and Norms* and its extension of his theory of discourse to the field of law.

Yet, the real world context is that of the Cold War. At the end of *The Philosophical Discourse of Modernity*, Habermas bursts forth from his abstract philosophical complexities into a polemical diatribe against "the colossus of worldwide capitalism," as well as attempting once again to patch up Marxism for the late twentieth century, and finally to cry out: "Who else but Europe could draw from *its own traditions* the insight, the energy, the courage of vision . . . to shape our mentality."[8]

Between Facts and Norms: Contributions to a Discourse Theory of Law and Democracy appeared within three years of the collapse of the Soviet Union. The Husserlian lifeworld is now characterized under the rubric of deliberative democracy and the issues discussed are in relation to law, the constitution, the courts, and rights—the conventional issues of Western political philosophy. Habermas rejects, however, the "liberal" account of democracy, which he describes as upholding negative rights of individuals against the state, and the promotion of private interests; he rejects also the "civic republican" view of democracy which he describes as representing rights as arising within the political practices of community. Deliberative democracy makes no substantive claims on behalf of individual or community: it is thoroughly procedural, modeled upon Habermas's ideal speech situation of unconstrained formation of consensus in matters of generalizable interests.

Thus the conflict between the economic and legal systems and the lifeworld has been transferred to the "interplay" between the formally organized institutions of the political system and the informal organization of civil society, with its proliferation of private groups and modes of mass media. Interplay between the political system and civil society occurs through the spread in civil society of centers of deliberative politics capable of engaging the focus of public opinion. Although the responsibility for decision-making rests with institutionalized legal procedures, it is the informal sphere of deliberative democratic practices that has the crucial responsibility for identifying and interpreting social problems in relationship to legal issues and to do so "in a way both attention-catching and innovative" that serves as an indirect influence on the institutionalized system. But this influence must be "self-limiting." Since the functionalist systems of government and economics must be understood to be autonomous in the social structure, Habermas cautions against the pursuit, through radical democracy, of the goal of over-turning them (the failed goal of the Soviet Union). But in his preface, Habermas responds to criticism of *The Theory of Communicative Action*: "Of course, the potential of unleashed communicative freedom does contain an anarchist core. The institutions of any democratic government must live off this core if they are to be effective in guaranteeing equal liberties for all" (p. XI).

Now, in reflecting upon America within the real world situation in which Soviet socialism has fallen, Habermas assails "the party which considers itself victorious" for having lost the opportunity to "drive ahead with the task of imposing social and ecological restraints on capitalism at the breathtaking level of global society." Basing their thinking upon "the improbable" theory of modern natural law, Western societies, he says, have lost their orientation and self-confidence before a "terrifying" background of problems: ecological dangers; social disparities between the northern and southern hemispheres; the task of converting state socialism into a "differentiated" economy; the pressures of immigration; the rise of ethnic and religious wars. The resulting unrest of the Western democracies he sees as having, however, a deeper source: the sense that "in an age of completely secularized politics, the modern rule of law cannot be had or maintained without radical democracy," (p. XLII) and that in its absence, there can be no reprieve from unrest and no social "redemption."

This gloomy picture of social disquietude, weakness in the face of seemingly unsurmountable problems, and the guilty sense of an unfulfilled redemption foreshadows a disastrous future for the victorious Western heirs of the Enlightenment and a foreboding return and fulfillment of the mythic vision of *The Dialectic of Enlightenment*.

CONCLUDING REMARKS

Has Habermas succeeded in his noble determination to find an Archimedean point, a foundation for social philosophy and for society? Habermas recognizes that the philosophic constellation of the Hegelian counter-Enlightenment tradition, linked to the primacy of the historically changing will and to the rejection of the rational normativity of the Enlightenment, cannot yield a grounding for social philosophy, despite his efforts to represent the German tradition as the *fons et origo* of modern philosophy.

Habermas copes with this recognition by introducing two strategies: he repudiates the philosophical significance of both the Enlightenment and counter-Enlightenment as failed philosophies, trapped in subjective consciousness. His second strategy is to take the linguistic turn to the discovery in speech of a set of universal validity claims and the construction of a distinction between a communicative language of understanding and the language of purposive instrumentality. From the oppositional linguistic structure there emerges the oppositional social structure between system and lifeworld, between the functionally organized and institutionalized economic and governmental subsystems, and the informally organized association of civil society, empowered by consensual, deliberative democracy. But how does the achievement of the free-floating, normless, anarchic consensus of procedural deliberative democracy protect human rights, affirm universal political ideals, or provide a foundation for social philosophy and a just society? The only answer seems to be that in critiquing institutionalized public policy, Habermasian deliberative democracy is serving not the philosophic function of ascertaining and sustaining a foundation for philosophy, but is instead serving the undermining of the capitalist economic system and Western constitutional democracy to make way for a movement toward socialism in its revived form as "democratic self-organization" for "emancipated forms of life."[9] Habermas has produced not a foundation for modern philosophy but a niche for the faithful who cling to socialist aspirations after the fall.

Habermas's social philosophy can now be perceived in its oppositional structures and their symbolic meaning: the Marxian opposition of economic base and the submerged proletarian truth; the opposition between instrumental language and the language of communicative understanding; the opposition between economic and governmental systems and the lifeworld; the opposition between institutional organization and informal deliberative democracy. These structural oppositions find their expression in the symbolism which pervades *The Philosophic Discourse of Modernity*: the dreaded myth of the dialectic of Enlightenment and the redemptive fantasy of the path yet to be taken.

More significant for the intellectual culture of modernity is the neglect, by this esteemed philosopher, of the great drama of philosophy in our time. This

is the drama occasioned by the dialectical struggle, rushing to climax in the twentieth century, between Enlightenment reason and its counter-Enlightenment opponent. The struggle between these philosophical constellations is refracted in the great wars of the twentieth century: World Wars I and II, the struggle of the Western democracies against right-wing Hegelian fascism; the long Cold War, the struggle against left-wing Hegelian Stalinist communism.

Thus the drama of the philosophical thought of the twentieth century and its historical development is lost.[10] The philosophic discourse of modernity has yet to be written. Its text, having been freed from the tenacity of ideological aspirations, and from erasures, and from concealing circumlocutions, will at the same time provide the sought-for foundation for social philosophy and a just society: it is the philosophic framework of modernity itself which is the foundation of all modern philosophies, in the dialectic of Enlightenment and its counter-Enlightenment other.

THELMA Z. LAVINE

ROBINSON PROFESSOR OF
PHILOSOPHY AND AMERICAN CULTURE
GEORGE MASON UNIVERSITY
AUGUST 1997

NOTES

1. The question of the erasure of the Enlightenment raised at the outset of this article begins to move toward an answer.

2. The research and discoveries of DNA, gene and gene therapy, intergalactic cosmology cannot be claimed by a communicative intersubjective language of understanding, nor by the narrowly construed language of purposive instrumentalism.

3. Cited by Derrida, *De L'esprit*, Paris: Galee, 1987, p. 111.

4. Marx is discussed in relationship to "praxis philosophy" but plays no major role in the discussion of *The Philosophic Discourse of Modernity*.

5. In the spirit of the early Frankfurt School and as a socialist.

6. Cf. *The Philosophical Discourse of Modernity* translated, by Frederick Lawrence (Cambridge: MIT Press, 1987), pp. 155–60; "Work and Weltanchauung: The Heidegger Controversy from a German Perspective," in *The New Conservatism: Cultural Criticism and the Historians' Debate*, ed. and translated by Sherry Weber Nicholson (Cambridge, Mass.: MIT Press, 1989), passim, especially pp. 144–48, 166–67. Text originally written as forward to the German edition of Victor Farias, *Heidegger et la Nazisme* (1988); English translation, *Heidegger and Nazism*, edited by Joseph Margolis and Tom Rockmore (Philadelphia: Temple University Press, 1989). Cf. also Thelma Z. Lavine, "Thinking Like a Nazi: A Review-Essay of Victor Farias, *Heidegger and Nazism*" *Washington Post Book World*, 1990; *Los*

Angeles Times, 1990; *Manchester Guardian*, 1990; *International Journal of Group Tensions* 20, n. 3 (1990).

7. Jürgen Habermas, "Neoconservative Cultural Criticism in the United States and West Germany," in *The New Conservatism* (cited in note 6), p. 45.

8. Cf. "Only from the Germans can world historical meditation come—provided that they find and defend what is German." Heidegger, cited in "Work and Weltanschauung," p. 155.

9. Cf. "If, however, one conceives "socialism" as the set of necessary conditions for emancipated forms of life about which the participants themselves must first reach an understanding, then one would recognize that the democratic self-organization of a legal community constitutes the normative core of this project as well." Preface, *Between Facts and Norms*.

10. Although fiercely fought philosophical conflicts are the substance of Habermas's writings, Habermas oscillates between leaning toward a narrow Rortyan "end of philosophy" viewpoint, and his own characteristic view of philosophy as "interpreter on behalf of the lifeworld." Cf. "Philosophy as Stand-In and Interpreter," *After Philosophy*, ed. Baynes, Bohman, and McCarthy (Cambridge: MIT Press, 1987), p. 313.

9

Beth J. Singer

Toward a Pragmatics of Artistic Utterance

Jürgen Habermas's opus is a monumental achievement, and his "Universal Pragmatics" is so well thought out and so carefully grounded that it seems presumptuous to criticize it. Actually, what I shall say here is not, strictly speaking, critical. I shall call attention to certain types or models of action and communication that Habermas mentions but sets aside and does not analyze, and I shall try to develop a systematic analysis of them, locating them if I can within the theoretical framework he provides, but supplementing the analysis with concepts and terms that I have drawn from other sources. At the same time, as does Habermas himself, I will modify the concepts I employ to better fit the intended context and subject matter. Unfortunately, space limitations do not permit me to present the detailed critique of the original statements of these concepts that they deserve. Nevertheless, I hope that my presentation is sufficiently clear to enable Habermas to assess its compatibility with his own system.

ART AND COMMUNICATION

Works and performances in the arts are instances of human communication, offered to audiences in the expectation that they will comprehend and appreciate them. But the means by which this communication is effected in the visual arts, instrumental music, and dance are not linguistic. What, then, does it mean to say that works in these fields communicate? What is communication in the generic sense, the sense in which nonlinguistic as well as linguistic acts and products can serve to communicate?

In *Art as Experience*, John Dewey maintains that "the expressions which constitute art are communication in its pure and undefiled form," and also that "art is the most effective mode of communication that exists."[1] While he takes the communicative force of art to be "most fully manifested in

literature," Dewey insists that it is "common to all the arts" and, beyond this, maintains that the artist's work "lives only in communication when it operates in the experience of others" (*AE*, pp. 244, 104). While he does not provide a technical analysis of communication, Dewey's characterization of it is broad enough to encompass communication of all kinds: "Communication," he says, "is the process of creating participation, of making common what had been isolated and singular" (*AE*, p. 244). In subsequent passages, he expresses not only what he takes to be the power of communication in general, but the special power he attributes to the arts:

> [P]art of the miracle it achieves is that, in being communicated, the conveyance of meaning gives body and definiteness to the experience of the one who utters as well as to that of those who listen. . . . Art breaks through barriers that divide human beings, which are impermeable in ordinary association. (Ibid.)

I have not found in Habermas's writings any concept of communication that is as broad as that which Dewey presents here, or an analysis or definition of communication in this inclusive sense. But in the absence of such a generic concept, we cannot understand the kind of communication that occurs in the nonlinguistic arts. In addition to the fact that they utilize nonlinguistic media, as I shall argue below, works in these fields have no adequate linguistic equivalents.

In his essay on universal pragmatics, in *Communication and the Evolution of Society*, Habermas speaks of "communication . . . in the sense of action oriented to reaching understanding."[2] Later, in *The Theory of Communication Action*, he refers to "communicative acts—that is, speech acts or equivalent nonverbal expressions," which "take on the function of coordinating action and make their contribution to building up interactions."[3] This is not to be taken as a definition of communicative action in the sense intended in the work's title, but it does refer to acts that serve to communicate and can therefore subserve communicative action in his technical sense. Distinguishing the latter from other categories of action, Habermas defines it to include "all interactions in which those involved coordinate their individual plans unreservedly on the basis of communicatively achieved agreement" (*TCA* I, p. 305). Despite the phrase "equivalent nonverbal expressions" on p. 278, he makes clear that the agreement by means of which communicative action is coordinated has been reached in a process of linguistic communication, that is, by "speech acts oriented to reaching understanding" (*TCA* I, p. 307). And, a few sentences later, "The term 'reaching understanding' (*Verständigung*) means, at the minimum, that at least two speaking and acting subjects understand a linguistic expression in the same way" (ibid.). In general, Habermas seems to take language to be the primary, if not the exclusive, vehicle of communication. In connection with

communicative action, it would appear to be the sole means. "The concept of communicative action," he states, "presupposes language as the medium for . . . reaching understanding" (*TCA* I, p. 99).

"Understanding" is to be construed here not simply in the minimal sense of comprehension, or even in that of mutual comprehension, in which both or all participants understand the linguistic expression in the same way. What is intended by "reaching understanding" is based on this and, in addition, on the recognition by the participants of the possibility of accepting or rejecting what has been said. Acceptance is reaching *an* understanding, coming to an agreement, an "accord relevant to the sequel of interaction," and achieved through linguistic communication (*TCA* I, p. 297). It is "when a hearer accepts a speech act" that "an agreement comes about" (ibid., p. 307).

Habermas sometimes speaks of "communicative utterances," in the sense of linguistic utterance in contradistinction to grammatical sentences employed therein (*TCA* I, p. 98). Utterance is a kind of action, but he is careful to distinguish between action and communication: "the communicative model of action does not equate action with communication," and "communicative action designates a type of interaction that is *coordinated through* speech acts and does *not coincide* with them" (*TCA* I, p. 101). However, even if action as such is not to be equated with communication, to refer to speech acts as communicative acts and as oriented to reaching understanding must be construed to mean that these acts can serve or function to communicate. In an important sense, it is persons who communicate, but they do so by means of the kinds of acts that count as utterance. However, products as well as acts of utterance, can communicate, even if only in a secondary sense. This is illustrated by a letter, or an essay that appears in print. The author communicates to the reader or readers by writing, which is a form of utterance, and the written document, which is *an* utterance, as is the oral expression of the same content, also communicates to them, and may communicate to persons other than those to whom it was addressed. But is linguistic utterance the only kind of communication, and is communication limited to the effort to reach agreement?

At the beginning of "What is Universal Pragmatics?" seemingly using "communicative action" in a looser sense than he would later, Habermas says, "I shall single out explicit speech actions from other forms of communicative action" (*CES*, p. 1). He continues, "I shall ignore nonverbalized actions and bodily expressions," suggesting that these can also be communicative acts in the aforementioned sense, but that he is setting them aside for other reasons (ibid.). But in other contexts, actions that are communicative in what is presumably this looser sense are explicitly described as linguistic and limited to the use of expressions having

propositional content. In the same paper on universal pragmatics, for example, Habermas sets communicative action apart from other types of action, "excluded from the category of communicative action because in nonpropositional systems the validity claim to truth is suspended" (ibid., p. 41). One of these is "*symbolic action* (e.g., a concert, a dance—in general modes of action that are bound to nonpropositional systems of symbolic expression)." Significantly, Habermas characterizes symbolic action as "still insufficiently-analyzed" (ibid., p. 41). That he himself does not analyze it leaves him without a basis for extending his theory into the sphere of aesthetics. I shall suggest an analysis and shall also maintain that such action can in fact communicate. Taking the category "symbolic expression" to encompass expression in the visual arts as well, I shall try to show what is common to all artistic works and performances that distinguishes them from other types of action or utterance, and what it means for them to communicate. This will require a concept of 'communication' that is broad enough to encompass all forms of artistic utterance, nonlinguistic as well as linguistic.

As with any important concept, communication has many senses and has been defined in many different ways, some broader, some narrower. But there is, in the Peirceian tradition, a concept that I believe allows us to encompass artistic utterances as well as the various types of illocutionary speech acts (cf. *TCA* I, pp. 325–27). Let me suggest that for an utterance of any kind to communicate, is for it to function as a sign, using this term in a sense that is derived from C. S. Peirce but which I shall modify in an important way. As Peirce defined it, a sign has both an object and an interpretant:

> A sign or *representamen*, is something which stands to somebody for something in some respect or capacity. It addresses somebody, that is, creates in the mind of that person an equivalent sign, or perhaps a more developed sign. That sign which it creates I call the *interpretant* of the first sign. The sign stands for something, its *object* . . . not in all respects but in reference to a sort of idea, which I have sometimes called the *ground* of the representamen.[4]

But if it is to cover all types of communication, the sign function cannot be thus restricted to representational signs. In addition to representational works, pure instrumental music, abstract and nonobjective painting and sculpture, and abstract dance (that is, dance that dies not "tell a story") may have this function and may be conceived as sign-structures. Certainly they seem to communicate in their own ways; we do not find them utterly opaque and incomprehensible as we would find an utterance or product for which we had no interpretation whatever. The latter would have no communicative value or effect.

To function as a sign, an utterance or expression must be interpreted by someone; for it to be employed as a sign is to call for interpretation. But while an interpretation may consist in or be accompanied by an idea or ideas in the mind of the interpreter, ideation is not the sole mode of interpretation. A performance of a work, for instance, is an interpretation of it. Whether or not the performers have mental images of their performance or concepts of the way in which they are interpreting or expect or plan to interpret particular works, the performance of a sonata or string quartet is an interpretation of a score; a dance performance is an interpretation in the form of bodily movements of the notational score or other directions provided by the choreographer.[5] Moreover, even mental interpretation need not be conceptual or propositional; instead of being intellectualized it may take the form of auditory or visual or other sensory images. Habermas takes the symbolic action in a concert or a dance to be nonpropositional. The visual arts and, I shall suggest, even the literary arts in an important respect, are so as well.

A word about terminology: As I noted earlier, Habermas refers to the modes of action exemplified in concerts and the dance as "symbolic" and as "bound to . . . systems of symbolic expression." Every art is characterized by its own system of expression and its own stylistic variants. If we take a symbol to be a vehicle of communication that calls for interpretation, 'sign' and 'symbol' are synonyms and we could speak of systems of symbolic expression as "sign-systems." But in connection with the arts, 'symbol' seems more appropriate. At the same time, to be sufficiently general in scope, as was said above about signs, symbols must be understood as not necessarily standing for or symbolizing anything other than themselves. While it may call up associations in the auditor, a piece of instrumental music, or a movement or phrase, save in rare cases, does not stand for, symbolize, or refer to any objects or situations. Even when it is intended to do so, the auditor or the reader of the score may not recognize this, and need not do so in order to interpret and appreciate the work. As for the term 'symbolic expression', only if we construe 'expression' as utterance of any kind whatever, rather than as the embodiment of feelings or emotions in the inner world of the creator or performer of a work, can the terms "artistic expression" or "symbolic expression" encompass all that can be communicated by artworks. With these provisos I shall speak of artistic utterances as symbolic or as instances of symbolic expression or communication, and shall also speak of the systems of symbolic expression—such as the different harmonic systems of Western and Chinese music—by which utterances in the different arts are bound. Such systems do not operate as strictly as do syntactical rules but they do function normatively. In what follows, I shall characterize the particular type of symbolic utterance involved in the arts, but first, let me further discuss the issue of communication.

COMMUNICATION, MEANING, AND UNDERSTANDING

We speak of "understanding"—or not understanding—artworks and artistic performances, and of their "having meaning." Meaning and communication are inseparable. For an utterance to communicate to us in any way, is for it to be found somehow understandable or meaningful, the "how" being a function of the particular system of symbolic expression to which it belongs. To be found meaningful is to be given an interpretation; absent this, I would say that nothing has meaning. That is, not even an utterance is meaningful in and of itself. The way it is viewed by its producer is no less interpretive than the way others perceive it, and this is how it acquires meaning for either one. The interpretations shape the way each one understands it. This does not mean that every interpretation is definitive or correct; in some respects these judgments may even be inapplicable. But despite the fact that in the arts departure from convention is not only acceptable but valued, there are claims to validity that are relevant, a topic I shall touch on below. What is important here, however, is that every instance of interpretation confers meaning, however inchoate or even inappropriate.

Pragmatists define meaning in terms of practical consequences. I suggest that the meaning of an interpretation, at least in the arts, is its consequences for further interpretation, and hence for further production or assimilation, whether in the ongoing process of producing or experiencing a given utterance, in repeated performances or experiences of any given product, or in producing or experiencing additional works. Every interpretation reflects the perspective of an interpreter, and perspectives in turn evolve and change as they are applied in continuing experience. Interpretations influence and condition subsequent interpretations and affect the way utterances come to be understood; experience, always perspectivally conditioned and shaped, may be enriched, altered or confirmed or, in some cases, impoverished as a result. But each system of symbolic expression provides the primary perspective for interpretation of the utterances that are bound by it; and this perspective is—or is expected to be—a component of the perspective, not only of the producer, but also of the recipients of every utterance in that medium or mode. In learning to appreciate Gregorian chant or jazz, Expressionist painting or twentieth-century architecture, we must internalize the symbolic perspectives that govern and distinguish them. The fact that the early compositions of Beethoven were considered strange at first, and many of the early paintings by French Impressionists that are now highly valued were denigrated and rejected, is evidence of this.

Any meaning acquired by an utterance is an interpretation placed upon it by either the one who utters it or another who perceives it or both. To the extent that they interpret it in different ways, we must speak of its meanings,

in the plural. The fact that artistic meaning is not necessarily linguistic or conceptual cannot be overstressed. Each system of symbolic expression determines meanings and generates interpretations of a particular type or types, even though the norms governing them may be only loosely binding. And within each frame are stylistic modes or schools, utilizing distinctive materials and techniques. In the literary arts, the materials are linguistic, so that systems of linguistic expression play a central role; but as employed in literature, especially poetry, linguistic utterances function differently than they do in practical or theoretical contexts, so that grammatical and syntactical rules may be violated. The distinctive character of literary utterance is part of what I shall try to explain.

All acts and products of artistic utterance are both embodiments of reflexive communication and interpretation and potential vehicles of interpersonal communication.[6] The producer or creator of an utterance, in shaping it, is trying to express a certain meaning, to embody a particular interpretation and, in the process, may develop or alter that interpretation and reshape the product through communicating with him or herself about it. Progressively determining the desired interpretation within the limits provided by the symbolic system being employed, the creator is judging the product in other ways as well: recurrently assessing the degree to which she or he is succeeding in structuring the utterance as intended, and also judging the extent to which the utterance as shaped seems able to compel the intended interpretive response. That is, the creator is trying not only to transmit the utterance but to convey the meaning it has for him or herself. To present or enact the utterance is an act of communication, and a purposive act; for it to be not only presented but also received, experienced by others, is a realization of this purpose. In this process of asymmetrical social communication, the recipient is not expected to respond with another utterance, but to interpret the utterance implicitly, in another process of reflexive communication. It is easy to think of the meaning of an utterance as that assigned to it by the one who has produced it. However, any utterance can receive unintended interpretations, and viewing it in a new way, a new perspective, can confer unprecedented meaning on it. Thus it would be truer to say that any given utterance (like any object) may acquire indefinitely many meanings, and in the arts this is legitimate.

Physical properties (taking these to include auditory properties and those of bodily motions in addition to the properties of physical materials and media) as well as relevant cultural norms (including, though not confined to, the systems of symbolic expression that are operative in the diverse arts and the styles in which the artist chooses to work) provide limiting conditions for artistic creation. However, the norms of virtually every artistic culture permit a significant degree of flexibility and room for innovation; stylistic originality is usually prized and systems of symbolic expression themselves

evolve (as in the case of the development of atonal music). And while the structure and perceivable traits of acts and products of utterance also provide limiting conditions for interpretation by the audience, they can still provoke a variety of responses. It is the perspective brought to bear by the interpreter, the framework of attitudes, expectations, and understandings (that is, previous interpretations) in terms of which the utterance is experienced and judged, that determine the way its traits are perceived or interpreted. This perspective will include both socially shared components and others that are individual and may be idiosyncratic.

If the perceiver of a work of art is familiar with other works in the same art form and style, that is, has internalized at least the rudiments of the symbol system by which it is bound, she or he will be able to locate the utterance in a perspective similar to that in which it was generated. Having internalized such a perspective, however, is not the same as being able to describe or analyze it. All it means is that, with both locating it in this perspective, the producer and recipient of an utterance will interpret and understand it in similar terms; they will find it to have—or, rather, give it—comparable artistic meanings. Like other normative perspectives, a system of symbolic expression is the perspective of a community, a "generalized other" such as the community of all who are trained in or familiar with Expressionist painting. Applying it, all members of this community would find the work comprehensible in the sense that they would recognize and accept it as a legitimate representative of the artistic field to which it belongs; that is, they would perceive it interpretively. But because of the element of individuality in their perspectives, their interpretations need not and could not be identical. Even if general features of their respective interpretations are shared; even if all have internalized the norms of the relevant system of symbolic expression, one and the same utterance may acquire different meanings or different shades of meaning for different interpreters or even for the same interpreter at different times or in different circumstances. For instance, two pianists, or one pianist in different performances, may play (interpret) the same sonata in different ways, stressing different passages or treating the phrasing or tempi differently, and producing a different effect in each case. Each represents a somewhat different understanding of the piece and each performance will in turn be heard differently, responded to and understood by those in the audience in their own individual ways.

Nevertheless, the system of symbolic expression in terms of which a work of art was generated plays a pivotal role. Art must be understood primarily, even if not exclusively, in its own terms. This is true even if the utterance is representational: to understand a narrative work such as the ballet, *Coppelia*, as representing or "telling" a story is but one facet of experiencing and understanding it as a work of art and as exemplifying a

particular art form. The artwork is not reducible to the story. There are no verbal equivalents of nonrepresentational works—a symphony, a *pas de deux*, an abstract painting—and even works that are representational cannot be fully or adequately translated into words. To tell the story embodied in a work (if it is a literary work, to retell it in one's own words) or to describe or explain what a picture or a statue represents is to bracket all the properties that distinguish the work, not only as a unique utterance, but as an artistic one. It is the distinguishing traits of the latter in which I am interested. In so far as literary works, those of the visual arts, and compositions and performances in the fields of music and dance are all artistic utterances, what do they have in common? To ask this is also to ask what distinguishes works of literary or linguistic *art* such as novels, plays, and poems from, say, reports, essays, or treatises. And it is also to ask what distinguishes the recitation of a poem or the performance of a play from the kinds of speech acts that communicate information or coordinate purposive social interaction. My answer will be that works of art and artistic performances are in a different mode of utterance from the practical or the propositional, a mode that, following Buchler, I shall term "exhibitive." What does this mean?

EXHIBITIVE JUDGMENT

Buchler's categorial name for the process of utterance, the production of utterances, is "judgment," and he takes every product or utterance to be a judgment in the sense that it reflects a position or attitude—a perspective—toward that which we are dealing with or responding to. To judge, in this sense, is not necessarily to judge evaluatively; nor is it necessarily to judge intellectually or cognitively; moulding clay is as much a process of judging as is making a statement, and so is raising one's arm. The first is a case of exhibitive judgment, the second, of assertive judgment, the third of active judgment, the approximate equivalents of "making, saying, and doing." But this is a very crude comparison. To begin with, the distinction is a functional one: any instance of utterance may operate in more than one of these ways. Austin's example of saying "I do," is a good example. It is both "saying certain words," as he puts it, and "doing something—namely, marrying.[7] In Austin's terminology, the utterance is a "performative," as well as a "locutionary act," but the saying is itself performative. That is, even when it consists in making a linguistic assertion that is either true or false or asking a question that can have a true or false answer, saying is a kind of doing—in Buchler's terms, of active judgment. The concept of active judgment is very broad, embracing not just physical movement but the enactment of any utterances or performances. And not only is saying active, we can use bodily movements, physical actions, as ways of saying,

as when in voting on a proposal at a meeting we raise a hand to express assent or dissent. One and the same utterance has both dimensions, active and assertive. Similarly, statements as well as physical actions can be used and function exhibitively. I shall return to the concept of exhibitive judgment momentarily.

In some contexts, Buchler uses the word "interpretation," as Peirce does, in explaining the concept of a sign. However, and here again I follow him, he insists that a sign does not necessarily stand for or represent anything else. To function as a sign, on his view, is only to be interpreted, and there is no a priori limit to what can be interpreted. Being themselves subject to interpretation, judgments in all modes may function as signs, but like anything else, to do so they need to be interpreted by (other) judgments. The interpretation of a judgment determines what it means to the one who interprets it and hence its communicative import, its meaning for the interpreter.

Judgments both are interpretations and are subject to further interpretation in reflexive and/or social communication. But pointing to the "mentalistic" connotation of "interpretation," for the most part Buchler chooses not to use this term, using "judgment" instead. Every judgment is a product—the product of a process of judging. And just as anything can acquire meaning only if it is judged, "so with a product: a product acquires its meaning in so far as it is the subject matter of another product or judgment."[8] As I have said using the terminology of interpretation, judgment is not necessarily linguistic or conceptual; we judge in all three modes, by our conduct and by shaping, arranging, or organizing materials of any sort, as well as by formulating and uttering assertions. We may also judge contemplatively, silently and without overtly expressing our judgment. Listening to music, watching a dance performance, looking at a painting or piece of sculpture, we are judging them even if we are not intellectualizing about them. We are interpreting them insofar as the *way* we look, listen, contemplate affects the way we experience them, and the meaning that they acquire may be only visual or auditory. But this is, at least in part, a consequence of the way we have judged them or similar products thus far and in turn has consequences for further experience and judgment, whether of the same or of other products. We experience judicatively, with consequences, however important or trivial, for later judicative experience. This is what we mean when we speak of a "fund" of experience. The subject matter of judgment may consist in feelings or emotions, in sensations, images or ideas; we judge situations and physical objects (be they human products or not) as well as linguistic products—anything that can enter into experience. Some things, such as the circulation of the blood in our veins, unnoticed under ordinary circumstances, can affect us without our judging them; but insofar as this is

the case, they are not meaningful and, it could be said, not experienced.[9]

The kind of judgment central to the arts is exhibitive. Buchler's term "exhibitive" connotes showing or presenting, but we should not construe this exclusively in the narrow sense of putting something on public view or formally presenting it to an audience. "An individual judges . . . exhibitively," he says, "whenever he rearranges materials . . . into a constellation that is regarded or assimilated as such" (*NJ*, p. 23). Building, shaping, organizing, arranging, as well as drawing and painting, composing, choreographing are all ways of judging exhibitively. And "materials" must be construed broadly enough to include linguistic materials. In his book on poetry, *The Main of Light*, Buchler defines exhibitive judgment as follows: "Exhibitive judgment, exemplified on the methodic level by art, but in no way restricted to the commonly recognized arts, is the process whereby men shape natural complexes and communicate them for assimilation *as* thus shaped—as novel complexes distinguished frm their bearing upon action and belief."[10] Words, which Buchler sometimes refers to as symbols, are natural complexes like any other and can be shaped into exhibitive structures. Thus, "A poem . . . is an exhibitive judgment wrought in language" (*ML*, p. 102). An artistic utterance is an exhibitive product, methodically wrought; it is a product of what Buchler calls "query," the genus of which inquiry is a species. There can be query in all the modes of judgment; inquiry is query in the assertive mode. Engaged in exhibitive query in whatever medium, the artist is communicating, reflexively, with him or herself, methodically probing the possibilities and limitations of the material and the developing product, structuring and restructuring the latter accordingly.

The exhibitive utterances of art have still another feature. The poet, Buchler says, "shape[s] a complex the prevalence of which is the object of wonder" (*ML*, p. 137). I would say this can be true of any artist. At its best, art generates a sense of wonder; wonder at the product itself—that this work, in its uniqueness, should be, that it prevails. The more compelling the work, the "greater" or "more powerful" we judge it to be, the greater the sense of wonder it inspires. But what distinguishes it as art, as exhibitive, is its power to compel us to attend to its character as a product, as a structure or complex that the artist has wrought. If it is a literary work, its exhibitive dimension does not lie in any assertions it may contain or the particular implications it may suggest but in its organization and its use of language to delineate or portray its subject. Even if this subject is a problem or a question, it is the portrayal that is the work of art, and a portrayal as such does not make or support a truth-claim or direct any particular course of practical or moral action. Insofar as it does any of these, the work has an assertive or active dimension. Art can be used for such purposes, but this is not what constitutes it *as* art.

Symbolic Action

The concept of symbolic expression or utterance is more inclusive than that of symbolic action. (I am not here speaking of the production of the utterance.) Both are equally exhibitive, but symbolic utterance encompasses the visual and literary as well as the performing arts. Paintings, statues, poems, novels, are no less symbolic utterances than are performances of music and dance or theatrical performances. This is also true of musical scores, the notational scores of dance, and the scripts of plays. All are products of exhibitive judgment and are themselves exhibitive judgments in the substantive sense. All are artistic utterances. (Not all exhibitive judgment, as I have indicated, is artistic. Arranging books on a shelf is exhibitive, but such an arrangement is not a work of art; it is not a product of exhibitive query.) At another level, while both are forms of action, the creation of a work of art differs from a performance (assuming that the latter is not purely improvisatory). In the first place, the performance is a second-order exhibitive judgment, an interpretation of a work previously created, of a product that is already available and remains available for subsequent interpretations. Second, both the production of the work and the interpretations of it are alike instances of exhibitive query and of exhibitive or symbolic utterance. But to interpret the work in and by a performance, unlike creating it, is to engage in symbolic action.

Action of the sort that Habermas terms "symbolic" is significantly different from the other types of action he identifies and analyzes. It is doubtless teleological, in the sense of being purposive, not accidental or coerced; and it is normatively regulated, although only loosely, as I have tried to show. But insofar as it is artistic, it is not strategic or designed to maximize utility for the agent. Theatrical performance seems to provide the model for dramaturgical action and, in being presented or offered by the artist to a public, all artistic utterance could be taken to have a dramaturgical dimension. But while it may be designed to embody the actor's intent as well as expressing that of the author, even a theatrical performance need not be, and most often is not, a "presentation of self" or revelation of the author's subjective and private feelings (Cf. *TCA* I, p. 90). Instead, the action of the performers in a play or a dance-drama is an exhibitive interpretation (judgment) of the characters who are being portrayed and of their feelings and reactions as well as their personalities. Insofar as the performers are offering their own interpretations, they are revealing their own judgments, but not their own "inner life." If they identify with the characters, the fact that they are expressing their private feelings is incidental.

Habermas's main concern, of course, is communicative action. Insofar as it is presented to an audience, rather than being a type of social interaction coordinated by way of communicatively achieved agreement, artistic

utterance is a form of asymmetrical communication. But consider performances of chamber music, which are collective products. What I want to suggest is that these are instances of a type of communicative action; interaction in which the action of the individual participants is coordinated, but by means that are not linguistic. For one thing, the players communicate with one another and coordinate their playing by gestures, signals—glances, nods of the head, raised eyebrows, etc., each understanding the gesture as the others would. But more importantly, they listen to one another's playing, and as they do, they respond to it interpretively. Each one's interpretation is an exhibitive judgment, embodied in and expressed by his or her playing. Their joint product emanates from this mutual interpretation and, when they succeed in coordinating their individual performances to their shared satisfaction, they may be said to have arrived at a common interpretation—an agreement, but one that is exhibitive, not assertive.

VALIDITY

We may ask what sort of validity claims are put forth by exhibitive utterances. For instance, do they call for assent? Certainly not in the assertive sense of assent to a proposition. And while the artist hopes to succeed in generating a particular response or interpretation in the audience, because schools and styles of art change as well as because of the variability of the interpretive perspectives that may be brought to bear, causing an audience to understand the work as the creator does cannot be a criterion of its validity or of the producer's artistic success. For the same reasons, there is no "correct" interpretation of a work of art. As the linguist, Edward Sapir (who was also a trained musician and composer) wrote, "[C]onsidering the music itself as our starting point, the interpretation suggested by the composer is by no means the only justifiable one, psychologically speaking."[11]

As I have already suggested, being culturally and stylistically conditioned, every artistic utterance makes some claim to normative validity, but in most cultures the strictures are loose and variations, especially original ones, encouraged. In fact, originality is itself a criterion, which may apply to an individual's style, the complete oeuvre of an artist, or a particular piece of work.

Does a work of art make a claim to truth? If by truth we mean factual truth, propositionally asserted and objectively or experientially verifiable, then, as exhibitive, it makes no such claim. Even representational art need not be veridical but is expected to portray its subject in its own way. But if it need not (or cannot) be true, an artistic utterance does make a claim to sincerity, and where this claim is not satisfied, as when (to cite the most extreme case) copies are fraudulently presented as originals, the work has been invalidated.

As for the expression and successful communication of feeling, even conventional symbols are susceptible of diverse interpretations. To quote Sapir again, "Select a half dozen musical examples of the expression of any typical emotion, say unbridled mirth or quiet sadness or poignant anguish, and compare them. The feelings they arouse in us are identical only when translated into the clumsy conceptual terminology of language. In actual fact they will be found to be quite distinct, quite uninterchangeable" (Sapir, p. 495).

The property most commonly attributed to art and taken to be the most important criterion of evaluation is, of course, beauty, but not all works, even great works, are beautiful, and not all are intended to be so. Some are frightening or shocking, even ugly (as are the paintings of De Kooning), and yet may be so compelling as to cause one to judge them great on these very grounds. This kind of communicative power is itself the embodiment of a kind of validity that can serve as a test of art. We expect a work of art to provoke and hold our interest, to inspire us to revisit it over and over, and to imbue us with a sense of wonder.

We also expect a work to cause us to experience it as a unified whole, but certain types of incoherence are not inconsistent with this; for instance, the termination of a piece of music with an unresolved dissonance is not incompatible with its producing a sense of closure a few seconds later. Experienced in context, the dissonance can cause us to feel the piece to be completed by the suspense at its end. As Buchler puts it, "A musical phrase, indifferent or even banal in itself, is validated by its musical allocation; a movement of the body is validated by the context which makes it part of dance . . ." (*TGT*, p. 155).

In addition, Buchler holds, "there is for exhibitive judgments a second kind of validation. . . . The validity of a work of art lies in the extent to which it modifies human query; its longevity and repute are significant only in so far as they mirror the depth of the modification" (ibid., p. 157). In being available for interpretation and reinterpretation, every artistic product has potential consequences for further utterance. If no work can antecedently embody a claim to modify subsequent artistic query in a lasting way or to a significant degree, an artist can at least aspire to such an achievement.

BETH J. SINGER

DEPARTMENT OF PHILOSOPHY
BROOKLYN COLLEGE
APRIL 1997

NOTES

1. John Dewey, *Art As Experience* (New York: Minton Blach and Co., 1934), pp. 244, 286. Hereafter cited as *AE*.

2. *Communication and the Evolution of Society* (1976); English translation, Thomas McCarthy (Boston: Beacon Press, 1979), p. 4. Hereafter cited as *CES*.

3. *The Theory of Communicative Action* (1981), Vol. I, *Reason and the Rationalization of Society*; English translation, Thomas McCarthy (Boston: Beacon Press, 1984), p. 278. Hereafter cited as *TCA* I.

4. Charles S. Peirce, "Logic as Semiotic: The Theory of Signs, in Justus Buchler, ed., *Philosophical Writings of Peirce* (London: Routledge and Kegan Paul Ltd., 1940), p. 99.

5. The score for a dance may be in Labanotation, a system devised by Rudolf Laban in the earlier part of this century.

6. Reflexive communication is "that species of communication wherein an individual both manipulates and interprets signs, or communicates with himself." Justus Buchler, *Toward a General Theory of Human Judgment* (New York: Columbia University Press, 1951), p. 31. Hereafter cited as *TGT*.

7. J. L. Austin, *How to Do Things With Words*, J. L. Urmson, ed. (New York: Oxford University Press, 1962), p. 13.

8. Justus Buchler, *Nature and Judgment* (New York: Columbia University Press, 1955), p. 163. Hereafter cited as *NJ*.

9. For simplicity's sake, I am avoiding Buchler's term, "proception," which has a wider scope than experience. Cf. *TGT*, Chapter I.

10. Justus Buchler, *The Main of Light: On the Concept of Poetry* (New York, London, and Toronto: Oxford University Press, 1974), p. 101. Hereafter cited as *ML*.

11. Edward Sapir, "Representative Music," *The Musical Quarterly* 4 (1918); reprinted in David G. Mandelbaum, ed., *Selected Writings of Edward Sapir in Language, Culture and Personality* (Berkeley and Los Angeles: University of California Press, 1958), p. 494.

PART TWO

COMMUNICATIVE ETHICS

10

W. S. K. Cameron

Fallibilism, Rational Reconstruction, and the Distinction between Moral Theory and Ethical Life

[E]ither we return to . . . Aristotelianism . . . or we modify the Kantian approach to take account of legitimate objections.

Habermas

Habermas is one of the few philosophers who've lived to experience both the blessing and the curse of stunning success. In the 1960s, Habermas's early work played a major role in dethroning positivism. Yet within a few years, the winds were blowing from another direction: Habermas's new opponents—under the influence of Wittgenstein and Winch—had apparently given up hope of discovering trans-cultural norms, or even trans-cultural facts. In every synthesis since that time, Habermas has sought to avoid the Scylla of positivism and the Charybdis of relativism. Since the mid-eighties, Habermas's primary strategy has been to isolate the legitimate objectives of moral theory from the ethical reflection which —important though it may be to our self-understanding—transcends the bounds of philosophical competence. In this paper, I will present the motives that have led Habermas to adopt this strategy. I hope thereby both to bring out the insights which the strategy embodies and the limits of the distinctions by which Habermas hopes to carry it out. My claim: on both practical and theoretical grounds, Habermas's own fundamental commitments prevent him from maintaining any sharp divide between ethical reflection and moral theory.

Before we question this distinction, however, we should recall why Habermas thought it important in the first place. The clues may be found in

the limits of his earlier studies. Already in *Knowledge and Human Interests*,[1] Habermas had exposed two co-relative errors: the positivists were either blind to their location and interests or, at best, thought them arbitrary and ignorable; interpretive sociologists, on the other hand, recognized their interests, but denied that radically different interest horizons could be commensurated. KHI attempted to resolve this dilemma by identifying three knowledge-constitutive interests. The main problem was that KHI lacked both a metaphysical and a transcendental deduction,[2] and thus could not justify its claims about the identity, number, and inescapability of the three interests it identified.

In his *Theory of Communicative Action*, Habermas adopted a more sophisticated strategy: he sought not so much to circumvent our linguistic context as to make it reflectively accessible from within.[3] Frankly admitting the provenance of critical theory in the language and lifeworld of a particular society, he assured us of its legitimacy by reconstructing its insights as the flower of a process of social rationalization.[4] We could give up the positivist illusion of pure unsituated theory without relinquishing the hope of reflective self-justification. If we could not theorize in utopia ("no place"), we could yet hope for a theory which arose out of the morass and was able to make sense of the morass.

Yet TCA needed supplementation and defense, for it could not cope with significant internal and external challenges. First, the internal difficulty: Habermas had offered a plausible sketch of the complex course of social evolution. But he had achieved that power at a cost: he left unanswered the concrete question, "Where do we go from here?" Even if we agreed that we had institutionalized progressively more abstract levels of moral reasoning, we still had to take up the practical challenge of deciding how to arrange our life together now. What principle or principles should guide the development and adjudication of future moral and political decisions?

The second challenge came from outside, as Lawrence Kohlberg's theory of moral development faced serious philosophical and empirical challenges. Habermas had argued that social rationalization involved the institutionalization of progressively more abstract patterns of moral reasoning. But his thesis presupposed the superiority of abstract reasoning; and as this assumption came under attack, it proved too controversial to serve as a foundation for critical theory.[5]

One possibility was to retreat to the neo-Aristotelianism which Habermas had indirectly encouraged. Such a contextualism might appear to solve Habermas's problems very neatly, since it would allow a developmental story *within* Western culture, the recognition of a legitimate context providing moral orientation, and a much less imperial attitude towards other cultures than has been characteristic of Enlightenment political theory. But Habermas rejected this move on four grounds. First, he found the political conservativism of many

neo-Aristotelians suspect (JA 125).[6] Second, neo-Aristotelianism was philosophically untenable. Aristotle had defined *phronesis* negatively by contrast with metaphysics. If we moderns had lost confidence that *episteme* was possible, the concept of *phronesis* thereby lost its foil: it had either to "dissolve into mere common sense" or be elevated as a form of reflective knowledge "that satisfies the criteria of procedural rationality" (JA 123–25). Third, while Habermas was aware that Bernard Williams and Charles Taylor were trying to ground morality in ethical theory, he argued that those aspects of the Western tradition with universalistic aspirations were too closely tied to discredited metaphysical assumptions. "[G]rounded in cosmological and religious worldviews," such "forerunners of moral universalism . . . are even more difficult to reconcile with postmetaphysical thought than the teleological worldview of Aristotle" (JA 125). Finally, even if we could work out the metaphysical objections, contextualism would not help us to resolve the most pressing moral disputes. Given the plurality of competing value orientations within—not to mention between—every influential culture, how could ethical reflection help us adjudicate practical conflicts? They could not be resolved simply by affirming our tradition, since the problem was that we do not all agree what our tradition *is*. We must thus choose between two unpalatable options: to relinquish either "the claim of classical philosophy . . . to place competing ways of life in a hierarchy . . . or the modern principle of tolerance according to which one view of life is as good as any other, or at least has equal right to exist and be recognized" (JA 122–23).

The question, of course, was whether Habermas could do any better. He faced a major critical challenge: to provide and justify a method for discerning how to move on from the current stage of social evolution. Habermas thus turned back to language for a third time,[7] seeking a concrete account of the interpretation and evaluation of needs. He now strove to demonstrate the inescapability of a moral point of view which could provide both a rule of moral induction and a cognitivist justification of the positions so generated. If Habermas is right, we cannot even initiate moral argument without presupposing commitments rich enough to justify a thin but genuinely universal moral point of view. His strategy is to reconstruct the pragmatic presuppositions of speech: that is, the universal presuppositions of language use, the commitments we all adopt every time we speak. He thus hopes to achieve the one thing he thinks the moral theorist can usefully do: defeat value skepticism (CES 26–33).[8]

Habermas's desire to avoid skepticism leads him to base his strategy on demonstrably universal and necessary interests; and this in turn pushes him, as it had pushed Kant, to a deontological narrowing of moral theory to "the class of justifiable normative judgments" (MCCA 196). Classical ethics had sought a rich and concrete grasp of the good life, but since it achieved this

by addressing itself to some particular *me* or *us*, it was never universalizable. The classical approach remains valuable, even essential: our very identity is constituted by our understanding of the good; thus it cannot be suspended for evaluation even temporarily the way moral beliefs can be. But while ethics is not completely beyond the pale of rational argument, it falls outside the bounds of moral theory proper, which succeeds only by excluding all talk of the good. He thus adopts a generically liberal and specifically Kantian approach: liberal in its narrowing of moral theory to make room for many interpretations of the good; and Kantian in its cognitivist focus on justification and in its insistence on the independence of the right and the good. Habermas knows he will be taxed on both counts: classical ethical theorists had hoped to achieve much more; current skeptical theories reject even his comparatively modest goals. Yet Habermas hopes to renew the promise of Kant by grounding morality "in a postmetaphysical fashion, not by appeal to a totality higher than the human mind but from reason itself as the source of world-constitutive ideas" (JA 71).

Picking up on the work of Karl-Otto Apel, Habermas enlists a method of rational reconstruction to demonstrate the necessity—that is, the universality *and* legitimacy—of a specific procedure of moral argumentation. Habermas's strategy involves four basic steps. First he must define "a universalization principle that functions as rule of argumentation" (MCCA 96). This principle articulates a kind of procedure of moral induction; more accurately, it identifies a condition which any morally binding norm must meet:

> A contested norm cannot meet with the consent of the participants in practical discourse unless (U) holds, that is,
>> Unless all affected can *freely* accept the consequences and side effects that the *general* observance of a controversial norm can be expected to have for the satisfaction of the interests of *each individual*. (MCCA 93)

Plausible enough—but how are we to justify the procedure of moral induction itself?

Habermas's second step involves exploring the preunderstanding that every competent subject brings to argumentation. By isolating those intuitions that "spring *spontaneously* from our intuitive grasp of what argumentation is" (MCCA 92), he hopes to identify the pragmatic presuppositions of argument—the kinds of commitments he had formerly associated with ideal speech:

> Language use . . . *always* demands that participants make certain formal pragmatic presuppositions if the practice is to exist *at all*—and this independently of whether they turn out *post hoc* to be counterfactual. We know at least

intuitively that certain of these presuppositions cannot be fulfilled under normal empirical restrictions, yet we must nevertheless assume that these idealizing presuppositions are *sufficiently* fulfilled. . . . Every speaker knows intuitively that an alleged argument is not a serious one if the appropriate conditions are violated—for example, if certain individuals are not allowed to participate, issues or contributions are suppressed, agreement or disagreement is manipulated by insinuations or by threat of sanctions, and the like. (JA 55–56)

But merely identifying these presuppositions is not sufficient; we must also recast them in a form that forces the skeptic to recognize that no other alternatives exist. Only then can we take up the third step: to make explicit the normative content of these pragmatic presuppositions. Finally, Habermas must show that "a relation of material implication holds between steps (3) and (1)"; that is, that the normative content of these inescapable pragmatic presuppositions entails principle (U) as a criterion of "every valid norm" (MCCA 65).

Habermas's strategy has clear advantages over traditional Kantianism. He does not presuppose an atomic self, a contractualist account of society, or the monological resolution of moral problems; and on the other hand, he *does* recognize the importance of application. Second, because he grounds morality on rational reconstruction, he can jettison discredited metaphysical assumptions and claim empirical sensitivity; yet insofar as the reconstructed principles are based on universal presuppositions, they can claim a legislative, quasi-transcendental status. Finally, Habermas draws the sting of the Hegelian charge of formalism. Discourse ethics *is* formal in "provid[ing] no substantive guidelines but only a procedure," but this does not mean that it ignores substantive questions. "It would be utterly pointless to engage in a practical discourse without a horizon provided by the lifeworld of a specific group and without real conflicts in a concrete situation" (MCCA 103). Moreover, discourse ethics does not simply generate tautologies, for it requires far more than mere logical and semantic consistency.

But Habermas never modifies Kant's strategy beyond recognition, and he frankly accepts some of its consequences. Habermas admits the necessity of application and socialization: we must internalize the wisdom to apply and the desire to follow moral norms. But though these are both necessary *conditions* of moral reason, they are not part of moral theory proper. Habermas thus maintains and even adds to Kant's dichotomies. We must, he insists, distinguish: the procedure of moral argument from its content; the problematizing attitude of the moral reasoner from the lived acceptance of ethical life; the justification of moral principles from the prudence necessary to apply them; and our richer sense of the good from our narrower concern for the right. We have arrived at last at our question: can Habermas defend these dichotomies?

JUSTIFICATION AND APPLICATION

Habermas's insistence on a moment of application is motivated by his desire to correct Kant: we need a principle of universalization, but cannot make do with universalization alone. To be sure, universalization aids the process of decontextualizing norms, thus clarifying whether they are in the common interest. Yet decontextualization works against the concrete application which is the final goal of justification. Clearly something else is needed if moral reason is to be *practical*, for "no norm contains within itself the rules for its application" (MCCA 206). Habermas thus accepts a version of one standard complaint against Kant: that the universalization of a concrete case is unilluminating because it simply recreates our perplexity under a more general description.

Yet this first attempt to weave justification and application together immediately raises an important critical challenge. Having agreed that moral inquiry must determine action in particular cases, Albrecht Wellmer asks whether Habermas's account of this process describes a human possibility. It does, after all, require "determining the consequences and side-effects of a *universal* observance of norms for *each* individual and, beyond that, of finding out whether *all* would be able to accept without coercion these consequences and side effects, as they would arise for each individual" (Wellmer, quoted at JA 35). Could anyone short of God complete such a task?[9]

Habermas responds by continuing to insist on the necessity of applica- tion, while distancing it from the process of justification. Finding the right thing to do in a particular situation "cannot be decided by a single act of justification—or within the boundaries of a *single* kind of argumenta- tion—but calls for a two-stage process of argument consisting of justification followed by application of norms" (JA 36). Habermas sometimes suggests that justification can proceed in independence of application. Approvingly, he cites Klaus Günther: "In justification only the norm itself, independently of its application in a particular situation, is relevant. . . . In application, by contrast, the particular situation is relevant, regardless of whether general observance is also in the interest of all" (Günther, quoted at JA 37). Again, universalization does not determine particular actions directly, but rather expresses our commitment to the impartial evaluation of norms. Individual situations, on the other hand, "illustrat[e] the conditions of application of a norm by means of examples," but "this is not a matter of correctly deciding a concrete case." In sum, "knowledge of valid norms does not extend to knowing how one ought to decide in a *particular* situation" (JA 128). Habermas thus refines the opposition between justification and application using two new complementary distinctions: between justification and the

adjudication of appropriateness, and between using examples and applying norms in a concrete case.

These contrasting pairs clearly capture distinctions both valid and useful; the only question is whether either one gives Habermas what he needs. To take up the latter first: Habermas notes real differences between using examples and deciding what to do in a concrete situation. Minimally, the existential stakes are not as high when no one will gain or suffer as the immediate result of our decision; and examples invariably leave open many particular details that will in fact be determined in a practical situation. But if considering an example is not the same as considering a concrete case, we must remember why we find the former helpful—indeed, unavoidable. Examples draw attention to the situations and consequences we can expect—and it is, after all, "the consequences and side effects" that we must consider. The justification of norms, in other words, is not possible *at all* in abstraction from our expectations about how they will be applied; conversely, if examples did not illuminate possible or likely applications, what use would they be to us—as examples?

And this brings us to the second distinction. Again, Habermas points to a real difference, but he does not thereby separate justification from application—or better, he does do so, but only in an equivocal sense. When resolving a specific problem, it can make sense to think of ourselves as applying the most appropriate of the norms whose justification we have independently secured. But this abstract distinction between justifying norms and determining their appropriateness leaves out the dynamic influence of time. Just because we must use examples which are sufficiently *like* particular cases, we must continually modify—or at least re-evaluate—a norm's appropriateness based on the particular cases we actually encounter. As Gadamer insists following his teacher Aristotle, we cannot forget the hermeneutic productivity of the individual case.

For in law, in the economy, in bureaucracies and in everyday life, individual situations productively determine the meaning of rules. Not only does the ordinary run of precedent govern our understanding of a norm, but the variations which become possible or necessary in changed circumstances continue to affect the meaning, and thus the justification, of a norm. In Canada, for instance, a new much stronger anti-pornography law composed with the input of prominent feminists was subsequently used in an attack on gay, lesbian, and feminist bookstores—not at all as its original backers intended. Its subsequent use may or may not be an argument against the law, depending on whether the higher courts allow that interpretation of the statute as legitimate. But if the courts uphold this use of the law, it clearly cannot maintain the justification it originally had. Learning processes, as Habermas has observed, are possible at the level of application—but only

because of its inextricable *link* to justification. Application is neither separable nor subsequent; it is a moment within the *continuing* process of justification.

Finally, Habermas's own principle (U) presupposes an internal link between justification and application. As we have seen above, justification is contingent on "the consequences and side effects that . . . a controversial norm can be expected to have" (MCCA 93). And this internal connection is implicit in another passage Habermas quotes with approval:

> The [competing] norms that are eclipsed by the norm actually applied in a given case do not thereby lose their validity but form a coherent normative order together with all other valid rules. From the standpoint of coherence, the relations within this order shift with each new case that leads to the selection of the "single appropriate norm." (Günther, quoted at JA 38)

It is certainly true that the coherence relations shift as the meanings of competing norms develop through application. But does this shift not have any relation to their justification? Where formerly the excluded norms were thought potentially appropriate, their repeated exclusion weakens their claim to appropriateness—that is, to justified application—to similar cases in the future. Such developments in the meaning of a norm thus inevitably affect both its interpretation and justification. While the adjudication of appropriateness is analytically distinguishable from the process of justification, justification not only guides, but is also constrained by, the history of a particular norm's application.

Some have thought such objections sufficient to dismiss Habermas altogether, but I do not think that they pose a major problem—yet. Habermas is clearly motivated by a legitimate concern: given the relation between justification and application, he must somehow forestall the objection that only an infinite intellect could carry it through. And this concern must be greatest for one who ties social growth to gains in the opportunity for self-consciousness. Hegel's *Phenomenology* describes Spirit's growth toward absolute self-consciousness; Habermas's TCA describes a parallel development as the "linguistification of the sacred": in both cases, we would need the fully lucid evaluation of a norm to put it entirely above question. If justification is possible for us, Habermas must find a way of curtailing what it requires.

But Habermas also offers a far more defensible argument which avoids the putative necessity of an infinite intellect. For if he cannot entirely divorce justification and application; if, that is, an *ideal* justification remains beyond our grasp, we need not conclude from this that no norm can be justified at all. For we focus—naturally and reasonably—on paradigmatic applications

(JA 36–37). This does mean, of course, that we will be less certain what to do when a new context differs dramatically from the old. Various options are possible, ranging from applying the old rule, to the claim that another justified rule is now more appropriate, to the argument that the context is sufficiently different from any we have known that we must begin an entirely new process of discursive will formation. In any case, the interrelation of justification and application does not force us to concede the necessity of an infinite intellect. A situation will either be relevant, in which case it may be considered, or so irrelevant or unexpected that it cannot be considered—which will not matter as long as it does not come up. It may, of course; and so our justifications can never be final. But this need not stymie us as long as we can renew our discursive procedure each time we need to do so to move on.

THE GOOD AND THE JUST

I have argued that Habermas cannot make a strict distinction between the interrelated processes of justification and application; yet this is no problem as long as he concedes that justification is partial: i.e., that it is always—but also *only*—possible "for now." And yet if the ideal or infinite justification is beyond us, we must raise further questions concerning the parallel distinction. Habermas insists that we make a "razor-sharp cut between evaluative statements and strictly normative ones," that is, "between the good and the just" (MCCA 104). Why does he think this second distinction necessary? Here again, he intends in part to limit the scope of moral reason in order to secure its possibility. But Habermas not only thinks this a condition of the theoretical possibility of justification, he also thinks it required by the inner logic of the moral point of view.

The moral point of view, to recall, required our generalization of "maxims and contested interests." This, in turn, "compels the participants to *transcend* the social and historical context of their particular community and adopt the perspective of *all* those possibly affected." Yet this "exercise of abstraction," in Habermas's view, "explodes the culture-specific lifeworld horizon within which processes of ethical self-understanding take place" (JA 24). Ethical decisions must at least be compatible with moral principles, of course, and they often imply a claim to intersubjective acceptance (MCCA 104). But since they are based on personal or communal, and not on universal commitments, they can claim only parochial validity. Habermas does not think that this relativization is a defect, for it follows from "the logic of a question directed to me (or us) alone and [which] *ultimately* can be answered only by me (or by us)" (JA 127). But it does set an ethical

approach decisively apart from the moral concerns which both can and should be addressed from a universal perspective.

The Aristotelian would demur at this point, arguing that practical reason or prudence is necessary to understand and apply moral principles. Unconvinced, however, Habermas offers a historical argument as evidence. "[T]he history of human rights in modern constitutional states offers a wealth of examples showing that once principles have been recognized, their application does not fluctuate wildly from one situation to another but tends to have a *stable direction*" (MCCA 105).

Unfortunately, this argument shows nothing. No one claims that principles are applied in a wildly fluctuating manner; and what Habermas's neo-Aristotelian and Hegelian critics offer is rather an explanation why their application has *not* fluctuated as much as one might have expected. Deep cultural and historical ties account for both the recognition of human rights and their consistent application in modern Western (and Western-influenced) democracies. It would be instructive to find a state which shared these principles but not the wider base of ethical life guiding their application—yet Habermas has not offered such an example, so we must return to the original issue.[10]

We may state the fundamental problem thus. Habermas asserts that cultural values are "at best *candidates* for embodiment in [universal] norms" (MCCA 104). But the key question is not whether *ethical* values can be candidates, but whether the putatively *moral* norms can be anything *more* than candidates. Is it possible to distinguish norms which are *really* universal from those which appear so "for us in our best judgment now"? We must examine in turn the practical and theoretical objections to asserting the radical independence of moral reason.

As we saw above, Habermas frankly admits a major problem at the practical level: generating moral motivation.

> A moral theory that no longer claims to know the telos of "the" good life must leave the question "Why be moral?" unanswered. On the premises of post-metaphysical thought, there is no reason why theories should have the binding power to *motivate* people to act in accordance with their insights when what is morally required conflicts with their interests. (JA 127–28, cf. 122)

The cost of adopting the moral point of view may, after all, be high for those of us who have long had a greater than proportionate share of privilege. And since Habermas believes that having moral reasons is compatible with weakness of will, the mere knowledge of a discursive procedure is insufficient to the task of sustaining moral action (JA 33). Again, Habermas:

> [A]ny universalistic morality is dependent upon a form of life that *meets it halfway*. There has to be a modicum of congruence between morality and the

practices of socialization and education. . . . In addition, there must be a modicum of fit between morality and sociopolitical institutions. Not just any institutions will do. Morality thrives only in an environment in which post conventional ideas about law and morality have already been institutionalized to a certain extent. (MCCA 207–8, cf. 108–9)

Habermas is clearly right to concede the practical necessity of being raised into an appropriate form of life. If someone from a less supportive culture may eventually recognize the universal presuppositions of which he had not been aware, still it is hard to imagine this happening except through contact with others modeling an openness which would itself amount to enculturation. But we must note this argument's corollary as well: our modern Western ethos presumably has much to do with our sense that the pragmatic presuppositions Habermas identifies are necessary.[11] Indeed, even the commitment to discovering a universal perspective reflects the modern context from which we derive our fundamental intuitions in the first place. Not only moral *action*, but moral *theory* is bound to particular forms of ethical life insofar as it is a practical possibility.[12]

And this brings us to an obstacle much more difficult than the tough but potentially tractable practical problem of socialization. For the hardest question is not whether we could motivate people, but whether we could even articulate moral commitments in abstraction from ethical intuitions. There are three progressively more serious *theoretical* objections to a radical distinction between our culturally-embodied ethical self-understanding and the moral commitment to a universal concept of justice.

HABERMAS'S PREEMPTIVE OFFENSE

The first of these is noteworthy, but not yet decisive: it concerns the weakness of Habermas's arguments in defense of our ability to reason about moral norms. Habermas appeals first to indirect definition. Alluding to Hegel's critique of Kant as hopelessly abstract, Habermas asks whether one can "formulate concepts like universal justice, normative rightness, the moral point of view, and the like independently of any vision of the good life." Having admitted that noncontextual definitions of morality "have not been satisfactory up to now," Habermas suggests an alternate approach. "Negative versions of the moral principle seem to be a step in the right direction. They heed the prohibition of graven images, refrain from positive depiction, and as in the case of discourse ethics, refer negatively to the damaged life instead of pointing affirmatively to the good life" (MCCA 205).

Habermas states the problem clearly, but his solution is simply a dodge. To be sure, negative principles seem to presuppose thinner accounts of the

good, for there is usually more agreement on the corruptions of human life than on its ultimate ends. But negative formulations do not free such principles of their ethical content, for the rejection of an evil still involves a positive commitment to some good. No mere logical point, this becomes obvious when one cashes it out. "I'm not sure what the meaning of life is, but surely it isn't *that*": such a comment may not tell us much, but can a life be "damaged" except with respect to some real standard? If no concept of the good were intended—be it ever so vague—pointing to the negative would be utterly uninformative. But it isn't.[13]

Habermas's second defense involves arguing that the task he proposes is not demonstrably impossible. He admits that the principles we agree upon will be more and more abstract, given the modern diversity of forms of life and life projects. But

> [i]t remains an empirical question how far the sphere of strictly generalizable interests extends. Only if it could be shown in principle that moral discourses must prove *unfruitful* despite the growing consensus concerning human rights and democracy—for example, because common interests *can no longer even* be identified in incommensurable languages —would the deontological endeavor to uncouple questions of justice from context-dependent questions of the good life have failed. (JA 91)

Habermas is on solid ground in questioning any attempt to prove that no interests or pragmatic presuppositions are universal. Not only would such a claim exceed what could be proven once we had acknowledged that every real conversation is limited (JA 53–56); Habermas could also enlist Gadamer's help in arguing against the possibility of incommensurable languages. Finally, it is indeed an empirical question how far our interests, our conversation, or our minds can extend; and in this context at least, Habermas apparently has technology on his side. Complete universality may be unlikely—but given the explosive growth of such aids as computer modeling, we must be wary of confident assertions about what we cannot do. Yet while this second defense is stronger than the earlier reference to negative definition, it is still far too weak to satisfy. Habermas is making a very ambitious and thus a very exciting claim—but he must do much more to show it possible than to argue that it is not demonstrably impossible.

JUDGMENT AND THE EVALUATION OF NORMS

The second problem is more threatening than the weakness of Habermas's preemptive offense, for it involves a lacuna in his theory of moral reasoning itself. Habermas answered Wellmer by admitting that our knowledge of

applications could not be complete; consequently our justifications must refer to paradigmatic cases. But if we secure moral beliefs in *this* way, then good judgment is another prerequisite of justification, for only such judgment could allow us to determine which applications are central. Moreover good judgment must be widely distributed in the general population if we are to seek a consensus and not just the balance of power by majority vote or an authoritarian expert decree.[14] Since we have not yet justified moral norms, we cannot presuppose their guidance; thus our judgment must be based on something epistemically prior. Here again we find ourselves forced to acknowledge ethical formation—not only as a condition of the practical *obedience* to, but now also of the theoretical *justification* of moral norms.[15]

But at this point Habermas could drop to his last line of defense. He may admit that we can never finally justify any norm, let alone any particular application. But he need not yet capitulate to the relativist attack, for ultimately he need neither establish particular norms nor their applications, but only the meta-rules which articulate the moral point of view, that is, he universal *procedure* of justification. As he asserts:

> every epoch sheds its own light on the fundamental moral-practical ideas. Nevertheless, in such practical discourses we always already make use of substantive normative rules of argumentation. It is *these rules* alone that transcendental pragmatics is in a position to derive. (MCCA 86)

Yet this move raises the third theoretical problem: is it possible to determine this discursive procedure in any final way?

JUDGMENT AND THE FOUNDATIONS OF MORAL THEORY

Structurally, this problem parallels the one raised immediately above. We require good judgment not only to apply (U) in discourse—for instance, during the evaluation of norms or of needs—but also to complete the original justification of (U) itself. *That* justification, to recall, was based on a rational reconstruction of the intuitions of competent speakers. But those speakers must also have good judgment about their intuitions, as they cannot claim that their intuitions are infallible.

After all—questions of cross-cultural, infra-cultural, and historical universality aside—are we even sure that our *own* fundamental intuitions are in harmony? Habermas sometimes seems to assume that they are universally shared and internally consistent, since they "spring *spontaneously* from our intuitive grasp of what argumentation is" (MCCA 92, emphasis in original). Elsewhere, he implicitly raises the question and then fudges this critical

issue. Though always clear that our rational reconstructions are fallible, Habermas asserts that the intuitions grounding them are "in a *certain* sense not fallible" (MCCA 97, my emphasis). But on the contrary, must we not admit their fallibility? Much hangs on the force of this "certain" sense.

Here Habermas cannot appeal to other types of rational reconstruction, since basic intuitions in both logic and fundamental mathematics have been questioned and modified as their implications were worked out. After Gödel denied the compossibility of proofs of completeness and consistency and Cantor argued for different "sizes" of transfinite "wholes," can we be altogether confident in identifying the pragmatic presuppositions of argument?

No: if the method of rational reconstruction differs from early modern rationalism, it can do so only by recognizing the fallibility of our intuitions. It certainly does not involve merely the fallibility of logical constructs. Descartes was well aware that his putative proofs might be faulty, and he invited us to discover and correct the flaws we found in their structure.[16] What makes us latecomers different from him is not our will to fix flawed logical reconstructions, but our recognition that even our "clear and distinct" intuitions may be wrong. Though they are our primary evidence and are thus relatively fundamental, they must be revised if we discover their inconsistency with yet more basic intuitions. In fact, Habermas confirms that this is his considered view in a passage from which we have already quoted. Having asserted that "rational reconstructions . . . have only a hypothetical status," he continues with the following explanation why: "[the reconstructions] may very well start from a false sample of intuitions; they may obscure and distort the right intuitions; and they may, even more often, overgeneralize particular cases. They require further corroboration."[17]

This concession renders Habermas consistent with the linguists and logicians he follows, and also with the empirical evidence that our modern Western views are unique. Our radical orientation to consistency and to considering all views, after all—even our will to recognize all language users as people—have been ignored, or at least not respected, over broad stretches of human culture and history. This may indicate that the intuitions themselves have changed over time or perhaps only that our *awareness* of the intuitions has changed, but in either case the fact of change raises two fundamental questions. First, are our present intuitions right? And second, even if we came to consensus about what intuitions were universal, could we secure them with the confidence of Kant?

A closer look at the limits of any possible human agreement leads inevitably to the following conclusion. We may distinguish intuitions which *appear* to be more or less universal; we may argue that some intuitions are shared by everyone, everywhere, always; and in making the claim that these intuitions are inescapable, we may in fact be right. Yet we can never

establish a radical distinction between what appears universal *to us* and what actually *is* universal. Or better, we may make the distinction at one end, for most groups will acknowledge some commitments which they accept but do not see as binding upon others. And we can make an analytic distinction—a distinction of critical reason—between the commitments we *think* universal and the ones which actually are. But the latter break—and thus any firm division between the moral and the ethical—cannot ever be secured. That task is not only difficult, but impossible in principle, as we can see on impeccably Habermasian grounds.[18]

We need only begin from an important concession: validity claims always point beyond the community of "us," because "every known community"—in contrast to the one of final resort—"is limited and distinguishes members from non-members through rules of inclusion" (JA 54). Thus we inevitably idealize our current consensus by assuming that it is the one to which the unlimited communication community would assent, for one of the presuppositions that "cannot be fulfilled under normal empirical conditions" is the hope that the two communities will ever be identical (JA 55–56). Not only are all known communities limited in size, but since even the broadest possible conversation can seek at most the agreement of finite minds, it is hard to imagine that any possible *human* consensus could encompass all relevant evidence concerning our most fundamental intuitions.

Even more significantly, Habermas himself draws attention to Arthur Danto's delightfully dry observation that we are "temporally provincial with regard to the future."[19] "We have no way of knowing whether [a current belief] will be among the valid statements that would *repeatedly* command assent . . . *ad infinitum*" (JA 164; cf. 49–55). Lacking this crystal ball, we cannot anticipate the ways in which a future perspective may shed a quite different light on intuitions we now think fundamental.

But our limits are far more profound than Habermas willingly admits. We will not achieve, or at least cannot assume, an intellect infinite either in time or in its ability to encompass all the evidence at once. But Habermas thus takes Peirce's idea of the unlimited communication community "to replace the moment of infinitude or timelessness . . . of truth with the idea of a procedure of interpretation and communication that transcends the limits of social space and historical time *from within the world*" (JA 165). But does Peirce really give Habermas everything he needs? Transcendence, to be sure, but transcendence of a finite form: it is only from within a *particular* world that we see—as we hope—the universal. And since we cannot escape this basic human condition, we can never finally secure the moral perspective by distinguishing it radically from our ethical world view.

For we face a critical theoretical problem of termination which can take

either a synchronic or diachronic form: how do we know when our intuitions are sound enough to ground our rational reconstruction? Habermas grants the *extensive* problem that our minds may be restricted both in their breadth and in their access to the future, but he does not seem to acknowledge the corresponding *intensive* problem which is just as severe. Imagine that we actually came upon the universal intuitions—could we ever secure them?[20] We could not, for any uncertainty about the adequacy and extent of our current consensus could only be resolved by checking the consensus again—that is, by re-creating it. And yet this does not help, for it only generates the diachronic form of the problem. No matter how carefully we check a particular presupposition, we can never rule out the new experience that forces its modification, thereby upsetting its systematic relation to other intuitions and thus our rational reconstruction as well.

Fallibilists lower the Cartesian criterion of truth substantially by legitimating claims to know what has not yet been disproven, on the condition that we remain continually open to new evidence. And this, of course, is the critical point of Peirce's ideal communication community: the most any *real* community can offer is its best understanding yet of what the ideal community would agree on. Even after years in consensus under ideal social conditions, the community of researchers could not and would not get up and go home, for continuing vigilance is their only defense against the suspicion that their reconstructions "obscure and distort . . . [or] overgeneralize particular cases." No final security is possible at any point in time. Our justifications are always hypothetical—never apodictic—which is not at all to say that they are wrong.

On this understanding, we are limited not so much by our mind's capacity to encompass as by its capacity to *know* what it has encompassed, but the upshot in either case is the same: since we cannot finally secure what intuitions or interests are universal, we cannot, *pace* Habermas, make any "razor-sharp cut" between evaluative statements and strictly normative ones. To put it another way, moral discourses are not unfruitful, but they are not as fruitful as Habermas seems to hope. They may claim a special status, since they build on the intuitions we think universal; thus they orient our approach to others and suggest starting points for discussion. And not only may our reconstructions *claim* to "point beyond particular . . . lifeworlds" (JA 50), they may actually succeed in identifying intuitions central to every lifeworld. But while we intend the latter result, we can never be sure that we have achieved it. And we can only *hope* to have done so by grace of the fallibilist humility that keeps us ever open to new experiences. Our finite intellects depend on ethical formation not only for the motivation to seek and follow moral norms, but for the good judgment that makes possible their

formulation and justification. And this side of an eschaton either religious or secular, both putatively justified norms and the procedure of justification itself must—on pain of abandoning fallibilism—acknowledge their provenance within a particular, finite ethical community.

W. S. K. CAMERON

DEPARTMENT OF PHILOSOPHY
LOYOLA MARYMOUNT UNIVERSITY
DECEMBER 1999

NOTES

1. Jürgen Habermas, *Knowledge and Human Interests,* trans. Jeremy J. Shapiro (Boston: Beacon, 1971). All further references to KHI will be from this edition.
 2. I'm using these terms in Kant's sense: see his *Critique of Pure Reason*, trans. Norman Kemp Smith (New York: St. Martin's, [1929, rev. 1933] 1965), B38.
 3. Jürgen Habermas, *The Theory of Communicative Action*, trans. T. McCarthy. (Boston: Beacon, vol. 1, 1984; vol. 2, 1987). All further references to TCA will be from this edition.
 4. TCA explained the symmetry conditions of ideal speech by reference to the original experience of cohesion and mutual presence before the sacred that was the anthropological basis of language itself. As we will shortly see, Habermas's more recent work provides an even more powerful, because less speculative, answer: the symmetry conditions are embodied in the pragmatic presuppositions of speech.
 5. Having synthesized the theoretical and empirical challenges to Piaget and Kohlberg, Thomas McCarthy concluded with a pithy summary of the problem:

> at higher levels, the empirical-reconstructive methods of Piaget and Kohlberg become increasingly blunt. At this level the model of the pre-reflective subject/reflective investigator gradually loses its foothold: in the end we are all participants in the debate as to what is higher. To be sure, explicit reconstructions of implicit know-how's retain their point—but only as contributions to this debate. They cannot by themselves settle it.

See his "Rationality and Relativism: Habermas's 'Overcoming' of Hermeneutics," *Habermas, Critical Debates*, ed. J. B. Thompson and D. Held (Cambridge, Mass.: MIT Press, 1982) 78.
 6. As will soon be apparent, I've taken my description of Habermas's project largely from his initial presentation in *Moral Consciousness and Communicative Action* and *Justification and Application*. In more recent work, Habermas has added a few refinements (see for instance his attempt in *Beyond Facts and Norms* to ground both moral theory and legal theory in discourse ethics). Yet the earlier works still provide the fullest articulation and defense of his approach. See *Moral*

Consciousness and Communicative Action, trans. Christian Lenhardt and Shierry Weber Nicholsen (Cambridge, Mass.: MIT, 1990); and *Justification and Application*, trans. Ciaran Cronin (Cambridge, Mass.: MIT, 1993). All further reference to MCCA and JA will be from these editions.

7. In case this count is not immediately clear: Habermas first turned to language and the forms of human investigation in *Knowledge and Human Interests*. In the *Theory of Communicative Action*, he returned to explore the development of forms of social integration under the rubric, "the linguistification of the sacred."

8. Jürgen Habermas, *Communication and the Evolution of Society*, trans. Thomas McCarthy. (Boston: Beacon, 1979). All further references to CES are from this edition.

9. Wellmer's challenge is certainly pertinent; it is based on a close paraphrase of Habermas's initial statement of (U): a norm is justified only if "all affected can *freely* accept the consequences and side effects that the *general* observance of a controversial norm can be expected to have for the satisfaction of the interests of *each individual*" (MCCA 93, emphasis in original).

10. Indeed even such an example wouldn't be sufficient. Suppose we did find a culture which purported to share our principles, but which applied them in a very different way. Would we be sure we were talking about the same ideas if we did not recognize them in their application? I have a comic on my door in which an executive proclaims a new company policy of eliminating gender discrimination in the workplace. Well and good—until one reads the punchline which makes clea. ais proposed method: "fire every woman on the payroll."

11. This suggests a question I often ask in class: assume you had grown up white in the South thirty years ago; are you confident that you would not be racist? Of course, this immediately raises the puzzle, "who are 'you'?" Philosophers can fairly claim to be reflective folk, but I, at least, must wonder whether my political views have been not been strongly influenced by three generations of politically active left-liberal forebears. An Aristotelian would surely affirm that they had; and I find myself hard-pressed either to deny it, or to imagine how it could have been otherwise.

12. This is especially significant given that Habermas accepts a pragmatic theory of truth. The practical impossibility of divorcing ethical and moral commitments should at least call into question, if it does not immediately undermine, the theoretical significance of the distinction.

13. Kant discusses such "infinite" judgments in his first *Critique* A72–74/ B97–99. His terminology may no longer be familiar, but he is surely right that such negative judgments are informative: at very least, they narrow the field of possibly true positive judgments.

14. Habermas's deep commitment to a form of the Rousseauian distinction between the "will of all" and the "general will" is most evident in his dispute with Ernst Tugendhat (MCCA 68–76).

15. Lest this distinction seem over-fine, I should offer some clarification. As we saw, a supportive ethos was important for practical reasons: without it, agents would not be committed enough to the moral point of view either to seek it out or to act

on its guidance. But if I am right here, the ethos is necessary for theoretical reasons as well: in its absence, agents would not know what cases were most important for constructing and justifying norms—even assuming that they had the good will to seek out and act on them in the first place.

16. See Descartes's *Discourse on Method*, trans. Donald A. Cress (Indianapolis: Hackett, 1980) 62–65.

17. Jürgen Habermas, "Interpretive Social Science vs. Hermeneuticism," in *Social Science as Moral Inquiry*, ed. N. Haan, R. Bellah, P. Rainbow, and W. Sullivan (New York: Columbia University, 1983) 261.

18. Though this argument is negative in its conclusion that one kind of claim is permanently beyond our reach, it does, as we will see, have a significant positive effect. Relinquishing the radical division between the moral and the ethical takes pressure off the two other problems that we have already identified: the practical necessity of linking moral principles and ethical formation, and the theoretical problem of making sense of good judgment.

19. Arthur Danto, quoted in Jürgen Habermas, "A Review of Gadamer's *Truth and Method*," in *Understanding and Social Inquiry*, trans. and ed. by F. R. Dallmayr and T. A. McCarthy (Notre Dame: University of Notre Dame, 1977) 349.

20. I should perhaps clarify what I mean lest the reader suspect that the question is loaded. I am asking "could we know it?" in the very strong Cartesian sense that has dominated philosophy for three hundred years, and according to which we know only what we can *show* that we know. By adopting a Peircean consensus theory of truth, Habermas rejects this criterion, though I do not think he consistently sees what this must mean for his attempt to distinguish moral theory from ethics.

11

Chung-ying Cheng

Confucian Reflections on Habermasian Approaches: Moral Rationality and Inter-humanity

INTRODUCTORY REMARKS

Habermas has inherited the best German tradition of both Hegel and Kant but opened himself to the American pragmatism of Peirce for his analysis and account of modernity and moral consciousness. His philosophical enterprise in terms of his theory of communicative action and discourse ethics has landed him in a process of triumphing Kant over Hegel and Peirce over Kant. To spell it out, he has argued vigorously for the primacy of right over good and for the collective inquiry for the right principles of morality over self-reflection in a narrowly defined monologically conceived individual. The significance of Habermas's project in providing a solid rational foundation for formulating moral principles cannot be underestimated even though his cognitivist arguments for moral universalism may still be open to many criticisms. We have to recognize that Habermas has strived to answer many of these criticisms and he has also carefully tried to show how his view stands out meritoriously in his friendly critique of Rawls.[1]

Whether Habermas's position as an exposition of moral rationality as revealed in our practical discourse is uniquely valid is still to be seen. But we have to point out that Habermas's moral rationalism has acquired a special importance in this new age of globalization where modernity is forced to yield its place to post-modernity and yet does not wish to give up its grip on affairs of the world. It is significant for Habermas to insist that modernity, in the form of rationalization and universalization, must assert itself for the better of humanity because it can preserve human values of

freedom and equality and justifying them in a unique form of discourse and by way of the public use of reason, and, therefore, must have a legitimate place in the global framework of the world of humanity. This no doubt depends on how we eventually come to understand modernity on the one hand and how modernity by itself comes to be shaped in the process of globalization of the human world. [2]

After criticizing Rawls's theory of a just society based on the veiled original position as shouldering more substantive burdens, Habermas claims that

> By contrast, I propose that philosophy limit itself to the clarification of the moral point of view and the procedure of democratic legitimation, to the analysis of the conditions of rational discourses and negotiations. In this more modest role, philosophy need not proceed in a constructive, but only in a *reconstructive* fashion. It leaves substantial questions that must be answered here and now to the more or less enlightened engagement of participants, which does not mean that philosophers may not also participate in the public debate, though in the role of intellectuals, not of experts.[3]

This is to me a revealing statement of Habermas's basic approach. It has presented many facets of Habermas's thought: the reconstruction versus construction, the procedural theory versus substantive theory, the moral point of view versus the non-moral point of view, public debate with public of reason versus private or personal reflection on human sentiments. How these polarities are to be understood and finally how an understanding of these could benefit our evaluation of Habermas's position would be extremely intricate but challenging questions, which may not have been fully explored. In this article I propose to confront these questions and undertake the task of exploring the limitations of the Habermasian view and its possible overcoming in light of a radically different tradition, the tradition of Confucian ethics. In doing so I shall also draw insights from Habermas to benefit the Confucian development of Confucian ethics in a modern milieu for a modern and post-modern world.

The reason I have chosen this comparative-critical approach for understanding Habermas is simple: it is my own belief that Confucius influenced Kant in the eighteenth century in the formation of his view of moral autonomy from which morality as an independent point of view is derived. As Habermas has to refer back to Kant, it is historically important to see how one primary source of the Kantian moral cognitivism and moral universalism could respond to him. Secondly, Confucian ethics as a universal realistic moral theory has been traditionally regarded as a paragon example of virtue ethics. But is Confucian ethics simply a matter of virtue ethics? Could we see Confucianism in a new light so that its strengths in

some other directions could be brought to bear on moral issues which concern us today? In taking this view we shall see a fuller picture of Confucian moral theory on the basis of which we could perhaps contribute to a more substantial development of Habermas's discourse theory of moral rationality into a more substantive theory.

In the following I shall deal with the issues of reconstruction versus construction, moral versus non-moral point of view, procedural versus substantive, and discursive reason versus reflective reason, right over good versus good over right in the context of a critical mutual interpretation of Habermas vis-à-vis his discourse ethics and Confucianism.

CONSTRUCTION AND RECONSTRUCTION

Habermas regards Rawls's theory of justice and specifically his political liberalism as an attempt to construct an ideal society of justice in the spirit of contractualism. Despite saying that his enterprise is reconstructive in contrast with Rawls, he also regards his enterprise of justifying the normative validity as analogous to the constructivist epistemology exemplified in works of pragmatism.[4] This reference to construction or constructivism suggests that we have to take an active role in formulating our theoretical understanding of the practical and this no doubt goes back to Kant. Using Kant as a pivotal reference, we can also speak of reconstruction of knowledge and ideal moral reason, because the Kantian approach to knowledge and morality can be understood as an attempt to retrieve and preserve the essential meaning of knowing truth and acting right by the human person. Kant asks under what transcendental conditions knowledge and morality are possible. His philosophy provides a reconstruction of our concepts of knowledge and morality which is at the same time a conceptual construction from our general understanding of knowledge and morality. Unless we have good reason to deny that our understanding cannot be conceptual, our pre-theoretical construction could still have a conceptual content which is subject to reconstruction. This may imply that reconstruction cannot separate from construction even though construction need not be reconstructive. If this is one way Habermas sees his difference from Rawls, it is interesting to ask by what criterion we would separate a reconstructive construction from a constructive construction.

It seems obvious that there are many concepts which have been used in our language but they may not be analyzed and made clear in terms of other concepts. But for understanding the use and meaning of the concept we need to raise the question of justification and application. Although justification and application may appear to belong to two separate areas of consideration,

it is often the case that we need justification for the purpose of application and we need application for the purpose of justification. Without a justifiable distinction between our concept of mammal and our concept of non-mammal animal, how could we identify a whale as a mammal as opposed to a marine species? Hence, in justifying our use of a conceptual term we need to construct an analytical hypothesis based on our understanding and come to a definition of the concept so that its given uses are a reflection of a fact and its application to new or future cases is assured and warranted. When application is thus confirmed and established, then justification of the conceptual distinction would hold. A conceptual construction is to give a definition or to produce a theoretical explanation of a concept which hitherto has not been so explained. We may cite Aristotle's definition of the human being as a rational animal as exemplifying such an effort. We may even regard Aristotle's formulation of disciplines of human studies in various domains as systematic constructions of a comprehensive understanding of the end and activities of the human person. Since there is no other similar enterprise before Aristotle, we may safely say that the Aristotelian enterprise is a construction, but not a reconstruction, namely not a construction based on or derived from an earlier construction.

A construction based on an earlier construction would be a reconstruction. Similar to construction, reconstruction must rely on logical and content analysis of the meaning of the concept so that it will reveal a structure which would make it more applicable and more justifiable in reference to fact and reality. Thus a reconstruction is simply a construction intended as a more acceptable construction or a more useful and more adequate construction in theory or in application. Various modern definitions of knowledge in terms of justified belief and other requirements are no doubt good examples of reconstruction of the Cartesian ideal of knowledge in terms of Descartes's basic intuition of the human self. As we do not yet have any completely foolproof notion of knowledge, our notion has to undergo an open on-going process of reconstruction just as our system of knowledge does.[5] Given this understanding, we may ask whether it is legitimate to characterize Habermas's system of ethics as reconstructive and Rawls's as merely a construction, and whether such a distinction sheds light on their differences at all.

For Rawls, the major difference between Habermas and him is this: Habermas's position on normative validity is a comprehensive doctrine which covers issues of meaning and reference, truth and validity for both theoretical and practical reason. But his own position regarding justice is simply a political theory which is independent of any particular comprehensive doctrine even though it may be derived from one or more comprehensive doctrines. To use Rawls's words, his theory of original position is "freestanding" whereas Habermas's theories of communicative action and

ideal discourse ethics have to stand on certain particular understanding of rationality and normative validity. Rawls also states a second difference: namely as devices of representation their views have different features and serve different purposes.[6]

Regarding this latter difference it is clear that Rawls wishes to establish an analytical construction of justice as fairness and a political society as a fair system of social cooperation among free and equal and rational human beings, whereas Habermas wishes to provide a reconstructive characterization of modernization as a process of rationalization and normative validation as a process of universalization. His doctrine of moral universalism no doubt is also intended to bring about a politically liberal society because it is by going through such a process a society would become politically free and equal and just. In my view, this difference is simply the difference between means and ends, although this difference is essential for understanding what the notion of a modern liberal society would involve and presuppose. We may thereby ask whether this difference could be explained in terms of a distinction between construction and reconstruction.

Given justice as a construction from ancient to modern times, Rawls's theory of justice as fairness and liberal society as a system of social cooperation is as much a reconstruction as a construction. As a reconstruction it answers to the spirit of the times as he claims that his principles of justice are designed for a constitutional democracy of free and equal citizens. In a sense the formation of the American Constitution has served as a base model and as the incentive for the development of his theory of original position and his theory of justice as fairness. Nothing is achieved in simply mentioning that Rawls's position is a construction. We may conclude that there is no difference between Habermas and Rawls insofar as the distinction between construction and reconstruction is concerned. We may instead speak of a reconstructive construction in which construction and reconstruction are present.

However, we may still push for whether the difference lies on a different conceptual level, namely, whether it lies on the level of using rationalism as a methodology. It seems clear that even though Habermas and Rawls have different subject matters at hand for reconstruction, they wish to do so from a radically rational point of view, namely, from the point of view that everyone, in doing this reconstruction, would end by engaging a similar resulting conception for a subject matter. For Habermas we would expect the similar conception of ideal discourse situation which Habermas would use Apel's Transcendental Pragmatics to achieve. For Rawls we would expect the same conception of justice as fairness because in the original position we are equally rational. This radically rational point is formulated as the principle of universalization in Habermas and as the theory of original position in

Rawls. At this level the question of difference and identity depends on how either one intends and formulates his notion of the radical rationality in his respective principle and theory.

For Habermas the radical rationality of a reconstructive construction is directed toward a method or methodology of resolving moral conflict and the establishing of universalistic ethics, whereas for Rawls the radical rationality of a reconstructive construction is directed toward the actual construction of an ideal society of justice. It is interesting to ask whether the Habermasian principle of universalization could give rise to a political reconstruction of justice as fairness and whether the Rawlsian theory of original position would justify the development of discursive (or argumentative) ethics and get the same respective results. The answer can also be a matter of critical analysis and a rational reconstructive construction in which we have to take into consideration factors such as the levels of rationality, the assumptions of collateral information and their ends-in-view. This suggests that even in attempting a rational reconstructive construction we may not free ourselves from historical and empirical considerations.

To be fair to Habermas, it is necessary to point out that Rawls's charge that Habermas's theory of communicative action is a substantive comprehensive theory whereas his own theory of political liberalism as simply a political theory is questionable. It is true that Habermas's theory is comprehensive in the sense intended by Rawls, but that does not mean that the principle of universalization must be such a theory and that this principle of universalization must be different from the theory of original position. It seems to me that both positions are derived from Kant's notion of separating appearance from reality or knowledge from experience. Kant's two-level theory also leads to the two-level theory of Habermas, the universalization principle which represents the ultimate use of reason and the actual process of reaching conclusions in social and moral situations, as well as the two-level theory of Rawls, the original position principle, which represents also the ultimate use of reason, and the actual society and state in the making. Although Habermas has discussed many aspects of how to reach normative validity in moral matters in comparison to reaching truth in natural sciences, and hence, make his theory comprehensive, it does not follow that the core of his position, namely, the ultimate principle of universalization, must be comprehensive in the sense of depending on substantive notions of truth and validity. In fact, that very principle is intended as the source of a comprehensive theory, not the result of such a theory. Similarly, for Rawls the theory of original position is the source of his reconstructive construction for a political justice, not its result. Thus, what Rawls has regarded as the first difference actually makes no difference at all.

Rawls's idea of an original position is a matter of constructing or

explicating "the most reasonable principles of political justice for a constitutional democracy" on the basis of free and equal, reasonable and rational citizens.[7] It amounts to explicating principles of political justice such as fair terms of social cooperation (justice as fairness) in a democratic regime on the premises of freedom, equality, and rationality. Here the idea of democracy has to be taken in as a premise or a conclusion, namely, in assuming the existence of free and equal citizens we have already presupposed the notion of a democratic institution according to which freedom and equality in voting and so on are guaranteed. Or, we may assume some rudimentary idea of democracy and use it as a basis for developing the rights of freedom and equality of citizens as history actually has demonstrated. Rawls's theory of original position is finally a project of explaining social justice or fairness in terms of freedom, equality, and rationality. The goal is to preserve the values of freedom, equality, and rationality in the process of political life such as electing people or making appointments and doing general management in a given state for preserving the values of freedom, equality, and rationality.

To be even more explicit, Rawls's purpose is to deduce the rationality of decisions and the arrangement in political life from freedom and equality alone so that freedom and equality can be preserved or enhanced. It is clear that in doing this rationality has to be assumed throughout. Rationality is charged with the job of preserving freedom and equality (perhaps in some abstract and in some concrete sense) in connection with concrete or abstract development of political actions and arrangement. What cannot be avoided is an understanding of the nature of such political action or arrangement: One needs to develop an adequate understanding of such action or arrangement so that one's idea of freedom and equality already acquired can be preserved or enhanced. The question is whether this involves a comprehensive theory of human community, as Rawls says, that Habermas has to involve in his construction of an ideal discourse situation. Another question is whether in the analysis of the concept of rationality substantial elements (not necessarily religious and metaphysical elements but cultural and historical or empirical elements) must be ruled out.

For Rawls it is the political and equally moral conception of justice as fairness in a pre-political sense that assures obtaining of "liberties of the moderns," the liberties of private conscience and free speech and thought and thus in its reasonableness imposes no prior restrictions on the people's will formation which eventually could be articulated in a constitution which would represent the "liberties of the ancients." But this is not a matter of defending the United States Constitution where he points out three shortcomings: no public financing for political elections, no fair distribution of income and wealth, as well as no health care.

Habermas has expressed his agreement with this Rawlsian project. But

his objection is that in implementing this project we need a starting point and a principle of validation of a normative construction and it is how he proposes the moral principle of universalization and his discourse ethics as both justification and application of moral and political actions. He wants to use his discourse ethics as an intersubjective background to check against the validity of a proposed constitution for protecting basic rights and to develop even people's will formation (popular sovereignty) in democracy. He sees that basic rights of freedom and equality and democratic sovereignty are each derived from an ideal value in practical communicative reason.

In the practical engagement of seeking truth, normal validity, and truthfulness of expression, human persons must practically commit themselves to (theoretically presuppose) a principle of universalization in both truth and normative validity. In making explicit this performative pre-grasping one can come to see why a principle of universalization must hold and how it must lead to the formation of a pluralist open democratic society. For Habermas a constitution-based democracy represents an on-going process of public discussion and negotiations among free and equal individuals. He calls this process "deliberative democracy." Although he does not adopt the reflective-transcendent approach as embodied in Rawls's theory of original position, his discursive-engaged approach is still purposively oriented albeit communicatively engaged, and thus shares much with the liberalist and yet contextualist stance of Rawls. His principle of universalization as a matter of fact incorporates the two principles of justice in an abstract statement of interests of everyone on both present and derived levels.[8]

Now given the above analysis of the methodological depth structure of Habermas vis-à-vis Rawls, we come to the Confucian point of view in a reflective understanding of normative validity, rationality, and justice. I shall first characterize Confucianism as a reconstructive construction and then show how Confucius differs from both Habermas and Rawls and how his difference constitutes a base for critical assessment of the radical rationalistic approaches in both Habermas and Rawls.

By "Confucianism" or "the Confucian point of view" I mean the views of Confucius and his school from the *Four Books*. But we must also introduce the *Five Classics* as a historical and philosophical background which we may speak of as a Comprehensive Doctrine of Confucianism. We may regard Confucianism as presenting itself on two levels: the moral-practical level where right and good are equally relevant concepts, and the theoretical level where right and good are founded on a sense of reality of cultural values (*wen* and *rendao*) and cosmic values (*tiandao*). If modernity means that the practical discourse of morality has to forge a universality pertaining to the public space of intersubjective reason or public reason, then

our question is whether we can replace the ethical and the onto-ethical with pure moral consciousness in the practical discourse of public reason.

We must see that on the onto-ethical level there are substantive elements which support the practical discourse of argumentation and that this cannot be forsaken if we look into the issues of practical moral discourse carefully. Rawls's theory of justice as fairness does not do this but he would see an overlapping consensus of comprehensive doctrines, each of which would give consent to the moral-practical principle of original position on which the sense of justice as fairness is based. Must Habermas reject an onto-ethical justification for moral rationality of universalization principle? Not necessarily, because if the question is a matter of normative validity, we need justification in a comprehensive theory of the human person for such a validity claim.[9] If, on the other hand, the question is a matter of truth, then we have to bring to bear on matters which deal with reality. What I call "onto-ethics" could include arguments for the goodness of human nature and for the existence of human nature as natural dispositions. I shall show and argue that from the Confucian point of view the claim of normative validity is oftentimes both a claim of validity and a claim of truth and even a claim of truthfulness of a perspective as well. Meta-theoretically onto-ethical commitments (views and values) are implicitly or explicitly introduced for understanding both the discourse ethics and the original position.

Let me start with the question of reconstructive construction in Confucianism. It is interesting to see that conceptual terms such as *ren* (benevolence), *li* (ritual action), *yi* (righteousness), *zhi* (wisdom), *dao* (the way), *de* (virtue), and *junzi* (superior person) in the Confucian ethics are all derived from texts and records of discourses of antiquity. What Confucius has done is to infuse a new meaning and value in the old existing conceptual terms to form a latent system of understanding of humanity and inter-humanity: by "humanity" is meant what a human person ought to know, ought to do, and ought to be or become; and by "inter-humanity" is meant how human beings ought to behave toward one other, and how they ought to be related and interrelated in a social institution. The notion of *ren* is precisely the broad notion of the oughtness of human conduct together with the notion of the oughtness of human relatedness, while the notions of *li* and *yi* embody the notion of oughtness of the inter-human relationship and human solidarity. What Confucius did, therefore, is to effect a moral transvaluation of the human individual and this holds as well for the inter-human relationship which gives rise to community and society. In this connection let us make several explanatory remarks on the nature of oughtness in regard to human conduct and human relating from the Confucian point of view.

First, we may observe how consciousness of moral oughtness arises in Confucian thinking. The key to this consciousness is the single outstanding

sentence from Confucius in the *Analects* which says: "If I will *ren*, then *ren* arrives immediately" (*woyu ren, siren zhiyi*).[10] In articulating *ren* as arising from my will and desire (*yu*),[11] Confucius has tied the oughtness of moral consciousness to the volitional nature of the person, for such a desire or will is independent of human physical needs and therefore can be only said to arise from the volitional assertiveness of human mind in light of a self-understanding of the human person. This suggests that moral normativity is not derived from some simple knowledge of facts nor does it represent a matter of intuition of metaphysical truth, but instead is rooted in our ought-desire or moral will as a human person. This also shows that consciousness of moral oughtness as embodied in *ren* reflects the existence of a moral will which is closely bound to self-understanding. This may not answer the question of emergence of social norms, but it does pinpoint a dimension of the formulation of social norms in the individual volitional consciousness of moral oughtness.

Second, oughtness is not a singular monadic property of an object but a relational property of an actual or potential action (A) of a person (P1) in relation to another person or persons (P2) or in relation to an end value (a value as an end) (V). From P1's point of view, oughtness comes from his will and his self-consciousness of will in seeking action to reach an end which he values intrinsically. In other words, oughtness describes consciousness of an obligation to achieve an ideally desirable state or an obligation to avoid an ideally undesirable state in relation to another person or persons. This consciousness may not only occur in P1, but may simultaneously occur in P2 and others because P2 would expect P1 to do an A in order to achieve an ideally desirable state or to avoid an ideally undesirable state. We can speak of the actual generality of the consciousness of oughtness. If this oughtness is directed to a specific person or group of persons, a consciousness of what ought to be done to him from A1 would lead to his consciousness of the rightness on his part, for it would be right for this action to be done. We may speak of the right-consciousness of the second person or third person in conjunction with the duty/obligation consciousness (oughtness consciousness) of the first person. Oughtness could lead to the rise of consciousness of rightness and the consequent consciousness of rights.[12]

Third, we must distinguish the nonmoral oughtness from moral oughtness in the oughtness consciousness. That one ought to eat less sugar and fat in order to reduce weight reflects a nonmoral oughtness which is based on causal instrumentality. On the other hand, in saying that you ought not to kill anyone, we have a moral consciousness which is based on our moral will toward a good for everyone, because a universal good including good to myself is intended. What this suggests is that moral oughtness

presupposes consciousness of universality based on self-reflection and generalization over all other persons. In brief, it reflects consciousness of a will of self-reflective generalization. Without the emergence of this will, there could not be such consciousness. It is a will for a universal moral oughtness and this consciousness of moral oughtness toward universality testifies to the emergence of the moral will. This universality is not only reflected in general positive or negative injunctions, but is embodied in all specific moral injunctions as a premise or foundation. Consider the injunction, "You ought not to harm your friend so and so." There could be many reasons why one should not harm a specific friend, but there could also be cases where one ought not to harm one's specific friend because he is a friend and also because he is a human person. In such cases we see that the specific moral injunction presupposes a universal moral injunction, namely, the moral principle of no harm for anyone.

Fourth, the will which leads to consciousness of moral oughtness is not only implicitly universalistic, it is also implicitly directed toward general goodness as an end. As the oughtness is a relational property which relates persons by way of action in regard to maintenance of a state or attainment of a new state, that state must be desirable intrinsically and that state would bring general goodness to all the related persons. Without preempting our notion of goodness, we may simply call the state resulting from or main-tained by an actual or expected virtual moral action "goodness." In this way we see how goodness of state should intrinsically relate to oughtness of action. As there is no action without a pre-action state and a post-action state to go with the action, oughtness of action is obviously anchored in a pre-action state and carries a reference to an ideally desirable state to be realized by the action. As oughtness of a moral principle is universalistic in scope and is intended for goodness in general, we may speak of universality in specific action and in specific goodness of state as well as in specific application of the principle of moral oughtness. The specific goodness is conceived by Confucian ethics to cover well-being, happiness, harmony, and truthfulness in both the substantive and formal sense. This intrinsic organicity of action and state will lead to the unity of good and right as an ontological actuality in Confucian ethics.

Given this analysis, we come to see that the principle of moral oughtness is a universal generalization over existential generalization in specific cases and the moral goodness is a universal generalization over existential generalization in specific goodness as well. Morality is, therefore, composed of two levels, the oughtness in general level (or the level of principle of moral oughtness) and the oughtness in particular level (or the level of application of the principle). These two levels form a unity of justification

and application, for the principle level justifies the instance level where the latter applies the former to individual cases. There cannot be morality without these two levels, because these two levels are in fact a representation of the moral self-consciousness of the human will over his own actuality or existence as constituted by reason, emotions, and desires which are faculties or abilities of the human heart-mind.[13] We also come to see that this moral oughtness consciousness as recognized as the principle of moral oughtness must be universalistic, agathonistic (pertaining to goodness), and aretaic (pertaining to virtue) and, hence, axiological (pertaining to value) as well. It also carries an implicit but actualizable consciousness of rightness which is the ground and source for consciousness of rights.

Here I wish to elaborate on the deontological universalistic form of *ren* and its inseparable teleological content of goodness.[14] Confucius has given three separate replies to the question, What is *ren*?, each of which seems to thematize on a dimension for the universalisitic-deonto-logical-teleological nature of moral action or moral consciousness. The first reply is, "Love people" (*ai ren*),[15] which thematizes the object of the moral action as human person in unrestricted scope. Here it is clearly represented as a moral command which should be fully represented as "You should love all people." This shows the dimension of oughtness and universalizability of the principle side of the moral action of *ren*.

The second reply is, "Do not do to others what you would not want others to do to you" (*jisuo buyu, wushi yu ren*)[16] which thematizes on the self-reflexivity as a test-criterion for the action and this no doubt is intended for and directed to all the human persons. It shows how oughtness consciousness is derived and reveals the self as the source of the moral consciousness, which leads to the Confucian understanding of the moral ontology. It further articulates the universality of the moral object without restriction of scope. It is a universality which depends on the self-reflexive reference to a moral agent who wills such universality. It might be regarded as a reciprocal relationship between the first person and the second person. But in fact it is intended for any reciprocal relationship over any two persons or groups of persons. Thus, it is directed toward all the persons because the word *ren* is unrestricted in scope.

It is noted that this is only a negative restriction of the self in moral oughtness. But then how about a positive application of the moral self (the self which has come to moral consciousness by reflection and self-conscious-ness)? Confucius responds with his statement, "If one wishes to establish oneself, establish others; if one wishes to attain a good end, help others to attain their good end." (*jiyuli er li ren, jiyuda er da ren*).[17] It is clear that in negative action one withholds doing an action from one's not wishing to do it to oneself. If the action is a good one, and if one does not wish to do it to

oneself, he would not then do it to others. This is certainly undesirable, because others may wish the good actions being done to them or to the moral agent himself. Then the question is how one would come to realize or see an action and wish or will to do it. This leads then to the question of self-cultivation, a highly characteristic requirement for the Confucian ethics of virtues.

Once good things are envisaged and desired, we may come to the positive formulation of the reciprocity of positive moral action: help others to do the same while one does the good action by oneself. The positive principle of reciprocity can be reformulated as, "Do to others those good actions what you will/wish to do to yourself." By analogy to this, if we also reformulate the negative reciprocity principle as: "Do not do to others any bad actions which you do not want to do to yourself," this may imply that we should not do to others those bad actions which you do not want to do to yourself. Then how about those bad actions which you do want to do to yourself? Certainly it is not intended that one can do bad things to others which one likes to do to oneself. The negative principle formulates the moral oughtness in such a way that whatever things, good or bad, which you do not wish to do to yourself, you ought not do to others. It is a principle of no harm. It is not a principle of benefit. Good and bad have to be positively identified before we can do good to others and withhold bad to both others and oneself. The negative principle is a first principle of moral consciousness prior to the formulation of the positive principle which requires the discovery and distinction of good from bad or morally right from morally wrong.

This then leads to the third reply from Confucius: "To control oneself and restore/practice proprieties is the *ren*" (*keji fuli wei ren*).[18] As *ren* represents the moral consciousness which can be seen as oughtness of negative action of no harm and oughtness of positive action of benefit with unrestricted reference to all human persons, it is clearly a deontological duty applied to all persons as moral subjects and to all persons as moral objects. But what would be the form in which this duty is realized? It is not just a question of motivation but a question of result. We have raised the question on the positive actions which must be based on a distinction between the right and wrong or good and bad. The third Confucian reply is intended to show that the very way of reaching self-consciousness of moral oughtness is the way in the second reply, by self-reflection, and unlike in the second reply, not in reference to what one does not want to do, but in reference to what one can control in doing and then realize it positively. This refers to controlling one's selfish and excessive desires going beyond one's proper limit which would lead to chaos and conflict. In exercising this control a good result will ensue, for one must conceive of controlling one's desires as an effort to bring out desires which are relative to an end-value.

Here the reference to *li*, or ritual actions which govern the human relationships and preserve inter-human harmony, is clearly a matter of moral teleology. *Li* are those codes as historically understood, which preserve social harmony and promote political ordering. The content of *li* no doubt is linked to actions of *yi* or rightness/righteousness, for the spirit of *li* is to secure righteousness in ordinary circumstances in view of the whole fabric of social behavior of all people. On the other hand, we may regard *yi* or actions of righteousness as moral actions of *li* which are individually judged with regard to their special rightness or wrongness. No matter whether we are dealing with a system of *li* or with the individual rules of prohibition and promotion in *yi*, we are already involved with specific actions of right and wrong, propriety or impropriety. In other words, in a deepening analysis of the moral consciousness of oughtness we reveal a world of good and bad, right and wrong. Confucius's third reply has specifically referred us to the world of *li* and *yi* which we may identify as a state of goodness founded on the moral actions of rightness and propriety.

Now we may put the three dimensions of the moral oughtness in *ren* together and conclude that for Confucius the consciousness of *ren* is the moral consciousness of deontological oughtness with reference to all people, originating from a self-reflection which leads to self-control toward either negative or positive moral actions, and which would give rise to or lead to a will for general comprehensive goodness for all people. With this understanding, it can be seen that the notion of *ren* as embodiment of the Confucian principle of moral oughtness not only can function as a universalization principle as Habermas advocates but can act as a principle of reflective transcendence as embodied in Rawls's theory of the original position. This is because *ren* is conceived independently of one's position in the world and it is intended to apply to a life-ideal independently of circumstances of life.[19] This means that one should always preserve and apply one's principle of moral oughtness at all times of life.

There is a difference between Confucius's notion of constancy of the moral principle and Rawls's notion of original position which is methodologically requisite for the theory of justice as fairness. Confucius has achieved moral consciousness by both self-reflection and observation of people in the world where moral consciousness of the universal oughtness is moral knowledge which is derived from experience of life and the world, whereas, for Rawls, the theory of justice as fairness has to be established on an assumption of the original position with a veil of ignorance.

The Confucian moral consciousness of *ren* represents an existential moral awakening of humanity, whereas the Rawlsian doctrine of fairness presents a rational exercise of a rational mind based on our general experience of life. Similarly with regard to the Habermasian principle of universalization, the consciousness of *ren* represents a much larger moral

consciousness than the principle of universalization and a need for moral critique. It represents both the deontology of right and the teleology of good over a universality of human people and a singularity of self-cultivated self.

Given the above observation, we may go back to the question of the reconstructive-constructive nature of the Confucian undertaking on the moral consciousness of *ren* and other consequential notions. All the moral concepts of Confucian ethics on the level of moral actions are drawn from the historical repertoire of the language of morals from antiquity. But in giving a new meaning to these concepts by redescription and redefinition, Confucius injects his overall moral consciousness into the moral language and effects a moral transvaluation. In doing so he constructs even though he does not suggest any new terminology, for all old concepts have been given a new life and new meaning. He constructs the ethical-moral lifeworld for all persons by reconstructing the old concepts from morals of the past. Thus, he constructs by reconstruction and reconstructs by construction. This makes his moral philosophy a holistic one and this moral holism has to represent a way of axial thinking which totalizes over any and all human actions in an effort to identify humanity and inter-humanity in a normative way.

One may question how the Confucian view acquires its normative validity. The reply is that it receives its normative validity by preserving the continuity from the past and by its applicability in moral discourse and moral language of his time. In fact, his ethics of virtues is extensively applicable because it is justified both by its own cogency of moral consciousness and by its actual preservation of the moral language. As Confucius stresses action and practice, the unity of moral consciousness and moral action is another reason why the moral oughtness, when formulated in moral norms, not only retains but strengthens its normative validity. Confucian ethics shares with Rawls the idea of a cultural base and people base for its moral awakening and ethical enterprise. While Rawls has the American constitution in mind when he speaks of his political justice, Confucius has the *Zhouli* (*The Rituals of Zhou*) in mind when he speaks of *ren* as controlling oneself and restoring/performing the *li*. For Habermas, his moral consciousness in terms of his discourse ethics and communicative action may have the scientific community as a reference group and in this regard he is engaged in a reconstructive construction based on both Kant and pragmatic theory of scientific inquiry.

PROCEDURAL AND SUBSTANTIVE CONSIDERATIONS

Habermas has claimed that his discourse ethics has basically presented a procedure for establishing the normative validity of moral norms and has left substantive issues of philosophy aside. He does not wish to present a

comprehensive theory of moral goodness but merely wishes to formulate a way of validating or justifying the given moral norms such as "You should not kill anyone," and so on. On the other hand, Rawls points out that Habermas's ethics of communicative action is in fact a comprehensive theory because it involves questions of truth and knowledge. He even quotes two passages from Habermas in order to show how substantively committed Habermas is. In criticizing what he himself calls "existing unreason" and "essentialist trust in reason," Habermas claims that he has developed instead a procedural reason, "a reason that puts itself on trial." But how does this procedural reason put itself on trial? It must criticize itself with the same rigor as it requires from any social norm. Now the question is how to understand this procedural reason as a requirement of both morality and rationality to be called "the principle of universalization."[20] Habermas has given this procedural reason the following formulation:

> All affected can accept the consequences and the side effects its general observance can be anticipated to have for the satisfaction of everyone's interests (and these consequences are preferred to those of known alternative possibilities for regulation).[21]

It is analytically clear that this principle involves the following four claims regarding the validity of any social norm or any moral rule: (1) General observance by all affected people will satisfy everyone's (that is, all affected people's) interests; (2) There are certain consequences and side effects of such general observance; (3) All affected people can accept such consequences and side effects; (4) All affected people will prefer these consequences and side effects than any known alternative possibilities. With this understanding, we see this principle of moral consciousness (to be called the U principle) is a conditional universalistic assertion expressing a capacity and preference of all affected people upon satisfaction of their interests. Even though it may apply to a norm of moral oughtness such as "You should not kill anyone," it does not seem to embody any element of moral oughtness which would require all affected to accept the results of satisfaction of their interests in following a given norm. Hence, how could this principle confer moral oughtness on any norm which must contain oughtness? This is the first criticism of the U principle.

Second, the U principle only specifies the subjects of the assertion to be those people who are affected by a given norm. But as a moral norm, a norm must affect all people. Here Habermas perhaps wants to allow a social norm to apply to a community in a multi-cultural society. This is fine but again we must make a distinction between a locally applicable social norm and a generally prevailing moral norm. The moral norm "You should not kill anyone" is presumably a moral norm which should apply to any community.

The U principle suffers from an ambiguity as a moral principle in that it can be construed as a sociological generalization.

There is also the third criticism: What are those interests of people the satisfaction of which would enable people to accept all the consequences and side effects of their observance? Here we must distinguish various kinds of interests and separate moral interests from nonmoral interests to the extent that satisfaction of the moral interests are essential for the absolute preferential acceptance of its consequences and side effects. For if a given interest of people does not have moral significance, its satisfaction does not necessarily and generally or universally lead to the acceptance of the rule and the consequences of following the rule. Again we see the ambiguity of social rules versus moral rules. The U principle can test a social rule for its satisfactoriness and preferability and therefore command an improvement of the rule. But if the rule is nonmoral, there is no practical necessity and theoretical universality or generality in accepting the rule and preferring its consequences in following it.

Given these three criticisms, it is not clear how the U principle would function as a test procedure for moral norms nor as a self-critical and self-justifying principle in the light of a self-understanding of its content. This latter point is again obvious: If it cannot distinguish itself as a moral rule by making a requirement of itself, how could it command our acceptance and preference and how could it guarantee satisfaction of our interests to the extent that we would bear its consequences in following it? A moral principle as a procedure must not lose its moral content and function and acts as if it is a formal leading principle in argument unless it can be proved to be formally valid. But in the case of moral principles, we simply do not have them as formally or logically valid principles. Consider the logically valid principle of *modus ponens*: If P implies Q and if P, then Q. This is a logically valid principle because it can be proved by the truth table of material implication for all values of P and Q. But the U principle has to be valid in virtue of the moral consciousness arising from the concept of a human person. It must depend on the formation of the will of a person's mind because it is the human person who can make moral decision on values and who can formulate the concept of values themselves.

Granted these, a moral principle cannot but presuppose the self-understanding of a person and the self-awareness of moral will as an intrinsic power of committing the person to action according to the values which he has come to see and embody. Regarding these values it is clear that insofar as they pertain to morality they must pertain to human persons as human persons and the universalistic requirement of fulfilling the essence of the human person as a human person. What is called the essence of the human person as a human person, which Confucian ethics would denote by the term

xing (human nature), is nevertheless an open concept to be realized by our individual and collective self-reflection and critical recognition which could become formalized into a process of inquiry. This is to say that we need not predetermine what this essence of humanity is but allow ourselves to come to an understanding of it in the process of inquiry so that we may approach a convergence of understanding within oneself and within a self-reflective community which can be extended to cover all human beings in the long run. We can nevertheless identify this essence by our ability to have or achieve moral consciousness and hold to the universality of this moral consciousness by our moral will.[22]

In light of this critique of the U principle of Habermas, we can perhaps reject his claim of a self-justifying procedural reason as such because of its lack of moral content and its failure to validate any moral rule. But if we are to reformulate this rule as a moral principle which we may call the Moral Principle of Universalization, then it cannot be a simple formal principle of procedure but must presuppose the moral consciousness of humankind as an achievement of moral will in the human person and, hence, must presuppose a substantive understanding or self-understanding of the human person as such. Thus the procedural nature of the moral principle cannot be separated from its substantive content.

The Moral Principle of Universalization perhaps could be phrased as follows in light of our critique of Habermas's U principle:

> All people must accept the consequences and side effects its general observance can be anticipated to have for the satisfaction of all people's interests pertaining to their being a human person as a human person.

According to this new formulation, one can then use this principle as a procedure to test any moral norm such as "You should not kill anyone" to see how it confers normative validity. We can see this test in terms of considerations of two aspects of following this rule: Observing the norm "You should not kill anyone" will satisfy the essential interests of a human person as a human person (for a human person cannot be arbitrarily slaughtered or killed for any private purpose and even for any purpose—the argument against capital punishment); the consequences are always preferred to any other known possibilities and must be accepted by all for we would enjoy a much greater freedom and stability of life. This seems to bring out our moral intuition about what we ought to do and ought not to do and, hence, performs a task of justification. We may also observe that it is precisely in the same spirit of insisting on the moral content of a moral principle that Kant formulates his Categorical Imperative as a command: Act only on that maxim through which you can at the same time will that it

should be a universal law.[23] It is clear that the reformulated U principle is closer to Kant than Habermas's original U principle.

Perhaps in light of the above difficulties Habermas has introduced another principle in order to give moral or practical content to his U principle and this principle he calls D referring to the discourse side of the morality:

> Only those norms can claim to be valid that meet (or could meet) with the approval of all affected in their capacity as participants in a practical discourse.[24]

Of course, we are talking about social norms at large, the D principle would no doubt represent the democratic and public side of the formation process of a norm. For a norm is either imposed on a community or is introduced as a proposal to be agreed upon by all people in community in virtue of their common consent. But this again does not make the norm either moral or universalistic. For the practical discussion and the consequent acceptance of the norm do not confer morality on the norm unless the norm has a moral intent and a moral content in the first place. A practical discourse, if morally motivated and morally oriented, could appear to warrant the validity of a moral norm, but this only means that the discourse is geared toward making the moral consciousness explicit or conferring a moral consciousness on the norm, which should be the purpose of the discourse. This again presupposes the pre-existing status of the consciousness of the moral oughtness in some individual or group of individuals.

Apart from this consideration of illumination in the discourse for common consent, the discourse may also serve as a process for criticizing a proposed norm regarding its moral content and, therefore, it must itself embody a moral consciousness apart from using common theoretical reason as stipulated in some form of semantics and pragmatics of communication. Here I do see the relevance of a general theory of communicative rationality, for communication as a means to shared understanding is always an important ongoing process of acculturation (from the historical past of one's own cultural tradition and from a horizontal exchange with other cultural traditions).

One final comment: because of the importance of the practical discourse many people can factually join in an open discussion of the formation and acceptance of a norm, but there are others who cannot join in such a discussion. The normative validity of a norm is established on the basis of the authority of not an actual discourse, but a potential one for all potential participants. For the validity of a moral norm, it is obvious that it has also to derive from its initial content and final approval from the moral self-consciousness and self-reflection of the individuals.

In this connection we may come to Rawls's concept of original position as providing a different approach regarding the establishment of a procedure for determining his interpretation of justice as fairness. Again I shall argue that this approach does not resolve or absolve of the substantive elements or presuppositions in a proposed procedure for moral oughtness but that it does indicate a way of revealing an important dimension of moral consciousness which is neglected in the Habermasian approach. Rawls sets his idea of the original position as follows:

> The idea of the original position is to set up a fair procedure so that any principles agreed to will be just. The aim is to use the notion of pure procedural justice as a basis of theory. Somehow we must nullify the effects of specific contingencies which put men at odds and tempt them to exploit social and natural circumstances to their own advantage. Now in order to do this I assume that the parties are situated behind a veil of ignorance. They do not know how the various alternatives will affect their own particular case and they are obliged to evaluate principles solely on the basis of general considerations. [25]

It is interesting to note that Habermas regards this design of original position as loaded with substantive issues because he thinks that in trying to preserve the intuition of moral oughtness in the Kantian moral principle of universalization Rawls has imposed a common perspective on the parties in the original position through constraining information by way of assuming a veiled ignorance. In fact the main thrust of his critique of Rawls is to question the representativeness of the idea of justice as embodied in Rawls's two famous principles which constitutes Rawls's interpretation of justice as fairness. For Habermas the central issue of reaching consensus on justice must be phrased in terms of a pluralism of interpretative perspectives and can only be resolved in an intersubjective practice of argumentation.

As mentioned, in answering Habermas, Rawls stresses the "freestanding" status of his position of political liberalism: his notion of justice is to be applied to a basic structure of society which is a fair system of social cooperation. In other words, Rawls regards his view as basically an analytical hypothesis which is reached independently of any particular comprehensive doctrine in the sense that it does not presuppose or depend on any one such doctrine. His final defense is that his ideas on a fair and cooperative society, and freedom and equality among reasonable citizens, are well understood in political discourse of modern days and therefore make perfect political sense.[26] But this answer may not meet with Habermas's objection, for Habermas may still push for the rationality of a procedure for determining the normative validity of a moral or political norm which must be acceptable to all people in a multi-perspective commodity.

Given the mutual critique between Habermas and Rawls regarding the

procedural reason in relation to justifying universality of moral oughtness or justice as fairness, it seems clear that neither Rawls nor Habermas speak of the substantive issues in the same sense or with regard to the same category. For Habermas the substantive issues which Rawls has to face are assumptions with regard to representation from equal and free individuals, constraint of information and knowledge and an obtaining of "overlapping consensus" of opinions based on an existing system of political institution. For Rawls, on the other hand, these assumptions are reasonable within our political discourse in a democratic society and, therefore, needs not to invoke serious doubt. Therefore, for him, these assumptions should provide a transcendent condition for testing the theory of justice as fairness he proposes. But he would rather doubt how a procedure like Habermas's could resolve political disagreement. He says: "In view of the imperfection of all human political procedures, there can be no such procedure with respect to political justice and no procedure could determine its substantive content. Hence, we always depend on our substantive judgments of justice."[27] To him the practical discourse in discourse ethics is just one political discourse or another. It could not lead to any substantive solution. Hence, Habermas has to make some substantive assumption in order to reach a discursive validity for a norm. This, in fact, would amount to making one's own proposal based on one's special moral intuition concerning the human person so that it can be tested for overlapping consensus.

In explaining the reasonableness of the assumption of original position we see that this assumption can be regarded as a methodological insight which arises from a state of reasonable understanding from the first person's point of view enlarged to the second person and then to the third person and finally to a universal point of view. Rather than speaking of a veil of ignorance, Rawls could speak of gradually ridding oneself of one's prejudices, attachments, and interests vested in one's given present position so that one could eventually come to an original position for balancing various views and possibilities of consequences and reach a decision on moral action. In fact, this state of original position is the same state which could be reached when all considerations are balanced off and reconciled in a state of self-reflection and reflection on all known possibilities. This state is called by Rawls "reflective equilibrium."[28]

It is clear that the original position is designed to catch the rationality which would collect in a reflective equilibrium. In this sense we need not speak of the veil of ignorance but rather seek knowledge of all possibilities and make a reflective equilibrium out of this knowledge for a universalizable perspective. We might say that Rawls's two principles of justice can be regarded as an emerging result of such reflective understanding which is a reflective equilibrium among all considered possibilities. But this again has

to presuppose that our mind would operate in such a way that insight into moral rationality would be possible and that we may even know our mind as capable of such moral intuition.

Rawls and Habermas need not be considered different in approaching the notion of moral rationality, for both wish to formulate a procedure for determining moral justice. The reformed Habermasian U principle simply brings out a general form of moral validity whereas Rawls's two principles of justice as fairness shows a concrete result of the moral consciousness and reflection. They both have to assume the existence of the human person and the moral mind in order to reach a consciousness of moral oughtness and justice as fairness. One is taking a general form whereas the other is taking a particular form. It is important to note that the particular form of the theory of justice as fairness could be shown to fulfill the two inner requirements of the Habermasian U principle. Namely, the first principle could be shown to satisfy our basic non-material needs, whereas the second principle accepts the consequences and side effects in comparison with other alternatives. It follows then that the reformed U principle and the two Rawlsian principles of justice in his theory of justice are theoretically equivalent and would also relate to each other as justification is related to application.

One important lesson we learn from this critique of the Habermas-Rawls mutual critique is that reflection cannot be dismissed as a major contributor toward the formation of moral will and public opinion or consensus among all equal and free people. It is clear that Rawls gives strong weight to reflection whereas Habermas focuses on communication and discourse. For establishing the normative validity of a public social or moral norm it is clear that we need both: the individual has to be self-reflective and the community needs to make both the discursive and reflective efforts in order to phrase and entrench a public norm. In this connection we can now go back to the Confucian point of view.

As morality requires moral consciousness, a Confucian thinker never fails to elaborate on the need for deepening one's self-reflection so that one could become more morally motivated and more integrated with regard to lessons one learns from interactive practice of one's moral faith. But morality is not only a matter of consistently maintaining one's faith but a matter of consistently testing one's feelings with others in one's interaction with people via both communication and action. A fundamental insight is that if one does not have a moral basis in oneself, one cannot extend to others and one cannot improve oneself by developing a more objective and universal practice. This means that self-reflection and self-understanding are equally essential to moral practice. Practical discourse and practical action as two sides of the moral practice must be brought together to form a convergence of moral consciousness and moral understanding.

A moral norm, therefore, must be established through this process of

interaction and interpenetration of the internal (the reflective) and the external (discussion and action). Confucian ethics would give equal weight to Rawls's notion of "reflective equilibrium" and Habermas's notion of "communicative action toward a communication community." It would consider mutual support, mutual checking, and mutual balancing between the two as the key toward validation and universalization of a moral norm. Mutual support, mutual checking, and mutual balancing must be seen as constituting a dynamic process of convergence and enlargement so that morality as a system of moral norms would be both constant and variable in its ability to creatively adjust to human needs at large and human situations in particular without sacrificing its principles. Humanity becomes inter-human in its ability to universalize and transcend.

In this light it is important to see how moral reason is to be retrieved and conceived as both a procedure and a substance. While the goal of Habermas is to establish a valid norm in morality via discourse and the goal of Rawls is to found a system of just laws which preserve fairness on the basis of freedom and equality through reflective equilibrium in individuals and overlapping consensus among individuals, the goal of Confucian ethics is to develop a community which would fulfill the order of mutual relatedness and mutual support in a harmonized unity of whole and parts. For this goal, both the Habermasian and the Rawlsian concerns are relevant but must not override each other. Rather, they should find their proper places in a dialectics of mutual checking and balancing toward forming a convergence and universalization of feelings. For the Confucian thinker moral rationality is not a just matter of reflection nor just a matter of discourse, but a matter of interaction of both and their integration in a process of deepening the understanding the self and the ritual (*li*) formation of the community.

As indicated in the preceding section, moral rationality or the practical reason is holistic, dynamic, and interactive as well as processlike. It cannot be confined to a state of original position nor to be decided by a logic of argumentation. Instead it has to be assessed from different angles and has to be eventually integrated on the basis of moral consciousness or the consciousness of moral oughtness in *ren*. Along this line, we see a dialectical process of moral reasoning in which both the internal and the external are brought together to form a unity and both the formal-procedural aspect and the substantive-referential elements are equally attended and regarded as two sides of the same coin.

Regarding the distinction between the internal and the external, we read the following significant message from the Doctrine of the Mean:

> To be sincere is to accomplish oneself, to make a way is to conduct oneself. To be sincere is the beginning and end of things. There is nothing if there is no sincerity. Hence, to be sincere is a precious thing for a superior person [superior

in morality in the sense of having achieved the moral consciousness]. To be sincere is not simply for the purpose of self-accomplishment, it is for the accomplishment of things. To accomplish oneself is benevolence (*ren*); to accomplish things is wisdom (*zhi*). Both are the virtues of the human nature, and it is a way (*dao*) of combining or unifying the external (*wai*) and the internal (*nei*). It is also a timely thing to do with fitting with a given situation.

"To be sincere" is to be true to oneself by self-reflection and this is, for the Confucian thinker, the way to go back to an original self (perhaps it can be called the original *position* of the self) so that one may consider all possibilities and choose the most reasonable way of treating others. This is regarded as both the beginning and the end of things because this subjective element of self-reflective authenticity cannot be lost in any moral consciousness even though moral consciousness has become objectified as a universalizable moral norm. In acting on such a norm the individual has to reflect on the norm for close understanding and self-motivation. Hence, to be sincere is the sustaining force for the achievement of moral rationality toward objectivity and universality. Without this a moral reason would not be considered moral at all. It is further stressed that to be sincere in the sense of reaching original self and to know what to do is not just for oneself but for all others so that all others could reach the same self-accomplishment together with accomplishment of the universalization of the moral norm.

In other words, moral rationality starts with one's sincerity but is essentially linked with all others through their own sincerity. In this regard consciousness of moral rationality reveals its intentionality toward others as well as being a matter of one's own nature. To be able to reflect on oneself and be sincere to one's reflection is to reveal the nature of oneself. With this revelation we can then speak of the two virtues in one's nature: one is benevolence (*ren*) and the other is wisdom (*zhi*). *Ren* means "to accomplish oneself in the sense of having achieved moral consciousness" whereas *zhi* means "to accomplish others." The concept of *ren* needs no further explanation, but the concept of *zhi* does.

"To accomplish others" is to know others or to "know people" (*zhiren*), to "know language" (*zhiyan*), and to "know rituals" (*zhili*) in Confucius's own words.[29] Confucius says: "If a person does not know rituals he is not able to establish himself; if a person does not know language he is not able to know people."[30] To know others is a broad enterprise which would include knowing their behaviors and their natural dispositions, their habits and their attitudes and to know how they interact with others and how they speak or toward what ends or values they act. It is also to know the feelings, needs, expectations, and historical and cultural background they have, to know their problems and their aspirations, etc. It is noteworthy that

Confucius singles out "to know language" (*yan*) as a necessary condition for knowing people. Here "to know language" means more than knowing linguistic and literary matters of language, it is to know how people express themselves and, therefore, how they think and how they feel, especially how they think they should act toward themselves, others, and the whole community, etc. It is in this spirit that Mencius explains "know language" as follows:

> Biased language I know where it errs; licentious [arbitrary] language I know where it falls; misleading language I know where it deviates; evasive language I know where it betrays itself.[31]

Confucius has also advanced his doctrine of "rectifying names" (*zhengming*) where he requests that names must correctly conform and hold up to correct values and actuality of human relationships.[32] By looking and recognizing the hidden moral requirements of our language we would be able to require our conduct to accord with these requirements. "Thus a ruler must be rulerlike and a father be fatherlike." This is indeed both a linguistic and a moral insight: by looking into our use of names we see that moral values and moral consciousness have been built in, and common language referring to human relationships has already imbued itself with our moral common sense and an overlapping consensus on moral values. This suggests that a process of communication and interaction among people has already created this result and it is important to apply our moral consciousness to individual usage of language so that we shall guard the process from deterioration.

Given this understanding, it is not far-reaching to say that Confucian ethics has been highly alerted to the process of communicative interaction which Habermas expounds in his theory of communicative interaction, and that a discourse ethics should be a proper part of this process, as this process represents a larger process of socialization rather than a narrow process of argumentation. To know language is to engage in a communicative interaction with others and to beware of the correct moral implications of our language, to socialize and integrate one's own reflective morality (moral sense and moral consciousness) with others so that one can determine what is right to do and what is right to say: it is to know a norm of morality by coming to an understanding of the universal moral principle which applies to everyone both descriptively and regulatively. This is then to know rituals (as parts of the social and moral norms) and to establish oneself (to be integrated with others both communicatively and interactively in a system of objectified morality as represented by the system of Confucian *li*).

The above analysis should show how the internal process of a Rawlsian

reflection in an individual person (self) and an external process of Habermasian discourse (in a larger sense of social and communicative intercourse) among people (self and others) have to interact to form a stream of moral understanding. On the basis of this understanding and interaction our social and moral norms are formatted and our moral community founded as a result of the convergence of the reflective wisdom (via a reflective generalization) and the discursive understanding (via discursive consensus-forming) in the larger framework of a pluralistic society. This is, then, what the Doctrine of the Mean calls the "way of combining/ unifying the external and the internal" for the purpose of "meeting the right needs and value visions of the ongoing times." We may in fact represent this process as follows:

We need further develop the Confucian point on unifying the internal reflective and the external discourse in order to reach a proper formulation of the moral norm in the sense of li_2 (principle/reason).[33] This li_2 originates from the meaning of pattern/patterning and develops into the meaning of a principle which has both an objective reference in reality and an subjective standing in the human mind. That it comes to enjoy such objective status is due to the result of converging and meeting of a comprehensive reflection and a comprehensive observation. It is in fact a result of a holistic onto-hermeneutic reconstructive construction in our understanding of the world and our place in this world. The rise of the term of li_2 just like the rise of the term $xing$ (nature/disposition) has to do with our self-experiencing and self-understanding of the human mind. The source-capability for cognitive activities of the mind is hypothesized as the $xing$, whereas a coherent logical pattern emerging from the cognitive activities of mind is projected as conceptual order or truth (li_2 the principle). But as principle a conceptual order could also function as a method or procedure which can be used to judge or measure how a specific norm can hold and apply to people, because a principle is regarded as

objective, universalizable, and valid in a whole system of total principles.

Yet in using a principle as a procedure for testing a norm we must not forget that this principle also has a substantive content insofar as it always embodies a value. Not only does the li_2 have a content, but also it correlates with the base of the mind, the $xing$, to form a double procedure for testing a moral norm. For we must not only ask whether a given norm conforms to the general requirements of a li_2 as being objective and universalizable, we must also ask whether it conforms to the inner feelings and sensibilities of the $xing$. The moral validity of a norm must be derived from satisfying both sides, internal and external, subjective and objective, in order for the norm to be said to be fully justified and applicable. Zhu Xi through the lively tradition of Neo-Confucianism has vigorously held the li as both a formal procedure and a substantive principle for testing and judging the moral legitimacy of any action.[34] He has gone so far as to identify $xing$ with the li_2 in an effort to regulate the feeling-desire content of the $xing$. But Dai Zhen criticizes this effort in a revolt against Zhu Xi for the purpose of restoring the human actuality of feelings and desires in the $xing$ without having to submit to a priorly formed forum of moral principles of the li_2.[35] This shows that the way to confirm the validity of a moral norm has been always a central question in the Confucian ethics throughout the long history of Confucianism/Neo-Confucianism.

In the above we can see how the $xing$ corresponds with the internal (*nei*) and the li_2 corresponds to the external (*wai*) in the Zhong Yong. Hence the problem of combining and unifying the li_2 and the $xing$ is exactly the problem of combining and unifying the internal and the external. Both stand for a pair of polarities which are opposite but complementary and this suggests that the formal and the substantial, the procedure and the principle can be distinguished but cannot be separated. In this light, when Habermas and Rawls are seen to be engaged in criticizing the other side as not being able to avoid substantive issues in their respective proposals of a procedural reason, one sees that both their criticisms are empty and misleading. In light of Confucian discourse we see how the U principle and the two principles of justice must be both procedural and substantive or substantive-implicating and why this is necessary for a full-fledged understanding of the validation of moral norms.

There are two more important pairs of polarities in Confucian ethics which should be cited to illuminate the nature of moral reasoning and validation of a moral norm. The first pair is that of centrality (*zhong*) and harmony (*he*) from the Zhong Yong. Centrality refers to a state of human emotions in a state of equilibrium before it becomes activated due to stimulation from outside. In a sense it provides a content to the notion of human nature (*xing*). When we come to Mencius, the content of human nature is further provided with the "four beginnings" (*si-duan*) of moral virtues of *ren*, *yi*, *li*, and *zhi*. This may be regarded as part of a comprehensive metaphysical doctrine of the human

person, but again it is founded on the basis of an epistemology of comprehensive observation and comprehensive reflection such as indicated in Mencius's well-known empirical-introspective argument for the root-feeling of the *ren* in terms of empathy-sympathy.[36]

Nevertheless, this subjective formulation of basic moral sentiments can be introspectively generalized by way of the self-reflexivity of *ren* so that it can be applied by extension to others as a moral maxim. Once it finds response and consonance from others and time and again is confirmed in an interactive communicative process, it would become objectively anchored in our knowledge and even in our conception of the human disposition and, thus, becomes the basis for an objective formulation of a moral norm. The state of the subjective corresponding and answering to the objective is like an arrow shooting right into an intended target which is then called the state of harmony or *he*. Thus, harmony as a moral fitting of the subjective into an objective situation is rooted in both the subjective nature of the human person and the objective actuality of an inter-human situation and satisfies both the requirement of *xing* and the requirement of li_2. It can be further enlarged over a community of people so that it becomes a moral harmony of a moral community to be described as fulfillment of oneself together with fulfillment of others and all related things.

It is clear from this analysis that both *zhong* and *he* can be used as procedural methods for determining the moral validity of moral claims but in doing so without giving up their substantive reference and implications.

The second pair of polarities of the way (*dao*) and the virtue (*de*) comes from the *Analects* of Confucius. In the *Analects* the *dao* refers to the ultimate principle of being a human person and in this sense the ultimate principle of moral rationality in terms of a generalized humanity in their communicative interaction toward forming a moral community of inter-humanity as indicated above. The very concept reflects an underlying unity of the Confucian thinking on the human existence and the process of moral development of the human person known as moral self-cultivation. The *dao* as a philosophical term in Confucius, refers also to the way that things are generated and moves on in a state of moral order and in a state of onto-cosmological harmony.[37] But here we are limited to the first meaning. In terms of this meaning the Way is the ultimate foundation of our moral nature which gives rise to our moral consciousness of *ren*.

Even though no exact and full exposition of this meaning has been suggested, *dao* does acquire the meaning of li_2 (principle) via Zhu Xi. But in a reconstructive construction over all the contexts of the use of this term in the *Analects*, *dao* is no doubt considered as referring to the whole process of fulfillment from moral development and cultivation of the individuals to the solidarity of community embedded in a benign/benevolent social and political

order. One might even point to the eight-term program of human and social development in the *Great Learning (Daxue)* as the concrete presentation of the Way of Human and Social Development. It is clear that *dao* is very much a procedural reason which ensures the full implementation of the moral rationality in the context of inter-human interaction in action and communication. Specifically, we may point to the requirement of "investigation of things and reaching for knowledge" (*zhizhi gewu*) as a requirement of discursive consensus-formation and the requirement of "making one's mind sincere and rectifying one's mind" (*chengyi zhengxin*) as a requirement of reflective generalization. The formal-procedural reason for moral validation cannot be separated from a substantive understanding of the things of the world and our minds.

To speak of the *dao* without the *de* is both incomplete and inconsistent. The reason we come to recognize the *dao* is that we have come to see in ourselves an ability to embrace, understand, and act on the *dao* by way of reflection. This ability which we may call moral ability is the *de*. Like the term *xing* which refers to human nature, the term *de* is a metaphysical-practical term because it occurs in our practical discourse which is tied to our action but which has a reference to the starting point and the ending point of the human action. Hence, if *dao* is totalistic in intent and refers to the whole fabric of moral development of the human person, *de* is molecular in intent and refers to the individual and concrete achievement of the moral development of the human person. *De* is therefore illustrated by the attainment of all the moral virtues such as *ren, yi, li, zhi,* etc. It eventually becomes the general base and a general carrier for all virtues. But we should not forget the inner dynamics of *de* and *dao* on the one hand and the inner dynamics of *de* and individual virtues on the other, in either of which *dao* and *de, de* and individual virtues, become mutually generative and form a structure of whole and parts. It is in terms of this whole structure of *dao/de* virtues that we see the moral idealization of the human nature which can be fulfilled in a process of individual self-cultivation and collective morality formation as described above. It is no coincidence that even in modern-day Chinese the concept of morality is always conveyed by the conceptual term *dao-de* where the term *dao* suggests a method, a procedure, and a wholeness and the term *de* suggests an achievement, a substance, and a concrete result of moral self-cultivation.

PRIORITY OF GOOD OVER RIGHTS OR RIGHTS OVER GOOD

In developing his rational discourse theory of the moral point of view in which individuals can participate as free and equal participants, Habermas has assumed the priority of rights over good. It is understandable that the

individuals in a community must be first guaranteed equal rights of freedom of speech and free participation (or free assembly) before they can choose their own life-plans, which incorporate their visions of good, and rationally discuss or negotiate with all others with the same status for a common conception of good in an intersubjective context of communicative action. In other words, individuals must take an "ideal role" (in George Mead's words) first before they can propose their vision of good as a universal value for all others taking (in) the same ideal roles. This is possible only if individuals have been guaranteed or allowed to have those basic liberties as basic rights. But in order to avoid the positive law approach of Thomas McCarthy which would undermine discourse ethics, Habermas has to grant that individuals have to be aware of their own right to be free and equal with others and also be rational enough to allow others to have the same rights or have the same moral consciousness which gives them the same rights. This means that a consciousness of moral rightness must have first dawned on individuals before they can make the right claims and test them against claims of others and allow others to do the same. Individuals can then be said to have achieved the status of moral autonomy. It is only in this sense that we can speak of the primacy of rights over good, namely, because an individual has to achieve a right consciousness first as an autonomous individual in order to choose values and even envision a conception of good.[38]

It is in light of this autonomy of an individual person that Habermas launches a cutting criticism of Rawls's approach. His criticism is that Rawls has to construe equal rights as "primary goods" (goods needed to realize individuals' life-plans) in his original position approach to justice as fairness. But in order to do this the individuals must have autonomy in the first place and, therefore, must have some rights as rights before choosing them. He says: "If I am correct, the conceptual constraints of the model of rational choice preclude Rawls from construing basic liberties from the outset as basic rights and compel him to interpret them as primary goods. This leads him to assimilate the deontological meaning of obligatory norms to the teleological meaning of preferred values."[39] He points out that in order to compensate for the leveling of the deontological dimension of his justice theory, Rawls accords the first principle of his justice theory priority over the second, which is basically a teleological principle. But in doing so Rawls still treats rights as primary goods from his original position of a theory of rational choice, even though Rawls later treats liberties of his first principle as those primary goods which would secure the development of the moral faculties of citizens as free and equal persons. This according to Habermas won't get Rawls out of the difficulty of presupposing the deontological distinction between rights and goods, for rights have to be exercised before one can speak of the fair value of rights.[40]

One can agree with Habermas's basic criticism of Rawls. The point of criticism is that even though Rawls could reclassify primary goods in his two principles of justice and order them in the way they are ordered, there is no escape from assuming rights of freedom and equality as rights *per se* in order to choose rights as a form of primary goods, which would reduce actual exercise of rights to simply actual opportunities to choose and to act. How, then, would Rawls answer? Rawls seems to simply reiterate his position that his political conception of justice as described in his two principles captures the basic structure of a modern democratic society and is endorsed by an overlapping consensus and can be applied to decide on public issues.[41] He considers this justification *pro tanto* and did not really worry about the difficulty Habermas has raised. This could mean that Rawls would accept the fact that one has to exercise rights of freedom and equality as an autonomous person before one could formulate the two principles of primary goods. I myself see no objection to this view, nor do I see any incompatibility between this position and the requirement of original position.

As I have already pointed out, there is no need to treat the requirement of original position as a position of veiled ignorance, but rather as a position of moral consciousness which is awakened to the consciousness of the moral will of the person and the consciousness of moral oughtness as discussed in connection with the meaning of the Confucian statement: "If I will *ren*, then *ren* arrives immediately." Then it is, of course, Rawls's moral consciousness of rights which dictates that he formulate his two principles of justice which he derives from his understanding of modern constitutional democracies and his reflection on his own independence of mind and will. Then the question is whether we have all the reasons to defer to rights as primary over goods and how they stand to each other. For this question we may now turn to Confucian ethics.

In analyzing Confucius's claim that "If I will *ren*, then *ren* arrives immediately," I have argued that Confucius has been awakened to the moral consciousness of universalizable oughtness. In his act of will Confucius has realized himself as a person of free will. As he also takes the position that every person should practice *ren*, in this regard he has regarded every person as free and equal. For Confucius his moral consciousness and claim of *ren* enable him to presuppose basic rights of freedom and equality as primary moral qualities of a human person or general humanity even though he may not have developed the jargon of rights as independent, abstract and general claims of humanity to be eventually rationally recognized among people and legally protected by the constitutional law. But this is not to say that if one has not realized and spoken of the right to free speech, that one, in speaking freely and responsibly, may not have reached a moral consciousness of free speech. It seems that our rights language becomes abstracted from our moral claims

and moral practice because we are prevented from doing so by an external coercive power or even become persecuted because of our exercise of the right to free speech. As a matter of fact, it is precisely in those cases that the language of rights arises as an independent discourse in order to secure protection of those rights.

The Confucian moral consciousness of universal humanity would eventually lead to moral consciousness of universal inter-humanity as explained in terms of the Confucian dialectics of unity of self-reflection and communicative interaction in action. But in light of this process the exercise of moral rights of freedom and equality is not separable from a content of moral action and moral goal. When Confucius speaks of his proposal and desire for the practice of *ren*, *ren* is not the right to be free or equal but the dictate to constrain one's selfish desires and love people without discrimination, which presupposes the right to be free and equal. It is a speech which articulates and expresses a value, the value of an individual life constituting the unity of the individual and the community of people. On this basis he then articulates and expresses other values which are the Confucian virtues in virtue of their intrinsic requirement for practice and incorporation in the self-cultivation program of individual persons. As these values were also inherited in some sense from a cultural tradition of the past, and are justified by the Confucians on the basis of a vision and plan for the realization of the common good and an ideal form of community, are we forced to conclude that the Confucian ethics is a typical example of communitarianism and has nothing to do with ethics and politics of rights such as presented in Rawls's theory of political liberalism and Habermas's theory of discourse ethics?

I believe that we need to make a distinction between the right-consciousness as inhering in the moral consciousness of moral oughtness and the rights consciousness as arising from separating rights from values. In the initial awakening of the moral consciousness of oughtness such as the consciousness of *ren* both rights and values arise together simultaneously, rights by exercising rights and values by envisioning a form of universalizable good such as loving all people. It may be also suggested that it is the vision of a good which arouses the strong need for committing oneself and acting on that vision of good that the rights-action of moral assertiveness takes place within the mind of a person who would formulate his moral principle based on his moral vision of the good. One has to see this in terms of a theory of the formation of will. It seems clear that despite Augustine to the contrary, human will arises from human mind in separation from ordinary desires in being the desire toward a form of good as unrestrained by the object of the desire or any other desires in the ordinary sense. In other words, the formation of human will is a matter of moral consciousness inherent in the nature of the human person which is always involved with our vision of a higher order of good.

We may see the mutual dependence and interpenetration of the "will to

good" and "good to will" in the moral consciousness of the moral principle or the moral point of view. To put it in the form of the language of Confucius, we may say: I will *ren* and *ren* is good to will. It is precisely true that *ren* is good so that I will it and it is also precisely true that I will *ren* so that *ren* is good. My willing *ren* as a moral agent and my seeing *ren* as worthy willing cannot be separated, for without my willing it *ren* not only cannot be articulated but cannot be, and this means that my willing and exercise of my willing for *ren* constitutes a necessary condition of the existence of *ren*. We may call this exercise of the willing for *ren* the formal aspect of the *ren* and the content of *ren* the substantive aspect of *ren*. In any practical discourse the formal and the substantive aspects of a moral consciousness of a moral principle cannot be separated nor can it be ordered in terms of one being prior over the other. Thus, similarly for the U principle of Habermas, we see that it has a content which can hardly be separated from its form as intended for testing the validity of a norm. Similarly, the Kantian categorical imperative though appearing to be devoid of any special content in fact is addressed to any maxim a person may adopt and hence has a general content.

The above observation should resolve some contradiction between liberalism as norms ethics or ethics of rights and communitarianism as values ethics or ethics of virtues. Granted the distinction Habermas has made between a norm and a value, a norm, of course, has to be chosen and a right has to be exercised, but a norm has to have a reason to be chosen and a right must be exercised with a goal. Their being the work of will does not deprive them of their being also the work of our cognitive-emotive minds. A practical discourse has always to have both senses of practicality: to act and to reach for a goal. Similarly, practical reason is not separable from theoretical reason, because it always presupposes the work of theoretical reason and has to participate in theoretical reason to articulate its practical claims. I can choose a good or even choose to choose a good and this does not make choosing a primary entity prior to what I choose. I cannot simply choose without choosing anything. The language of choice and will must be complemented and completed by the language of values and knowledge. Thus, there cannot be any distinction between liberalism and communitarianism in the beginning formation of our moral consciousness of a moral principle. But it can be granted that once a moral norm is formed, it is to be intended volitionally for practice of everyone independently of any system of values apart from the system of values embodied in the norm. In other words, it is not up to the values already accepted or incorporated in a community to decide what to choose and what to act. The individual person should already exercise his moral autonomy of freedom and equality to advocate what he thinks right and subject his opinions to a test of consensus or majority vote via the discourse and communicative action.

On the other hand, a person could accept and advocate a given system of

values as already validly embodying the moral consciousness of a people and that any individual needs not, or should not, ignore or forsake those value-norms or norms-value in his moral practice or practical discourse. Instead he could argue that we should act and defend those values from a moral point of view for the realization of the envisioned common good and do not wish to make another choice nor to open to further (if it is further) discursive consensus-formation regarding values. In these two cases, it is clear that the former position is the position of liberalism and the latter position is that of communitarianism. As Habermas differs from Rawls in advocating the procedure of discourse and communicative action in distinction from the semi-constitutional approach of Rawls, we may in fact call the Habermasian one the "discursive liberalism" and the Rawlsian one the "semi-constitutional liberalism." But it is also clear that a liberalist position need not deny that we can live on values which include our rights that are already incorporated in our community. It needs to set itself against communitarianism. Similarly, a communitarian could agree on using our moral autonomy to propose many new rights with their value contents without having to give up one's committedness to a system of values which have proved to be a common good and a shared vision of ideal society.

We may still have the dispute whether rights are prior over values or values prior over rights, but this dispute is simply a matter of conviction and formal style. It could be such that both a liberalist and a communitarian value the same set of rights for the individuals and the same set of values for the community, and there exists no incompatibility between these two sets; then whether one set must be chosen first before the other is an open question which should be judged on both the rights ground and the values ground because both must appeal to our primary moral consciousness of a moral principle or moral point of view. We may not have a decision procedure for making a general choice and not every dispute on concrete right versus value is formally decidable. To resolve conflicts, we have to recover our moral vision in formatting our moral principle and our moral consensus in the long run. I see that Rawls has every reason to count rights as primary goods and his two principles of justice are precisely an attempt to combine and synthesize the liberalist and communitarian positions. Of course, he is more a liberalist than a communitarian because he places the first principle prior to the second principle. Yet there is no logical reason why he could not also justify the first principle in terms of the second principle insofar as he is speaking of rights as primary goods. Whether one wishes to maintain given rights over given values or to maintain given values over rights, it is simply one's free decision to make; but such a decision need not be defended as an exclusively valid moral decision, because both rights and values could result from this freedom to make a decision.

As a Confucian thinker takes the position that *ren* should be universally

practiced and other virtues following *ren* must also be cultivated within oneself to form a moral person and a moral community, there are both liberalist and communitarian elements in the Confucian ethics. As argued above, the individual moral consciousness of *ren* marks the formation of a free and equal individual human person. The cultivation of a person according to the content of the moral principle of *ren* together with other implicated virtues are germane to the perfection of the human person as a moral individual who would transcend private interests and collective prejudices to claim values of a common good for the whole humanity. A Confucian thinker is ultimately and primarily a rights person but his rights are not separable from virtues which pertain to his perception of human relationships.

As I pointed out above, Confucius is morally concerned not only with what a person ought do but with what he ought to become and be. He has proposed a systematic transvalution of the ancient terms as a way of fulfilling the moral potential of the human person and the human community as constituted by the morally self-cultivated human persons. The Confucian ethics is very much an ethics of norms and an ethics of rights. Yet on the other hand, since the Confucian articulation of values did hark back to an idealized tradition of the past and the values which Confucius came to see did become incorporated in the community and became a tradition by itself since the Han times, there are as many reasons to call the Confucian ethics an example of communitarianism as would Aristotelian ethics in the pre-modern West according to Alasdair MacIntyre.[42]

In actuality Confucian ethics is both liberalist and communitarian in intent: the Confucian moral principle exhibits the principles of freedom and equality of all persons and it argues for the perfection of a person in the perfection of others and humanity. Confucian liberalism disposes itself toward Confucian communitarianism, and Confucian communitarianism, as it requires the free and equal participation of all persons in a process of interactive communication and action, would also dispose itself toward Confucian liberalism, which would become a program of regenerating values and incorporating moral and political rights in a modern democratic society. This would then demonstrate how the modern disputes about priority of rights or values, about liberalism and communitarianism, could be resolved on the Confucian grounds of unifying and integrating both in a continuing dialogue and dialectics of individual reflection and collective discussion.

CONCLUDING REMARKS.

In the above we have dealt with Habermas's discourse ethics in contrast with Rawls's reflective original-position moral point of view in an effort to bring

out the dominating issues of moral consciousness of universalizable oughtness for a critical evaluation in light of the Confucian ethics of moral self-cultivation. It is important to see this approach as both comparative and critical-analytical because it focuses on the central issue of moral consciousness in a human person. It leads to questions of universalism versus relativism, construction versus reconstruction, procedural reason and substantive reason in moral-practical discourse, as well as the formal-substantive issues on the priority of rights over values or values over rights.

In the spirit of a discursive communicative action, we bring in the Confucian point of view in order not only to mediate between the Habermasian and the Rawlsian approaches but to articulate the actuality and potentiality of the Confucian view as a modern theory of morality despite its old age. Perhaps it is due to its old age that we can come to see how rights and values are equally needed and are inseparable as elements in a reflective stream of moral consciousness of the human person. With such a stream of moral consciousness as both a background and as an intersubjective context of discussion, we are able to forge an actual way out from the contemporary debate between liberalism and communitarianism to which both Habermas and Rawls have made invaluable contributions. It is also interesting and relevant to note briefly that it is by combining the liberalist and the communitarian positions that we could transcend both the pre-conventional and conventional forms of morality and transform our moral discourse and moral norms into a post-conventional understanding of moral intersubjectivity and moral inter-humanity as understood in the Confucian ethics.[43]

There are many other issues which remain untouched, but this mediational approach of Confucianism should provide an example of how modern controversies about moral theories and moral issues should not be limited to only Western sources or Western participants.

CHUNG-YING CHENG

DEPARTMENT OF PHILOSOPHY
UNIVERSITY OF HAWAII AT MANOA
JANUARY 2000

NOTES

1. See Jürgen Habermas, "Reconciliation through the Public Use of Reason: Remarks on John Rawls's *Political Liberalism*," *Journal of Philosophy* 92, no. 3 (March 1995): 109–31; John Rawls, "Reply to Habermas," ibid., 132–80.

2. More is to be explored both empirically and theoretically, for this involves the question of how human understanding, as brought out by what Habermas called "communicative action," would contribute to a globalization of humanity apart from

and in addition to globalization of economy and politics, which are largely rational-purposive activities leading to possible forms of domination.

3. Ibid., 131.

4. See "Remarks on Discourse Ethics," in *Justification and Application*, trans. Ciaran Cronin (Cambridge: MIT Press, 1995), 29–30.

5. Contemporary epistemology has shown how a mainstream position of internalism and foundationalism on knowledge has been challenged and taken over by the position of externalism and non-foundationalism. Our account of knowledge has to change according to what criteria we have to introduce to characterize our knowledge.

6. See "Reply to Habermas," 133–39.

7. From his "Reply to Habermas," 132–80.

8. Rawls also points out that the constitutional approach implicit in the original position theory can be also an open process of active and positive engagements and corrections. For making a strong point on this, Rawls even quotes Jefferson's idea of holding a constitutional convention every nineteen or twenty years for revising or remaking the American constitution. See "Reply to Habermas," 160.

9. Habermas does not agree with this for he thinks that normative validity comes from general agreement or consensus from a discursive argumentation among participants of a community to which a given norm applies. But the question is: Are we speaking of limited community or an unrestricted community of participants? If the community is intended as universal as his moral universalism requires, we have to deal with a case of representation or we have to bring in some justification of the validity of a norm on the strength of a comprehensive theory or the overlapping consensus of many comprehensive theories as embodied in various cultural traditions or perspectives.

10. See the *Analects* of Confucius, 7–30 (according to *Harvard-Yenching Index to the Analects*). The translation of this quotation and other quotations from the Confucian texts are exclusively my own.

11. The term *yu* has the double meaning of will and desire or wish. The term has been generally more used in connection with physical needs and desires. But in speaking of *yu-ren* or desiring benevolence or moral goodness, *yu* becomes a mental act directed to an ideal state and a principle which only will is able to do.

12. We might posit that the reification of rightness as a source of right action in a human person would be the basis for the origin of rights as both attributive or inherent properties of the human person.

13. Here we use the well-established notion of the human heart and human mind in holistic unity as embodied in the Confucian philosophical texts. See my article "Confucian Hermeneutics: Morality and Ontology," forthcoming in the first issue of 2000 *Journal of Chinese Philosophy*.

14. In arguing and showing how this deontological and teleological consciousness of oughtness is actually embodied and represented by the Confucian notion of *ren* (humanness/humaneness/humanity/inter-humanity), we need to point out the presence of a consciousness of self in the formation of *ren* upon the willing of *ren* in a human person. We shall see how this moral *self*-consciousness eventually leads to the notion of human nature (*xing*) as an existential source of *ren* consciousness.

See my article "Toward a Theory of Confucian Selfhood: Self-Cultivation and Free Will," *Komparative Philosophie, Begegnugen ziwishen Oestlichen und westlichen Denkwegen*, edited by Rolf Ebrfeld, Johnann Kreuzer, Guenter Wohlfart, and John Minford (Muechen: Willhelm Fink Verlag, 1998), 51–86.

15. See the *Analects*, 12-22.

16. See ibid., 12-2.

17. See ibid., 6-30.

18. See ibid.,12-1 (8).

19. Consider what Confucius has said: "If a superior person gives up *ren*, how could he be called a superior person? The superior person does not violate the *ren* even during the brief period of a meal. At any time of life whether smooth or difficult one would not violate the *ren*." The *Analects* 4-5.

20. See his book *Factuality and Validity* 1992, 11.

21. Habermas, "Discourse Ethics: Notes of a Program of Philosophical Justification," in *Moral Consciousness and Communicative Action*, trans. Christian Lenhardt and Shierry Weber Nicholsen (Cambridge: MIT, 1993), 65.

22. We shall see that self-reflection of the human individual, overlapping consensus in a community as well as an open process of communicating action and interaction, are equally crucial for moral consciousness and moral will formation of a community regarding their self-understanding of the nature of the moral individual.

23. See Kant, *The Groundwork of the Metaphysics of Morals*, trans. from the German original of 1785 by H. J. Paton, (London: Hutchinson, 1948), 421.

24. Habermas, *Moral Consciousness and Communicative Action*, 66ff.

25. See John Rawls, *A Theory of Justice* (Cambridge: Harvard University Press, 1971), 136–37.

26. Rawls, "Reply to Habermas," 116–17 and 134–35.

27. Ibid., 176–77.

28. See *A Theory of Justice*, 48–51.

29. See the *Analects*, 12-22; 20-3; 7-31.

30. Ibid., 20-3.

31. See the Mencius, 2a-2.

32. See the *Analects*, 13-3. Both Mencius, after Confucius, and Xunzi, after Mencius, have continued to advance this doctrine. In Xunzi's famous essay "On Rectifying Names" we see Xunzi distinguishes three fallacies in using names in language: the fallacy of confounding names with actuality, the fallacy of confounding actuality with names, and the fallacy of confounding names with names.

33. For those who are not familiar with the Chinese language it is important to understand that we are speaking of another Chinese character with a different meaning which just happens to have the same sound of the word *li* which stands for rites, proper rules, and a system of moral/ social norms and which I have discussed in the earlier parts of this essay. I designate this *li* as *li₂* in distinction from the first *li* simply written as *li*.

34. See Zhu Xi, *Zhuzi Yulei* (Classified Conversations of Zhu Xi), first part.

35. See his work *Mengzi Ziyi Suzheng* (Commentaries on the Conceptual Terms of the Mencius), especially its part 3.

36. See the Mencius (Harvard-Yenching Index), 2a-6.

37. For discussion of this and other meanings see Chung-ying Cheng, *New Dimensions of Confucian and Neo-Confucian Philosophy* (Albany: State University of New York Press, 1991); part II, chapter 11, "Dialectic of Confucian Morality and Metaphysics of Man: A Philosophical Analysis."

38. For this issue see Habermas's position in his "Remarks on Discourse Ethics," sections 6, 11, and 12, in *Justification and Application*, op. cit., 48ff and 88ff. He says also, in his critique of Rawls, the following: "An equal distribution of rights results only if those who enjoy rights recognize one another as free and equal," "Reconciliation through the Public Use of Reason," op. cit.

39. Ibid., "Reconciliation through the Public Use of Reason," 114.

40. Ibid., 115–16.

41. Ibid., 146–47.

42. See Alasdair MacIntyre, *Whose Justice? Which Rationality?* (Notre Dame University Press, 1988); also confer Habermas's critical discussion in his *Justification and Application*, 96–105.

43. For a challenging discussion on the problem of stages of moral development and the formation of the highest desirable form of moral consciousness and moral discourse and action, see Habermas's essay on "Moral Consciousness and Communicative Action" in *Moral Consciousness and Communicative Action*, op. cit., 116–94.

12

Enrique Dussel

The Formal Thought of Jürgen Habermas from the Perspective of a Universal Material Ethics

In the thought of the latest thinker of the Frankfurt School there is continuity about a theme of profound political sensibility: From the concept of the "public sphere [*Oeffentlichkeit*]" to the notion of intersubjective validity in arguments "free from domination" there is a commitment to the problematic of a democratic institutionalization of legitimation. This issue brings together the whole of Habermas's life, and it is organized around the attempt to restore the ethical sense to the merely "external" level of the political or of law [*derecho*], as found in Kant when the latter writes: "Just as law in general has as its object only what is external [*äusserlich*] to actions, law strictly, that is, what is unmixed with anything ethical, demands nothing but external foundations for the determination of the will."[1]

Habermas attempts to reconcile the public (external) or political level with the ethical level. In any case, we can find two periods [*épocas*] in the development of Habermas's philosophy, which are definable in terms of a political crisis (namely, the student leftism of '68), and a theoretical crisis (namely, the systematic subsumption[2] of the philosophy of the *linguistic turn*).

I

The first period (the last period in the "first" Frankfurt School) begins with Habermas's work at the Institute as an assistant in 1956 and his first works on Frankfurt's student politics, and it could end with the appearance of

Translated from the Spanish by Mario Sáenz.

Towards the Reconstruction of Historical Materialism[3] (when our philosopher finds himself already fully in his second period).[4] The problematic of this moment, simplifying its great richness, is framed on one side by the methodological debate already began by Adorno against Popperian positivism in particular.[5] We have a critique of instrumental reason from a dialectical or ontological position. The central work of this period is *Knowledge and Interest* in 1968. The philosophy of liberation learned a lot from this first Habermas. On another side, this moment is framed by a dialogue with Marxism, which had then a strong tradition in Germany (and the world). The central philosophical work here is *Theory and Praxis* of 1963.[6]

We want to focus on one issue in order to reveal an early reductionism in Habermas's thought, specifically, a certain difficulty in discovering the sense and universality of what we have called the material aspect of ethics (in terms of its content). As a matter of fact, his interpretations, beginning with his first works, point to a reduction of one of Marx's fundamental intuitions; this is so from the beginning because he never "practiced" political economy. Habermas says, "In the advanced capitalist countries the standard of living, including that of broad sectors of the population, has risen so far that society's emancipatory interest cannot be expressed any more inmediately in economic terms. *Alienation* has lost its self-evident economic form."[7]

As the reader can imagine, in Latin America, Africa, and Asia (85% of today's humanity) such considerations do not make sense. In a text of his second period, Habermas again exhibits his vision of political economy:

> In the eighteenth century it [political economy] entered into competition with rational natural law and brought out the independence of an action-system held together through functions and not primarily through norms [. . .] Economics as a specialized science has broken off that relation. Now, it too concerns itself with the economy as a subsystem of society and absolves itself from questions of legitimacy.[8]

Habermas refers always to sociology (a social science that since Weber situates itself at the formal level), but he systematically leaves aside political economy, which would have forced him to reflect on the material aspect of ethics. Let us look at the question from a key case: How does Habermas deal with Marx? Often in an indirect way, rarely in a textual way. When he does the latter, he commits serious interpretative mistakes. Let us take two examples. The first is from *Theory and Praxis*,[9] and it refers to a text from Marx's *Grundrisse* where Marx writes:

> To the extent that big industry develops, the creation of *real wealth* becomes less dependent on labor time and the quantity of labor used . . . [T]he same

movement does not take place at the same time in relation with the *immediate* labor time that its production costs, but it depends instead on the general state of science and the progress of technology.[10]

Habermas tries to show that there is a contradiction in Marx's labor theory of value. However, we must not forget that Marx's text refers to "fixed capital."[11] We are not dealing with a "revisionist" text, but rather with the use of a category that Marx was still developing in 1858.[12] Contrary to what Habermas thinks, Marx shows that the law of value applies; for, the machine (or science or technology) consumes in its use (namely, in the circulating value of fixed capital) less value than "labor-power"[13] would have consumed in the production of the same use-value.[14] The machine, science, or technology do not create exchange-value; they only transfer and save exchange-value; that is, they make it possible for more use-value to be produced in the same amount of labor-time (or equal amounts of use-value with less exchange-value). They are not in any way, contrary to Habermas's opinion,[15] "sources of [*exchange-*] value," which is what interests Marx. That is to say, "the creation of real wealth [use-value] becomes less and less dependent on labor-time." I do not see how there can be any contradiction here. Consider this other example.

Habermas wants to show that: "Marx always refers to something like nature *in itself,* which has priority with respect to the world of men. . . . *Nature in itself* is an abstraction. . . . Kant's *thing-in-itself* reappears under the form and title of a nature prior to human history."[16] The text to which Habermas refers is from Marx and Engels's *The German Ideology*:

It is true that the priority [*Priorität*] of external nature remains, and that all of this is applicable to primeval man . . .; but this difference only makes sense as long as man is regarded as something distinct from nature. Besides, this nature that is *anterior* [*vorgehende*] to human history is not the nature in which Feuerbach lives, but rather a nature that, besides a few Australian coral islands of recent formation, does not exist today anywhere and, therefore, does not exist for Feuerbach either.[17]

This issue, which seems only secondary and terminological, leads directly to the "material" question in ethics to which we want to refer. In fact, Marx points explicitly to the opposite of what Habermas wants him to say. Marx asserts critically that in Hegel "nature" is only a negative moment that has value only in the process of subsumption [*Aufhebung*] of self-consciousness, that is, of the thinking that returns to itself towards Absolute Knowledge. "Nature" as such is not relevant for Hegel. Marx has to show that nature exists "of itself" (and from itself), in order to refute Hegelian absolute idealism. But what really interests Marx (in contrast to naïve or meta-

physical-cosmological materialists, and later standard Marxist positivists) is nature as "matter [*material,* with "a," that is, content][18] of labor" (for example, as culture or as economy), because mere "nature prior to human history"—and here Marx's irony is lost in Habermas—is of interest to neither Feuerbach nor Marx, nor to the Ethics of Liberation. Marx points to some of the essential moments of a material ethics: "The objects of man's drives exist *outside* [*ausser*] him. . . . Hunger [*Hunger*] is a natural *necessity* [*Bedürfnis*]; man needs therefore a nature[19] *outside* him, an object *outside* him, to satisfy and calm himself. . . . The sun is the object of the plant, an indispensable object for it, a giver of life.[20]

It is here that we can appreciate how for Habermas the material aspect (in German, *material* with "a," *qua* "content" [*Inhalt*]) of ethics in Marx consists only in labor, in physical-animal survival [in German, *materiell,* with "e"]. Furthermore, Habermas does not take into account the universal ethical principle of reproduction and growth of the human life of the subject, which Marx always has as a part of the horizon of his (pre-ontological[21] and ethical) political economy. Habermas cites the following by Marx.

> Labor is an *independent condition* of all social formations *of human existence* [*Existenzbedingung des Menschen*] insofar as it is formative of use-values or is useful labor; it is a natural and eternal necessity of mediating the exchange between man and nature, and, consequently, of mediating *human life* [*menschliche Leben*].[22]

I think that Habermas is not aware of the importance of the text cited above. By contrast, it is a fundamental thesis in our Ethics of Liberation. In fact, Marx is referring to nothing less than the always presupposed material *universal a priori* criterion (and principle) from which one "posits" and "critiques" goals, values, cultures, economic systems, and ontological horizons; also, that criterion is *internal* to all of those levels. First, in the Ethics of Liberation one always speaks of "*human* life," and not of merely physical or animal life; that is to say, it refers to the higher functions of the mind (for Marx these are consciousness, self-consciousness, and freedom), and of culture and economic systems. "*Human* life" reproduces itself and grows in the dialectical relation of the human being with nature (that is, the living and its medium, which are not reducible to a merely physical nature). The transcendental relations of that real human subject's life cannot be merely contemplative, linguistically expressive or passive; they have to be active or *real* relations. In this transcendental and always necessary sense, labor is the *actualization* of the condition[23] of human existence, independently of all social formation; the "metabolism" or exchange between humans and nature consists of this.

Life is the absolute pre-ontological condition of human existence or reality in general (here the "ontological" is understood as a historical system); it is the universal "content" of "originary ethical reason"; it is from life that "originary ethical reason" may assert "ethical judgments of reality" with regard to ends themselves (and their value judgments), and to cultural values (and their value judgments). This level is not merely the level of the "transcendental conditions of possible objectivity of the objects of experience."[24] Instead, it is the content of reality itself *qua* vitality [*Lebendigkeit*], *qua* mode of reality from which the human moves as a "possible" subject. It is human life and not mere nature. Marx says that

> Man is not only a natural being, but instead a *human* natural being [*menschliches Naturwesen*]; since he exists for himself . . . , he has to prove himself by his own action, both in his being and in his knowing.[25] *Human* objects are not natural objects as these immediately appear; nor are the human senses mere *human* sensibility, human objectivity, in their direct and objective reality. Nature is not found ready-made either subjectively or objectively for the *human* being.[26]

Furthermore, Habermas affirms often in many of his texts that Marx's concept of labor does not sufficiently account for "interaction," and that Marx thus falls into "productivism." Habermas does not realize that Marx is situating himself at a more fundamental level. Marx is interested in referring to a *material universal criterion of the human life of the subject*. This level lies beyond all cultures and economic systems. In relation to this fundamental level, cultures, economic systems, values, and ends (that is, those posited by Max Weber) are "modes" for realizing "the reproduction and growth of *human* life." Labor, the relations of production, capital as a system (or "totality"), and the economy itself (as activity and "science") are moments in a process of "reproduction and growth of human life" (namely, the "sur-vival" of the human subject), which ground materially, because of their "content," the whole of human ethical life.

Thus, Habermas criticizes Marx in this first period of the former's theoretical development from a dialectical perspective of *interaction*, reducing Marx's thought to the horizon of instrumental reason (specifically here as a productivist reason).[27] I think that Habermas—in this period from the perspective of an ontological dialectic and, afterwards, from a pragmatic point of view—has not paid attention to Marx's fundamental intuition regarding the material aspect (that is, of ultimate *content*) of a *universal* ethics; this ethics proposes the criterion of the reproduction and growth of the human life of the subject in community as condition always presupposed for the possibility of the human reality as such. Within the sphere of reality, in which the practical-material or original-ethical reason is operative, one

discovers the exigencies and fundamental duties that can "posit" and "judge" the ends, values, well-being, virtues, and other material moments of ethics, from *within* the cultures themselves (that is, projects for "the good life"). I do not think that Charles Taylor reaches this level of depth.

II

In his second period, the definitive perspective of which is already evinced in his 1976 work "What is Universal Pragmatics?,"[28] Habermas assumes the thematic developed by Apel in the decade of the seventies. This thesis is expressed in Habermas's recent works starting with *The Theory of Communicative Action*[29] and especially his works on discourse ethics.[30] In this period the interlocutors change. First, on the philosophical front, the interlocutors are the analytic philosophers of the *linguistic turn*, regarding whom Habermas articulates the transformation from a solipsistic and abstract paradigm towards pragmatics, the metaphysical thought of someone like Dieter Heinrich,[31] and postmodern irrationalism.[32] Second, on the political front, Habermas's preoccupation is to ground social democracy, and the state of law[33] in Europe and Germany in particular, on a formal rationality. In the third place, on the front of the strictly ethical problematic rooted in Apel's thought, we are dealing with Habermas's confrontation with material ethics (such as Taylor's) and in even more detail with the formal analytic and Rawlsian[34] ethics. Here, on this third front, we will be able to see that it is not possible for Habermas to ever integrate a material moment (and even less Marx's economic sphere or Freud's psychoanalytic horizon [*ámbito*]) to his thought; because of this, he will lose once and for all in this second period of his thought the already diminished "critical theory" of the first Frankfurt School. Let us focus only on this third moment, namely, Habermasian discourse ethics.

In *Moral Consciousness and Communicative Action* we find one of the most extensive texts on the theme of morality proper,[35] written by Habermas under the pressure of MacIntyre's critique.[36] In it, Habermas sets out to deal with the subject of moral foundations, rejecting the notion of an "ultimate" foundation towards the end of the essay in a critique of Apel.[37] Strawson's thought permits Habermas to start from a phenomenological (and not merely formal) description of a phenomenon in which, incidentally, the Ethics of Liberation is keenly interested: that is, "the sense of indignation with which we react when faced with offences . . . in the case of actions that injure the integrity of the other."[38] Here it is shown in a participatory description that ethical attitudes and feelings (for example, culpability or the awareness of an ought), which the empiricist sceptic cannot deny, are something different

from mere "affectively neutral judgments on means-ends relations."[39]

Since Toulmin,[40] there begins a demolition of many moral studies in the analytic tradition. Connected with this, Habermas rightly demonstrates that it is necessary "to explain the meaning of *moral truth*,"[41] by distinguishing between the validity-claims of *descriptive statements* (constative or assertive, which would be something like Weber's "judgments of fact"[42]) and the validity-claims of *normative statements* (prescriptive and practical, which should be distinguished from Weber's "judgments of value"). The former have claims to truth, and the latter have claims to rightness[43] (or "moral truth"). Because of this, G. E. Moore is mistaken when he pretends to put "good" and "yellow" on the same level. As a matter of fact, analytical formalism since that beginning in 1903 criticizes the material ethics of the utilitarians precisely on this issue: "Our first question is, then, what is good? and what is bad? And I call *ethics* the examination of this question (or these questions)."[44]

Moore took the wrong turn by identifying descriptive predicates (for example, yellow) with prescriptive predicates (for example, good).[45] Because of repeated failures, subjective solutions were attempted:

> With equal clarity Toulmin has seen that the subjectivist response to the failure of the moral objectivism of Moore and others is only the other side of the same coin. Both sides begin with the false premise of the truth-validity [*Wahrheitsgeltung*] of descriptive claims . . . because normative claims . . . cannot be proved by using the same rules used for descriptive claims.[46]

Habermas thinks that both types of claims must also be distinguished from emotional or subjective claims (which express preferences, convictions, requirements, wishes, or inclinations).[47] Ayer[48] identified them, thus confusing them. In the same way, Hare,[49] with a prescriptivist attitude, is of the opinion that "existential claims, imperatives, and intentional claims would be the most adequate linguistic forms"[50] that a meta-ethics must study. Thus, Hare wants to show that it is impossible to argue or to claim any validity whatsoever for moral statements. According to Habermas, analytic meta-ethics is sceptical, not cognitivist. The moral everyday world is completely devalued from a scientific or objectivist point of view.[51] Habermas tries to show that it is a rational task to prove the validity claims to rightness of normative statements and of moral decisions that seek to arrive at an intersubjective understanding. The whole issue of "foundations" in the context of normative acts consists in this.

One must distinguish, therefore, (1) the descriptive claims, "Iron is magnetic" and "It is true that iron is magnetic" from (2) the normative claims, "One shall not kill" and "It is an imperative that one should not kill." Their objectivity is different, since in "normative validity claims (2) there is

an obvious reciprocal dependence between speech and the social world, which is not the case, by contrast, between speech and the objective world in (1)."[52]

Furthermore, our philosopher from Frankfurt strives to develop, through the aforementioned distinction, a foundational principle for all practical discourse (or normative statements), namely, the principle of pragmatic communicative universality. By integrating the positions of K. Baier[53] and B. Gert,[54] Habermas argues that normative claims ought to be universally[55] and publicly open to argumentation in order to attain a "rationally valid formation of the moral judgment." Thus, he arrives at the "principle of Discourse Ethics (D)": "A norm can aim at validity only when all those affected [*Bettroffenen*] by it can reach an understanding [*Einverständnis*] inasmuch as they are participants in a practical discourse (or can reach an agreement) in which such a norm is valid [*gilt*]."[56]

This principle "D" needs a "bridge principle [*Brückeprinzip*]" that is neither monological[57] nor fictitious (as, by contrast, Rawls's "original position" is) in order for it to be possible to *apply* it.[58] The [following] principle "U" deals with a *real* argumentation by those affected in their needs, concerning which it is necessary to carry out a discursive proof:

> Every valid norm must satisfy the condition that the consequences and secondary effects that follow from its *general* observance for the satisfaction of (presumably) the *interests* of each person can be as a result accepted by *all* affected persons (and also preferred by them to the effects of substitutive regulatory possibilities).[59]

Here is where the formal touches on the material: "Needs [*Bedürfnisse*] are interpreted in light of cultural values [*kulturelle Werte*]; since these are always a component part of an intersubjectively shared tradition, the revision of those values that interpret *needs* is not something of which isolated indi- viduals can dispose monologically."[60]

How is it known that 'X' need determines the ethical requirement to bring the affected person to the discussion? Are the affected persons brought to the discussion under conditions of symmetry? Who or what ethical criterion discovers said needs and with what principle is symmetry "produced"? Habermas does not solve these and many other material problems.

Lastly, what is a material ethics or an ethics of content for Habermas? First, it is at this level that one finds value statements. Let us consider the following text.

> When we define practical questions as questions regarding the good life [*guten Lebens*], referable in each case to the totality of an individual form of life [*das Ganze einer individuellen Lebensform*] or to the totality of a particular

biography, ethical formalism is, in fact, decisive: The postulate of universality functions as a knife that cuts in *the good* [*das Gute*] and *the just* [*Gerechte*],[61] and between evaluative statements [*evaluative Aussagen*] and strictly normative statements.[62] Cultural values carry with them, of course, a claim to intersubjective validity[63]; but they are so implicated in the totality of a particular form of life that they cannot aspire, without more, to normative validity in the strict[64] sense.[65]

Habermas can consider only one relation, namely, between morality and ethics. By contrast the Ethics of Liberation can consider five. Let us look at the question in more detail.

FIGURE 1

Relations between the Formal-Moral and the Ethical-Material Levels

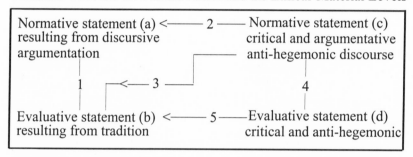

Explanation of Figure 1: Relation (1): The only relation indicated by Habermas's analysis. Relations (2) to (5): Relations suggested by the Ethics of Liberation.

For Habermas the evaluative statement is fixed; it seems that it is not criticizable. The only relation (relation 1) that Habermas can analyze is the one that points to the passage from the dogmatic level of the evaluative statement (b) to the normative statement (a) with intersubjective, rational, argumentative validity. The Ethics of Liberation can also (in relation 2) question valid moral agreements (a)[66] from the standpoint of critical normative statements (c).[67] However, and this is even more important, the oppressed may also call into question discursively (in relation 3) prevailing evaluative statements (b), but now for them argumentatively judged to be oppressive and dominating. They will also be able to argue with a validity claim to material rightness (in relation 4) future evaluative judgments (realistic and possible utopia) (d), from which standpoint, materially or by their content, they will be able to call into question prevailing evaluative judgments (b) (in relation 5). This is a case of an "inversion of values

[*Umwertung*]" for which Nietzsche was not able to adequately explain either the ethical sense or the practical rationality in use.[68] This is an ethical "continent" that Discourse Ethics should still discover but has not discovered; but then, it would stop being Kantian even if its Kantianism were to be radically transformed. This is not a case of either morality or ethicity exclusively, but rather of morality, ethicity, and criticizability articulated in terms of process or diachronically without exclusions. This is a new ethical project and a new architectonic, as we will see.

Habermas cannot analyze what evaluative statements are, nor can he analyze what type of rationality, even argumentative rationality and critical discursive rationality, they have. They are formal insofar as the intersubjective procedure, whether private or public, is concerned; and they are material because of their content and with a view to the requirements that the reproduction and growth of the human life of the subject express. The reason why Habermas is unable to make this analysis lies in his absolute exclusion from morality of an ethics of content: "[Morality] has nothing to do with axiological preferences, but rather with the ought-to-be of norms of action."[69]

Normative statements may be evaluative (with a claim to rightness because of their material content or their ethical truth), or they can be merely moral (with a claim to formal or moral validity): "In this respect, it is reasonable to classify discursive ethics as *formal*. It does not offer any orientations[70] whatsoever regarding content, but only a procedure [*Verfahren*], that is, that of a practical discourse."[71]

Secondly, as is also the case with Apel, the material in Habermas is only the cultural ("the totality of a particular form of life"), the hermeneutic-ontological. This level is not transcended. There are texts in Habermas that seem to suggest otherwise: "Cultural values transcend factual processes of action. . . . Axiological orientations illuminate and make it possible for subjects to distinguish between the *good life* and the mere reproduction of life [*nackten Lebens*]."[72]

Unfortunately, this "life" as such is *only* biological, vegetative-animal life. It is not "human life" as absolute condition of possibility, and universal criterion with respect to which each culture is a mode of life's reproduction; because of that, Habermas cannot discover ethical-material exigencies or requirements, the "ought-to-be" that "human life" involves in its own content.[73] (We are thus arguing also against those who think that there is a naturalist fallacy involved here.)

Habermas, in a long polemical text aimed at D. Heinrich,[74] deals practically with the question of the reproduction of the concrete human life in a manner very similar to the one which I would have defended. But Habermas does not realize that it has to do with the whole problematic of a content ethics:

The process of self-conservation [of human life], by having now to satisfy the conditions of rationality of communicative action, goes on to depend on the interpretative actions of the subjects who coordinate their action through validity claims open to critique. . . . Unlike instrumental reason, communicative reason *cannot* [!] be subsumed *without resistance* under a blind self-preservation [of human life].[75]

Here Habermas does not know how to articulate the moral-formal intersubjective principle of a Discourse Ethics with an ethical-material principle of a material ethics; he contrasts them, denies the latter, and cannot conceive their unity.

Third, Habermas busies himself with the grounding of the "only"[76] formal principle of a Discourse Ethics. On our part, we are of the opinion that the material principle of every possible ethics must still be grounded. Habermas's reductionist view of the material level compels him at the end to accept with Apel that "ethics of a Kantian type specializes in questions of *justification*, but it leaves without answer questions relative to its *application* [*Anwendung*]"[77]:

Every deontological ethics, which is also cognitivist, formalist and universalist, owes its relatively rigourous concept of morality to an energetic abstraction. Therefore, the problem is posed as to whether questions of right [read here *validity*] can be isolated from the particular contexts in which the idea of the good life is in each case defined.[78]

This "energetic abstraction," which is also carried out in the Ethics of Liberation, is not "energetic," but rather, reductivist of the level of ethical content; consequently, the second moment cannot be carried out:

The question immediately arises . . . as to whether the ideas that stem from a universalistic morality have the possibility of being applied in practice.... What happens to the moral justification of a political action that sets for itself the goal of creating the social conditions in which it is possible[79] to develop practical discourses?[80]

Since Discourse Ethics cannot take recourse in an "objective teleology" (another reduction of the ethical-material level), nor

is it in its hands to make amends for the injustice and the pain suffered by past generations, on which our actual situation bases itself, is it not obscene that we, who were born afterwards, who are the beneficiaries of its norms . . . dare to suppose, at least counter-factually, the agreement of those humiliated and offended in the past?[81]

According to Habermas, ethics must "renounce to make on its own substantial contributions."[82] Hence,

The moral philosopher does not have a privileged access[83] to *moral truths* [*moralischen Wahrheiten*]. [This is so] in light of the four great political-moral shames that affect our existence: The hunger and misery of the Third World, torture and the continuous violation of human rights in states without law, the growing unemployment and disparity in the distribution of social wealth in the industrialized nations of the West and, finally, the risk of self-destruction that nuclear armaments pose.[84]

Habermas has expressed here some of the themes that concern the Ethics of Liberation. The only difference is that since Discourse Ethics is purely formal, it cannot enter into a rational-philosophical discourse regarding content; that is not the case with the Ethics of Liberation. There is, then, in Habermas an awareness of the problems and of the impossibility of dealing with them; for, the procedural moral function, if it is articulated to a material ethics, must be to apply the contents; but if it has not defined these appropriately, it is then a vacuous logic.

Fourth, by discursively grounding a norm that is lacking in "a motivational anchor for moral ideas," "the postconventional interweaving of morality and ethics signifies a loss or diminution of the support provided by cultural evidence and, in general, by the constitutive certainty of the lifeworld."[85] This is partially compensated by will-formation in a constitutional state. The Ethics of Liberation, by contrast, does not lose contact with the level of content; instead, it adds a profound sense of solidarity to an anti-hegemonic critical intersubjectivity and never loses the "support of cultural evidence"; even though it often maintains a critical-negative attitude, it is moved by projects of liberation which are also material.

Fifth, facing the impossibility of formulating concepts such as those of "universal justice, normative rightness, a moral point of view independent from a vision of a *good life* [*eines guten Lebens*]," Discourse Ethics confronts a greater difficulty: "It is possible that until now the formulation of a moral principle with independence from context has not yet been achieved. But successful new perspectives [. . . open up,] in terms of a negation of the wounded and broken life, rather than in terms of a positive reference to the good life."[86]

This Habermasian suspicion could be analyzed in greater detail when we study in another work the material origin of critique in the negation of the proposed "good life," and even more radically in the negation of the human life of the subject as such (for example, in the poverty and marginality of our time). Habermas posits the problem by approximation, but the architectonic of his system is too narrow to allow him to analyze extensively his own intuition. In fact, it will be by means of a negation of the positive principle of material ethics (in for example, Marx, Freud, Foucault, Levinas, and so on), that critique is possible; but for that, one must affirm beforehand the

universality of the material principle (which, again, is impossible for Habermas).[87] His unawareness of the material principle in ethics prevents him from discovering ethically the impossibility of the reproduction and growth of the human life of the subject in this or that concrete (and filled with content) ethical system.

Sixth, and we side here with Hegel against Kant, Discourse Ethics "tears problematic actions and norms from the contexts of substantial ethicity represented by the lifeworld, in order to subject them, in a hypothetical attitude, to examination without taking into account operative motives or prevailing institutions."[88] By contrast, the Ethics of Liberation begins positively at the material level (not only in the sense of culture but also from within the universal compass of the reproduction and growth of human life in general); yet it confronts concrete material problems critically and problematically from the standpoint of an anti-hegemonic intersubjectivity, thus having abandoned the naïve validity of hegemony, *à la* Gramsci; but that is not a reason for it to shy away from experimenting with "operative motives and prevailing institutions" (although it ought to overcome them transformatively).

Seventh, the Ethics of Liberation cannot accept Habermas's suggestion of "the primacy of what is morally obligatory or right [*Richtigen*] over what is ethically desirable or preferable."[89] It cannot accept, either, Taylor's contrary proposal.[90] It is necessary to articulate both aspects, taking up both of them positively,[91] as codeterminations without one having primacy over the other.

Lastly, Habermas proposes with Apel a post-conventional ethics, by situating himself in *stage 6* of Kohlberg's "moral consciousness."[92] However, the intersubjective community of those who have reached the post-conventional order, ruled strictly by "universal ethical principles,"[93] runs the risk of losing, as we have seen, evaluative-cultural motivations, unless they take recourse in the formation of a will that can, by means of a learning-process, constitute itself as something like a "superego," the content of which being those formal universal principles. The Ethics of Liberation, by contrast, can again not only subsume all the positive aspects of the formal universalist intersubjectivity, but also articulate it with an ethical consciousness (a *Gewissen* and not merely a cognitivist *Moralbewußtsein*) that arises from a cultural ethos, before which it critically situates itself (thus abandoning a naïve adherence to it); but it does so in such a way that it adopts its material aspects and thus transforms them and reconstitutes them into the moment of a new "growth," from the standpoint of a universal material ethical principle as the requirement for the reproduction and growth of the "human life of the subject" in general.

The "critical post-conventional ethicity"[94] of liberation does not leave aside an account of the concrete culture of the oppressed and the excluded;

it begins from that culture; but at the same time it situates itself critically with respect to Discourse Ethics insofar as the latter is not critical. For example, when Discourse Ethics confronts "late capitalism," it does not know how to criticize it *as* capitalism. It does not propose a "postconventional ethicity," but a formal "post-conventionality" *within* the hegemony of the ethicity of the culture and the system of our planet's North, without an explicit awareness of its complicity with it.

Habermas concludes one of his works by citing Horkheimer: "In order to overcome the Kantian idea of a perfect constitution, it is necessary to develop a *materialist theory* of society."[95] However, in so doing, he contradicts everything that he had said before. For, a "materialist" theory (from the German *material* and not *materielle*) requires an ethics of content, which Habermas has declared impossible in principle. By taking leave from a material ethics, Habermas bids a definitive farewell to the critical theory of the first Frankfurt School.

ENRIQUE DUSSEL

UNIVERSIDAD AUTÓNOMA METROPOLITANA
IZTAPALAPA (MEXICO CITY)
OCTOBER 1999

NOTES

Note about the translation of quoted passages: Unless otherwise noted, I translated the passages from German and English sources into Spanish. Professor Sáenz translated these quotations from Spanish into English.

1. Immanuel Kant, *Metaphysik der Sitten*, AB 36 in Immanuel Kant, *Kant Werke*, v. 6, 'Darmstadt: Wissenschaftliche Buchgesellschaft, 1968', p. 339. This "external level" is the "public sphere" that Habermas will reconstruct as the intersubjective validity of consensus in accordance with the communication community.

2. In his debates Habermas does not reject his opponents' positions; instead he subsumes them and enriches himself through them.

3. Jürgen Habermas, *Zur Rekonstruktion der Historischen Materialismus* (Frankfurt: Suhrkamp, 1976). See also among his works of this time the following works by Habermas: *Strukturwandel der Oeffentlichkeit. Untersuchungen zu einer Kategorie der bürgerlichen Gesellschaft* (Berlin: Luchterhand, 1962); *Theorie und Praxis* (Frankfurt: Suhrkamp, 1963); *Zur Logik der Sozialwissenschaften* (Frankfurt: Suhrkamp, 1967, 1982); *Erkenntnis und Interesse* (Frankfurt: Suhrkamp, 1968); *Technik und Wissenschaft als "Ideologie"* (Frankfurt: Suhrkamp, 1968); *Legitimationsprobleme im Sprätkapitalismus* (Frankfurt: Suhrkamp, 1973).

4. See Thomas McCarthy, *The Critical Theory of Jürgen Habermas* (Cambridge, Mass.: MIT Press, 1988).

5. See Theodor Adorno, *Der Positivismusstreit in der deutschen Soziologie* (Berlin: Luchterhand, 1969); Habermas, *Zur Logik der Sozialwissenschaften, op. cit.* (in the 1982 edition of the latter work, Habermas traces the path from Karl Popper to Hans Albert and Niklas Luhman).

6. Weber's influence is determinant, although Hegel is used to point to a wider problematic than Marx's.

7. Habermas, *Theorie und Praxis*, 228. For an extended treatment of Habermas's position on Marx see my work, Enrique Dussel, *El último Marx (1863–1882) y la liberación latinoamericana* (Mexico City: Siglo XXI, 1990), 319–33. We will refer to this work here.

8. Jürgen Habermas, *Theorie des kommunikativen Handeln* (Frankfurt: Suhrkamp, 1981), vol. I, 19; English edition: *Theory of Communicative Action*, trans. by Thomas McCarthy (Boston: Beacon Press, 1987), vol. I: *Reason and the Rationalization of Society*, 3–4.

9. Habermas, *Theorie und Praxis*, 256–57. The text is of interest to Habermas because he repeats it in Habermas, *Erkenntnis und Interesse*, 67ff., although there with other consequences.

10. Karl Marx, *Grundrisse der Kritik der politische Oekonomie* (Berlin: Dietz, 1974), 592.

11. In Marx's *Grundrisse* the question is not yet clear; for that we will have to wait until Marx's *Manuscripts of 1861–1863*. See my works: Enrique Dussel, *La producción teórica de Marx. Un comentario a los* Grundrisse (Mexico City: Siglo XXI, 1985), 291ff; and Enrique Dussel, *Hacia in Marx desconocido. Un comentario de los Manuscritos del 61–63* (Mexico City: Siglo XXI, 1988), 132ff, 153ff, and 197ff.

12. Of course, Habermas does not pay attention to the chronology of the texts he cites, and he does not know all of the problematics of the "archeology of categories" in Marx.

13. At this time Marx speaks of *Arbeitvermögen* and not of *Arbeitskraft*.

14. "Real wealth [*wirklichen Reichtum*]" is use-value, not exchange-value.

15. He calls them *Wertquelle* (Habermas, *Theorie und Praxis*, 256).

16. Habermas, *Erkenntnis und Interesse*, 47.

17. Karl Marx and Frederick Engels, *The German Ideology*, in *Marx-Engels Werke (MEW)* (Berlin: Dietz, 1956 ff), v. III, 44; Habermas, *Erkenntnis und Interesse*, 46.

18. The word *Stoff* is used, not simply to mean physical matter, but rather, as "that with which" one works. Marx does not develop a "cosmology" or a "metaphysics of nature"; he is interested instead in nature as "matter [content] of labor." It is a theory of production, not a Physics. Soviet Engelsian materialism (and Habermas's theory in this case) attribute to Marx what he is explicitly rejecting.

19. Marx writes in reference to Hegel's concept of "nature": "Nature as nature . . . is nothing, a nothing that confirms itself as nothing, that lacks sense or only has the sense of a subsumed exteriority" (*Manuscripts of 1844*, in *MEW*, v. EB I, 206). Hegel has lost the sense of the "real," and he has also confused it with the "reality

of the concept" of nature, that is, with the reality of the self-consciousness of knowing.

20. Marx, *Manuscripts of 1844,* in *MEW,* EB I, 195.

21. That is so if "ontology" is the "totality" of the Being of capital, i.e., of value that acquires value (see Dussel, *El último Marx (1863–1882) y la liberación latinoamericana,* ch. 10). An ethical critique of "capital" as *totality* is what we have called an "ethical judgment of reality" (i.e., of the system as totality, anterior to the ends of factual judgments and to the values of value judgments).

22. Karl Marx, *Capital: A Critique of Political Economy,* vol. I: *The Process of Capitalist Production* in *Karl Marx–Friedrich Engels Gesamtausgabe (MEGA)* (Berlin: Dietz, 1975 ff), *Das Kapital,* vol. I, in *MEGA* II, 6 (1987), 76. Habermas, *Erkenntnis und Interesse,* 39. Habermas cites another text: "Labor [. . .] sets in motion the natural forces that pertain to its corporeity [*Leiblichkeit*], arms and legs, head and hands, in order to appropriate for itself the materials of nature [*Naturstoff*] in a form useful *for its own life [für sein eigenes Leben]*" (Marx, *Das Kapital,* I, in *MEGA* II, 6, 192).

23. We are saying here that labor is the "actual condition" of an even more fundamental "condition," namely, human life as *the* material and universal condition *par excellence* of every possible ethics. Apel's and Habermas's concept of "survival" refers merely to the animal-physical.

24. Habermas, *Erkenntnis und Interesse,* 39.

25. This is what we refer to as the "sur" of "*sur*-vival," namely, self-consciousness, a higher function of the mind.

26. Marx, *Das Kapital,* I, in *MEGA* II, 6, 162.

27. Habermas will later add his critique from the standpoint of discursive reason to the paradigm of instrumental productivism in Marx. See Jürgen Habermas, *Der philosophische Diskurs der Moderne* (Frankfurt: Suhrkamp, 1985), 99ff.

28. Jürgen Habermas, *Vorstudien und Ergänzungen zur Theorie des kommunikativen Handelns* (Frankfurt: Suhrkamp, 1984), 353–439.

29. See Habermas, *Theorie des kommunikativen Handeln,* two volumes, *op. cit.*

30. See Jürgen Habermas, *Moralbewußtsein und kommunikatives Handeln* (Frankfurt: Suhrkamp, 1983) and *Erläuterungen zur Diskursethik* (Frankfurt: Suhrkamp, 1991); some works in English translation: Jürgen Habermas, *Justification and Application* (Cambridge, MA: MIT Press), "Justice and Solidarity: On the Discussion Concerning *Stage 6,*" in *The Philosophical Forum,* XXI, 1–2 (1989–1990), 32–51. See also William Rehg, *Insight and Solidarity: The Discourse Ethics of Jürgen Habermas* (Berkeley: University of California Press, 1994); and Michael Kelly, "Hermeneutics in Ethics and Social Theory," in *The Philosophical Forum* XXI, 1–2 (1989–1990), special issue edited by Michael Kelly, with essays by Habermas, Michael Walzer, Agnes Heller, Seyla Benhabib, Thomas McCarthy, etc.

31. See Jürgen Habermas, *Nachmetaphysisches Denken* (Frankfurt: Suhrkamp, 1988).

32. See Habermas, *Der philosophische Diskurs der Moderne, op. cit.*

33. See Jürgen Habermas, *Faktizität und Geltung* (Frankfurt: Suhrkamp, 1992).

34. See Jürgen Habermas, "Reconciliation Through the Public Use of Reason: Remarks on John Rawls's Political Liberalism," in *Journal of Philosophy* 92, no. 3 (March 1995), 109–31.

35. See Habermas, *Moralbewußtsein und kommunikatives Handeln*, 53–126.

36. See Alasdair MacIntyre, *After Virtue: A Study in Moral Theory* (South Bend, IN: University of Notre Dame Press, 1981). Inspired by this communitarian thinker, Habermas brands as sceptical analytic meta-ethics. However, he improves on MacIntyre's arguments and uses them to situate his own universalist moral pragmatic position regarding normative statements with their own validity claims to argumentative-rational rightness (*Richtigkeit*). Discourse Ethics defines itself as a normative universal morality that can ground itself and norms rationally; it is critical of meta-ethics because of insufficiency, since meta-ethics mistakenly delimits the type of statements on which it bases itself, and it is critical of material ethics because it cannot be universal.

37. For a more recent position, see Habermas, *Erläuterungen zur Diskursethik*, 185–99.

38. Habermas, *Moralbewußtsein und kommunikatives Handeln*, 55–56.

39. Habermas, *Moralbewußtsein und kommunikatives Handeln*, 60.

40. See Stephen Toulmin, *An Examination of the Place of Reason in Ethics* (Cambridge, 1970).

41. Habermas, *Moralbewußtsein und kommunikativen Handelns*, 62: ". . . von *moralischer* Wahrheit."

42. For Weber "value judgments," of mere taste, have to do with the values prevailing in a culture. Habermas will speak in this case of "evaluative judgments" as material, as having content. These are not the judgments to which Habermas is referring, since these are not susceptible to rational argument with a claim to consensual validity; instead, they would merely impose themselves dogmatically by the authority of tradition. We for our part will have to describe this type of statement in another way.

43. Here one will have to distinguish, in different languages, the terms to be used. "Rightness" (*Richtigkeit* in German, *rectitud* in Spanish, *orthós* in Greek) may be "formal" or "material"; hence, the term must be made more precise.

44. George E. Moore, *Principia Ethica* (Cambridge: Cambridge University Press, 1968), I, A, 2, p. 3. Since Habermas is not a formalist, he cannot accept a mere meta-ethics of language, at a solipsistic, neutral (non-participative), assertoric, pre-pragmatic level. For the classification of ethics of an analytical nomenclature, see Eduardo Rabossi, *Estudios éticos. Cuestiones conceptuales y metodológicas* (Valencia, Venezuela: Universidad de Carabobo, 1979); Rabossi's descriptions go from a descriptive (empirical) ethics, a normative (traditional or metaphysical) ethics, and an analytical ethics (the meta-ethics that Habermas criticizes) (33ff), to either objectivist or subjectivist ethics (57ff), etc. Rabossi pays special attention to criteria of classification (59ff). On intuitionism see 72ff.

45. Later, faced with Bernard William's argument (*Ethics and the Limits of Philosophy*, Cambridge: Cambridge University Press, 1985), Habermas clarifies the difference between theoretical and practical reason. See Habermas, *Erläuterungen zur Diskursethik*, 120–25.

46. Habermas, *Moralbewußtsein und kommunikatives Handeln*, 64.

47. Habermas, *Moralbewußtsein und kommunikatives Handeln*, 64.

48. See Alfred Jules Ayer, *Language, Truth and Logic* (London: Gollancz, 1958); Spanish edition: *Lenguaje, verdad y lógica* (Buenos Aires: EUDEBA, 1971). Ayer is guilty besides of reductionisms such as, for example, when he writes the following: "If now I generalise my previous statement and say, 'Stealing money is wrong,' I produce a sentence which has no *factual* meaning. . . . It is as if I had written 'Stealing money!!'" (Ayer, *Language, Truth and Logic*, p. 107). Ayer would be right, if it were a solipsistic enunciation that were kept at a semantically abstract level, and if it were not "factual." But when I say pragmatically, *factually*, and intersubjectively the following, "I assert that stealing money *is bad* (as *speech act* in Austin's and Searle's sense), I add something with the propositional content "is bad": I state explicitly, and therefore I thus add semantic content, the claim to defend intersubjectively arguments that I propose as having practical truth, or put forward with a claim to ethical validity. The subject may be examined, insofar as descriptive "speech-acts" are concerned, in Jürgen Habermas, *Vorstudien und Ergänzungen zur Theorie des kommunikativen Handelns* (Frankfurt: Suhrkamp, 1984), ch. 2, "Wahrheitstheorien," 127ff, and "Was heisst Universalpragmatik? 353ff; and Enrique Dussel, "La razón del Otro. La *interpelación* como acto-de-habla," in Enrique Dussel, *Apel, Ricoeur, Rorty y la filosofía de la liberación* (Guadalajara, Mexico: Universidad de Guadalajara, 1993), 33–66.

49. See R. M. Hare, *The Language of Morals* (Oxford: Oxford University Press, 1952).

50. Habermas, *Moralbewußtsein und kommunikatives Handeln*, 65.

51. Ethical controversies could not then be resolved argumentatively. Albert's position coincides in this case. See Hans Albert, *Felbare Verunft* (Tübingen: Mohr, 1980). See also Hans Albert, *Traktat über kritische Vernunft* (Tübingen: Mohr, 1968).

52. Habermas, *Moralbewußtsein und kommunikatives Handeln*, 71. The difference between the validity claims of consensus and the validity claims of norms, in the face of norms, are defined in Habermas, *Erläuterungen zur Diskursethik*, 125–131.

53. K. Baier, *The Moral Point of View* (London, 1958).

54. B. Gert, *The Moral Rules* (New York, 1976).

55. See M. G. Singer, *Generalization in Ethics* (New York, 1961).

56. Habermas, *Moralbewußtsein und kommunikatives Handeln*, 76. This proposition is found also in other places of Habermas's definitive work.

57. See a defense against Wellmer's theory of "non-applicability" [*Nichtanwendbarkeit*] (Albrecht Wellmer, *Dialog und Diskurs*, Frankfurt: Suhrkamp, 1986) in Habermas, *Erläuterungen zur Diskursethik*, 137–42.

58. Nevertheless, a monological moment is always concomitantly necessary; that is to say, all the participants each by himself or herself must accept or reject the argument proposed with a validity claim to rightness. It is here, as we will see, that we find the intersection between the claim to *moral* truth of the utterance and the claim to *validity* of the same utterance. This is an issue with which Habermas does not deal because of his consensualist position regarding the subject of truth as such.

59. Habermas, *Moralbewußtsein und kommunikatives Handeln*, 74. See Wellmer, *Dialog und Diskurs*, 55ff. See also William Rehg, *Insight and Solidarity: The Discourse Ethics of Jürgen Habermas* (Berkeley: University of California Press, 1994), 66ff.

60. Habermas, *Moralbewußtsein und kommunikatives Handeln*, 78.

61. "The right" [*das Gerechte*] is here equivocal. Formal morality does not deal with "the right"—an ambiguity begun by Rawls—but rather with "the valid." "The just" or "the right" [*richtig*] can be formal (valid) or material (to give to each his or her own: we are dealing here with the material [*material* in German] *par excellence*).

62. There is here again an ambiguity that Habermas wants to remove with the term "strict" [*streng*]; This is so because evaluative utterances are equally normative. What Habermas calls "normative utterances" are the "*valid* practical or moral utterances" (or with a "claim to moral validity").

63. They have a traditional or habitual "claim to intersubjective validity." It is not the fruit of argumentation. However, something that Habermas does not pose but that is essential for the Ethics of Liberation is that the traditional claims of cultural values can also enter into a *crisis* (from the vantage point of the oppressed). In this case, the dominant morality will be arguing in the face of the *critique* of the sceptics, but here they will be sceptical of values *in so far as they are dominant*). All of this is precisely the problematic that is of interest to a *critical* ethics. Discourse Ethics long ago stopped being critical.

64. Here again the term "strict" points to an ambiguity.

65. Habermas, *Moralbewußtsein und kommunikatives Handeln*, 113–14.

66. For example, in Habermas's case, the economy and misery are not operative here as fundamental ethical problems. That is to say, the material critique of *Spätkapitalismus* is impossible for Habermas from a Discourse Ethics.

67. Here we are dealing with what we referred to in another text as "ethical judgments of reality," which arise from the ethical exigencies for the reproduction and human life of the subject, beyond and within any particular culture, system, or "world" in its ontological Heideggerian sense.

68. In this case "critical rationality" is fulfilled from moment "c" to "b" as mediated by "d" (by the relation of 4 to 5).

69. *Moralbewußtsein und kommunikatives Handeln*, 114: "The validity of the ought-to-be of norms of action" can also be the "axiological preferences" of an anti-hegemonically intersubjective critical ethical consciousness. For example, the utterance, "I should risk my life in the struggle for *justice* against capitalism in the world's periphery," is a utterance that includes an ought-to-be, namely, a norm of action, in view of the preference for a "value" (that is, "justice"), which is the result of an economic material analysis that discovers that a historical system hinders the reproduction of human life (a material criterion and principle). Here we articulate formal procedure with the exigencies of human life's material conditions.

70. For Habermas, these "orientations" [*Orientierungen*] are not the tasks proper to a philosophical morality. But they certainly are for an Ethics of Liberation, although they are so in a universal and abstract sense, not in a concrete sense; otherwise, they would be the themes of experts in the social sciences,

political parties, social movements, etc.

71. Habermas, *Moralbewußtsein und kommunikatives Handeln*, 113.

72. Habermas, *Moralbewußtsein und kommunikatives Handeln*, 118.

73. Habermas approaches our problematic when he gives the example "One shall not kill anybody" (Habermas, *Moralbewußtsein und kommunikatives Handeln*, 70), or when he refers to suicide (Habermas, *Moralbewußtsein und kommunikatives Handeln*, 110 and 127). But in this case the attempt to ground ethics should not confront the sceptic, but the cynic instead who does not justify the impossibility of using reason in ethics, but rather justifies death.

74. See D. Heinrich, "Die Grundstruktur der Modernen Philosophie," in H. Eberling, ed., *Subjetivität und Selbsterhaltung* (Frankfurt, 1976).

75. Habermas, *Theorie des kommunikativen Handelns*, I, 532–33. Note that it is not understood that the self-conscious material reproduction of the human life of the subject should always be integrated with argumentative intersubjectivity, so that the former is not, nor *should it be*, "blinded." We will come back to this question in future works, so that we will analyze the difference between the "first" and the "second" Frankfurt Schools.

76. The "D" principle is "the sole [*einziges*] moral principle" (Habermas, *Moralbewußtsein und kommunikatives Handeln*, 103).

77. Habermas, *Erläuterungen zur Diskursethik*, 24.

78. Habermas, *Erläuterungen zur Diskursethik*, 28.

79. This is the whole issue of the nonexistent symmetry in the real communication community which is the application condition for Apel.

80. Habermas, *Erläuterungen zur Diskursethik*, 29.

81. Habermas, *Erläuterungen zur Diskursethik*, 29.

82. Habermas, *Erläuterungen zur Diskursethik*, 29.

83. Not only does not Habermas have a "privileged" access to "moral truth," but he cannot have it either. For, "moral" truth should be found at the material level that he has denied from the beginning of his ethical project.

84. Habermas, *Erläuterungen zur Diskursethik*, 30.

85. Habermas, *Erläuterungen zur Diskursethik*, 44.

86. Habermas, *Erläuterungen zur Diskursethik*, 22.

87. The reflection that negation presupposes affirmation is an excellent reflection. On that basis, Habermas himself should know that the negation of the life of the oppressed presupposes its previous affirmation as a positive and universal material principle. See Habermas, *Erläuterungen zur Diskursethik*, 116–76, against Albrecht Wellmer, *Dialog und Diskurs* (Frankfurt: Suhrkamp, 1986) and other authors.

88. Habermas, *Erläuterungen zur Diskursethik*, 25.

89. Habermas, *Erläuterungen zur Diskursethik*, 176. See also Habermas, *Erläuterungen zur Diskursethik*, 199–208, in dialogue with McCarthy and Rawls.

90. We cannot approve of Taylor's cultural-ontological conception of ethics, which makes him fall into a certain incommensurable particularism and does discover the universality of human life as such; nor can we accept the "aestheticism" that he ends up proposing. Aesthetics has a liberating sense, but not

with the meaning to which Taylor points.

91. We have learned and adopted a lot from Habermas, especially his critique of analytic meta-ethics, as can be seen in our Ethics of Liberation. See Enrique Dussel, *Ética de la liberacion en la edad de la globalización y la exclusión* (Madrid: Editorial Trotta, 1998).

92. See Habermas, *Moralbewußtsein und kommunikatives Handeln*, 127ff and Habermas, *Erläuterungen zur Diskursethik*, 49ff, in reference to Lawrence Kohlberg, *Essays on Moral Development* (Harper and Row, 1981) and Lawrence Kohlberg and Anne Colby, *The Measurement of Moral Judgement*, volumes I and II (Cambridge: Cambridge University Press, 1987).

93. Habermas, *Moralbewußtsein und kommunikatives Handeln*, 135.

94. Again, the criticality of "ethical judgments of reality" judge Kohlberg's universal moral principles from the vantage-point of the concrete reproduction of the life of human subjects. It has a sphere of alterity relative to those formal, universal moral principles.

95. Max Horkheimer, "Materialismus und Moral" in *Zeitschrift für Sozialforschung* (Jg. 2, 1933); cited in Habermas, *Erläuterungen zur Diskursethik*, 30.

PART THREE

COMMUNICATIVE
POLITICS

13

Douglas Kellner

Habermas, the Public Sphere, and Democracy: A Critical Intervention

Jürgen Habermas's *The Structural Transformation of the Public Sphere* is an immensely rich and influential book that has had major impact in a variety of disciplines. It has also received detailed critique and promoted extremely productive discussions of liberal democracy, civil society, public life, and social changes from the Enlightenment to the present, among other issues. Few books of the second half of the twentieth century have been so seriously discussed in so many different fields and continue, almost forty years after its initial publication in 1962, to generate such productive controversy and insight. While Habermas's thought took several crucial philosophical twists and turns after the publication of his first major book, he has himself provided detailed commentary on *Structural Transformation* in the 1990s and returned to issues of the public sphere and democratic theory in his monumental work *Between Facts and Norms*. Hence, concern with the public sphere and the necessary conditions for a genuine democracy can be seen as a central theme of Habermas's work that deserves respect and critical scrutiny.

In this paper, I will first explicate Habermas's concept of the public sphere and its structural transformation in his early writings and then will note how he takes up similar themes in his recent 1990s work within the context of a significant transformation of his own work in his linguistic turn. After setting out a variety of critiques which his analysis has elicited, including some of my own, I attempt to develop the notion of the public sphere in the contemporary era. Hence, my study intends to point to the continuing importance of Habermas's problematic and its relevance for debates over democratic politics and social and cultural life in the present age. At stake is delineating a concept of the public sphere which facilitates maximum public participation and debate over the key issues of the current

conjuncture and which consequently promotes the cause of participatory democracy.

HABERMAS WITHIN THE FRANKFURT SCHOOL: ORIGINS AND GENESIS OF *THE STRUCTURAL TRANSFORMATIONS OF THE PUBLIC SPHERE*

The history and initial controversy over *The Structural Transformation of the Public Sphere* are best perceived within the context of Habermas's work with the Institute for Social Research. After studying with Horkheimer and Adorno in Frankfurt, Germany in the 1950s, Habermas investigated both the ways that a new public sphere emerged during the time of the Enlightenment and the American and French revolutions and how it promoted political discussion and debate. As I indicate below, Habermas developed his study within the context of the Institute analysis of the transition from the stage of liberal market capitalism of the nineteenth century to the stage of state and monopoly organized capitalism of the twentieth century developed by the Frankfurt School (see Kellner 1989).

Indeed, Habermas's 1960s works are firmly within the tradition and concerns of the Institute for Social Research. One of his first published articles provided critical perspectives on the consumer society and other early texts contained studies of rationalization, work and leisure, the media, public opinion, and the public sphere (Habermas 1972). Subsequent works undertaken in the context of developing Institute positions include interventions in the positivism debate where Habermas defended the Frankfurt School conception of a dialectical social theory with practical intent against the conception of a positivistic social theory (Habermas 1976). And in *Theory and Practice*, Habermas maintained the unity of theory and practice central to classical Marxism and the critical theory of society, while fleshing out the moral and political dimensions of critical theory (Habermas 1973).

Habermas's initial works with the Institute for Social Research concerned studies of the political opinions and potential of students. In an examination of *Student und Politik* (published in 1961), Habermas and two empirically oriented members of the Institute carried out "a sociological investigation of the political consciousness of Frankfurt students" (13ff.). The study was similar to the Institute's earlier *Gruppenexperiment* which had attempted to discern the democratic and anti-democratic potential in wide sectors of German society after World War Two through survey analysis and in-depth interviews (Pollock 1955). Just as earlier Institute studies of the German working class and post–World War II German citizens disclosed a high degree of political apathy and authoritarian-conservative dispositions (see Fromm 1989), so too did the surveys of German students disclose an

extremely low percentage (4 percent) of "genuinely democratic" students contrasted with 6 percent rigid authoritarians. Similarly, only 9 percent exhibited what the authors considered a "definite democratic potential," while 16 percent exhibited a "definite authoritarian potential" (Habermas, et al., 1961: 234). And within the more apathetic and contradictory attitudes and tendencies of the majority, a larger number were inclined more toward authoritarian than democratic orientations.

Habermas wrote the introduction to the study, "On the Concept of Political Participation," which provided the conception of an authentically democratic political participation that was used as a norm to measure student attitudes, views, and behavior. As he was later to do in his studies of the public sphere, Habermas sketched out various conceptions of democracy ranging from Greek democracy to the forms of bourgeois democracy to current notions of democracy in welfare state capitalism. In particular, he contrasted the participatory democracy of the Greeks and radical democratic movements with the representative, parliamentary bourgeois democracy of the nineteenth century and the current attempts at reducing citizen participation in the welfare state. Habermas defended the earlier "radical sense of democracy" in which the people themselves would be sovereign in both the political and the economic realms against current forms of parliamentary democracy. Hence, Habermas aligns himself with the current of "strong democracy" associated with Rousseau, Marx, and Dewey.[1]

In his early study of students and politics, Habermas defended principles of popular sovereignty, formal law, constitutionally guaranteed rights, and civil liberties as part of the progressive heritage of bourgeois society. His strategy was to use the earlier model of bourgeois democracy to criticize its later degeneration and decline, and thus to develop a normative concept of democracy which he could use as a standard for an "immanent critique" of existing welfare state democracy. Habermas believed that both Marx and the earlier Frankfurt School had underestimated the importance of principles of universal law, rights, and sovereignty, and that a re-democratization of radical social theory was thus a crucial task.

Student und Politik was published in 1961 and during the same period student radicals in the United States developed similar conceptions of participatory democracy, including emphasis on economic democracy.[2] Henceforth, Habermas himself would be concerned in various ways and contexts to develop theories of democratization and political participation. Indeed, from the beginning of his career to the present, Habermas's work has been distinguished by its emphasis on radical democracy, and this political foundation is an important and often overlooked subtext of many of his works.

Habermas conceived of his study of the bourgeois public sphere as a

Habilitationschrift, a post-doctorate dissertation required in Germany for ascension to a Professorship. Calhoun claims that Adorno and Horkheimer rejected the dissertation, finding it insufficiently critical of the ideology of liberal democracy (see Calhoun 1992a: 4f). Wiggershaus, however, claimed that "Adorno, who was proud of him, would have liked to accept the thesis," but that Horkheimer believed Habermas was too radical and made unacceptable demands for revision, thus, in effect, driving away the Institute's most promising student and forcing him to seek employment elsewhere (1996: 555).

Habermas submitted the dissertation to Wolfgang Abenroth at Marburg, one of the new Marxist professors in Germany at the time, and in 1961 became a *Privatdozent* in Marburg, while receiving a professorship in Heidelberg in 1962. In 1964, strongly supported by Adorno, Habermas returned to Frankfurt to take over Horkheimer's chair in philosophy and sociology. Thus, Adorno was ultimately able to bestow the crown of legitimate succession on the person whom he thought was the most deserving and capable critical theorist (Wiggershaus 1996: 628).

THE DIALECTICS OF THE PUBLIC SPHERE

Habermas's focus on democratization was linked with emphasis on political participation as the core of a democratic society and as an essential element in individual self-development. His study *The Structural Transformation of the Public Sphere* was published in 1962 and contrasted various forms of an active, participatory bourgeois public sphere in the heroic era of liberal democracy with the more privatized forms of spectator politics in a bureaucratic industrial society in which the media and elites controlled the public sphere.[3] The two major themes of the book include analysis of the historical genesis of the bourgeois public sphere, followed by an account of the structural change of the public sphere in the contemporary era with the rise of state capitalism, the culture industries, and the increasingly powerful positions of economic corporations and big business in public life. On this account, big economic and governmental organizations took over the public sphere, while citizens became content to become primarily consumers of goods, services, political administration, and spectacle.

Generalizing from developments in Britain, France, and Germany in the late eighteenth and nineteenth century, Habermas first sketched out a model of what he called the "bourgeois public sphere" and then analyzed its degeneration in the twentieth century. As Habermas puts it in the preface to the book: "Our investigation presents a stylized picture of the liberal elements of the bourgeois public sphere and of their transformation in the

social-welfare state" (Habermas 1989a: xix). The project draws on a variety of disciplines including philosophy, social theory, economics, and history, and thus instantiates the Institute for Social Research mode of a supra-disciplinary social theory. Its historical optic grounds it in the Institute project of developing a critical theory of the contemporary era and its political aspirations position it as a critique of the decline of democracy in the present age and a call for its renewal—themes that would remain central to Habermas's thought.

After delineating the idea of the bourgeois public sphere, public opinion, and publicity (*Offentlichkeit*), Habermas analyzes the social structures, political functions, and concept and ideology of the public sphere, before depicting the social-structural transformation of the public sphere, changes in its public functions, and shifts in the concept of public opinion in the concluding three chapters. The text is marked by the conceptual rigor and fertility of ideas characteristic of Habermas's writing, but contains more substantive historical grounding than much of his work and in retrospect discloses the matrix out of which his later work emerges. My summaries in the following sections merely highlight a few of the key ideas of importance for explicating the conception of the public sphere and its structural transformation which will help to evaluate the significance and limitations of Habermas's work for elucidating the conditions of democracy in contemporary society.

The bourgeois public sphere, which began appearing around 1700 in Habermas's interpretation, was to mediate between the private concerns of individuals in their familial, economic, and social life contrasted to the demands and concerns of social and public life. This involved mediation of the contradiction between *bourgeois* and *citoyen*, to use terms developed by Hegel and the early Marx, overcoming private interests and opinions to discover common interests and to reach societal consensus. The public sphere consisted of organs of information and political debate such as newspapers and journals, as well as institutions of political discussion such as parliaments, political clubs, literary salons, public assemblies, pubs and coffee houses, meeting halls, and other public spaces where socio-political discussion took place. For the first time in history, individuals and groups could shape public opinion, giving direct expression to their needs and interests while influencing political practice. The bourgeois public sphere made it possible to form a realm of public opinion that opposed state power and the economic interests that were coming to shape bourgeois society.

Habermas's concept of the public sphere thus described a space of institutions and practices between the private interests of everyday life in civil society and the realm of the state. The public sphere mediates between the domains of the family and the workplace—where private interests

prevail—and the state which often exerts arbitrary forms of power and domination. What Habermas called the "bourgeois public sphere" consisted of social spaces where individuals gathered to discuss their common public affairs and to organize against arbitrary and oppressive forms of social and political power.

The principles of the public sphere involved an open discussion of all issues of general concern in which discursive argumentation was employed to ascertain general interests and the public good. The public sphere thus presupposed freedoms of speech and assembly, a free press, and the right to freely participate in political debate and decision-making. After the democratic revolutions, Habermas suggested, the bourgeois public sphere was institutionalized in constitutional orders which guaranteed a wide range of political rights, and which established a judicial system that was to mediate between claims between various individuals or groups, or between individuals and groups and the state.

Many defenders and critics of Habermas's notion of the bourgeois public sphere fail to note that the thrust of his study is precisely that of transforma-tion, of the mutations of the public sphere from a space of rational discus-sion, debate, and consensus to a realm of mass cultural consumption and administration by corporations and dominant elites. This analysis assumes and builds on the Frankfurt School model of the transition from market capitalism and liberal democracy in the nineteenth century to the stage of state and monopoly capitalism evident in European fascism and the welfare state liberalism of the New Deal in the United States in the 1930s. For the Institute, this constituted a new stage of history, marked by fusion between the economic and political spheres, a manipulative culture industry, and an administered society, characterized by a decline of democracy, individuality, and freedom (see the texts in Bronner and Kellner 1989 and the discussion in Kellner 1989).

Habermas added historical grounding to the Institute theory, arguing that a "refeudalization" of the public sphere began occurring in the late nineteenth century. The transformation involved private interests assuming direct political functions, as powerful corporations came to control and manipulate the media and state. On the other hand, the state began to play a more fundamental role in the private realm and everyday life, thus eroding the difference between state and civil society, between the public and private sphere. As the public sphere declined, citizens became consumers, dedicating themselves more to passive consumption and private concerns than to issues of the common good and democratic participation.

While in the bourgeois public sphere, public opinion, on Habermas's analysis, was formed by political debate and consensus, in the debased public sphere of welfare state capitalism, public opinion is administered by

political, economic, and media elites which manage public opinion as part of systems management and social control. Thus, while in an earlier stage of bourgeois development, public opinion was formed in open political debate concerning interests of common concern that attempted to forge a consensus in regard to general interests, in the contemporary stage of capitalism, public opinion was formed by dominant elites and thus represented for the most part their particular private interests. No longer is rational consensus among individuals and groups in the interests of articulation of common goods the norm. Instead, struggle among groups to advance their own private interests characterizes the scene of contemporary politics.

Hence, Habermas describes a transition from the liberal public sphere which originated in the Enlightenment and the American and French Revolution to a media-dominated public sphere in the current era of what he calls "welfare state capitalism and mass democracy." This historical transformation is grounded, as noted, in Horkheimer and Adorno's analysis of the culture industry, in which giant corporations have taken over the public sphere and transformed it from a sphere of rational debate into one of manipulative consumption and passivity. In this transformation, "public opinion" shifts from rational consensus emerging from debate, discussion, and reflection to the manufactured opinion of polls or media experts. Rational debate and consensus has thus been replaced by managed discussion and manipulation by the machinations of advertising and political consulting agencies: "Publicity loses its critical function in favor of a staged display; even arguments are transmuted into symbols to which again one can not respond by arguing but only by identifying with them" (1989a: 206).

For Habermas, the function of the media have thus been transformed from facilitating rational discourse and debate within the public sphere into shaping, constructing, and limiting public discourse to those themes validated and approved by media corporations. Hence, the interconnection between a sphere of public debate and individual participation has been fractured and transmuted into that of a realm of political information and spectacle, in which citizen-consumers ingest and absorb passively entertainment and information. "Citizens" thus become spectators of media presentations and discourse which mold public opinion, reducing consumer/citizens to objects of news, information, and public affairs. In Habermas's words: "Inasmuch as the mass media today strip away the literary husks from the kind of bourgeois self-interpretation and utilize them as marketable forms for the public services provided in a culture of consumers, the original meaning is reversed" (1989a: 171).

Habermas offered tentative proposals to revitalize the public sphere by setting "in motion a *critical* process of public communication through the very organizations that mediatize it" (1989a: 232). He concluded with the

suggestion that "a critical publicity brought to life within intraorganizational public spheres" might lead to democratization of the major institutions of civil society, though he did not provide concrete examples, propose any strategies, or sketch out the features of an oppositional or post-bourgeois public sphere. Still, Horkheimer found Habermas's works to be too left-wing, in effect rejected the study as a *Habilitations* dissertation and refused to publish it in the Institute monograph series (see Wiggershaus 1996: 555ff.). It was published, however, in 1962 and received both an enthusiastic and critical reception in Germany; when translated into English in 1989, it promoted yet more discussion of Habermas and the public sphere, lively debates still continuing, as my study will indicate.

HABERMAS AND THE PUBLIC SPHERE: CRITICAL DEBATES

Habermas's analysis of the public sphere has been subjected to intense critical argumentation which has clarified his earlier positions, led to revisions in later writings, and has fostered intense historical and conceptual research into the public sphere itself.[4] Few books have been so systemati- cally discussed, criticized, and debated, or inspired so much theoretical and historical analysis. The result, I believe, is a considerably better understand- ing of the many dimensions of the public sphere and democracy itself.

Habermas's critics argue that he idealizes the earlier bourgeois public sphere by presenting it as a forum of rational discussion and debate when in fact certain groups were excluded and participation was thus limited. Habermas concedes that he presents a "stylized picture of the liberal elements of the bourgeois public sphere" (Habermas 1989a: xix), and should have made it clearer that he was establishing an "ideal type" and not a normative ideal to be resuscitated and brought back to life (Habermas 1992: 422f). Indeed, it is clear that a certain idealization of the public sphere was present in Habermas's text, but I believe that this accounts both for its positive reception and a good deal of the critique. On the affirmative side, precisely the normative aura of the book inspired many to imagine and cultivate more inclusive, egalitarian, and democratic public spaces and forums; others were inspired to conceive of more oppositional democratic spaces as site of the development of alternative cultures to established institutions and spaces. Habermas thus provided decisive impetus for discussions concerning the democratization of the public sphere and civil society, and the normative dimension helped generate productive discussions of the public sphere and democracy.

Yet Habermas's idealization of the earlier bourgeois public sphere as a space of rational discussion and consensus has been sharply criticized. It is

doubtful if democratic politics were ever fueled by norms of rationality or public opinion formed by rational debate and consensus to the extent stylized in Habermas's concept of the bourgeois public sphere. Politics throughout the modern era have been subject to the play of interests and power as well as discussion and debate.[5] It is probably only a few Western bourgeois societies that have developed any public sphere at all in Habermas's sense, and while it is salutary to construct models of a good society that could help to realize agreed upon democratic and egalitarian values, it is a mistake to overly idealize and universalize any specific public sphere as in Habermas's account.

Moreover, while the concept of the public sphere and democracy assume a liberal and populist celebration of diversity, tolerance, debate, and consensus, in actuality, the bourgeois public sphere was dominated by white, property-owning males. As Habermas's critics have documented, working class, plebeian, and women's public spheres developed alongside of the bourgeois public sphere to represent voices and interests excluded in this forum. Oskar Negt and Alexander Kluge criticized Habermas for neglect of plebeian and proletarian public spheres (1972 [1996]) and in reflection Habermas has written that he now realizes that "from the beginning a dominant bourgeois public collides with a plebeian one" and that he "underestimated" the significance of oppositional and non-bourgeois public spheres (1992: 430).

Hence, rather than conceiving of one liberal or democratic public sphere, it is more productive to theorize a multiplicity of public spheres, sometimes overlapping but also conflicting. These include public spheres of excluded groups, as well as more mainstream configurations. Moreover, as I argue below, the public sphere itself shifts with the rise of new social movements, new technologies, and new spaces of public interaction.

Mary Ryan notes the irony that not only did Habermas neglect women's public spheres, but marks the decline of the public sphere precisely at the moment when women were beginning to get political power and become actors (1992: 259ff). Indeed, the 1999 PBS documentary by Ken Burns *Not For Ourselves Alone* vividly illustrates the vitality of a women's public sphere in nineteenth-century America, documenting the incredible organizing efforts of Susan B. Anthony, Elizabeth Cady Stanton, and others from the 1840s well into the twentieth century in a sustained struggle for the vote and women's rights. A visit to Hull House in Chicago reveals the astonishing interventions into the public sphere of Jane Addams and her colleagues in developing forms and norms of public housing, health, education, welfare, rights and reforms in the legal and penal system, and public arts (see the texts in Bryan and Davis 1969). These and other women's groups discussed in Ryan (1992) were an extremely active element in a vital women's public sphere.

Indeed, Howard Zinn's *People's History of the United States* (1995), among others, documents the presence of oppositional movements and public spheres throughout U.S. history to the present. Reflections on the civil rights movement in the U.S., the 1960s movements, and the continuation of "new social movements" into the 1970s and beyond, suggest that Habermas's analysis downplays the continuing richness and vitality of the public sphere well into the twentieth century. And in a concluding section, I will suggest how activities in the new public spheres of cyberspace provide further expansion of the public sphere and new sites for democratic politics.

Despite the limitations of his analysis, Habermas is right that in the era of the democratic revolutions a public sphere emerged in which for the first time in history ordinary citizens could participate in political discussion and debate, organize, and struggle against unjust authority, while militating for social change, and that this sphere was institutionalized, however imperfectly, in later developments of Western societies. Habermas's account of the structural transformation of the public sphere, despite its limitations, also points to the increasingly important functions of the media in politics and everyday life and the ways that corporate interests have colonized this sphere, using the media and culture to promote their own interests.

Yet in retrospect, Habermas's analysis is too deeply embedded in Horkheimer and Adorno's philosophy of history in *Dialectic of Enlightenment* and theories of mass society which became a dominant paradigm in the 1950s. As noted, Habermas's account assumes the validity of the Institute analysis of the culture industry, that giant corporations have taken over the public sphere and transformed it from a sphere of rational debate into one of manipulative consumption and passivity. Moreover, like Horkheimer and Adorno who nostalgically look back to and idealize previous forms of the family, so too does Habermas's *Transformations* idealize the earlier bourgeois public sphere—despite its limitations and restrictions repeatedly pointed out by his critics.

It is not just his colleagues Horkheimer and Adorno, however, who influenced this conception, but also participants in debates over mass culture and communications in the United States in the 1950s and in particular C. Wright Mills. Although Habermas concludes *Transformations* with extensive quotes from Mills's *The Power Elite* on the metamorphosis of the public into a mass in the contemporary media/consumer society, the vast literature on Habermas's concept of the public sphere overlooks the significance of Mills's work for Habermas's analysis of the structural transformation of the public sphere.[6]

C. Wright Mills himself tended to utilize the Institute models of the media as agents of manipulation and social control, although he sometimes qualified the media's power to directly and consistently manipulate the public. In *White Collar*, Mills (1951) stressed the crucial role of the mass

media in shaping individual behavior and inducing conformity to middle class values. He argued that the media are increasingly shaping individual aspirations and behavior and are above all promoting values of "individual success." He also believed that entertainment media were especially potent instruments of social control because "popular culture is not tagged as 'propaganda' but as entertainment; people are often exposed to it when most relaxed of mind and tired of body; and its characters offer easy targets of identification, easy answers to stereotyped personal problems" (ibid, p. 336).

Mills analyzed the banalization of politics in the media through which "the mass media plug for ruling political symbols and personalities." Perceiving the parallel between marketing commodities and selling politicians, Mills analyzed tendencies toward the commodification of politics, and in *The Power Elite*, he focused on the manipulative functions of media in shaping public opinion and strengthening the power of the dominant elites (Mills 1956). In an analysis that anticipated Habermas's theory, Mills discusses the shift from a social order consisting of "communities, of publics," in which individuals participated in political and social debate and action, to a "mass society" characterized by the "transformation of public into mass" (298ff.). The impact of the mass media is crucial in this "great transformation" for it shifts "the ratio of givers of opinion to the receivers" in favor of small groups of elites, who control or have access to the mass media. Moreover, the mass media engage in one-way communication that does not allow feedback, thus obliterating another feature of a democratic public sphere. In addition, the media rarely encourage participation in public action. In these ways, they foster social passivity and the fragmentation of the public sphere into privatized consumers.

When I presented this interpretation of Habermas's conception of the bourgeois public sphere in a conference at Starnberg in 1981 (see Kellner 1983), he acknowledged that indeed conceptions of Horkheimer and Adorno and C. Wright Mills influenced his analysis and indicated that he saw his work as providing a historical grounding for Horkheimer and Adorno's theory of the culture industries and that Mills provided a contemporary updating and validation of the Institute model. Yet in terms of finding both a standpoint and strategy of critique, as well as a practical politics to revitalize democracy, the analyses of Horkheimer, Adorno, and the early Habermas have led to a cul-de-sac. In the analyses of the culture industry and public sphere in Horkheimer and Adorno's *Dialectic of Enlightenment* and Habermas's *Structural Transformation*, the Institute strategy of immanent critique could not be used, there was no institutional basis to promote democratization, and no social actors to relate theory to practice and to strengthen democratic social movements and transformation. Hence, critical theory reached a deadend with no robust normative grounds for critique or social forces capable of transforming existing society.

In the 1930s, the Institute had used the method of immanent critique by which they criticized fascist and totalitarian societies from the standpoint of Enlightenment concepts of democracy, human rights, individual and social freedoms, and rationality. In this way, the Frankfurt School used standards "immanent" to bourgeois society to criticize distortions in its later developments in fascism. But Horkheimer and Adorno's *Dialectic of Enlightenment*, written in the 1940s and first published in 1947, showed how Enlightenment norms had turned into their opposite, how democracy had produced fascism, reason had produced unreason, as instrumental rationality created military machines and death camps, and the culture industries were transforming culture from an instrument of *Bildung* and enlightenment into an instrument of manipulation and domination (see the discussion in Kellner 1989, chapter 4). In this situation, the procedure of using "bourgeois ideals as norms of critique"

> [has] been refuted by the civilized barbarism of the twentieth century. When these bourgeois ideals are cashed in, when the consciousness turns cynical, the commitment to those norms and value orientations that the critique of ideology must presuppose for its appeal to find a hearing becomes defunct. I suggested, therefore, that the normative foundations of the critical theory of society be laid at a deeper level. The theory of communicative action intends to bring into the open the rational potential intrinsic in everyday communicative practices. (1992: 442)

Like Horkheimer and Adorno in *Dialectic of Enlightenment*, Habermas had produced an account of how the bourgeois public sphere had turned into its opposite. Recognizing that using an earlier form of social organization to criticize its later deformation was nostalgic, Habermas called for a renewed democratization of public institutions and spaces at the end of *Structural Transformation* (1989: 248ff), but this was merely a moral exhortation with no discernible institutional basis or social movements to realize the call. Hence, both to discern a new standpoint for critique, to provide new philosophical bases for critical theory, and to contribute a new force for democratization, Habermas turned to the sphere of language and communication to find norms for critique and an anthropological basis to promote his calls for democratization.

THE LINGUISTIC TURN

Habermas's argument is that language itself contains norms to criticize domination and oppression and a force that could ground and promote societal democratization. In the capacity to understand the speech of another, to submit to the force of a better argument, and to reach consensus,

Habermas found a rationality inherent in what he came to call "communicative action" that could generate norms to criticize distortions of communication in processes of societal domination and manipulation and cultivate a process of rational discursive will-formation. Developing what he called an "ideal speech situation," Habermas thus cultivated quasi-transcendental grounds for social critique and a model for more democratic social communication and interaction.[7]

Consequently, Habermas made his linguistic turn and shifted to language and communication as a basis at once for social critique, democratization, and to establish critical theory on a stronger theoretical foundation to overcome the impasse that he believed the Frankfurt School had become trapped in. Over the past several decades, Habermas has been arguing that language and communication are a central feature of the human lifeworld that can resist the systemic imperatives of money and power which undermine communicative structures. This project has both generated a wealth of theoretical discussions and has provided normative bases for social critique and democratization.

Habermas's theory of communicative action, his linguistic turn, and quasi-transcendental grounding of language have received a tremendous amount of commentary and criticism which I will merely allude to here to promote further critical discussion of his conceptions of democracy and the public sphere. I do want to stress, however, since this is often overlooked, that it was not just theoretical imperatives and insights that led Habermas to his concern with language and communication, but the deadlock that he and the Frankfurt School had reached and the need for stronger bases of socio-political criticism and democratization. Hence, while, as I will argue, there are continuities between Habermas's early analysis of the public sphere and his later theory of communicative action, there are also important alterations in his theory.

For starters, Habermas switches his focus from the socio-historical and institutional mooring of critical theory in *Structural Transformation* to a more philosophical ground in his post-1970s theoretical works. This has serious implications, I believe, for his theory of language and communication. In the contemporary highly historicist and constructivist milieu, it is often remarked that Habermas's notion of language is too universalistic and ahistorical. On the constructivist and historicist view, language itself is a socio-historical construct, with its own rules, conventions, and history. Meanings and uses shift over time, while different societies have their own language games and forms of language and communication, which are subject to a multiplicity of varying social forces and institutions.[8]

Indeed, for contemporary poststructuralist theory, language and communication are integrally embedded in power in an existing social system, they serve interests of domination and manipulation as much as

enlightenment and understanding, and are subject to historically contingent and specific constraints and biases. Hence, on this view, language in contemporary society is functionalized and rationalized, its meanings and uses are socially constructed to serve hegemonic interests, including legitimation and domination, and so language is never pure and philosophical, universal and transcendent of social conditions. While there is a utopian promise in language and communication that minds can meet, that shared understanding can be established, that truth can be revealed, and that unforced consensus can be reached, this is merely a utopian ideal. In the post-structuralist/constructivist view, language is thus integrally related to power and is the instrument of particular social interests that construct discourses, conventions, and practices, while embedding language and communication in untruth and domination, making it an imperfect model for rationality and democracy.

From this perspective, language suffers its contradictions; it is situated within a conflict between truth and untruth, universality and particularity, communication and manipulation.

Hence, it has been argued that Habermas's philosophical grounding of language and communication is problematic and requires concrete sociohistorical specification. Further, critiques have emerged of the distinction between system and lifeworld which has stood at the center of Habermas's work.[9] For Habermas, contemporary societies are divided between a lifeworld governed by norms of communicative interaction and a system governed by "steering imperatives" of money and power. This distinction mediates between systems theory and hermeneutics, arguing that the former cannot grasp the communicative practices of everyday life while the latter ignores the systemic forces that have come to dominate the lifeworld. For Habermas, the "steering media" of money and power enable business and the state to control ever more processes of everyday life, thus undermining democracy and the public sphere, moral and communicative interaction, and other ideals of Habermas and the Frankfurt School. It has frequently been argued that this dichotomy is too dualistic and Manichean, overlooking that the state and political realm can be used benevolently and progressively, while the lifeworld can be the site of all sorts of oppression and domination.

From the standpoint of theorizing the public sphere, Habermas concedes that from the time of developing this distinction, "I have considered the state apparatus and economy to be systematically integrated action fields that can no longer be transformed democratically from within, . . . without damage to their proper system logic and therewith their ability to function" (Habermas 1992: 444). That is, like technology and production, Habermas thinks that the economy and state follow certain systemic imperatives that render them impossible to democratically transform. All one can do, from this perspective, is to protect the communicative spheres of the lifeworld

from encroachment by the forces of instrumental rationality and action and the imperatives of money and power, preserving a sphere of humanity, communication, morality, and value in the practices of everyday life.

From the time that the theory of communicative action and the contrast between system and lifeworld became central to his project, Habermas's emphasis has been on political will formation through the process of "deliberative democracy," conceived as processes which cultivate rational and moral subjects through reflection, argumentation, public reasoning, and reaching consensus (Habermas 1992: 445f). Severing political discussion from decision and action, however, focuses the locus of Habermasian politics strictly on discussion and what he calls a discourse theory of democracy. Whereas theories of strong democracy posit individuals organizing, deliberating, making decisions, and actively transforming the institutions of their social life, Habermas shifts "the sovereignty of the people"

> into a flow of communication . . . in the power of public discourses that uncover topics of relevance to all of society, interpret values, contribute to the resolution of problems, generate good reasons, and debunk bad ones. Of course, these opinions must be given shape in the form of decisions by democratically constituted decision-making bodies. The responsibility for practically consequential decisions must be based in an institution. Discourses do not govern. They generate a communicative power that cannot take the place of administration but can only influence it. This influence is limited to the procurement and withdrawal of legitimation. (1992: 452)

This is quite a shift from the perspectives of *Structural Transformation* where Habermas delineated an entire set of institutions and practices that could directly impinge upon and transform all realms of social life. Despite the pessimistic conclusion of *Transformation*, which posited the decline of the bourgeois public sphere in the contemporary era, Habermas earlier held out the hope for societal democratization of the major realms of politics, society, and everyday life, although he did not specify any particular tactics, strategies, or practices. Over the past two decades, however, his work has taken a philosophical turn that focuses on the discursive conditions of rational discussion, anchored in communicative relations of everyday life.

In his later work, I would argue, Habermas indulges in a romanticism of the lifeworld, appealing to the "true humanity" operative within interpersonal relations, assuming face-to-face communication as his model of undistorted communication, and replacing structural transformation with the ideal of cultivation of the communicatively-rational individual and group. His analysis is discourse-oriented, developing discourse theories of morality, democracy, and law, grounded in a theory of communicative action. While these analyses provide some extremely powerful insights into the conditions

of democratic deliberation and consensus, moral action and development, and the role of communication in spheres ranging from morality to politics to law, the quasi-ontological separation of the sphere of communicative action/lifeworld from system is problematic, as is his specific categorical bifurcation of the social system.

The crux of the problem with Habermas's analysis is that he makes too rigid a categorical distinction between system and lifeworld, constructing each according to their own imperatives, thus removing the "system" (that is, economy and state) from democratic transformation, while limiting the site of participatory democracy to the lifeworld. Against this conception, I would argue, as Habermas himself recognizes, that the lifeworld is increasingly subject to imperatives from the system, but that in the current era of technological revolution, interaction and communication play an increasingly important role in the economy and polity that Habermas labels the "system." Moreover, I will suggest that the volatility and turbulence of the contemporary "great transformation" that we are undergoing constitute a contradictory process where the lifeworld undergoes new threats from the system—especially through the areas of colonization by media and new technologies that Habermas does not systematically theorize—while at the same time there are new conflicts and openings in the economy and polity for democratic intervention and transformation.

Earlier, Habermas made a similar categorical distinction between production and interaction, arguing that the former (including technology) was governed by the logic of instrumental action and could not be transformed, while "interaction" was deemed the categorical field for rational discourse, moral development, and democratic will-formation. In the remainder of my study, I want to argue that in an era of technological revolution in which new technologies are permeating and dramatically transforming every aspect of what Habermas discusses as system and lifeworld, or as production and interaction, such dualistic and quasi-transcendental categorical distinctions can no longer be maintained.

In particular, Habermas's system/lifeworld dualism and the reduction of steering media within the system to money and power neglects the crucial functions of media of communication and new technologies in the structure and activity of contemporary societies and unnecessarily limits Habermas's political options. Andrew Feenberg will develop an argument in this volume concerning the need to theorize technology as a crucial "steering media" of contemporary society and to democratically transform technology to make it a force and field of societal democratization. I will focus here, as a subset of this concern, on the importance of communication media and technology for the processes of democratization and reconstruction of the public sphere.

In my book *Television and the Crisis of Democracy* (1990), I contend that the media, state, and business are the major institutional forces of

contemporary capitalist societies, that the media "mediate" between state, economy, and social life, and that the mainstream broadcasting media have not been promoting democracy or serving the public interest and thus are forfeiting their crucial structural importance in constructing a democratic society. Hence, I am assuming that the communication media are something like what Habermas calls "steering media," that, as I suggest below, they have crucial functions in a democratic social order, and that they have been failing in their challenges to promote democracy over the last decades, thus producing a crisis of democracy. In the remainder of this article, I will address this situation and propose remedies grounded in Habermas's early work and the first generation of critical theory.

In my view, Habermas does not adequately theorize the nature and social functions of contemporary media of communication and information, they are for him mere mechanisms for transmitting messages, instruments that are neither an essential part of the economy or polity in his schema, and of derivative importance for democracy in comparison to processes of rational debate and consensus in the lifeworld. In the conclusion to his "Further Reflections on the Public Sphere," Habermas makes a distinction between "the communicative generation of legitimate power on the one hand" and "the manipulative deployment of media power to procure mass loyalty, consumer demand, and 'compliance' with systemic imperatives on the other" (1992: 452). Such a distinction can be analytically made and strategically deployed, but in Habermas's use, the media are excluded *tout court* from the realm of democracy and the possibility of democratic transformation, since they are limited by definition in his optic to systemic imperatives of manipulation, governed by "media" of money and power, and thus are excluded from the possibility of contributing to the politics of a broader societal democratization.[10]

Hence, Habermas never really formulates the positive and indeed necessary functions of the media in democracy and cannot do so, I maintain, with his categorical distinctions. In *Transformations*, he sketches the degeneration of media from print-based journalism to the electronic media of the twentieth century, in an analysis that, as his critics maintain, tends to idealize earlier print media and journalism within a democratic public sphere contrasted to an excessively negative sketch of later electronic media and consumption in a debased public sphere of contemporary capitalism.

This same model of the media and public sphere continues to be operative in his most recent magnum opus *Between Facts and Norms* (1998), where Habermas discusses a wide range of legal and democratic theory, including a long discussion of the media and the public sphere, but he does not discuss the normative character of communication media in democracy or suggest how a progressive media politics could evolve. Part of the problem, I think, is that Habermas's notion of the public sphere was

grounded historically in the era of print media which, as McLuhan and Gouldner have argued, fostered modes of argumentation characterized by linear rationality, objectivity, and consensus.[11] Obviously, Habermas is an exemplary public intellectual, intervening in the public sphere in many crucial issues of the past decades, writing tirelessly on contemporary political events, criticizing what he sees as dangerous contemporary forms of conservativism and irrationalism, and in general fighting the good fight and constructing himself as a major public intellectual of the day, as well as world-class philosopher and social theorist (again, Dewey comes to mind as a predecessor).

Since writing is his medium of choice and print media is his privileged site of intervention, I would imagine that Habermas downplays broadcasting and other communication media, the Internet and new spheres of public debate, and various alternative public spheres in part because he does not participate in these media and arenas himself and partly because, as I am suggesting, the categorical distinctions in his theory denigrate these domains in contrast to the realms of communicative action and the lifeworld. But these blind spots and conceptual limitations, I believe, truncate Habermas's discussions of democracy and undermine his obvious intention of fostering democratization himself.

Hence, despite extremely detailed discussion of democracy in *Between Facts and Norms*, Habermas fails, in my view, to adequately explicate the precise institutional and normative functions of the media and the public sphere within constitutional democracy. As conceived by Montesquieu in *Spirit of the Laws* and as elaborated in the American and then French revolutions of the eighteenth century, a democratic social order requires a separation of power so that no one social institution or force dominates the polity. Most Western democracies separate the political system into the Presidency, Congress, and the Judiciary so that there would be a division and balance of powers between the major political institutions. The Press was conceived in this system as the "fourth estate" and freedom of the press was provided by most Western democracies as a fundamental right and as a key institution within a constitutional order based on separation of powers in which the media would serve as a check against corruption and excessive power in the other institutions.

But democratic theory also developed stronger notions of citizen participation, or what has become known as participatory democracy, in theorists such as Rousseau, Marx, and Dewey. In this conception, famously expressed by Abraham Lincoln, democracy is government by, of, and for the people. For such a conception of radical democracy to work, to create a genuinely participatory democracy, the citizens must be informed, they must be capable of argumentation and participation, and they must be active and

organized to become a transformative democratic political force. Habermas, as we have seen, limits his analysis of procedural or deliberative democracy to valorization of the processing of rational argumentation and consensus, admittedly a key element of real democracy.

But not only does he limit democracy to the sphere of discussion within the lifeworld and civil society, but he omits the arguably necessary presuppositions for democratic deliberation and argumentation—an informed and intellectually competent citizenry. Here the focus should arguably be on education and the media, for schooling and the media play a key role in enabling individuals to be informed, taught to seek information, and, if effectively educated, to critically assess and appraise information, to transform information into knowledge and understanding, and thus to make citizens capable of participating in democratic discussion and deliberation (on the role of education and the media in democracy see Kellner 1990 and 1998).

From this perspective, then, the media are part of a constitutional balance of power, providing checks and balances against the other political spheres *and* should perform a crucial function of informing and cultivating a citizenry capable of actively participating in democratic politics. If the media are not vigilant in their checking of corrupt or excessive power (of corporations, the state, the legal system, and so on) and if the media are not adequately informing their audiences, then they are not assuming their democratic functions and we are suffering a crisis of democracy (an analysis that I made in Kellner 1990 and 1992, but will qualify below).

Habermas's various analyses in his by now astoundingly prolific and monumental work recognizes these two sides of democracy, but does not adequately delineate the normative character of the media in democracy and does not develop a notion of radical democracy in which individuals organize to democratically transform the media, technology, and the various institutions of social life. In particular, he does not theorize the media and public sphere as *part* of a democratic constitutional order, but rather as a sphere of civil society that is

> a sounding board for problems that must be processed by the political system. To this extent, the public sphere is a warning system with sensors that, though unspecialized, are sensitive throughout society. From the perspective of democratic theory, the public sphere must, in addition, amplify the pressure of problems, that is, not only thematize them, furnish them with possible solutions, and dramatize them in such a way that they are taken up and dealt with by parliamentary complexes. Besides the 'signal' function, there must be an effective problematization. The capacity of the public sphere to solve problems *on its own* is limited. But this capacity must be utilized to oversee the further treatment of problems that takes place inside the political system. (1998: 359)

In Habermas's conception, the media and public sphere function outside of the actual political-institutional system, mainly as a site of discussion and not as a locus of political organization, struggle, and transformation. In fact, however, I would argue that while the media in the Western democracies, which is now the dominant model in a globalized world, are intricately intertwined within the state and economy, in ways that Habermas does not acknowledge, nonetheless oppositional broadcast media and new media technologies such as the Internet are, as I argue below, serving as a new basis for a participatory democratic communication politics. Habermas, by contrasts, fails to perceive how new social movements and oppositional groups and individuals use communication media to both educate and organize oppositional groups and thus expand the field of democratic politics.

Habermas himself does not distinguish between the differences in the public sphere under the domination of big media and state broadcasting organizations in Europe contrasted to the corporate and commercial dominated system of big media in the United States. In Europe's system of state-controlled broadcasting, a fusion emerged between the political sphere and the public sphere, in which state-financed and often controlled broadcasting organizations attempted to promote the national culture and in some cases to inform and educate its citizens. In the United States, by contrast, it was big corporations which colonized the public sphere, substituting popular entertainment for expressions of national culture, education, and information. In the United States, in contrast to Europe and much of the world, public broadcasting never emerged as a major cultural or political force and never served as the instrument of the state—although conservative critics constantly attacked its "liberal" biases, while radical critics attacked its centrist and conservative spectrum of programming, and exclusion of more radical perspectives and views.

The difference between a state-controlled public broadcasting system contrasted to a more commercial model has, of course, itself collapsed in the era of globalization where commercially-based cable television has marginalized public broadcasting in most countries and where in a competitive media environment even public broadcasting corporations import popular, mostly American, entertainment, and are geared more toward ratings than political indoctrination, or enlightenment. Nonetheless, public broadcasting continues to offer an ideal of public interest communication geared toward the common good and, ironically perhaps, the proliferation of new media, including the Internet which I discuss below, have multiplied information and discussion, of an admittedly varied sort, and thus provide potential for a more informed citizenry and more extensive democratic participation. Yet, the dis- and misinformation that circulates on the Internet

undermines democratic information and discussion, pointing to sharp contradictions within the current media system.

Habermas, however, neglects intense focus on the vicissitudes of the media, excludes democratization of the media from the realm of democratic politics, and does not envisage how new media and technology could lead to an expansion and revitalization of new and more democratic public spheres. In fact—and this is the crux of my critique of his positions—, Habermas simply does not theorize the functions of the media within the contemporary public sphere, deriving his model more from face-to-face communication and discussion, rather than from media interaction or communication mediated by the media and technology.[12] In the next section I will argue, however, that the development of new global public spheres with the Internet and new multimedia technology require further development of the concept of the public sphere today and reflection on the emerging importance of new technologies within democracy.

GLOBALIZATION, NEW TECHNOLOGIES, AND NEW PUBLIC SPHERES

In this concluding section, I wish to argue that in the contemporary high-tech societies there is emerging a significant expansion and redefinition of the public sphere comprising new sites of information, discussion, contestation, political struggle, and organization that include the broadcasting media and new cyberspaces as well as the face-to-face interactions of everyday life. These developments, connected primarily with multimedia and computer technologies, require a reformulation and expansion of the concept of the public sphere—as well as our notions of the critical or committed intellectual and notion of the public intellectual (see Kellner 1995b for an expansion of this argument). Earlier in the century, John Dewey envisaged developing a newspaper that would convey "thought news," bringing all the latest ideas in science, technology, and the intellectual world to a general public, which would also promote democracy (see the discussion of this project in Czitrom 1982: 104ff). In addition, Bertolt Brecht and Walter Benjamin (1969) saw the revolutionary potential of new technologies like film and radio and urged radical intellectuals to seize these new forces of production, to "refunction" them, and to turn them into instruments to democratize and revolutionize society. Jean-Paul Sartre too worked on radio and television series and insisted that "committed writers must get into these relay station arts of the movies and radio" (1974: 177; for discussion of his *Les temps modernes* radio series, see 177–80).

Previously, radio, television, and the other electronic media of communication tended to be closed to critical and oppositional voices both in systems

controlled by the state and by private corporations. Public access and low power television, and community and guerilla radio, however, opened these technologies to intervention and use by critical intellectuals. For some years now, I have been urging progressives to make use of new communications broadcast media (Kellner 1979; 1985; 1990; 1992) and was involved in a public access television program in Austin, Texas since 1978 which has produced over 600 programs and won the George Stoney Award for public affairs television. My argument has been that radio, television, and other electronic modes of communication were creating new public spheres of debate, discussion, and information; hence, activists and intellectuals who wanted to engage the public, to be where the people were at, and who thus wanted to intervene in the public affairs of their society should make use of these technologies and develop communication politics and new media projects.

The rise of the Internet expands the realm for democratic participation and debate and creates new public spaces for political intervention. My argument is that first broadcast media like radio and television, and now computers, have produced new public spheres and spaces for information, debate, and participation that contain both the potential to invigorate democracy and to increase the dissemination of critical and progressive ideas—as well as new possibilities for manipulation, social control, the promotion of conservative positions, and intensifying of differences between haves and have nots. But participation in these new public spheres —computer bulletin boards and discussion groups, talk radio and television, and the emerging sphere of what I call cyberspace democracy require critical intellectuals to gain new technical skills and to master new technologies (see Kellner 1995b, 1997, and 1999 for expansion of this argument).

To be sure, the Internet is a contested terrain, used by Left, Right, and Center to promote their own agendas and interests. The political battles of the future may well be fought in the streets, factories, parliaments, and other sites of past conflict, but politics today is already mediated by media, computer, and information technologies and will increasingly be so in the future. Those interested in the politics and culture of the future should therefore be clear on the important role of the new public spheres and intervene accordingly.

A new democratic politics will thus be concerned that new media and computer technologies be used to serve the interests of the people and not corporate elites. A democratic politics will strive to see that broadcast media and computers are used to inform and enlighten individuals rather than to manipulate them. A democratic politics will teach individuals how to use the new technologies, to articulate their own experiences and interests, and to promote democratic debate and diversity, allowing a full range of voices and ideas to become part of the cyberdemocracy of the future.

Now more than ever, public debate over the use of new technologies is of utmost importance to the future of democracy. *Who* will control the media and technologies of the future, and debates over the public's access to media, media accountability and responsibility, media funding and regulation, and what kinds of culture are best for cultivating individual freedom, democracy, and human happiness and well-being will become increasingly important in the future. The proliferation of media culture and computer technologies focuses attention on the importance of new technologies and the need for public intervention in debates over the future of media culture and communications in the information highways and entertainment by-ways of the future.[13] The technological revolution of our time thus involves the creation of new public spheres and the need for democratic strategies to promote the project of democratization and to provide access to more people to get involved in more political issues and struggles so that democracy might have a chance in the new millennium.

Further, in an era of globalization and technological revolution, the increased capacity of information, technology, and automation in the economy puts in question both Karl Marx's labor theory of value, upon which the early work of the Frankfurt School was based, as well as Habermas's distinction between production and interaction/communication as the fundamental distinction to make sense of, interpret, and criticize contemporary societies. Habermas, of course, often argued himself that the expanding functions of science and technology in the production process undermined the Marxian labor theory of value (see Habermas 1973: 226ff.). Expanding this argument, I contend that increased intensification of technological revolution in our era undermines Habermas's own fundamental distinction between production and interaction, since production obviously is structured by increased information and communication networks, while the latter are increasingly generated and structured by technology.[14] Hence, where Habermas earlier argued (1973, 1979, 1984, and 1997), and continues to argue, that production is governed by the logic of instrumental action, whereas relations in the lifeworld are governed by the logic of communicative action, more and more communicative action is playing a direct role in production, as information technology, communications, and interpersonal interaction structure the field of labor, and more modes of instrumental action become constitutive aspects of everyday life, as my typing this article on a computer and the exchange of e-mail between the editor and contributors which helped shape this volume, would suggest.

Thus, I have argued in this paper that Habermas's project is undermined by too rigid categorical distinctions between classical liberal and contemporary public spheres, between system and lifeworld, and production and interaction. Such dualistic conceptions are themselves vitiated, I have argued, by technological revolution in which media and technology play

vital roles on both sides of Habermas's categorical divide, subverting his bifurcations. The distinctions also rule out, I believe, efforts to transform the side of Habermas's distinction that he considers impervious to democratic imperatives or the norms of communicative action. My perspectives, by contrast, open the entire social field to transformation and reconstruction, ranging from the economy and technology to media and education.

Yet it is the merit of Habermas's analysis to focus attention on the nature and the structural transformations of the public sphere and its functions within contemporary society. My analysis suggests that we should expand this analysis to take account of the technological revolution and global restructuring of capitalism that is currently taking place and rethink the critical theory of society and democratic politics in the light of these developments. Through thinking together the vicissitudes of the economy, polity, technology, culture, and everyday life, the Frankfurt School provides valuable theoretical resources to meet the crucial tasks of the contemporary era. In this study, I have suggested some of the ways that Habermas's *Structural Transformation of the Public Sphere* provides a more promising starting point for critical theory and radical democracy than his later philosophy of language and communication and have suggested that thinking through the contributions and limitations of his work can productively advance the project of understanding and democratically transforming contemporary society. In particular, as we move into a new millennium, an expanded public sphere and new challenges and threats to democracy render Habermas's work an indispensable component of a new critical theory that must, however, go beyond his positions in crucial ways.

DOUGLAS KELLNER

GRADUATE SCHOOL OF EDUCATION
UNIVERSITY OF CALIFORNIA, LOS ANGELES
JANUARY 2000

NOTES

1. While working on an article on Habermas and Dewey in the early 1990s, I asked Habermas if Dewey had influenced him and he responded that Dewey's strong notion of liberal democracy, of politics and the public, and of the active connection between theory and practice made a strong impression on him; see Antonio and Kellner 1992 for details. Hence, I think it is fair to say that Habermas has emerged as one of the major theorists and defenders of a robust conception of liberal democracy in our day, and thus can be seen as a successor to Dewey.

2. On SDS, see Sale 1974; Gitlin 1987; and Miller 1994.

3. Habermas 1989a [1962]; A short encyclopedia article succinctly summarizes Habermas's concept of the public sphere (1989b).

4. For a discussion of the initial critiques of Habermas's *Offentlichkeit*, see Hohendahl 1979; for a bibliography of writings on the topic, see Görtzen 1981; and for a set of contemporary English-language discussions of the work, after it was finally translated in 1989, see Calhoun 1992. To get a sense of the astonishingly productive impact of the work in encouraging research and reflection on the public sphere, see the studies in Calhoun 1992 and Habermas's "Further Reflections on the Public Sphere" that cite a striking number of discussions, criticisms, and developments of his study.

5. One example relevant to Habermas's time frame: the framing of the U. S. constitution as analyzed in Beard 1998 who demonstrates that the U. S. form of constitutional government was decisively formed through compromises between competing Northern and Southern elites rather than through rational argumentation and consensus concerning common interests.

6. There is no mention, for instance, of C. Wright Mills in the index of the collection of articles on Habermas and the public sphere in Calhoun 1992. Mills himself was influenced by the works of the Institute for Social Research and paid explicit homage to the Institute in a 1954 article where he described the dominant types of social research as those of the Scientists (quantitative empiricists), the Grand Theorists (structural-functionalists like Talcott Parsons), and those genuine Sociologists who inquire into: "(1) What is the meaning of this—whatever we are examining—for our society as a whole, and what is this social world like? (2) What is the meaning of this for the types of men and women that prevail in this society? and (3) how does this fit into the historical trend of our times, and in what direction does this main drift seem to be carrying us? (Mills 1963: 572). He then comments: "I know of no better way to become acquainted with this endeavor in a high form of modern expression than to read the periodical, *Studies in Philosophy and Social Sciences*, published by The Institute of Social Research. Unfortunately, it is available only in the morgues of university libraries, and to the great loss of American social studies, several of the Institute's leading members, among them Max Horkheimer and Theodore Adorno, have returned to Germany. That there is now *no* periodical that bears comparison with this one testifies to the ascendancy of the Higher Statisticians and the Grand Theorists over the Sociologists. It is difficult to understand why some publisher does not get out a volume or two of selections from this great periodical" (ibid.).

7. Habermas has been developing these positions since the 1970s; see, among others, Habermas 1970, 1979, 1984, and 1987a.

8. In a sense, Habermas and poststructuralism articulate the opposing poles of language: while Habermas argues that language and communication involve a relation to meaning, truth, recognition, and universality, post-structuralism stresses its embeddedness in power and its potential for untruth, distortion, and domination (for Habermas's own critiques of poststructuralist conceptions, see Habermas 1987b). I will argue below that both sides are one-sided and express contradictions of language and communication that must be worked through and mediated in order to develop more comprehensive theories.

9. Habermas indicates how problems in his 1960s work led him to develop this distinction in the 1970s (1992: 443f), a framework articulated most systematically in *Theory of Communicative Action* (1984 and 1987a), but crucial to all of Habermas's post-1970s works.

10. One exception in Habermas is a reference to the role of communication media in promoting the overthrow of state socialism: "The transformation occurring in the German Democratic Republic, in Czechoslovakia, and in Romania formed a chain of events properly considered not merely as a historical process that happened to be shown on television but one whose very *mode of occurrence* was televisual" (Habermas 1992: 456). Habermas cites this example to indicate "the ambivalent nature of the democratic potential of a public sphere" and to suggest contradictory functions of electronic media, but he does not theorize in any systematic way how communication media and technology could be democratized and serve the ends of democratic transformation, and thus has no democratic media politics, a project that I outline below. I should perhaps also note here that there are ambiguities in Habermas's choice of the term "media" for steering-mechanisms of money and power, and thus are not given independent status as an important societal force. While I do not deny that money and power, corporations and the state, control the media of communications in the current situation, I am claiming that communications media have a normative role in democratic theory and that without a democratizing of the media, more expansive and inclusive societal democratization is not foreseeable.

11. See McLuhan 1961 and 1964 for arguments that print media were a fundamental constituent of modernity, helping produce individualism, secularism, nationalism, democracy, capitalism, and other key features of the modern world. Gouldner (1976), while avoiding McLuhan's excessive technological determinism, sets out some of the ways that print media fostered rationality, objectivity, political participation, and cnsensus.

12. While Habermas describes the public sphere as "a network of communicating information and points of view" in *Between Facts and Norms*, he then states: "Like the lifeworld as a whole, so, too, the public sphere is reproduced through communicative action, in which mastery of a natural language suffices" (1998: 360). His public sphere is thus grounded in a lifeworld with an "intersubjectively shared space of a speech situation in concrete locales where an audience is physically gathered" (1998: 361). On this analysis, then, the public sphere is anchored in concrete physical relations of the lifeworld, so that communications media information and debate, or disembodied communication in cyberspace on the Internet, are excluded from the very concept of the public sphere and democratic will-formation. I would argue, however, that providing important information for democratic discussion and debate and the processes of dialogue and argumentation are crucial for democracy and can legitimately take place in broadcast media and new computer informational cyberspaces as well as face-to-face diliberation.

13. On media and communications politics of the present, see Kellner 1990, 1995a, 1997, and 1999.

14. I have suggested in this paper the expanding role of technology in politics, communication, and everyday life and will augment the discussion of the ways that

new information, entertainment, and communications technology are restructuring the global economy and all dimensions of social life in further writings; for extensive documentation of the role of information/communication technology in the global economy and rise of the "network society," see Castells 1996, 1997, and 1998 and Best and Kellner forthcoming.

REFERENCES

Antonio, Robert J. and Douglas Kellner (1992) "Communication, Democratization, and Modernity: Critical Reflections on Habermas and Dewey." *Habermas, Pragmatism, and Critical Theory*, special section of *Symbolic Interaction* 15, no. 3 (Fall 1992): 277–98.
Adorno, T. W., et al. (1976) *The Positivist Dispute in German Sociology*. London: Heinemann.
Beard, Charles (1998) *An Economic Interpretation of the Constitution of the United States*. New York: Transaction Press.
Benjamin, Walter (1969) *Illuminations*. New York: Schocken Books.
Bronner, Stephen Eric, and Douglas Kellner, eds. (1989) *Critical Theory and Society. A Reader*. New York: Routledge.
Bryan, Mary Lynn McCree, and Allen F. Davis (1969) *Years at Hull-House*. Bloomington: Indiana University Press.
Calhoun, Craig (1992a) "Introduction: Habermas and the Public Sphere." In Calhoun 1992: 1–48.
Calhoun, Craig, ed. (1992b) *Habermas and the Public Sphere*. Cambridge: MIT Press.
Castells, Manuel (1996) *The Rise of the Network Society*. Oxford: Blackwell.
——— (1997) *The Power of Identity*. Oxford: Blackwell.
——— (1998) *End of Millennium*. Oxford: Blackwell.
Czitrom, Daniel (1982) *Media and the American Mind*. Chapel Hill, N.C.: North Carolina University Press.
Downing, John (1984) *Radical Media*. Boston: South End Press.
Fiske, John (1994) *Media Matters*. Minneapolis, Minn.: University of Minnesota Press.
Fromm, Erich (1989) *The Working Class in Weimar Germany : A Psychological and Sociological Study*. Cambridge, Mass.: Harvard University Press.
Gitlin, Todd (1987) *The Sixties. Years of Hope, Days of Rage*. New York: Doubleday.
Görtzen, R. (1981) *J. Habermas: Eine Bibliographie seiner Schriften und der Sekundärliteratur, 1952–1981*. Frankfurt.
Gouldner, Alvin W. (1976) *The Dialectic of Ideology and Technology*. New York: Seabury.
Habermas, Jürgen (1962) *Strukturwandel der Öffentlichkeit*. Neuwied and Berlin: Luchterhand.
——— (1970) "Toward a Theory of Communicative Competence." In Hans Peter

Dreitzel, ed. *Recent Sociology No. 2*. New York: Macmillan, 1970, 114–48.
——— (1973) *Theory and Practice*. Boston: Beacon Press.
——— (1979) *Communication and the Evolution of Society*. Boston: Beacon Press.
——— (1983 and 1987) *Theory of Communicative Action*. Vols. 1 and 2. Boston: Beacon Press.
——— (1987) *The Philosophical Discourse of Modernity*. Cambridge, Mass.: MIT Press.
——— (1989a) *Structural Transformation of the Public Sphere*. Cambridge, Mass.: MIT Press.
——— (1989b) "The Public Sphere: An Encyclopedia Article." In Bronner and Kellner 1989: 136–42.
——— (1992) "Further Reflections on the Public Sphere." In Calhoun 1992b: 421–61.
——— (1998) *Between Facts and Norms*. Cambridge, Mass.: MIT Press.
Habermas, Jürgen et al. (1961) *Student und Politik*. Berlin: Neuwied.
Hammer, Rhonda, and Douglas Kellner (1999) "Multimedia Pedagogical Curriculum for the New Millennium." *Journal of Adolescent & Adult Literacy* 42, no. 7 (April): 522–26 and longer version forthcoming in *Journal of Religious Education*, Special Issue on Holocaust Education 95, no. 4 (Fall 2000).
Hohendahl, Peter (1979) "Critical Theory, Public Sphere and Culture: Habermas and His Critics." *New German Critique* 16 (Winter): 89–118.
Kellner, Douglas (1979) "TV, Ideology, and Emancipatory Popular Culture." *Socialist Review* 45 (May–June): 13–53.
——— (1985) "Public Access Television: *Alternative Views*." *Radical Science Journal* 16, *Making Waves*: 79–92.
——— (1989) *Critical Theory, Marxism and Modernity*. Cambridge and Baltimore: Polity Press and John Hopkins University Press.
——— (1990) *Television and the Crisis of Democracy*. Boulder: Westview Press.
——— (1992) *The Persian Gulf TV War*. Boulder: Westview Press.
——— (1995a) *Media Culture*. London and New York: Routledge.
——— (1995b) "Intellectuals and New Technologies." *Media, Culture, and Society* 17: 201–17.
——— (1997) "Intellectuals, the New Public Spheres, and Technopolitics." *New Political Science* 41–42 (Fall): 169–88.
——— (1998) "Multiple Literacies and Critical Pedagogy in a Multicultural Society." *Educational Theory* 48, no. 1: 103–22.
——— (1999) "Globalization From Below? Toward a Radical Democratic Technopolitics," *Angelaki* 4, no. 2: 101–13.
McLuhan, Marshall (1962) *The Gutenberg Galaxy*. New York: Signet Books.
——— (1964) *Understanding Media: The Extensions of Man*. New York: Signet Books.
Miller, James (1994) *'Democracy Is in the Streets': From Port Huron to the Siege of Chicago*. Cambridge: Harvard University Press.
Mills, C. Wright (1951) *White Collar*. Boston: Beacon Press.
——— (1956) *The Power Elite*. Boston: Beacon Press.

———— (1963) "IBM Plus Reality Plus Humanism=Sociology." In *Power, Politics, and People*. Boston: Beacon Press.

Pollock, Friedrich, ed. (1955) *Gruppenexperiment*. Frankfurt: Institut fur Sozialforschung.

Ryan, Mary (1992) "Gender and Public Access: Women's Politics in Nineteenth Century America." In Calhoun 1992: 259–88.

Sale, Kirkpatrick (1974) *SDS*. New York: Vintage.

Sartre, Jean-Paul (1974) *The Writings of Jean-Paul Sartre*. Edited by Michel Contat and Michel Rybalka. Evanston, Ill.: Northwestern University Press.

Wiggershaus, Rolf (1996) *The Frankfurt School*. Cambridge: MIT Press.

Zinn, Howard (1995) *A People's History of the United States: 1492 to Present*. New York: Harperperennial.

14

David Ingram

Individual Freedom and Social Equality: Habermas's Democratic Revolution in the Social Contractarian Justification of Law

Throughout his distinguished career as a social philosopher Habermas has been cast in two leading—and by no means compatible—roles. Prior to 1981, the year that witnessed the publication of his *magnum opus*, *The Theory of Communicative Action*, he was typically cast as a Marxist critic of liberalism and capitalism. Since then, however, he has sought to cultivate his image as a liberal defender of the rule of law and its functional base: an efficient, market-driven economy that accords individual freedom a certain pride of place. Accordingly, he now finds Marx's idea of an egalitarian, democratically regulated economy hopelessly utopian. Still, despite this change in his thinking, he continues to maintain that capitalism conflicts with genuine liberalism. In this respect he follows the path marked out by his predecessors in the Frankfurt School tradition of legal philosophy, Franz Neumann and Otto Kirchheimer, who eventually came to realize that the protection of equal individual liberties could only be fully implemented under a regime of democratic socialism.

I shall argue below that Habermas's most ambitious defense of liberalism and the rule of law, *Between Facts and Norms* (1993—hereafter *BFN*), is also his most compelling critique of capitalism.[1] This critique, however, is somewhat occluded by his peculiar attachment to a social contractarian notion of capitalist markets that seems to rule out any substantial democratic planning, be it exercised by workers as members of cooperatives or by citizens as members of communities. This outcome seems counterintuitive given the text's central claim. *BFN* presents itself as a resolution of the debate between liberals and their communitarian and civic republican opponents concerning the validating basis of law, with the former locating this basis in universal ideas of freedom, justice, and equality that are

transparent to any mature individual exercising his or her independent faculty of reasoning and the latter locating it in the temporally and spatially bounded agreements and customary understandings that unite citizens of particular communities. In fact, *BFN* shows that the universal rights of individuals to act freely in accord with their private interests and the political rights of communities to democratically legislate the specific scope of such rights through public deliberation are mutually interdependent, complementary, and co-original—rather than opposed.

Ultimately, *BFN* shows that a consistent libertarian who esteems individual liberty above social equality must concede the parity of these supposedly opposed values. Others have argued this point as well by showing that some egalitarian redistribution of wealth is necessary in order to prevent the violation or diminution of the liberty of the poor and weak at the hands of the wealthy and powerful. These arguments typically assume that the liberties of these antagonistic groups are contradictory, so that the liberty of the wealthy and powerful must be limited for the sake of either maximizing the liberty of the greater number or allowing the poor and weak an equal liberty to pursue their self-preservation.[2] Formulated in terms of the social contract, since the wealthy and powerful benefit the most from gaining the cooperation of others whose lesser bargaining power makes it disadvantageous for them to cooperate, the former (the wealthy and powerful) ought to accept limits on their economic freedom to acquire and transfer wealth in return for the disadvantaged accepting limits on their natural freedom to do whatever they need to do in order to survive.

Habermas also accepts this *reductio* refutation of libertarianism. In his opinion, the unequal distribution of economic resources renders the poor especially vulnerable to criminal depredation, legal coercion, and a host of internal and external constraints on their liberty. However, in contrast to defenders of the welfare state, he does not think that this unequal distribution of liberty can be satisfactorily rectified by redistributing economic resources. For, unless redistribution is accompanied by guaranteed job security and substantive equality of opportunity to participate in the democratic process, it will simply perpetuate the freedom-denying dependency, passivity, and dehumanization associated with welfare paternalism.

Habermas's advance over libertarian and social welfare paradigms of law—which remain entrenched within individual, subject-centered conceptions of negative and positive freedom, respectfully—consists in showing that personal freedom to act with capacity and without constraint is inconceivable apart from public freedom to participate in the making of laws that define freedom as such. What *BFN* proposes is a dialogic emendation of Rousseau's social contractarian idea that individual liberty cannot exist unless its meaning and scope are legally defined and enforced. Even Locke—the founder of libertarianism—understood that real liberty

exists only as a mutual right to go about one's proper business without arbitrary interference from others. However, he failed to notice two things: First, mutuality (or moral equality) is not based on some individually possessed natural (factual) equality, be it of innate faculties or of divine origination; second, what is one's proper business and what constitutes an arbitrary infringement on it are not individually intuitable with any rational certainty, but must itself be agreed upon by all concerned. Indeed, despite Locke's own belief in the natural, prelegal origin of contractual relations between free and equal persons—a plausible assumption given the implicit trust and understanding that united the roughly equal and independent commodity producers who dominated market transactions in late seventeenth-century England—even he had to concede that such relations needed the stability afforded by civil and constitutional law (44).

What Locke failed to see was that the social inequalities naturally generated by market transactions after their transformation into a complex monetary system must not only be protected by law but also legitimated and limited by it. The unforeseeable and unintended inequalities generated over time by an aggregate of such transactions could not be legitimated solely by a "tacit consent" to the use of money, since it is possible that neither these inequalities nor their coercive side effects would have been expressly consented to by rational agents. In order for stable and noncoercive social cooperation to be possible after the introduction of money, the resultant deviation from 'natural' equal autonomy would have had to have been ratified by the express consent of all affected, after they had deliberated in common. As Habermas notes, not only would the contractors have had to agree on what ought to count as a 'natural' limit on market inequalities, but the orientation toward equality—far from being naturally inculcated in each individual by God—would first have arisen out of social relationships between persons who, in communicating to one another as equals, resolved on fair terms of social cooperation. Dialogic equality in turn would have required an equal distribution of the economic, social, and cultural resources requisite for leisurely, dispassionate, and informed discussion.

This, then, is the basic gist of Habermas's libertarian refutation of libertarianism. We can further clarify the way in which he proposes to qualify unequal market liberties by egalitarian dialogic constraints with reference to the peculiar advantages of a social contractarian theory of law (SCTL). A SCTL provides an attractive alternative to traditional legal theories in that it departs from a realistic assessment of the limited capacity of persons living in modern, market-oriented societies to behave altruistically and assent to shared moral and religious dogmas.[3] When these *facts*—of individual egoism and moral pluralism—are seen from the vantage point of an individual who prizes above all else the freedom to pursue what he or she thinks is right and good within a field of more or less equally situated

individuals, they dictate a common course of cooperation based on a mutual agreement (contract) to abide by reasonable rules guaranteeing, as Rawls and other Kantians maintain, the most extensive freedom of each to pursue his or her individual conception of the good compatible with a like freedom for all.

Unfortunately, the strength of this libertarian account of the SCTL in its Hobbesian, game-theoretic formulation—that is, its departure from a minimalist, or amoral, notion of strategic rationality that solely consists in the calculation of efficient means for maximally satisfying personal preferences—is also its Achilles' heel. Unless an enforcement agency were already agreed upon and in place prior to the reaching of an agreement, it would not be in the rational self-interest of the contracting parties—no matter how morally disposed they might otherwise be—to trust their compatriots long enough to keep to their agreement. And even if such an agency were in place, the less morally inclined among them would be tempted to break the agreement whenever they calculated that the reward for doing so substantially outweighed the risk of detection and punishment (92–94).

It was Kant himself who first observed that those party to civil contracts for personal gain must already possess, in addition to strategic rationality, moral reasoning requisite for viewing these transactions from an impersonal (that is, intersubjective) point of view. Habermas proposes to defend this same idea in a manner that does not rely on personal transcendental intuitions. Appealing to facts about socialization, he argues that the necessary conditions for an individual's experiencing a meaningful world include that individual's having learned to speak a meaningful language. As Wittgenstein taught, the meaningfulness of an expression is bound up with its correct usage, which usage refers to socially agreed-upon rules. Taking his cue from Chomsky's research on the innate grammar underlying the individual's ability to produce sentences, Habermas argues that, besides the particular rules regulating the production of particular expressions, there must also be a more general, rule-governed competence underlying the production of communicability as such. More precisely, the production of meaningful utterances presupposes a mutual understanding between persons about a shared meaning, and this understanding itself is structured by the mutual expectation that each speaker is sincere and capable of giving reasons in support of the appropriateness, rightness, and veracity of what he or she has said. Most importantly, the dialogic conditions underlying reasoned justification—the only recourse that speakers have for restoring faith in their claims in the face of challenges—require that speakers be free from internal and external coercion, have equal chances to give (or challenge) reasons, and join with one another solidaristically in trying to reach an impartial agreement. Mutual understanding of a common meaning here implies mutual recognition of equal autonomy. Thus, in stark contrast to the Hobbesian

model of the social contract, social agents, for Habermas, are already party to communicative agreements in which they are obligated to fulfill certain moral expectations as a condition of thinking and acting meaningfully. To break this moral bond out of some misbegotten notion of one's self-interest would be irrational, since it would violate the solidaristic conditions underlying one's own sense of self.

Like other social contract theorists, Habermas presents his own communication-based account of practical reasoning as providing a very general orientation for behavior, one that upon due reflection could be acknowledged by all persons regardless of their different moral beliefs. What he thinks distinguishes his view from theirs, however, is its postmetaphysical status, that is, its being grounded in empirically testable hypotheses regarding communicative competences that have evolved over time. Indeed, it is normative precisely in the sense that the mutual recognition of free and equal interlocutors necessary for mutual understanding already implies something like the liberal idea of universal human rights. In fact, despite his own protestations to the contrary, such an orientation appears to have a status very similar to classical natural law: it shows that the bare idea of individual rights necessarily follows from the "natural" (or unavoidable) conditions of modern—freely negotiated rather than traditionally habituated—association. As he himself repeatedly insists, the equal chance to speak freely and impartially is the closest approximation to rationally convincing discourse that we know of, and so confronts us as a kind of ineluctable fact of reason (to use Kant's phrase) that constrains our reasoning and willing regardless of our cultural backgrounds.

To be sure, the sheer inescapability of having to reason with others as equals that governs so much of our enlightened form of life yields no obligation equivalent to that prescribed in the classical natural law tradition; the general norm of conversational civility that compels us to treat others with equal respect and openmindedness as a condition for adequately understanding them does not prescribe specific laws or commands. At best, the sheer ideality (counterfactuality) of this norm requires that we constantly criticize and improve upon existing legal institutions that supposedly instantiate and interpret it. Although concretely binding obligations exist only in the form of conventionally agreed upon rights (as communitarians and civic republicans insist), the dialogic norm under which we consent to them ideally urges the progressive augmentation of freedom and equality in a manner that transcends what any right actually prescribes—hence the revolutionary impulse inherent in the constitutional project.

Habermas thus insists on the prelegal status of universal norms of communication as unsaturated placeholders for basic categories of rights. Were he not to do so, he could not appeal to them as a context-transcending

moral basis for critically evaluating the de facto laws passed by particular democratic majorities. Unfortunately, this way of formulating the relationship between universal moral rights and parochial laws seems viciously circular or self-defeating. If rights have no prescriptive content or force apart from what particular communities agree upon in democratic deliberation, then they cannot function as an independent criterion for critically assessing the justice of such agreements. Conversely, if they possess such a content and force prior to their being deliberated on—perhaps one that each of us can intuit in moments of solitary meditation—then democracy, as a rational procedure for resolving on and legitimating rights, seems unnecessary, if not misleading.

To appreciate this dilemma fully I recommend that we draw several distinctions. First, we should distinguish between different sorts of abstract norms—or categories of rights—and their different senses and justifications. Second, within the sphere of morality proper we need to distinguish between such abstract norms and their concrete interpretations. Finally, we need to distinguish between morality and legality. In each of these instances we find that rights mean very different things.

To begin with, some widely accepted norms endow us with rights, understood as personal liberties, that we think individuals ought to have simply in order to live well by some measure of humanity. For instance, we think that persons ought to have the right to procure their self-preservation, since it is natural and good for human beings, as a species, to do so. Beyond that, we might also think that persons ought to have the right to speak and associate freely for political purposes, and for the same reason. Significantly, to endorse such freedoms on account of their naturalness is compatible with the notion that what is natural will be understood by different cultures differently. Hence persons socialized in liberal democracies—in contrast to those socialized in authoritarian religious orders—will esteem freedom of speech and association as natural and good; and persons in both societies might esteem the right to life in the same way. In this sense the communitarian notion that what is good precedes our understanding of what is right (or just) seems correct.

The important thing to note here is that we can justify a general norm, or category of right, by appeal to its natural goodness for people in general or just for people like us. Its justification appeals to the natural order of things as understood by a community, not to the fact that it has been consented to by the community (although community consent might be proffered as evidence for its being natural and good). Thus we customarily say that persons ought to have a prima facie right to conduct their lives without arbitrary interference not simply because the majority happens to say so but because doing so is necessary for procuring our natural interest in self-preservation, period.

It might seem that Habermas cannot accept this concept of a naturally justified right without renouncing his Kantian abhorrence of metaphysical dogmatism—a point that touches on the internal consistency of his own Kantianism.[4] Or, conversely—to cite Charles Larmore—it might seem that he can, but only if such a right is necessary for fully exercising a life-sustaining—socially evolved but now universally indispensable—communicative competence.[5] Now, it is true that Habermas attempts to ground basic rights in the normative presuppositions regulating possible communication, rather than in the natural pursuit of life. Elsewhere, in contrast with this assertion, he insists that prescriptive rights are justified solely in virtue of their having been consented to, not because they are necessary for exercising any natural competence, be it communicative or otherwise. Both of these assertions, in turn, are contradicted by his claim that "private rights mark out the legitimate scope of individual liberties and are thus tailored to the strategic pursuit of private interests" (27). These private rights have a justification that is not exhausted by their instrumental function in maintaining democracy, since Habermas says that individuals might exercise them in ways that are largely personal, rather than public-regarding (461). And, as he here suggests, they are tailored toward an instrumental interest in technical control (or self-preservation) which earlier in his career he had characterized as rooted in the natural history of the species.

In order to resolve this confusion we must distinguish between natural and social senses of normativity, or right. Qua natural, rights are individual freedoms tailored toward the strategic pursuit of private interests, be it self-preservation, communication, or what have you. Qua social, they are obligations that persons agree to impose on one another. In modern liberal polities, rights have the further social meaning associated with equality and reciprocity. Here the "naturalness" of rights—assuming that it is permissible to use this expression to designate a necessary social signification—has less to do with their instrumentality toward procuring biological survival than with their instantiation of a common humanity that fully manifests itself only in communication. The justification for equal rights in general must be traced to *this* natural foundation; the justification for any particular right, however, must consist in its conventional acceptance by all those affected by it.

The distinction between natural and social significations of right—that consisting in the furtherance of a strategic interest in self-preservation and that consisting in the instantiation of a community of free and equal persons—must be supplemented, as we have just seen, by a distinction between abstract categories of rights (to life, speech, association, conscience, and so on) and their particular interpretations, which lend them determinate meaning and force. The semantic force of natural freedom and social equality associated with rights in their generality neither prescribes nor proscribes anything of sufficient determinacy capable of coordinating

behavior between strategic actors. We thus need what Habermas calls discourse—or rational conversation—for resolving disagreements about the prescriptive meaning and scope of our basic rights. Only after having consented to a definite right with a limited scope and conditional force, would one be obligated to obey it.

Here we see that the problem of circularity raised earlier is scarcely avoidable: general ideas of right inform just procedures of discourse by which rights in their specificity are chosen. What makes this circularity less vicious is that specific rights always signify something more universal than what is literally specified by them, and this something more—however abstract, vague, and open-ended it might be—permits us to imagine better alternatives for (or instantiations of) what our basic rights are.

This takes us to our third distinction—between morality and legality. Moral rights are still too open-ended to provide a solitary basis for generating and sustaining a harmonistic flourishing of individual freedoms. Given the difficulty of resolving moral conflicts under modern conditions of cultural pluralism and individual conscience and voluntarily complying with (and organizationally implementing) their resolution, moral agreements must be supplemented by laws. More precisely, legislative and judicial procedures establish definitive mechanisms for resolving disagreements about general norms and policies, while administrative procedures provide mechanisms for their punitive enforcement and implementation.

The need to supplement morality with legality touches on another aspect of the problem of circularity. On the one hand, the justice of any legal system—and therewith its capacity to elicit voluntary compliance—minimally requires that it not violate universal moral rights. So legality presupposes morality. On the other hand, morality—which presupposes the prior existence of free, responsible agents—cannot subsist without law and order. The cognitive, motivational, and organizational uncertainties associated with morality thus paradoxically entail that moral freedom be secured through legal coercion; namely, that legal institutions define and secure the very procedures that, in turn, lend them moral legitimacy (27–28, 106–7).

For Habermas, the apparent circularity that exists between law and morality is dispelled once we understand that law does not simply mirror morality, or exhaust itself in codifying and adjudicating moral maxims. To begin with, as noted above, morality proper is a matter of respecting rights for conscience's sake alone, whereas in legal matters it suffices that persons obey for any reason whatsoever. Second, the imperative of consistency and universality governing our moral deliberations first and foremost dictates what Kant called "perfect duties," or duties forbearing us from harming others wrongfully. Only some—indeed, the most important—of these duties find their legal equivalent in criminal statutes prohibiting murder, theft, and fraud; however, many laws do not directly instantiate moral maxims at all. Some laws

establish conventional mechanisms for coordinating social interaction (such as driving on the right side of the road). Others establish procedures for maintaining the general welfare (such as tax policies, national healthcare programs, social security schemes, and the like).

The distinction between law and morality outlined above bears directly on Habermas's refutation of libertarianism. Libertarians argue that law properly exhausts itself in enforcing a select class of perfect moral duties and coordination rules. However, it is Habermas's contention that the libertarian condition for exercising moral autonomy—freedom from external coercion—cannot be universally and equally guaranteed without legal policies guaranteeing equal social welfare.

To begin with, libertarians generally insist that reasonable social contracts be both inclusive in application and equitable in the advancement of mutual interests. As for the first condition, they hold that the law must remain impersonal, applying to all individuals the same way, regardless of their differences. In Habermas's opinion, this demand, which seems cogent enough in the case of criminal procedure—appears misplaced when the law is called upon to guarantee the rights of persons who are physically handicapped or who have suffered discrimination. Persons confined to wheelchairs need special legal recognition of their handicap, just as minorities need special legal recognition of their disadvantage in procuring employment under circumstances of racial exclusion. In these instances a legal theory that equated impartiality with an unqualified refusal to draw distinctions between different classes of persons would in fact countenance the worst form of partiality—that on behalf of the nonhandicapped and privileged. As for the second condition, libertarians have argued that the only laws that advance the interests of all equally are laws that protect private property and solve coordination problems. These laws are restricted to criminal and civil statutes, traffic ordinances, and the like. In their opinion, social laws that advance collective goods—especially those that mandate transfers of income from wealthy to poor—do not advance the property rights of all equally, and so violate equity. However, as I noted earlier, in the absence of such transfers, the freedom and property of the weak and poor will not be adequately protected, thereby frustrating the aim of social cooperation.

According to Habermas, the failure of libertarianism to expand its conception of law beyond securing moral rights resides in its mistaken view that rights derive solely from nature. For them, the social contract does not delimit the precise scope of any right—since this is supposed to be clearly known by each contractor prior to their association. Instead, it merely establishes the enforcement framework for adjudicating and executing it. But such a naturalistic view of rights forgets that their instantiation of common humanity—of reciprocity and equality—is based on their communicability; and it likewise forgets that their precise scope and force originates in

unconstrained social agreement. Indeed, it is because we disagree in our intuitions about the meaning and scope of basic rights that we need democracy in the first place.

If law is what mediates between our "natural" rights and our "social" duties, then democracy is the legitimate mechanism by which this is accomplished. But why should this be so? Libertarians, in particular, insist that the rule of law be distinguished from the rule of the people. Habermas disagrees. Legal form, which attaches predictable sanctions to certain sorts of conduct, can at most coordinate social interaction by stabilizing mutual expectations between private subjects; it cannot guarantee that the social interaction it stabilizes is equitable, guaranteeing fair terms of cooperation.

The concept of equity, however, descends from more basic concepts underlying the moral point of view—reciprocity, mutual recognition of humanity, and the like—that first arise within communication. In other words, it is only by applying the basic norm of civility underlying communicative interaction—what Habermas elsewhere calls the principle of discourse—to the concept of legal form that we can derive the concept of the rule of law. The principle of discourse states that "just those norms are valid to which all possibly affected persons could agree on as participants in rational discourse" (107). On a first reckoning, it is clear that the rule of law must express itself as a system of basic rights that even a libertarian would be hardpressed to deny: the right to the greatest measure of freedom compatible with a like freedom for all (including freedom of movement, vocation, ownership, and the like); the right to citizenship (including the right to emigrate); and the right to due process (including access to effective and impartial courts for indemnifying claims (121–22).[6]

The above legal code presupposes a state apparatus without yet imposing any concrete limitations on it. In order for the libertarian to show that the rule of law so conceived also imposes constitutional limits on state power we need to make an additional move—toward democracy. The abstract categories of right comprising the above legal code derive their prescriptive meaning and force from agreements struck by representatives of a community in a constitutional convention and from succeeding acts of statutory legislation. The reason why this concretization of the legal code must be done democratically is that any legislation that was paternalistically imposed on a community of citizens would violate the conditions of voluntary consent that generate a prima facie obligation to obey the law. Thus, contrary to the libertarian, the principle of democratic self-determination essentially informs the rule of law.

Indeed, the libertarian should be the first to appreciate this fact, since—as we noted earlier—without democracy coercive law simply violates the moral freedom that supposedly legitimates it. So construed, the individually exercised rights to non-interference, citizenship, and due process that comprise the legal code presuppose for their actualization democratic political rights

that enable citizens to publicly revise the scope of their private freedom over time. Because democracy is more than just a mechanism for electing officials and aggregating preferences, and is also a public forum for communicating group perspectives and critically shaping basic values and interests, the right to participate as a political equal includes more than a right to run for office, join political parties, and cast an equally weighted ballot in the voting booth; it also includes a right to voice an educated and informed opinion that will effectively contribute to the setting of the political agenda in the broadest sense of the term.

To be sure, democracy instantiates the principle of discourse differently than morality does. Both democracy and morality are rooted in the dialogic expectation that speakers who respect one another as autonomous equals will try to reach a unanimous consensus favorable to all and harmful to none. In this way the freedom of each—expressed in their voluntary consent to what is just—is inextricably wedded to the solidaristic principle of equal respect and concern for everyone. However, whereas the principle of universa lizability requires that participants in moral discourse reach a unanimous agreement on principles that ideally extends beyond the spatial and temporal boundary of their community—in this sense moral discourses are like hypothetical thought experiments—the principle of democracy requires that participants in political discourse try to reach agreement on interests that might not be shared by persons living outside their community. Here—in contrast to moral discourse—real deliberation about basic rights, no less than deliberation about policies aimed at securing the general welfare, occurs within a communitarian context in which ethical questions regarding what is good and valuable to citizens inform more general questions about what is just for them.

The application of the principle of discourse to law requires additional modifications regarding "social complexity" that Habermas is careful to emphasize: the legitimate play of self-interest combined with differences in comprehensive belief systems suggest that interests will frequently be compromised and aggregated through voting mechanisms that favor the interests of the majority. Likewise, the pressure to resolve disagreements in a timely fashion and adjudicate them impartially requires the creation of more specialized and elite bodies of democratic deliberation—legislative, judicial, and executive—that bestow unequal decision-making powers on some citizens. Be that as it may, Habermas insists that within the arena of everyday political life every citizen ought to be guaranteed a full, equal right to participate in democratic deliberation aimed at influencing public opinion.

Here Habermas emphasizes the way in which a third general category of social rights to welfare, equal opportunity education, adequate housing, healthcare and employment extends political democracy in the direction of social democracy. Persons must be adequately educated, informed, and

motivated to express a rationally convincing opinion *and* they must be secure in their jobs and homes—free from the pressures of crime and poverty—in order to find time to inform themselves and get involved. So construed, the libertarian conception of law as a criminal and civil code guaranteeing individuals' negative freedom from arbitrary interference cannot be effectively realized apart from social policies—including income redistribution schemes—guaranteeing them the positive resources requisite for avoiding such interference.

In the first part of my paper I argued that Habermas's logical genesis of law develops a social contractarian (indeed libertarian) refutation of libertarianism that goes beyond a defense of social welfarism. As we have seen, the extent to which social welfare enables the exercise of citizens' private freedom is itself circumscribed by the extent to which democracy defines that freedom. So construed, liberal freedom and social equality are but partial and dependent aspects that derive their primary justification from a larger process of democratic law-making. Still, the question we must now address is whether Habermas has artificially limited the scope of his democratic revolution. Has he overestimated the inherent necessity and rationality of capitalism, with all its undemocratic inequities? Has he underestimated the extent to which markets are susceptible to democratic regulation? And, finally, has he neglected the extent to which business enterprises are susceptible to internal democratic restructuring?

Let me begin my query by recalling that Habermas himself adamantly denies that the welfare state denotes an unqualified enhancement of individual freedom. First, he notes that the welfare state—as a conjunction of capitalist economic system and a democratic polity—cannot fully realize the egalitarian conditions requisite for full democracy: "The informal public sphere must . . . enjoy the support of a societal basis in which equal rights of citizenship have become socially effective. Only in an egalitarian public of citizens that has emerged from the confines of class and thrown off the millennia-old shackles of social stratification and exploitation can the potential of an unleashed cultural pluralism fully develop . . ." (308). Assuming that capitalism by its very nature promotes social stratification, exploitation, class domination, and ideological hegemony, no state that functions within it—including the welfare state—can possibly realize equal rights of citizenship.

Second, Habermas argues that the welfare state not only fails to realize the right to participate politically, but actually undermines it. Put simply, the welfare state cannot allow basic questions of economic justice to become central topics of political debate without upsetting the potentially volatile compromise between business interests and labor, consumer, and environmental interests. Government is torn between contradictory imperatives—to

subsidize the costs of doing business and to compensate the victims of business. And government must have leeway to regulate the economy without interference from the public—as is amply evidenced by monetary policies that benefit financial interests to the detriment of labor interests—all in the name of sustaining stable growth through deflationary measures. What all this amounts to is a system of government that discourages radical democratic involvement while promoting the idea that the business of government is too delicate a matter to be left to the non-technical mind of the average citizen.

Third, welfare capitalism as such generates models of freedom and self-fulfillment that encourage private consumption—the engine that drives the economic machine—to the detriment of civic involvement. Aside from the legally sanctioned bribery of publicly elected officials by wealthy interest groups and the commodified packaging of political spectacles, welfare capitalism promotes a careerist or vocational attitude toward work and a familial orientation to leisure that doesn't leave much time for political activity. So extreme is this privatistic absorption in consuming and working that Habermas has labeled it a social disease that has taken over areas of life—family, education, and culture—that ought to be geared towards the cultivation of civic aptitudes.

Finally, Habermas notes that the way in which the welfare state compensates the victims of recessionary cycles and uneven development paradoxically undermines their private and public autonomy. Welfare and unemployment benefits are supposed to provide a safety net ensuring continuing consumption and civic participation. But the paternalistic and often punitive manner in which these entitlements are dispensed engenders dependency and robs the beneficiaries of a sense of self-worth. Worse, unlike social security and workers compensation, welfare and unemployment benefits are not regarded as full entitlements that the beneficiaries themselves contributed to. Those receiving these benefits—mostly single mothers—are rather stigmatized as dysfunctional and needy of therapeutic oversight. Thus, instead of allowing the victims of economic dysfunction to decide what their needs are and how they might be satisfied with dignity, the state simply imposes on them its own norms of neediness (often reflecting hidden sexist and racist prejudices).[7]

All of the above reasons would seem to indicate that, for Habermas, the welfare state as we know it is *not* the final endpoint of the legal revolution. Indeed, neither the liberal paradigm that sees law as a protection against state encroachment nor the welfare paradigm that sees law as a protection against social insecurity adequately conceives rights as social relationships to be forged in the crucible of democracy. On the contrary, they still conceive rights as individual possessions or entitlements that a quasi-autonomous government paternalistically distributes (504).

Oddly, despite his criticism of welfare democracy, Habermas seems hesitant to endorse one democratic revolution that his legal theory seems to imply—namely the transition from capitalism to socialism. In his words,

> (T)he social-welfare project must neither be simply continued along the same lines nor broken off, but must be pursued at a higher level of reflection. The intention is to tame the capitalist economic system, that is, to "restructure" it socially and ecologically in such a way that the deployment of administrative power can be simultaneously brought under control (410).

Given his earlier analysis of the stratifications, crises, and pathologies endemic to the welfare state *as* a failed compromise between capitalism and democracy, it is hard to fathom what kind of restructuring of capitalism Habermas has in mind here. Shouldn't the intention of revolutionary democracy be to restructure capitalism out of existence?

As we shall now see, Habermas's belief that market economies are more efficient (and hence, functionalistically speaking, more rational) than command economies, coupled with his tacit identification of market economies and capitalist economies, leads him to downplay the radical implications of his revolutionary account of democracy and prevents him from considering another alternative: a market socialism composed of democratically operated businesses.

Habermas's attitude toward markets is highly ambivalent. On one hand, he readily understands why Marxists would hold that "a society integrated through associations instead of through markets would be a political, yet domination-free, order" (481). The "scandalous 'natural fate' imposed by the labor market," which places workers in a constant state of insecurity and dependency, elicits no satisfactory response from the welfare state, for social safety net provisions reinforce the insecurity and dependency of unemployed and marginally employed clients, thereby undermining the autonomy requisite for citizenship (480). A similar resignation to the laws of the market occurs on a global scale. Although the "parliamentarization of Brussels expertocracy" may seem like a step in the direction of consolidating the European Community under the auspices of a kind of democratic economic regulation (503), it is really just the consolidation of a new consortium of multinational corporations and financial institutions. In Habermas's opinion, the "Five Freedoms of the Common Market" seem to deprive the citizens of the member nation-states of protectionist remedies by which they might harness—to their own cultural, political, and social needs—"economic imperatives that have become independent of everything else" (502). Hence what he earlier maintained with regard to the welfare state he now applies to the global economy: "the relation between capitalism and democracy is fraught with tension" (501).

On the other hand, Habermas concedes that the "anarchist" projection of

a society made up entirely of democratic associations is more utopian than ever. Without some institutionalized legal bureaucracy—with all of its attendant political inequalities—face-to-face deliberations among equals must remain indecisive and ineffectual. Such associations do not bestow power on the people, they "dissolve" it. As for council democracy, Habermas argues that the "idea of workers' self-governance had to fail—and fail even if the workers' social utopia was imagined, with Marx, as a realm of freedom to be established on the basis of an ongoing, systemically regulated realm of necessity" (479). Two reasons support this conclusion. First, modern societies possessing the kind of technological sophistication and division of labor envisaged by Marx in his account of socialism necessarily evolve systemic mechanisms—principally money-driven markets and power-steered admin-istrations—that "do not necessarily coordinate actions via the intentions of participants, but objectively, 'behind the backs' of participants" (39). Second, as we have seen, no adequate notion of democracy is conceivable apart from the notion of liberal rights. But, according to Habermas, these rights and their contractarian ideologies evolved in response to—and as normative conditions for—an increasingly self-regulating market system (504).

Now, it may well be that the contractual model and its market presuppositions reflect gender (that is, masculine) as well as political and economic biases, as some of Habermas's feminist critics have pointed out.[8] It may also be true that the inherent logic of Habermas's discourse ethics transcends the libertarian limitations of this model altogether in the direction of a utopian transfiguration of liberal democracy, wherein persons transform their selfish natures in the context of a trusting and mutually nurturing community of conversation. Notwithstanding the validity of these points, Habermas continues to view his discursive theory of law as if it were a more complete realization of the contractarian model rather than an absolute break with it. In keeping with this interpretation the question arises whether the contractual model and its market assumptions only make sense within an undemocratic polity imprisoned within capitalism.

In *The Theory of Communicative Action* (1981) Habermas criticized Max Weber for failing to distinguish a general logic of modernization (or societal rationalization) from one contingent instantiation of it: capitalism. Given his insistence—against Marx—that markets are an unavoidable outgrowth of this logic, he could not have sustained his criticism of Weber without at least having entertained the possibility of non-capitalist (presumably socialist) markets. However, only in a few scattered remarks has Habermas somewhat dismissively entertained this possibility. On the contrary, in his later work he seems to have accepted Weber's view that modernization and capitalism are virtually inseparable. Thus, in discussing the formerly neutral concept of system integration he says that "like the bureaucratic state, the capitalist

economy too developed a systemic logic of its own. The markets for goods, capital, and labor obey their own logic" (500). This equation of modernization and capitalism would explain why he pitches his discussion of the aims of democratic reform at such a low level of intensity: "to impose social and ecological limits on the economic system *without impinging on its inner logic*" (505—my stress). It seems as if capitalism can only be tamed and not surpassed—no matter how antagonistic it is to the realization of democracy.

The above remarks, however, do not serve to explain fully Habermas's rejection of "simple recipes of worker self-management," for some models of worker self-management and ownership are actually compatible with capitalist markets.[9] The rejection is even less understandable in light of his recognition that the separation of management and labor contributes to a "fragmentation of consciousness" in which "the need for normatively secured or communicatively achieved agreement is decreased and the scope of tolerance for merely instrumental attitudes, indifference, or cynicism is expanded."[10] Furthermore, there need not be any conflict between a democratic polity structured along classical partisan lines—which also gives free rein to the diverse grass roots associations and non-economic "publics" that comprise "civil society" in Habermas's sense—and a democratic society composed of worker- and community-managed and owned enterprises. And despite his own tendency to assign economic enterprises to a system that is functionalistically regulated by steering imperatives of money and power, Habermas (unlike Hannah Arendt) is savvy enough to know that even economic decisions are subject to the pressure of non-instrumental, discursive legitimation.

Since making his disparaging remarks about workplace democracy Habermas has altered his thinking to the point where he now concedes that models for market socialism "pick up the correct idea of retaining a market economy's effective steering effects and impulses without at the same time accepting the negative consequences of a systemically reproduced unequal distribution of 'bads' and 'goods'."[11] The question, as always, is whether—with the decline of the nation-state—the newer 'nation-combines' such as the European Union and, most importantly, the United Nations, can impel a "reorganization of world economic relationships" that will rectify global market imbalances between North and South. He himself has recently affirmed the hope that the United Nations might evolve into a Federal democratic union of social-democratic states—replete with courts and enforcement mechanisms—that might make the concept of "world citizenship" a reality. Such a supra-national constitutional democracy, he insists, is not only necessary to rectify the uneven economic development between poor and rich states that global capitalism encourages, but also to regulate the accompanying effects of global ecological damage and intra-state marginalization of economic underclasses.[12]

Habermas has devoted more energy toward clarifying the common political understandings establishing the possibility of a multicultural democracy of "strangers linked in solidarity" than he has toward clarifying the possibility of a global market socialist economy, let alone one composed of democratically organized businesses. Yet this is surprising given his growing concern about the way in which global communication networks, under the sway of capitalist mass consumption and production, fragment and level the public sphere.[13]

Space limitations do not permit me a full defense of the viability of such an economic model.[14] Suffice it to say, worker-managed enterprises operating in socialist markets will expand and contract in response to fluctuations in demand, no less than their capitalist counterparts. This efficiency, however, will not be compromised by patterns of excessive and uneven growth typically associated with capitalist markets. Because worker-managed firms will seek to maximize profit per worker rather than total profit, they will not expand as rapidly to increased demand; yet the need to maintain their market share will prevent them from laying off workers for the sake of maximizing profit per worker. Such firms might be tempted to invest more heavily in capital expenditures than labor, but not if they procure their funds from community banks that target loans to the creation of new jobs. Finally, the objection that worker-managed firms will reward equal skills unequally—for example, by not replacing some of their own members with others who will work for less pay—also applies to capitalist firms, as evidenced by the disproportionately high salaries of American CEOs in comparison to their European and Asian counterparts. Such allocational deficiencies, which get reflected in price differentials for goods of comparable real costs, are in fact quite negligible. Finally, although market dislocations in any kind of economy will necessarily result in temporarily laying off a small fraction of the work force, these effects will be much less arbitrary and severe in socialist markets that allow for more democratic planning.

In sum, I began my essay by showing how Habermas's discourse ethics provides a libertarian justification for a radically egalitarian democracy. It redeems both the libertarian and egalitarian presuppositions underlying social contract theory by showing how negative private liberty—the freedom that grounds the logic of the market—must be legally protected and *realized* in the communicative medium wherein positive public freedom is exercised. Market systems are no more self-regulating than labor contracts: both depend on democratic intervention for their realization. The principle of inclusive democratic participation transforms the corporate enterprise into a public sphere of stakeholders whose individual liberties are "staked" on their social equality. There is no reason why basic activities of consumption and pro-duction upon which our private freedom depends should be left in the hands of private persons, especially since other less basic areas of

life—the governance of municipal planning and school boards—are not. Here the need to establish the non-political politically—which continually frustrates the libertarian's fetishization of a natural division between the public and the private—lends credence to Habermas's conviction that "constitutional democracy is becoming . . . the accelerated catalyst of a rationalization of the lifeworld beyond the political" (489). In this respect his critique of con-tractarianism applies to the modern corporation as well: "To the extent that we become aware of the intersubjective constitution of freedom, the possessive individualist illusion of autonomy as self-ownership disintegrates" (490).

DAVID INGRAM

DEPARTMENT OF PHILOSOPHY
LOYOLA UNIVERSITY
MAY 1998

NOTES

1. Jürgen Habermas, *Between Facts and Norms: Contributions to a Discourse Theory of Law and Democracy*, trans. W. Rehg (Cambridge, Mass.: Princeton, 1996). All citations refer to this text unless otherwise indicated.

2. For classical critiques of libertarianism along these lines, see G. A. Cohen, "Robert Nozick and Wilt Chamberlain: How Patterns Preserve Liberty," *Erkenntnis* 11 (1977): pp. 5–23; and J. Sterba, "From Liberty to Welfare," *Social Theory and Practice* 11, no. 3 (Fall 1985): 285–305.

3. Habermas argues that the demise of a shared ethos in the wake of the religious warfare that racked Europe in the sixteenth century ushered in modern ideas of moral self-determination (individuality and the pursuit of one's personal conception of happiness) (95).

4. Habermas sees his discourse ethic as an alternative to both the metaphysical authoritarianism of moral realism and the conventional authoritarianism of legal positivism. At issue, however, is whether this alternative does not try to borrow a page from both of these doctrines. As noted above, Habermas defends the transcendent universality of principles of justice vis-à-vis particular conceptions of the good. In response to the positivist's counter that these principles are vacuous apart from being concretely interpreted and legally posited in accordance with some community's particular conception of the good, he notes that their universal content is not entirely vacuous and resides, if not in a common propositional knowledge, then at least in the form of a commonly intuited, pre-interpreted know-how (*BFN*, pp. 311–12). This invocation of a pre-interpreted—one is tempted to say, metaphysical—given contradicts his own hermeneutical sociology, which shows that how we discursively interpret (or propositionally reconstruct) our shared, intuitive competence as speakers determines how that competence affects our

behavior. See J. Habermas, *Justification and Application: Remarks on Discourse Ethics*, trans. Ciaran Cronin (Cambridge, Mass.: MIT Press, 1993), pp. 31, 53ff, 81ff; and my *Reason, History, and Politics: The Communitarian Grounds of Legitimation in the Modern Age* (Albany: SUNY Press, 1995), pp. 211–12.

5. C. Larmore, *The Morals of Modernity* (Cambridge: Cambridge University Press, 1996), p. 218.

6. Ken Baynes' otherwise excellent reconstruction of this argument wrongly assumes that, for Habermas, the legal form as such implies the principles of equity and equal standing, so that the need to link the latter to the principle of discourse is solely motivated by the imperative to generate specific concrete rights. That this is not the entire story is confirmed by the history of legal formalism in the liberal era, which tolerated numerous exceptions to both principles (most notably in the treatment of women, male wage earners, domestic servants, and certain peoples of non-European descent). The legal form establishes a system of mutual expectations, but these become equitable and exceptionless only by being related to the mutual recognition of a common humanity that first comes to the fore in communication. Cf. K. Baynes, "Democracy and the *Rechtsstaat*: Habermas's *Factizitat und Geltung*," in *The Cambridge Companion to Habermas*, ed. S. K. White (Cambridge: Cambridge University Press, 1995), pp. 209–210.

7. Cf. N. Fraser, *Unruly Practices: Power, Discourse, and Gender in Contemporary Social Theory* (Minneapolis: University Of Minnesota Press, 1989), pp. 161–90.

8. S. Benhabib, "The Utopian Dimension of Communicative Ethics," *New German Critique*, no. 35 (1985): 83–96.

9. P. Dews, *Autonomy and Solidarity: Interviews with Jürgen Habermas* (London: Verso, 1986), p. 187.

10. Habermas, "Reply," in *Critical Debates*, ed. D. Held and J. B. Thompson (Cambridge: MIT Press, 1982), p. 281.

11. Habermas, "A Conversation about Questions of Political Theory," in *A Berlin Republic. Writings on Germany*, trans. by Steven Rendall (Lincoln: University of Nebraska Press, 1997), pp. 141–42.

12. Habermas, *Die Einbeziehung des Anderen* (Frankfurt am Main: Suhrkamp, 1996), pp. 147–53.

13. Ibid., p. 145–46.

14. Cf. D. Schweickart, *Against Capitalism* (Cambridge: Cambridge University Press, 1993).

15

Paul G. Chevigny

Law and Politics in
Between Facts and Norms

INTRODUCTION

The kernel of the concept of law that Habermas draws upon in *Between Facts and Norms* (BFN) is familiar. He is exploring the implications of a Kantian idea of legality, which combines the positive fact of a legal enactment—that it has behind it the power of official coercion—with its validity in the broader sense that we obey it because we recognize the force of its rationale and the legitimacy of its source (BFN 28). Although Habermas discusses problems of legal interpretation, then, his project is not so much jurisprudential as it is political; it is scarcely part of that project to problematize the concept of law. It is convenient for him to make use of a relatively uncontroversial basic concept because he means to draw implications from that familiar legal landscape that have far-reaching consequences.

Those implications lie at the heart of the problem of knowledge and politics with which Habermas has been grappling for a generation. All social inquiry is in search of valid knowledge, and, as Habermas has told us repeatedly, when "there is neither a higher nor a deeper reality to which we could appeal" (BFN xli), validity lies in a consensus reached through dialogue—a dialogue, moreover, in which judgment depends on an unconstrained discussion including all claims and all persons. There is scarcely a reader of Habermas's work who has not asked what political conditions could make such communication even approximately possible. The sociologist in Habermas constrains him to try to answer the question.

He finds a large part of the answer in a system of law rooted in democratic political and constitutional principles designed to facilitate

communication. For a lawyer trained in the United States, that conclusion is, on its face, not very surprising; we are accustomed to thinking of communication as preserved and protected by constitutional rights. But the prescriptions that Habermas finds necessary for the protection of valid decision-making write large for us how far our current legal and political system is from fostering unconstrained communication. On the other hand, those prescriptions raise the question whether the legal system is able, in theory or in practice, to protect the political process in the way that Habermas envisions.

DEMOCRATIC LAW-MAKING

For Habermas, the Kantian ideal of legality, where law is coercive but at the same time recognized as valid, is possible in a modern democratic state only when citizens have the power to participate fully in making the laws that bind them, and when the state itself is bound by law (BFN sec. 1.3.1; p. 132). A chief source of the legitimacy of law is a tradition of liberalism pursuant to which every participant has his rights protected, and recognizes the rights of others; freedom depends on rights that protect the actor from the state and from other actors. Personal rights are essential to social communication because they secure "symmetrical relations of mutual recognition" (BFN 251).

Habermas goes farther, to claim that law offers a strategy of "circumscribing communication and giving it unhindered play" (BFN 37). And here he means to go beyond the freedom afforded by familiar legal principles, allowing the actor to believe, say, and publish what he pleases, to channel communication so as to expose "all norms and values to critical testing" (BFN 38). Circumscribing communication while giving it unhindered play is, of course, known to be extremely problematic from the point of view of law, norms, or politics. Later in this essay I will look a little more closely at what Habermas has proposed to solve the problem.

The basic insight upon which Habermas is drawing for democratic law-making is that engaged political actors would choose to have an unconstrained dialogue in order to reach decisions that are "valid." This choice is embodied in "Principle D," which says that "just those action norms are valid to which all possibly affected persons could agree as participants in rational discourses" (BFN 107). Habermas conceives of this principle as pre-political, meaning that actors would not accept as legitimate a state that did not recognize Principle D (BFN 455). Under a state that has the power to make coercive rules, then, the legal system must choose basic rights that are the equivalent of rules that actors would choose for themselves.

Habermas claims that these fall into five categories (BFN 122–23):

(1) The greatest measure of equal individual liberties;
(2) Rights that derive from membership;
(3) Legal actionability of rights;
(4) Autonomous political participation;
(5) Provision of living conditions necessary to the exercise of the first four sets of rights.

These are not axioms; they are what citizens would demand in return for accepting the strictures of a system of law.

Habermas recognizes that in contemporary society, the sources of dissension and confusion are so many that it is difficult to adhere to the D principle. The legal system replaces individual moral and ethical decision-making for every separate communicative encounter with more general rules that simplify the process of participation. Habermas, indebted here to the sociological tradition of Durkheim and Parsons, views modern law as "a mechanism that, without revoking the principle of unhindered communication, removes tasks of social integration from actors who are already overburdened in their efforts at understanding . . ." (BFN 38; see also 114). In short, through law people rely on previous decisions as a guide in similar situations.

Since what the participants are after is decision-making through unconstrained communication, the state has to be intensely democratic, indeed a system of "popular sovereignty." And just here is an interesting characteristic of Habermas's argument; he envisions a polity that is connected to the grass-roots, that is responsive to economic change and changing social needs at every level, but he does not suppose that such popular sovereignty can be found in some "general will" (BFN 100–103). He claims that the way to create and preserve popular sovereignty lies in a system of state-sanctioned laws that create the conditions for popular will-formation. A republican-inspired communitarian might suppose that popular sovereignty could not be confined within legal forms but would have to be rooted in common political values (BFN 279–282; 310–311); the experience in this century of the distortions produced by charismatic leadership acting in the name of popular will, however, drives Habermas to search for institutions that can keep open the channels of popular communication. The problem, as he puts it, is to join popular sovereignty with human rights (BFN sec. 3.1).

Here is the reason that Habermas refers to his as a proceduralist model of the state; it is the job of the state to establish and administer rules that are equivalent to the ones the participants themselves would write. He thinks that law is "especially suited for the social integration of economic

societies, which rely on the decentralized decisions of self-interested individuals in morally neutralized spheres of action" (BFN 83). He recognizes that even under ideal conditions in some cases there may be no generalizable interest, and thus no consensus, particularly in relation to economic decisions. "In these cases," he writes, "there remains the alternative of bargaining, that is, negotiating between success-oriented parties who are willing to cooperate" (BFN 165). Here the discourse principle can do no more than regulate the fairness of the bargaining: "the negotiation of compromises should follow procedures that provide all the interested parties with an equal opportunity for pressure, that is, an equal opportunity to influence one another during the actual bargaining, so that all the affected interests can come into play and have equal chances of prevailing" (BFN 166–67). Later he expands, "Compromise procedures are intended to avert the danger that asymmetrical power structures and unequally distributed threat potentials could prejudice the outcome of bargaining" (BFN 177).

It is clear, then, that Habermas does not suppose that discourse in a democratic society will always lead to results that are the best for each participant, as if the choice were made alone or even by consensus. Unconstrained discourse leads not to a consensus result but to a bargaining procedure, at least for some types of decisions, which in turn leads to results that are fair in the sense that they allow for equalized participation. Habermas goes on to recognize that majority rule must be allowed in legislative and other political processes, because the decision is not definitive, but only "rationally motivated but fallible" (BFN 179).

The preservation of even this imperfect level of discourse requires a strong and detailed system of laws. The decision, for example, whether an argument falls into an arena of bargaining or is eligible for a decision that may lead to a consensus is itself a decision that must be regulated by democratically instituted law (BFN 173). Thus Habermas posits a constitutional structure calculated to facilitate democratic will-formation through positive law. State and civil society must be separated, so that private organizations and the public sphere can influence government policy, rather than the other way around. Similarly, there must be separation of powers within the government, so that the administration of the laws is subject to review both by the legislature and by a judiciary independent of other political institutions.

This arrangement of institutions shows its roots in the *Rechtstaat* as well as in the U.S. Constitution; but its purposes are not only to control state power and keep it from interfering with citizens, as in those traditional models, but even more to ensure that decisions are made democratically in as unconstrained a manner as possible. Political representatives have to be

selected in a way that reflects all their constituents' interests and that permits constant contact with changing opinion outside the legislature. The touchstone of the entire political system has to be that power is to flow into the government from outside, rather than the reverse (BFN sec. 4.3). So for example, in constitutional decision-making, a court must "work within the limits of its authority to ensure that the process of lawmaking takes place under the legitimating conditions of *deliberative politics*" (BFN 274).

The tree of deliberative politics has to be kept green by a constant flow from civil society and the public sphere. Civil society constitutes those institutions, not primarily market-driven, that are protected by the basic rights, such as voluntary associations; it shades off into the public sphere, which is the unstructured arena of discussion and will-formation that stretches out to the periphery of society. Habermas's earlier use of the concept of the public sphere had been criticized, for example, by feminists who pointed out that the borders between the public and the private have historically been used to deprive women of participation (Benhabib 1992; Fraser 1992); so in *Between Facts and Norms*, the concept is broadened to include all sources of opinion, even individual readers and listeners (BFN sec. 8.3.3). For Habermas, the political system has to be structured in such a way that the opinion-formation in the public sphere makes its way to the center through the administrative, legislative, and judicial institutions of the government. The law, he thinks, ought to negate its historic tendency to simplify, by resisting the "communicative, cognitive and motivational limitations on deliberative politics" and thus helping to preserve social complexity (BFN 327). The system of legal rights, in other words, must be used to introduce the complexities of informal decision-making to the political sphere. In the passage that perhaps explains his proceduralist version of the state most concretely, Habermas writes:

> The well-known proposals to insert plebiscitary elements into the constitution (direct popular vote, petitions for a referendum, etc.), as well as the proposals to introduce democratic procedures at a grassroots level (in the nomination of candidates, will-formation inside the party, etc.) are meant to counteract the subversion of the *political public sphere* by power. The attempts at a stronger constitutional regulation of the *power of the media* have the same intent. The mass media must be kept free from the pressure of political and other functional elites; they must be capable of raising and maintaining the discursive level of public opinion-formation without constraining the communicative freedom of critical audiences. . . . Passing through the channels of general elections and various forms of participation, public opinions are converted into a communicative power that authorizes the legislature and legitimates regulatory agencies, while a publicly mobilized critique of judicial decisions imposes more-intensive justificatory obligations on a judiciary engaged in further developing the law. (BFN 442)

THREE PARADIGMS OF STATE AND LAW

It is clear how Habermas's proceduralist state is neither the liberal state nor the welfare state. In the classical liberal model, the function of rights was to create a realm that protected citizens against the state as well as against one another. "Political rights have not only the same structure but the same meaning as private rights that provide a space within which legal subjects are free from external compulsion" (BFN 270). While the constitution did not legislate the common good, politics could aggregate private interests into a "political will that has an impact on the administration" (BFN 270). The liberal state, insofar as it took social justice into account at all, implied at most that social equality would be established through individual freedom. Economic inequality, however, was in the long run found to interfere with the exercise of formally protected rights to the extent where the state was obliged to interfere in turn to make private rights effective. The social-welfare state intervened to correct inequalities, and in the process, according to Habermas, developed a paternalism that interfered with personal autonomy through cumbersome administrative machinery (BFN sec. 9.1.3; 9.3.1).

Habermas's proceduralist model has strong ties with liberalism; a principal purpose of the model is to preserve personal autonomy as well as the decentralized decision-making that is characteristic of liberal society. Thus it is that Habermas reiterates that the public sphere must be "embedded in liberal patterns of political culture" (BFN 358); people must think through public issues in light of their own rights while respecting the rights of others. But individual rights exist in the proceduralist model not primarily in the interest of the individual as against the state and other individuals and in order to protect a private realm, but in the interest of collective understanding and the formation of a public realm. The function of the strong procedural protections is to maintain that public realm as democratic, and thus to let everyone participate in making laws that they would make for themselves, after a free discussion concerning the implications for all of the alternatives. What remains unclear is how the legal system is to shake off the encrustations of the regulatory state and thus increase individual autonomy.

We can use the proceduralist model as a normative ideal to mount a critique of the ways that existing governments fall short of democratic will-formation. I propose to use Habermas's model to analyze some aspects of U.S. constitutional law, particularly as it relates to the media and political rights. On the other hand, we can mount a critique of the proceduralist state itself, by asking whether it implies a weight and complexity of regulation that might be at odds with the personal autonomy derived from the liberal tradition as well as with popular sovereignty.

NOTES ON CULTURE AND POLITICAL RIGHTS IN THE UNITED STATES

From Habermas's perspective, the present constitutional state in the United States is a liberal regime almost unalloyed. Rights under the Constitution are interpreted to protect persons from one another and often from the state, but there is in constitutional doctrine only a weak policy encouraging the informed participation of citizens. We can see this vividly illustrated in two areas of legal doctrine that have passed through the processes of the U.S. Supreme Court repeatedly in the last generation: regulation of the electronic media and campaign finance reform. The first of these is so important to civil society and the public sphere that Habermas would advocate positive law-making to ensure that the media are open to broad debate. The second, campaign finance, is similarly concerned with preserving "the broadest possible spectrum of interpretive perspectives, including the voices of marginal groups" (BFN 183). But it is, of course, at the heart of the political process, rather than at the level of civil society or the public sphere.

In the United States, there has always been a policy in favor of "balance" in the presentation of opinion in the broadcast media (Chevigny 1988: 137–40; Bollinger 1976), although the policy has been growing weaker as popular media, such as cable, have emerged as competitors of television and radio broadcasting, and as the economics of free-market competition have become more dominant. Part of that policy was to encourage diversity in broadcast programming not only directly, through a balance of opinion, but indirectly, through diversity in ownership. In *Metro Broadcasting v. FCC* (1990), the Supreme Court upheld a regulation of the Federal Communications Commission that afforded a preference to minority applicants in awarding broadcast licenses. In light of the fact that blacks owned only 2.1 percent of television and radio stations in the United States in 1986, the decision was hailed as a breakthrough for cultural diversity, with the claim that "ownership enables one not merely to sell to others or to offer oneself to the call of the market; it also provides the opportunity to propagate oneself in the marketplace of cultural images" (Williams 1990: 537).

Five years later, in *Adarand Constructors, Inc. v. Pena*, the Supreme Court decided that another federal regulation, granting an incentive to building contractors to hire minority subcontractors, was an unconstitutional denial of equal protection of the laws to Adarand, a subcontractor who did not get the bid on a federal construction job. In the course of that opinion, the Court reached out to overrule *Metro Broadcasting*, as it did other cases that upheld affirmative actions under federal law, on the basis that they are all unconstitutionally discriminatory unless they can withstand "strict scrutiny," a scrutiny which is often fatal to the regulation scrutinized. In the political world of Jürgen Habermas, this is a curious way of reasoning;

Metro Broadcasting is about diversity in culture, and *Adarand* is simply about the awarding of construction contracts. As Habermas might say, the broadcasting case is concerned with the all-important sphere of public discussion, in which it is imperative that there be room for minority voices, whereas the other case is concerned with the allocation of economic resources, a subject about which citizens may be unable to reach principled decisions and about which they may have to compromise. For him, a decision in the *Adarand* case would be unlikely to govern the broadcast decision. But the U.S. Supreme Court is refusing to recognize such a distinction. In the realm of rights, the Court found it difficult and distasteful to make distinctions of value, to say that one realm—the ownership of broadcast facilities—was to be subjected to standards different from other property decisions.

The law of campaign finance reform has followed a course that is parallel from Habermas's perspective. Amidst a storm of criticism about campaign slush funds in connection with the Watergate scandal, Congress sought to control the amount spent on campaigns for federal office. Legislation passed in 1974 limited the amount that an individual or a "political action committee" (often organized by businesses or labor unions), could contribute to a campaign, and limited the total amount that a candidate could spend, either from his own funds if he were wealthy, or from funds that he had raised. The legislation was intended not only to prevent corrupting the loyalty of candidates through huge contributions, but also to prevent candidates from distorting the political debate through disproportionate expenditures on publicity.

To be sure the wisdom of the legislation as a practical matter was very doubtful, particularly because the ceilings for expenditures were set so low that it was doubtful that a challenger who limited his expenditures to the levels required by the new law could make enough of an impression on the electorate to overcome the name-recognition of a popular incumbent. In *Buckley v. Valeo* (1976), the Supreme Court went beyond such practical concerns, however, to hold the expenditure ceilings for candidates unconstitutional in principle as an infringement of free speech. The limitations on contributions, the Court thought, could be justified as controls on corruption. But the limitations on expenditures could not be justified on the argument that they would create a more nearly equal competition in political debate. The Court said, "The concept that the government may restrict the speech of some elements in our society in order to enhance the relative voice of others is wholly foreign to the First Amendment" (424 U.S. 1). The effect of the decision is that the amount spent by a candidate cannot be controlled (unless the candidate can get public funding, which has never been adopted in the national system except in presidential campaigns), although the size of

contributions can be controlled. It has resulted in the baneful present system, in which the candidate spends many of his working hours trying to raise large amounts of money through relatively small contributions.

In the Habermas view of democratic politics, the *Buckley* decision equates speech that is directed at immediate control of the legislative and executive process with speech that is at the periphery. It may be clear, for example, that the government cannot limit the total printing of a magazine on the basis that some other magazine ought to become more popular, but it does not necessarily follow that the government could not take action, during a campaign for an office of which the winner would vote on national policy, to ensure that all candidates get an equal hearing. As Habermas tells us repeatedly, what happens in the public sphere can be seen as legally different from what happens at the heart of the legislative process. The public sphere should be as free of government control as possible, but for Habermas, at the center of the political process the conditions for democratic politics have to be protected by law.

For the majority in the *Buckley* case, on the contrary, all free expression, including speech at the heart of the political process, was an open market. The objection to some campaign speech that its power is entirely economic, deriving from the ability of the speaker to pay writers and to buy extra time in the media was for these justices scarcely any objection at all. To be sure, not every jurist agreed with them. One of the federal circuit judges whose decision upholding the campaign reforms of 1974 was reversed in *Buckley v. Valeo*, J. Skelly Wright, criticized the politics of the Supreme Court decision at the time in words that would ring familiar to Habermas (Wright 1976:1016–19):

> By this pluralist line of reasoning, the First Amendment's highest function is to let group pressure run its course unimpeded, lest we skew the process that determines for us the public interest. Giving and spending money are important ways for groups to bring pressure—to magnify intensity—and thereby to make the process work. . . . [W]hat the pluralist rhetoric obscures is that *ideas,* and not intensities, form the heart of the expression which the First Amendment is designed to protect. Money may register intensities, in one limited sense of the word, but money by itself communicates no ideas. . . . Courts ought to judge restrictions on giving and spending accordingly.

Thus it would not have been too difficult for the Supreme Court to have reached a different conclusion, if electoral politics had been seen as a special realm, or if the Court had any interest in a balance in communication. But the Court has always been hesitant about government efforts at balancing speech, not only because they of necessity poach upon some part of the exercise of rights by the individual, but also because the Court doubts that

the balance can ever be "fair," rather than in favor of some special interest. The Court believes that it has no standards for deciding what a "fair" balance is. The Court's skepticism about government-imposed "balance" partakes of a more general characteristic of liberal law, at least in the United States at present; contemporary courts doubt that the law, when it tries to equalize, can ever be free from the influence of special interests that manipulate the apparent equalization to their own advantage. Such skepticism appeared in the *Buckley* litigation, where the (ultimately victorious) opponents of the legislation argued that the expenditure limits of the so-called "campaign reform" act were set so suspiciously low as to make the law in reality an "incumbent-protection" act (Chevigny 1981:210). This attitude to rights says, essentially, that the law is doing as well as it can if it protects the rights of individuals as against one another and the state; when it puts its hand in the scale, it skews it in favor of special interests, and often not even on behalf of those interests for whom it purports to act.

Habermas, as we shall see shortly, is not fully persuaded that liberal law is as neutral as it purports to be in theory, or indeed that the law ought to pretend to be so neutral; he believes, for example, that the legal system should affirmatively favor popular sovereignty. But the liberal paradigm continues to pose the question whether the modern legal system has the tools that Habermas would desire in order to protect democracy in the political system.

LAW AND CRITICAL THEORY

It is not difficult to criticize the contemporary skepticism in U.S. law about whether rights can or should be used to rectify inequalities. Critics would point out that the very neutrality of the law, in failing to rectify inequalities, itself acts to advance special interests and exacerbate inequalities. The controversy about campaign finance is a prime example; when the courts take the position that it is not their function to intervene in a campaign, in cases where the campaigners have very unequal resources, that decision itself favors the candidate with more resources (Chevigny 1981). Jurists committed to pluralism might not think that such a bad thing; for them, it is better for the struggle among private forces to determine the outcome than for the government to intervene.

Critical legal theorists go further to argue that legal doctrines about rights are indeterminate because there are contrasting strands of argument about every controversial issue. Consider, for example, U.S. law relating to expression: on the one hand public speech is free and unfettered by the government, while on the other hand speech is not unfettered when it

presents a clear and present danger to a substantial government interest, or when one of the speakers has a near monopoly of the channels of communication. Furthermore, U.S. law recognizes limits on speech when it is performed within some public institutions; in legislatures and courts, for example, restrictions on speech are highly formalized.[1] The Constitution and its interpretation did not tell us unambiguously which approach ought to be used in the case of campaign contributions and expenditures. Thus when the justices chose the model of unfettered speech for the law of campaign finance in *Buckley*, the critical theorist would say, they were not making a neutral decision dictated by doctrine; they were choosing the model that favored the better-financed candidate. The indeterminacy of law would imply that the liberal legal system does not really stand outside the struggle between persons, nor systematically protect the individual against the state; it takes sides for ideological reasons (Altman 1986).

Habermas is ill at ease in this controversy. On the one hand, because he wants to foster popular sovereignty, he can not favor the liberal model of law, in which the government stays outside struggles for power, either economic or political. On the other hand, he cannot favor the critical theory of indeterminacy, in which one side or the other of a doctrinal dichotomy is chosen for ideological reasons, because he is in search of determinate legal institutions that will preserve the channels of democratic will-formation.

In his chapter "The Indeterminacy of Law and The Rationality of Adjudication" (BFN ch. 5), Habermas begins by offering support for the liberal side of the controversy by provisionally endorsing the view, derived from Ronald Dworkin, that legal contradictions can be resolved by repairing to levels of legal principle, as distinguished from rules. But this possibility may be no more than theoretical; Habermas recognizes in the application of principle a hermeneutic process that may be so complex as to "overtax even professional adjudication. Hence, in actual practice, the complexity of this task is reduced by the *paradigmatic legal understanding* prevailing at the time" (BFN 220). Examples are the paradigms of "bourgeois formal law and welfare-state materialized law." In a turn that is at first surprising, then, Habermas accepts the proposition that legal certainty can be found chiefly, if not exclusively, through systems of belief that are, as he puts it, "susceptible to ideological distortions" (BFN 221). Habermas thus begins by giving polite credit to those, like Dworkin, who claim that there is a determinate "right answer" to legal questions, then turns to the position that legal decisions are made in a socio-political context that skews the answer ideologically.

What Habermas is seeking, then, is a paradigm that will orient the decision-making process in favor of popular sovereignty, and this is exactly what his proceduralist paradigm is intended to do. The institutional

protections for the channeling of opinion from the public to the political sphere, and particularly the direction to the courts to ensure that lawmaking "takes place under the . . . conditions of *deliberative politics*" (BFN 274), are normative standards that are to be used to ensure popular decision-making. The proceduralist paradigm is not a vision of a value-neutral process that stands outside the political system and decides disputes; instead it must be actively involved in preserving popular sovereignty. In effect, the judges have to have a constitutional predilection for popular sovereignty.

Nevertheless, there remains a serious question whether the legal system could effectively make the sort of decisions required to protect the legal-political world that Habermas envisions. Let us consider, for example, the process for determining whether a controversy is a subject for bargaining or instead for a full discursive decision with a view to consensus. In Habermas's political world, this appears to be a legal decision, which is, of course, ultimately controlled by the courts (BFN 173 and sec. 4.3.2); when there is disagreement about the process for decision-making, a court must decide what sort of process is to be used. Supposing that the court follows a paradigm that favors popular will-formation, the decision is still going to involve difficult questions about types of knowledge and discourse. It is the sort of decision that the U.S. courts, for example, have sought to avoid just because it entails distinctions about discourse that involve questions of value—for example, whether the question is one of morality or of economic policy—that courts feel ill-equipped to decide.

It is by no means clear, furthermore, that the administrative body will always make the "right" decision (the one that favors deliberative politics, for example), because it may be swayed by argument advanced in the personal interest of one of the participants in the effort to put the case in one category or another. It is characteristic of Habermas's proceduralist paradigm, oriented to supporting the popular will, that such support will sometimes threaten the power of economic elites. Decisions that favor consensus decision-making as against compromise, or that try to govern compromise in the interests of equality of participation, are likely always to be hard-fought even if they are successful in preserving the proceduralist paradigm. Powerful parties will devise powerful arguments, and they can be expected to appeal to a higher court when they can if those arguments do not prevail. In short, legal choices that favor the power of the people are going to be difficult to maintain. Such circumstances, however, only make it more necessary that the procedural machinery to protect deliberative politics be put in place. Without those protections, the process will gradually change into one that offers less protection to channels of open communication and decision.

As a result, decision-making in the proceduralist paradigm is likely to be cumbersome and uncertain; it is just the sort of process that the liberal

tradition in law tried to shun, and that is characteristic of the modern administrative state from which Habermas is trying to escape. In short, it is difficult to see how the legal system in the proceduralist paradigm can have enough control of the connection between the political center and the public sphere at the periphery to maintain the popular government that Habermas desires, and at the same time foster the simpler values of the liberal tradition that he hopes to preserve. In the economically open and diverse society that Habermas envisions, preserving deliberative politics for everyone is always going to be a struggle; success in that struggle will require strong and complex institutions.

Although I believe this tension is unresolvable, it may not be the worst result in the end. Habermas envisions a state where the "paradigmatic legal understanding" favors popular participation. At present we do not have such a state; we do have cumbersome legal-administrative systems in every Western nation, which are unlikely to disappear. If they can not be eliminated, it would at least be preferable if they operated in the interests of the many instead of the few.

The state that Habermas envisions, nevertheless, must be very different from the contemporary state. A polity that supports popular sovereignty could not be run through pluralist coalitions; it would have to be run by the people. The legal system would be structured so that if the people live in a culture that values liberty, and they demand to participate, they must be able to participate, with as little manipulation of their views as possible. As Habermas recognizes, legal institutions can help to protect the culture of freedom, but they cannot create it out of whole cloth. "[I]n the proceduralist paradigm of law, the structures of a vibrant civil society and an unsubverted political public sphere must bear a good portion of the normative expectations, especially the burden of a normatively expected democratic genesis of law" (BFN 461). With such citizens, perhaps even modern bureaucracies could be made leaner and more responsive.

PAUL G. CHEVIGNY

SCHOOL OF LAW
NEW YORK UNIVERSITY
APRIL 1998

NOTE

1. C. Edwin Baker has adapted the model of speech in public institutions to critique the prevailing law of campaign finance, drawing on Habermas's distinctions between the political center and the periphery, including the public sphere (Baker 1998).

REFERENCES

Adarand Constructors, Inc. v. Pena. 515 U.S. 200 (1995).
Altman, Andrew. 1986. "Legal Realism, Critical Legal Studies, and Dworkin." *Philosophy and Public Affairs* 15: 205–35.
Baker, C. Edwin. 1998. "Campaign Expenditures and Free Speech." *Harvard Civil Rights-Civil Liberties Law Rev.* 33: 1–55.
Benhabib, Seyla. 1992. "Models of Public Space: Hannah Arendt, The Liberal Tradition, and Jürgen Habermas." In *Habermas and the Public Sphere*, edited by Craig Calhoun. Cambridge, Mass.: MIT Press.
Bollinger, Lee. "Freedom of the Press and Public Access: Toward a Theory of Partial Regulation of the Mass Media." *Michigan Law Rev.* 75: 1–42.
Buckley v. Valeo 424 U.S. 1 (1976).
Chevigny, Paul. 1981. "Review Essay: The Paradox of Campaign Finance." *New York University Law Rev.* 56: 206–26.
————. 1988. *More Speech: Dialogue Rights and Modern Liberty.* Philadelphia: Temple University Press.
Fraser, Nancy. 1992. "Rethinking the Public Sphere: A Contribution to the Critique of Actually Existing Democracy." In *Habermas and the Public Sphere*, edited by Craig Calhoun. Cambridge, Mass.: MIT Press.
Habermas, Jürgen. 1996. *Between Facts and Norms: Contributions to a Discourse Theory of Law and Democracy* (William Rehg trans. of *Faktizitat und Geltung*). Cambridge, Mass.: MIT Press.
Metro Broadcasting, Inc. v. FCC 497. U.S. 547 (1990).
Williams, Patricia. 1990. "Comment: Metro Broadcasting, Inc. v. FCC: Regrouping in Singular Times." *Harvard Law Rev.* 104: 525–46.
Wright, J. Skelly. 1976. "Politics and the Constitution: Is Money a Speech?" *Yale Law J.* 85: 1001–1021.

16

Lorenzo C. Simpson

On Habermas and Difference: Critical Theory and the 'Politics of Recognition'[1]

At the dawn of the millennium, the deprovincializing forces of globalization and of postcolonial migration have increasingly transformed modern societies into sites of confrontation and difference. Such societies will therefore increasingly become laboratories, microcosmic sites, where experiments to forge global humanity will succeed or fail. Central among the concerns of democratic and democratizing societies is the challenge to find a principled way to acknowledge the claims of the distinct cultural groups comprising them. Unfortunately, much contemporary discussion about the possibility of community within culturally diverse societies seems stuck in an unproductive opposition between homogenizing versions of community and heterogenous, fragmented, and "decentered" constellations of difference. Jürgen Habermas enters this conversation via his conception of discursive democracy, promising thereby to offer a compelling alternative to three influential contemporary social and political discourses, an alternative to the strand of contemporary liberalism that eschews public acknowledgment of the distinct cultural identities of members of multicultural societies, to the communitarian failure to do justice to difference, and to postmodern attempts to valorize discontinuity and fragmentation.

In the course of this essay, I shall argue that, despite its manifest virtues, Habermas's intervention is not fully satisfactory. I shall suggest that his position does not offer a sufficiently distinct alternative to the liberal conception of an overlapping consensus, and that, accordingly, his framework cannot fully exploit the transformative potential inherent in cultural material that lies beyond the borders of such a consensus. As a consequence of this, I suggest that he is unable to redeem adequately his own assertion that modern cultural world views implicitly raise validity claims. And, lastly, I suggest that associated with this failure to respond adequately to the

challenge posed, and the opportunity provided, by cultural others is a relative insensitivity to the diversity of configurations that politically relevant claims can assume, to the variety of narrative genres in which such claims can be couched.[2]

I begin with a brief summary of Habermas's discourse theory of normative legitimacy, then turn to consider some of his recent remarks made in response to critics, and, finally, consider his explicit intervention into current debates on multiculturalism and the recognition of cultural minorities. It is in this intervention that he exploits the resources of his conception of discursive democracy for the respectful accommodation of matters of difference.[3]

I

So first a general overview of Habermas's understanding of practical discourse. If empirical or scientific speech aims at truth, practical discourse or political and moral discussion aims at what Habermas calls a "generalizable interest." Importantly, Habermas denies that all needs or interests are merely subjective and, therefore, that they would necessarily lead to irreconcilable conflict when groups with differing interests must share the same social space. Those interests that *are* irreconcilable in this way, he refers to as "particular interests."[4] Opposed to purely particular interests, generalizable interests for Habermas are those that can be communicatively shared, those that reflect an unforced consensus about what *all* could want. (A genuinely particular interest is one that fails to be shareable in this way.)

It is important to emphasize that generalizable interests are not simply found or discovered but that they are rather forged and shaped in discussions among, in the ideal case, all persons concerned.[5] Both the social norms regulating and reflecting interests or needs and the interpretation of the needs themselves form the subject matter of practical discussions. That is, need interpretations are among the items of discussion. For Habermas, there are certain requirements that ideally govern such discussions, the requirements of what he has called the ideal speech situation. These requirements are meant to guarantee that a participant need not accept any interpretation of her needs in which she cannot recognize what she truly wants. Such a dialogue situation is structured then by conditions which insure that no participant be coerced to give her consent to an assertion against her will, by conditions which insure that everyone is free to engage in various speech acts—to make assertions, to challenge others' assertions, to question, to reveal their inner feelings, to suggest rules for the discussion, and so on. Also included among the ground rules for the ideal form of such a discussion are conditions insuring the freedom to move from a given way of framing a

discussion to increasingly abstract ways of framing the discussion and to *alternative ways* of framing a discussion, that is, to call into question and modify the originally accepted conceptual framework. For example, in a discussion structured by a particular normative ethical framework, participants are free to move to a metaethical discourse that calls that framework into question. Since the interpretation of needs and interests is constrained by the discursive framework in which those interpretations are articulated, it is important that the chosen framework not be inappropriate to express what we really want. For example, could women's need for self-respecting fulfillment find an appropriate interpretation in a framework structured by a simple opposition between responsible domesticity and corrupting ambition? This feature of practical discourse, its reflexive aspect, is important because it allows for the negotiation or forging of a framework that might accommodate apparently divergent points of view. This underwrites the possibility of there being a common language in which the needs of everyone concerned can be given a voice and gain a respectful hearing.

The point then of practical discussion is to search for ways to frame the needs of everyone concerned in such a way that common or generalizable interests can be found. The idea of generalizable interests then suggests *one* possible basis for the discursive construction of community, albeit perhaps of a rather thin form of community founded on overlapping interests.[6] Nevertheless, it is important to keep in mind that on this view, an interest is *presumed* generalizable or shareable until proven particular, and that proof would have to take the form of a dialogue whose outcome cannot be judged a priori.

The situation that we are faced with is, I believe, one where it is always a matter of mutual adjustment between *putatively* valid norms and concrete interests, so that sometimes a norm will have to be revised in order to take a concrete interest into account, and sometimes a concrete interest will have to be devalued in light of its conflict with an achieved, supposedly rational, consensus. In general, there are no a priori criteria to tell us under what conditions to do which.

There are important similarities between this situation and what can be seen to be the case in science when we consider how an unanticipated event is ultimately treated by the scientific community. Let us use the term 'phenomenon' to refer quite generally to an event or state-of-affairs that is perceived to stand in some tension with the anticipated order of things. I want to use the terms 'anomaly' and 'counterexample' to mark a distinction in the manner in which a phenomenon is ultimately received by the community of inquirers. An anomaly ultimately leaves the relevant law, expectation or regularity unchallenged, whereas a counterexample ultimately threatens the relevant law, expectation or regularity. An anomaly *apparently* violates the rule without ultimately threatening the rule, while a counter-

example proves ultimately to be a nail in the coffin of accepted theory. For example, the unexpected motion of the planet Uranus, which Newtonian theory was able to accommodate, turned out to be an anomaly, and the precession of Mercury's perihelion turned out to be a counterexample to classical Newtonian celestial mechanics. Now, there is no a priori procedure for deciding which is which, that is, for determining whether a given phenomenon is an anomaly or a counterexample. Sometimes a phenomenon ends up having instigated a research program to further articulate a given paradigm or expectation of regularity so that the phenomenon can be accommodated; in other instances phenomena are viewed as falsifying cases. Only the future will allow us to say in which category a given phenomenon should be placed.

Like an anomaly, a particular interest claim may prove itself capable of being accommodated into a somewhat altered, or slightly differently conceived, existing consensus over generalizable interests. Or, it may be rejected as ungeneralizable. The current controversy over affirmative action can readily be framed in these terms. Since ideally only the outcome of a domination free discourse will decide the issue, we cannot, in general, say beforehand whether or not a specific interest content is generalizable.

<center>II</center>

As useful as his account is, I would urge that we go beyond Habermas here. I want to claim that what he calls sheerly particular interests or, now, existential or ethical commitments, are *also* amenable to conversational negotiation, a negotiation whose terminus need not be consensus, but rather mutual understanding and edification. In my view, consensus is not projected as an ultimate ideal, except at the meta-level where participants in discourse collaboratively seek to articulate and acknowledge mutually available and non-invidious descriptions of each other. For all of his commendable relativization of the distinction, when discussing practical discourse, Habermas remains mired in the false dilemma of a generalizable, discursively redeemable, consensus *or* a sheerly particular, idiosyncratic, private, and ultimately pluralistic congeries of fundamental commitments. But, I would argue, the achievements of mutual understanding and edification need be *neither*. Though Habermas has among his own theoretical resources the notions of "aesthetic" and "therapeutic" critique, he does not seem fully to consider their consequences for the idea of practical discourse[7] or to exploit them to illuminate communication processes between existential or ethical positions.

In his recent work, in which he responds to criticisms prompted by the increasing salience of matters of cultural diversity, Habermas refers to the

setting in which current philosophical thought must find its purchase as "postmetaphysical." By this he refers to the historical stage at which cultural traditions have become reflective in the sense that competing world views cannot simply *assert* themselves against each other, but rather are compelled to *justify* their claims to validity self-critically.[8] In acknowledging the explicitly *interpretive* self-understanding of modern, postmetaphysical world conceptions, Habermas's understanding of *metaphysics* is very close to Heidegger's in that it refers to systems of thought which do *not* acknowledge their interpretive status and which claim to reflect an "order of things" which is legislative for human will and action. For Habermas, it is important to distinguish the postmetaphysical condition of modernity from the putative stage of *postmodernity*. For while in the former case competing world views raise reciprocal validity claims understood to be subject to redemption, in the latter case competing world views would be understood to be enacted in indifference to or with suspicion towards claims to validity.

Modern world views have associated with them the reflexive awareness that there are alternatives, and hence, reasons not to be dogmatic about their status. Habermas adds, however, that such world conceptions make validity claims. But in what sense can they be understood to do this, and what scope can we give to their claims for validity? Given Habermas's current distinction between the right and the good, between questions concerning moral obligation and questions concerning the nature of the good life, and given that the plurality of answers to questions concerning the good are anchored in the plurality of world views, the validity claims raised by world views cannot be reduced to any of Habermas's traditional triumvirate of truth, truthfulness, and rightness. What then are these validity claims claims about?

Habermas, in an appreciative discussion of Rawls, refers to modern world views as being subject to the "burdens of reason."[9] But, of course, such world views cannot be subject to the pressure of reasons in the abstract. Reasons and reasoning must proceed from premises, and if the relevant premises are in turn anchored in comprehensive world views, different and competing world views will give us different and competing premises (except, of course, in the special case of an overlapping consensus). That is, comprehensive world views might be more appropriately understood as the frameworks *within* which validity claims are made. In order for Habermas to counter successfully a Rortyian ironical redescription of modern world views as simply "contingent final vocabularies," none of which can make a non-circular appeal for its own justification, Habermas must say more about what the redemption of these claims to validity would consist in. Given his wider commitments, this would take the form of articulating the connection between learning processes, on the one hand, and world-disclosure, on the other, a connection which Habermas criticized Heidegger for failing to

respect. And Habermas would make this connection, in part, by assuming the tradition-invariance of the problems addressed by learning processes, by maintaining that there is a nontrivial level of description at which all social actors face the *same* set of problems. This is, I shall argue, one of the problems in Habermas's more recent work.

He seems unwilling to acknowledge the extent to which different socially and culturally defined groups may not face the same problems or may not find the same problems to be *salient*. As a consequence, Habermas can conceive of a comparative evaluation of competing tradition-based resources for problem solving only by reference to a *commonly held* set of problems rather than with reference to how well the resources provided by competing traditions measure up with respect to a set of problems relatively peculiar to a given tradition. Thus, in his response to Alasdair MacIntyre he seems mistakenly to believe that we can have rational evaluation of competing traditions *or* non-invariant social problems, but not both. Accordingly, Habermas is obliged to understand, again mistakenly in my view, MacIntyre's position on the rational evaluation of traditions as implying the necessity of irrational conversion when a given tradition comes to prefer resources from another tradition to its own, as opposed to that tradition's understanding its resources as having been *rationally* discredited in terms of its own standards of rationality.[10]

I *do* appreciate Habermas's evocation of a bilingually extended identity in the course of his polemic against MacIntyre, but rather than describe this "fusion of horizons" in terms of a "convergence between 'our' perspective and 'theirs' guided by learning processes" as he does, I would describe it in terms of a convergence on or a consolidation of what I call a "situated metalanguage," the collaboratively forged language that is suitable to accommodate non-invidious and mutually acknowledged representations of self and other.[11] It is only in terms of such a metalanguage—itself forged through rigorous and thoroughgoing hermeneutic reflection—that the different perspectives of "ours" and "theirs" can first even be *articulated* and common problems, where they exist, *identified*. Only then can we talk about the possibility of convergence guided by learning processes. Again, I think that Habermas very problematically maintains that social and cultural problems are shared and identified in the same way across cultural/linguistic boundaries. Or that "our" perspective and "theirs" will always be operating in the same register. Or that such problems are *self-announcing across* cultural/linguistic horizons.

As a way of acknowledging the difficulty of rationally adjudicating competing conceptions of the good under contemporary conditions of globalization and multiculturalism, Habermas invokes a distinction between the moral and the ethical, which corresponds roughly to his earlier distinction between the domain of generalizable interests and that of particularity,

respectively, but without the latter distinction's invidious intent. The moral refers to what can be justified universally, the ethical to what has only local purchase.[12] But there is considerable ambiguity in Habermas's deployment of this distinction. Sometimes he writes as if "morality" captures the rational core of competing conceptions of the good, their "overlapping consensus." In this sense, morality would operate in a different register from the good or from competing ethical claims; morality would thus be neutral with respect to competing ethical claims. The moral and the ethical would have their purchase at different categorial levels and hence, in principle could not conflict. Accordingly, the universality of the moral point of view—where one is concerned with questions of the rightness of procedures and their outcomes—would not conflict with the particularity of the ethical point of view—where one is concerned with questions of authenticity and existential self-understanding.

Yet Habermas acknowledges the possibility of instances where questions of morality and of ethics do not remain neatly separated in different categorial or conceptual registers, cases where morality is not neutral with respect to the good, cases where an *acknowledged* moral obligation conflicts in a presumably irreconcilable way with an existential self-understanding.[13] A paradigm case of this sort of conflict would be the experience of citizens of a procedural liberal democracy whose self-understanding is informed by theocratic fundamental commitments. But first, to what extent could such a moral claim be acknowledged as placing a person whose interest in authenticity is not accommodated by it under an *obligation* to respect its validity? How could a person or group be *morally* required to recognize a norm that entailed abdicating their interest in cultural authenticity? This question is especially pressing, given Habermas's account of what consti-tutes a morally justified norm, that is, one that fulfills what he calls condition 'U': "*All* affected can accept the consequences and the side effects its *general* observance can be anticipated to have for the satisfaction of *everyone's* interests (and these consequences are preferred to those of known alternative possibilities for regulation)."[14] If the vocabulary in which a person's identity is made salient cannot be accommodated in a moral consensus, do we want to say that such vocabularies are not morally relevant, that they should be registered only at the level of the good? The problem is that Habermas wants a principled way of accommodating matters of difference by reserving a conceptual space for them in his architectonic. But as he himself acknowledges, such matters often refuse to remain on the reservation. When faced with a conflict between the right and the good, how do we rationally adjudicate it? The framework for such an adjudication cannot of course be that of moral discourse, for that would be blatantly question-begging. In cases where it has become clear that we have to do with conflict between competing ethical positions drawn from different contexts

of self-understanding, as in the abortion controversy, Habermas has recourse to the language of fair compromise and, perhaps, though he does not mention it in this context, of aesthetic critique.[15] But the issue that concerns us here is not, at least on its face, one of competing ethical commitments, but rather the hybrid competition of the moral *versus* the ethical. If principle U does not have the status of a trump card, are we to entertain the plausibility of an "existential opting out of the moral"? Does the absence of a rationally guaranteed bulwark against such "seepage," the absence of a metaframework for addressing such issues, point to an important lacuna in Habermas's thought?

One response that Habermas *might* make to what I have here suggested is to point out that identity is itself conversationally negotiable, that one can always raise the question whether social or cultural identity can be reconfigured without being destroyed in such a way that it may harmonize more completely with a reformed moral consensus. The point would be to *enlarge* and *expand* the overlapping consensus through reciprocal, mutual discursive reflection on the existential claims brought to the table. Accordingly, he might say that we should be as wary of dogmatically using identity as a trump card as I suggested we might be about principle U. And not only would I have a great deal of sympathy with this response, but it is also consistent with my reading of Habermas's position on the conversational forging and negotiation of interests. But his discussion of this matter in *Justification and Application* does not take this form.

Rather, what he seems to suggest there is that I would be mistaken to understand him to want a principled distinction or a distinction *in kind* between the moral and the ethical, a distinction which is more than an analytical distinction between different aspects or facets of an issue, a distinction that allows for an a priori parsing of which is which.[16] So there is no principled distinction between what counts as the *content* of a moral as opposed to an ethical issue. Such a distinction will have to await the outcome of a discourse. This relativization of the distinction between the moral and the ethical would then permit Habermas to say that identity articulating vocabularies are not morally irrelevant *qua* identity articulating vocabularies, but that some such vocabularies may, as a matter of fact, "pass" (as being generalizable or as warranting public acknowledgment) and be allowed into the club, and some will not. It cannot be decided a priori which aspects of a tradition-bound self-understanding can be incorporated into a moral consensus and which aspects will end up being relegated to the merely existential.

However, from the moral point of view, from the vantage point that most engages Habermas's interest, existential or ethical claims are *at best* candidates for generalization; in the idiom of the philosophy of science, they are claims emerging from the context of generation that are candidates for

success within the context of justification. This has two troubling consequences. First, this focus upon the moral which in turn is understood in terms of what can command general assent tends to marginalize material that fails to meet that standard and thereby threatens to deprive us of world-disclosive and world-informing resources that we might not otherwise entertain as live options. His focus is too restricted to give us a satisfying account of how we can fully exploit the transformative possibilities in cultural material that lies beyond the confines of a potential moral consensus. That is, Habermas's base is too cramped to do justice to the *public* salience of such cultural material.

Second, and perhaps despite his intentions, the moral/ethical distinction ends up informing invidious distinctions among cultural identities. Insofar as inharmonious views of the good life are among the interests to be regulated in moral discourse, consensus will require, in the operational sense, a "shearing off" of the irreconcilable residue. Will this process not always play itself out in favor of participants who are willing to make the requisite distinctions allowing for a separation of the right from the good? Or whose notion of the good furnishes an autonomous sphere for the right? Habermas avers that moral discourse requires "distancing oneself from the contexts of life with which one's identity is inextricably interwoven."[17] But, some are thereby called upon to distance themselves more and in different ways than are others. Will not potential participants who are unwilling to make the requisite distinctions be asked to give up more in terms of their identity-informing commitments than others? For instance, those whose ethical self-understanding is such that it is only with extreme difficulty and at considerable existential expense that they can entertain a principled distinction between the right and the good would be at a distinct disadvantage compared to cosmopolitan liberals. It will not do to make it a condition of participation that one avow such willingness, or disavow unwillingness to do so. If it did, how could Habermas envision the possibility of someone who in the course of ingenuous participation acknowledged a moral obligation that he could not fulfill under pain of self-abnegation? Surely, Habermas would not claim that all of those who view this distinction with suspicion can be as easily dismissed as can members of what he calls "fundamentalist cultures."[18] And for similar reasons, Habermas cannot say "we" are all moderns now. It is starting to look suspiciously like what is at issue here are two competing conceptions of the good, where one is given pride of place, rather than a matter of the right *versus* a conception of the good.

In a related objection, Thomas McCarthy points out that questions of the right cannot be completely separated from questions of the good, from the very values and interests whose harmonization Habermas's conception of practical discourse was devised to secure.[19] As a consequence, the principles

in terms of which competing values are to be adjudicated could themselves be as much subject to dispute as are the values in contention. Habermas's reply to McCarthy seems to beg the question in that it presupposes the very distinction between good-based reasons and right-derived reasons that McCarthy has questioned.[20] And given Habermas's own admission that the condition of multiculturalism has the effect of driving questions of the right to more and more abstract levels,[21] we should look again at the rational potential and resources of the claims for the good that are posited in the world views that compete for our attention.

So I would not shy away, as is Habermas's wont, from genuine conflicts between versions of the good. Moreover, taking versions of the good *per se* as commanding our rational appraisal will help to answer the question I posed to Habermas earlier, namely, in what sense do world conceptions make validity claims? I believe they are validity claims in a more indirect way than are truth or rightness claims, but that they are validity claims nonetheless. They are validity claims in that they are not immune to criticism. One can always ask, what way of framing the world is good, given the projects a determinate people is engaged in, given their interpretations of who they are, and given the people with whom they are likely to interact (this move away from the merely local is especially important given the globalization of society). Understanding modern world views to have such a hypothetical status is another way of saying that the confrontation of world-disclosing frameworks may throw into relief, in a symmetrical fashion, what each side may come to acknowledge as defects in its practices, aspects of its practices whose interrogation and possible transformation may allow social agents to flourish more fully.

III

My discussion thus far has been pursued for the most part within the register of ethics and culture. Habermas's concern, however, lies primarily at the level of law and politics. This point of departure helps to explain his relative indifference to the concerns I raise. The kinds of question this orientation inclines him to ask, the site from which he chooses to begin, unavoidably perhaps, implicate him in a dialectic of insight and blindness. What gets eclipsed thereby is the potential for reciprocal learning processes that are fueled by the cognitive, moral, and aesthetic resources of competing existential/ethical contexts.

The concern that authorizes this restriction is explicit in his recent intervention in the "politics of recognition." It takes place in an essay entitled "Struggles for Recognition in the Democratic Constitutional State," a response to Charles Taylor's reflections on multiculturalism. In the essay

Habermas pursues the question whether the universalist emphasis upon *individual* rights necessarily conflicts with *group-based* demands for recognition. Given Habermas's current concern with practical reason's role not only in the justification of norms but also in the *application* of moral norms in concrete situations,[22] he can now explicitly maintain that not only is it a mistake to construe the universalistic interest in granting priority to basic rights as being at odds with the public recognition of concrete forms of cultural expression, but that such an interest actually *requires* the encouragement and promotion of the viability of such cultural expression. He holds that not only does an individualistically construed theory of rights not conflict with demands for the recognition of collective identities, but that such a theory, correctly understood, actually requires such recognition. For among the protections afforded individuals must be the recognition and protection of the intersubjective contexts from which their identities are forged and which sustain their capacities for agency.[23] For example, consistent with this concern would be the institutionalization of maternal leave policies to address the factual preconditions for women to be able to take advantage of equal opportunity. And Habermas accordingly endorses extensive protections of non-dominant cultural groups in the form of government subsidy of minority cultural initiatives, various infrastructural benefits, and so on.[24] In this way he splits the difference between liberalism and communitarianism. While seeking to protect basic rights he nevertheless acknowledges the communal basis of identity formation.

Full autonomy requires not only the equal freedom to realize private life projects, but also the freedom for conversational participation in and negotiation of the social and legal norms regulating the application of principles of equality. Hence, Habermas speaks of the internal connection between public and private autonomy.[25] Here is where the conversational negotiation of need interpretation that I mentioned earlier comes into view and where the implication for need satisfaction of the acceptance of norms is thematized. Because there is an internal relationship between respect for individuals and respect (in the sense of legal recognition and protection) for the cultural sources of their identity formation, the Kantian notion of moral equality has to be extended to the equality of respect accorded to cultures within which individual identities are forged.[26] So, on this account the protection of cultural groups is underwritten by legal demands for the protection of individual autonomy, not, as Habermas thinks Taylor believes, from estimations of the presumed excellence of one's culture of origin.[27]

The legal systems in democratic constitutional states are co-determined by the universalistic procedures of post-traditional morality from "above" and by the cultural self-understanding of particular legal communities from "below."[28] So the application of universalistic procedures is shaped by a nation's cultural self-understanding, by its political culture or *ethos*. But

insofar as the political culture that informs the articulation of legal systems should remain neutral with respect to the various ethical-cultural communities comprising the nation, the former axis of integration, *political* integration, can be analytically uncoupled from the "thicker" *social* integration manifested in the "local" solidarities of particular cultural and ethnic affiliation. However, as a nation becomes more multicultural, the "complexion" of the overlapping consensus—the agreement that underwrites the political integration that undergirds the allegiance to constitutional democracy—will be altered.[29] This might be described as a "capillary effect," whereby cultural material from newly included social and cultural groups rises to refashion the identity of the political community as the context for the application of universalistic principles changes.

Since the moral pressure for group recognition is fueled by the categorical demand to protect and enable individual autonomy, the moral significance of group recognition is determined by the degree to which such recognition furthers or hinders such autonomy. This puts Habermas in a position to endorse the public recognition of social and cultural difference but also, and correctly in my view, to worry about the oppressive potential of what can be called "identity politics," that is, the tendency to embrace overly prescriptive, and therefore restrictive, accounts of ethnic/cultural membership and to assume that such membership is definitive of one's identity.[30]

This is all to the good. But it is important to note that only two sorts of learning process are authorized by this approach. First, there are those "corrective" learning processes that encourage the requisite transformations of political self-understanding to accede to the "base line" perspective of acknowledging the principled distinction between the right and the good. This is a process that has already been undergone by the cosmopolitan West. We know from Habermas's larger project that he adduces rational reconstructive arguments to demonstrate the developmental superiority of the standpoint of modern procedural universalism.[31] So this clearly asymmetrical learning process is one to be undergone by "them," not by "us." Second, there are the alterations that are made in the discursively induced collective will formation as a result of arguments made by previously marginalized groups for transforming the way in which universalistic norms are applied. (The need interpretations that inform these alterations are embedded in concrete social and cultural contexts; they are shaped by diverse cultural self-understandings and commitments.) It remains the case, however, that it is only under the aspect of that cultural material's relevance for fashioning a public political consensus that it comes into our purview. So, in neither case is there thematized a conceptual space where genuinely symmetrical *cross-cultural* learning processes can occur.

So, the way Habermas frames his discussion has the effect of bracketing

concrete cultural self-understandings and modes of world disclosure—and the interpretive and evaluative discourses addressing them—except insofar as they are relevant to questions of political and legal regulation. Now, his principled exclusion of evaluative presumptions, his taking them out of play for the purposes of determining social recognition, is a salutary gesture insofar as it avoids placing marginalized social and cultural groups on the defensive when making their demands for social recognition. Here Habermas explicitly distances himself from Charles Taylor's invocation of the presumed excellence of one's culture of origin. I have, however, two concerns about this framework. First, as I have been suggesting throughout, it prevents our bringing into focus the reciprocal learning processes guided by critical evaluations within the register of world disclosure. This deprives us of the sort of challenging encounter that edifies us concerning the nature and limits of our own presuppositions, that challenges us to re-view the world we had taken for granted. It deprives us, for instance, of a lively sense of the variety of humanly viable conceptions of the moral relationship of the individual to the community, or of the relationship between the cognitive and the symbolic, or of the relationships between religion and a variety of domains such as art, science, politics, and the law.

Second, it underestimates the significance of the fact that such margin alized groups have to mount an *argument* that the prevailing institutionalization of the principle of equal rights fails to accommodate their *legitimate* need interpretations. Thus, rational evaluations of legitimacy and of claimed failures to accommodate legitimate needs have to be made. Habermas rightly emphasizes not only the unavoidable necessity of all those affected by a given norm having the opportunity to give voice to the implications of its general observance for their needs and identities, needs and identities within which, to be sure, the signs of social and cultural specificity are clearly to be discerned, but also the necessity of *justifying* their assessments of those implications in public discussion.[32] So there is clearly an evaluative moment that is *internally* related to the public acknowledgment of a failure to accommodate a legitimate need. Habermas has explicitly thematized this evaluative moment elsewhere himself when he argues for the internal connection between understanding and evaluation.[33] So, despite his attempt to distinguish himself from Charles Taylor here, an evaluative moment is unavoidably implicated in his position.

And a greater degree of sensitivity to the cultural materials involved in this evaluative transaction, and to the fact that modes of argumentation and of self-presentation are also strongly culturally indexed, would strengthen Habermas's explicitly *political* theory in the face of critiques aimed at his overly restrictive assumptions concerning the style of political discourse, critiques such as Iris Young's. Young makes the claim against Habermas's conception of deliberative democracy that it fails to attend to the "cultural

specificity of deliberative practices."[34] Her discussion suggests the ways in which storytelling and narrative can make salient, in ways that strictly argumentative discourse cannot, the value commitments and underlying structures of meaning that inform the very need interpretations that are subject to political negotiation. Moreover, a greater sensitivity to the cultural register *per se* would render Habermas's theory more in tune with the actual hermeneutic interpretive processes that should operate at the heart of constitutional discourse itself in multicultural societies.[35]

For Habermas questions of "difference" remain questions of "application," of the application in different contexts of universalistic principles. Aspects of difference not relevant to questions of application, the aspects that speak to issues of meaning and world disclosure, are effectively taken out of play. Habermas's categorial framework cannot accommodate the dimensions of difference that would give meaning informing contexts *per se* a public character. He restricts his purview primarily to what can garner a public consensus in favor of its recognition and consequent protection. In doing so, he occludes the hermeneutic learning processes fueled by confrontations with alien cultural materials—aesthetic, metaphysical, ethical and so on—which, while perhaps protected, are not engaged to see what radical self-questioning they may provoke. It is one thing, and a very good thing indeed, to protect the stranger. It is quite another to risk learning from her.

I have not attempted a dismissive critique of the universalistic principles embodied in democratic constitutional states. Indeed, I am inclined to embrace them for their humanitarian implications and, at least as they are read by Habermas, for their implicitly self-corrective mechanisms deployed in public discussion. I have rather pointed to the limitations of those principles insofar as they authorize us to ask the undeniably crucial question, What should we recognize and seek to protect? but not the equally important question, What can we learn?

LORENZO C. SIMPSON

STATE UNIVERSITY OF NEW YORK AT STONY BROOK
DECEMBER 1999

NOTES

1. I wish to acknowledge the Woodrow Wilson International Center for Scholars for fellowship support while I undertook the research for this essay.
2. This is a criticism that is made perhaps most forcefully by Iris M. Young in "Communication and the Other: Beyond Deliberative Democracy," in *Democracy and Difference: Contesting the Boundaries of the Political*, ed. Seyla Benhabib

(Princeton: Princeton University Press, 1996). I respond to Young in my "Communication and the Politics of Difference: Reading Iris Young," in *Constellations: An International Journal of Critical and Democratic Theory* 7.3, forthcoming.

3. For an earlier assessment of Habermas's work in this regard, see my "On Habermas and Particularity: Is There Room for Race and Sex on the Glassy Plains of Ideal Discourse?" *Praxis International* 6 (1986): 328–40.

4. Jürgen Habermas, *Legitimation Crisis*, trans. Thomas McCarthy (Boston: Beacon Press, 1975), p. 108.

5. Jürgen Habermas, "A Postscript to *Knowledge and Human Interests*," *Philosophy of the Social Sciences* 3 (1973): 177.

6. See Habermas's discussion of Rawls in *Justification and Application: Remarks on Discourse Ethics*, trans. C. Cronin (Cambridge, Mass.: MIT Press, 1993), pp. 93–96.

7. See Georgia Warnke, *Justice and Interpretation* (Cambridge, Mass.: MIT Press, 1993), p. 108.

8. Jürgen Habermas, *Justification and Application: Remarks on Discourse Ethics*, trans. Ciaran P. Cronin (Cambridge, Mass.: MIT Press, 1993), pp. 94, 181 (n. 58).

9. Ibid., p. 94.

10. Ibid., pp. 100–101. See also my discussion of this issue in MacIntyre's work in my *Technology, Time and the Conversations of Modernity* (New York and London: Routledge, 1995), pp. 130–31.

11. Habermas, *Justification and Application*, pp. 103, 105. I elaborate upon the nature and significance of situated metalanguages in my forthcoming *The Unfinished Project: Towards a Postmetaphysical Humanism* (New York and London: Routledge).

12. Habermas, *Justification and Application*, p. 69.

13. Ibid., p. 87.

14. Jürgen Habermas, *Moral Consciousness and Communicative Action*, trans. Christian Lenhardt and Shierry Weber Nicholsen (Cambridge, Mass.: MIT Press, 1990), p. 65.

15. Habermas, *Justification and Application*, pp.59–60.

16. Cf. Ibid., pp. 105–6.

17. Ibid., p. 12.

18. Cf. Habermas, "Struggles for Recognition in the Democratic Constitutional State," in *Multiculturalism: Examining the Politics of Recognition,* ed. Amy Gutmann (Princeton: Princeton Univ. Press, 1994), pp. 132–33, 139.

19. Thomas McCarthy, "Practical Discourse: On the Relation of Morality to Politics," in *Ideals and Illusions: On Reconstruction and Deconstruction in Contemporary Critical Theory* (Cambridge, Mass.: MIT Press, 1991), pp. 191f, cited in Habermas, *Justification and Application*, p. 90.

20. Habermas, *Justification and Application*, pp. 90–91.

21. Ibid., p. 91.

22. Habermas, *Justification and Application*, pp. 13–14.

23. Ibid., 113.

24. Ibid., p. 129.

25. Ibid., pp. 112–13, 116.

26. Ibid., p. 129.

27. Ibid., p. 129.

28. Ibid., p. 137.

29. Ibid., p. 139.

30. Ibid., p. 130.

31. I have argued that his rational reconstructive demonstrations are flawed by their unacknowledged hermeneutic moments in my *Technology, Time and the Conversations of Modernity*, pp. 92–93.

32. Habermas, "Struggles for Recognition," p. 116.

33. Habermas, *The Theory of Communicative Action*, vol. 1, trans. Thomas McCarthy (Boston: Beacon Press, 1984), pp. 113–15.

34. Young, "Communication and the Other," p. 123.

35. See James Tully, *Strange Multiplicity: Constitutionalism in an Age of Diversity* (Cambridge: Cambridge University Press, 1995).

17

Martin Beck Matuštík

The Critical Theorist as Witness:
Habermas and the Holocaust

The beginnings of these reflections on bearing witness to the disaster of the Holocaust can be traced to a breakfast conversation during which I spoke to Professor Jürgen Habermas about my past. That I could bear witness as a second-generation descendant of the survivors and victims of the Holocaust and that I could be understood by another second-generation witness, Habermas, who is neither a survivor nor a descendant of the victims of Germany's disaster, is possible only if the past is not closed. Such a contemporary conversation between a speaking witness and a listening witness embodies an *anamnestic solidarity* with the victims of history. That this solidary remembrance of the traumatic past could take place at all between two contemporaries prompted me to revisit Walter Benjamin's and Theodor Adorno's reflections on the past. I will address specifically their and Shoshana Felman's question whether and how it is possible to bear witness to disaster and to the disaster of the Holocaust in particular. Through my prefatory sketches, I discover a witness at the heart of Habermas's fundamental project in critical theory. I conclude with a profile of the critical theorist who learns by (the) disaster, who remembers the traumatic past dangerously, and who is called upon to witness in communication to the unspeakable.

I. CONVERSATION AS WITNESS

On the autumn morning of October 10, 1998, in Denver,[1] I shared with Habermas that I had recently discovered my lost Jewish relatives who had survived the Holocaust and who after 1948 had left Czechoslovakia and settled in Australia. After a two-year search, I made the first contact with my Sydney cousin, Gary, on August 29, 1997. He later mailed me the ancient

photograph from the wedding of my mother's parents. This group photo bears witness to my past, a past of which I did not know until that August day of 1997. Two thirds or more of about thirty wedding guests who are pictured in that photo from 1928 were murdered by the Nazis. From among the minority of those who in 1945 returned from various camps or from hiding with the partisans, most left Europe after 1948. The relatives who moved to Sydney descend from Etelka, the first-born sister of my mother's father: Etelka with her daughter, Olga, survived Auschwitz and a labor camp. After 1945, my mother's family remained in Czechoslovakia, yet my mother, Magdalena, neither continued contacts with her surviving relatives nor openly acknowledged her Jewish identity or spoke of her war trauma. By her not speaking of that past directly, I neither knew the details of her Jewish life before the wartime nor the extent to which the Holocaust affected the entire extended family. Habermas, with whom I studied in 1989–91, likewise did not know any of this until I told him in Denver. I suggested to him that my mother nonetheless communicated even in silence her and my past.

While I am free to testify about my life and can only invite another to give testimony, the very act of speaking about the traumatic past already witnesses to the unspeakable. Critical theorists, unlike traditional theorists, are not threatened by a contradiction between theory and practice (Horkheimer 1986). Concepts and ideals emerge in and are motivated by historical forms of life and liberation struggles. In the aftermath of Nazism, critical theory in exile and in its postwar return to Germany bears witness to Auschwitz and, thereby, becomes at its core a form of critical witness in general (Adorno 1973: 361–81; Marcuse 1991: 257; cf. 225–46). Yet Habermas's communications theory is not overtly justified as a theory of remembrance, at least not in the manner as this becomes true for Adorno or Benjamin. I get across this obstacle by turning to Habermas's scattered autobiographical statements. Even though I distinguish existential motives from normative justifications of theory, I want to show how experience motivates his critical appropriation of inherited traditions and his mature communications theory. Note how he communicates the difficulty of beginnings, the difficulty of speaking about the unspeakable past:

- *I'd rather not say terribly much about my youth.* A true retrospective can only be made at seventy [that date passed on June 18, 1999][2]. . . . I grew up in Gummersbach, in a small town environment. (KPS 511/AS 77; italics added)

- There is nothing at all to which I have an unambivalent attitude, at least apart from very rare moments. For this reason even my naive connection to social relations is not really naive, but profoundly ambivalent. This has to do with *personal experiences, which I would rather not speak about*, but also with *critical moments*—for example with the coincidence of great events and my own puberty in 1945. (NU 203f./AS 126; italics added)

- The political climate in our family home was probably not unusual for the time. It was marked by a bourgeois adaptation to *a political situation with which one did not fully identify, but which one didn't seriously criticize either.* (KPS 511/AS 77; italics added)

- *I was in the Hitler Youth*; at fifteen *I was sent* to man the western defences. (KPS 512/AS 78; italics added)

- At the age of 15 or 16 *I* sat before the radio and *experienced what was being discussed* before the Nuremberg tribunal; when *others, instead of being struck silent* by the ghastliness, *began to dispute* the justice of the trial, procedural questions, and questions of jurisdiction, there was *that first rupture, which still gapes.* (PpP 62/41; italics added)

- When I was a student, in 1953, I wrote a comparable article on Heidegger's 1935 lectures, because *I was outraged by the inability of the protagonists* (such as Heidegger . . .) *to utter even one word admitting a political error. But I avoided any confrontation with my father, who was certainly only considered to be a passive sympathizer* [*Mitläufer*, literally: fellow traveler]. (NR 23/AS 231; italics added)

- "Partisanenprofessor im Lande der *Mitläufer*." ("The Partisan Professor in the Country of Sympathizers": the main title of the essay for Wolfgang Abendroth's 60th birthday, *Die Zeit*, 29 April 1966, in German PpP 249–52; italics added)

- All the professors *who had any importance to me* were already professors before 1933 (KPS 514/AS 80; italics added). *My own two teachers*, under whom I wrote my dissertation—Ernst Rothacker and Oskar Becker—were cases in point. (AS 192; italics added)

- *Painful revelations of the conduct of one's own parents and grandparents can only be an occasion for sorrow; they remain a private affair between those intimately involved.* . . . An awareness of *collective liability* emerges from widespread individually guilty conduct in the past. This has nothing to do with the ascription of collective guilt. . . . (ÜöGH 25, 27/24, 26; italics added)

Habermas, born in Düsseldorf on June 18, only a year after the wedding photo of my grandparents was taken, spends the war years in a small German town, Gummersbach. He lives sheltered by his boyhood, but also by the provincial town-life, by his father's passive "sympathy" for National Socialism, and by his family's uncritical relation to the Nazi regime. Given these trappings of family and tradition, towards the end of the war Habermas joins his peers in the Hitler Youth.[3]

How can one begin to experience distance from the traditions embraced by one's culture, family, and peers? With respect to this question we gain an insight into the existential beginnings of Habermas's later emphasis on

communication. I propose that his communications model of critical theory emerges from a distancing relation to bankrupt traditions, integrating a witness-posture towards an inherited liability for the Holocaust in particular and an assumed responsibility for the future of disastrous traditions in general.

One would have been compelled to break with the Nazi continuity, had one experienced a tension between one's birth in it and its criminal progress: if one were a German Jew, if one were of a Roma or Sinti origin (Gypsy), if one were a Leftist or dissident, or if one were known as a practicing homosexual. Given what we know of Habermas's conventional Protestant upbringing, he could not have found distance from tradition in any of these ways. Unlike most in the first generation of the Frankfurt School, he was not born a Jew. He was not a Roma and he becomes a Left-leaning intellectual in adolescent postwar years. Habermas is of school age and in his early teens during the war. We can imagine that a German boy could want to integrate himself into his social group within the received channels of Nazi individualization through socialization. The Hitler Youth met just that need. Habermas reveals in all but one caustic sentence that at the end of the war (at 15) he goes with the Hitler Youth to the western front (KPS 512/AS 78).

As the war ends on May 8 (Habermas often recalls that beautiful spring) with the suddenness of a passing storm, this world-historical event ruptures his silent world. The boy who an instant ago was in the Hitler Youth, who was protected by conventional life, experiences May 8, 1945 as his existential, philosophical, and political birthday. Two cumulative events are of watershed importance: in 1945, when history is accentuated by Habermas's puberty, the entire edifice of received tradition collapses; and in 1953, during university studies, his already shaken consciousness comes into critical maturity when he becomes offended at the complicity of the great majority of the established German professorate with the Nazis. His confrontation with Heidegger's generation is intensified later, for example, during the student revolt of 1968. When, through a critical witness who learns by (the) disaster, lived history, or a momentary conversation translates an unspeakable past into experience, then even traumatic silence communicates.[4]

II. DANGEROUS MEMORY AS WITNESS

Even if the unspeakable can be communicated in silence, how can any conversation about the traumatic past take place within contemporary experience? How can one bear or hear witness to the traumatic past? And how can one extend solidary remembrance to the victims of history especially if someone like Habermas is neither a survivor nor a descendant

of victims? Benjamin's and Adorno's reflections on the past open onto the memory-work on trauma. Felman, in a masterful study of Lanzmann's film, *Shoah*, asks how one can bear witness to the Holocaust. Sketching their answers to the same question—what does learning from *Shoah* mean?—I preface the possibility of the critical theorist as witness.[5]

The Translator as Witness

In Hebrew, *Shoah* designates the Holocaust; but "without the article," Felman reminds us, it signifies disaster. Inspired by Benjamin, she suggests that by disaster we learn

> the very foreignness of languages, the very namelessness of a catastrophe which cannot be possessed by any native tongue and which, within the language of translation, can only be named as the *untranslatable*: that which language cannot witness; that which cannot be articulated in *one* language; that which language, in its turn, cannot witness without *splitting*. (Felman and Laub 1992: 212f.)

Benjamin (1968: 69–82) contrasts traditional and critical translators.[6] The traditionalist seeks literal renditions of information which are supposedly contained in an intact original; but this view secures only the "dead theory of translation" (73). The critical translator, instead, embodies "a mode" (70). Instrumental translators are technocrats of an "inaccurate transmission of an inessential content." But "[i]f translation is a mode, translatability must be an essential feature of certain works" (70f.). What inheres essentially in the original may not be a set body of information but rather "a specific significance" which renders texts translatable. This translatability cannot be calculated. Yet it links the "life" of an original with an "afterlife" of a translation. The link engenders a vital history inhering in living texts. Translation's mode embodies the living history of the original. Like history, translation spans a life and, in transformation, an afterlife. It is only by virtue of their temporal modalities that texts and histories are translatable (71).

As a vital link, translation not only transforms the original through its intertextual afterlife (73), but also facilitates *reciprocity of communication*. "Languages are not strangers to one another, but are, a priori and apart from all historical relationships, interrelated in what they want to express" (72). The "suprahistorical" reciprocity of languages testifies to their communicability; the latter, however, cannot be owned by any one language alone. "[I]t is translation which catches fire on the eternal life of the works and the perpetual renewal of language" (74). Translation is thus a work of love (78): one may possess neither the original nor the "pure language" of translation (77). As in loving, "the language of a translation . . . must . . . let itself go"

in order to give voice to reciprocity. Just as one may not possess loving reciprocity, so "[i]n all language and linguistic creations there remains in addition to what can be conveyed something that cannot be communicated" (79). The translator aims to "release" and "liberate" sedimented languages, historical memory, the original (80). This act of liberation excavates meaning "from abyss to abyss," treading near the unspeakable of language (82). The task poses "the enormous danger inherent in all translations: the gates of a language thus expanded and modified may slam shut and enclose the translator with silence" (81). *Witnessing to what makes any meaning speakable and various languages reciprocally communicable* captures only a "provisional . . . instant" (75). Benjamin yearns "for that language which manifests itself in translations" (77). But the unspeakable mode of translatability "eludes any direct attempt" to make the "foreignness of languages" into a familiar hearth (75).

After distinguishing between three levels of witnessing—from oneself, from others, and the process of witnessing itself—Felman (1992) defines "witness" as someone who refuses amnesia, who takes responsibility for truth. But *Shoah*, the Holocaust, *the* disaster, is an event bereft of witnesses. It lacks witnesses because they were exterminated, and the crime was masterfully hidden. Even survivors are often unable to witness to themselves or others, whether the latter are insiders or perpetrators or bystanders. If the event could not be experienced and communicated, did it happen? This communication's unspeakable dimension defines the lived, temporal structure of trauma (75, 80, 204, 207ff., 215).

Felman intimates the unspeakable dimension of communication:

> The historical reality of the Holocaust became, thus, a reality which extinguished philosophically the very possibility of address, the possibility of appealing, or of turning, to another. But when one cannot turn to a "you" one cannot say "thou" even to oneself. The Holocaust created in this way a world in which one *could not bear witness to oneself*. . . . This loss of the capacity to be a witness to oneself and thus to witness from the inside is perhaps the true meaning of annihilation, for when one's history is abolished, one's identity ceases to exist as well. (82)

Habermas theorizes communicative action under formal and pragmatic presuppositions, those which are assumed by speakers and hearers whenever they communicate with one another about something in the world. These conditions define the normative ideal of dialogic reciprocity among the participants in conversation and their symmetrical access to raising, defending, or questioning the validity claims to truth, rightness, and sincerity. But how can we restore this ideal communicative reciprocity and validity to any intersubjectivity damaged by (the) historical disaster? We can

do so only if we succeed in translating the trauma. I will argue that *this ability to translate and mourn the past, with an attendant responsibility for the future, indicates a priority of the unspeakable dimension as the condition of the possibility of communicative action.*

> Memory is conjured here essentially in order to *address* another, to impress upon a listener, to *appeal* to a community. . . . To testify is thus not merely to narrate but to commit oneself, and to commit the narrative, to others: to take responsibility—in speech—for history or for the truth of an occurrence, or something which, by definition, goes beyond the personal, in having general (nonpersonal) validity and consequences. (Felman and Laub, 1992: 204)

Felman underscores the special illocutionary force empowering one to witness the unspeakable:

> Bearing a witness to a trauma is, in fact, a process that includes the listener. . . . [T]here needs to be a bonding, the intimate and total presence of an other—in the position of one who hears. Testimonies are not monologues; they cannot take place in solitude. The witnesses are talking *to somebody*. . . . (70f.)

Mourning as Witness

Adorno (1986) analyzes the memory of disasters that have been suppressed, silenced, rendered unspeakable. He invites *us* to come to terms with and work through the traumatic past. Witnessing to an erasure of witnesses and history in postwar Germany, he inhabits the Benjaminian temporal mode of critical translation. Adorno (115) enters the heart of the abyss:

> One wants to get free of the past: rightly so, since one cannot live in its shadow, and since there is no end to terror if guilt and violence are only repaid, again and again, with guilt and violence. But wrongly so, since the past one wishes to evade is still so intensely alive.

And he unmasks the nightmarish afterlife of ghosts who, awake, survive their dying:

> National Socialism lives on, and to this day we don't know whether it is only the ghost of what was so monstrous that it didn't even die off with its own death, or whether it never died in the first place—whether the readiness for unspeakable actions survives in people, as in the social conditions that hem them in.

How can readiness for monstrosity survive at the core of the intersubjective fabric? Adorno warns that the failure to work through trauma comes to motivate our living history with "madness" (124). Just as the

Benjaminian translator receives and transmits tradition, culture, and history in a discontinuous mode; so also the Adornian memory-work with trauma requires "a democratic pedagogy" (125). This performative "task" bears responsibility not only for "educat[ing] the educators" but also for "public enlightenment" (126). Witnessing to trauma becomes now a critical work of resistance to "the destruction of memory" and the "loss of history" (117). There is the *monstrous-unspeakable* dimension of speech and history. Against its repressively willed (117f.), ignorant silence, witnessing to the *dangerously-unspeakable* horror of tradition releases its critical memory.[7]

When Felman (1992) analyzes Lanzmann's (1985) ten-hour film, which is made of contemporary insider and outsider testimonies, we witness a living drama of *the* disaster. In working through trauma, witnessing embodies "the *performance*" of "a *critical* activity" (Felman and Laub 1992: 206; cf. 160). The "original" event, in its unspeakability, could not have witnesses. The Holocaust consists in erasing witnesses, Felman explains. Yet even if survivors or film-makers or translators may not appeal to tradition, culture, or a given "*community of seeing*" or "*community of witnessing*"; even if they cannot appeal to some original event itself; and even if bystanders and perpetrators continue to conceal; that triply failed performance constitutes layers of witnessing addressed to contemporary experience (211; cf. 159f.).

Translators of the traumatized past, like its film-makers or critical theorists, can become at best "*second-degree witnesses* (witnesses of witnesses, witnesses of testimonies)" (213). In assuming responsibility for truth about our past and future, witnessing can recover the dangerous memory of trauma. But witnessing translates the critical possibilities of such mourning memory for contemporary generations. "[T]his impossibility of witnessing is, paradoxically, inherent in the very position of the translator, whose task is nonetheless to try to render—to bear witness to —the original" (159). Working off the past necessitates a critical activity of stripping off the presumed innocence of historical origins. The critical translator transmits history, traditions, texts by "bearing witness to what the 'perception' or the 'understanding' precisely fails to see or fails to witness" (160). "Translation is the metaphor of a new relation to the past, a relation that cannot resemble, furthermore, any past relation to the past but that consists, essentially, in the historical performance of a radical discontinuity" (162).

Can There Be Witnesses if the Past is Closed?

The Adornian task of working through the traumatic past rises or falls with the possibility of bearing witness to (the) disaster. By answering Felman's

question, how one can witness (or bear witness to) the Holocaust, whether in the first or second degree, we should be able to settle the Benjaminian issue whether or not the past is closed or open to liberation or, if you prefer a more postsecular language, to messianic redemption. Neither critical theorists in general, nor Habermas in particular, could witness to (the) disaster if the traumatic past were irretrievably closed. *My thesis is that Habermas's philosophical-political profile, and, with some qualifications, his answer to the Benjaminian issue of the past, testify to the openness of history.*

Before developing my thesis, I will sum up the Benjaminian outcome of the highly debated issue of the past and Habermas's current position on it. The issue of the open or closed status of the past, especially of the injurious one, arises out of Benjamin's claim that "the work of the past remains uncompleted for historical materialism" (1982 [1937]: 233; 1955: 311; cf. Peukert 1986: 206). In a letter from March 16, 1937, Max Horkheimer rebuts the above claim with this either/or: history is either closed or it requires an ahistorical, theological explanation. In the *Passagen-Werk* for the *Arcades* project, Benjamin (1989: 61) cites Horkheimer's letter: "Past injustice has occurred and is done with. The murdered are really murdered. . . . If one takes incompleteness completely seriously, one has to believe in the Last Judgment. . . ." Benjamin appends this "corrective" to any scientistic orthodoxy of 'historical materialism': "history is not just a science but also a form of memoration. What science has 'established', memoration can modify. Memoration can make the incomplete (happiness) into something complete, and the complete (suffering) into something incomplete." Redemptive criticism and memoration of the injurious past are "theology," even if not theologically dogmatic.

Still, Benjamin's corrective embraces materialist historiography. His corrective, moreover, wields a two-edged sword. First, having discovered that human history never had innocent origins, one must face the difficulty of its beginnings. "Barbarism inheres in the very conception of culture . . . " (1989: 56; cf. 1968: 256; 1982: 233). Second, the history written from the view of its victorious progress "is a kind of transmission that is a catastrophe." Redemptive criticism and materialist memoration are to "rescue" tradition from this double catastrophe—an inherited presumption of innocence and progress (1989: 63; cf. 81).

In his last completed work from 1940, Benjamin (1968) differentiates a progressivist "historical materialism" (253) from a messianic remembrance integrated with historical revolution. Rolf Tiedemann (1989: 175–209) emphatically reminds us that even as Benjamin invokes messianic time, redeeming the claims made by the victims of history on present generations, his theological concepts are thoroughly materialist. Benjaminian messianic

hope enters through the gates of human history for the sake of those without hope.

> The past carries with it a temporal index by which it is referred to redemption. There is a secret agreement between past generations and the present one. Our coming was expected on earth. Like every generation that preceded us, we have been endowed with a *weak* Messianic power, a power to which the past has a claim. The claim cannot be settled cheaply. Historical materialists are aware of that. (Benjamin, 1968: 254)

Because of *our weak messianic power*—the phrase to be repeated and transmuted by Habermas on numerous occasions—witnessing to (the) disaster becomes possible. And it becomes necessary because without witnessing to the unspeakable, *"even the dead* will not be safe from the enemy if he wins" (Benjamin, 1968: 255). The past remains open through the temporal trajectory of the now-time (*Jetztzeit*), "of the present as the 'time of the now' which is shot through with chips of Messianic time" (263; cf. 261). By remembering the victims, *we* endow revolutionary praxis with the dangerous memory of the messianic promise of liberation. The critical historiographer must resist homogenizing the past. Against blueprints or idols of future progress, Benjamin witnesses to discontinuous, redemptive time as our present experience of the past. One can inhabit time which is no longer empty, knowing that "every second of time . . . [is] the strait gate through which the Messiah might enter" (264).

The issues separating Horkheimer and Benjamin are revisited by Helmut Peukert (1986: 206–10), Christian Lenhardt (1975), Johann Baptist Metz (1989), at one end, and Habermas at the other. Lenhardt introduces *anamnestic solidarity*, now a widely used term, to argue that future, thus present, generations may not consciously accept their liberation and happiness as brought about by those in history whose oppression and unhappiness stay without redress. Peukert (1986: 209f.) and Metz (1989: 736f.) insist that, short of willed amnesia, Habermas's communicative ethics presupposes *anamnestic solidarity* as the condition of its possibility.

In the end, Habermas parts with Horkheimer's rebuttal to Benjamin and accepts instead a secularized variation of Peukert's (1986: 210) formulation of the Jewish tradition: "The paradox of an existence that refuses to extinguish the memory of the victims of history in order to be happy." But Habermas does not share Peukert's reinterpretation of communicative action through Christian fundamental theology. Rather than Peukert's Christian theological or Horkheimer's despairing positions, he adopts a communicative rendition of the Judaic claim laid by past generations to our *"weak* Messianic power" (Benjamin, 1968: 254). Benjamin's weak *messianic* power becomes Habermas's weak *anamnestic* power. *Anamnestic solidarity*

is beyond despair, yet it sheds theological pretensions: "social theory offers no consolation, has no bearing on the individual's need for salvation" (KPS 489/AS 60). He speaks of "the [murdered] dead who have a claim to the weak anamnestic power of . . . [our] solidarity" (EAS 141/NC 233).

My preliminary conclusion is that Habermas's mature theoretical position situates him between Benjamin and Horkheimer and, with a more nuanced reading, closer to the former.

> *Now our responsibility extends to the past as well. This cannot simply be accepted as something fixed and over and done with.* Walter Benjamin has probably defined most precisely the claim which is made by the dead on the anamnesic [sic] power of living generations. Certainly, we cannot make good past suffering and injustice done; but we have *the weak power of an atoning remembrance.* Only our sensitivity towards the innocently martyred, from whose inheritance we live, can generate a reflexive distance from our own traditions, a sensitivity to the profound ambivalences of the traditions which have formed our own identity. (NR 155/AS 242f.; italics added)[8]

I can now develop my thesis from Habermas's Benjaminian affirmation: because the past is not closed, witnessing to (the) disaster is not impossible; ergo present and future generations can face their traumas. Whether in the first or second degree, witnessing empowers *our anamnestic solidarity* with the victims of history. If "[t]he catastrophes of our century have . . . altered . . . [our] awareness of time" (NR 155/AS 242; cf. LD), then they must have altered our communicative competencies. *This century has taught us that communicative action is possible in the first place because in principle one can bear witness to the unspeakable.*[9]

III. THE CRITICAL THEORIST AS WITNESS

If there is a silver lining in Habermas's profile, its discernible contours begin on liberation day, May 8, 1945; all tracks vanish in an unspeakable or unspoken memory before that day.[10] As I find Habermas revisiting the vanishing moment of his difficult beginnings, I feel justified in characterizing that day, with him at 15, as his existential, philosophical, and political birthday. Insofar as the May liberation breaks the false continuities and presumed normality of his sheltered life, he returns to that instant as a witness to responsible self-choice. I wish to focus on two sides of Habermas's returns to the liberation instant: his critique of the present age and his enlightenment hope of learning from (the) disaster. In my conclusions, I address the question of what it means to learn from (the) disaster today.

Shadows of (the) Disaster

The second-degree witness to the Holocaust acts indirectly and yet may directly expose evasion of or deception about the criminal past. We find Habermas adopting this role at key historical moments; and those performative instants form his trajectory and philosophical-political profile. In one heated moment of the German Historians' Debate, Habermas invokes the dangerous memory of Auschwitz. His words might be describing a still-life canvas, a photograph, a director's cut for a film testimony. He situates himself as a second-degree witness at the unloading ramp for the cattle cars arriving with the Holocaust victims:

> Contemporary history remains fixated on the period between 1933 and 1945. It does not move beyond the horizon of its own life-history; it remains tied up in sensitivities and reactions that, while spread over a broad spectrum depending on age and political stance, still always have the same point of departure: the images of that unloading ramp at Auschwitz. (EAS 137/NC 229)

My reference to the filmic quality of Habermas's testimonial is not gratuitous. As he ponders whether or not the unspeakable horror of tradition could be translated into something utterable, into "the liberating power of words," and thereby healed through reliving it in the ethico-moral dimensions of communicative action, he alludes to his own viewing experience of Lanzmann's *Shoah*. In that vivid film-passage of contemporary testimonials, Habermas is "able to follow the almost physical process of the work of remembering." That silent, unspeakable horror "was put into words for the first time." Habermas's witnessing of the witnesses, whose testimonies mark "an increasingly intense involvement with the Holocaust on the part of the Jews," places in sharp contrast his experience of the words uttered by those who wish to revise the Nazi past, that is, its perpetrators and new bystanders. Habermas develops that contrast against the relief of 1945. Today's revisionist words "for good reasons had not been used since 1945, at least not in public" (EAS 138/NC 230).

With Habermas situated at second-remove from the unloading ramp in Auschwitz, I can decipher the four-fold temporal dimensions of his contemporary witnessing situation. There is the unspeakable, because incommunicable, silence containing the untranslatable event experienced by the victims and survivors of the Holocaust. There is the unspeakable, because willed, silence of the perpetrators and the bystanders. There is the contemporary memory work communicated to others by the survivors and their children. And there is the contemporary second-degree witnessing to the witnesses and to the process of witnessing. Habermas enters through the fourth dimension, becoming that critical theorist who witnesses responsibly

against contemporary erasures of witnesses, against forgetting (the) disaster. The publicness of Habermas's political interventions underscores the communicative heart of witnessing. I highlighted the communicative dimension of Adorno's democratic pedagogy and Benjamin's rescue of the past. From *our* historical vantage point, witnessing unearths the silver lining running around Habermas's political writings and his theory of communicative action. The willful forgetfulness of the perpetrators and bystanders demands that the critical theorist become a contemporary witness to (the) disaster. Against obscene "words [that] flowed again from mouths that had long been shut," Habermas takes recourse "in the liberating power of words," even as he acknowledges the unspeakability (untheorizability) of horror (EAS 138/NC 230).

Witnessing to the unspeakable trauma of victims or to the unspeakable denial of liability can render silence intelligible. Thinkers in the existential traditions from Søren Kierkegaard to Karl Jaspers to Václav Havel distinguish between personal guilt for past acts and collective liability for the future, detaching both of these attitudes of responsible mourning from the faulty ascription of collective guilt. Situated at the juncture between the unspeakability of deceptive forgetting and the unspeakability of trauma, Habermas, following Jaspers (EV 263f./46; EAS 140ff./NC 232–35; MHFI 25) and other existential thinkers, speaks as an indirect witness.[11]

In the 1990s, heeding lessons of the Historians' Debate from the 1980s, Habermas unmasks the two Big Lies of the postwar (democratic) and of the post-Wall (normalizing) erasure of the criminal past. The former Lie asserts Germany's and Kurt Adenauer's postwar beginnings as something *always already* democratic; the latter Lie suggests that Helmut Kohl's post-Wall unified Germany is normal *once again*. The temporality of these two public *Noble Lies*—their *always already* and *once again*—betrays the willed dimension of their ignorance. That lies about history are possible at present indicates that the past is not closed, that victims are not safe from the enemies. The four-fold temporality of witnessing, in opening the deceptively shut past, undoes indirectly, through critical memory-work, the existential-neurotic cluster of repressive forgetting (VaZ, "The Asylum Debate" 136; ZLB; NBR 161f./155f.).[12]

We may learn from Adorno who unmasks the willed dimension of lying about the past:

> The effacement of memory is more the achievement of an all-too-wakeful consciousness than it is the result of its weakness in the face of the superiority of unconscious processes. In this forgetting of what is scarcely past, one senses the fury of the one who has to talk himself out of what everyone else knows, before he can talk them out of it. (Adorno, 1986: 117f.)

Publicly sanctioned self-deception gets its neurotic funding from existential motivation, that is, one's will to be deceived. Motivated self- and other-deception crystallizes around objective social conditions. But motivated ignorance does not simply arise from an objective lack of knowledge or absence of democratic institutions. Otherwise, as Habermas acknowledges in numerous places, Adenauer's regime would not need the student revolt to denude the surviving Fascist culture. In motivated ignorance, *we* become what *we* want to be by communicating deception through *our* willingness to deceive. Undoing the motivated core of self-deception requires more than knowledge or the military defeat of a criminal regime from without. Even in the absence of Jews, Adorno (1986: 128) remarks, one could invent other targets. One may, for example, fear and hate Blacks in U.S. towns, or in power-structures where they comprise less than two percent. Re-educating madmen, delusional paranoid nationalists, anti-Semites, misogynists, and racists requires an active resistance to willed ignorance, Adorno insists (124). The critical theorist in the role of witness to an unreprocessed past meets this requirement.[13]

Interestingly, both Adorno and Habermas exhibit strong ambivalence towards the nonreformist side of the German student movement in the 1960s.[14] But with regard to the Adenauerean *Noble Lie* of the postwar readiness of Germany for democracy, Habermas credits this very student revolt for managing to strip away the publicly practiced and politically mastered self-deception (VaZ, "The Asylum Debate" 136). The student upheaval ruptures the false German continuities that held firm well beyond 1945. I argue elsewhere that the democratic-constitutional needs of the generation of 1945 require the existential-revolutionary core of the '68ers as the lived condition of their possibility. Habermas, by acknowledging the students in forcing their parents to face the horror of the Nazi period, ingeniously integrates in his critical theory two generational aspirations, the structural needs for democratic constitution (1945) with the motivational core of publicly debating the future of *our* traditions (1968).[15]

As a university student, Habermas displays, uncharacteristically for him now, Benjamin's impatience with reformism; he wishes for a revolutionary transgression of the cultural Lie.

> I was nineteen, and one is still very immature at that age. During my time at university, from 1949 to 1954, the politically dominant factors for me were first of all a strong moral reaction to the Nazi era, and secondly the fear that a real break with the past has not been made. I thought then what one cannot say today without criticism: *if only there had been some spontaneous sweeping away, some explosive act which then could have served to begin the formation of a political entity. After such an eruption we would have at least known what we couldn't go back to. There simply was no struggle.* (KPS 513/AS 79; italics added)

Habermas holds on to the Benjaminian promise of messianic time insofar as he still values those critical discontinuities. They rupture the continuities of a normalized criminal past from which another past, to wit another future present, must be rescued. Against the catastrophe of empty time—that deceptively willed progress which passes over victims of time—the revolting discontinuity of the now-time enters the temporal dimensions of witnessing (the) disaster: the "traumatic refusal to pass away of a moral imperfect tense that has been burned into our national history [and] entered the consciousness of the general population" (EAS 137/NC 229f.).[16]

I have underscored Habermas's Benjaminian performance: implied is his stance, 'I witness here to the unspeakable since I cannot do otherwise'. My accent on discontinuity does not *require* (the) disaster to happen as a warrant of communicative learning. Auschwitz is a historical event, not the original sin. That event became part of the German-Jewish history, albeit passed to *us* indirectly as untranslatable and without witnesses. The historical memory of the unspeakable does not grant Germany a special path (*Sonderweg*). In theorizing, concept constructions, and political thinking, *we* may learn from or by (the) disaster, but that does not make historically unspeakable facts somehow transcendentally necessary. Nor do the existential beginnings of this learning disvalue the normative justification of critical theory.[17]

Learning from (the) Disaster

Habermas learns from Adorno's (1986: 125) "democratic pedagogy." In examining the traditions that once betrayed *us*, Habermas inherits Benjamin's task of the translator. Recall Habermas's depth analysis of socially institutionalized self-deception: "Big Lies are pathologies that stabilize themselves through their own existential usefulness" (VaZ, "The Asylum Debate" 136). If willed ignorance is existentially useful, then critical pedagogy calls for an existential distancing from one's self-deceptive individualization through deceptive socialization. We must experience how we have neither been always already democratic nor become normal again. This uncovering of *our* fundamental Lie is facilitated by the translator of the silent and repressed contents of texts or traditions. Habermas's enlightenment pedagogy learns from the disaster of the Jewish-German relations. He links this critical learning to his own autobiography:

[A]ll biographical facts have an idiosyncratic element. . . . [T]he intellectual and cultural provincialism we were plunged into by the Nazis was not overcome at a stroke, but relatively slowly. The traditions of the Enlightenment and of radical modernism did not become generally accepted before the end of the fifties. . . . [T]his breakthrough would have been scarcely conceivable without the outstanding intellectual impact of the last generation of German-Jewish

scholars, philosophers and artists who returned to Germany after everything was over, either in person or through their works and writings. (KPS 470/AS 45f.)

In turn, he theorizes the general need for critical distancing from criminal traditions. Witnessing the disaster of German-Jewish relations, he seeks here the translator's bridge to the unspeakable:

> [T]hose who had long been part of German culture, without ever really belonging to it, taught us how to identify with our own, with German traditions, and yet while standing within them, to keep a certain distance from them, which enabled us to continue them in a self-critical spirit, with the scepticism and the clairvoyance of the man who has already once been fooled. (KPS 471/AS 46)

Habermas admits: the fact of Auschwitz affects not only the existential conditions of innocent historical continuity and cultural identity, but even those of transparent communicative competencies. We can assume neither that *our* native tradition should be trusted nor that in "face-to-face dealings with other people" we could not be deceived in a more sinister manner than suggested by Descartes's "*deus malignus.*" He drives this insight home, leaving no doubt:

> In my view, it is precisely this basis of trust which was destroyed before the gas chambers. The complex preparation and extensive organization of a coldly calculated mass murder, in which hundreds and thousands—indirectly a whole people—were involved, took place, after all, with the appearance of normality preserved, and was even dependent on the normality of highly civilized social intercourse. The monstrous occurred, without interrupting the steady respiration of everyday life. Ever since, a *self-conscious* life has no longer been possible without suspicion of those continuities which are sustained unquestioningly, and which seek to draw their validity from their unquestionability. (NR 150/AS 238)

Habermas's second-degree witnessing is unique in the way he fashions the dual Adornian-Benjaminian task of critical pedagogy and *anamnestic solidarity*. He calls for an ongoing publicly performed existential either/or debate on the future of our traditions. I stress again that Habermas rejects with Jaspers and other existential thinkers the notion of collective guilt, but he espouses that of collective liability for the inherited past and of attendant responsibility for the future (EAS 140–42, 164, 174/NC 232–36, 252, 262). Learning from the disaster of Auschwitz requires a dual temporal approach to counter the temporal dimensions of denial and willful forgetting. Turning to the past for which *we* are liable, *we* must enjoin Benjaminian *anamnestic solidarity* with the victims of history; turning towards the future, *we* must enact public performatives of an existential either/or—opting for those traditions which *we* will continue and against those *we* must jettison.

By joining this "Kierkegaard's *Either/Or*" (EAS 178/NC 266) with "Benjaminian legacy," Habermas questions himself and his contemporaries, witnessing before the speaking public to the unspeakable: "But what follows from this existential connection between traditions and forms of life that have been poisoned by unspeakable crimes?" (EAS 141/NC 233)

He transforms his inherited liability into solidary responsibility for the past and future:

> Our own life is linked to the life context in which Auschwitz was possible not by contingent circumstances but intrinsically. Our form of life is connected with that of our parents and grandparents . . . that is through a historical milieu that made us what and who we are today. (EAS 141/NC 233; and citations below)

A mad alternative to the lived madness of repressed liability and to the madness of unmourned trauma is the madness of losing oneself as a person and ourselves as a community. Against such blind alleys, Habermas insists: "We have to stand by our traditions, then, if we do not want to disavow ourselves." With George Herbert Mead, he accepts that "a historical milieu . . . made us what and who we are today." With *anamnestic solidarity* and responsibility, he takes a step beyond Mead's thesis of individualization through socialization towards its existential amplification. The question, who am I, who are we to become?—given the disaster *we* have become— pertains to the temporal possibilities of "the anamnestic redemption of an injustice" (PDM 26/15) and to the existential possibilities of communicative freedom. Habermas indulges in a rare profane illumination of his own:

> This need for redemption on the part of the past epochs who have directed their expectations to us is reminiscent of the figure familiar in both Jewish and Protestant mysticism of human responsibility for the fate of a God who, in the act of creation, relinquished his omnipotence in favor of human freedom, putting us on an equal footing with himself. (PDM 24/14, trans. altered)[18]

The critical theorist, inspired by a Benjaminian-Kierkegaardian illumination, expecting the messianic time and working for liberation, has no need of the guarantees of Messianism. Habermas retains his undogmatic sober hope in theory and in political praxis—even as in communicative freedom this hope is already claimed by the victims of history (VV 630f./490).

> [T]here is the obligation incumbent upon us in Germany—even if no one else were to feel it any longer—to keep alive, without distortion and not only in an intellectual form, the memory of the sufferings of those who were murdered by German hands. It is especially these dead who have a claim to the weak anamnestic power of a solidarity that later generations can continue to practice

only in the medium of a remembrance that is repeatedly renewed, often desperate, and continually on one's mind. . . . This has political implications as well. (EAS 141/NC 233)

Habermas's anamnestic atonement retains Benjaminian revolutionary attitude of dangerous memory, "the attitude we are to take—for our own sake—towards our own traditions" (EAS 141/NC 234). Since he shapes his politics with "responsibility for a piece of history [which] is assumed *consciously*," Habermas cannot interpret the publicly exercised, radical existential self-choice by forgetting "our own disastrous traditions" (EAS 178/NC 266). His reading of Kierkegaard through Adorno and Benjamin leaves no place for resurrecting the German political existentialists of the 1930s who confuse their responsibility with the *Führer's* will. We find Habermas, as an existential witness, returning to that unloading ramp. "After Auschwitz our national self-consciousness can be derived only from the better traditions of our history, a history that is not unexamined but instead appropriated critically." The critical witness acquires "a gaze educated by the moral catastrophe, a gaze that is, in a word, suspicious" (EAS 142/NC 234).

IV. COMMUNICATIVE ACTION AND THE UNSPEAKABLE

What does it mean to learn by (the) disaster today? My conversation with Habermas about my past and Germany's past revealed the difficulty of speaking about the unspeakable—the difficulty of beginnings. Because that past has not been closed, even silence can communicate the unspeakable. Moreover, in actively bearing witness to *the* disaster, a contemporary conversation heightens that unspeakable in the unfulfilled and the normalized past—the waiting and repressed past. Any such conversation begins to perform an anamnestic rescue through its critique of the past present and its responsibility for the future present. Just as my surviving relatives—by recording the unspeakable in testimonies for Steven Spielberg's *Video History Foundation*[19] and by speaking to me in Sydney in 1999—opened to me the past I did not experience, that same past of which my mother communicated in her silence, so does this written record perform a testimony that is now witnessed by others.

I draw my first conclusion from this experience of conversation as witness: the past cannot be closed if the present is to make available to us the possibility of communication. The radical openness of the past is the condition of the possibility of the future-oriented present.

Insofar as Habermas takes on the role of a witness, the patterns of his theory and praxis elicit a portrait of the critical theorist who learns by (the) disaster and remembers the traumatic past dangerously. Such learning attests

to the prescriptive imperative that in coming to terms with the injurious past one ought to witness within the performance of communicative action to the unspeakable. This attestation neither justifies prescriptive theory from historical practices nor demotes communicative reason as such. But it does testify to a certain priority of the unspeakable within communication. The critical theorist, such as Habermas, acts as a second-degree witness of witnesses, of the witnessing process, and of the denials of (the) disaster. The critical theorist as witness touches upon the twofold unspeakability of trauma—as experienced by the victims of history and as repressed by the perpetrators, bystanders, and latter-day revisionists. Since both modes of unspeakability reside within communication, the witnessing act, Felman reminds us, is necessary for restoring communicative competencies to traumatized silence. The witnessing-performatives inscribe the past- and future-orientations of critique and responsibility into communicative action. Critical witnesses unmask the shadows of the criminal past, while responsible witnesses determine the future of *our* disastrous and life-giving traditions.

I have argued that if in communicative action speakers and hearers performatively constitute both their identities and the linguistic structure of validity claims, which they raise in speech, then witnessing to intersubjective experience is a necessary condition of the possibility of all communication. The Holocaust embodies only the historically annihilating point of existing as a speaker and hearer in communicative action. Yet *our* learning from *this* disaster attests now also to the theoretical implications for communicative action. *I thus formulate my second conclusion: Responsibility for the truth of (the) disaster is necessary for restoring the voice to speech, restoring the voice to its validity claims of truth, rightness, and sincerity. Even if one actually fails to witness to the unspeakable, the regulative ideal of critical theory and praxis calls for a corrective. The twofold posture of critical and responsible witnessing attests to the unspeakable dimension in the constitutive priority of communicative action.*

Adorno's (1986: 115) warning is worth remembering as we ponder the unspeakable in democracy: "I consider the continued existence of National Socialism *within* democracy potentially more threatening than the continued existence of fascist tendencies *against* democracy." Nationalism, anti-Semitism, hatred of foreigners, and a desire for innocent origins form "a paranoid delusional system," which provides "the substitute for the dream that humanity could organize its world humanely" (124). Whatever Habermas might still hope for under the heading of *Europe's Second Chance* (see VaZ, BH, Z), it has been repeatedly buried in the Persian Gulf War, Sarajevo, Kosovo, and finally in NATO's fiftieth-anniversary mission to uphold democracy with moral arguments for human rights and yet with

an internationally illegal military action. *My third conclusion for communi-cations theory and praxis sounds a self-limiting political caution: appeals to the legitimating consensus of the U.N. in the Persian Gulf War or of NATO in the bombing of Serbia protect neither this consensus-formation nor its future chances from the deceptive return of disaster within democ-racy itself.*[20]

Instead of accentuating incoherence between Habermas's methods in theory and in politics, I focused on their shared unspeakable dimension in communication. A single existential profile is more hermeneutically coherent, comprehensive, and productive of a heuristic explanation of this thinker's theory and praxis than an antinomical model would be. If this profile dramatizes an existential unity-in-tension rather than a gap, then learning by (the) disaster *today* must show how the two dimensions of the unspeakable are operative *within* the formal presuppositions of communica-tive action. How is the double contingency of validity claims, playing the field between speakers and hearers, shot through with the double dimension of the unspeakable? As a second-degree witness to the doubly unspeakable trauma, Habermas employs discontinuity in restoring truth and justice to communication. *In my fourth conclusion, I claim that bearing responsibility for the unspeakable preserves the distinct dimension of witnessing, in theory and praxis alike, to the possibility of disaster in legitimate and rational communication. Only by witnessing to this possibility actively, may we begin and continue to resist its return.*[21]

MARTIN BECK MATUŠTÍK

PHILOSOPHY DEPARTMENT
PURDUE UNIVERSITY
JUNE 2000

ABBREVIATIONS AND BIBLIOGRAPHY OF HABERMAS WORKS CITED
(*Alphabetically ordered by abbreviations*)

AS *Autonomy and Solidarity: Interviews with Jürgen Habermas.* Ed. Peter Dews. London: Verso, revised and enlarged ed., 1992.

EAS *Eine Art Schadensabwicklung: Kleine Politische Schriften VI.* Frankfurt a/M: Suhrkamp, 1987. [Partially trans. in NC (q.v.)].

BH "Bestialität und Humanität: Ein Krieg an der Grenze zwischen Recht und Moral," *Die Zeit*, April 29, 1999, 1, 6–7.

EV "Entsorgung der Vergangenheit: Ein kulturpolitisches Pamphlet," *Die Zeit*, May 17, 1985. Cited from NU 261–66. / "Defusing the Past: A

Politico-Cultural Tract." Trans. Thomas Levin. In Hartman (1986: 43–51).

FuG *Faktizität und Geltung: Beiträge zur Diskurstheorie des Rechts und des demokratischen Rechtstaats.* Frankfurt a/M: Suhrkamp, 1992. / *Between Facts and Norms: Contributions to a Discourse Theory of Law and Democracy.* Trans. William Rehg. Cambridge, Mass: MIT Press, 1996.

IEM "Interview with Eduardo Mendieta." Collection of Habermas's essays on religion, ed. by Eduardo Mendieta. Cambridge, UK: Polity Press, forthcoming. [Cited by the # of each question and answer.]

KFnT "Kommunikative Freiheit und negative Theologie." In Emil Angehrn, Hinrich Fink Eitel, Christian Iber and Georg Lohmann, eds. *Dialektischer Negativismus: Michel Theunissen zum 60. Geburtstag.* Frankfurt a/M: Suhrkamp, 1992, 15–34. / "Communicative Freedom and Negative Theology." Trans. Martin J. Matuštík and Patricia J. Huntington. In Martin J. Matuštík and Merold Westphal, eds. *Kierkegaard in Post/Modernity.* Bloomington & Indianapolis: Indiana University Press, 1995, 182–98.

KNV "Keine Normalisierung der Vergangenheit" ("Der Intellektuelle ist mit seinem Gewissen nicht allein," *Süddeutsche Zeitung,* November 19/20, 1985), cited from EAS (q.v.) 11–17.

KPS *Kleine Politische Schriften (I-IV).* Frankfurt a/M: Suhrkamp, 1981.

LD "Learning by Disaster? A Diagnostic Look Back on the Short 20th Century." Trans. Hella Beister. *Constellations* 5(3) (1998): 307–20. [Translation of PK 65–90].

MHFI "More Humility, Fewer Illusions," A Talk between Adam Michnik and Jürgen Habermas, *The New York Review of Books* XLI/6, March 24, 1994, 24–29.

MHgH "Mit Heidegger gegen Heidegger denken. Zur Veröffentlichung von Vorlesungen aus dem Jahre 1935." *Frankfurter Allgemeine Zeitung,* # 170, 25 July 1953. Cited from PpP (q.v.) 67–75. / "Martin Heidegger. On the Publication of Lectures from the Year 1935." Trans. Dale Ponikvar. *Graduate Faculty Philosophy Journal* 6, no. 2 (Fall 1977): 155–64.

NBR *Die Normalität einer Berliner Republik.* Kleine Politische Schriften VIII. Frankfurt a/M: Suhrkamp, 1995. / *A Berlin Republic: Writings on Germany.* Trans. Steven Rendall. Intro. Peter Uwe Hohendahl. Lincoln: University of Nebraska Press, 1997.

NC *The New Conservatism: Cultural Criticism and the Historians' Debate.* Ed. and trans. Shierry Weber Nicholsen. Intro. Richard Wolin. Cambridge, Mass.: MIT Press, 1989. [A partial trans. of EAS (q.v.) and NU (q.v.) with essays from other volumes].

NR *Die nachholende Revolution: Kleine politische Schriften VII.* Frankfurt a/M: Suhrkamp, 1990.

NU *Die neue Unübersichtlichkeit: Kleine politische Schriften V.* Frankfurt a/M: Suhrkamp, 1985,

PDM *Der Philosophische Diskurs der Moderne: Zwölf Vorlesungen.* Frankfurt a/M: Suhrkamp, 1985. / *The Philosophical Discourse of Modernity:*

Twelve Lectures. Trans. Frederick Lawrence. Cambridge, Mass.: MIT Press, 1987.

PK *Die postnationale Konstellation: Politische Essays*. Frankfurt a/M: Suhrkamp, 1998.

PpP *Philosophisch-politische Profile*. Frankfurt a/M: Suhrkamp, 1971. / *Philosophical-Political Profiles*. Trans. Frederick G. Lawrence. Cambridge, Mass.: MIT Press, 1983. [Incomplete edition of the German text].

RC "A Reply to my Critics." Trans. Thomas McCarthy. In John B. Thompson and David Held, eds. *Habermas: Critical Debates*. Cambridge, Mass.: MIT Press, 1982, 219–83.

TaP *Theory and Practice*. Trans. John Viertel. Boston: Beacon Press, 1973.

TCA *Theorie des kommunikativen Handelns*. Frankfurt a/M: Suhrkamp. Band 1: *Handlungsrationalität und gesellschaftliche Rationalisierung*, 1981, Band 2: *Zur Kritik der funktionalistichen Vernunft*, 1985. / *The Theory of Communicative Action*. Two Volumes. Trans. Thomas McCarthy. Boston: Beacon Press. Vol. 1: *Reason and the Rationalization of Society*, 1984; Vol. 2: *Lifeworld and System: A Critique of Functionalist Reason*, 1987.

TiTD "Transzendenz von innen, Transzendenz ins Diesseits." In TuK (q.v.) 127–156. / "Transcendence from Within, Transcendence in this World." Trans. Eric Crump and Peter P. Kenny. In Don S. Browning and Francis Schüssler Fiorenza, eds. *Habermas, Modernity, and Public Theology*. New York: Crossroad, 1992, 226–50.

TuK *Texte und Kontexte*. Frankfurt a/M: Suhrkamp, 1991.

ÜöGH "Über den öffentichen Gebrauch der Historie: Warum ein 'Demokratiespreis' für Daniel Goldhagen?" / "On the Public Use of History: Why a 'Democracy Prize' for Daniel Goldhagen?" Trans. Max Pensky. *Aus der Geschichte Lernen—How to Learn from History: Verleihung des Blätter-Demokratiespreises 1997*. Eds. Karl D. Bredthauer and Arthur Heinrich. Bonn: Blätter Verlag, 1997, 14–37 [side-by-side German-English publication].

VaZ *Vergangenheit als Zukunft*. Zürich: Pendo, 1990. / *The Past As Future: Interviewed by Michael Haller*. Trans. and ed. Max Pensky. Lincoln: University of Nebraska Press, 1994. ["The Asylum Debate (Paris Lecture, 14 January 1993)," 121–41, "Afterword (May 1993)," 143–65, and Trans. Notes, 167–81 are only in the Engl. edition].

VV "Volkssouverentität als Verfahren" [Popular Sovereignty as Procedure] (1988). In FuG (q.v.) 600–631/463–90.

Z "Zweifellos." *Süddeutsche Zeitung*, 112, May 18, 1999, 17.

ZLB "Die zweite Lebenslüge der Bundesrepublik: Wir sind wieder 'normal' geworden," *Die Zeit*, December 11, 1992, 48. [The text partially overlaps with "The Asylum Debate (Paris Lecture, 14 November 1993)," in VaZ (Engl., q.v.) 136–41].

NOTES

1. The Society for Phenomenology and Existential Philosophy (Denver, October 10, 1998). Cf. Matuštík (1993: 259–64; and 1999).

2. This chapter was originally invited by Lewis E. Hahn for The Library of Living Philosophers, Open Court's volume on Habermas. Significantly that volume would have required Habermas not only to respond to all contributors but also to prepare an extensive intellectual autobiography.

3. According to Clemens Albrecht ("Die Frankfurter Schule in der Geschichte der Bundesrepublik," in Albrecht et al 1999: 497–529), it is possible to distinguish four ideal-typical generational "cohorts" (500) born in Germany between 1900 and 1946. We can situate Habermas within the third generation born between 1926 and 1937. Albrecht calls this type the "skeptical generation" (506), which takes over the educational task of coming to terms with the liability as well as guilt of the preceding generation. The members of this group would have "experienced the end of the war partly [working] as anti-aircraft artillery auxiliaries [*Flakhelfer*], but their childhood and youth belong within the Third Reich and in greater part was still linked with the [Nazi] youth organizations." Habermas's generation thus differs from the preceding "securing generation" of World War II soldiers or adult sympathizers who are born between 1900 and 1925 and who conserve their postwar survival. His generation also differs from the following "protesting generation" (506), born between 1938 and 1946, which before the war's end neither could have made "politically interpretable life decisions" nor could have belonged to the existing Nazi orgnizations (500). Had Habermas been born a year later, in 1930, he would have belonged within his skeptical cohort to the sub-group, which, being too young to be recruited by the Hitler Youth between 1944 and the beginning of 1945, "itself had no experience of the war front" (504).

4. It is worth perusing the key historical events still now punctuating Habermas's life (Matuštík 1999; and forthcoming): Habermas, born on June 18, 1929, is four when the Nazis first seize power in 1933, fifteen on May 8 of 1945, and twenty when Konrad Adenauer's German Federal Government is established. At twenty-four, Habermas exposes in the *Frankfurter Allgemeine Zeitung* Heidegger's (1953) republication of the 1935 lectures, which he finds to be a form of deliberately masked yet shamelessly enduring Nazi sympathy (MHgH). Habermas's essay marks an existential parting with Heidegger's unreconstructed political existentialism. One must appreciate the significance of this event given that not just Heidegger but also Habermas's dissertation directors (in German, doctor-*fathers*) in Bonn, Erich Rothacker and Oskar Becker, were more or less enthusiastic supporters of National Socialism (see Leaman 1993). Slaying one's father-figures is never safe, and certainly not in Habermas's Germany and one year before defending his Ph.D. dissertation. Yet Habermas must wait until the thaw following Adolf Eichmann's trial in Jerusalem (1961), the Auschwitz trial in Frankfurt (1963), and finally the generational revolt of the '68ers against the generation of the '45ers to root his

postwar student conscience in a social form of life. Habermas acknowledges in later interviews (NR 25/AS 233; KPS 364–67) that he misfired when in 1967 he publicly warned that Left Fascism was transmigrating as a phantom into the student revolt (KPS 214; 249–60). During the German Autumn of 1977 and in the Historians' Debate of 1985–87, his dangerous memory of liberation once again imparts sharpness to his critical witness. From the anti-terrorist measures of 1977 to the Bitburg cemetery memoration of the war victims along with the SS-soldiers on May 5, 1985; Habermas fearlessly intervenes as a vocal public critic. As the turn (*Tendenzwende*) of the late 1970s and the 1980s reacts to the 1960s—the neoconservative eras attempting to rehabilitate the Nazi era —Habermas calls the German public to its responsibility for the future of disastrous traditions. He intensifies his call from November 9, 1989 (the fall of the Berlin Wall) to October 3, 1990 (the unification of Germany) regarding controversies surrounding the shape and contents of World War II memorials and museums.

 5. Felman and Laub (1992). Benjamin (1968: 69–82 ["The Task of the Translator"—1923] and 253–64 ["Theses on the Philosophy of History"—1940]); and Benjamin (1989). Adorno (1986). Lanzmann (1985).

 6. See Horkheimer (1986).

 7. See Mitscherlich (1975) and Maier (1997).

 8. For Habermas's references to Benjamin with an existential variation on the same insight, see chronologically: "Walter Benjamin: Consciousness Raising or Rescuing Critique" (1972), in PpP; KPS 488f./AS 60f.; RC 246f.; PDM, chap. I, "Excursus on Benjamin's Theses on the Philosophy of History"; EAS 141/NC 233; VV; NR 155f./AS 242f.; TiTD; and KFnT.

 9. After having formulated my thesis in this article and in Matuštík (forthcoming), I was asked by Basil Blackwell Publishers to endorse Dews's (1999) anthology; having read in it Pensky's contribution (1999), I discovered correspondences between his and my original theses, arrived at independently. Pensky writes: "[W]e should regard . . . the trauma of the moral catastrophe of the Holocaust itself . . . [as] the rock-bottom experiential foundation for Habermas's oldest and most unshakable convictions" (219). "Indeed it is the uneffaceability and the unapproachability of the Holocaust as an object of writing that forms the point around which the antinomy between these two [theoretical and political] carefully distinguished sides of Habermas's work revolves. . . . [I]t is in essence a misreading of Habermas's career as a politically engaged intellectual to divide his political writings into this or that 'debate'. . . . [T]here has been a *single*, continuous debate with a single objective and a single, if constantly multiplying, opposition" (224). My analysis, however, draws a different set of implications from the centrality of Habermas's witness.

 10. A more specific thread runs through Habermas's four returns to Adorno (1986 [1959]): On the 40th anniversary of the Nazi defeat, Habermas exposes the neoconservative *diffusions* of the past at Bitburg (EV). In his 1992 newspaper article, Habermas resumes Adorno's essay in the title and raises his voice against

the normalizing trends of the post-Wall Germany (NBR, chap. 2). On the 50th anniversary of the Nazi defeat, Habermas examines the caesura of 1989 in the shadows of resumed false continuities conjured up in the present from before 1945 (NBR, chap. 6). In a key chapter (LD) from his 1998 book on postnational constellations (PK), he examines the constructive possibilities of learning by (the) disaster in the next millennium.

11. See Matuštík (1993: Part 3; and 1998). Cf. Pensky's (1989) excellent analysis of Habermas's inspiration by Benjamin during the Historians' Debate; it is, however, distorted by ascribing to Habermas the faulty view of "collective guilt." This misreading of Habermas runs consistently throughout Pensky's essay (1989: 352, 353, 355, 356, 357, 358, 375, 376). Duvenage's innovative work on apartheid (1999: 7, 11, 21) reproduces Pensky's error.

12. Plato (The Republic) uses the Noble Lie of three metals to keep concord in the *polis*.

13. The notion of willed or motivated ignorance comes from Kierkegaard (1980), and it is developed in the Sartrean bad faith as well as Freud's clinical studies of repression and neurosis. Cf. Sartre (1995); Gordon (1995); and Becker (1973).

14. See Adorno and Marcuse (1999). Cf. Habermas, KPS 213ff., 249–60.

15. For this argument, see Matuštík (1999, and forthcoming).

16. On the "now-time" (*Jetztzeit*), see Benjamin (1968: 261, 263); cf. Habermas's PDM 21–26/11–16; on the secularized messianic now-time of permanent democratic revolution, VV 609/471. On permanent democratic and existential revolution, see Matuštík (1993: 253–57).

17. The Nazis believed in Germany's *Sonderweg*; the historical revisionists, longing for that past, invert that belief; they claim that the development from 1945 to 1989 marks an abnormal *Sonderweg*; on this reading, post-Wall Germany becomes normal again. The suggestion that Auschwitz makes Germany's path special is a variation on this theme (cf. VaZ, "The Asylum Debate" 137–41). Pensky (1999: n25) cites Bohrer (1992: 69) on "negative chiliasm."

18. Habermas's theme recurs: TaP, chap. "Between Philosophy and Science: Marxism as Critique," sec. on Critique and Crisis; PpP 60/39; PDM 377/324; KFnT, sec. II; and IEM, #8.

19. I am referring to the testimony by my great-aunt, Olga (Binetter) Santo (1996).

20. In the "Appeal" (1999) to the German Greens, American Jews reject comparisons of the Holocaust with the ethnic cleansing of the Albanian Kosovars by Slobodan Milošević's regime. Habermas mentions the Jewish Holocaust within the context of his discussion of NATO's bombing of Yugoslavia (BH6).

21. *Postscriptum: Public Presentation and Debate as Witness.* Several questions were raised after my presentation of a shorter version of this paper at the Prague conference on "Philosophy and Social Science" (May 19, 1999). While David Rasmussen voiced his skeptical sympathy that even my attractive Benjaminian reading of Habermas cannot transform his communications theory into a theory of

remembrance with its requisite categories of temporality, trauma, and memory, Hubertus Buchstein argued for the received view of Habermas for whom there can be no validity domain of the unspeakable. Everything is to be rendered speakable, whether in a public or in a private therapeutic or personal discourse. Milan Znoj added that my account conflates ethical-hermeneutical with moral-normative discourse. Discursive contexts differentiate what can be said within each of them. This Kantian compartmentalization of discourse, theory, and practice was reinforced when another objection was raised that my existential starting point suffers either from the problem of induction or the naturalistic fallacy: I am deriving and justifying normative conclusions about communications theory from Habermas's subjective motivation rather than from objective, that is rational, grounds. Maeve Cooke further worried that focusing on Habermas's motives may either instrumentalize the victims or exclude those who want to learn from the past but lack the personal motivation of a witness.

If it were possible to commence with a quasi-transcendental platform to come to terms with the traumatic past, then bearing witness to (the) disaster would be always-already available to theory. My existential starting point has intentionally created a tension within communications theory and practice, and this is what Rasmussen captures where others resist its implications. Critical theory—learning from Hegel, Marx, and existential and pragmatist thinkers of the value-and-history-laden origins of concepts—already departs from the positivist standpoint of traditional theory and thus from the blackmail of the naturalistic fallacy. Neither Kant's domains of the rational nor G. E. Moore's raised hand can suffice in coming to terms with the traumatic past. To wit, the critical theorist as witness testifies to the unspeakable dimension at the heart of the rational distinctions among the forms of normative, ethical, and pragmatic discourse. Since that dimension remains irreducible to the distinction among discourses, no witness to Auschwitz can begin with unsituated, transcendental theory alone. I commence with Habermas's historical experience of May 8, 1945 in order to highlight the tension between his rational ideal and the dangerous memory of the past trauma, for this tension proves beneficial for articulating directions in *new critical theory*.

I have received other helpful comments on this paper from Janet Afary, Tina Chanter, Peg Birmingham, Leonard Harris, David Ingram, Paul Jaskot, Bill Martin, Bob Melson, Bill McBride, Marilyn Nissim-Sabat, Calvin O. Schrag, Iris M. Young, and Peter Zeillinger.

REFERENCES

Adorno, Theodor W. (1973) *Negative Dialectics*. Trans. E. B. Ashton. New York: Continuum.
——— (1986 [1959]) "What Does Coming to Terms with the Past Mean?" In

Geoffrey H. Hartman, ed., *Bitburg in Moral and Political Perspective*. Indianapolis: Indiana University Press, 114–29.

Adorno, Theodor, and Herbert Marcuse (1999) "Correspondence on the German Student Movement." Trans. Esther Leslie. *New Left Review*, 233 (January/February): 123–36.

Albrecht, Clemens, Günther C. Behrmann, Michael Bock, Harald Homann, and Friedrich H. Tenbruck (1999) *Die intellektuelle Gründung der Bundesrepublik: Eine Wirkungsgeschichte der Frankfurter Schule*. Frankfurt and New York: Campus.

"An Appeal from American Jews to the Green Party of Germany" (1999), signed by Noam Chomsky, Edward Herman, Robert Weissman, Michael Albert, Mitchel Cohen, Michael Brün, Mark Weisbrot, Dean Baker, and Robert Naiman, (May 9), Internet <http://www.preamble.org>.

Becker, Ernest (1973) *The Denial of Death*. New York: The Free Press.

Benjamin, Walter (1955) *Ausgewahlte Schriften* II. Frankfurt a/M: Suhrkamp.

——— (1968) *Illuminations: Essays and Reflections*. Ed. and with an intro. by Hannah Arendt, trans. Harry Zohn. New York: Shocken Books.

——— (1979) *One-Way Street and Other Writings*. Intro. Susan Sontag, trans. Edmund Jephcott and Kingsley Shorter. London: Verso.

——— (1982 [1937]) "Eduard Fuchs: Collector and Historian." In Andrew Arato and Eike Gebhardt, eds., *The Essential Frankfurt School Reader*. New York: Continuum, 225–53.

——— (1989 [1928–40]) "N [Re the Theory of Knowledge, Theory of Progress]". Trans. Leigh Hafrey and Richard Sieburth, in Smith (1989: 43–84).

Bohrer, Karl-Heinz (1992) "Why We Are Not a Nation—and Why We Should Become One." In *When the Wall Came Down: Reactions to German Unification*, ed., Harold James and Marla Stone. New York: Routledge.

Dews, Peter, ed. (1999) *Habermas: A Critical Reader*. London: Basil Blackwell.

Duvenage, Pieter (1999) "The Politics of Memory and Forgetting after Auschwitz and Apartheid." *Philosophy and Social Criticism* 25, no. 3: 1–28.

Felman, Soshana, and Dori Laub, M.D. (1992) *Testimony: Crises of Witnessing in Literature, Psychoanalysis, and History*. New York: Routledge.

Gordon, Lewis R. (1995) *Bad Faith and Antiblack Racism*. Atlantic Highlands: Humanities.

Heidegger, Martin (1953) *Einführung in die Metaphysik*. Tübingen.

Horkheimer, Max (1986 [1937]) "Traditional and Critical Theory." *Critical Theory*. New York: Continuum, 188–243.

Kierkegaard, Søren (1980) *The Sickness unto Death*. Trans. Howard and Edna Hong. Princeton: Princeton University Press.

Lanzmann, Claude (1985) *Shoah: An Oral History of the Holocaust*, the complete text of the film. Preface by Simone de Beauvoir. New York: Pantheon Books.

Leaman, George (1993) *Heidegger im Kontext: Gesamtüberblick zum NS-*

Engagement der Universitätsphilosophen. Hamburg: Argument-Verlag.

Lenhardt, Christian (1975) "Anamnestic Solidarity: The Proletariat and its *Manes.*" *Telos* 25: 133–55.

Maier, Charles S. (1997 [©1988]) *The Unmasterable Past: History, Holocaust, and German National Identity.* With a new Preface. Cambridge, Mass: Harvard University Press.

Marcuse, Herbert (1991 [©1964]) *One-Dimensional Man: Studies in the Ideology of Advanced Industrial Society.* With a new Introd. by Douglas Kellner. Boston: Beacon Press.

Matuštík, Martin Beck (1999) "Existence and the Communicatively Competent Self." *Philosophy and Social Criticism* 25, no. 3 (May): 93–120.

——— (forthcoming) *Jürgen Habermas: A Philosophical-Political Profile.* Lanham: Rowman and Littlefield.

——— (1993) *Postnational Identity: Critical Theory and Existential Philosophy in Habermas, Kierkegaard, and Havel.* New York: Guilford Press.

——— (1998) *Specters of Liberation: Great Refusals in the New World Order.* New York: State University of New York Press.

Metz, Johann Baptist (1989) "Anamnetische Vernunft. Anmerkungen eines Theologen zur Krise der Geisteswissenschaften." In Axel Honneth, Thomas McCarthy, Claus Offe und Albrecht Wellmer, eds., *Zwischenbetrachtungen: Im Prozeß der Aufklärung.* Frankfurt: Suhrkamp, 1989, 733–38.

Mitscherlich, Alexander and Margarete (1975) *The Inability to Mourn: Principles of Collective Behavior.* Trans. Beverley R. Placzek. New York: Grove Press.

Pensky, Max (1989) "On the Use and Abuse of Memory: Habermas, 'Anamnestic Solidarity', and the *Historikerstreit.*" *Philosophy and Social Criticism* 15, no. 4: 351–80.

——— (1999) "Jürgen Habermas and the Antinomies of the Intellectual." In Dews (1999: 211–37).

Peukert, Helmut (1986 [©1984]) *Science, Action, and Fundamental Theology: Towards a Theology of Communicative Action.* Trans. James Bohman. Cambridge, Mass.: MIT Press.

Santo, Olga (Binetter) (1996) Interviewed by Erica Turek, video, *Survivors of the Shoah: Visual History Foundation,* founder Steven Spielberg (Sydney, 23 February).

Sartre, Jean-Paul (1995) *Anti-Semite and Jew.* Preface by Michael Walzer. New York: Schocken Books.

Smith, Gary, ed. (1989) *Benjamin: Philosophy, Aeshetics, History.* Chicago: Chicago University Press.

Tiedemann, Rolf (1989) "Historical Materialism or Political Messianism? An Interpretation of the Theses 'On the Concept of History'." In Smith (1989: 175–209).

18

Scott Bartlett

Discursive Democracy and a Democratic Way of Life

"Did you suppose democracy was only for elections, for politics and for a party name? I say democracy is only of use there that it may pass on and come to its flower and fruit in manners, in the highest form of interaction between men, and their beliefs—in religion, literature, colleges, schools—democracy in all public and private life."

Walt Whitman, *Democratic Vistas*

It would be surprising, given his background in Critical Theory, if Jürgen Habermas did not intend his discourse theory to be used as democratic theory. The early hopes of Critical Theory were tied to the belief that society could achieve a democratic way of life. Habermas shares this belief, and has recently made this connection between discourse theory and democratic theory explicit in *Between Facts and Norms*. The scope and depth of this book is, like much of his work, impressive, but as I read it with hopes of finding a means to reinvigorate modern democracy I'm left with the feeling that we are getting only half of the story. If it is true that we can identify Professor Habermas's general orientation as proceduralism, with the opposing civic-republican or communitarian tradition as its foil, then we should expect that a discursive democracy would be weighted toward an elaboration of rights. That is, the institutionalization of certain human rights through the medium of law, argues Habermas, becomes the proper domain of discourse theory in societies that are becoming more complex and pluralistic.

To Habermas's credit he does not advocate a purely neutral procedure to settle moral or political problems. Although impartiality plays a central role

in discourse theory, it is realized through human discourse with all its vagaries and permeability. He writes in *Between Facts and Norms*, "In short, the ideal procedure of deliberation and decision making presupposes as its bearer an association that agrees to regulate the conditions of its common life *impartially*. What brings legal consociates together is, *in the final analysis*, the linguistic bond that holds together each communication community."[1] I will briefly describe how Habermas converts his discourse ethics into democratic theory while keeping the following question in mind. Does his discursive, procedural democracy offer the theoretical support for a vital and cooperative society?

Habermas's goal in his translation of discourse theory into political theory is to institutionalize practical discourses by employing forms of communication that promise that all outcomes reached by the procedure are reasonable. He draws on John Dewey for support for this assertion. He quotes from Dewey's *The Public and Its Problems*, "Majority rule, just as majority rule, is as foolish as its critics charge it with being. But it never is merely majority rule. . . . The means by which a majority comes to be a majority is the more important thing: antecedent debates, modification of views to meet the opinions of minorities. . . . The essential need, in other words, is the improvement of the methods and conditions of debate, discussion and persuasion."[2] Habermas concludes that the discursive level of public inquiry constitutes its most important variable. This conclusion may place discourse theory close to Dewey's instrumentalism, an instrumentalism that recognizes language as the "tool of tools." What Habermas does with this conclusion is, however, quite different from Dewey's approach.

In an analysis of the means by which a majority comes to constitute itself as a majority I shall discuss several elements of Habermas's discourse theory of democracy. Habermas is adamant that discourse theory is not a full-blown neutrality thesis, even though the moral point of view requires impartiality. Since it is not fixated on producing a clearly delimited division of the private and public spheres, for example, discourse theory deviates from traditional liberalism. However, as James Bohman points out, Habermas's discursive democracy must split into formal and informal spheres of public reason. This dualist view of democracy will enable Habermas to argue that political theory can include a robust normativity while maintaining connections with socially descriptive theories. Finally, I will discuss how consensus operates as the criterion that ensures the legitimacy of the legal order.

Regarding moral theory, Habermas is clear that the moral point of view requires a strong commitment to impartiality. "If we do not want to settle questions concerning the normative regulation of our everyday coexistence by open or covert force—by coercion, influence, or the power of the stronger interest—but by the unforced conviction of a rationally motivated agreement,

then we must concentrate on those questions that are amenable to impartial judgement. . . . We must ask what is *equally good for all*."[3] The impartiality required by discourse theory is an underlying assumption of any practical discourse.

When a society becomes highly pluralistic and complex, much more than traditional face-to-face interactions are required to promote cooperation. On the local level, moral norms serve as the cohesive bond. By shifting from what is good for individuals to what is good for all practical reason obtains a certain level of intersubjectivity. Morality becomes effective beyond the local level, claims Habermas, by being translated into the medium of law. This translation secures a wider intersubjectivity, and thus can provide the justification of legitimate lawmaking.

The discourse principle can supposedly secure the legitimacy of any norm in a discursive process. As a *democratic* principle it aims at securing a procedure for legitimate lawmaking in a particular society. "Specifically, the democratic principle states that only those statutes may claim legitimacy that can meet with the assent of all citizens in a discursive process of legislation that in turn has been legally constituted."[4] This principle has more meat on it than the generic discourse principle. There is a specificity: it involves an association of people in a specified legal community. There is also self-determination: free and equal persons come together of their own accord. Because of this specificity the democratic principle "lies at *another level* than the moral principle."[5]

The "level" of the democratic principle is an institutional one. It presupposes the validity of moral norms which hold true regardless of a specific political context. If moral norms cannot be discursively redeemed, then legal norms cannot be either. Since Habermas is no moral skeptic, he holds open the possibility that legal norms can also be legitimated. The democratic principle specifies how opinion and will-formation can be institutionalized through a system of rights. This system of rights should secure the effective participation of all citizens in the political process. It should, "contain precisely the basic rights that citizens must mutually grant one another if they want to legitimately regulate their life in common by means of positive law."[6] These rights constitute the conditions for the possibility of a legitimate democracy.

A system of rights embodied in legal and political institutions is necessary, claims Habermas, in order to deal with the pluralism and social complexity of modern democracies. These institutions compensate for the cognitive indeterminacy, the motivational insecurity, and the limited coordinating power of moral norms and informal norms of action in general."[7] The political sphere is incomplete without extra-communicative institutional channels. The informal public sphere must, as Bohman puts it, secure uptake into formal forms of political mediation.[8] More pointedly,

public interests must be taken up in the context of liberal constitutionalism and its institutions, which establish a system of basic human rights. Habermas writes, "A constitution-making practice requires more than just a discourse principle by which citizens can judge whether the law they enact is legitimate. Rather, the very forms of communication that are supposed to make it possible to form a rational political will through discourse need to be legally institutionalized themselves."[9] Law is the institution that supplements the discourse principle.

A system of basic human rights constitutes and regulates the lawmaking process. Through the rights that Habermas enumerates the legitimate genesis of law can be democratically secured. These rights are not justified in the manner of traditional liberalism. That is, human rights are intersubjectively created through law as an institution. They are not the properties of atomistic individuals.

Rights, according to Habermas, are intersubjective elements of a legal order based on mutual recognition and self-legislation. Rights of due legal process, negative liberties, and rights of membership guarantee both private autonomy and rights to political participation. They ensure that law "preserves its connection with the socially integrative force of communicative action."[10] Habermas does not, however, overstate the role that such rights should play. These rights enable democratic problem solving, but they do not settle these conflicts. They are necessary conditions for equality and participation, or what Habermas calls the conditions for "mutual recognition." Rights are formally transmitted by the medium of law: "For law is a medium through which the structures of mutual recognition already familiar from simple interactions and quasi-natural solidarities can be transmitted. . . ."[11]

Habermas's presentation of these rights moves from the abstract to the concrete. There are three categories of rights that supposedly generate the legal code by defining the status of legal persons. (1) Basic rights that result from the politically autonomous elaboration of the right to the greatest possible measure of equal individual liberties. These rights necessarily require the following corollaries: (2) Basic rights that result from the politically autonomous elaboration of the status of a member in a voluntary association of consociates under law. (3) Basic rights that result immediately from the "actionability" of rights and from the politically autonomous elaboration of individual legal protection.

When the discourse principle is brought to bear on social norms, the basic right to equal liberties emerges. "Only by bringing in the discourse principle can one show that *each person* is owed a right to the greatest possible measure of *equal* liberties that are mutually compatible."[12] In short, the discourse principle states the classical liberal position that each person

should be entitled to as much freedom as possible given that this freedom does not infringe on the freedom of another. This first category of basic rights guarantees private autonomy.

Habermas is careful, however, to place his discourse principle on a "higher level" than the traditional liberal public/private distinction. Traditional liberalism attempts to carve out separate spheres for the private pursuit of "happiness" and the public's need to regulate behavior that infringes on the rights of others. The consequence of this delimiting of spheres is that private matters remain off limits to legal regulation. Contemporary theorists have put this distinction in the form of the distinction between ethical matters, which roughly correspond to the values within the private sphere, and questions of justice, where the legal order must remain neutral toward these ethical matters.

According to Habermas, the discourse required in *any* common deliberation requires impartiality. To achieve consensus, discourses must be guided by an ideal of impartiality. This regulative ideal gives reasons their consensus-producing force. He sees a significant difference between the impartial character of consensus and the more "strategic" nature of compromise. "Whereas parties can agree to a negotiated compromise for different reasons, the consensus brought about through argument must rest on identical reasons that are able to convince the parties in the same way."[13] According to Habermas those citizens who hold positions that do not gain acceptance give their conditional agreement until they can convince the majority of the truth of their particular view. And this should be done based on identical reasons.

From the standpoint of Dewey's experimental democracy this convergence of perspectives may be too demanding. Habermas, like Rawls, demands that citizens converge in the long run on the same reasons rather than agree for different reasons. This may explain why Habermas's interest in the pragmatic tradition is flavored more by Peirce than by Dewey. The hopeful convergence of perspectives can be a powerful ideal, but if reified as the sole criterion of political legitimacy we can be left confused and deflated when dissensus remains. In deeply rooted conflicts continued cooperation should be our primary concern.

Habermas's three categories are intended to secure the equal standing of all participants in a common enterprise of constructing a legal order. In many ways these three categories carve out a prepolitical sphere of free and equal persons reminiscent of state of nature theories. Habermas argues, however, that these categories should not be understood as "*Abwehrrechte*, that is, liberal rights against the state, because they only regulate the relationships among freely associated citizens prior to any legally organized state authority. . . . "[14] Leaving aside the issue of whether or not this is

simply another way to voice a state of nature theory, it is obvious that Habermas is moving from the abstract to the yet to be seen concrete.

In the final analysis this abstract starting point may not prove to be a liability. It seems, however, that an inquiry such as Habermas undertakes in *Between Facts and Norms* reverses the order of an experimental democracy. That is, an inquiry into legitimate democracy should begin in concrete problematic situations where these actual conditions point toward the methods of cooperative problem solving. Habermas may spend too much effort in solving wholesale problems due to the abstractness of his starting point.

The reason Habermas can claim to do justice to both popular sovereignty and impartiality is that he has a dualist view of democracy. Habermas believes, along with his Critical Theorist predecessors, that democratic theory must be both normative and sociologically descriptive. Purely normative theories, such as Rawls's theory of justice, are, he claims, "sociologically naive." They downplay the persistent inequalities and plural values in society. These blind spots in Rawls's theory of justice leave him open to feminist criticisms, for example. On the other hand, purely descriptive sociology, such as Luhmann's systems theory, can be overly technocratic.[15]

Habermas realizes that discourse theory may overly idealize the necessary conditions and procedures for decision-making processes in all institutions. The discourse principle is, indeed, idealistic in its structural demands. Through the discourse principle's moment of idealization, communication under ideal conditions, Habermas claims to be able to separate the normative from the descriptive. Thus he is careful to claim that the discourse principle is properly suited for "formal" political channels. By formal he means such established institutional paths as legislatures and courts. The fear that these formal procedures will be too strict, and thus sociologically naive, must be kept in mind with the fear that democratic theory can be overly descriptive, and often skeptical.[16]

Habermas tries to keep both of these balls, the normative and the descriptive, in the air at once. Legitimate law must be analyzed both as a "system of knowledge," as sets of public norms, and as a "system of action," or set of institutions embedded in social contexts. This is his two-track or dualist account of democracy. Institutionalized procedures must follow two tracks. They must be open to inputs from an informal public sphere, and, at the same time, be structured to provide reasonable discursive criteria. Pluralistic societies push and pull at the limits of these two tracks. Ideally, some level of face-to-face interaction can be preserved in such contexts and can make their way into more formally institutionalized decision-making bodies.[17]

Which should be the focus of discourse theory's inquiry into democratic legitimacy: formal or informal forms of deliberation? If one takes a more pessimistic stance toward the plural and complex (even colonized) society, then perhaps formal channels of deliberation should be the focus of democratic theory. Perhaps society is too large and complex to foster effective participation in any direct way. This expression of democratic skepticism is at the center of arguments for the uncoupling of the legal and the ethical, for example. It plays this role for Habermas in that discourse theory seems better suited to formal bodies such as courts and legislatures than to the informal sphere of morality. If this position is accepted, then political deliberation should be the domain of representatives and judges, not the public at large.

Conversely, if one underestimates the pluralism and complexity of society, then public deliberation should be located primarily in the informal channels of the public sphere. For example, in fundamentalist Muslim societies there is a built-in consensus on the core values of the culture. The formal political bodies of such fundamentalist governments simply mirror the homogeneity of the culture, and in turn reinforce that homogeneity. These two positions become caricatures in their extreme forms. It is hard to find proponents of either complete democratic rule, that is, non-representative forms of democracy, or a completely representational democracy that ignores the wishes of the people. A third way appears more reasonable. The false choice between formal, representative democracy and informal democratic deliberation must be avoided in search of a way to bring participatory citizenship more fully into democratic institutions.

For Habermas, the third way means that legislatures provide the institutional channel for the broad, scattered, or "subjectless" communication that is scattered across the public sphere. The public communication that is necessary for a discursive democracy is so scattered that it is, in Habermas's words, "subjectless" or "anonymous." "The self of the self-organizing legal community disappears in the subjectless forms of communication that regulate the flow of discursive opinion-and-will formation in such a way that their fallible results enjoy the presumption of being reasonable."[18] Thus, "Parliamentary bodies should work within the parameters of what, in some sense, is a 'subjectless' public opinion, which naturally cannot form in a vacuum but only against the background of a liberal political culture."[19] The anonymity that is required for Habermas's informal public sphere will be attacked by communitarian critics who think that this anonymity cannot function as a democratic community.

The solidarity that is the product of discourse theory is, then, mediated through a common recognition of the terms of fair discourse. It is not the immediate solidarity of a shared identity, although it is, argues Habermas,

the only source of solidarity available in pluralistic societies.

> Discourse theory reckons with the higher-level intersubjectivity of processes of reaching understanding that take place through democratic procedures or in the communicative network of public spheres. . . . The normative implications are obvious: the socially integrating force of solidarity, which can no longer be drawn solely from sources of communicative action, must develop through widely diversified and more or less democratic opinion- and will-formation institutionalized within a constitutional framework.[20]

The size and complexity of modern society means that there will be a host of often unconnected discourses in which many groups arrive at partial glimpses of truth. Dewey variously described these publics as "inchoate," "amorphous," and "unarticulated." But whereas Dewey saw this plurality as the context for a more fervent attempt at coordination and cooperation among actual publics, Habermas chooses to view it as a diffuse network of discourses with "validity spheres" that correspond to specific forms of argumentation, such as morality, efficiency, or interest positions. This potential pool of reasons is "anonymous" since it is not located in any particular person or group. It is the network of reasons in communication itself that gives this subjectless public its existence. But, we might ask, aren't reasons usually convincing when they are "somebody's" reasons? This "phantom public" doesn't seem to be able to operate as a societal community.[21]

In both the informal and formal spheres the idea is to foster processes of communication and to design institutional procedures that at least make it more likely that political decisions will be based on reasons that would correspond to those that would emerge from a discourse under ideal conditions. Although Habermas believes that these discourses should remain "underspecified," their function is to promote interchange between publics and institutions. They should create channels of public influence.

The creation of channels of public influence that flow from the informal to the formal spheres is indeed valuable. However, too strong a separation of public opinion and formal institutions may undermine the most valuable component of democracies, namely participatory self-rule. The participation that is required in democracies must be motivated by the shared value of intelligent inquiry that relies on democratic cooperation.

Deliberations in formal legislative contexts are not always reasoned debates. Compromises and bargaining constitute much of legislative activity since legislative bodies are almost as pluralistic as society itself, and since much of this activity takes place with tight time constraints. Given this, it seems counterproductive to set the standard of consent too high. Diverse and potentially conflicting cultural self-understandings do not often admit of convergence toward consensus. Such value conflicts cannot always be

ignored or impartially resolved, especially if disagreements persist in the very articulation of the problem. Habermas's discourse theory may underestimate the meliorative potential of cooperative compromise.

The "proceduralized reason" that discourse theory provides sets the standard for political communication. Is this standard too high, however? Discourse theory is committed to consensus as a regulative ideal of political communication. As Habermas sees it, human communication is based on an implicit commitment to an ideal speech situation which serves as the constitutive condition of rational speech. Consequently, this serves as the normative foundation of agreement. The ideal speech situation is one in which all the parties involved are committed to a search for consensus. He views the commitment to a search for consensus as an integral, constitutive component of the communicative aspirations inherent in human reason.

Unsurprisingly, political debates deviate from the deliberative ideals of discourse theory. Discursive democracy, as Habermas articulates it, can expose the irrationality of public communication, but it cannot, as a procedure, explain why various publics either continue to cooperate or cut their cooperation short.[22]

Darryl Gunson and Chik Collins utilize Habermas's discourse theory as a means to test whether actual political deliberations ever achieve a genuine consensus. They believe that discourse theory is a natural tool for analysis due to the cooperative language of understanding, discussion, participation, and consensus that typifies Habermas's approach. They use discourse theory to see if particular individual interests can be converted into a general interest. In Gunson and Collins's language, the realization of a "rational" or "emancipated" society involves the transition from the *I* or *Us* to the *We*. They agree with Habermas in that processes of public input must be created so that deliberators within the framework of administrative institutions are compelled to take diverse perspectives into account as they constantly revise their basic framework for decision making. The problem is to develop relations of trust between administrators and the public. This problem was acutely evident in the case of the Ferguslie Park housing partnership near Glasgow, Scotland.

Ferguslie Park is a local authority owned and managed housing estate consisting of around 5,500 tenants. The families in Ferguslie Park are for the most part unskilled manual laborers and those on some sort of governmental assistance. There arose, subsequently, a view of these people as shiftless and dangerous. This stigma has only intensified and has led to something akin to the phenomena that is currently taking place in American cities, urban flight. The ability of the people of Ferguslie Park to better their economic situation has been gradually eroded due to the shrinking opportunities for revitalization.

Steps were taken to correct for this decay. A group of Scottish Office

civil servants met with the Ferguslie League of Action Groups (FLAG), a group of tenant leaders, to form a partnership "to address the problems of Ferguslie Park once and for all."[23] With a partnership model as their guide they sought to work together toward consensually agreed upon objectives. Importantly, the tenants themselves were to play the central role in this process.

Gunson and Collins tell us that the tenants had some serious misgivings about this partnership. They did not trust either the motives or the process that was offered them due to the checkered past of the other experiments that had previously been tried. This was, as the residents were keenly aware, the same government that had implemented the cruel poll tax, and that was blamed for the continued poverty of the region. They were also wary of the claim that this partnership would eliminate the inequalities that had been so stark in the history of the estate. They were skeptical of yet another procedure with claims of bringing about a just solution to their problems. Gunson and Collins evaluated the initial steps, the subsequent problems, and the final breakdown of the partnership.

What actually happened with the partnership undermined the residents' hope that any type of true consensus could be reached. A couple of years after the partnership was formed several members of FLAG approached Chik Collins to voice concerns over the breakdown of the partnership model. The FLAG members realized that instead of a cooperative effort to solve the problems of the community, the partnership was one-sided and top-heavy. The officials from the Scottish Office ignored the concerns of the residents, treated them as if they were stupid, and often barred residents from participating or even attending meetings. It seemed as if the initial hopes of a true partnership were falling under the weight of another paternalistic agency.

Gunson and Collins argue that the initial hope of a partnership was akin to the hope for an ideal speech situation. That is, the open and democratic language of a partnership seemed likely to the participants to produce a just outcome. The ideal speech situation, as a regulative ideal, can be used to test whether or not an actual deliberation is focused on a just and inclusive outcome. When deliberations fall short of Habermas's rather strict and demanding criteria, which they always do, the question is then how should we analyze the failure to meet the demands of an ideal speech situation. Gunson and Collins refer to this as "measuring the gap." Discourse theory sets standards that enable participants to measure the degree to which actual deliberations fall short. This measuring of the gap seems to be a valuable tool of analysis in that it forces deliberators to view their deliberations in the light of high standards of rationality. It can make the more powerful party face up to the problems that are made visible by the ideal speech situation.

The problems that the Ferguslie Park Partnership encountered called for

something more than just measuring the gap. Indeed, most deliberations call for more than this minimal level of procedural analysis. That is, not only should discourse theory enable us to measure the gap, but it should also allow us to explain the gap. Gunson and Collins believe that for discourse theory to be an effective democratic tool it must not only give procedural criteria of rationality but should also take the identities of the participants into account. "It is vital to focus on the social identities of the speakers in any situation because these have crucial implications for their freedom to use language."[24] A procedure, no matter how rational, cannot itself generate legitimate democratic practices. Who the participants are and the contexts in which they deliberate must also be a part of democratic theory if a mere de facto democracy is to be avoided.

In the remaining pages I will describe Dewey's political theory as an alternative to Habermas's proceduralism. Dewey believed that democracy could be both a procedure and a living embodiment of a particular community's identity and higher aspirations. He believed that democracy could become a living expression of a reflective and cooperative way of life. To be sure, the achievement of this goal requires intelligent procedures that are employed in formalized inquiries. But a democratic way of life relies on more than formalized methods of problem solving. This is the insight that is articulated by contemporary communitarians such as Charles Taylor.

Dewey shares with the communitarians a commitment to the active participation of all members of society in the political process. According to Taylor, participation in the political life of the community is constitutive of the identity of its members. In Dewey's language, democracy should be more of a way of life than a form of government. For Dewey, however, not only is participation in the political sphere necessary for a strong democracy, but participation in various non-political spheres as well. The main task for a democratic society is the promotion of cooperation across many publics.

Dewey also shares with communitarians the belief that specific social goods should not be excluded from public deliberation. For Habermas, specific values and self-understandings, while important, are not the proper topics of public deliberation given the fact that they do not lend themselves to the impartiality demands of discourse theory. They do not offer the hope that they can be regulated normatively. This leads Hans Joas to remark, "Consequently, interaction that is not normatively regulated, or is so only slightly, is lacking in Habermas's typology."[25] For Dewey, these values serve to animate the public and set the goals of public inquiry. Self-understandings and value commitments provide necessary motivation for a democratic way of life. At the same time, however, Dewey does not lift specific self-understandings of a particular group out of the public contestation of norms and hold them up as more valuable than others prior to inquiry. Taylor seems to have a particular set of values in mind when he

calls for their inclusion. This is an uneasy fit for a pluralistic democracy. Rather than attempting to identify more singular sources of value, Dewey's view sees a pluralism of different value orientations as an advantage for a cooperative and experimental democracy.

Dewey concluded his *The Public and Its Problems* by saying that, "Till the Great Society is converted into a Great Community, the Public will remain in eclipse."[26] This conversion will rely on wider and more vigorous cooperation. Taylor makes a similar point when he worries about the ever growing fragmentation of society. Sounding much like Bloom and Bellah, he writes, "Fragmentation arises when people come to see themselves more and more atomistically, as less and less bound to their fellow citizens in common projects and allegiances."[27] This fragmentation shows itself by fostering narrow identifications with single issue politics, by breaking down more inclusive ties among citizens, and, ultimately, in an apathetic citizenry.

Dewey argued that the cultivation of cooperative habits cannot be achieved by viewing democracy as simply a form of government. A democratic way of life begins in the earliest years of individual growth, and is strengthened by schools that promote cooperation and concern for societal problems. This is why Dewey's democratic theory cannot be separated from his educational theory. A purely formal education, in which Dewey saw a lingering class prejudice against all things "practical," misses the democratic possibilities inherent in cooperative and experimental learning. Social life is transformed when all citizens participate in the determination of the ends and goals of society.

> A society which makes provision for participation in its good of all its members on equal terms and which secures flexible readjustment of its institutions through interaction of the different forms of associated life is in so far democratic. Such a society must have a type of education which gives individuals a personal interest in social relationships and control, and the habits of mind which secure social changes without introducing disorder.[28]

The willingness to let intelligence guide our cooperative efforts to secure individual growth is an ethical or moral act. To be committed to this end is to engage in the moral life of the community. In this regard liberalism cannot be governed by the neutralist thesis. Those ends that promote individual growth should be pursued, and those that hinder this growth should not. Axel Honneth has pointed to this aspect of Dewey's political theory and has argued that this puts Dewey, at least the young Dewey, in the tradition of Aristotle and Rousseau.[29] The teleological pursuit of human growth or flourishing, Aristotle's *eudaimonia*, is an ethical project that eschews the classical liberal commitment to neutrality. Political theorists who rely on a negative type of freedom miss this participatory component.

Dewey links negative freedom with the positive pursuit of those ends that promote individual and societal growth.

Although the goal of our participation in the public sphere is the development of individual growth, the activity itself is not carried forward individually. There is a collective dimension to our individual freedom. Our freedom depends on the participation of as many citizens as possible working together to solve social problems. Dewey does not, however, argue that there exists or should exist a single community which embodies all the social interests of the individual citizens. Instead, there are a variety of publics that are constituted by different interests. In a pluralistic society there are many groups, and participation in these various groups constitutes a social and individual good.

One worry concerning the positivity of Dewey's view that government should take an active role in securing the individuality of its citizens is that the state might paternalistically impose a certain set of values. What makes the atomist position appealing is that it operates on the premise that each individual knows for herself what is in her own interest, and the government has no right to impose on this autonomy. Dewey sees the value in this negative account, but he links it to positive freedom. He knows that the state cannot and should not force someone to be free. Genuine freedom, genuine autonomy, must issue from a citizen's own choice. But there is a real fear that government may not promote the right values. What if certain laws are passed, for instance, that issue from and favor only a few of the most powerful special interest groups?

Communitarians often worry about coercive state action. This dark side of Rousseau can reveal an excessive republicanism. This is why Dewey does not simply replace the negative view with the positive. Instead he joins the two. The negative view is valuable for merely instrumental reasons. That is, protections for individual freedoms can be codified in a bill of rights. These rights, as usually perceived, are legal protections against intrusions from the state. As an instrument for our individual security, these legal protections are crucial. We run into trouble, however, when we equate these legal guarantees with freedom in its richer sense. Legal freedoms may be necessary conditions for individual growth, but they are not sufficient. This is why a liberalism that relies on atomistic premises, or as Habermas's theory suggests, retreats into the legal sphere, cannot promote freedom in its fuller sense.

One of the consequences of relying too heavily on negative freedom in the form of legal guarantees is that democracy becomes a legal affair. More social problems come to be decided by judicial review instead of legislative channels. This can be a good thing, especially if the society is not living up to its constitutional responsibilities. The judicially forced integration of

public schools in the South that resulted from *Brown v. Board of Education* brought about social conditions that may not otherwise have occurred, or at least would have taken much longer. In societies that rely more on legislative action, for instance, Canada, this reliance on judicial review can seem undemocratic by channeling political action into efforts to get judges on the bench that will interpret the constitution the way the executive branch desires. *Roe v. Wade* is perhaps the most famous case in which legislative efforts are bypassed by judicial action.

This shift of democratic energy to the legal sphere tends to make political decisions a winner-takes-all proposition. The messy world of political action is more often characterized by compromise and the building of broad and often divergent coalitions. The recent protests against the World Trade Organization and the World Bank, for instance, involved such strange bedfellows as the Sierra Club and Pat Buchanan. When political decisions are couched in the language of rights, compromises are hard to come by. Habermas's more restrictive model seems more at home in situations in which decisions are made by either saying yes or no to specific human rights. When an even more emotional conflict such as the abortion debate is viewed as a battle between the rights of the fetus versus the rights of the mother there is no wiggle room left for compromise.

What this reliance on judicial action also means is that democratic participation becomes more fixated on single issue politics. Single issues can often be the impetus to political participation. This can be valuable. The abortion issue has served to animate some citizens who might not otherwise have gotten involved with politics. For example, the Christian Right has mobilized many churchgoers to vote for candidates who support a pro-life agenda. The problem is, however, that the problems of society as a whole are not addressed by such single issue fixations. This feeds the fragmented atomism that worries Taylor. Cooperative action among differing groups is replaced by turf battles. Identification with all citizens in a common project is substituted for identification with an ethnic group, a religious group, or an economic class. When these groups' individual agendas are not realized, the tendency is to give up.

For Taylor, the way to avoid this fragmented political culture is to uncover the source of our common commitments. He claims, but does not provide an argument, that the Judeo-Christian tradition provides such a source. Taylor realizes that a vital democracy requires hope in our better possibilities. But, it seems to me, this hope should not be tied to a particular religion since that would exclude a great majority of citizens in our pluralistic society. Instead we should look to more expansive and inclusive sources for our democratic faith. We do not forfeit our ideals when we cooperatively work together to actualize our better possibilities. As Dewey wrote in *A Common Faith*, "All possibilities, as possibilities, are ideal in

character. The artist, scientist, citizen, parent, as far as they are actuated by the spirit of their callings, are controlled by the unseen. For all endeavor for the better is moved by faith in what is possible, not by adherence to the actual."[30]

Taylor seems to think that a purely secular description of social cooperation denies the motivational role of our higher aspirations, and thus dispatches with the good altogether. But there are two erroneous assumptions at work here. The first is that a secular account of social cooperation necessarily entails an avoidance of high ideals. Dewey's social activism is an obvious example of how high ideals can flow from secular sources. And the second is that one religious tradition contains our only hope of realizing these ideals.

To his credit, Dewey viewed democratic opinion- and will-formation as the mere fact of social cooperation. This cooperation can be cut short when religious motivations are translated into political justifications. Social action in the name of religion can result in the type of fragmentation that so worries Taylor. Further, it takes quite a bit of historical selectivity to argue that secular motivations are anemic when compared with those of religion. According to Dewey, organized religion has not been the spearhead of social justice, but has lagged behind. More often than not it has concerned itself with moral symptoms, such as unmarried mothers or media violence, than with broader social challenges like poverty and institutionalized racism. These issues require the cooperation of a myriad of publics that constitute civil society. This does not mean that religious sources are denied or disparaged, but that they must serve as sources of cooperation in a broader secular culture.

In many ways Dewey can be viewed as an advocate of procedural liberalism as well. The solution to societal problems will depend upon intelligent procedures. Experimentation and cooperation rely upon the constant use of intelligence in the public sphere. Where Dewey diverges from Habermas's proceduralism is in his insistence that democracy is a form of life that extends beyond the narrowly defined political sphere. Habits of societal cooperation must first become part of the everyday lives of citizens before our institutions can embody democratic practices. Habermas eschews this almost patently obvious component of democracy because he wishes to avoid the problems associated with the republican thesis, but Dewey shows us why he does not have to do this. The normative component of democracy is characterized by the shared practice of cooperating intelligently with people who share varying ethical outlooks, but at the same time are committed to the jointly shared good of continued cooperation. The demands of discourse theory do not exhaust this normative practice.

Habermas worries that Taylor assumes too much singularity in the public sphere. As a result, communitarians view the political and legal spheres as

concrete expressions of a society's identity. The theoretical task is then to "persuade us of the preeminent importance of the orientation to the good; it should *sensitize* us to the hidden dimension of the good and infuse us with the strength for passionate engagement in the cause of the good."[31] According to Habermas, however, this task is too difficult for a postmetaphysical philosophy that must operate in pluralistic and complex societies.

Dewey would accept Habermas's reservations, and would emphasize intelligent procedures of public problem-solving. He would not, however, jettison the project of reconstructing a democratic value community. Habermas's theory of democracy downplays the role of these values in order to preserve his discursive ideal. Dewey, by contrast, links both democratic procedures and democratic values. The concerns of both Habermas and Taylor are contained in Dewey's conception of democracy. As Honneth writes, "Because Dewey wishes to understand democracy as a reflexive form of community cooperation, he is able to bring together the two opposing positions of current democratic theory."[32]

By augmenting his earlier democratic theory, as expressed in his essay "The Ethics of Democracy," that stressed the voluntary cooperation of a democratic value community, with experimental methods of problem-solving, Dewey could see that democracy must be both a shared idea of the good and a rational procedure. Honneth puts his finger on the point of contact between these two poles. This synthesis of the ideas of communitarianism and proceduralism is made with Dewey's use of the "public." In *The Public and its Problems* Dewey defined the public as "all those who are affected by the indirect consequences of transactions to such an extent that it is deemed necessary to have those consequences systematically cared for."[33] Larry Hickman sees in this idea of the public a means to functionally differentiate spheres of control. The private individual is unable to exercise control over public policy, whereas those individuals that can make up a public. The public allows the citizen a medium in which to join with other citizens for the purpose of democratically controlling their interaction.

Questions arise in complex and pluralistic societies, however, about the extent to which publics can democratically participate in the public sphere. Dewey was not so naive to assume that formal institutions would automatically follow the democratic will of the public. This is why he saw the necessity of a prepolitical commitment to democratic problem solving. The cooperative problem solving that is the hallmark of democracy must already be a part of the everyday practices of citizens. A democratic way of life begins in early education and is furthered by the expectation that democratic participation will be effective. In small townships where face-to-face meetings directly influence political activity citizens can see that democratic

participation leads somewhere. Dewey's Burlington was such an environment where town meetings operated as the democratic transmission belt. This type of immediacy is no longer common in situations where large and impersonal institutions are perceived as paternalistic surrogates for democratic participation. This is why democratic practices must become more widespread instead of the purview of more formal institutional channels. We need more democracy in politics, in civil society, in economics, and all other areas of public and private life.

By conceptualizing the democratic ethical community as a locus for cooperative social problem solving Dewey can avoid what Honneth calls an "overethicized republicanism." In response to what many contemporary theorists see as an erosion of public and private virtue there has been a call for a reexamination of classical virtues. This is part of what Taylor means by retrieval. Although Taylor is not so nostalgic to claim that those values articulated by Aristotle should be cut and pasted onto the contemporary scene, he does come close to those "rear-guard" proponents of historical virtues such as William Bennett. For communitarians, citizens are expected to develop specific political virtues which are essential to a democratic way of life. These virtues, which are thought of as ends-in-themselves, must be operative in each member of society, and require political participation as the means toward their realization. According to Dewey, organized intelligence is not a process of retrieval or the defense of established values. It is instead a formative process. "It must be the method not only of *maintaining* values . . . but of *obtaining* them."[34] Further, these values are not specifically political. Since humans are not only political agents but are also involved in many nonpolitical activities, the formation of democratic values must make use of those values as well. The democratic task becomes one of intelligently cooperating across these often divergent value orientations.

For Habermas an ethical understanding of democracy overtaxes the political practice of impartially regulating social life. Dewey's experimental democracy may even appear to Habermas as too ethical, too willing to let values into what he sees as an exclusively discursive practice. Instead of viewing democracy as a form of communal cooperation, as Dewey does, Habermas grounds democracy in intersubjective speech, a far more restrictive practice. The linguistic bond which takes place in intersubjective speech provides the only source of democratic solidarity.

Recall as well that for Habermas communication in the public sphere is so scattered that it is "anonymous." This will mean that political institutions become the locus of democratic life. The informal, prepolitical, sphere is so scattered that democratic procedures cannot gain a foothold. But, as Hickman has suggested, Habermas may ignore the level of cooperative inquiry that must take place *before* formal institutions can translate public

interests into public policy. That is, there must be a level of democratic problem solving in the prepolitical sphere that can lead to the expectation that formal political institutions will operate democratically as well.

Along the lines of American pragmatism, Habermas believes that political deliberation begins in problematic situations, and like the pragmatists, he realizes that free and open communication is required to solve social problems. The measure of these solutions, for Habermas, will be the extent to which they have been impartially discussed and the level of consensus that is subsequently reached. I have argued that Habermas demands too much from a discourse theory of democracy. Because democratic cooperation is what is at stake the demands of discourse theory, characterized as an ideal speech situation, seem to be too strong. A successful outcome of social and political deliberations should achieve some level of democratic agreement, but more importantly, it should allow for the continued cooperation of various publics in a shared endeavor to solve social problems.

If democracy is to be more than an institutional affair, if democratic practices are to find a place in the informal sphere of human relations, then democratic theory must include values and goods.[35] Taylor's criticisms of proceduralism suggest this inclusion. He realizes that democratic procedures lack the motivational power that value commitments provide. We participate in the public sphere when we are motivated by those things we care about, by our values. However, Taylor offers an overly selective account of our values. In pluralistic societies many sources are at work in which our higher social aspirations are expressed. In Dewey's writings we find an account that embraces the full range of democratic possibilities. If we want a participatory democracy, then we should embrace all possible sources of democratic participation. Democracy then, is more than a procedure and more than an expression of local values. "The clear consciousness of a communal life, in all its implications, constitutes the idea of democracy."[36]

SCOTT BARTLETT

PHILOSOPHY DEPARTMENT
SOUTHERN ILLINOIS UNIVERSITY AT CARBONDALE
JANUARY 2000

NOTES

1. Jürgen Habermas, *Between Facts and Norms* (Cambridge: MIT Press, 1996), p. 306.
2. Ibid., p. 304.

3. Habermas, "Morality, Society, and Ethics: An Interview with Torben Hviid Nielson," in *Justification and Application* (Cambridge: MIT Press, 1993), p. 151.

4. Habermas, *Between Facts and Norms*, p. 110.

5. Ibid.

6. Ibid., p. 118.

7. Ibid., p. 397.

8. See James Bohman, *Public Deliberation: Pluralism, Complexity, and Democracy* (Cambridge: MIT Press, 1996), pp. 58–59 for an explanation of this uptake.

9. Habermas, *Between Facts and Norms*, pp. 454–55.

10. Ibid., p. 111.

11. Ibid., p. 318.

12. Ibid., p. 123.

13. Ibid., p. 411.

14. Ibid., p. 122.

15. Bohman, *Public Deliberation*, p. 176.

16. The skepticism that Habermas wishes to avoid is primarily that of the systems theory of Luhmann. Other forms of skepticism include the theoretical retreat of Horkheimer and Adorno, as well as Walter Lippman's "phantom public."

17. Bohman, *Public Deliberation*, p. 176.

18. Habermas, *Between Facts and Norms*, p. 301.

19. Ibid., p. 184.

20. Ibid., p. 299.

21. Bohman, *Public Deliberation*, p. 178.

22. What is surprising when looking at the ways in which Habermas proposes to convince us that ongoing communication is necessary is his relative silence on educational theory. It seems that the early school years would be the perfect place in which to learn the values and practices of discourse theory.

23. Darryl Gunson and Chick Collins, "From the I to the We: Discourse Ethics, Identity, and the Pragmatics of Partnership in the West of Scotland," *Communication Theory* 7, no. 4 (1997): 280.

24. Ibid., p. 293.

25. Hans Joas, "The Unhappy Marriage of Hermeneutics and Functionalism," in *Communicative Action: Essays on Jürgen Habermas's The Theory of Communicative Action,* ed. Honneth and Joas. (Cambridge: Polity Press, 1991), p. 100.

26. John Dewey, *The Later Works*, vol. 2: *Essays, Reviews, Miscellany, and The Public and Its Problems*, ed. Jo Ann Boydston (Carbondale: Southern Illinois University Press, 1988), p. 324.

27. Charles Taylor, "Liberal Politics and the Liberal State," in *Philosophical Arguments* (Cambridge, Mass.: Harvard University Press, 1995), p. 282.

28. John Dewey, *The Middle Works*, vol. 9: *Democracy and Education*, ed. Jo Ann Boydston (Carbondale: Southern Illinois University Press, 1989), p. 105.

29. See "Democracy as Reflexive Cooperation: John Dewey and the Theory of Democracy Today," *Political Theory* 26, no. 6 (December 1998).

30. John Dewey, *The Later Works*, vol. 9: *Essays, Reviews, Miscellany, and A Common Faith*, ed. Jo Ann Boydston (Carbondale: Southern Illinois University Press, 1989), p. 17.

31. Habermas, "Remarks on Discourse Ethics," in *Justification and Application*, p. 75.

32. Axel Honneth, "Democracy as Reflexive Cooperation: John Dewey and the Theory of Democracy Today," p. 765.

33. Dewey, *The Later Works*, vol. 2, pp. 15–16.

34. Larry Hickman, "The 'Truth' About Truth and History," an unpublished manuscript, p. 3.

35. Judith Green has made this point much better than I in her recent book *Deep Democracy*. "Deeply understood, the democratic ideal is a normative guide for the development of diversity-respecting unity in habits of the heart that are shaped and corrected by reflective inquiry. Such ideal-guided democratic deepening of habits of the heart is a necessary concomitant to democratic institutional evolution within our increasingly globalized, highly vulnerable, shared social life." *Deep Democracy: Community, Diversity, and Transformation* (Lanham, Maryland: Rowman and Littlefield Publishers, Inc. 1999), p. ix.

36. Dewey, *The Later Works*, vol. 2, p. 328.

19

Max Oelschlaeger

Habermas in the "Wild, Wild West"

In her wonderful book, *Rodeo*, Elizabeth Lawrence argues that the western rodeo is a ritualistic re-enactment of the triumph of humanity and civilization over savage animals and hostile landscapes (Lawrence, 1984). Rodeos, unfortunately, have been professionalized and commercialized, as with virtually everything in liberal bourgeois society. What urbanites typically view are simulacra of the "thing in itself." Those who have not witnessed small town, western United States rodeos cannot know the richness and complexity of, let alone experience, the ritual. What the outsider lacks (and scholars, with their objectivity, are "outsiders") is a conscious awareness of how these events serve to create and maintain a sense of individual, community, and cultural order. For the participants and spectators—the vast majority of whom are residents of the nearby landscapes—rodeo maintains the logos of civilization against the chaos of wilderness.

By analogy (and I have neither hope nor pretense of offering a "knock-down argument"), I want to argue that Jürgen Habermas's theory of communicative rationality is, at least in the context of the wild, wild West (more on this to come) a simulacrum. Readers should understand that I am not a Habermasian antagonist. The conversation concerning communicative rationality, whether political theory or moral-political project, is headed in the right direction. But if there is to be any hope for good and sustainable living in the western United States, particularly the intermountain West (those eleven states east of the Cascades and Sierras, most of which straddle portions of the Colorado Plateau, and mostly comprised of public lands), then Habermasian theorists have to "get real," that is, *ground*[1] the theory of communicative rationality, so that it is no longer a simulacrum of political life, but rather becomes a chthonian and/or rhizomic narrative, invisibly but pervasively connecting inhabitants or dwellers who are also citizens with each other and the landscapes of inhabitation.[2]

Arguably, the theory of communicative rationality can be revised to facilitate the political work of building viable and sustainable western communities. Habermasian theory can enable a robust sense of solidarity that fosters the articulation of collective intentions and public values that play out into real policies and practices. However, as it stands, Habermasian theory (i) disconnects place and citizenship, so that the only grounds Habermas has for community life are either pre-existing individual commitments to the theory of communicative rationality (with its transcendental, foundational baggage) or a pre-existing discursive community that at least loosely subscribes to Habermasian process. However, I intend to argue, (ii) connecting citizens with place *grounds Habermas's political theory* in a way that makes it practical as well as ecologically efficacious.

At the risk of keenly observing the obvious, I note that in my western community of 55,000 souls there are probably ten people, or maybe a hundred, familiar with Habermas; so there are no pre-existing commitments —in Flagstaff, Arizona, or anywhere else in the intermountain West—that ground communicatively rational practice. And Habermasians committed to practice cannot defend the theory on the grounds that he speaks only of "ideal speech situations" or "universal linguistics." The political challenges for living are actual, here and now, not transcendental or ahistorical. But given that individuals can actually identify themselves as members of a "real" community by such characteristics as residence (what Wallace Stegner calls "stickers" and Heideggerians call "dwellers"), then the theory of communicative rationality can be normative. That is, a guide to rational political practice.

I. THE IMPORTANCE OF POLITICAL THEORY IN ENVIRONMENTAL CONTEXT

Academic philosophy has been subject to considerable, even intense, criticism in the last century or so. Charles Sanders Peirce catches one critical theme in the aphorism, "Do not block the path of inquiry" (Peirce, 1955, p. 54). More recently, the American pragmatist John Stuhr argues that "There is little life in most academic philosophy today" (Stuhr, 1997, p. 45). Clearly, he believes, as do many, that academic philosophy blocks the "path of inquiry," that is, the complicated, multidimensional processes through which cultures adapt to the exigencies of existence.

The large question entertained here is whether there is life, more specifically "political life," in Habermas's theory of communicative rationality. Does Habermas's political theory make a practical difference, that is, encourage communicative processes through which inquiry (broadly conceived) and thus adaptation might occur? Or is the theory of communicative rationality a meta-theory that, rather than opening the door of democratic

inquiry, actually closes it?[3] Does it help citizens engage the consequential environmental issues that threaten sustainable living in particular places?[4] More generally, does Habermas's theorizing succumb to the criticism of philosophy (specifically, Feuerbach) that Marx made, namely, being little more than speculation that changes nothing in the world?

Such questions concerning Habermas specifically and political theory more generally are vitally important to the future of Western civilization. That claim, of course, is huge. Many might disagree with such an assertion. Yet surely informed readers know that anthropogenic modification of natural systems and processes threatens multiple ecocatastrophes, such as irreversible climate change or an anthropogenic mass extinction of species or "virus X."[5] And surely informed readers know that adaptive responses to these complicated problems must in part be achieved through political processes. The most recent and comprehensive overview of the challenge to sustainability makes these points unequivocally and plausibly (Board on Sustainable Development, 1999). The science and technology that leads toward sustainability, while uncertain, is more than adequate to begin the reconstruction of society. The two primary challenges yet to be met are simultaneously normative, that is, what specific goals are to be pursued, and political, that is, marshaling "the political will to turn this knowledge and know-how into action" (Board on Sustainable Development, 1999, p. 7).

The centrality of politics to the timely resolution of environmental issues in the wild West is widely recognized. The Western Governor's Association[6] ENLIBRA initiative is based on the recognition that existing institutional and legal frameworks are inadequate to the policy challenges of moving toward sustainability in the western states. Similarly, the United Nations 1992 conference in Rio de Janeiro (U. N. Conference on Environment and Development) was based on the international recognition that existing legal and institutional frameworks are inadequate to tasks of environmental protection. While my focus here is on "Habermas in the Wild, Wild West," I note that John Dryzek believes that the international political stage offers better possibilities for discursive democracy than regions or nations (Dryzek, 1990).

My philosophical roots and commitments are primarily in American pragmatism rather than European philosophy. Pragmatism makes me impatient with theory that does not have (perhaps too obvious) potential for transforming the problematized contexts in which human beings live and move and have their being. I realize that Habermas has a pragmatic bent; so my criticism is perhaps best read as an attempt to make Habermasian theory (or at least the pragmatic strain of his work) more relevant to the discursive challenges of life in the intermountain West.

Pragmatism, as I read its texts, is a response by American intellectuals to the challenges posed by Darwin and other evolutionary theorists. One simple

way of understanding those challenges is through the recognition, beginning with Darwin's own observations, that insofar as we are uniquely human we are language animals. Darwin argues in *The Descent of Man* that the primary differences in the intellectual capacities of humans and our nearest kin are primarily attributable to our highly developed capacity for and use of language. Derek Bickerton (and many others) pushes this line of analysis to the conclusion that, in biophysical context, language has given us (i) the capacity to be good stewards of the earth, as well as (ii) to destroy other species and the biochemical and ecological processes upon which human survival depends (Bickerton, 1990). It is through language and only through language that we can transform our presently problematic relations with the earth.

Arguably, useful political theorizing must recognize our linguisticality as set in the context of environmental problem solving. "Politics" is crucial, since political process per se either facilitates or frustrates cultural transformation. Stated differently, in times of environmental exigency, theorizing the political process is more than idle speculation. It is crucial. Granted that Habermas acknowledges the centrality of language (or communicative process), and is thus potentially useful, the question entertained here is whether the theory of communicative rationality helps solve "environmental problems," that is, promotes desirable practical outcomes. Or is it part of the problem, that is, philosophical speculation that blocks the path of inquiry? Or is it also a theory that, if biophysically recontextualized, might facilitate adaptive response to environmental exigencies?

II. ECOPOLITICALLY CONTEXTUALIZING HABERMAS

Figure 1 below represents a continuum of ecopolitical theorizing. The right side ("right" does not equate with "conservative"; Paehlke is a liberal) denotes Robert Paehlke's theory of progressive politics. To adumbrate Paehlke's arguments, he maintains that the institutions of liberal democracy

Ophuls <------------------> Johnston <------------------> Paehlke

FIGURE 1

are adequate to formulating timely and efficacious policy responses to complex environmental problems. The combination of ecological sciences and the "greening" of public opinion are sufficient, he believes, to drive public policy in the direction of sustainability. Paehlke, at least implicitly,

also makes the point that adaptive response to environmental exigencies must begin by assuming the existing political-economy (Paehlke, 1988).

Contrary to Paehlke's argument, R. J. Johnston argues that the liberal democratic state privileges wealth and power in ways inimical to timely and efficacious responses to environmental problems (Johnston, 1989). Again, to adumbrate complex arguments, Johnston's basic premises are (i) that the first order of business for any civil society is to maintain its basic form, and (ii) that the basic form of liberal industrial states is incapable in principle of timely and efficacious response to environmental problems. Thus, given the present political economy of western states, putatively adaptive policy responses deal only with the overt symptoms of environmental malaise rather than underlying causes (such as petrochemical technologies that are inimical to life, energy technologies that generate massive amounts of pollution, population growth, and so on). Johnston, however, does not offer constructive proposals for the reform of liberal democratic institutions and policy making processes.

Enter William Ophuls, on the left side of the continuum ("left" does not equate with "liberal"), who does offer proposals for reconfiguring political institutions and processes. He argues that "we need a completely new political philosophy and set of political institutions" (Ophuls, 1992, p. 3). Further, and contrary to arguments like Paehlke's, he maintains that "politics must rest on an ecological foundation" (Ophuls, 1992, p. 8). Thus, the ecological sciences are not supplemental to the institutions and policy processes of liberal democratic states; rather, the institutions and policy processes are themselves to be reformulated in terms of an ecological world view.

Baldly stated, such a thesis seems "to stretch" the bounds of credibility; the problem, however, is less one of Ophuls's arguments than the limits of space to recount his position. Ophuls argues that "ultimately politics is about the definition of reality itself" (Ophuls, 1992, p. 282). Contemporary science ("the new science") informs us that no vantage point on reality is intrinsically privileged or definitive. The Nobel laureate Ilya Prigogine argues that "Whatever we call reality, it is revealed to us only through the active construction in which we participate" (Prigogine, 1984, p. 293). And science alone does not govern the construction. "We can no longer accept the old a priori distinction between scientific and ethical values," Prigogine continues (Prigogine, 1984, p. 312). Scientific communities themselves are set inside and exist only inside cultural worlds. And from within such worlds there are no "god's-eye" viewpoints, but rather "an irreducible multiplicity of representations. . . . The wealth of reality . . . overflows any single language, any single logical structure" (Prigogine, 1984, p. 225).

Consider also the argument of the noted biologist Ernst Mayr. It is "a

tragedy," he contends, that the basic political and economic institutions of western liberal democracies were overdetermined by the paradigm of classical physics. Biology played no role (Mayr, 1982). Thus, for example, the rights of individuals (atoms) are privileged, the freedom of individuals to act (move) is to be constrained only insofar as state restrictions are necessary to guarantee the optimum freedom possible for each individual, and individuals are related only by efficient causes, such as the operation of the market, and never by internal relations. Markets, of course, serve the interests of individuals (*Homo economicus*), and are either inimical or at best indifferent to community interests or public goods.

Clearly Mayr is "on the same page" with Ophuls. Both believe that the advance of evolutionary thinking, specifically biological and ecological thinking, places us in a position to reconsider the basic assumptions upon which political-economy rests. There are conceptual alternatives (and thus alternative political-economic realities) to those of atomism and individualism. And both believe that relations and processes are more important than individuals and states (that is, static conditions). Speculation about determinate policy outcomes of an "ecologically grounded" society are just that, conjectural, at best. Yet surely one can argue that, at the minimum, the political process would be less responsive to (for example) maximizing short-term economic benefits accruing to individuals, and more responsive to (for example) avoiding long-term ecological costs that are shared by everyone.

Can Habermasian theory be meaningfully set in this framework of discussion? Good question, since Habermas is not concerned with either ecological politics or environmental problems per se. In this sense, Habermas cannot be positioned in relation to figure 1. Yet, in another sense he can; in many ways his position most resembles Johnston's, and least resembles that of Paehlke. Like Johnston and Ophuls, Habermas believes that the basic institutions of liberal democratic life must be reconfigured. Unlike Ophuls, however, he does not argue for the reorganization of democracy on the basis of ecology.

His position is more like Johnston's in that he believes the present configuration of democracy privileges wealth and power. Thus, certain interests (say those of capital and industry) trump other interests (say those of labor and environmentalists). The theory of communicative rationality is Habermas's proposal for reconfiguring democratic institutions in ways that level the playing field in response to social problems.[7] Clearly, Habermas is more concerned with (for example) ideal speech situations which facilitate communicative interactions among individuals by diminishing the influence of power and wealth, than with specific social problems. But does Habermas's theory meet the objections that Johnston raises concerning the

basic incapacity of industrial liberal democracies to make efficacious environmental policy decisions?[8] In theory, yes; but, in practice, I will argue, no. But there is, I will also argue, "a fix," a way to ground Habermas's theory so that it might become more than abstract theory.

III. A PROBLEM FOR WESTERN INTELLECTUALS

Insofar as we are language animals (or self-interpreting language animals, as Charles Taylor argues), then all intellectuals, Habermas and Oelschlaeger included, are enframed by language (Taylor, 1985; Taylor, 1989). We are collectively embedded in cultural narratives—and thus assumptive frameworks—in which we had no constructive hand. We are simply put there by the accidents of birth. And one of the most fundamental, indeed foundational, narratives of the West is that the human species has somehow achieved "civilizational take-off," so that in effect culture is the abode of humanity, the total and complete source of human meaning, and the earth (and the biophysical processes which support the human species) is nothing more than a basket of goodies to fuel civilizational Progress. (Shepard, 1982, develops this thesis at length.) Since our humanity—as defined by articulations of worth, ideals that lend a sense of human dignity, and purposes which guide us—is disconnected from earth, then an instrumental relation to "nature" seems rationally appropriate.

Clearly, Habermas's theory of communicative rationality, whatever its merits, is part of the dominant Western intellectual tradition. Which is to say that narratives recounting the importance of earth, place, or landscapes do not fundamentally count, despite the presence of occasional heretics and heretical communities, like the Romantics, in the larger scheme of things. But should "place" count in political theorizing? Can we not (and should we not) have a theoretically coherent account of political process and institutions apart from any involvement with the particularities of landscapes and bioregions?

Certainly such "placeless theorizing" is consonant with the Western intellectual tradition. Yet such placeless theorizing—or language—as Bickerton implies (see above), and Hans-Georg Gadamer suggests, may be potentially disastrous in times of environmental crisis. "In our contemporary situation," Gadamer argues, "faced as we are with an increasingly widespread anxiety about human existence as such, the issue is the suspicion . . . that if we continue to pursue industrialisation . . . and to turn our earth into one vast factory as we are doing at the moment, then we threaten the conditions of human life in both the biological sense and in the sense of specific human ideals even to the extreme of self-destruction." Could this be,

he continues, "because of the baleful influence of language . . . ?" (Gadamer, 1988, p. 491). That is, to make Gadamer's long story very short, the very way in which reality is schematized by language and history, while the historicity and linguisticality of the schematization eludes us.

Thus, political theory has always been written from the standpoint of a universal spectator, disconnected from context and circumstance. Should it continue to be so? Two immediate arguments can be brought to bear on the salience of place to political theory. One is proffered by the noted ecologist, Eugene Odum. He argues that the primary challenges to the future of civilization are rooted in dysfunctional relations between cultural and natural systems (Odum, 1993). The visible manifestations of dysfunctionality (for example, extinction of species, degradation of habitat, polluted air) are themselves a function of the *theoretical disconnection* of cultural and natural systems. Odum concludes that new ways of thinking (he terms them "interface disciplines," though I prefer "interdisciplinary conversational communities") that unite our comprehension of natural and cultural systems are essential to survival. Political theory of the sort represented in figure 1 (above), where politics and environment become mutually conversant, is the beginning of such work.

A second argument comes from Frank Golley, also an ecologist, and a colleague of Odum's. He argues that hard and fast distinctions between human ecology and natural ecology are dubious, that is, not capable of either scientific or philosophic (epistemological) support, and also increasingly dangerous (Golley, 1993). Cultural activities, whatever the underlying intentions, powerfully influence the natural world; and natural processes powerfully influence the human world. Thus, more pointedly than Odum, Golley's argument implies that a political theory that is not simultaneously conversant with human *and* natural ecology is dubious and dangerous.

Now, such a conclusion clearly seems strange, and perhaps irrational. Is it strange because, as Stephen Toulmin argues, new forms of rationality often violate old forms of rationality? (Toulmin, 1958). Or is it strange because we are only beginning to come to grips with the issue? Which is to say that we have not as yet developed an ecopolitical theory that marries human and natural ecology. As Gadamer, Bickerton, and Prigogine all suggest, following in the wake of Darwin's basic insights into temporality, the process is the reality. And cultural processes are profoundly over-determined by language and history. "Language [political theory included]" Gadamer concludes, "is not its elaborate conventionalism, nor the burden of pre-schematisation with which it loads us, but the generative and creative power unceasingly to make this whole fluid" (Gadamer, 1988, p. 498).

My point, then, is simply this (however elliptical): *place must count*, insofar as political response to environmental exigency is necessary to

sustain civilization.[9] I will return to this point in relation to Habermas. But first consider an analogy from economic theory. Our economic systems, institutions, and theories are disconnected from biophysical processes. This reality is a "preschematisation," as Gadamer would call it. Under the present paradigm it is economically rational to clear-cut forests, dam rivers, and allow the byproducts of fossil fuel energy generation to dissipate into the atmosphere. Economically considered, such activities enrich the present generation of producers and consumers. They are profitable; and they lower the costs of goods and services. Ecologically considered, such activities are irrational, that is, they impair the integrity of biodiversity, hydrological systems, and the atmosphere itself. Ethically considered, such activities are unjust, since they foreclose the possibilities of future generations to enjoy the same or other benefits that the present generation enjoys; they also deny the intrinsic value of evolutionary complexity. (The fallacies of the dominant economic paradigm have been clearly explained by Nicholas Georgescu-Roegen [Georgescu-Roegen, 1971] and, in a specifically western context by Thomas Power [Power, 1996].)

Pace Odum, Gadamer, and others, emergent conversational communities might create new theories/narratives that enable adaptive response to the exigencies of existence. Ecological economics (cf. for example, the journal of *Ecological Economics*) is a response by an emerging epistemic community that attempts to create an analytical economic paradigm conversant with ecological realities. (Jansson, 1994, offers examples of such conversations).

Political theory faces a similar challenge. Driven by premises and assumptions inherent in pre-ecological (and pre-evolutionary) world views, political theory is in the main—in a way similar to economic theory—disconnected from biophysical reality. Political theorists, such as Robert Paehlke, R. Johnston, and W. Ophuls, are among today's leading ecopolitical theorists (see figure 1 above). Paehlke's theory of progressive politics is ecological minimalism; that is, he believes that environmental dysfunctionality can be addressed through political process without fundamentally reconfiguring political theory and the presently institutional-ized scheme. Ophuls's theory of ecological politics goes to the other extreme, where what he terms the "politics of scarcity" trumps human interests. Ophuls's mistake, ironically, is that he perpetuates the disconnection between natural and human ecology that Golley warns against, since nature trumps human interest.

The next section resumes "the question" concerning Habermas. The argument is that the theory of communicative rationality (or some variation on the theme) can, *under conditions that ground the theory*, open the door of democratic inquiry, that is, transformative responses to environmental exigencies.

IV. IS HABERMAS USEFUL IN ECOPOLITICAL CONTEXT?

While perhaps no "consensus position" among critics of the western liberal democratic state exists, a common feature is the charge that the political institutions of the state serve to perpetuate established, largely economic (and thus private) interests. Public interests, in short, are not served, although the language of public interest and collective goods is ceremonially used to legitimate state objectives. Theorists such as Mark Sagoff argue that (i) policy responses to environmental problems within the dominant political framework are typically reduced to market questions and policy, and legitimated in the name of the public interest; but environmental problems (ii) are not primarily economic issues requiring market adjustments; rather (iii) they are *fundamental political questions* about the goals and objectives of society itself, especially noneconomic goals and objectives (Sagoff, 1988). Thus, on Sagoff's account, politics as usual, that reduces environmental policy questions to market questions, is not a winning strategy.

Clearly, Habermas's theory of communicative rationality supports discursive democracy, an alternative to liberal democratic politics and over-determination of policy by markets (Dryzek, 1990, passim). Habermas theorizes an alternative set of political institutions, ones that are arguably more inclusive and also more open. These institutions, Habermas believes, are not overdetermined by the wealth and power of the dominant social order. Rather, citizens are empowered, through free, open, and inclusive deliberative process, to determine policy objectives and the means toward them. Apparently, then, Habermas's theory of communicative rationality can accommodate questions of environmental policy in principle.

But on second look does it? Can communicative rationality meet the test of environmental policy in the wild West? Not a simple question, even to understand. Try thinking of the question this way. Does the theory of communicative rationality overcome the instrumental and objectivist rationality which drives the institutions of the modern state (partly by reducing the role of the citizen to voting, partly by turning the political process over to experts, partly by demeaning the competency of citizens to deal with complex policy issues, and so on: see Barber [Barber, 1984] and Dryzek [Dryzek, 1990] for extended discussion)? Does the theory of communicative rationality engender open-ended and inclusive conversations among citizens, in the absence of predetermined standards, that could drive environmental policies leading toward good and sustainable bioregional living?

The answer, as I shall attempt to show, is that Habermas takes a first step, but fails to advance us toward the realization of fully participatory democratic arrangements that can meet the actual challenges of creating

policies that build good and sustainable communities. The primary reason why the theory of communicative rationality fails is that place—actual biophysical systems, with forests and mountains, watersheds and biodiversity, and also storied residence—does not figure consequentially. Indeed, for Habermas, place—in its contextual specificity and reality—does not exist. Only nature. And nature is nothing more than a standing reserve of materials for technological exploitation and economic development. Habermas's explicit instrumentalism is part of the standard ecopolitical criticism of communicative rationality. Dryzek argues that "Habermas tries to draw a clear line between the relationships we construct with the natural world and those we establish with one another. He avers that the only attitude toward the natural world which is fruitful in securing the material conditions for human existence is an instrumental one. The domination of nature is a price that Habermas is willing to pay for fulfillment of the Enlightenment's promise of human emancipation . . ." (Dryzek, 1995, pp. 107–8).

Of course, there is no surprise in the fact that Habermas neglects place (landscape, environment, or ecology). The intellectual history of the West, and our contemporary institutionalized disciplines, as I have already argued, are oblivious to place. And especially Western philosophy (Oelschlaeger, 1997; Oelschlaeger, 1991).

There is even a more serious problem beyond Habermas's reduction of place to resource. Namely, the neglect of place defeats the basic rationale and/or justification for the theory of communicative rationality itself. One argument for this point can be found in, ironically, the writings of the experts who themselves adopt an instrumentalist orientation in relation to questions of environmental policy, but argue that no realistic policy decisions can be made apart from place. In short, *rational environmental policy must be place specific*. The National Academy of Science Board on Sustainable Development argues that "it is in specific regions with distinctive social and ecological attributes that the critical threats to sustainability emerge, and where a successful transition will need to be based" (Board on Sustainable Development, 1999, p. 285). What constitutes "place" remains, of course, open to interpretation, but "distinctive social and ecological attributes" are part of a minimal definition.

V. THINKING ABOUT PLACE AND THE WILD WEST

At present the wild West is a contested political landscape. Conflicting opinions and thus disputes among various interest groups coalesce into what Daniel Kemmis calls the "politics of stalemate"—roughly equivalent to the

exercise of negative freedom that blocks rather than assists adaptation. Part of the politics of stalemate is due to the fragmented nature of governance itself, spread helter-skelter over federal, state, regional, county, and city jurisdictions. Fragmentation thus compounds the issues of substance. Some of the issues of substance are obvious, like ongoing conflict between economic interests pursuing mining, logging, ranching, and tourism versus environmentalist interests in wilderness and biodiversity. Intermountain national forests, for example, continue to exist in highly degraded conditions because of seemingly irresolvable conflicts between timber interests interested in economic benefits and conservationists interested in protecting watersheds and species. And, even more pointedly, between competing paradigms for stewardship of the public lands, such as preservationists who argue for a strict hands-off policy, based on the premise that "nature knows best," as over against restorationists, who argue that strategic interventions are necessary to restore the health of ecosystems pushed far from equilibrium by previous human interventions. And, perhaps the biggest battle of all, communities large and small find themselves increasingly caught up in conflict over growth and development.

Habermas's theory of communicative rationality seems to be an ideal guide for achieving the mutuality of understanding that would promote "positive freedom"—that is, constructive policies that lead toward sustainability. Theorists, such as John Dryzek, read Habermas's theory as contributing to the possibilities for a discursive democracy up to the challenges of resolving environmental problems (Dryzek, 1990). Richard Bernstein's reading also emphasizes the contributions of Habermas to the procedural (formal, or transcendental) notions of rationality that can then play out in practical reason and community life (Bernstein, 1983). My thesis (stated above) is that without recontextualizing the theory of communicative rationality, it cannot serve either a procedural or a normative function in political life. Three questions immediately confront us. (i) Why, generally, is this so? (ii) What, specifically, might alternatives be? (iii) And can the theory of communicative rationality be recontextualized to capture alternatives?

The first question was addressed—at least obliquely—in the previous section through the arguments of Odum and Golley. However, some might contend that the arguments of scientists cannot be brought to bear meaningfully on the arguments of a philosopher such as Habermas (since his research takes a "transcendental" form, that is, aspires to be a universal pragmatics. See Richard Bernstein for an interesting analysis of the "scientific" status of the theory of communicative rationality. Is it science? And thus a claim about what in fact exists? Or is it rather a moral-political

project? And thus a normative argument about what ought to be?) (Bernstein, 1983). Thus, on this thesis, the theory of communicative rationality normatively stands, even if divorced from considerations of natural ecology and/or scientific corroboration.

But consider Marjorie Grene's argument. She reinforces the arguments of (for example) Odum and Golley in a way conversant with philosophy. She argues that contemporary European philosophy has not faced up to the problem of the "cut between the scientific and the human or historical. . . . We still have the image of a human world shorn of any roots in nature and a natural world devoid of places for humanity to show itself." Clearly, there is a convergence here between Golley's observations and Grene's. "We need," Grene continues, "to show how historicity, as a necessary condition for, and defining principle of, human being, can be within, not over against, nature, in a way superior to, while at the same time dependent on, the possibilities left open by the organization of the natural world within which man as an artifact-needing, culture-dwelling *animal* has become a possibility and, for the moment, an actuality" (Grene, 1986, p. 182).

The second question (ii above) relates to the question of alternatives that move Habermasian theory away from the transcendental toward an existential reconciliation of the cultural and the natural. Figure 2 below offers a scheme for considering the importance of place in the political processes of the wild West.

Stegner <--------------> Kemmis <---------------> Cortner

FIGURE 2

As I will explain below, place figures significantly in the work of each of these thinkers in ways that *ground* practical reason.

While unknown in the philosophical world, Wallace Stegner was one of the leading expositors of the American West. A prolific writer, place figures centrally throughout the Stegnerian corpus. His earliest book, *Crossing the Hundredth Meridian*, is a historical study of the so-called opening of the American West (so-called because the lands west of the Mississippi River were inhabited long before the coming of Euro-American culture). A significant part of the book revolves around John Wesley Powell—a man who, because of his emphasis on the importance of place, was out of step with his own time (Stegner, 1954).

What Powell reported back to Washington, Stegner explains, was that the institutions of democracy needed to be tailored to the realities of western landscapes. Stegner terms Powell's report to Congress on the arid lands of

the western U.S. a "Blueprint for a Dryland Democracy" (Stegner, 1954, p. 228). Powell argued that, however well the institutions of liberal democracy suited the temperate lands of the East, where citizens could be self-interested atoms, that system was not going to work very well in the arid West. He focused his analysis on the commons, that is, the grasslands and watersheds, and argued that community governance was the key to successful human inhabitation. Such communal democratic process could, among other objectives, check self-interested parties who would exploit the landscape in the short-term regardless of the long-term consequences.

More recently, and even more insightfully, Stegner explores his own vision—a contemporary vision—for the wild West (Stegner, 1987). The people who hold the key to the future are what he terms "stickers," that is, individuals who have figuratively dug into particular landscapes and taken root. Stickers, typically living in the small to mid-size western communities, care about their neighbors and the landscapes that they are dependent upon. (Stickers are roughly equivalent to Heidegger's dwellers, people who have reconnected with place.)

Stickers are distinct from what Stegner calls "invaders," the people who come West, driven by self-interest and the search for quick profit or, in some cases, a simpler less-crowded way of life. Invaders, unlike stickers, never connect with the native lands and people or the communities where they reside. They bring with them the cultural forms, like Madisonian democracy, that they impose on the new places of settlement and steadfastly stick to them, whatever the consequences.[10]

What needs to happen in the wild West, if sustainability is to have a chance, Stegner argues, is that cultural forms must be adapted to the realities of place. "We have to adapt not only to our changed physical environment but to our own adaptations, and sometimes we have to backtrack from our own mistakes" (Stegner, 1987, p. 63). For example, if the Colorado Plateau watershed is to maintain biodiversity, and the River itself its beaches, then some of the dams on the Colorado might have to be decommissioned. And some of the proposals to further develop the "water resources" of the Colorado, such as transporting water from Lake Powell to St. George, Utah, so that a city rivaling Las Vegas and Salt Lake City might grow there, in the dry lands of southern Utah, might need to be reconsidered. To what end, Stegnerian's wonder, are such projects dedicated?

An "emergent culture," one attuned to the realities of western landscapes and culturescapes, is a real possibility, Stegner believes. Such an emergent culture is a *grounded culture*, one that grows out of the connection of citizens to place and to each other (community) *ab initio*, or existentially, and not transcendentally, through philosophical theory. It is in those "towns and cities still close to the earth, intimate and interdependent in their shared

community, shared optimism, and shared memory," Stegner argues, that we find "the seedbeds of an emergent Western culture. They are likely to be there when the agribusiness fields have turned to alkali flats and the dams have silted up, when the waves of overpopulation that have been destroying the West have receded, leaving the stickers to get on with the business of adaptation" (Stegner, 1987, pp. 85–86).

Daniel Kemmis, the former mayor of Missoula, Montana, and now director of the Center for the Rocky Mountain West, is best known for his book *Community and the Politics of Place*. While philosophically related to Stegner in emphasizing place, Kemmis goes beyond Stegner by developing a theory of democracy that is connected with ecology—call it a situated or "wild democracy."

Kemmis believes that the wild West is presently locked into the politics of stalemate. Unless westerners can find a way beyond this stalemate, he argues, the outcome will likely be that the West becomes more and more like the East, with relentless growth and development that rides roughshod over landscapes and culturescapes until cultural and ecological limits are overrun. The politics of stalemate is not, however, part of a cabalistic plot or conspiracy. Rather it is a consequence of what Kemmis terms "Madisonian" assumptions about human nature, primarily the assumption that humans are egoistic, selfish, and therefore incapable of reaching agreement on collective goods and public values. Here are the beginnings of powerful resonances with Stegner's notion of the adaptation of cultural forms: in this case, democratic forms themselves.

Kemmis explores the possibility for another form of governance in the West, one based on associations conditioned by residence in a particular place and Jeffersonian philosophical views on the possibilities of citizens coming together and working out collective intentions. But citizens are not citizens because they are held under the sway of constitutions or governed by the universal principles of communicative rationality. Rather, citizens are citizens because they are grounded and thus connected. "What holds people together long enough to discover their power as citizens is their common inhabiting of a single place" (Kemmis, 1990, p. 117).

Place figures initially in citizenship because of propinquity. "Neighbors are essentially people who find themselves attached to the same (or nearly adjoining) places. Because each of them is attached to the place, they are brought into relationship with each other" (Kemmis, 1990, p. 117). But place figures in more ways than just propinquity (the nearness that makes conversation possible). For Kemmis, place figures substantively in policy outcomes where "shared inhabitation" or "neighborliness"—roughly, near dweller—is central. Through placed citizenship individuals become stakeholders in a shared tomorrow, fellow travelers on a common journey,

mutually vested in meeting the challenges of the present and creating a vision for tomorrow.

Hanna Cortner (and her collaborator, Margaret Moote) takes a further step beyond, yet preserves the fundamental insights of Kemmis and Stegner in her work, *The Politics of Ecosystem Management*. While her arguments focus primarily on "ecosystem management" in the wild West, and thus moves in the direction of resource management issues involving, for example, watersheds, biodiversity, or ecological restoration of forests, they are fully consonant with Stegner and Kemmis. She argues, for example, that if sustainable living in the wild West is to be possible, then changes in the ways we make resource policy decisions (as reflected in the concept of ecosystem management) must be understood as also and simultaneously involving changes in political institutions, processes, and—perhaps most of all—citizenship. "Such changes are necessary not only for ecological sustainability, but the health of democracy itself. Attention must be directed toward building the social capital that is requisite for effective involvement in a civic society . . ." (Cortner, 1999, p. 138–39).

The third question concerning Habermas's theory in the context of environmental problems that threaten cultural survival will be considered below. Figure 2 makes clear that there are thinkers whose arguments position place consequentially in political process. Can these theorists facilitate a provisional recontextualization of Habermasian theory?

VI. TOWARD A "PLACED" THEORY OF COMMUNICATIVE RATIONALITY

The introduction (p. 387ff. above) suggests that there is a disconnection between place and citizenship in the theory of communicative rationality. The only apparent grounds Habermas has for community life are either pre-existing individual commitments to the theory of communicative rationality as a guide to action or a pre-existing discursive community that at least loosely subscribes to Habermasian norms.[11] Succeeding sections argue that (i) Habermas's theory reflects the pervasive disconnect between the cultural (as the unique home of humankind) and natural; that (ii), pace Odum, Golley, and others, the continuing disconnection of nature and culture is a dichotomy precluding rather than facilitating cultural adaptation; that (iii) the challenge is to reconfigure Habermasian theory so that political process is intimately associated with sociological (communal) and ecological facticity (rather than an appeal to putatively universal, and therefore necessarily abstract, communicative norms). The preceding section argues that thinkers who connect citizenship and thus membership in discursive community with place offer a strategy for grounding Habermas's theory. By so grounding his

theory it becomes practical and functional, that is, actually capable of bearing on the resolution of environmental questions affecting specific groups of people in specific places that, more often than not, are situations of conflict that can only be resolved through mutuality, that is, collaborative process.

What does a "placed theory of communicative rationality" look like? What does it mean? What follows is (i) only a beginning, and a provisional beginning, to a placed theory of communicative rationality; and (ii) is as abstract (in one sense, since it is not connected to a real place) as Habermas's theory of communicative rationality; that is, it only points toward the possibility of bioregional, situated narratives, chthonian, rhizomic narratives that are socially articulated and historically evolve through time in response to the changing exigencies of placed existence.[12]

Figure 3 below schematizes an approach to recontextualizing Habermas suggested by figure 2 above. Place is the precondition and inescapable site of citizenship; on Madisonian, procedural grounds, place is irrelevant. But liberal democracy is not discursive democracy; indeed, rather than facilitating communicative process it arguably precludes communicative rationality (Dryzek, 1990).

<center>Place --------> Citizen --------> Polis</center>

<center>FIGURE 3</center>

Place comes first in the figure, leading toward the citizen, implying that citizenship itself is (fundamentally, but only partially) identified through residence in a particular landscape. One is a citizen by virtue of being an inhabitant, a dweller—that is, one who has roots (rhizomic metaphors, again: see note 12) in a particular place. On this account the idea of a disinterested Habermasian—or Kantian—citizen is an abstraction, a philosophical conjecture. One is first a citizen through location rather than mentation (or philosophical belief), through physical/psychological connection with the biophysical and ecosocial circumstances that places one in a particular context, rather than intellectual abstraction.

Through place one becomes a citizen, a stakeholder. As a stakeholder, or through citizenship, one becomes a member of a discursive community, a polis. As a stakeholder, one has a material (noneconomic) affiliation, a bioregional involvement with one's place and one's neighbors.[13] One is intimately connected, rhizomically connected, with the land and with other people. One is an inhabitant, a dweller. Voting registration in part reflects the reality of residence (due to requirements for registration); but voting per se is the primary political act in liberal (or thin) democracy, not discursive

(or strong) democracy (Barber, 1984). A stakeholder (placed citizen) votes, but more importantly actively participates in the polis.

A stakeholder, then, is a discursive citizen. And citizenship comes before community (see figure 3), suggesting that community itself is an active, creative mutuality among citizens, an ongoing, open-ended conversation about a common journey. The polis is literally a public space that comes into existence only through citizenship. And through citizenship—through active citizenship—discursive democracy comes into being, that is, actually exists.

Kemmis catches one part of the idea as follows. "Only citizenship can save politics, and only relatively whole people are capable of reclaiming the human meaning of citizenship from the rubble of a political culture inhabited largely by sullen 'taxpayers' [and voters]" (Kemmis, 1995, p. 14). Roy Morrison catches another part of the idea thus. "Ecological democracy is the work of ordinary people, the daily politics of communities in motion" (Morrison, 1995, p. 231). Timothy Beatley observes that such discursive conversation is "as much a process as an outcome . . . It is about carrying on a sustained dialogue about how the community wants to grow and evolve, what it wants to look like in the future, what will likely be the results if not changes in practice and policy are made, how it will address its moral obligations . . . and so on" (Beatley, 1997, p. 205).

Arguably, on these grounds Habermas's insights into communicative rationality take on real life, connected life, opening rather than closing the door of inquiry, facilitating rather than hindering discursive democracy. At the minimum, Dryzek's charges against Habermas, namely, that the theory of communicative rationality is dis-placed and thus disconnected from the world, and that the world becomes nothing more than an economic resource, and not a site for ongoing inhabitation, can be countered (Dryzek, 1995, pp. 107–8). Through recognition that we live "inside" placed communities, as stakeholders, the virtue of Habermas's commitments to communicative rationality can become normative, that is, ideals to which we collectively aspire rather than empty theoretical foundations. While I cannot claim that "if and only if" the Habermasian conditions for communicative validity are met, namely, comprehensibility, truth, truthfulness, and rightness, surely those criteria are useful in discursive democratic context where questions of survival are at stake.

VIII. CONCLUSION

Some observers of the wild West believe that we find there the last best chance for truly participatory democracy. Yet the road ahead will not be easy. Can a "grounded Habermas" help? Let us reconsider Habermas in the wild, wild West.

Donald Worster argues that westerners have caught themselves in a paradox, wanting at one and the same time open spaces and wild lands, and the amenities of rural and small town living, while also desiring economic development, rising standards of living, and abundant, cheaply priced infrastructure amenities, such as water and energy. "To date," he writes, "the West has hardly acknowledged that it has created any contradiction at all. It has simply built more dams, made more money, packed in as many people as it could, ignored the costs to the environment and society that had to be paid, and told itself all the while it was the freest place around. Now that will no longer do" (Worster, 1992, p. 90).

What will do, then? Worster believes that we must have an alternative vision, a vision of a new West, as I like to call it, one that preserves the natural amenities that gives western life its qualitative richness while also, as he puts it, allows us to "live well for the longest period of time. . . . [Such a vision] ought to suggest how we can occupy this place without consuming it or letting it consume us." And it ought to involve all of us who live here, "men and women, white and nonwhite, natives and immigrants alike" (Worster, 1992, p. 90).

But there is something more, on Worster's account, something that brings us full circle back to Wallace Stegner, Daniel Kemmis and others who have valorized the vital, irreplaceable role that the small and middle-sized communities of the West will play. "I believe," Worster continues, "that such a vision will begin to appear when and as, and only when and as, the people of the West begin to care deeply about their communities, especially their smaller communities where the relationships among people are the most direct and intense. Those communities may not in every case be models of decency or intelligence or tolerance, but it is only through caring about them that we can begin to learn to be at home in this place" (Worster, 1992, p. 90).

The way ahead, I contend, begins at this historic moment, the moment where we begin to perceive ourselves as living in the gap between our retrospections of the past and our projections of the future, seemingly caught between a failed past and future powerless to be born. Further, it is precisely in the intermountain West, in the small and mid-sized communities of the public lands West, the wild West, where place and people come together in a fateful rendezvous. Where collective visions of sustainable futures might emerge. Where the possibilities envisioned by Stegner, Kemmis, and Cortner are palpably real. Where the mettle of discursive democracy and communicative rationality will be tested, either empowering us to forge good and sustainable communities that match the scenery, or frustrating us, as discursive democracy and communicative rationality reveal themselves itself as yet more mirages appearing on the horizon of arid landscapes, promising so much when viewed from afar, but delivering nothing in the end.

A *grounded Habermasian vision*—call it the vision of a *wild democracy*[14]—can help citizens break out of the politics of stalemate and begin to identify collective goods, opening rather than closing the path of collaborative inquiry, that is, discursive democratic conversation. Just as rodeo, detached from place, becomes a simulacrum, signifying nothing that actually exists, so with a *dis-placed* theory of communicative rationality. If *grounded*, however, that is, connected to real communities with real citizens in real places, communicative rationality can be part of a wild democracy that drives public policy toward sustainability.

MAX OELSCHLAEGER

MCALLISTER ENDOWED CHAIR
OF COMMUNITY, CULTURE, AND ENVIRONMENT
NORTHERN ARIZONA UNIVERSITY
MAY 2000

NOTES

1. "Ground" here does not imply philosophical "foundation"; "ground" connotes storied residence in particular locales or bioregions of the intermountain West.

2. On "chthonian" see John Caputo (Caputo, 1987). On "rhizomic" see Deleuze and Guattari, and note 12 below (Deleuze, 1987).

3. Richard Rorty critiques the theory of communicative rationality on the grounds that, because it is committed to rational consensus, per the dominant epistemological tradition of the West that seeks foundational and thus single truth, it blocks fundamental or genuinely novel societal changes that might be, among other avenues, fostered through discursive conversation. Rather than "validity norms" which can be used to measure the rationality of conversation, Rorty is committed to inventing new vocabularies or stories that are abnormal discourses, outside the constraints of Habermasian rationality (Rorty, 1980).

4. Much like Rorty, who sees Habermas as caught up in a failed Enlightenment project, John Dryzek argues that Habermas privileges instrumental reason, and thus is more part of an environmental problematic than solution (Dryzek, 1995, pp. 107–8).

5. Consider the following sources: Firor, *The Changing Atmosphere* (Firor, 1990); Gelbspan, *The Heat is On* (Gelbspan, 1998); Wilson, *The Diversity of Life* (Wilson, 1992); McMichael, *Planetary Overload* (McMichael, 1993); and Siebert, "Plagues at the Gate" (Siebert, 1995).

6. The Western Governor's Association is constituted by the Western states, including Hawaii and Alaska. However, my remarks here should be interpreted in the context of the eleven states of the intermountain West.

7. However, Habermasian philosophy is directed primarily toward theory rather than practical issues.

8. Obviously, if Habermasian theory does not speak to issues of survival, of

sustainability, then it is profoundly idealistic and not pragmatic. In this context see Will Wright's *Wild Knowledge* (Wright, 1992). Wright argues that Enlightenment conceptions of rationality are misguided in that they do not connect knowledge with the locus of life: the earth, or nature, itself.

9. Place should not be understood as a metaphysical concept or first principle. Place is better understood as a locus or site for inhabitation, residence, dwelling.

10. For example, people who build homes in the Sonoran desert with Kentucky blue grass lawns nourished by water from the impoundments on the Colorado River (forty-four in total), and pumped uphill by energy from coal taken from the sacred lands of Black Mesa, the ancestral home of the Hopi, which was "signed, sealed, and delivered" by the under the table maneuverings of a lawyer who worked for Hopi and, unknown to them, Peabody Coal. See Charles Wilkinson's *Fire on the Plateau*, which chronicles the post–World War II "big build up" of the inter-mountain West and the ecological and sociological consequences on landscapes and native people. Water, as westerner's say, always flows to money. And power (Wilkinson, 1999).

11. And, if so, Habermas evades the basic political problem. See Barber's *Strong Democracy* (Barber, 1984).

12. Bruce Foltz suggests the provisional aspects of any and all such grounded conversations. "The earth," he writes, and I suggest "any place" as well as the earth, "can be earth only as it is involved in a rich set of interrelations—more than be comprehended [or told, spoken, interpreted, recounted, articulated] by human ecology or biology or by geography, literature, politics, theology, philosophy, or other science or discipline [or narrative form]" (Foltz, 1995, p. 173). Deleuze observes that "What is real is the becoming itself, the block of becoming, not the supposedly fixed terms through which that becoming passes," thus suggesting the ineluctable openness of the world-at-play (Deleuze, 1987, p. 238). He uses a rhizomic metaphor to characterize human becoming/communication. A "rhizome," literally, is the horizontal, usually underground, and thus invisible stems that send out roots and shoots from its nodes, and that through the exchange of energies with the above-ground, and thus visible world, nourish becoming/life. The metaphor, as I am using it, suggests that "place" is rhizomic, breaking forth in speech. Compare Deleuze and Guattari (Deleuze, 1987). "There is a block of becoming between young roots and certain microorganisms, the alliance between which is effected by the materials synthesized in the leaves (rhizosphere). If there is originality in neoevolutionism, it is attributable in part to phenomena of this kind in which evolution . . . ceases to be a hereditary filiative evolution, becoming [instead] communicative or contagious" (Deleuze, 1987, p. 238).

13. "Stakes" are typically thought of as holdings of economic (monetary) value. "Stakes" in the sense in which I am interested are something else; they support the visible, above-ground appearances that are connected with the below ground, the invisible soil of being. One thinks of Thoreau's longing, in this context, for words that have earth clinging to their roots.

14. The metaphor is deliberate. Consider, for example, "wild knowledge," a term that refers to a knowledge that is grounded, literally grounded, through reference to the particularities of biophysical process rather than the artifices of science, economics, and the like. See Wright (Wright, 1992).

REFERENCES

Barber, Benjamin R. *Strong Democracy: Participatory Politics for a New Age.* Berkeley and London: University of California Press, 1984.

Beatley, Timothy, and Kristy Manning. *The Ecology of Place: Planning for Environment, Economy, and Community.* Washington, D.C.: Island Press, 1997.

Bernstein, Richard J. *Beyond Objectivism and Relativism: Science, Hermeneutics, and Praxis.* Philadelphia: University of Pennsylvania Press, 1983.

Bickerton, Derek. *Language and Species.* Chicago and London: University of Chicago Press, 1990.

Board on Sustainable Development, Policy Division, National Research Council. *Our Common Journey: A Transition Toward Sustainability.* Washington, D.C.: National Academy Press, 1999.

Caputo, John D. *Radical Hermeneutics: Repetition, Deconstruction, and the Hermeneutic Project.* Bloomington: Indiana University Press, 1987.

Cortner, Hanna J. and Margaret A. Moote. *The Politics of Ecosystem Management.* Washington, D.C.: Island Press, 1999.

Deleuze, Gilles, and Félix Guattari. *A Thousand Plateaus: Capitalism and Schizophrenia.* Trans. Brian Massumi. Minneapolis: University of Minnesota Press, 1987.

Dryzek, John S. *Discursive Democracy: Politics, Policy, and Political Science.* Cambridge and New York: Cambridge University Press, 1990.

———. "Green Reason: Communicative Ethics for the Biosphere." *Postmodern Environmental Ethics.* Ed. Max Oelschlaeger. Albany, NY: State University of New York Press, 1995.

Firor, John. *The Changing Atmosphere: A Global Challenge.* New Haven & London: Yale University Press, 1990.

Foltz, Bruce V. *Inhabiting the Earth: Heidegger, Environmental Ethics, and the Metaphysics of Nature.* Atlantic Highlands, NJ: Humanities Press, 1995.

Gadamer, Hans-Georg. *Truth and Method.* Trans. Garrett Barden and John Cumming. New York: Crossroad Publishing, 1988.

Gelbspan, Ross. *The Heat is On: The Climate Crisis, The Cover-Up, The Prescription.* Reading, Mass.: Perseus Books, 1998.

Georgescu-Roegen, Nicholas. *The Entropy Law and the Economic Process.* Cambridge: Harvard University Press, 1971.

Golley, Frank B. *A History of the Ecosystem Concept in Ecology: More than the Sum of the Parts.* New Haven & London: Yale University Press, 1993.

Grene, Marjorie. "The Paradoxes of Historicity." *Hermeneutics and Modern Philosophy.* Ed. Brice R. Wachterhauser. Albany, NY: State University of New York Press, 1986.

Jansson, AnnMari, Monica Hammer, Carl Folke, and Robert Costanza, eds. *Investing in Natural Capital: The Ecological Economics Approach to Sustainability.* Washington, D.C.: Island Press, 1994.

Johnston, R. J. *Environmental Problems: Nature, Economy and State.* London: Belhaven Press, 1989.

Kemmis, Daniel. *Community and the Politics of Place*. Norman: University of Oklahoma Press, 1990.

————. *The Good City and the Good Life*. Boston: Houghton Mifflin, 1995.

Lawrence, Elizabeth Atwood. *Rodeo: An Anthropologist Looks at the Wild and the Tame*. Chicago and London: University of Chicago Press, 1984.

Mayr, Ernst. *The Growth of Biological Thought: Diversity, Evolution, and Inheritance*. Cambridge: Harvard University Press, 1982.

McMichael, A. J. *Planetary Overload: Global Environmental Change and the Health of the Human Species*. Cambridge: Cambridge University Press, 1993.

Morrison, Roy. *Ecological Democracy*. Boston: South End Press, 1995.

Odum, Eugene P. *Ecology and Our Endangered Life Support Systems*. Sunderland, Mass.: Sinauer, 1993.

Oelschlaeger, Max. "Helping Philosophy Find Its Place: Geography in a Time of Cultural Crisis." *Ecumene* 4, no. 4 (1997): 373–88.

————. *The Idea of Wilderness: From Prehistory to the Age of Ecology*. New Haven & London: Yale University Press, 1991.

Ophuls, William, and A. Stephen Boyan, Jr. *Ecology and the Politics of Scarcity Revisited: The Unraveling of the American Dream*. New York: W.H. Freeman, 1992.

Paehlke, Robert C. *Environmentalism and the Future of Progressive Politics*. New Haven & London: Yale University Press, 1988.

Peirce, Charles Sanders. *Philosophical Writings of Peirce*. Ed. Justus Buchler. New York: Dover Publications, 1955.

Power, Thomas Michael. *Lost Landscapes and Failed Economies: The Search for a Value of Place*. Washington, D.C.: Island Press, 1996.

Prigogine, Ilya, and Isabelle Stengers. *Order Out of Chaos: Man's New Dialogue with Nature*. New York: Bantam Books, 1984.

Rorty, Richard. "Pragmatism, Relativism, and Irrationalism." *Proceedings and Addresses of the American Philosophical Association* 53 (1980): 736.

Sagoff, Mark. *The Economy of the Earth: Philosophy, Law, and the Environment*. New York: Cambridge University Press, 1988.

Shepard, Paul. *Nature and Madness*. San Francisco: Sierra Club Books, 1982.

Siebert, Charles. "Plagues at the Gate." *Outside* (May 1995): 75ff.

Stegner, Wallace. *The American West as Living Space*. Ann Arbor: University of Michigan Press, 1987.

————. *Beyond the Hundredth Meridian: John Wesley Powell and the Second Opening of the West*. Boston: Houghton Mifflin, 1954.

Stuhr, John J. *Genealogical Pragmatism: Philosophy, Experience, and Community*. Albany, NY: State University of New York Press, 1997.

Taylor, Charles. *Human Agency and Language: Philosophical Papers 1*. Cambridge: Cambridge University Press, 1985.

————. *Sources of the Self*. Cambridge: Harvard University Press, 1989.

Toulmin, Stephen Edelston. *The Uses of Argument*. Cambridge and New York: Cambridge University Press, 1958.

Wilkinson, Charles. *Fire on the Plateau: Conflict and Endurance in the American*

Southwest. Washington, D.C.: Island Press, 1999.

Wilson, Edward O. *The Diversity of Life.* Cambridge: The Belknap Press of Harvard University Press, 1992.

Worster, Donald. *Under Western Skies: Nature and History in the American West.* New York: Oxford University Press, 1992.

Wright, Will. *Wild Knowledge: Science, Language, and Social Life in a Fragile Environment.* Minneapolis: University of Minnesota Press, 1992.

20

Bill Martin

Eurocentrically Distorted Communication

Perry Anderson and Peter Dews: "The Frankfurt School tradition as a whole has concentrated its analyses upon the most advanced capitalist societies, at the comparative expense of any consideration of capitalism as a global system. In your view, do conceptions of socialism developed in the course of anti-imperialist and anti-capitalist struggles in the Third World have any bearing on the tasks of a democratic socialism in the advanced capitalist world? Conversely, does your own analysis of advanced capitalism have any lessons for socialist forces in the Third World?
Jürgen Habermas: I am tempted to say "no" in both cases. I am aware of the fact that this is a eurocentrically limited view. I would rather pass the question.
(Peter Dews, ed., *Autonomy and Solidarity*, p.183)

For many years Jürgen Habermas has been almost obsessively concerned with the problem of Europe. Professor Habermas is not unusual in this regard. Many European intellectuals have made an occupation out of this preoccupation, many to a much greater extent than has Habermas. (Among "continental" philosophers and theorists in the U.S., I hasten to add, this preoccupation is often even more Eurocentrically-inclined than it is with actual Europeans.) It cannot be said that Habermas has not been forthright in his concern regarding the fate of Europe, and we might propose as a hypothesis that to have these concerns is not in itself Eurocentrism. But Habermas has never been concerned with Europe as itself a problem, a very difficult problem for the larger world, that is. This lack of concern runs headlong into the ethical-political universalism that Habermas has been such

an eloquent spokesperson for. In interviews, Habermas has had very little to say about the Third World—other than to say that he has very little to say on this question. Although one might appreciate his honesty and modesty, it seems to me that his always quick return to Europe as the necessary center of the political-philosophical universe itself represents a massive summation on the question of the Third World.

I understand the sense in which, from a Kantian or Hegelian position, one might argue for a kind of either/or with regard to the Third World: *either* Enlightenment universalism is truly universal, and therefore it applies to the Third World as well as to Europe and the rest of the advanced capitalist countries—if not right now, then eventually, *or* the Third World is simply "other," and, working out of a philosophical-political framework established in Europe, one would do well to simply not comment on the non-European world. If the former disjunct more appropriately describes the situation, then the best way to further the Enlightenment project would be to rearticulate this project at its "core," so to speak, from within and in terms of Europe. If European conceptions of ethics and politics are the future of all humanity, then it would be best to work on those conceptions in their own terms, without complicating the picture with non-European historical trajectories (which, at least under a more Hegelian model that Habermas does not avowedly subscribe to, cannot be considered as "histories" in any case—there is only one "history," and it is singular and ultimately European). And, if the non-European world is simply other, then one can do little more than make recommendations concerning the policy of the first world toward "it." At least, this is the extent of what Habermas has had to say about the Third World, with never a substantive recognition that there is a basic relationship between the Same and the Other, a relationship that plays a defining role on either side of the divide (I avoid saying "for both," for it is only European history that presumes to be singular), a relationship that insinuates itself into any conception of ethical-political universalism or Enlightenment.

Before continuing, I want to offer a proviso and a preview. The proviso is that I hope the reader will take the criticisms I offer of Habermas in a constructive light. In all of the writing that I have done on the work of Jürgen Habermas, both in published form and in oral presentation, I have been careful to note that he is, to my mind, the most important social theorist of recent decades. There is no question that any attempt to create a radical social theory must come to terms with Habermas's work. As James L. Marsh puts it (in "What's Critical about Critical Theory"), "It is tempting to compare Habermas in [his] simultaneously enabling and inhibiting role at the end of the twentieth century with Hegel at the beginning of the nineteenth century." We can't simply get around these giants of Enlightenment,

nor should we try. The preview is that I will draw further on James Marsh's work in what follows, both as useful summary and incisive analysis (and I should add that the essay from which I just quoted is to some extent a distillation of Marsh's important book, which I recommend to the reader, *Critique, Action, and Liberation*). My aim is to develop and extend some of the positions Marsh argues for; this does not mean, I should add, that Professor Marsh will necessarily agree with all of my extensions. Finally, I first quoted Marsh on the point about Hegel for a reason, which will be developed in due course.

There are a number of efforts afoot to, as it were, save Habermas from himself, to develop the radically democratic potential of discourse ethics and communicative action over and against what seem to be politically very mainstream liberal impulses. (In addition to James Marsh's work, among these efforts would be those of Martin Matuštík, David Ingram, David Rasmussen, and George Trey.) The worry is that, as Marsh put it, "rather than a communicative action [that leads] into radical social transformation, Habermas cashes out communicative action very conservatively"; Marsh adds, "it is hard to see why" (p. 558).

Marsh deals with a number of factors that might explain Habermas's cautiousness, including the failure of the Eastern European model, the seeming inevitability of bureaucracy and the more general problem of social complexity, and the supposed virtues of the welfare state system in the West. On the complexity question, James Bohman is developing an interesting analysis regarding the connection between social complexity and democratic deliberative procedures. If complexity is an unavoidable fact of life—or, at least, of a certain form of life that is deemed desirable and even superior to alternatives—then, one might argue, the real political questions are those of the most feasible democratic procedures within the existing complexity at any given point. Thus a relatively conservative, reformist approach is recommended. Although we cannot get very far into these questions here, the form of life that is clearly rendered "unrealistic" by such an approach is that proposed by communitarians. And this raises an interesting set of issues for anyone, such as Marsh, who wants to defend a vision of critical modernism, albeit in a more radical form than that currently proposed by Habermas (and probably Bohman as well). The model of "complexity" that we know from critical modernism is *both* a European (I am not yet asserting that it is Eurocentric) model *and* an extremely urban-centric model (and it is no coincidence that these terms find themselves together, European and urban-centric). I place the term "complexity" in scare-quotes because the fact is that the urban-centric conception of complexity is horribly and very dangerously simple-minded, stupid even, when it comes to certain questions, especially the question of agriculture. A longer discussion of these issues

would have to raise more general questions regarding the place of commu-
nity in theories of radical democracy and the place of democracy in radical
theories of community.

As Marsh argues, the defensive posture regarding the Western welfare
state model exemplified by the liberal wing of critical modernism belies an
avoidance strategy regarding capitalism. Capitalism has been for many
decades now a global economy, one that brings the entire world under a
single system of production. To only concentrate on the supposedly "up"
side of the global equation, the welfare net that has existed in the "Western
democracies" (and that is now eroding or being dismantled, of course) since
the Second World War, is not to deal with the human cost of the equation
when understood in properly global terms. When we shift to that scale, we
see that neither is it possible to simply talk about the "extension" of what the
West has achieved to the Third World, any more than it is possible to talk
about the extensions of the benefits enjoyed by the slavemaster to the slave,
nor is it possible to understand the Third World as "simply other" when it
has been forcibly brought under the rule of the West's cash nexus.

One other term might be added to this discussion of Habermas's
cautiousness: danger. While Habermas is a theorist on a grand scale, he is
exceedingly worried about grand political programs and their potential for
cataclysm. (This question is discussed at length in my *Humanism and its
Aftermath*, pp. 159–65.) Marsh invokes Ernst Bloch's argument "about the
coexistence within Marxism of a rational, scientific, 'cool' stream and a
radical, prophetic, 'hot' stream" (p. 560; significantly, Marsh cites Derrida's
Specters of Marx as an example of the latter). Undoubtedly, Habermas
prefers cool reason to prophetic politics. (Marsh argues that the "hot" and the
"cool" need to be linked; I agree in principle—Derrida's term, "structural
messianism," from *Specters*, comes to mind—but the question that remains
concerns the form this "linkage" might take.) Perhaps, then, to talk about the
need for a "critical theory of neo-imperialism," as Marsh does, would simply
be too provocative for Habermas. After presenting an eloquent description
(that draws on Noam Chomsky, Enrique Dussel, and Jacques Derrida) of the
real facts of life in the international frame, Marsh sums up, rather bluntly:

> Now what does Habermas have to say about all of this? Unfortunately very
> little, except to support the empire occasionally in some of its worst aspects and
> interventions. One of Habermas's noteworthy acts was to support the Gulf War;
> one of the main reasons for this support seemed to be that it was a U.N. action.
> This justification misses, I think, the fact that the U.S. bribed or threatened
> almost every member of the Security Council to go along with its aims. The
> U.N. resolution to intervene was almost a perfect example of strategic action,

not communicative action; [this action] occurred within an imperial structure that is asymmetrical[,] involving enormous differences of economic, political, and social power between North and South (pp. 563–64)

I might add that another reason Habermas gave for supporting the Gulf War was solidarity with the State of Israel out of a sense of German indebtedness to the Jews (see Anson Rabinach, "German Intellectuals and the Gulf War"). My own position on the question of Israel and the Jews is more complex, I hope, than what is generally put forward by some other Marxists (see "The hardest questions," in my *Politics in the Impasse*). But it is hard for me to see that the question of the fate of the Jews is advanced one iota by the slaughter in Iraq, and the question may have been set back considerably in the long run. Furthermore, it strikes me as an exceedingly, ridiculously Eurocentric form of "solidarity" to think that Germany can help make amends for killing millions of Jews in the Holocaust by helping the United States kill tens of thousands of Arabs in the Gulf War.

In any case, we see that, in Habermas's anti-danger, anti-utopian politics, there is apparently no danger in a desert storm. It's all a sideshow, as exemplified by the set of interviews with Habermas collected under the title, *The Past as Future*. Here the discussion begins with the Gulf War, but quickly moves back to what's really important, Europe. James Marsh argues that,

> It is not an adequate defense of Habermas to say that this stance on the Gulf War is just a personal, political position that does not affect the validity of his theoretical stance. On the contrary, [and] using Derridean resources again, I would argue that something apparently external, accidental, supplemental, "the logic of the supplement," reveals something deeply problematic about the theory itself. Indeed, I would argue that Habermasian critical theory, unless it begins to undertake an interpretation and critique of neo-imperialism, becomes in fact and reality, even if in principle and intention it is not so, Eurocentric. (p. 564)

How does this happen? Marsh takes up arguments from Enrique Dussel to show that exclusion of the Third World from an account of modernity structurally generates a "triumphalistic myth of modernity," a myth where, I would argue, all timelines and histories become one, hegemonic, Western time. And who does Western time better, so to speak, than the West? (An excellent discussion of the politics of historical time, building on Derrida's work, is Robert Young's *White Mythologies: Writing History and the West*.)

In the interview on the Gulf War, Habermas makes it clear once again that, in his view, the West has generated a set of basic institutions that, despite some flaws and shortcomings, are the model for democractic

societies. Preceding the passage that I am going to quote, Habermas has given a capsule analysis of his arguments for political universalism and the "duties and responsibilities that [the Western powers] implicitly assume when they make use of [universalist arguments] for legitimation" (pp. 22–23). In other words, Habermas is drawing out the normative implications and requirements of an ideal of communicative action that he sees implicitly at work in the deliberations leading up to the Gulf War—an ideal that may be distorted and shortchanged, but is nonetheless present. The interviewer has been pushing Habermas on some of these points; I quote the latter's response at length:

> Now, you'll immediately object that these are precisely the kind of universal- istic slogans that have served to cover over the business of politics as usual. That's not entirely false, but neither is it entirely true. Each of these normative demands can be matched up with real and increasingly unavoidable problems; if left unresolved, those problems will lead to consequences that the West will feel as sanctions.
>
> We're talking about the Gulf War, a war that was virtually universally perceived as a continuation, by atavistic means, of a ruinously unsuccessful politics. If such things aren't simply to repeat themselves, then our efforts have to go into dismantling the category of war . . . reconfigured as interventions of a military force under the command of the UN. Of course, even this is only treating symptoms unless it can also simultaneously lead to a revisioning of the category of foreign policy as a multilaterally coordinated world domestic policy. But for this too there are at least institutional nuclei, on the model of interna- tional organizations or standing conferences. (pp. 23–24)

The philosophical kernel of this argument, with which we might deal more even-handedly than its political significance—which I find abhorrent, for it seems to treat the Gulf War as an interesting experiment in communicative action, even if there were some problems—is the idea that ethical-political universalism is something that works from the core outward. At least in the West there are the nuclei of the institutions and frameworks that are needed, one might say.

This argument should not be taken lightly. After all, one might argue, perhaps invoking something like Donald Davidson's "principle of rational accommodation" (what he used to call the "principle of charity"), that we have no other choice than to work outward from our own conceptions. Personally, I think this is true, but there is a question of the form that the "work" should take. Looking back to the issues James Marsh framed, we can also raise this question in terms of the ability of communicative action to encompass the critique of imperialism. Marsh argues that the great irony is that "a communicative ethics and praxis that is in principle open to the

marginalized other seems not only possible, but indeed necessitated, by the terms set out by Habermas" (p. 24). Then the question becomes one of spelling out, in practical terms, the force of the "in principle." We will return to this point.

Let us take a moment, then, to consider Habermas's argument for working from the "core"—again I will quote at length. Referring to "one of the very few philosophical problems with an immediate political relevance," Habermas asks,

> Are the principles of international law so intertwined with the standards of Western rationality—a rationality built in, as it were, to Western culture—that such principles are of no use for the nonpartisan adjudication of international conflicts? For example, does the claim to universality that we connect with the concept of human rights simply conceal an especially subtle and deceitful instrument of domination of one culture over another—as in the slogan, "Whoever speaks of humanity is a liar"? Or is it the case that universal world religions converge in some core condition of moral intuition according to their own claims, a core that we interpret as equal respect for all, equal respect for the need to promote the integrity of each individual person, and for the damageable intersubjectivity of all forms of human existence? Is there not, as my colleague John Rawls maintains, an "overlapping consensus" within world perspectives and religious interpretations of deep moral feelings and elementary experiences of communicative interaction? (p. 20)

It would be difficult, I think, not to find this statement very powerful and compelling, and therefore I wish that I did not have to point out that, at the same time, universalistic rhetoric of this sort has also been used as a cover for the most grotesque crimes committed by the West, of which the Gulf War has been only one. Of course, this is news to no one, and it is certainly not news to Habermas. Part of his argument is to point out the dangers of simply throwing out this rhetoric because it is—or can be, at any rate—hollow. However, this rhetoric has been used not only as a cover, but further, as legitimation and justification. And, in any case, this rhetoric has rarely held the West back from committing large-scale crimes against humanity.

To invoke the term "humanity" is itself to partake of universalist rhetoric, even if somewhat against the grain, even if in terms of a rearticulation of that rhetoric in terms of its marginalized other. In conclusion, then, I propose two points where this rhetoric has to be rethought (and, in one case, "deconstructed") at its roots. By these roots I mean Kant and Hegel.

Marx argued that capitalism initiates the period in which we can truly begin to speak of "world history." In this era of a global mode of production—imperialism—capitalism has always encountered resistance in the

Third World. Through this resistance, Third World peoples have undeniably entered the stage of *this* world history; the Third World is a "subject," even in terms of Western hegemony (indeed, only in these terms is the Third World a single, homogenous subject). Perhaps we could deconstruct Hegelian terms in order to get a fix on this subject and its political and hermeneutical significance. Eurocentric theorists tend to see the self-development of humanity as occurring at (or from) the "center," that is, in Europe. Habermas may have cast off the philosophy of history, but that does not mean that he has abandoned the idea that Europe is the staging ground for all of the political developments that matter (to him, at any rate). We might make the argument, in a way similar to Stephen Jay Gould's and Niles Eldredge's theory of punctuated equilibrium, and to Jacques Derrida's theory of meaning and interpretation, and to Mao Tsetung's theory of revolution as necessarily going against the tide, that the real developments occur first in the margins. Perhaps proponents of the European "core" would be on better grounds, as we have discussed, if "East is East and West is West"—but this will not explain the presence of Green Berets in Peru, much less the role of Western banks, working through the International Monetary Fund and the World Bank, in structuring the economies of Third World countries. More to the point, in terms of the crucial ethical dimension of any redemptive politics that aims toward justice on a global scale, there is neither East nor West. (Obviously, I am playing off of the assertion that, "In Christ there is no East or West.") We are on good Hegelian grounds in asserting this because we are talking about the margins of globally interwoven social structures. Critical theory, insomuch as this term applies to the legacy of the Frankfurt School or theorists working out of Habermas's framework, has shown no interest in the response of Third World peoples to the "issues" posed to them by the West. But will they recognize the issues themselves, and see that, on the underside of Europe and its idea, in the margins of European "universalism," people have been struggling to frame these issues and to practically and theoretically engage with them? It seems to me that this struggle can once again be understood in broadly Hegelian terms, as the reconstruction of ethical and political universalism in the margins of the dominant culture and polities.

Another way to put this is simply to ask if it is possible to imagine ethical-political universalism setting sail from other shores, from other experiences, than those of Europe. Obviously, in proposing this I am not rejecting communicative action or overlapping consensus or the political-philosophical legacy of the European Enlightenment, but instead asking what would happen to the model if we were to work inwards from the margins rather than outward from a supposedly self-secure core (as it were, from the European cogito). Of course, insomuch as this working inwards is

"impossible," to use Derrida's term for it, we violate a core conception of Habermas's (or Rawls's, for that matter) model of rationality, and therefore this discussion has to be taken much further. There are many ways to frame this discussion between Habermas and Derrida, but one way to look at it might be to ask where the meeting place is between Habermas's "norms" and the messianic ideal spoken of by Derrida in *Specters of Marx*. Or, to return to James Marsh's terms, the question is one of a possible linkage between cool reason and prophetic politics. One would hope for a meeting place that is neither merely lukewarm or rhetorically histrionic. Therefore we would have to ask if something has to give.

If we can raise a "formal" concern with Hegel, it is only fair that we raise a practical concern with Kant—and really what we are asking about is the *force* of the normative commitments that Habermas derives from communicative action. As I think about the possible integrations of the second and third formulations of the categorical imperative, and especially as I attempt to think the third formulation in terms of what is required of the rational agent by the second formulation, it seems to me that there is a fundamental issue of social structures that has to be dealt with. If there is some structure that stands in the way of treating persons as ends-in-themselves, then all rational agents have an obligation to do something about that structure. If some agents are more responsible for the existence of the structure, and perhaps even gain some benefit by perpetuating the structure, then those agents have a special responsibility with regard to the structure. If I say that I want to hear what you are saying, but there is a wall between you and me, then, if I really do want to hear you, I'd better do something about that wall.

In a formulation that also integrates claims similar to the ones I was making about Hegel, James Marsh speaks to this question rather directly in *Critique, Action, and Liberation*:

> The excluded other, then, brings into play at least three . . . dimensions of rationality more or less hidden from the person in the privileged center: the necessity of recognizing and overcoming a gap between theory and practice, the necessity of recognizing and providing the material conditions requisite for such participation, and a certain utopian character to rationality. Because the ideal speech situation is, indeed, an ideal, it measures any finite situation and finds it wanting. The gap between ideal and reality points to and requires a future theoretical and practical praxis that would overcome or narrow the gap and supply the requisite material conditions for participation. If people are structurally, unjustly deprived of food, employment, health care, housing, wealth, income, self-respect, and opportunity to participate, then such structural justice has to be overcome. A material or political-economic basis for the ideal speech situation exists that needs exploring. (p. 133)

This, by the way, is what we might call Marx's "fourth formulation": "the categorical imperative to overturn all structures in which humanity is debased."

To sum up rather too quickly, then, it seems to me that if one were to really take into account the global issues that have been thematized here, one would have to see that a communicative action that really aims to listen to the marginalized other would have to make a qualitative break with the present form of its attachment to the European core, in the sense of being open to the rearticulation of that core at the margins.

As postscript only, I would like to mention that, in a recent talk (at Northwestern University) on "Two Hundred Years of 'Perpetual Peace'" (now published as "Kant's Idea of Perpetual Peace, with the Benefit of Two Hundred Years' Hindsight"), Professor Habermas did speak to some of these questions and I found that encouraging. For the first time, I heard him speak of imperialism, global systemic inequality, the Third World, and cotemporality (the simultaneous existence of the many timelines of diverse cultures). (Significantly, he also spoke of "virtual reality" and its potential effect on the ideal of communicative ethics.) Although I still found his general framework, in the end, to be what I would call Eurocentric, I was still hopeful about this development. On the other hand, Habermas's pronouncements on the NATO invasion of Yugoslavia, as well as his unwillingness to engage in dialogue with critics in a volume of the esteemed *Library of Living Philosophers* (apparently he was pushed in this direction on the advice of some of his American followers, who worried that Habermas might run into some "flamethrowers"—as one of these followers put it; in their view, I most likely fall into that category myself, but I am in good company there), do not bode well for an ethics of discourse.

BILL MARTIN

PHILOSOPHY DEPARTMENT
DEPAUL UNIVERSITY
SEPTEMBER 1999

REFERENCES

Bohman, James. *Public Deliberation: Plurality, Complexity, and Democracy.* Cambridge, Mass.: M.I.T. Press, 1996.

Derrida, Jacques. *Specters of Marx: The State of the Debt, the Work of Mourning, and the New International.* Peggy Kamuf, trans. New York: Routledge, 1994.

Habermas, Jürgen. *The Past as Future.* Interviews with Michael Haller. Max Pensky, ed. and trans. Lincoln: University of Nebraska Press, 1994.

Marsh, James L. "What's Critical about Critical Theory?" Paper presented at the 1995 meeting of the Society for Phenomenology and Existential Philosophy, Chicago and published in the present volume.

———. *Critique, Action, and Liberation*. Albany, N.Y.: State University of New York Press, 1995.

Martin, Bill. *Humanism and its aftermath: The shared fate of deconstruction and politics*. Atlantic Highlands, N.J.: Humanities Press, 1995.

———. "The hardest questions: Reflections on socialism after Emil Fackenheim." In *Politics in the impasse*. Albany, N.Y.: State University of New York Press, 1996; pp. 143–57.

Rabinach, Anson. "German Intellectuals and the Gulf War." *Dissent* (Fall 1991): 459–63.

Young, Robert. *White Mythologies: Writing History and the West*. New York: Routledge, 1990.

PART FOUR

COMPARISONS

21

William L. McBride

Habermas and the Marxian Tradition[1]

The first time I saw Jürgen Habermas was at a session of the Korčula Summer School, off the Dalmatian Coast of what was then the Croatian Federated Republic of Yugoslavia, in the summer of 1973. He there presented a paper entitled "Die Rolle der Philosophie im Marxismus". It was first published in what proved to be, to the best of my knowledge, the last international issue of the Yugoslav journal, *Praxis*, before its suppression by the government.[2] The issue is devoted to two themes, "Le monde bourgeois et le socialisme," under which Habermas's contribution is included, and "Technique contemporaine et destinée du monde". The first paper dealing with the first theme, and bearing the German version of the theme as its title, was by Ernst Bloch. One of the contributions listed under the second theme was a paper of mine entitled "Intellectual Productivity in Capitalist and Post-Capitalist Societies".[3]

One of my next encounters with Professor Habermas, if not the very next, was at my own university, Purdue, a couple of years later. On that occasion he presented an English-language version of his well-known paper, "Zur Rekonstruktion des historischen Materialismus", which, together with "Die Rolle der Philosophie im Marxismus" and ten other essays, constitutes the volume which bears the same title, *Zur Rekonstruktion.* . . . [4] I have followed, albeit somewhat at a distance, the progress of his career over the quarter-century since then—for example, the publication of his massive *Theorie des Kommunikativen Handelns*, his involvement in the acrimonious discussions about the disposition of the *Stasi* secret files, his turn to the philosophy of law in *Faktizität und Geltung*, his increased fascination with the philosophy of Carl Schmitt, and, most recently, his contribution to the occasional literature surrounding the

brief NATO war against Yugoslavia. It is by means of an extended reference to this essay, "Bestialität und Humanität",[5] a title that itself comes from a text by Carl Schmitt which he cites, that I propose to approach my chosen topic, Jürgen Habermas and the Marxian tradition.

It may well be objected that "Bestialität und Humanität" is, as I have called it, an *occasional* essay, written for a German newspaper, *Die Zeit*, and hence not intended to express deep philosophical ideas. I would like to urge that this objection be dismissed, on several diverse grounds. First, and most important to me, Habermas himself not only took the essay very seriously—it is long and quite carefully constructed, and it invokes, in places, some of the central themes of his later political philosophy—but he also apparently approved of the publication of a summary of it in a French magazine soon after its initial appearance. Therefore, it must be taken to represent his considered view. Secondly, even though much of his writing displays a highly abstract style with which, alas, philosophy as such is too often identified, Habermas himself has been more successful than perhaps any other philosopher since Sartre at playing the role of a public intellectual, at least within his own country. (Sartre was, I think, clearly *more* successful, particularly if one takes into account the international dimension of his "publicness", but his times were very different from ours, and intellectuals as such were both more respected and more contemned than they generally are now.) So Habermas has *intended* that his philosophy and his essays for the intelligent general public be linked, the former reinforcing the latter, and I regard this intention as a worthy one. One can of course distinguish the two genres, at least up to a point, but this does not entail making a radical distinction between their intellectual contents. Finally, I subscribe strongly to the view that philosophy, if it is to be done well, must be based in lived experience, and it seems to me that the NATO bombing of Yugoslavia constitutes one of the most important experiences of the last part of the exceedingly dramatic twentieth century; if one is somehow not allowed to reflect philosophically upon it, then philosophy itself is worth very little.

A second objection, probably more weighty than the first, against my using "Bestialität und Humanität" as a starting point for my discussion of Habermas and the Marxian tradition is that there does not appear to be any necessary connection between one's views about Marxism and one's opinion of the NATO bombing: opinion on the Left, for instance, was divided, whereas some writers who regard themselves as very strong opponents of Marxism were also strongly opposed to NATO's policy. This is factually correct, and could lead to an interesting philosophical discussion of the meanings of "Left" and "Right" today. But I intend to try to make a case, through a combination of historical connections and textual and conceptual analyses, that the direction of Habermas's intellectual

evolution over the years implied at least an *a priori* likelihood that he would take the qualifiedly pro-NATO position that he in fact did, and that this position in turn reflects a general attitude of moderate complicity with the institutions of contemporary capitalism that is incompatible with the Marxian spirit of radical critique of the capitalist system. I do not claim to be offering proof of *necessary* connections, of course: the types of subject matters with which I am dealing here never permit of such proofs, in any case.

What exactly is Habermas's position in this essay? It is, in effect, one of cautious endorsement of the bombing, along with a preference that in the future such actions should be undertaken by the United Nations rather than by NATO. Of course, he says, citing Ulrich Beck, the hegemonic United States has a longstanding tradition of blending together humanitarian selflessness and imperialistic power logic. Germans should be thankful about the way in which, as a result of this tradition, they were treated by this country after World War II. So the "straightforward and uncompromising" manner in which the United States government pursued the war against Yugoslavia as a matter of "normative power politics" is quite understandable (*"plausibel"*) in the same light.[6] But the precedent is somewhat problematic, for what if some day in the future a sinister military regime in some less enlightened part of the world, such as Asia, should decide to undertake armed conflict on the basis of a very different interpretation of the "law of peoples" or of the United Nations Charter? He therefore laments the absence of full *legal* legitimacy in NATO's actions, while accepting their *moral* legitimacy. Even though it is undoubtedly true that the nineteen member states are democratic, he says they nevertheless constitute just one party, acting paternalistically in a way not fully endorsed by global civil society.

He also, it should be noted, rehearses certain reservations that other Germans also expressed about some details of the bombings and some of their consequences. He cites approvingly the words of a Christian Democratic politician, Karl Lamers, to the effect that our understanding tells us that our consciences should be clear but that our hearts will not listen to this, and hence we are uncertain and troubled. As I have already noted, he based the title of his article on a slogan adopted by the anti-humanistic, sometime Nazi thinker, Carl Schmitt, "Humanität, Bestialität", whose ideas have greatly preoccupied Habermas and some of his followers in recent years. Schmitt maintained that the idea of mankind is a fraud; Habermas worries that the guiding principle of "our red-green regime", *legal pacifism* as he identifies it (at one point in English), may be put into question by the events in Yugoslavia.[7] But ultimately, of course, he rejects such pessimism in the name of the new world order that was already being created at the time of the Gulf War (which, it will be remembered, he

endorsed even more enthusiastically than this one because it had the United Nations' blessing) and that he foresees as becoming more robust in mankind's bright future. He dismisses boasts of national sovereignty by "states like Libya, Iraq, or Serbia" as "neurotic".[8] And he cites with approval the remark of the Slovenian thinker, Slavoj Žižek, as follows: "But the Serbs who are dancing in the streets of Belgrade are, as Slavoj Žižek asserts, 'no Americans in disguise, who are waiting there to be released from the curse of nationalism.' "[9] Therefore, he concludes, a political order that guarantees equal rights for all citizens is being imposed upon them "*mit Waffengewalt*" (by force of arms).[10]

When I read this my mind flashed back to the beaches of Korčula of many years ago, when Habermas was being treated with hospitality and even lionized by philosophers from Serbia, Croatia, Slovenia, Bosnia, and other parts of Yugoslavia as it was then. Some of those individuals, such as our mutual acquaintance Mihailo Marković, did indeed slip into versions of nationalism leading to consequences that in my view can only be seen as highly negative—though each individual case is somewhat different. Probably few or none of the Korčula philosophers of 1973 were among the dancers on the streets during the bombings, for generational reasons if for no others. But to dismiss "*the* Serbs" in their entirety as a quasi-barbaric group of people, and moreover to treat as an illustration of their barbarism the courageously defiant dancing that mostly younger people engaged in as a way of showing mutual solidarity in the face of a *Luftwaffe* that was treating them as things—quite expendable things in the cases of those who happened to suffer the misfortune of becoming "collateral damage"—is itself, it seems to me, inhumane if not beastly, exhibiting a seriously flawed sensitivity and raising profound questions about the writers' claims to superior rationality. One of those dancers was in fact Natalija Mićunović, the daughter of one of the erstwhile *Praxis* philosophers and the founder of the opposition Democratic Party in Serbia, Dragoljub Mićunović, and who herself completed, three years ago, her Purdue University doctoral dissertation in philosophy, entitled "A Critique of Nationalism".[11] I find it thoroughly inappropriate for Habermas to invoke Žižek's witticism in order to compare the life-threatened Serbs unfavorably to the people whose government is, in most important respects in today's world, clearly the most nationalistic of all: Americans!

Up to this point, I have not mentioned Marx or Marxism except in citing the titles of a couple of Habermas's earlier papers. Neither, of course, in the article upon which I have been focusing, does Habermas—not once. Why should he? In his most recent *magnum opus*, *Faktizität und Geltung*, Marx is still discussed occasionally, though considerably less frequently than Luhmann or Rawls.[12] In the index to the long 1992 collection of essays by Habermas scholars on that book (with a reply by Habermas), the product of

a conference at the Cardozo Law School in New York, *Habermas on Law and Democracy: Critical Exchanges*, there is not a single entry for Marx or Marxism.[13] In Habermas's more recent collection of articles, *Die Einbeziehung des Anderen*,[14] I find only three indexed one-line references to Marx, of which two are entirely incidental and the other merely refers to Marx's alleged need to find a substitute for law in future society. All of these content-analysis observations may seem trivial, but I hope now to begin to try to show not only that they betoken a huge and growing crater within Habermas's later thought, but also that there is an important connection between them and the contents of "Bestialität und Humanität".

As Tom Rockmore has noted in his book, *Habermas on Historical Materialism*, "In an interview in 1979 [Habermas] stated without qualification that it is not possible to save the Marxian theory of value, but he is proud to consider himself a Marxist."[15] In an article published in 1982 entitled "Habermas and Marxism", Agnes Heller concentrated on two sets of problems with respect to which, as she saw it, Habermas continued to be engaged with and critical of Marx, to wit, the relationship between theory and practice and, once again, historical materialism. She asserted there that Habermas was quite un-Marxian in certain fundamental ways—in particular, in being compelled by his own theoretical presuppositions "to disregard the whole motivational system of human beings,"[16] in excluding the more "romantic" elements in Marx's way of thinking, and in maintaining, in contrast to Marx, an "unconditional" view of progress in human history from which the sense of *tragedy* is entirely absent. "For him," she says, "progress is a fact—at least he wants to persuade us that it is. We are developing splendidly."[17] But she still appears to situate Habermas more within than without the Marxian tradition.

However, Rockmore seems to me to make a fairly conclusive case that Habermas had abandoned Marxism by the time his longest book of all, *The Theory of Communicative Action*, saw the light of day, which was one year prior to the appearance of Heller's article. Of course, as Rockmore himself acknowledges, this assertion depends in part on just what one understands by "Marxism". In this context, one should never forget the claim made by Lukács, Heller's early teacher and apparently an especially important initial influence in shaping Habermas's understanding of Marx, to the effect that Marxism would remain true as a method even if all of its principal specific propositions were to be falsified. One might, alternatively, mean either the Marxism of Marx himself or one or another strand of theory and/or practice that identifies with a tradition begun by Marx. With respect to this, Heller again makes some very apt remarks: "Habermas turns to Marx with a sovereign gesture. He never undertakes to dissect the delicate fibres of the tissues called the *oeuvre* of Marx, nor does he attempt to understand a *cogito* called Karl Marx. His Marx is the institutionalised one: Marxism, historical

materialism."[18] Given this, one is still somewhat shocked to read, at the
outset of "Toward a Reconstruction of Historical Materialism," that the
version of it which Habermas proposes to reconstruct is the 1938 formula-
tion undertaken by Stalin in his *Dialectical and Historical Materialism*, a
version which, according to Habermas, exerted considerable subsequent
influence.[19] What the reader finds, in any case, as this long article evolves is
that Habermas makes fewer and fewer references to Marx, much less to
Stalin, and that he begins to elaborate a quite different historical anthropol-
ogy based primarily on a number of non-Marxian authors. So it is not very
surprising to find the later Habermas giving up all pretense at believing in
historical materialism in any meaningful sense, or in the Marxian conception
of base and superstructure, or above all in the labor theory of value.

 Is this the end of the story with respect to scholars' perceptions of
Habermas and the Marxian tradition—to wit, a gradual but decisive parting
of the ways? Hardly. David Ingram, for example, in his *Habermas and the
Dialectic of Reason*, detects certain respects, notably a renewed emphasis on
the phenomenon of reification, in which the Habermas of *The Theory of
Communicative Action* seems to have come closer once again to certain
Marxian ways of thinking.[20] Jane Braaten, in her useful brief overview of his
thought entitled *Habermas's Critical Theory of Society* (1991), at one point
identifies him as "a contemporary Marxian [who] diverges from Marx."[21]
And Nancy S. Love, in her even more recent (1995) contribution to *The
Cambridge Companion to Habermas*, "What's left of Marx?" appears to
conclude, on the basis especially of extensive references to a 1991 Habermas
essay entitled "What Does Socialism Mean Today?" that the answer to *her*
question, at any rate, is "Quite a lot."[22]

 To be more precise, what she says in her next-to-last sentence, citing
from Dennis Fischman's book entitled *Political Discourse in Exile: Karl
Marx and the Jewish Question*, is: "Ultimately, what is left of Marx is the
conviction that 'people can be more human than their society permits.' "[23]
I find it most interesting that this conclusion concerning Habermas's
socialism, with its accompanying suggestion that the tradition of Jewish
mysticism (according to which humanity is "in exile") furnishes some
ground for hope of a sort that cannot be more concretely specified, sounds
strikingly similar to the so-called "last words" of Jean-Paul Sartre—the
latter's interviews with Benny Lévy, published just prior to his death, which
were given the title, "Hope, Now", and in which he took solace in certain
aspects of Jewish Messianism and continued to cling to his long-cherished
dream of "achieving the human", or "achieving humanity", despite the
rottenness of the world situation as he saw it.[24] But I question whether,
despite her having located (not surprisingly, given the culture in which he

lives) a few religious references in various Habermasian texts, Love's rather creative interpretation of Habermas via Fischman's interpretation of Marx is really very successful in capturing the essential Habermas. In fact, one of the three specific points which she identifies as constituting, at least according to her, major matters of contention between Habermas and Marx is the question whether "history is progressive."[25] (The others are their respective views of the role of labor, to which I shall return, and the perception of societies as totalities.) On this issue, in apparent total contrast to Heller's previously-noted assertion on this point, Love claims that Habermas rejects all teleologies of history, hence any conviction of inevitable progress, and maintains that "moral-cognitive developments only create the logical space for new forms of social organization," not a *necessity* for them.[26] This is a very sober, unromantic view of the historical possibilities of human emancipation which appears to me to be thoroughly in keeping with Habermas's preference for Enlightenment-inspired rationality; but such a world-outlook has very little in common with religious mysticism, with its connotations of passion, tragedy, and mystery. Rather, Enlightenment thinking seeks radically to recontextualize the latter by developing *concepts* (instead of mere "images") that have "a scientific bearing".[27]

Even if Love's "mysticism" thesis is somewhat dubious, however, is it not true that Heller was simply wrong in contending, in stark contrast to what Love appears to be claiming, that, for Habermas, there has been and is progress, and "we are developing splendidly"? I think not. Despite his laudable disapproving allusions to the "colonization of the lifeworld" by money and power, the tone of all of his more recent work with which I am familiar strikes me as being that of, at best, a liberal critic who finds some worrying trends in contemporary society but is on the whole not deeply unhappy with its evolution—or, if one prefers, "progress". It would, in fact, be difficult for someone for whom the word "*Aufklärung*" conveys such a positive resonance to feel otherwise. Love herself admits, at several points in her article, that her interpretation is more of a future vision of Habermas as "consciously embracing socialism as a 'politics of return'," a development which according to her "might transform [his] theory of communicative rationality," than a description of his present position.[28] She also notes that he at one point, somewhat uncharacteristically, singles out the women's movement as "the only contemporary emancipatory movement because it alone 'follows the tradition of bourgeois socialist liberation movements' and pursues 'the realization of a promise that is deeply rooted in the acknowledged universalist foundations of morality and legalism.'"[29] Love expresses a number of reservations about this language. In fact, it is difficult not to see in these utterances both an enormous conceptual distance from the world of

Marx (who was, of course, deeply suspicious of all alleged "universalist foundations of morality and legalism") and an at least implicit sense that historical progress is continuing to take place, though perhaps not quite at the pace that one might wish. These attitudes, I maintain, are generally reflected throughout *The Theory of Communicative Action* and the later, strongly law-oriented *Faktizität und Geltung*.

Even if this claim—a rather difficult one to prove with rigor when such lengthy texts, filled with analyses of still other thinkers, are involved—should be contested with respect to them, it strikes me as quite inescapable when applied to the text with which I began, "Bestialität und Humanität". Here, while he expresses reservations over the unilateral nature of NATO's decision to bypass the United Nations, a decision which obviated the possibility of acting with the full international legal legitimization that he would have preferred, Habermas declares the bombing to have been morally justified and expresses satisfaction that it was undertaken in the service of democracy and of a global order in-the-making. As the newspaper's large-print summary of his message on the first page of the text puts it, "Resort to force? If nothing else works, democracies must be allowed to hurry to the rescue, says the Frankfurt philosopher. Jürgen Habermas advocates a global civil law [*Weltbürgerrecht*]. . . . "[30] And while, as I noted earlier, he acknowledges doubts about some details of the military action and about the apparent mixed motives of the American involvement, he evinces little sense of the deep tragedy involved (the ruin of so many lives, even if the numbers of deaths were relatively low, and the destruction of an entire nation's infrastructure) or, even less, of the enhancement of dominant global politico-economic interests which was such an obvious objective. Rather, in the manner of the most unreflective citizen parroting NATO propaganda, he denounces the dancing citizens of Belgrade for not thinking like Americans and pronounces them deserving of what they are getting.

In fact, the Rambouillet Ultimata (to call them "Accords" is to invoke the spirit of Orwell) that NATO tried to impose on the Serbian authorities just prior to the bombing envisaged, among other things, unlimited access of NATO to any part of the territory of Yugoslavia to which it might please it to go, and "reform" of the country's laws and economic institutions in order to bring it into line with global capitalism by eliminating remaining socialist vestiges; I shall return to this latter point. They were drawn up secretly and without consultation with parliamentary bodies, much less the populace at large, in, as far as I am aware, any of the NATO countries; the decision to "punish" the Yugoslavian government (but of course not the people, as President Clinton assured them in an almost inconceivably hypocritical radio broadcast in the early days of the bombing) was made in a similar way by a few high-level executives. The government of at least one NATO country

that was in principle opposed to this action, Greece, relented under extreme pressure from the others, led, of course, by the United States government. The governments of at least two neighboring countries that are not parts of NATO, Romania and Bulgaria, were strongly pressured to accommodate NATO planes in their airspaces; but they were apparently not consulted about NATO's decision to halt commerce, upon which their already-fragile economies depended in part, on the Danube River by destroying and submerging several of the largest bridges within Yugoslavian territory. Under these circumstances, Habermas's phrases, "*19 zweifellos demokratische Staaten*" (that is, the countries of NATO) and (concerning "*Staaten wie Libyen, Irak oder Serbien*") "*neurotisch auf ihre Souveränität pochen*",[31] can only be characterized as pathetic. There was virtually no democratic process at any point, and to characterize as "neurotic" the wish, on the parts of smaller states (including some that are *not* currently being advertised by CNN and other international mass media as the incarnations of evil), to preserve a measure of independence in today's world of increasingly extreme dominance by hegemonic "money and power" (to use Habermas's own expression) is itself pathological.

How has the heir to the Frankfurt School of Critical Theory managed to come to this point? There are no doubt many reasons, among which one should probably count historical disappointments such as the self-destruction of the regimes of so-called "really existing socialism" and, at a more personal level, the disastrous failures of theoretical and practical leadership by thinkers such as Marković, who at a certain point actually aligned himself publicly with Slobodan Milošević, and other *Praxis* philosophers who could perhaps have made a positive difference in former Yugoslavia.[32] (The suggestion that Habermas may have felt, however marginally and in passing, disappointment over the latter set of developments is somewhat speculative on my part, but it is a fact that Habermas cited the *Praxis* philosophers as being a significant movement in "Die Rolle der Philosophie im Marxismus", the paper that he first presented at Korčula to which I referred at the outset of this paper, and he has done so elsewhere as well.) Events such as these have undoubtedly contributed to an enormous decline in the perceived stature of the radical intellectual tradition inaugurated by Karl Marx, even though from a strictly logical point of view the failures of regimes and individuals who claim to have been inspired, in one way or another, by a certain body of thought does not *eo ipso* invalidate that body of thought. (Marx, it might be objected, is an exception to this because a conviction that the imminent triumph in practice of his revolutionary expectations—in other words, a belief in inevitable historical progress within a relatively brief and roughly predictable time period—constitutes an important part of his doctrine, so that the lack of such "progress", at least as he conceived it, *does*

invalidate the doctrine; but for reasons that I have discussed elsewhere[33] and that it would take us too far afield to rehearse in this paper, I dissent, *pace* Nancy Love and many, many others, from this conception of Marx's philosophy.) Habermas has appeared very eager, over the years, to be well attuned to perceptions of what is *à la mode* in intellectual circles. Unlike Jacques Derrida, for instance, he does not now seem to be haunted by Marx's ghost.

But, if concerns about the future of human society that once led him to declare himself a Marxist and even more recently, and no doubt still today, to be a socialist (although perhaps of the "bourgeois" variety, like contemporary feminism as he conceives it) remain important to him, he should be. For, while technological developments over the past quarter-century have brought about an exponential multiplication of certain kinds, though not necessarily consensus-building kinds, of the human communication that has always been so dear to Habermas's heart, at the same time the exercise of dominance by certain groups (call them "classes", if you dare)[34] over others in the political and economic spheres domestically, and by a few governments and international alliances that are increasingly controlled by those groups over the rest of the world at a global level, has intensified enormously. I do not consider it necessary to argue for this contention here; statistics, even some published by very pro-capitalist institutions, leave no doubt as to its validity, and I and many other writers have argued for it elsewhere. In a certain sense, the question may be seen as one of comparative *importance*: Is the undoubtedly praiseworthy increased commitment to issues of individual human rights, at least in theory and among a certain global elite (a word that I am not using pejoratively here), though obviously not in practice in many places—a commitment regarded as overriding claims to national sovereignty, except of course in the cases of the strongest and most powerful states—of greater concern, ultimately, than the stupendous progress of global economic and political hegemony on the part of the single remaining superpower, its close allies, and the transnational corporations that play such a large role in setting their strategic agendas? Habermas has, by all accounts, said very little of a systematic nature about the latter phenomenon in recent years, though much about the former, the cause of human rights. The ghost of Marx, endowed with the realization that early Habermasian talk of "*Spätkapitalismus*" was at best premature, gestures with insistence toward "*l' état de la dette, le travail du deuil, et la Nouvelle Internationale*"[35] and urges him and all of us political philosophers to recognize the transcendent importance, today, of focusing on the global economic dimension—without, of course, disregarding other dimensions.

Without wishing to dwell here on the place of NATO's war against Yugoslavia within this canvas, a place that I consider to be perhaps as

significant for the historical future as were the 1989 events in Eastern Europe and the subsequent collapse of the USSR, I will simply point out two facts. First, during the bombing there was a great deal written by NATO cheerleaders such as Thomas Friedman and, once the bombing began, Henry Kissinger about the importance of "success" for preventing any future challenges to United States global hegemony, as distinguished from the significance of outcomes within Yugoslavia itself. Obviously, Kosovo itself has no great economic value, as far as anyone knows, within the context of global capitalism; but it was used as an occasion. Second, there has been considerable talk since the end of the bombing, even in such NATO-loyal media as the BBC, about the alleged need to bring Yugoslavia to its knees, or lower, in order to end its economic exceptionalism and thus make the Balkans and beyond conform to the global capitalist model. The previously mentioned inclusion of clauses mandating such conformity in the Yugoslav economic "system", presumably leading to parallel conformity within its "lifeworld", in the Rambouillet Ultimata appears to confirm this analysis.

There is much that has already been written, and much that still remains to be written, about certain characteristic features of Habermas's style of philosophical thinking which, from the standpoint of critics like myself, occlude at least as much as they illuminate social reality. His tendency to dichotomize or trichotomize, to draw extremely sharp lines between, for instance, "system" and "lifeworld" (or, say, between *"Moralität"* and *"Sittlichkeit"*, *"Theorie"* and *"Praxis"*, and so on) is perhaps the most salient such feature, one which he is by no means, of course, the first philosopher to have employed, but with which his writing is especially replete. In the case of the "system/lifeworld" dichotomy, a number of critics have remarked that, while it may seem clear enough at the level of abstract conceptualization, it is not so clear or perhaps even so useful at the level of application. If we take the metaphor of "colonization" seriously, for example, how are we to conceive of one distinct type of entity's spawning colonies within another type of entity that is supposed to be radically different from the first? It reminds me of the science fiction enterprise of aliens from another planet trying to colonize Earth; does it make sense as a faithful representation of what is really going on, concretely, in the contemporary world? Or is it not rather the case that elements of system and of lifeworld are, in the *real* world, already inextricably intertwined?

There is only one Habermasian dichotomy upon which, in conclusion, I would like briefly to focus here, and it is one around which, even some years ago, he took his distance from Marx: "goal-rationality"—that is, work or labor *per se* together with strategic decisions made in the process of carrying it out, roughly corresponding to what Marx called the "sphere of production"—*versus* "communicative rationality". In stressing production

over communication, Habermas has always maintained, Marx made a fundamental error, the presumed need to rectify which may in a sense be seen as the original inspiration of the entire Habermasian philosophical project. One of Habermas's *many* critics on this issue, John Patrick Murray, makes an especially strong and clear case to the effect that Habermas was simply wrong to deny that labor, or at least labor or work as understood by Marx, includes a communicative component;[36] among other things, he points out, Habermas simply misunderstood a crucial text in Marx's *Grundrisse* on which he relied heavily in making that denial. Heller, in her article referred to earlier, confirms Murray's point, making the same criticism: "There is only *one viewpoint* in which work is identical with material production: that in which we define it as the metabolism of society with nature. Marx did define it in this way, but not exclusively; with Habermas the definition becomes exclusive." She points out that "even rational communication—even discourse—can be defined as work."[37]

In the paper that I myself presented at Korčula, long since buried figuratively, and almost literally, beneath its sands, I addressed the question of "Intellectual Productivity in Capitalist and Post-Capitalist Societies," beginning with the question of just how Marx himself viewed the intellectual (or, if you will, "communicative") professions of teaching, writing, and so on. I agreed that, for Marx, such "labor" had to be considered, at least at first glance, unproductive within capitalist societies, where by definition the only real "products" are "commodities with exchange value." Not only must one add some qualifications to this initial understanding even within capitalism, I showed, but for Marx it would no longer make sense to view the same activities in the same way in post-capitalist societies. A careful analysis especially of certain passages in *Theories of Surplus Value*—the much-neglected so-called "fourth volume" of *Capital* in which Marx discusses in great detail the works of some of his predecessors in the field of political economy—shows the basis of his thinking: it was Adam Smith who, in large measure out of contempt for the clergy, whom he considered thoroughly unproductive, devised this distinction which Marx clearly proceeded to use, as was his wont, as the basis of an internal critique of both Smith's thought and the economic system that it defended. Moreover, as Marx showed in this work, Smith sometimes slips into the confusion of an extremely crude materialism, whereby "production" is equated with the making of material things; Marx, far from going along with this equation, identifies and severely criticizes it.

Perhaps if Habermas had been actually present when I presented my paper at Korčula he would have come to rethink his criticism of Marx's thought as being inhospitable to the activity of communication within the sphere of production and his consequent relegation of the Marxian tradition

to the other side of an alleged labor/communication divide. I jest, of course. The very idea of so simply achieving a communicative consensus between and among diverse philosophical interpretations, whether of Habermas or Marx or anyone else, is in fact just as "idealistic", in the pejorative sense of that word, as is the proposal of postulating a similar consensus as a regulative ideal for the social world.

<div align="right">WILLIAM L. MCBRIDE</div>

PURDUE UNIVERSITY
OCTOBER 1999

NOTES

1. I am grateful to my colleague, Martin Matuštík, who has just completed a manuscript entitled *Jürgen Habermas: A Philosophical-Political Profile*, for having helped me with many suggestions. I should point out, however, that his own judgments of Habermas's thought, while not unmitigatedly positive, are far more so than some that I make here. I wish further to express my gratitude to participants in the semi-annual meeting of SOFPHIA, held on September 25, 1999 in North Leverett, Massachusetts, for their critical comments on an earlier draft of this text. I am especially grateful to Jane Drexler, graduate student in philosophy at the University of Binghamton, for her initial presentation of it, in accordance with SOFPHIA's practice.

2. Jürgen Habermas, "Die Rolle der Philosophie im Marxismus", *Praxis* 10, no. 1–2 (1974): 45–52.

3. William L. McBride, "Intellectual Productivity in Capitalist and Post-Capitalist Societies", *Praxis* 10, no. 1–2 (1974) 227–36.

4. Jürgen Habermas, "Zur Rekonstruktion des Historischen Materialismus", in *Zur Rekonstruktion des Historischen Materialismus* (Frankfurt am Main: Suhrkamp, 1976), pp. 144–99.

5. Jürgen Habermas, "Bestialität und Humanität: Ein Krieg an der Grenze zwischen Recht und Moral", *Die Zeit* 18, April 29, 1999, pp. 1, 6, and 7.

6. Ibid., p. 7. All the words and phrases cited in English from this article are my translations, unless otherwise noted.

7. Ibid., p. 1.

8. Ibid., p. 7.

9. Ibid.

10. Ibid.

11. Natalija Mićunović, "A Critique of Nationalism" (Ph.D. diss., Purdue University, 1996).

12. Jürgen Habermas, *Faktizität und Geltung: Beiträge zur Diskurstheorie des Rechts und des demokratischen Rechtsstaats* (Frankfurt am Main: Suhrkamp, 1992).

13. Michael Rosenfeld and Andrew Arato, eds., *Habermas on Law and Democracy: Critical Exchanges* (Berkeley/Los Angeles/London: University of California Press, 1998).

14. Jürgen Habermas, *Die Einbeziehung des Anderen: Studien zur politischen Theorie* (Frankfurt am Main: Suhrkamp, 1996).

15. Tom Rockmore, *Habermas on Historical Materialism* (Bloomington and Indianapolis: Indiana University Press, 1989), p. 110.

16. Agnes Heller, "Habermas and Marxism", in John B. Thompson and David Held, eds., *Habermas: Critical Debates* (Cambridge, Mass.: MIT Press, 1982), p. 25.

17. Ibid., p. 37.

18. Ibid., p. 22.

19. Habermas, "Zur Rekonstruktion des Historischen Materialismus", p. 144.

20. David Ingram, *Habermas and the Dialectic of Reason* (New Haven and London: Yale University Press, 1987).

21. Jane Braaten, *Habermas's Critical Theory of Society* (Albany: State University of New York Press, 1991), p. 128.

22. Nancy S. Love, "What's left of Marx?" in Stephen K. White, ed., *The Cambridge Companion to Habermas* (Cambridge/New York/Melbourne: Cambridge University Press, 1995), pp. 46–66.

23. Ibid., p. 63.

24. Jean-Paul Sartre and Benny Lévy, *Hope Now: The 1980 Interviews*, trans. Adrian van den Hoven (Chicago and London: University of Chicago Press, 1996).

25. Love, op. cit., p. 49.

26. Ibid., p. 51.

27. Jürgen Habermas, "Between Philosophy and Science: Marxism as Critique", in *Theory and Practice*, trans. J. Viertel (Boston: Beacon Press, 1973), p. 236. He makes this point in the second sentence after his reference to structural parallels between Marx's early writings and God's "mythical act" of self-alienation that is cited by Love, op. cit., p. 48, following Fischman, as evidence of connections with religious, and specifically Biblical, ways of thinking.

28. Love, op. cit., p. 62.

29. Ibid., p. 58.

30. *Die Zeit*, April 29, 1999, p. 1.

31. Habermas, "Bestialität und Humanität", p. 7.

32. I discuss this in my *Philosophical Reflections on the Changes in Eastern Europe* (Lanham: Rowman & Littlefield, 1999), pp. 57–58.

33. See the chapter on "Prediction" in my *The Philosophy of Marx* (London: Hutchinson, 1977), pp. 116–26.

34. Habermas, especially in his later writings, tends to regard such terminology as *passé*.

35. This is the subtitle of Jacques Derrida's *Spectres de Marx* (Paris: Éditions Galilée, 1993).

36. John Patrick Murray, "Enlightenment Roots of Hegel's Critique of Marx", *Modern Schoolman* 57 (Nov. 1979): 7.

37. Heller, op. cit., p. 34.

Response to William Mcbride's "Habermas and the Marxian Tradition"[1]

Jane Drexler

In "Habermas and the Marxian Tradition," William McBride approaches a two-sided question: (1) what is Habermas's relation (if any) to Marx and Marxism, and (2) how does what appears to be a lack of such connection affect his position concerning the NATO intervention in Yugoslavia? Referring to Habermas's recent essay, "Bestiality and Humanity," on the Kosovo conflict, written for *Die Zeit* weekly magazine, McBride draws several conclusions about how Habermas's divergence from a Marxist critical analysis of international affairs has resulted in the (unacceptable) "cautious endorsement" of the bombings and other military activity in Kosovo, and can also shed light on a more general problem within Habermas's work: a lack of consideration for economic-hegemonic factors fundamentally involved in contemporary politics and the "push" for a "new civil world order."

As I said, McBride summarizes Habermas's position on the conflict as a "cautious endorsement." "Cautious" in that: (1) it did not have full legal legitimacy, since NATO bypassed the endorsement of the UN; (2) that the U.S., for instance, has often linked humanitarian selflessness with imperialistic power logic; (3) that the lack of institutionalized humanitarian standards of international intervention sets a problematic precedent because there are no proper guidelines for intervention by different countries; as well as reservations held by other critics of the intervention, relating to, for instance, Carl Schmitt's skepticism that those who use the rhetoric of humanitarianism are usually hiding some bestial intentions behind it. On the other hand, Habermas endorses the intervention in that it has been undertaken in the service of democracy and a global order in the making and in that it is morally justified (if not legitimated and codified).

McBride finds Habermas's position here substantially uncritical and pretty much wrong, and wonders how, as the heir to the Frankfurt School and critical theory, Habermas could have gotten to this point. While he

speculates about the possibility that his position emerges from a disillusion-
ment of the radical intellectual tradition and the failures of "actually-
existing" socialist regimes, ultimately the focus of McBride's argument is to
claim that Habermas's views here originate from his rejection of several
crucial aspects of Marxian thought.

McBride utilizes the work of several Habermasian scholars and critics to
briefly sketch out (a) where they find Habermas remaining aligned with or
at least engaged with Marx (that is, his renewed interest in reification, a
conviction that people can be more human than their society permits, and so
forth); and (b) where they find Habermas very un-Marxist—generally
speaking, in that he has almost entirely abandoned Historical Materialism.

At this point, then, it may help to spend a little time discussing how and
why Habermas rejects, or in the case of the essay to which McBride and
myself refer, "reconstructs" Historical Materialism.[2]

In response to the Frankfurt School's focus on the critique of enlighten-
ment rationality and instrumental reason as, rather than leading to emancipa-
tion, in fact being severed from it, Habermas argues for a distinction between
instrumental and "communicative" rationality.[3] He argues that the problem
with Marx's analysis of base/superstructure is that it posits an unnecessary
causal dependency of the superstructure (the social relations, culture,
morality, law, and so forth) on the base (the economic system of a society).
According to Habermas, Marx does not acknowledge the interactive/
communicative aspects involved in the relations of production. The social
aspect of labor implies social cooperation, which requires linguistic com-
munication, which, in turn, precedes both production and social organiza-
tion.[4] Secondly, Habermas argues, a look at history shows that productive
forces coincide with several different modes of production, and therefore
there seems to be, not a necessary connection between *this* productive force
and *that* mode of production, but rather only a logical possibility for the
evolution of modes of production—based on, as Habermas conceives of it,
the level of development of a society's communicative rationality and its
moral-practical knowledge.[5] Additionally, Habermas claims that while a
Marxist conception of society may explain how societies reach critical crises,
it cannot explain how societies can and do resolve them.[6]

Here, Habermas rejects what he sees in Marxist historical materialism as
a "unilinear, necessary, uninterrupted, progressive development of a
macrosubject."[7] Generally speaking, then, Habermas argues that the super-
structure (or rather, what he calls the lifeworld) is not fully determined by
the base (what he calls the system), and that, therefore, there are politi-
cal/cultural/moral/legal possibilities for undetermined, emancipatory reason
and action.

Perhaps contra McBride, I am very sympathetic to a number of
Habermas's positions regarding subjectivity and politics. As Nancy Love

points out (and McBride notes) Habermas seems to be aligned with Marx in the sense that humans can be more than their society allows—that emancipatory action is possible and that people can act to change the society in which they live. And, therefore, he may be right to try to figure out what more is at work in the construction of the lifeworld than merely the instrumental reason originating from the system. That there is a potential for political agency within an oppressive system seems like an important and correct position for which to argue.

However, I think that McBride has shown that Habermas's re-theorizing on social organization, crisis and politics, specifically in "Bestiality and Humanity," does more to dismiss or ignore the realities of the economic power and political and ideological hegemony within the contemporary world than to address those issues in an attempt to answer the concerns above. While one of Habermas's chief arguments in his *Theory of Communicative Action* is that in modern society the lifeworld is "colonized" by the instrumental reason originating from the system (and that, therefore, power and hegemony illegitimately intrude upon civil society and politics), it is difficult to see how this insight into the "colonization of the lifeworld" plays out in his (at times) overly-enthusiastic approval of NATO's bombing of Kosovo. Here, it seems that McBride has noticed, correctly, that Habermas has marginalized (or dismissed) his own recognition of power and hegemony. In this way, he fails to address, in "Bestiality and Humanity," his recognition that in modern society debate within civil society and politics has been corrupted by instrumental reason.

Given all this, on the one hand, one could respond, "so what?" so Habermas is not a Marxist. And move on. But things get more difficult when one attempts to include an analysis of power and hegemony within a political model that relies on Habermas's notion of communicative rationality—a model that has become increasingly interesting to philosophers trying to develop a theory and practice of "the political."[8] This is where, it seems to me, the question of just how much Habermas can add to an attempt to construct a politics that does not render invisible power and hegemony is difficult, but necessary, to think through.

If we are to think about the possibility of utilizing any of Habermas's theories for models of radical democratic politics, and even more so for a world civil order, it seems we need to address his claim that societies can affect new social organization only to the extent allowed by their level of communicative rationality, or their moral-practical "development." In "Bestiality and Humanity," Habermas makes what appears at the outset to be an insightful note: At this point in history, first-world countries (who 200 years ago were "neurotic" about their own national sovereignties) are now affluent, powerful, stable, and so forth enough (and assumedly rationally-developed enough) to understand that the transition to a global politics and

economics is preferable and necessary. At the same time, however, second-world countries are in the (developmental) stage "we" were in 200 years ago (thus, their neurosis about their own national sovereignty). While he sees this as a serious issue that must be accounted for—and not, in my understanding, as an outright justification for imposing this world order by force—he nevertheless ultimately concedes that intervention into second-world countries is justified.

This notion of "development" has led many of Habermas's critics to level the accusation that his theories are Eurocentric—a charge that Habermas himself would find unacceptable if true. However, Habermas's explanation of Second and Third World neuroses does appear to be founded on a problematic notion of development. What is missing here is a recognition of the effect of first-world economics and hegemony on these "Second (and Third) Worlds," and moreover, a recognition of the Second and Third Worlds' natural resources, laborers, and such upon which the First World relies for its power and prominence.

I am reminded here of Enrique Dussel, who, in his 1992 address to the Frankfurt school, reminded the German audience of Europe's rise to power by the colonization of South America, India, and other countries—in terms of trade, labor, resources, produced knowledges, and so on; and yet the European consciousness saw itself as the center of History, culture, knowledge, and science; unrelated to and certainly unreliant on the "primitive" societies European countries colonized and exploited.[9] It seems, then, that Habermas may be falling into this same Eurocentric trap by conceiving of second-world countries such as Libya, Syria, and Iraq as less rationally developed (both in terms of communicative rationality and technical rationality) than the First World by at least 200 years. My sense is that Habermas's notion of development (and its Eurocentrism) here may stem directly from his separation of the economic system from the lifeworld. I mean, then, to say *more* than just that Habermas may be Eurocentric—an over-stated and ultimately unuseful charge (like charging Plato with sexism). I mean to posit the possibility that because Habermas theoretically separates the lifeworld and system (albeit with movement across this distinction), he loses the opportunity to recognize his own idea of development as, itself, a result of a colonialist consciousness. This loss also, then, seems to be linked to his maintaining the idea of "progress" and "development" of the First World's rational desire for a "new world order." This charge seeks to ask radical-democratic theorists who use Habermas to work through this dilemma. The point here is not necessarily to drop Habermas, by any means. It is rather to ask how to negotiate his concept of rational development alongside his insights on the "colonization of the lifeworld" and the possibilities of emancipatory rationality while we theorize and act in an increasingly globalized social and political world.

Finally, as I reach the end of this essay, I realize that all of this above commentary has rendered invisible the actual terrorist and genocidal events in Yugoslavia. Some argue that although the rhetoric of humanitarianism is being thrown around, it is merely hiding something bestial like a desire for more dominance by, for instance, American and corporate superpowers. However, I agree with Habermas's point, in his essay, that it is not quite as simple as that—that while there is no legal legitimacy for humanitarian intervention, there is a necessity for it. Genocide, terrorism (in its many forms), displacement, and so forth involve major political, economic, and hegemonic forces, and do require action.

What seems more difficult to agree with Habermas on, though, is his understanding of how to legitimate such intervention, and what that intervention should look like. Since Habermas's rejection of a Marxist critical analysis has seemingly led him to endorse the intervention with, at best, a sideways glance at how power and dominance are playing a large part in the global civil order whose inauguration he awaits, I would like to begin rethinking how these necessary interventions could be thought out and legitimated in ways that account for power (on multiple levels) and hegemony.

<div align="right">JANE DREXLER</div>

PHILOSOPHY DEPARTMENT
SUNY-BINGHAMTON
JANUARY 2000

NOTES

1. I would like to thank the following people for their comments and conversations regarding this essay: Michael Hames-Garcia, Bat-Ami Bar On, Max Pensky and the Socialist Feminist Philosophers Association (SOFPHIA). Additionally, I would like to thank William McBride for the opportunity to respond to his essay, and for our conversations about it. Of course, any errors in this text are solely my own.

2. Jürgen Habermas, "Towards a Reconstruction of Historical Materialism," *Habermas on Society and Politics*. Beacon Press, Boston: 1989.

3. Steven Seiderman, "Introduction," *Habermas on Society and Politics*, Beacon Press, Boston: 1989, p. 10.

4. Habermas, "Towards a Reconstruction of Historical Materialism," see, e.g., p. 119.

5. Habermas, "Towards a Reconstruction of Historical Materialism," p. 121–23.

6. Habermas, "Towards a Reconstruction of Historical Materialism," p. 125.

7. Habermas, "Towards a Reconstruction of Historical Materialism," p. 121.

8. See, for example, Iris Marion Young, *Justice and the Politics of Difference* (Princeton University Press, New Jersey: Princeton University Press, 1990); and Nancy Fraser, *Justice Interruptus* (New York: Routledge, 1997).

9. Enrique Dussel, "Eurocentrism and Modernity (Introduction to the Frankfurt Lectures)," *Boundary* 2, no. 20 (1993): 3.

22

Marie Fleming

Social Labor and
Communicative Action

This essay focuses on Habermas's understanding of social labor and communicative action. It pays particular attention to his treatment of gender and raises questions about the validity of concepts that are fundamental for his theory of communicative action. Although my discussion stems from feminist values, I do not see myself developing a specifically feminist perspective on his theory, but rather providing an immanent critique that speaks to the interests of all those committed to universalist principles of inclusiveness and equality. It is precisely those principles that are at risk in Habermas's theory of communicative action, notably in connection with his thesis of the internal colonization of the lifeworld. As I will show, historically specific gender perspectives help shape important features of his colonization thesis and undermine his universalist aims, but my main objective is to try to explain why his theory gives rise to the difficulty. I suggest that to answer this question, we have to examine the relation between Habermas's theory and the reinterpretation of the Marxian concept of social labor that he developed in the years preceding his major work on communicative action. If, as I will argue, there are important connections between his reinterpretation of the concept of social labor and his theory of communicative action, and if, as I will show, his discussion of social labor makes explicit reference to gender, we can expect that his reinterpreted concept of social labor will contain clues for a more explicit determination of the gender-related difficulties in his later theory.

I. DEFINING THE PROBLEM

Habermas's thesis of the internal colonization of the lifeworld states that the increase in system complexity in democratic welfare states leads to excessive

and ultimately debilitating juridification of the lifeworld, as ever more areas of life become subject to economic and state administrative imperatives. However, in his demonstration of the juridification problem, he does not simply refer (as his analysis leads one to expect) to the increasing reification and the creation of new dependencies connected with the implementation of socially necessary welfare policy, but also, and especially, to what he sees as the pathological effects of extending the process of juridification to the lifeworld areas of family and school. He claims that legal-bureaucratic intervention into family and school strikes at and erodes the communicative practices that develop through socialization in the family and teaching in the school and that the intrusion of a systems rationality into lifeworld processes of communication will have dysfunctional effects, not only for the lifeworld areas of family and school, but for society more generally.[1] As I argue in my recent book,[2] lifeworld reproduction is the core concern of Habermas's colonization thesis, and because he understands lifeworld reproduction (descriptively and normatively) as the function of family and school institutions, the only examples he could have chosen to demonstrate his thesis of the progressive deterioration of the lifeworld's communicative practices under conditions of advanced capitalism were the ones he gave: family and school. But, if there are no other possible examples, we have to conclude that family and school are not really examples at all and that the primary concern of the colonization thesis is not excessive juridification of the lifeworld as such, but rather the negative effects for society of extending the juridification process to the lifeworld areas of family and school.

Habermas does not deny the democratic aims behind much juridification. In fact, he identifies the judicial enforcement of "basic rights" in family and school with the establishment of "basic legal principles: recognition of the child's fundamental rights against his parents, of the wife's against her husband, of the pupil's against the school, and of the parents', teachers', and pupils' against the public school administration." He also acknowledges that, in the case of the family, legal-bureaucratic intervention has resulted in the dismantlement of the "authoritarian position of the paterfamilias" and led to "more equal distribution of the competencies and entitlements" of family members. Similarly, the legal regulation of the "special power relation" between government and schools has opened up the school system to a measure of public accountability as regards the needs of children and the wishes of parents. Yet, for Habermas, these benefits in increasing democracy have come at a cost because, in his view, family and school institutions are so organized that they cannot be subject to judicial control and legal-bureaucratic intervention without disrupting the pattern and development of communicative practices constitutive of the lifeworld.[3] But, even if he is right about the debilitating effects of extensive juridification in family and school, his

colonization thesis is normatively deficient because it gives no further advice on how to deal with the issue of basic rights for women and children that has been a primary motivation (among feminists and law-makers generally) for extending the process of juridification. If, as Habermas suggests, the juridification of family and school should be kept to a minimum, and ideally eliminated, can he say anything about the basic rights of women and children beyond reiterating his commitment to equality for all citizens? If not, why not?

The problem of gender in Habermas's theory can be understood, initially, in terms of the anxious attention he gives to the reproduction of the lifeworld's communicative practices and his corresponding relegation of the question of basic rights for women and children to a matter of secondary theoretical importance. How is it that in a theory aiming at universalism, the basic rights of a class of persons are accorded only secondary consideration? The difficulty is obviously related to the importance Habermas attributes to family and school institutions in the reproduction of communicative practices, but we still need to know why socialization and lifeworld reproduction are so important for his theory that they can lead to bad results on the basic rights question. The difficulty turns up as well in Habermas's attitude toward the nurturer role. Although he understands the nurturing/socialization of the young as crucially important for sustaining and reproducing the lifeworld's communicative practices, he does not include the nurturer role among the social roles (which he lists as employee, consumer, client, citizen) in the system/lifeworld interchange. Why is that role not theorized somewhere on the system/lifeworld interchange, especially when Habermas picks out the juridification of family and school to demonstrate the harmful effects of extensive legal-bureaucratic intervention into socially integrated lifeworld contexts?

The absence of the nurturer role from the list of social roles in Habermas's theory is not reducible to a simple oversight, and as I will argue, understanding the nature of this absence helps explain why his colonization thesis leads to gender-related difficulties. I now want to establish a basis for this argument by turning to Habermas's reinterpretation of the Marxian concept of social labor.

II. Social Labor

In his 1976 essay on historical materialism Habermas claims that by social labor Marx and Engels mean not only labor processes, but also cooperation between individuals and groups. He maintains that the tradition of historical materialism gives insufficient attention to the cooperative elements of labor processes and that we can correct for this imbalance by understanding social labor in terms of two types of rules, those that apply to instrumental and strategic action and those that apply to communicative action. He explains that

instrumental action refers to "goal-directed" processes for transforming physical material into products of labor and that strategic action involves cooperative strategies for collectively coordinating individual effort within the labor process. Communicative action is yet another type of cooperation, and he identifies it with rules for distributing the products of labor. For the distribution of labor products, what is crucial is the "systematic connection of reciprocal expectations or interests." According to Habermas, the distribution process "requires rules of interaction that can be set intersubjectively at the level of linguistic understanding, detached from the individual case, and made permanent as recognized norms or *rules of communicative action*." His aim, in reconfiguring the concept of social labor as a nexus of rules of instrumental/strategic and communicative action, is to bring out what Marx and Engels meant by social labor, but the point of this exercise is to provide a framework for challenging their claim that social labor distinguishes human and animal life.[4]

Habermas suggests that, to test the Marxian claim about social labor, we first need to specify the "human mode of life" more precisely. The specification he has in mind involves the question of how human life evolves, and he refers to recent anthropological work on hominization to describe three distinct types of evolutionary processes. In the primate stage of development there , is an "exclusively natural" evolution (the species are still evolving), whereas the hominid stage is characterized by a "mixed" type of evolution involving natural selection, in which the most important variable is brain development, but also the "active, adaptive accomplishments of hunting bands of hominids." Similarly, whereas hominid life is characterized by a "mixed organic-cultural" type of evolution, with the appearance of "homo sapiens" there comes into existence an "exclusively social" evolution. "No new species arose. Instead, the exogamy that was the basis for the societization of homo sapiens resulted in a broad, intraspecific dispersion and mixture of the genetic inheritance." He claims that if social labor (understood as socially organized instrumental action) indicates the specifically human form of reproducing life, we should not be able to find within hominization any evidence of the rules of instrumental and strategic action, nor of the rules of communicative action. But, according to Habermas, once we examine hominization, we find that those rules apply to both hominid and human life. He argues that the cooperative hunt introduced by the hominids was driven by instrumental action and sustained by social interaction, that hominid society fulfilled the conditions for an economic reproduction of life, and that their cooperative hunt was the first mode of production. He concludes that the concept of social labor, even when reformulated to represent Marx and Engels's meaning, cannot help us understand the difference between human and animal life.[5]

But if Marx and Engels were mistaken about the significance of social

labor, Habermas still regards the question of the difference between human and animal life as relevant and important. He also gives an indication of how he will answer that question in his argument that the hominids fulfilled the conditions for an economic reproduction of life. That argument refers to the economic activities of the adult male hominids and is based on a prior exclusion, from the concept of social labor, of the economic activities of adult females (and children). According to Habermas, the "division of labor in the hominid groups presumably led to a development of two subsystems." The "adult males . . . [came] together in egalitarian hunting bands and occupied, on the whole, a dominant position," whereas the "females . . . gathered fruit and lived together with their young, for whom they cared." This hominid sexual division of labor, which would have issued from the socio-cultural elements of the "mixed organic-cultural" type of evolution regarded by Habermas as characteristic of hominization, functions as a transition phase to a human reproduction of life that was to evolve on an "exclusively social" basis. Having argued that the Marxian concept of social labor applies to both hominid and human society because each has an economic form of reproducing life, he now states that the human reproduction of life has to be distinguished from the hominid one by the institutionalization of the "father role" in a family system. "We can speak of the reproduction of *human* life, with homo sapiens, only when the economy of the hunt is supplemented by a familial [male-headed] social structure." He explains that, with the "familialization of the male," a kinship system based on exogamy was introduced, and "the male society of the hunting band became independent of the plant-gathering females and the young, both of whom remained behind during hunting expeditions."[6]

Habermas speculates that some time following the initial (hominid) differentiation of male and female subsystems, hominid society would have evolved to the point where it presumably experienced a "new need for integration, namely, the need for a controlled exchange between the two subsystems." This new need for integration arises in the mode of production of the cooperative hunt. It is Habermas's view that the gradually developing egalitarianism within the cooperative hunt became incompatible with the one-dimensional rank order of the primates, in which "every individual could occupy one and only one—that is, in all functional domains the same—status" and retain it by virtue of his capacity to threaten. In response to system difficulties in the hunting band, and in a process lasting millions of years, the animal status system was supposedly replaced by a system of social roles that was more suited to the emerging egalitarian relations within the cooperative hunt. A social role system is better suited to egalitarian relations because it is "based on the intersubjective recognition of normed expectations of behavior" and involves a *"moralization of motives for action. . . .* Alter can count on ego fulfilling his (alter's) expectations because ego is counting on alter fulfilling

his (ego's) expectations." To participate in a social role system requires interactive competence: individuals must be able to "exchange the perspective of the participant for that of the observer" and learn how "to adopt, in regard to themselves and others, the perspective of an observer, from which they view the system of their expectations and actions from the outside, as it were." They must also expand their *"temporal horizon* . . . beyond the immediately actual consequences of action . . . [so that] spatially, temporally, and materially differentiated expectations of behavior . . . [can] be linked with one another in a single social role." Social roles also have to be connected with "mechanisms of sanction . . . to control the action motives of participants." Hominization never succeeded in developing such a social role system, though, in Habermas's view, it was evolving in that direction.[7]

The establishment of a system of social roles that was the eventual response to the new need for integration in the male subsystem of the hunting band required not only a reorganization of relations within the hunting band, but also a fundamental reorganization of sexual relations. Given Habermas's view that the familial principle of organization marks the difference between human and hominid life, his reasoning can be reconstructed as follows. As male and female subsystems were becoming differentiated in hominid society, a basis was being laid for the (eventual) institutionalization of the father role that would complete the changes needed to fulfil the new need for integration, a need that was of such evolutionary importance that, once fulfilled, it meant the end of hominization and the beginning of "human" society. However, while subsystem differentiation is a structural requirement, the institutionalization of the father role could not take place in the context of the status-dependent sexual relations that hominids shared with the primates. Habermas explains that the primate/hominid pattern of status-dependent sexual relations was becoming even more obsolete, "the more the status order of the primates was further undermined by forces pushing in the direction of egalitarian relations within the hunting band." In the circumstances of the two subsystems and under evolutionary pressures, the new need for integration was fulfilled with the transformation of the primate/hominid pattern of status-dependent sexual relations to a "family system based on marriage and regulated descent." "Only a family system based on marriage and regulated descent permitted the adult male member to link—via the father role—a status in the male system of the hunting band with a status in the female and child system." The family system made it possible for the same individual to unify "various status positions": an individual could, for example, be a member of the cooperative hunt and a father. It also became possible for different individuals to have access to the same status: all members of the cooperative hunt could be fathers. Only then, according to Habermas, was it possible to have a "socially regulated exchange between functionally specified subsystems," the one subsystem for social labor and the other for "nurture of the young."[8]

There is still the question of why the adult male needs controlled access to the female and child system and why one subsystem has to be reserved for the "nurture of the young." In a hominid society that knew no "fathers," the physical and emotional needs of the young would have been met in the female and child relation, so that the introduction of the father role must be a response to the demand for a type of nurture that goes beyond the requirements of the physical and emotional care provided for in hominid society. The nurture of the young in the father-headed family has to be regarded as directly linked to the new need for integration that arises in the male subsystem. The social role system that eventually comes to integrate social labor in a human society is linguistically and culturally organized, requires highly competent individuals, and is crucially dependent on the transmission of competences from one generation to the next; an animal status system, by contrast, is directly related to personality and to the power to threaten of the individual occupying any given status. From an evolutionary point of view, the males in the hunting band, on the threshold of becoming "human," would have had to gain controlled access to the female and child system, in order to secure, through the socialization of the young, the linguistic and cultural bases of their social role system and the individual competences needed for the integration of social labor. Habermas is unequivocal that the "familial social structure" is fundamental to the integration and functioning of male and female subsystems. He also claims that, compared to production and social labor, socialization and care of the young are "equally" important for the reproduction of a human species dependent for its integration on the interactive competences of a social role system.[9]

This proposal for rethinking the significance of social labor retains important features of arguments Habermas presented in his *Knowledge and Human Interests*. In that book, published in 1968, he treated the Marxian concept of social labor as an epistemological category and argued that Marx had tended to conflate the labor processes necessary for securing the physical means of survival with the "reflection" necessary for entering into the class struggle and achieving a new level of social synthesis. At that point, he thought that the philosophy of reflection and Freudian psychoanalytic theory could provide resources for giving expression to the "reflective" aspects of social movements, and he tried to bring together a Marxian understanding of social labor and a Freudian understanding of family and socialization.[10] In the 1970s he gave up philosophy of reflection for formal pragmatics and rational reconstruction, but his core concerns about Marx and the limitations of the concept of social labor remained. As well, he continued to hold that understanding the role of socialization processes in social development could help correct for the Marxian tendency to conflate the categories of labor and interaction. Moreover, in 1968, as in 1976, the question that motivated Habermas was how to defend a historical materialism that stood for social

evolution and historical progress. In 1976 he secured a foundation for answering that question in his claim that, with the transition to a social role system and the establishment of the familial principle of organization, the structures of social labor enter into a new stage of development in which there is learning in two separate dimensions of human existence: labor and interaction.

As formulated by Habermas, historical materialism states that each new mode of production allows for the technically useful knowledge needed for developing the productive forces and provides a basis for achieving a new form of social integration. The question is why any society takes an "evolutionary step," and he argues that it is not enough to point to social movements, historical conflicts, and the political struggles of oppressed groups. We need to direct attention to "how we are to understand that social struggles under certain conditions lead to a new level of social development." He suggests that learning takes place not only in the area of technically useful knowledge needed for production, but also in the area of the interactive competences needed for social integration and learned through socialization processes connected with the family. He maintains that there are two types of learning, cognitive-technical and moral-practical, that they each have their "own logic," and that each type of learning can be reconstructed as a series of stages. To support his view of the developmental stages of moral-practical knowledge, he refers to the Piagetian research tradition of cognitive-moral psychology. At a *preconventional stage* "only the consequences of action are evaluated in cases of conflict"; at a *conventional stage* "conformity with a certain social role or with an existing system of norms is the standard"; and at a *postconventional stage* systems of norms "require justification from universalistic points of view."[11] I take Habermas to be arguing that research projects like those of Piaget and Kohlberg indicate possible ways to give concrete expression to the idea that there is a "cumulative learning process" in moral-practical insight, however we might define moral-practical insight. That is, if we continue, in one way or another, to hold on to the idea of social evolution, which is closely related to claims about historical progress, we also have to say what this might mean.

Whereas Habermas argued in 1968 that Marx was wrong not to draw on the philosophy of reflection to establish philosophical foundations for critical social theory, in 1976 he no longer sees this tradition of philosophy as providing solutions to the normative deficits he sees in historical materialism. In turning to the pragmatics of language use, his strategy is to establish historical materialism on the "normative foundation of linguistic communication, upon which, as theoreticians, we must always (already) rely." If validity claims are "bound up with the cognitive potential of the human species," a theory of social evolution that understands historical progress as the "expansion of the potential of reasoned action" cannot, and does not have to, defend

its normative implications. Habermas concludes his (1976) essay by reiterating the view that historical materialism involves the recognition that there is "progress in objectivating knowledge and in moral-practical insight."[12] But the entire argument of that essay is constructed to show that the learning processes connected with moral-practical consciousness and social integration only become possible with the "transition to the sociocultural form of life, that is, with the introduction of the [male-headed] family structure."[13]

The concept of social labor, as employed by Marx and Engels, is critical as well as descriptive. It shows the limitations of classical economic categories for understanding economic processes and develops new economic categories based on the idea of labor power, surplus value, and so on. These new categories, developed from the perspective of (objectively conceived) working-class interests, allow for the inclusion of the working class in theories of the economy. Moreover, the Marxian analysis of capitalism ensures that the working class, notwithstanding its oppression, enjoys a privileged relation to the means of production, a relation that is to be the basis for human emancipation as such. To begin from the sexual division of labor, as Habermas does, and to reconstruct historical materialism in inclusionary terms, one would have to show why and how female labor has to be included in social labor, and explain what it is about women's oppression that putting an end to it facilitates human liberation. Furthermore, a reconstruction of historical materialism that begins from the sexual division of labor would not simply apply pre-given Marxian categories developed from the perspective of the working class, but would involve a fundamental reconceptualization of social labor.

It apparently never occurred to Marx and Engels to include female labor in social labor, despite Engels's concern about the "world historical defeat of the female sex" that led him to investigate the origins of the family.[14] Engels's account of the family has been criticized on numerous grounds—among other things, he obscures the problem he seeks to understand by giving primacy to class and by linking the idea of women's oppression too closely to the development of private property. However, whatever the limitations of his argument, it established the problem of women's oppression as an important concern of historical materialism. With Habermas's reconstruction of historical materialism, and despite the fact that he begins from the sexual division of labor, the sexual division of labor disappears even as a problem to be addressed. Not only does he not develop a theory of women's oppression, he traces "human" society to the subordination of women in a father-centered family structure and offers a theory of human evolution that does not even raise the question of how women are to be liberated from such subordination.

Habermas does not (and cannot) include "female" labor in the concept of social labor because he formulates that concept in such a way that it explicitly excludes the type of labor involved in socialization. Engels might have been puzzled by the difficulty of accounting for women's oppression under

capitalism, but he (and Marx) had no special category of "female" labor, so that, under their view of the abolition of capitalism, the division of labor between the sexes would also come to an end and women would be released from their double oppression as workers and as women. By contrast, in Habermas's rethinking of historical materialism, female work, with its special value, cannot be eliminated and conceivably cannot be reduced, and if it is not done by females, then it has to be done by males. But that work can never be included in the concept of social labor.

Habermas's proposal for reconstructing historical materialism is a matter of concern because it excludes "female" labor from the site of egalitarian relations and historical progress. Moreover, his treatment of gender in this specific instance warrants general concern because his discussion of historical materialism prepares the ground for his theory of communicative action, and we need to know whether his exclusion of "female" labor from the concept of social labor emerges in some form in the later theory. I will now discuss how Habermas's understanding of social labor intersects with, and helps determine, the crucially important system/lifeworld distinction of his 1981 theory of communicative action.

III. Social Labor and Communicative Action

An important aim of Habermas's discussion of historical materialism is to account for the cooperative elements of communicative action that Marx and Engels assumed, but did not theorize. As I have explained, he identifies those cooperative elements with the interactive competences of adult humans and insists that such competences are learned in a distinctive process associated with moral-practical insight. His argument is that socio-cultural evolution is directly dependent on two types of learning processes, one type involving the technically useful knowledge needed for production, as Marx and Engels maintained, but also another type involving the moral-practical insight needed for social integration. In the theory of communicative action, technically useful knowledge is linked to system processes and moral-practical insight to lifeworld ones, so that Habermas's system/lifeworld distinction, which drives his colonization thesis, can be viewed as making possible a more complex interpretation of what Marx and Engels understood as the basic components of social labor. This view is confirmed in Habermas's remark that system and lifeworld appear in Marx as "realm of necessity" and "realm of freedom."[15]

Habermas's aim in further dividing system and lifeworld, the one into economy and state administration and the other into private and public spheres, is to provide for an understanding of advanced capitalism that takes into account the increasing complexities of welfare state democracies. Specifically, he wants to allow for examination of the crucial interchange

between lifeworld (public and private) and system (economy and state administration). According to Habermas, the system/lifeworld interchange takes place in the media of money and power and is institutionalized in the social roles of employee, consumer, client of state bureaucracies, and citizen of the state. In reference to the consumer role, he describes private households as having been "converted over" to mass consumption, "redefined" as system environments, and made subject to the economic and administrative impera-tives of the "monetary-bureaucratic complex." The consumer role bears further examination, but the initial question is what to make of the absence of the nurturer role from the configuration of the four social roles (employee, consumer, client, citizen). While Habermas acknowledges the universalistic aspirations of the women's movement, he is solidly committed to the four social roles of employee, consumer, client, and citizen, and he does not see that taking feminism seriously would involve not only addressing the status of the nurturer role, but opening up discussion of the gendered pattern of all social roles.[16]

The problem is not that Habermas puts little value on "women's work." As discussed above, in his reconstruction of historical materialism he argues that, compared with the production and social labor of men, the activities of nurturing and socialization performed by women are "equally important" for the reproduction of the human species. In fact, he considers the nurturer/ socialization role so important for a theory of socio-cultural evolution and historical progress that his reconstruction of historical materialism requires the supplementation of the Marxian concept of social labor by the familial principle of organization. While Habermas is less explicit in his theory of communicative action about the gendered identities and obligations attached to socialization processes, he continues to understand social evolution in terms of learning processes connected to interactive competences and moral-practical insight, and he still holds that socialization processes are centered in family institutions. In some respects, he views the nurturer/socialization role as even more important for modernity than it was for the earliest "human" societies.

Central to Habermas's theory of communicative action, as a contribution to a reconstructed historical materialism, is the idea of a communicatively structured lifeworld. However, if he is to link that idea in a meaningful way to the learning involved in moral-practical insight, he needs a concept of the lifeworld that can refer to the lifeworld's structural components and to the mode of reproduction of those components. He maintains that the lifeworld is structured by culture, society, and personality, that these components are reproduced through the interconnected processes of cultural reproduction, social integration, and socialization, and that, because any one process can be dominant for a given lifeworld, we can envision different types of lifeworld reproduction. He gives three possible variations. Two of these indicate a "premodern" mode of lifeworld reproduction: the dominant process in the one

case is cultural reproduction, in the other, social integration, but in each case personality systems are underdeveloped and socialization is relatively unimportant. By contrast, in the third variation, identified with modern lifeworlds, strong personality systems are the key to the successful reproduction of the lifeworld and the dominant reproduction process is socialization.[17] Because Habermas understands socialization processes as crucial for sustaining and renewing the individual competences associated with strong personality systems, the "female" work of socialization not only does not lose its importance in modernity, but comes to dominate the overall process of reproducing the lifeworld.

The importance Habermas gives to socialization processes for reproducing the modern type of lifeworld makes all the more conspicuous the absence of the nurturer role from the social roles institutionalized in the system/lifeworld interchange. However, there is a pattern here. Whereas the familial principle of organization had to be "added on" to the concept of social labor to understand the "human" mode of reproducing life, so the nurturer role has to be "added on" to the social roles of the system/lifeworld interchange for understanding the reproduction of the modern type of lifeworld. That is to say, the nurturer role, despite its importance for the reproduction of the modern lifeworld, is not viewed by Habermas as a "social" role, and it is for that reason that it gets omitted from the list of social roles (employee, consumer, client, citizen) institutionalized in the system/lifeworld interchange. Moreover, whereas his proposal for reconstructing historical materialism envisions male and female subsystems as connected by a "socially regulated exchange," his theory of communicative action understands the familial and public lifeworld spheres as functionally connected through processes of socialization. Familial and public lifeworlds are also separated by an unbridgeable gulf, as we can see from his comments on the relation between the social role of consumer and the private household.

In the tradition of the Frankfurt School Habermas links the private household to the consumer role, but he rejects Horkheimer's view that the decline of paternal authority in the bourgeois family should be seen in the context of the spread of monopoly capitalism in which the family's psychic structures are harnessed for system needs. Instead of a Freudian theory of instincts as employed by Horkheimer, Habermas advocates a theory of socialization that can connect Freud with Mead, put more weight on structures of intersubjectivity, and replace "hypotheses about instinctual vicissitudes with assumptions about identity formation." He argues that the transformation of the bourgeois family should not be understood simply in functionalist terms, that is, as serving the interests of capital; it can also be understood in structural terms, that is, as providing for the development of egalitarian relations within the family, individuation in discursive practices, and liberalized childrearing.[18] These developments do not, however, translate into questions of gender

equality, as one might have thought. Rather the point of Habermas's discussion is to determine what the transformation of the bourgeois family means for understanding the new conditions of socialization.

Habermas argues that there is a "growing autonomy" of the nuclear family because it is now cut off from the figure of the father that once represented societal repression and so brought system imperatives into the family context. He also regards the structural changes in the bourgeois family as representing the "inherent rationalization of the lifeworld" because, in the transformation from a family unit based on paternal authority to one providing for egalitarian relations, "some of the potential for rationality ingrained in communicative action is *also* released." It is apparently because the communicative infrastructure of familial lifeworlds gains a new independence that familial lifeworlds are able to understand economic and administrative imperatives as "coming at them from outside." In Habermas's view, this development means that socialization processes now take place in a "largely deinstitutionalized communicative action," that is, in communication structures "that have freed themselves from latent entanglements in systemic dependencies." He suggests that the increasing polarization between a communicatively structured lifeworld and the formally organized contexts of the system brings with it a "different type of danger" for socialization because, while the Oedipal problematic is no longer so significant, the adolescent's adjustment to adult social roles now becomes more complex and risky. The reason for this, he explains, is that the competences, motives, and attitudes learned in the socialization processes of the familial lifeworld, that is, in a relatively independent communication infrastructure, are to some extent incompatible with the functional requirements of adult social roles (located in the system/lifeworld interchange). As a result, adolescent crises grow in significance.[19]

Habermas's discussion of family life is focused on understanding the new conditions for socialization provided by the structural transformation of the bourgeois family. He understands those conditions not simply in terms of historical events, but as the product of an unfolding of an inner logic inherent in the family's internal structures of communication. The family is presented as self-contained, having its own integrity, growing in autonomy, predisposed to seeing itself as separate from the basically alien economic and administrative imperatives that come at it from the "outside." This aestheticization of the family's internal relations also makes it immune to criticism and indicates that, despite his reinterpretation of the Frankfurt School's understanding of the family, and notwithstanding the considerably reduced importance he gives to a Freudian instinct theory, he continues, like Horkheimer and Adorno, and like Marx before them, to naturalize family relations. But Habermas places a more explicit weight on the family as a site of freedom. Socialization processes are tied up with claims not only about the family's internal structures of communication, but also about what those structures represent in and of themselves.

In his discussion of the rationalization of the familial lifeworld, Habermas uses identical terms to those he uses in his more general characterization of the rationalization of the lifeworld. In each case, there is "growing autonomy" from the processes of material reproduction and a release of the "potential for communicative rationality ingrained in communicative action."[20] The rationalization of the lifeworld would appear to involve not just one process, but rather two parallel processes, the one in the familial lifeworld sphere and the other in the lifeworld's public sphere. He remarks, for example, that "the inner logic of communicative action 'becomes practically true' in the deinstitutionalized forms of intercourse of the familial private sphere as well as in a public sphere stamped by the mass media."[21] There would appear to be no retreat from the immediacy he assigns to family relations. Thus, even though he aims at a theory based on equality, and even though he admits that power and money still pervade the relations of the private household,[22] his theory does not, and apparently cannot, provide for criticism of the power and economic relations of a gender-structured lifeworld.

CONCLUSION

Habermas reinterprets the Marxian concept of social labor in terms of the rules of instrumental/strategic action and communicative action, but it is his supplementation of this (reinterpreted) concept of social labor by the idea of socialization that allows him to develop the notion of an "exclusively social" evolution based on the cognitive and interactive competences of a laboring humanity. I have argued that his reconstitution of social labor as a site of egalitarian relations distinct from, yet dependent on, the "female" labor of socialization is brought directly into his theory of communicative action through the categories of system and lifeworld. Just as he adds the familial principle of organization onto the concept of social labor to understand the specifically human reproduction of life, so the nurturer role has to be added onto the social roles institutionalized in the system/lifeworld interchange to understand the reproduction of the modern type of lifeworld. The problem goes beyond an uncritical use of Marxian categories. Habermas not only reproduces Marx and Engels's exclusion of "female" labor from social labor, but places a special value on what he excludes, so that what is excluded from social labor is also essential to it. The difficulty surfaces in serious form in his colonization thesis: the importance Habermas attributes to the "non-social" nurturer role for reproducing the lifeworld's communicative practices runs up against his universalist principles, and in the end his theory is not able to produce critical categories for challenging the injustice of historically specific gender relations. Given the positioning of the nurturer role in his theory, one

would have to conclude that the production of relevant categories would require considerable rethinking, especially as regards social labor and socialization, historical progress and socio-cultural evolution.

In this essay I have concentrated on the relation between Habermas's understanding of social labor and his theory of communicative action. However, as I discuss in my book, the difficulties also pertain to his discourse ethics where the structural relation between social labor and socialization presented in his earlier work is replicated in the split he makes between morality and ethical life, justice and the good life, moral questions and evaluative questions. In a gesture not unlike that of his theory of communicative action where the nurturer role is viewed as not strictly social, his discourse ethics holds that gender and other "good life" questions can claim a "social" validity, but are not "strictly normative."[23] While Habermas now presents a more nuanced description of the juridification problem and allows for a shifting boundary between public and private,[24] the matter is also not resolved in his theory of law and democracy where he encourages feminists to come forward in the public sphere to say which gender differences are relevant for "an equal opportunity to take advantage of individual liberties." Even apart from the question of how to interpret his idea of a "feminist public" that operates as one of a plurality of competing and overlapping publics in an anarchically structured network of communication processes, Habermas's call for the public autonomy of women will not be of much help in addressing the gender-related difficulties generated within his philosophical framework.[25]

Where does this leave us? After all, I claim to be speaking to the interests of all those committed to universalist principles of inclusiveness and equality. I also agree with Habermas that feminist critiques of modernity presuppose "rights to unrestricted inclusion and equality."[26] It is from that perspective that I have given my view of what is wrong with Habermas's theory, and I will be interested in having his response. At this point, I am convinced that his theory is not sufficiently critical, not sufficiently universalist, and also not sufficiently historical. I maintain that we should not be too quick to choose between being historical and being universalist and that, in fact, we may become more universalist if we strive to find ways to give attention to culture and history. As my analysis of Habermas indicates, opting for a universalism that distances itself from history and culture can also mean being more indebted than one wants to historically specific lifeworld perspectives.

MARIE FLEMING

POLITICAL SCIENCE
UNIVERSITY OF WESTERN ONTARIO
OCTOBER 1997

NOTES

1. Jürgen Habermas, *The Theory of Communicative Action*, 2 vols., trans. Thomas McCarthy (Boston: Beacon Press, 1984 and 1987) (German edition, 1981), vol. 2, pp. 332–73.

2. See my *Emancipation and Illusion: Rationality and Gender in Habermas's Theory of Modernity* (University Park: Pennsylvania State University Press, 1997).

3. Habermas, *Theory of Communicative Action*, vol. 2, pp. 368–69.

4. Jürgen Habermas, "Toward a Reconstruction of Historical Materialism," in his *Communication and the Evolution of Society*, trans. Thomas McCarthy (Boston: Beacon Press, 1979), pp. 131–33. (The essay was published in German in 1976.)

5. Ibid., pp. 133–35.

6. Ibid., pp. 134–36.

7. Ibid., pp. 134–37.

8. Ibid., pp. 135–36.

9. Ibid., p. 138.

10. Jürgen Habermas, *Knowledge and Human Interests*, trans. Jeremy J. Shapiro (London: Heinemann, 1972), esp. pp. 25–63, 274–89. (German edition, 1968.)

11. Habermas, "Historical Materialism," pp. 147–56.

12. Ibid., p. 177.

13. Ibid., p. 165.

14. Friedrich Engels, *The Origin of the Family, Private Property and the State* (Harmondsworth: Penguin Books, 1984), p. 87.

15. Habermas, *Theory of Communicative Action*, vol. 2, p. 340.

16. See ibid., pp. 351, 393–95.

17. Ibid., pp. 140–41.

18. Ibid., pp. 386–89.

19. Ibid., pp. 387–88.

20. Cf. ibid., pp. 145–46, where Habermas, in reference to the lifeworld as such, refers to the "growing autonomy" of the lifeworld and to a "release of the rationality potential inherent in communicative action."

21. Ibid., p. 403.

22. This is how I am taking Habermas's remarks on the "patriarchal oppression" of women and the "sexual division of labor" in the bourgeois household, in ibid., pp. 393–94.

23. Jürgen Habermas, *Moral Consciousness and Communicative Action*, trans. Christian Lenhardt and Shierry Weber Nicholsen (Cambridge, Mass.: MIT Press, 1990), esp. pp. 104–9. Cf. my *Emancipation and Illusion*, pp. 172–76.

24. Despite these changes, the principal features of Habermas's colonization thesis remain intact. See discussion in my *Emancipation and Illusion*, pp. 92–96.

25. Jürgen Habermas, *Between Facts and Norms: Contributions to a Discourse Theory of Law and Democracy*, trans. William Rehg (Cambridge, Mass.: MIT Press, 1996), pp. 373–74, 425–26.

26. See Jürgen Habermas, "Further Reflections on the Public Sphere," in *Habermas and the Public Sphere*, ed. Craig Calhoun (Cambridge, Mass.: MIT Press, 1992), p. 429.

23

G. B. Madison

Critical Theory and Hermeneutics: Some Outstanding Issues in the Debate

There now exists a sizable literature comparing and contrasting the approach taken to philosophical issues on the part of Jürgen Habermas and Hans-Georg Gadamer. Much of this literature deals with the famous *Auseinandersetzung* that took place between these two leading German thinkers in the 1960s. I do not propose in what follows to add to the literature that grew up around this debate. In a number of ways, the positions then taken by Habermas and Gadamer are now of merely historical interest. This is in part because Habermas subsequently took to heart some of Gadamer's criticisms (for example, in regard to his earlier reliance on psychoanalysis as a model for social critique) and also because he subsequently proved more willing to accept hermeneutics' claim to universality than he was then. Since the 1960s Gadamer has shifted or enlarged the focus of his own work, devoting greater attention to socio-political issues (as instanced, for example, in his critique of technologism and the administered society)—largely as a result of the encounter.[1] Differences do remain, however, and they are not insignificant. As I view the matter, though, there are more affinities and *points de convergence* between Habermas's critical theory and Gadamerian hermeneutics than is often generally recognized, and it is in light of these basic affinities that I would like to situate what appears to me to be some of the important differences that remain (and which are perhaps not altogether insurmountable). First, to the affinities.

Like rhetoric, hermeneutics is (from one point of view) the inventive art

of finding *loci commune*; we gain a better understanding of two different things when we discover a common context within which to situate them both. The hermeneutical context that confers the most intelligibility on the philosophical projects of both Habermas and Gadamer is, I submit, the debate over the nature of *rationality* growing out of Max Weber's discussion of the imperialism, so to speak, of purposive, means-end rationality (*Zweckrationalität*) in modern times—what Horkheimer was to call instrumental rationality. Both Habermas and Gadamer were not prepared to subscribe to Weber's pessimism, his belief that the dominance of instrumental reason was irresistible and that social relations were doomed to come under the sway of a thorough-going bureaucratic rationality—Weber's famous "iron cage," to which he thought moderns were ineluctably condemned. Habermas and Gadamer were not alone in this: Heidegger's project (his critique of calculative reason) could equally well—and equally profitably—be situated in this Weberian context, as could that of the earlier Frankfurt School (Horkheimer and Adorno).

What specifically binds Habermas and Gadamer together, and what distinguishes their position from that of either Heidegger or Adorno, is *the* way in which they seek to contest the dominance of technocratic rationality. They do not concede the validity of Weber's analysis, attempting subsequently to come up with an alternative (a "way out") to rationality understood as the utilitarian calculus of means and ends (as was the case with Adorno's noncognitivist aestheticism and Heidegger's postphilosophical poeticizing). Rather, they have sought to confront the dominance of instrumental reason on strictly rational grounds by contesting the claim on the part of instrumental rationality to be reason incarnate. This, it could fairly be said, constitutes the heart and soul of their philosophical projects (it accounts for Habermas's focusing upon communicatively rational action[2]—what Gadamer refers to as communicative understanding—and Gadamer's critique of "method" in his *magnum opus*). What both Habermas (a one-time student of Adorno) and Gadamer (a pupil of Heidegger) have in effect sought to demonstrate throughout their work is that instrumental rationality is only *one* form of rationality—and not the highest (or most basic) at that. What, in short, they have both contested is not so much the claim to *universality* on the part of scientific-technological rationality as the *exclusivist* manner in which this claim is made. Reason is not, fundamentally, mere instrumental rationality.

Both Habermas and Gadamer have sought to rehabilitate reason in, as it were, a postmodern fashion: reason not as monological technique but as *dialogue* or "conversation." Both Gadamer and Habermas have objected to the monological "philosophy of consciousness" so prevalent in modern thought and have emphasized the essentially *intersubjective* nature of

reason. They differ, of course, in the means by which they seek to redefine reason (while Habermas appeals to the technical intricacies of speech-act theory, Gadamer prefers to invoke the basic principles of classical rhetoric), but they are at one in the way in which they understand the issue. The differences between critical theory and philosophical hermeneutics are best understood in relation to the *Problematik* they share in common.

One of Canada's leading hermeneuticists, Jean Grondin, has spoken of the "fundamental solidarity" that exists between Habermas and Gadamer and has said that, in the light of this solidarity, "the controversy between hermeneutics and ideology critique, however vociferous, concerns only secondary matters."[3] Grondin is of course right when he points out that a number of the differences separating Habermas and Gadamer at the time of the original debate have since been transcended. A believer in dialogue though I may be, I cannot quite bring myself to believe that the differences that remain are only "secondary," as I shall attempt to demonstrate. It is important to note, however, that these differences are ones that have meaning only in terms of the "solidarity" that exists between critical theory and hermeneutics. What Habermas and Gadamer have above all in common is that they are primarily normative thinkers, concerned with the *ethical* and *political* dimensions of human existence. This is obviously the case with respect to Habermas, but it is no less the case with respect to Gadamer.[4]

In this regard, critical theory and hermeneutics are alike in distinguishing themselves from traditional modes of theorizing in laying claim to being theory with "practical intent." The critique of instrumental rationality on the part of both Habermas and Gadamer is animated throughout by what are essentially ethical and political concerns, and, in both cases, this is an ethics and a politics that is guided by emancipatory interests (Gadamer maintains that freedom is the highest of rational values). One difference between the two thinkers is that whereas Habermas inherits his concern for emancipatory praxis from the Marxist tradition, Gadamer's stems from his adherence to the classical humanist tradition and appeals to the Aristotelian notion of *phronesis* (*scientia practica sive politica*).[5] Though he meant it as a criticism, Stanley Rosen was altogether right when he said: "Every hermeneutical program is at the same time itself a political manifesto or the corollary of a political manifesto."[6] Habermas knows this, and it would perhaps not be altogether inappropriate to say that both Habermas and Gadamer view politics as, in the words of Václav Havel, "the practice of morality."[7]

Two features common to the moral theory defended by Habermas and Gadamer are an emphasis on *language* and a claim to *universality*. (The emphasis that Gadamer has placed on language—"the essential linguisticality of all human experience of the world"[8]— is recognized by

everyone, but his equally central emphasis on universalism seems to be something that members of the Frankfurt School have difficulty recognizing.)[9] Both Habermas and Gadamer defend a kind of *Sprachethik* or discourse ethics, and both see the universality of the ethical as residing in its essential linguisticality. This is one area where Habermas can be said to have taken a lesson from hermeneutics subsequent to the great debate: When Habermas views discourse ethics as drawing its sustenance from the universal idea of agreement presupposed in language, he is subscribing to the hermeneutic notion of understanding (*Verstehen*) as consisting in the linguistically mediated search for agreement (*Verständingung*). Habermas agrees with Gadamer that natural language is essentially reflexive (not merely instrumental) and that reflection is itself an emancipatory power. Despite these areas of broad agreement between the two thinkers, there are some persistent differences between them that are not, in my view, merely "secondary." Let us consider briefly Habermas's version of discourse ethics.

Habermas maintains that "normative claims to validity have cognitive meaning and can be treated *like* claims to truth."[10] He argues that the cognitive nature of normative choices is guaranteed by the principle of universalization (he refers to this as "**U**"), which he articulates in the following way: "*All* affected can accept the consequences and the side effects its *general* observance can be anticipated to have for the satisfaction of *everyone's* interests."[11] For Habermas, practical discourse is a procedure for "*testing the validity* of norms that are being proposed and *hypothetically* considered for adoption"[12] (if *all* concerned can agree that a hypothetical norm serves *everyone's* interests, then that norm is [universally] valid). This reminds one of what he had earlier referred to as the "ideal speech situation." In both cases, Habermas equates universality with unanimity and sees the test for truth and rightness as consisting in *consensus*. Hermeneutical ethics questions the soundness of these various assumptions.

It is ironic that earlier on Habermas should have accused Gadamer of falling into a *Sprachidealismus*, a linguistic idealism, for the Gadamerian hermeneuticist is inclined to accuse Habermas himself of idealism in the way in which he deals with communicative action and discourse ethics, namely, in terms of "ideal" situations. Habermas readily acknowledges that his approach in this regard is "counterfactual," and there is nothing inherently wrong with having recourse to a nice counterfactual now and then. There is, however, an inherent danger in counterfactuality, in that counterfactual thinking often obscures actual reality more than it illuminates it (this is certainly the case with Rawls's "veil of ignorance" construct which tells us nothing about how real, flesh-and-blood, sexed[13] individuals are able to arrive at contractual agreements). Hermeneutics, it must be admitted, is constitutionally adverse to "ideal" thinking of a counterfactual sort,

grounded as it is in phenomenology and the latter's overriding concern to return to "the things themselves," that is, its concern to philosophize (theorize) out of actual human experience. If it difficult to see what an "ideal speech situation" would actually amount to in real world terms, it is even more difficult to see what it could possibly mean to say that any de facto form of communication does, or does not, "adequately approximate ideal conditions."[14] What tangible criterion do we have that could ever enable us to "adequately" measure the degree to which any given communicative action "approximates" an "ideal" end-state which, per definitionem, does not (yet) exist (and probably never will)? What sense does it even make to talk like that? The difficulty of such an undertaking is on a par with comparing the worthiness of any actually existing table with its Platonic Ideal. What the former Marxist, Cornelius Castoriadis, has said of the myth of scientific progressivism and the scientistic idea of truth as an ideal end-state (and science's Habermasian way of valorizing "universal validity and utter transparency") applies, I think, to Habermas as well. Castoriadis writes: "[I]t was customary to speak—indeed it still is—of the asymptotic progress of science towards knowledge, without even suspecting that this expression is meaningless if one does not possess the asymptote it evokes, and would be absurd if one did."[15]

Hermeneutics sees no reason for equating *universalizability* (a principle to which it firmly subscribes, and which is not identical to Habermas's "universalization") with de facto universality, that is, *consensus* (what *everyone* agrees to—or "would," in some intelligible heaven, agree to). Gadamer does, of course, equate truth with agreement (*Einverständnis*), but he does not, like Habermas, absolutize agreement and does not hold that consensus is the actual goal (the ideal end-state) of communicative rationality. Clifford Geertz put the hermeneutical point nicely when he said that progress in human affairs "is marked less by a perfection of consensus than by a refinement of debate."[16] Hermeneuticists would maintain that in holding to consensus as an ideal, Habermas is in effect *idealizing* the actual practice of discourse and is, thereby, being unfaithful to what is demanded of any thoroughgoing *practical* philosophy (analogously to the way in which, as Husserl said, Galilean, mathematicized science is unfaithful to the human lifeworld).

Allied to this criticism is the criticism that in privileging the notion of consensus, Habermas's "top-down" method is one which is somewhat ill-suited for understanding actual human practices, since a proper understanding of human reality requires (or so hermeneutics would maintain) that one seek to conceptualize it not in terms of *end-states* but in terms of *process*. Habermas's "idealism" reminds one of the idealism of mainstream neoclassical economists who attempt to conceptualize human economic

reality, that is, market *processes*, in terms of equilibrium (end) states (this is perhaps the chief criticism leveled against main line economics by the interpretive economists; it is the charge of "unreality"). Habermas has made a strenuous effort to counter utilitarianism, but in thinking in terms of end-states, he is being less than radical in his critique of "Weberian" rationalism and is not being as "postmetaphysical" as he could be,[17] for metaphysical rationalism has always privileged *stasis* over *process*. Habermas's notion of "consensus" is conceptually unsuited to any actual discussion process; what it describes, ironically enough, is a state of affairs that would prevail once the conflictual pursuit of truth has *come to an end*, that is, a state of affairs wherein with everyone in full agreement there would no longer be any need for discussion.

The idea of consensus is especially dangerous when it comes to thinking the political. It is in fact a recipe for authoritarian governance, be it (right-wing) fascism or (left-wing) totalitarianism. It should be noted, too, that the value placed on consensus in some societies often works to diminish or suppress individual rights and liberties. The political fact of the matter is that consensus politics is hostile to the practice of liberal, representative democracy. Despite his Marxist background, Habermas has valiantly defended the basic principles of political (though not economic) liberalism in present-day Germany. Habermas is no anti- or unliberal communitarian. He clearly recognizes that what communitarians protest the most, that is, non-discriminatory, "color-blind" *proceduralism*, is the very essence of liberal democracy (which is why, unlike communitarians like Charles Taylor,[18] he maintains, as hermeneuticists do, that a universal morality can be concerned only with what is [rationally] *right*, not with what is [culturally] *good*).[19] And yet, by privileging the idea of consensus, Habermas leaves himself open to the charge that the way he conceptualizes democracy is not sufficient to rule out various forms of *illiberal* democracy. This is in effect the charge directed at Habermas by a fellow postmarxist social democrat, Chantal Mouffe, who writes: "[I]t is important to abandon the myth of a transparent society, reconciled with itself, for that kind of fantasy leads to totalitarianism."[20]

In a truly democratic society, the "truth" (what everybody could, *in principle*, agree to) is nothing substantive (having to do, for instance, with a certain agreed-upon distribution of wealth or opportunities, that is, "equality of conditions," defined in this or that way); it is nothing other than the democratic process itself, that is, free and open "conversation" in the Gadamerian sense of the term. Liberal democracy has nothing to do with consensus, if by this one means the *elimination* or transcendence of *conflict*. Democracy has to do, rather, with the *management* of conflict. No liberal would ever believe that the conflict of interests between individuals could

ever be eliminated, and individual rights and freedoms still be respected. *No one* (even those in positions of power) can ever consult with *everyone* who *might* conceivably be affected by this or that common agreement ("equal opportunity"—a requirement for "true" communication according to Habermas— never actually obtains in any strict sense in discursive situations or in life in general); nor could any real discursive situation ever, strictly speaking, be "domination-free," "ever so subtle or covert" that "repression" may be.[21] Just as common agreements do not do away with conflicts of interest, so also they do not require the prior abolition of inequalities of "power" (another ineradicable feature of the human condition). All conversations, however open and well-meaning they might be, are *constrained* by exogenous factors, even if only by the time factor. Hermeneutics is very much a theory of democracy, but it does not conceive of democracy as a future ideal state-of-affairs in which everyone, with an unlimited amount of time on their hands, would find themselves in a common agreement with everyone else as to what is right. Rather, it views democracy as a *way of life*, a mode of praxis in the here and now, whereby individual and group differences can be dealt with (which does not necessarily mean resolved) in a communicatively rational manner. As is the case with respect to truth and justice, democracy, from a hermeneutical point of view, is, and can only be, a *relative* concept. When it is absolutized to refer to an ideal state of unanimous consent (the "general will" Habermas alludes to), it becomes a formula for tyranny.

Thus, if one is inclined to speak of consensus, one must always add the qualification: *dissenting* consensus. Tolerance (of "difference") and pluralism (an actual *respect* for "difference") are the hallmarks of genuine democracy. Paul Ricoeur expresses the point nicely when he says that what characterizes a *liberal* democracy is a "conflictual consensus."[22] Invoking the thought of another former Marxist, Claude Lefort, Ricoeur observes that democracy is that "regime which accepts its contradictions to the point of institutionalizing conflict."[23] Thus, as Ricoeur rightly observes, democracy is that "regime for which the process of its own legitimation is always in process and always in crisis."[24] Habermas could likely agree with several of these points (he is, as was said, no communitarian); my only criticism is that his tendency (a leftover, as it were, from his Marxist past) to think in terms of end-states (conflict-free, ideal speech situations) makes it unnecessarily difficult for him to do conceptual justice to them, that is, to think in terms of *process*. As Gadamer has recently said, Habermas's appeal to an idealized notion of communicative action "implies a highly abstract concept of coercion-free discourse which totally loses sight of the real conditions of human praxis."[25]

When it comes to societal affairs, Habermas, perhaps in an overreaction to Adorno's pessimism,[26] is inclined towards an excessive optimism, hoping

("counterfactually") for the best while ignoring the fact (based in human "nature") that the best that can realistically be hoped for is something only relatively less unjust than what currently exists. Democracy, as Churchill once famously said, is the worst form of government—except for all the others. At the time of the original debate, Gadamer accused Habermas of being a "utopian," and, although over the course of the years Habermas's stance has gained greatly in philosophical sophistication and refinement, the charge, it seems to me, retains its validity. Or as Grondin pertinently observes, Habermas's continued denial of the charge "n'effacera jamais les tonalités hautement utopiques du corpus habermassien."[27]

On the whole, Habermas's approach to ethical issues differs from Gadamer's in its excessive intellectualism.[28] There is a danger in this, in that when Habermas maintains that "normative claims to validity have cognitive meaning" and that they "can be treated *like* claims to truth," he tends to subsume ethics under epistemology, which is to say, to subordinate the practical to the theoretical all over again. This is, of course, the standard move in traditional rationalism, and it is precisely this move or mind-set that philosophical hermeneutics has sought most strenuously to counter. For Gadamer, practical discourse is precisely *not* a procedure for "testing" the "validity" of "hypothetical" claims; in practical reasoning one seeks to show the *persuasiveness* or *reasonableness* of this or that (always contestable) interpretation, not to demonstrate its *validity*. The latter view—a typically positivist one—was defended by E. D. Hirsch, Jr., who, like Habermas (and at about the same time), accused Gadamer's hermeneutics of being overly "romantic." In order to transform hermeneutics into a "science," Hirsch attempted to transfer the positivistic notion of hypothetico-deductionism and falisficationism from the philosophy of the natural sciences to the humanities. By maintaining that interpretive judgments are hypotheses whose validity can be tested in a rigorously scientific manner, Hirsch was, in effect, attempting to "colonize" (as Habermas would say) the human lifeworld (interpretive praxis) by scientistic means.[29] It is ironic that Habermas, who subjected positivism (and its objectivistic illusion of "disinterestedness") to such a penetrating criticism in his early *Knowledge and Human Interests*, should nonetheless remain preoccupied with the epistemological (and modernist) issue of "validity" and, in this way, retain something of a positivistic approach to moral issues in his later writings. This leads one to wonder if it could perhaps be the case that there is inevitably in any Marxist-inspired critical theory ("I am defending *a* Marxist approach in my concrete work")[30] that seeks to base itself on scientific or positive "fact" (theories held by various psychologists and social scientists, in Habermas's case) and that retains vestiges of Marxist-style evolutionism ("historical materialism")[31] what Marx himself (speaking of Hegel) referred to as a "latent positivism."

I have said that both Habermas and Gadamer, in their attempt to rehabilitate *philosophical* reason, uphold the universality of ethical principles and that, accordingly, both make a distinction between the right or the just and the good, that is, between philosophical principles (*Moralität*) and culturally-relative views as to what constitutes the good life (*Sittlichkeit*). There is, however, a revealing difference between them in this regard: Gadamer's approach to ethical issues is much less formalistic than Habermas's, and it emphasizes much more than Habermas does the *embeddedness* of moral norms (*Moralität*) in cultural practices (*Sittlichkeit*). Habermas adheres to a formalistic ethics,[32] and for him ethical formalism is "incisive in the literal sense: the universalization principle acts like a knife that makes razor-sharp cuts between evaluative statements and strictly normative ones, between the good [the cultural or the particular] and the just [the philosophical or the universal]."[33] Whereas Habermas's discourse ethics is a form of deontological ethics (a formalistic moral universalism), hermeneutical ethics is neither deontological nor consequentialist (utilitarian). It is an ethics that holds to "principles of reason" (as Gadamer would say), but it is also one that believes that no clear-cut, "razor-sharp" distinction can be made between the universal and its necessarily varying particular (cultural) "applications" or instantiations. It is one which is neither a priori nor a posteriori but which seeks to reconcile universality and context-sensitivity and which recognizes that all philosophical (that is, universal) value judgments are invariably matters of *interpretation*, that is, ones which can never lay claim to "validity" in the scientistic sense of the term.

It would be unfair to say that for Habermas a rational morality, formalistic though it may be, must abstract altogether from cultural (practical) content (as some of Habermas's feminist critics allege), but the fact remains that a hermeneutical ethics, sensitive to the ambiguities of human existence, emphasizes more than Habermas does the imbrication of rational critique and cultural practice. This is why Gadamer lays greater stress than Habermas does on *tradition*. But this, I would maintain, is only a "secondary" difference. Gadamer's insistence on "tradition" and "historically-effective consciousness" (*wirkungsgeschichtliche Bewusstsein*) does not make of him an anti-Enlightenment "conservative," as Habermas now concedes.[34] What Gadamer objected to was a certain Enlightenment rationalism which opposed tradition and reflection as antithetical ("abstract reflection"). The notion of critical reflection is *both a cultural inheritance and a philosophical ideal*; it is, as Gadamer says, a cultural ideal in the light of which any and all inherited cultural practices may be subjected to rational critique. The search for hermeneutical understanding is not an attempt to preserve inviolate any particular tradition but is, rather, a critical "task," one which "may help us to gain our freedom in relation to everything that has

taken us in unquestioningly."[35] For Gadamer, as for Habermas, to the degree that this or that form of human community fails to embody the universal values of communicative rationality, it is a legitimate object of critique.[36] The philosophical enterprises of both Habermas and Gadamer are animated by the idea (as Richard Bernstein has said of Gadamer) of a "freedom and solidarity that embrace all of humanity."[37] The chief difference between Habermas and Gadamer in this regard is that whereas Habermas's formalistic-counterfactual approach cannot, as Habermas himself recognizes, vouch for its own conditions of possibility, Gadamerian ethics knows that the conditions which make it possible reside in a particular (though universalizable) cultural—humanist and liberal —tradition.

It could be said that, subsequent to the 1960s, critical theory and philosophical hermeneutics have increasingly shown themselves to be closely allied forms of thought animated by common, "emancipatory" concerns. As Michael Kelly has rightly noted: "Hermeneutics and critical theory provide two distinct but related paradigms of critique . . . ; each represents a mode of philosophical reflection which is aware of its historical conditionedness yet which demonstrates that such conditionedness is not only compatible with critique but even necessary for it."[38] As we are now in a position to see, the term "critical theory" could be applied equally well to the thought of both Habermas and Gadamer—albeit, it goes without saying, not without significant qualifications. One qualification that bears mentioning in this connection is that, in line with the general difference in the style of their thinking, Gadamer's "critical hermeneutics" is less "radical" than is Habermas's ideology-critique—less radical because less utopian and more realistic. The difference between Habermas and Gadamer has to do not with the issue of whether reason has a critical role to play with regard to human praxis (it does for both) but with the nature of critique itself.

In opposition to Habermas, Gadamer has stressed the impossibility of a *totalizing* critique of inherited practices (the "tradition"); the only way in which we can critically scrutinize certain presuppositions ("prejudices") is by tacitly appealing to others. The trouble with the kind of transparency and "undistorted" communication Habermas holds up as an ideal of communicative action is that it is a hermeneutical impossibility, for it would require us to extricate ourselves, Baron Münchausen-wise, from our historical situatedness altogether—a "counterfactual" if there ever was one. As Ricoeur has said, speaking of the Habermas-Gadamer debate, "an exhaustive critique of prejudice—and hence of ideology—is impossible, since there is no zero point from which it could proceed."[39]

Where Gadamer's critical hermeneutics differs crucially from Habermas's critical theory is in its maintaining that for communicative rationality to prevail over what Gadamer calls "social irrationality"[40] it is not at all necessary that relations of power and inequalities of condition be

eliminated from the discursive situation; all that matters is that the interlocutors come to the discussion in a spirit of "good will." The search for a consensus that could guarantee that it is altogether "distortion-free" and that could be assured that it was achieved "under the idealized conditions of unlimited communication free from domination," that is, which could be sure that it is "a true consensus," is a quixotic quest.[41] It is to engage in chimerical thinking to maintain that, in order to reach genuine agreements, people must, as a matter of fact, engage in the formal anticipation of an ideal consensus "to be realized in the future." Moreover, contrary to what Habermas maintained in his earlier critique of Gadamer, there is *no* "reason to assume that the background consensus of established traditions and of language-games may be a forced consensus which resulted from pseudocommunication."

There is no legitimate reason to assume a priori, as Habermas did in his early essay, "The Hermeneutic Claim to Universality," that tradition is inevitably the source of illusion and deception. To assume that any inherited belief or practice that has not expressly received the seal of approval or *nihil obstat* of what Habermas then called "a critically enlightened hermeneutic" is, for that very reason, likely to be "systematically distorted" is to engage in a super-critical hermeneutics of suspicion that verges on the pathological. The sharp distinction that Habermas drew in that essay between "dogmatic recognition and true consensus" is excessively absolutist, and is thus a spurious one which does not contribute significantly to democratic praxis, that is, to elucidating how agreements can actually be attained that can contribute to the betterment of the human condition and can serve to promote (as traditional liberals liked to say) the "equal freedom of all." Habermas may, over the years, have softened his critique of hermeneutics (and Gadamer's notion of "tradition"), but he seems not, on the whole, to have greatly modified the idealistic assumptions on which it was based. As Agnes Heller (who, unlike Habermas, clearly recognizes that "symmetric reciprocity"—the imperative of any true discourse ethics—"does not exclude a hierarchy resulting from the division of labour," that is, an inequality in the distribution of "power"[42]) has said of Habermas's more recent discourse ethics, "Put bluntly, if we look to moral philosophy for guidance in our actions here and now, we cannot obtain any positive guidance from the Habermasian version of the categorical imperative."[43]

Several of Habermas's students and philosophical associates have sought to amend his discourse ethics in this regard—and in ways which often tend to bring it into greater alignment with hermeneutical ethical theory (contributing thereby to the prospects that, one day, a genuine dialogue might actually be instituted between critical theory and philosophical hermeneutics). For instance, Seyla Benhabib, invoking the name of

Gadamer, has sought "to save [Habermas's] discourse ethics from the excesses of its own rationalistic Enlightenment legacy."[44] To this end, she has attempted "to highlight, emphasize and even radicalize those aspects of a discourse ethic which are universalist without being rationalistic" (the chief characteristic, as was mentioned above, of hermeneutical communicative ethics). Benhabib has, in particular, criticized Habermas's reliance on the notion of "consensus," which she considers to be a "counterfactual illusion." She writes:

> The goal of such conversation ["a moral conversation, exercising the art of 'enlarged thinking'"] is not consensus or unanimity (*Einstimmigkeit* or *Konsens*) but the "anticipated communication with others with whom I know I must finally come to some agreement" (*Verständigung*). This distinction between "consensus" and "reaching an agreement" has not always been heeded in objections to communicative ethics. At times Habermas himself has overstated the case by insisting that the purpose of universalizability procedures in ethics must be the uncovering or discovering of some "general interest" to which all could consent. . . . In ethics, the universalizability procedure, if it is understood as a reversing of perspectives and the willingness to reason from the other's (others') point of view does not guarantee consent; it demonstrates the will and the readiness to seek understanding with the other and to reach some reasonable agreement in an open-ended moral conversation.[45]

This aptly describes the hermeneutical conception of "agreement" and Gadamer's notion of "good will." In her reworking of discourse ethics, Benhabib is making an altogether Gadamerian point when, correcting Habermas, she writes that consent or agreement "alone can never be a criterion of anything, neither of truth nor of moral validity." "We must," she says, "interpret consent not as an end-goal but as a process for the cooperative generation of truth or validity." When, as she goes on to say, "we shift the burden of the moral test in communicative ethics from consensus to the idea of an ongoing moral conversation, we begin to ask not what all would or could agree to as a result of practical discourses to be morally permissible or impermissible, but what would be allowed and perhaps even necessary from the standpoint of continuing and sustaining the practice of the moral conversation among us."[46] This way of reconfiguring Habermasian discourse ethics serves to align it quite nicely with what Gadamer has said about "the conversation that we are."

When Habermas's discourse ethics is recast in a form such as this, the basic "solidarity" between the concerns which inform it and those which animate Gadamer's "conversation ethics" becomes fully apparent. It also becomes, or should become, apparent that these two versions of a dialogically formulated universalist ethical theory together constitute a

powerful antidote to both the anti-universalism of communitarian ethics which have become fashionable and the nonrational ethics of various forms of genealogical and deconstructive poststructuralism and relativistic postmodernism which have become firmly institutionalized in various quarters of academia.

There is one final issue I would like to address in this paper. It is one in regard to which the controversy between hermeneutics and critical theory remains fairly vociferous. Yet, if some of the important differences that continue to set critical theorists and hermeneuticists at unnecessary odds with one another are to be addressed, the issue itself must be squarely addressed. The issue concerns the nature of rationality as it appertains to the *economic* realm of human praxis. As was pointed out at the outset of this paper, both Habermas and Gadamer have sought to contest the dominance of purely instrumental rationality; they have both sought to show how a higher (or more fundamental) form of rationality—communicative rationality—can and should be the ultimate regulative principle in human affairs. Habermas has not, however, attempted to rethink "the economic" in terms of communicative rationality. On the contrary, his way of characteriz- ing the economic order as a "sub*system*" (an inherently scientistic term) and his speaking of "steering mechanisms" in regard to the economy suggest that he continues to think of the economic realm in modernistic terms, as one area of human praxis that is rightly subject to instrumental rationality. This is unfortunate.

Socialist economics—the idea of a command or centrally planned economy—was, it is true, a superb instance of instrumental or technocratic rationality of "late modernism." It was a superb instance of Weber's bureaucratic "iron cage." The socialist idea is now defunct, however, and it is generally conceded, by liberals and social democrats alike, by both conservatives and progressives, that the only form of economy that is viable in (post)modern societies is the *market economy*. This makes it important to rethink the logic of this way of ordering human economic affairs.[47] A number of economists have attempted to do so, drawing on hermeneutics and on Gadamer in particular.[48] In opposition to both neoclassical economics and social thought since the time of Weber, they maintain that the logic of a market economy, that is, of market *processes*, is not appropriately conceptualized—is, indeed, profoundly misunderstood ("systematically distorted")—when it is viewed as a form of instrumental or technological rationality.[49] Their approach has been two-fold.[50]

They have, on the one hand, addressed themselves to fundamental issues in economic methodology, contesting many of the core assumptions of mainstream, neoclassical economics, and they have, on the other hand, sought to work out what they believe to be a more appropriate means of

conceptualizing the way in which a market economy actually works. Applying a hermeneutical form of critical theory to economics, they have criticized the objectivistic presuppositions of main line economics—the concept of *homo economicus*, the Robinson Crusoe view of human beings as isolated individuals, the idea of general equilibrium, rational expectations theory, and so on—for being hopelessly "idealistic" and (as idealizing abstractions, in Husserl's sense of the term) for being unsuited for coming to grips with the real world of flesh-and-blood economic agents in the everyday economic lifeworld.[51]

They have also argued that while the logic of intra-economic entities such as the *firm* may be appropriately characterized as purposeful or instrumental (although even that would need to be qualified), the logic of a market *economy* as a whole, that is to say, of market *processes*, is something altogether different. A market economy is the opposite of a command economy; the (quite remarkable) order that it manifests is not the result of conscious planning and deliberate design on the part of anyone in particular but emerges in a spontaneous manner from the actions of a myriad of disparate human agents, each seeking to better his or her own condition, in his or her own particular way. This spontaneous order,[52] hermeneutical economists argue, is best conceived as a form of communicative rationality in the Gadamerian sense of the term.

In brief, hermeneutical economists view the market process as a kind of conversation aiming at "agreement" and conducted in the language of prices.[53] When they are determined not by arbitrary fiat (by a central planning bureaucracy or a price control board) but by the spontaneous workings of the market, prices are *embodied meanings*, ones which perform a *communicative* function (with regard to the saleability of commodities and other valuations attached to them by consumers). These understandings based on pricing are thoroughly embedded in economic praxis and are generated *in the very process of exchange*; they can therefore never be fully "thematized" in such a way as to be subject to conscious planning and control. Deriving, as they do, from communicative interaction in the economic lifeworld, the valuations of goods and services that market prices express are in no way objectivistic, reified "exchange values" in the old Marxist sense. It is for these reasons that hermeneutical economists insist that human agency in the context of a market economy must be treated under the rubric not of *technè* but of *praxis*, that is, practical reasoning in Gadamer's sense of the term. (It may also be noted in passing that there is a form of communicative ethics that is embodied in the actual workings of a market economy.)[54]

Addressing himself to the work of the hermeneutical economists, Gadamer has said: "[I]t makes sense to me that the market economy presents

a convincing analogy to communication in a dialogue." When these writers speak of the "language of prices," he says they

> could equally well have talked of the balancing-out (*Sich-Einspielen*) of prices in the market event, and this corresponds exactly to my own concept of play (*Spiel*) and its model function in the linguistic event as well as in understanding art. . . . Theory should only be developed out of praxis. . . . [I]t is convincing and important that in the field of the economic sciences one should also speak more of the experience of practice than of the regulative schemata of economic models. . . . The market event is indeed really like a good discussion: one cannot know in advance what will come out of it.[55]

Interpretive economists believe that to the degree to which an economy is a *free*[56] market economy, such an economy constitutes what Habermas himself refers to as "a communication community existing under constraints toward cooperation" and that it is one of those "intersubjective life-contexts in which communicative reason is embodied."[57] Objecting to what Grondin calls the "Platonic dualism of the material and the symbolic [that] governs the Habermasian conception of reason,"[58] they believe that in a free market economy the economic realm is (as Adam Smith had already remarked) a *symbolic* realm permeated by communicative rationality and is not merely, as Habermas would have it, a "functionalist" system concerned only with *material* needs.

Given the deep affinities that exist between critical theory and philosophical hermeneutics, the objections I have advanced are meant in a sympathetic or constructive spirit, not a hostile one. This holds also for the objections that, from a hermeneutical point of view, could be made to Habermas's approach to economic rationality. Were Habermas to engage in a dialogue with the hermeneutical economists, he might well come to see that an interpretive approach to "the economic" affords a more praxially appropriate way for conceptualizing the rationality that principally characterizes market processes than does the positivist-instrumentalist approach of mainstream neoclassicism. There is no reason why positivism should be accorded an exclusive mandate to think the economic any more than it should be allowed a methodological exclusivity in regard to any other dimension of the social lifeworld. In not calling into question the modernist tendency to equate "the economic" with "the instrumental," Habermas unnecessarily perpetuates in this regard the pessimism of Weber and that of the crisis thinking of the earlier Frankfurt School. What the recent triumph of liberal economics over technocratic socialism should indicate to as keen an interpreter of historical trends as Habermas is that the time is now ripe (at "the ambiguous end of metaphysics"[59]) for reconceptualizing the economic in a decisively non-technocratic, postmodern manner.

Taking a hermeneutical approach to the economic could greatly serve the

(emancipatory) interests of Habermasian-style critical theory: It could enable this mode of critical thought to effect *pertinent* criticisms of "actually existing" market economies, that is, criticisms which, by being expressly aware of the logic that is specific to the market process itself, do not deteriorate into vapid denunciations of "late capitalism" and "capitalist rationality" that are motivated more by ideology than by a spirit of constructive criticism. For the fact of the matter is that leftist critiques of market economics, that is, of economic liberalism, are often sorely lacking in focus; the problem they invariably encounter was well described by liberal economist Frank H. Knight a number of decades ago:

> We must always keep in mind the relations between ethical and mechanical aspects of the economic system. In so far as undesirable results are due to obstructions or interference of a frictional character in the workings of the organization machinery, the correct social policy will be to remove these or to supplement the natural tendencies of the system itself. In so far as these natural tendencies are wrong, the effort must be to find and substitute some entirely different machinery for performing the right function in the right way. There is much confusion in the popular mind on this point: critics of enterprise economy who do not have a fair understanding of how the machinery works cannot tell whether to criticize it because it doesn't work according to theory or because it does.[60]

Like other critical theorists today, Habermas, while endorsing political liberalism, remains hostile to economic liberalism. There is no necessary reason why this should be so. After the bankruptcy of the socialist ideal, it is clear that any viable social democratic politics must ally itself with the market economy, and it is in the great interest of any welfare politics that it "do no harm" (as the medical injunction has it) to the economy on which it must rely for its financial resources. Ill-advised, ideology-driven political interventions in the market economy can easily be economically counterproductive and can even in the long run (and in accordance with the "law of unintended consequences") produce harmful effects on the interests of those whom the interventions were intended to benefit. Prudence therefore dictates that political intervention in the economy be, as much as possible, *marktkonform*, as the theorists of the original German Social Market Economy put it, that is, that it respect the logic of the "system." This, of course, is possible only if one possesses a proper understanding of the logic in question. It is this theoretical understanding that hermeneutical economic theory seeks to develop, and theory of this sort has practical import; it can facilitate the formulation of enlightened policy, be that policy liberal or social democratic.

Interpretive economics is a minoritarian school in the economics establishment, which continues to be dominated by a positivistic objectivism

and a technocratic obsession with mathematical modeling. However, its concerns and the issues it seeks to address overlap in interesting ways with other contestatory schools, such as institutionalism and some forms of Marxian economics. What all of these have in common is the belief that modern, positivistic economics—which views itself as a kind of Newtonian mechanics of human affairs—is intellectually anemic and that a proper treatment of the economic calls for a revival of an older tradition in economic thought, that of *political economy*, which did not artificially abstract economic factors from the wider context of political and societal organization—of *human action* in general.

The altogether dismal hegemony of instrumental rationality in late modernity was well diagnosed by Max Weber earlier in this century. Unlike some of their more pessimistic *confrères*, however, neither Gadamer nor Habermas was prepared to accept Weber's fatalistic prognosis. Throughout their long and prolific careers, both Habermas and Gadamer have sought, in a highly conscientious way, to rehabilitate philosophical reason in an age of instrumental science. This task will not be complete until, perhaps sometime in the next, less crisis-ridden century, it has been effected in *all* the various realms of human agency—the moral-cultural, the political, and the economic—in such a way as to allow full scope for the exercise of an ethics of communicative rationality in all these domains of human endeavor.

G. B. Madison

Department of Philosophy
McMaster University
January 1998

NOTES

1. See Hans-Georg Gadamer, "Reflections on My Philosophical Journey" in Lewis E. Hahn, ed., *The Philosophy of Hans-Georg Gadamer* (The Library of Living Philosophers, vol. 24) (Chicago: Open Court, 1977), p. 55: "My studies since *Truth and Method* have . . . taken me in another quite different direction: into practical philosophy and the problems of the social sciences. The critical interest that Jürgen Habermas showed in my work during the 1960s itself gained critical significance for me and drew my interest into these areas."

2. For a succinct statement of Habermas's notion of communicative action, see his "Aspects of the Rationality of Action" in Th. F. Geraets, ed., *Rationality To-Day/La rationalité aujourd'hui* (Ottawa: Editions de l'Université d'Ottawa, 1979).

3. Jean Grondin, *Introduction to Philosophical Hermeneutics* (New Haven, Conn.: Yale University Press, 1994), p.130.

4. Richard Bernstein, an ally of the Frankfurt School, had earlier on remarked that Gadamer's philosophical hermeneutics confronts us with "a practical task," that is, "to foster the type of dialogical communities in which *phronesis* [practical reason, communicative rationality] becomes a living reality and where citizens can actually assume what Gadamer tells us is their 'noblest task'—'decision-making according to one's own responsibility'—instead of conceding that task to the expert" (*Beyond Objectivism and Relativism: Science, Hermeneutics, and Praxis* [Philadelphia: University of Pennsylvania Press, 1983], p. 159).

5. Cf. Habermas: "If I should undertake to locate Gadamer's philosophical effectiveness in the political context of German postwar history, I would emphasize as its most significant element, and as a purifying element, his magnificent actualization of the humanist tradition, which is oriented to the formation of the free spirit and is pervasive as a secret competitor and as a complement to the characteristic force of modern science throughout modernity" (*Philosophical-Political Profiles.*, trans. F. G. Lawrence [Cambridge, Mass.; MIT Press, 1983], p. 196).

6. Stanley Rosen, *Hermeneutics as Politics* (New York: Oxford University Press, 1987), p. 141.

7. See Václav Havel, *Summer Meditations,* trans. P. Wilson (New York: Alfred A. Knopf, 1992), p. 15.

8. See Gadamer, *Philosophical Hermeneutics*, trans. D. E. Linge (Berkeley: University of California Press, 1976), p. 19.

9. It is, of course, true that Gadamer's universalism is of a particular sort, neither formalist nor rationalist, as I shall attempt to indicate below.

10. Habermas, *Moral Consciousness and Communicative Action*, trans. C. Lenhardt and S. W. Nichosen (Cambridge, Mass.: MIT Press, 1990), p. 68.

11. Ibid., p. 65.

12. Ibid., p. 103, emphasis mine.

13. Just as feminists have raised objections to Rawls's ignoring of the "gender factor," so also, for somewhat similar reasons, they have objected to Habermas's "idealized" discussants; see, for instance, Nancy Fraser, "What's Critical about Critical Theory? The Case of Habermas and Gender," *New German Critique* 35 (Spring/Summer 1985) (reprinted in Fraser, *Unruly Practices: Power, Discourse and Gender in Contemporary Social Theory* [Minneapolis: University of Minnesota Press,1989]) and Marie Fleming, "Critical Theory between Modernity and Postmodernity," *Philosophy Today* 41, no. 1 (Spring 1997) (both Fraser and Fleming are sympathetic critics).

14. See, for instance, *Moral Consciousness and Communicative Action*, p. 88.

15. Cornelius Castoriadis, *Crossroads in the Labyrinth*, trans., K. Soper and M. H. Ryle (Cambridge, Mass.: MIT Press, 1984), p. 150.

16. Clifford Geertz, *The Interpretation of Cultures* (New York: Basic Books, 1973), p. 29.

17. Cf. Habermas, *Postmetaphysical Thinking: Philosophical Essays*, trans. W. M. Hohengarten (Cambridge, Mass: MIT Press, 1992).

18. See Habermas's critical rejoinder ("Struggles for Recognition in the Democratic Constitutional State") to Taylor's communitarianism in A. Gutmann, ed., *Multiculturalism: Examining the Politics of Recognition* (Princeton, N.J.: Princeton University Press, 1994).

19. Philosophical hermeneutics is more concerned with the "right" than the "good" in that, in its critical mode, it does not (in contrast with communitarianism) presume to sanction any particular cultural way of life or *ethos*. There are many different ways in which different cultures may embody universal principles of reason; just as there is no one "correct" interpretation of a text, so likewise there is no single "best" way of institutionalizing the practice of communicative rationality (*phronesis*). See in this regard my "Hermeneutics, the Lifeworld, and the Universality of Reason," *Dialogue and Universalism* (Polish Academy of Sciences) 7 (1995): 79–106.

20. Chantal Mouffe, *The Return of the Political* (London: Verso, 1993), p. 18.

21. See Habermas, *Moral Consciousness and Communicative Action*, p. 89.

22. Paul Ricoeur, *Lectures 1: Autour du politique* (Paris: Editions du Seuil), p. 174.

23. Ibid., p. 174.

24. Ibid., p. 277.

25. Gadamer, "Reflections on My Philosophical Journey," p. 32.

26. See Habermas, "Theodor Adorno: The Primal History of Subjectivity—Self-Affirmation Gone Wild" in *Philosophical-Political Profiles*.

27. See Jean Grondin, *L'horizon herméneutique de la pensée contemporaine* (Paris: Vrin, 1993), p. 122.

28. The difference between the two approaches could perhaps be summed up by saying that whereas Habermas attempts "to ground ethics in the form of a *logic* [emphasis mine] of moral argumentation" (*Moral Consciousness and Communicative Action,* p. 57), Gadamer approaches ethical questions from the point of view of a *rhetoric* of moral argumentation, much in line with Chaïm Perelman's *nouvelle rhéthorique* or *théorie de l'argumentation*. The latter approach to normative issues is *qualitatively* different from what Habermas appeals to under the heading of "informal logic" (*Moral Consciousness and Communicative Action*, p. 63). In his "Reflections on My Philosophical Journey," Gadamer writes: "[I]n *Truth and Method* I have expressly related myself to rhetoric and from many sides found corroboration. For instance, the work of Chaim Perelman, who takes legal practice as his starting point" (p. 30).

29. For a Gadamerian critique of Hirsch's "hermeneutical positivism," see my "Eine Kritik an Hirschs Begriff der 'Richtigkeit'" in H. G. Gadamer and G. Boehm, eds., *Seminar: Die Hermeneutik und die Wissenschaften* (Frankfurt: Suhrkamp, 1978); English version in Madison, *The Hermeneutics of Postmodernity: Figures and Themes* (Bloomington: Indiana University Press, 1988).

30. See Geraets, ed., *Rationality To-Day/La rationalité aujourd'hui*, p. 212.

31. Cf. Habermas's reflections on historical materialism in his *Communication and the Evolution of Society*, trans. T. McCarthy (Boston: Beacon Press, 1979).

32. Tom McCarthy, one of America's best known Habermas scholars, states: "In his approach to moral theory Habermas is closest to the Kantian tradition" ("Introduction" in Habermas, *Moral Consciousness and Communicative Action*, p. vii). In regard to Habermas's Kantianism Grondin observes: "Habermas est parfois plus kantien que Kant dans le sens où son formalisme va si loin qu'il n'énonce jamais les moyens de réalisation ou d'acualisation de la rationalité communicationnelle, non stratégique" (*L'horizon herméneutique de la pensée contemporaine*, p. 127).

33. Habermas, *Moral Consciousness and Communicative Action*, p. 104.

34. It is unfortunate that Georgia Warnke, in her otherwise fine study of Gadamer's philosophical hermeneutics, should adhere to what could be called the "standard Frankfurt line" in maintaining that one defect in Gadamer's hermeneutics is its "conservatism" (see Warnke, *Gadamer: Hermeneutics, Tradition and Reason* [Stanford, Calif.: Stanford University Press, 1987]). The fact of the matter is that Gadamer is neither an "intellectual" conservative (*à la* Alasdair MacIntyre, that is, what Habermas calls a "neoconservative") nor a political conservative (*à la* Edmund Burke)—as he himself has attempted to make abundantly clear. Fallacious charges of this sort serve only to impede the development of a meaningful dialogue between critical theory and hermeneutics. A hermeneuticist wonders if there might not be something self-serving in this Frankfurt criticism which continues to linger on despite all efforts on the part of hermeneuticists to correct the misunderstanding.

35. Gadamer, *Reason in the Age of Science*, trans. F. Lawrence (Cambridge, Mass.: MIT Press, 1981), p. 150.

36. See G. B. Madison, "Hermeneutics: Gadamer and Ricoeur" in R. Kearney, ed., *Continental Philosophy in the 20th Century* (Routledge History of Philosophy, vol. 8) (London: Routledge, 1994), p. 335.

37. Bernstein, *Beyond Objectivism and Relativism*, p. 163.

38. Michael Kelly, "Introduction" in Kelly, ed., *Hermeneutics and Critical Theory in Ethics and Politics* (Cambridge, Mass.: MIT Press, 1990), p. vii.

39. Ricoeur, *Hermeneutics and the Human Sciences*, ed. J. B. Thompson (Cambridge: Cambridge University Press, 1981), p. 71. As Ricoeur also remarks:
The task of the hermeneutics of tradition is to remind the critique of ideology that man can project his emancipation and anticipate an unlimited and unconstrained communication only on the basis of the creative reinterpretation of cultural heritage. If we had no experience of communication, however restricted and mutilated it was, how could we wish it to prevail for all men and at all institutional levels of the social nexus? (ibid., p. 97)

40. See Gadamer, *Reason in the Age of Science*, p. 74.

41. This and other quotes in this and the following paragraph are taken from the last pages of Habermas's "The Hermeneutic Claim to Universality," a reprint of which can be found in J. Bleicher, *Contemporary Hermeneutics: Hermeneutics as Method, Philosophy and Critique* (London: Routledge and Kegan Paul, 1980).

42. See Agnes Heller, *Can Modernity Survive?* (Berkeley: University of California Press, 1990), p. 148.

43. Heller, "The Discourse Ethics of Habermas: Critique and Appraisal," *Thesis Eleven*, no. 10–11 (1984–85): 7.

44. Seyla Benhabib, *Situating the Self: Gender, Community and Postmodernism in Contemporary Ethics* (New York: Routledge, 1992), p. 8.

45. Ibid., p. 9.

46. Seyla Benhabib, "Afterword: Communicative Ethics and Current Controversies in Political Philosophy" in S. Benhabib and F. Dallmayr, eds., *The Communicative Ethics Controversy* (Cambridge, Mass.: MIT Press, 1990), pp. 245–46.

47. Curiously enough, perhaps, this is a task that mainstream economic science has yet failed to undertake in any serious way, as institutional economist Geoffrey Hodgson remarks:

> The study of market behaviour is a major theme, if not the major theme, of economic science as we know it. . . . Remarkably, however, definitions of the market in the economic literature are not easy to find, and analytical discussions of the institutional concepts involved are extremely rare. Mathematical models of market phenomena abound, and there is a voluminous literature on the theoretical determinants of market equilibria. Yet if we ask the elementary question, 'What is a market?', we are given short shrift. . . . For too long 'the market' has been taken for granted. (*Economics and Institutions: A Manifesto for a Modern Institutional Economics* [Philadelphia: University of Pennsylvania Press, 1988], pp. 172–73)

48. The hermeneutical task in regard to economics is no different from what it is in regard to all other realms of human activity, from the production of texts to the generation of cultural forms of life. In all such instances hermeneutics sets itself the task of explicating (interpreting) the "logic" of the order in question (text, culture, economy). For discussions of hermeneutical or interpretive economics see: P. Boettke, ed., *The Handbook of Austrian Economics* (Aldershot: Edward Elgar, 1993); P. Boettke and D. Prychitko, eds., *The Market Process: Essays on Contemporary Austrian Economics* (Aldershot: Edward Elgar, 1993); D. Lavoie, ed., *Economics and Hermeneutics* (London: Routledge, 1990), G. B. Madison, "Economics" in L. Embree, ed., *Encyclopedia of Phenomenology* (Dordrecht: Kluwer Academic, 1997); G. B. Madison, *The Political Economy of Civil Society and Human Rights* (London: Routledge, 1998); D. L. Prychitko, ed., *Individuals, Institutions, Interpretations: Hermeneutics Applied to Economics* (Aldershot: Avebury, 1995).

49. To the degree that the logic or dynamic of market processes is systematically distorted as a result of government intervention and control, to that degree the rationality of the market is, to be sure, "technologized," and the market economy is inclined in the direction of "state capitalism," differing only in degree from bureaucratic socialism. Unlike Habermas, who appears to equate "late capitalism" with just such a form of instrumental-rational action, the hermeneutical economists view this state of affairs as a pathology of the economic lifeworld that it is the function of hermeneutical theory in its critical mode to address.

50. For a summarizing account of the approach taken by hermeneutical economists in this dual regard, see G. B. Madison, *The Political Economy of Civil Society and Human Rights* (London: Routledge, 1998), chap. 5.

51. What, in short, hermeneutical economists have criticized, on strictly methodological grounds, is the mainline, positivistic version of neoclassical economics, that is, the version of economic science that Habermas appears to accept uncritically. Habermas writes: "Economics as a specialized science has broken off that relation [to society as a whole]. Now it too concerns itself with the economy as a subsystem of society and absolves itself from questions of legitimacy. From this perspective it can tailor problems of rationality to considerations of economic equilibrium and questions of rational choice" (*The Theory of Communicative Action*, vol. I [Boston: Beacon Press, 1984], p. 4).

This characterization of economic science is, of course, true enough of mainstream neoclassical economics. The point that the hermeneutical economists are trying to make is that this objectivistic way of conceptualizing "the economic" is incapable of doing (theoretical) justice to human economic praxis. What they are attempting to do is to extend the critique of instrumentalist rationality undertaken by Habermas and Gadamer to the economic realm itself.

52. The idea of "spontaneous orders" was developed above all by F. A. Hayek. For reasons I am unable to fathom, critical theorists seem averse to everything Hayek has written. The fact remains that such an aversion, completely without ground in my opinion, remains one of the great obstacles to any genuine dialogue between critical theory and philosophical hermeneutics.

53. In this paragraph, I am drawing upon an earlier article in this series, "Hermeneutics' Claim to Universality" in L. E. Hahn, ed., *The Philosophy of Hans-Georg Gadamer* (The Library of Living Philosophers, vol. 24) (Chicago: Open Court, 1997), p. 355.

54. See, on this matter, G. B. Madison, "Self-Interest, Communalism, Welfarism" in H. Giersch, ed., *The Merits of Markets: Critical Issues of the Open Society* (Berlin: Springer-Verlag, 1998).

55. Gadamer, "Reply to G. B. Madison" in *The Philosophy of Hans-Georg Gadamer*, p. 367.

56. "Free" means uncontrolled (unplanned), but it most definitely does not mean *unregulated* ("laissez-faire"). In order to function properly (in order that it may serve the common good), a market economy requires a well-worked out legal and regulatory framework, which it is the responsibility of the political realm to provide.

It is altogether misleading, however, to speak of "steering mechanisms" in this regard. As the hermeneutical economist, Don Lavoie, has pointed out, to speak of "steering" the economy is to have recourse to an inept metaphor, in that what chiefly characterizes a market economy is that there is no one in the driver's seat; an economy of this sort "steers itself." Lavoie writes:

> The interplay of the market is itself the source of knowledge of what the more effective ways of doing things are, so that for the government to try to guide or steer the market is, in fact, to blindly intervene in a self-ordering process. . . .
>
> The proper function of government in a free and democratic society should be seen as maintaining and improving the rules by which we live peacefully among one another, not as deliberately carrying out any one person's plan. Policymaking should pay attention to setting up such institutional frameworks in order to get market processes to flourish. But the flourishing itself is a creative discovery process that, like a good conversation, cannot be under any participant's control.
>
> Democratic government should not try to run or steer the market any more than it should try to orchestrate scientific advances, to dictate artistic standards, or to design political discussions. It should just set in place and maintain the legal context that is required for markets to work, in much the same way that it should try to set the context in which political, scientific, and cultural discourse works. ("Glasnost and the Knowledge Problem: Rethinking Economic Democracy," *The Cato Journal* 11, no. 3 [Winter 1992]: 448–49)

57. See Habermas, *The Philosophical Discourse of Modernity*, trans. F. Lawrence (Cambridge, Mass.: MIT Press, 1987), p. 40.

58. Grondin, *L'horizon herméneutique de la pensée contemporaine*, p. 131.

59. See Habermas, *Philosophical-Political Profiles*, p. 192.

60. Frank H. Knight, *Freedom and Reform: Essays in Economics and Social Philosophy* (Indianapolis: Liberty Press, 1982 [1947]), p. 57.

24

Richard E. Palmer

Habermas versus Gadamer? Some Remarks

When, as a career-long Gadamer scholar, I recently expressed to Lewis Hahn my great admiration for the work of Habermas, and my sentiment that the famous Habermas-Gadamer debate misled many people into overlooking the commonality between them and the actual complementarity of their contributions, he invited me to contribute a few observations on this topic to the present volume. It is indeed an honor to do so.[1]

First, the personal relationship between the two thinkers was always respectful, even when they engaged in sharp public debate. The famous "Habermas-Gadamer debate" was not definitively won by one side or the other, but it certainly stimulated both thinkers to clarify and subsequently modify their positions. For Habermas, the debate with Gadamer brought further national and international attention. As he modified his critical theory in response to it, he moved toward his later theory of communicative action. Gadamer, on the other hand, became cognizant of some limits of his hermeneutical perspective, and this caused him to address social issues more directly in such books as his *Vernunft im Zeitalter der Wissenschaft* (1976; *Reason in the Age of Science*, MIT Press, 1981) and his *Lob der Theorie* (1983; *Praise of Theory*, Yale University Press, 1998). The debate has been the object of intensive discussion in numerous articles and in books by Demetrius Teigas, Alan How, Thomas McCarthy, Robert C. Holub, Scott Cameron, and others, so I will here attempt to defend the more general claim I made at the outset, that there is a good deal of common ground between the two thinkers, and where they differ their contributions tend to be complementary.[2] I will claim that Gadamer's philosophical hermeneutics and general contribution to philosophy have not been rendered irrelevant or obsolete by Habermas's theory of communicative action, as some of Habermas's followers, unconsciously presupposing the developmental model of the sciences, seem to assume. Instead, Habermas and Gadamer have had different missions and goals. Their careers are more closely related

than is generally realized. I will argue that even today, at the turn of the century, Gadamer's thought can still serve as a balance to the very powerful reasoning of Habermas.

In profiling the contributions of the two thinkers, I would like first to call attention to their considerable difference in age and experiences, and then take up the interrelation of their careers, the contrasting philosophical currents in which they were operating, and the fundamental contrast in their "knowledge-guiding interests." These help us to put in perspective the famous debate as well as the commonalities and complementarity of the two famous thinkers.

Gadamer was born in Marburg, Germany, on February 11, 1900, barely escaping military service in World War I. His early interests were in art history and literature, but at Marburg University he was drawn to philosophy under the famous Plato scholar, Paul Natorp, and took his doctorate in 1922, writing on Plato. He served as Heidegger's assistant during the five years Heidegger was in Marburg (1923–1928) and was powerfully influenced by Heidegger's explication of classical texts, especially Aristotle. To counterbalance the powerful influence of Heidegger's interpretations, he studied classical philology and was certified to teach it in 1927, a year and a half before he habilitated under Heidegger with a dissertation on Plato's dialectical ethic. For a number of years he did not receive a call to a professorship and remained at the University of Marburg as a private teacher without pay except for a year as a professor at Kiel (1934–1935), after which he returned to Marburg where he taught until 1938, when he was called to Leipzig. Although he obtained this position because of the intervention of Graf Willi Gleispach, leader of a Nazi-sponsored camp for academics that Gadamer attended voluntarily (hoping to get a job), he tried after he got the position at Leipzig to be as politically inconspicuous as possible, working in the discipline of ancient philosophy. For this he was rewarded after the war by being made Rector at Leipzig because he had had no affiliation with the Nazis.[3]

In 1947 he received a call to Frankfurt, and through skillful persuasion obtained permission to emigrate from East Germany. In 1949 he was called to Heidelberg, where he remained as chair of the department until his retirement in 1968. After his retirement he continued to lecture at Heidelberg when not serving as a guest professor in the United States or Canada, where he was able to stimulate interest in his *Wahrheit und Methode*, which was not translated into English until 1975 as *Truth and Method*. Four volumes collecting his essays appeared between 1967 and 1977 (*Kleine Schriften*). More than a dozen other works followed, mostly collections of essays on different topics, such as Plato, Hegel, Heidegger, Celan, interpretations of poetry, his autobiography, collections such as *Reason in the Age*

of Science and *Praise of Theory*, and in the nineties (his nineties) several new books, including *Die Verborgenheit der Gesundheit* (1993, *The Enigma of Health*, 1996) and two volumes on the pre-Socratics Parmenides and Heraclitus.[4] Between 1985 and 1995 he selected and edited the essays for the ten volumes of his *Gesammelte Werke*. But his 500-page hermeneutical magnum opus, *Truth and Method*, remains the work on which his fame has rested up to the turn of the century. His life has spanned the century; he survived Hitler by retreating into classical scholarship, and due to the delays entailed by the era of National Socialism, with the difficult years after World War II, only attained national recognition beginning at age sixty with the publication of *Truth and Method*.

Jürgen Habermas was born twenty-nine years after Gadamer, on June 18, 1929, in Düsseldorf. Like Gadamer, he was born too late to be drawn into military service in a war, but the traumatic events that took place as he grew up in Hitler's Germany, up to and including World War II, deeply affected Habermas. He was just turning sixteen when the war ended in 1945, and of course this was followed by years of privation in all of Germany after the war.

Habermas studied at the universities of Göttingen, Zürich, and Bonn, and eventually submitted his doctoral dissertation on Schelling's philosophy of identity at Bonn in 1954. From 1955 to 1959, he was Adorno's assistant at the Institute for Social Research at Frankfurt. This was followed by a life-long advocacy of Critical Theory, but this was his own importantly evolving form of Critical Theory, with criticisms of earlier Critical Theorists. After his years at Frankfurt, he continued his studies in Marburg and habilitated in 1961, thirty-two years after Gadamer. Gadamer, as department chair in Heidelberg at the time, then called him to Heidelberg, where he taught from 1961 to 1964, publishing in 1962 his influential *Strukturwandel der Öffentlichkeit* (*The Structural Transformation of the Public Sphere*, translated in 1989), and in 1963, *Theorie und Praxis* (trans. 1973).[5] A prolific reader and writer, Habermas attained recognition already in his forties as a leading representative of the Critical Theory put forward by the Frankfurt School. He was also personally active in the student protests of the 1960s and to this day actively speaks out on political issues. In 1964 he was called back to Frankfurt as professor of philosophy and sociology, where he taught until he was called to be co-director of the Max Planck Institute in Starnberg. In 1983 he again returned to Frankfurt where he remained until his retirement in 1994. According to Tom McCarthy, a leading Habermas scholar, in Germany Habermas was "one of the most prominent public intellectuals, speaking out on a wide array of issues, from violations of civil liberties and the attempted 'historicizing' of the Holocaust to immigration policy and the manner of German unification" ("Habermas" entry, *Encyclopedia of Philosophy*, 1996 Supplement). Perhaps his most important theoretical work, and the theoretical

basis of his later writings, was the 1,150-page *Theorie des kommunikativen Handelns* (2 vols. 1981, trans. 1984, 1987). Habermas retired in 1994 but has continued to publish writings in social and political theory, such as: *Between Facts and Norms: Contributions to a Discourse Theory of Law and Democracy* (1996) and *The Inclusion of the Other: Studies in Political Theory* (1998).[6]

These two brief biographical sketches show the historical intersection of the careers of Habermas and Gadamer, but there were further overlaps. For example, Gadamer had close connections with Frankfurt and Frankfurt Critical Theory. It was Gadamer who, while at Frankfurt, called Adorno back to the philosophy department in the late 1940s. Habermas later served as Adorno's assistant just as Gadamer had been Heidegger's assistant in the 1920s. In both cases the philosophical impact was decisive. Also, Gadamer presented his habilitation under Heidegger at Marburg in 1929; Habermas presented his habilitation also at Marburg thirty-two years later. It was Gadamer who issued the call for Habermas to come to Heidelberg University in 1961, where he taught for three years before returning to Frankfurt. Yet there were also many contrasts in the two careers, of course, especially with regard to political activism and social theory. For Gadamer to have been an activist under Hitler during the 1930s would have been fatal, so he chose political quietism. In the 1960s, however, Habermas found a sympathetic audience among university students, and he became an unflinching political activist. Gadamer was retiring in 1968, just as Habermas was becoming popular. In spite of their public interchanges at the time and in spite of Gadamer's continuing association with Heidegger, the two thinkers remained friends. Habermas's *Zur Logik der Sozialwissenschaften* was first published in Gadamer's journal, the *Philosophische Rundschau*, and in it he invokes hermeneutics as an ally in the reconstruction of the social sciences. Gadamer loved a debate between sincerely held positions and worthy competitors, so his debate with Habermas (unlike his later debate with Derrida) only enriched their relationship. For Gadamer, philosophical debate was one of the highest exercises of reason, and the critique arising out of reasoning together enabled the debater to see and correct things he would never have seen on his own.

Their philosophical positions arose in different time periods, their life experiences had parallels and contrasts, and their special fields of interest also contrasted. Gadamer, for his part, had specialized in ancient Greek philosophy at Marburg, taking a doctorate on Plato under Natorp in 1922, but he was looking for something additional in phenomenology under Nikolai Hartmann when he stumbled on it in Heidegger in 1923. Heidegger's daring interpretations of Aristotle fascinated him and his intimidating intellectual power caused Gadamer to take up classical philology in self-defense. His state examination in classical philology in 1927, which has been preserved written in his tiny

Latin longhand, was on the Greek poet Pindar. This not only licensed him to teach classical philology, it also set a lifetime course of harvesting the neglected conceptual riches of Plato and Aristotle. Finally, according to Gadamer, hearing Heidegger give his lectures on the origin of the work of art at Frankfurt in 1935 was decisive for his later work on *Truth and Method* (1960), even though he had distanced himself from Heidegger personally, due to his National Socialist views, and only renewed their acquaintance after the war when, as chair at Heidelberg, he invited Heidegger there to speak. The encounter with the artwork described by Heidegger as an eventing of truth became the Archimedean point for his claims in *Truth and Method* that the humanities could claim a validity and truth independent of scientific measures of truth. Despite this important Heideggerian component in his thinking, the life-long resource for his ideas, as we have said, lay in the philosophies of Plato and Aristotle.

Habermas, by contrast, experienced the trauma of fascist terror in Hitler's police state as a youth, living through the defeat of Hitler and the subsequent occupation of Germany by the allied powers. It was in this post-war context of physical need and political re-establishment of democracy that he pursued his study of philosophy. His interest was not in ancient philosophy but in Kant and Fichte, then in Marx. As assistant to Adorno he familiarized himself with Critical Theory but not uncritically. Unlike Adorno, Habermas found in hermeneutics a tool for showing the limits of positivism. His exceptional fluency in English (in contrast to Gadamer) served him well in relating to Anglo-American philosophies of pragmatism, empiricism, and analytic philosophy, and to English-speaking social theorists like Talcott Parsons.

Gadamer, after the war still following Heidegger philosophically, worked out "a philosophical hermeneutics" that undertook to defend the truth-claim of the *Geisteswissenschaften* in the face of claims that science is the sole measure of truth. Habermas, following the lead of Adorno, developed a Critical Theory that, in the face of a growing social science that was scientistic, empiricist, and ahistorical, put forward an account of the development of society that was historical, sociological, and philosophical. In keeping with the neo-Marxist views of Critical Theory, he used and revised Marxian materialism, but he also used and revised many other thinkers, such as Kant, Fichte, Hegel, Peirce, Freud, Max Weber (*verstehende Soziologie*), Dilthey (hermeneutics), Heidegger, Gadamer, Piaget, Kohlberg, Parsons, and Luhmann. In fact, a strength and trademark of Habermas's writings is his encyclopedic and comprehensive critical awareness of American, English, and German social theorists, psychologists, and philosophers. He not only borrows from them, he criticizes and revises what he takes and thereby transcends the limits of the earlier Critical Theorists—whom he also criticizes as well as uses. In contrast to Habermas,

Adorno moved beyond Critical Theory, without leaving it behind, in his writings on music, writing a major work on Beethoven, for instance. Habermas moved beyond Critical Theory in the direction of language, ethics, legitimation, and political democracy.

It should be remembered that Gadamer also modified and developed the standpoint of *Truth and Method* as he replied to its critics in articles and in introductions and appendices to the second and third editions.[7] And he further developed the modern implications of *phronesis* and practical philosophy in Aristotle. He wrote on reason in an age of science, Hegel on dialectic and art, the relevance of the beautiful, and phenomenology of ritual and language. Although Gadamer, after his retirement in 1968, also commented on social issues, it was generally to commend practical philosophy to social theorists and philosophers. He did not make social and political philosophy his central focus as Habermas did in commenting on and criticizing major thinkers. Habermas developed his thinking as both philosophy and social theory—philosophy in the tradition of Kant, Fichte, Hegel, and Marx, and social theory following Weber, Horkheimer, Adorno, and later, Luhmann. In contrast, the main topics of Gadamer's writings were phenomenology, hermeneutics, aesthetics, Aristotelian practical philosophy, and Platonic dialogue. The main modern figures in Gadamer's thought were Hegel and Heidegger, although Gadamer ranged freely through the history of Western philosophy, and his autobiographical reflections in *Philosophical Apprenticeships* (1977, trans. 1985) are a roll-call of major thinkers and theorists in the twentieth century.

Habermas and Gadamer, then, obviously have different areas of special interest and participate in contrasting currents of thought in twentieth-century German thought. The current of twentieth-century philosophy in which we find Gadamer is that of phenomenology and Heideggerian philosophy, while the main philosophical currents of thought of the twentieth century in which to situate Habermas are Critical Theory and pragmatism, supplemented by developmental psychology, Weberian sociology, analytic philosophy, social theory (especially the functionalism of Parsons and Luhmann), philosophy of language, and political philosophy. While Habermas edited a collection of Nietzsche's epistemological writings in 1968 (*Erkenntnistheoretische Schriften*), Gadamer wrote about Nietzsche very little. In this respect, Ricoeur finds the contrast between Habermas and Gadamer in the hermeneutics of suspicion (Marx, Freud, Nietzsche) versus a hermeneutics of disclosure.[8] Gadamer takes ancient philosophy and classical philology as his special realms of expertise, but Habermas does not venture much into ancient philosophy, concentrating instead on philosophy in the period from Kant to Marx. Gadamer, despite the affinities of his hermeneutical philosophy with Wittgenstein and

American pragmatism, offers little discussion of these, but they loom large in Habermas.

We may now contrast the "knowledge-guiding interests" of Gadamer and Habermas. The goal of Gadamer's hermeneutical writings was to defend philosophy and the humanities against the universalizing claims of science and scientific thinking. In doing so, he had recourse to the experience of art, the historicality and facticity of understanding as Dilthey and Heidegger developed it, and the dialogical openness he found in Socrates. The knowledge-guiding interest in Habermas's writings was to legitimize social theory against the universalizing claims of science and scientific thinking and to develop an alternative form of rationality, the rationality of communicative action, as a new foundation for his political and social thought. Here, he had recourse to philosophers Kant, Fichte, Hegel, Heidegger, Gadamer, Wittgenstein, Austin, Searle, among others, and a broad range of social and political thinkers. From different starting points and different life experiences, from different philosophical emphases, their thinking developed in quite different directions: the one in hermeneutics and ancient philosophy, the other in modern philosophy and social and political theory. Twentieth-century philosophy is made richer by both thinkers.

At this point I would like to make just a comment or two on the Habermas-Gadamer debate itself. As Scott Cameron has noted, one finds both sides in the debate accusing the other of dangerous prejudice, romanticism, and one form or another of abstract idealism. Each side makes claims to universality, but a different kind of universality in the two cases. And, as Cameron notes, "close analyis of Gadamer and Habermas's views shows that each of their projects actually requires the other."[9] I think in the interim since the debate each side has mellowed, but the texts themselves show us two thinkers who impute positions to the other that they do not actually hold. Gadamer follows Heidegger in advocating a hermeneutic finitude that does not go with the "idealism of language" of which Habermas accuses him. And Habermas's later theory of communicative action moves toward to a different kind of universality. Gadamer's claim to universality simply asserts that every act of understanding is historically situated, linguistically conditioned, and finite rather than infinite and perfect. He does not attempt to evaluate these from the vantage point of an ideal speech situation. The universality of Habermas's theory of communicative action is actually a hermeneutically oriented universality, a universality of dialogue and appeals to reason as the basis of dialogue. Both Gadamer and Habermas see language as dialogical, and both propose to set forth the preconditions for understanding. Both see consensus-building as an important goal in dialogue.

Habermas proposes psychoanalysis and critique of ideology as limit cases in which understanding is distorted and communication impeded. In these situations, he says, the expert partner in the dialogue has to go behind the mask of apparent communication to see what is covertly at work there. A "hermeneutics of suspicion," as Ricoeur calls it, is called for, not a hermeneutics in which one accepts as benign the fact that the invisible hand of tradition is guiding understanding. Gadamer defends the fruitfulness of "prejudice" and the importance of respect for authority, whereas for Habermas these constitute barriers to social change. What is needed, he asserts, is a theory that can serve as the basis for social analysis and change. That is what he proposes to develop. In later writings Habermas appeals to an ideal speech situation of unimpeded, undistorted communication as a reference point for communicative action. For Gadamer, such a situation is a counter-factual, normative, theoretical construct. It offers a system for unmasking distortions in communication by appeal to an ideal, undistorted communication. But such a system is no longer descriptive but explanatory. It offers a hypothetical theory of reason and communication as a basis for social theory. This is very interesting and valuable for this purpose, but it actually presupposes Gadamer's hermeneutics when it does not contradict it. It only contradicts what Habermas sees as the universal claims of hermeneutics and Gadamer's provocative arguments for the fruitfulness of prejudice and the importance of respect for authority.

Habermas's theory of communicative action serves as a basis for a rationality-based social and political science, and as such has a scientific universality that claims to subsume Gadamerian hermeneutics. But this moves in precisely the direction of a scientific universality of which Gadamer seeks to show the limits. I would suggest that a scientific theory has its place and contribution, but it oversteps itself when it seeks to replace or subsume philosophy. Certainly Habermas profits from philosophy, from Marx, Peirce, Dilthey, Wittgenstein, Searle, Gadamer, and many others. Indeed, it is a special strength of Habermas to reach out and include ideas of many thinkers. This encyclopedic reach and rigorous theoretical system are hallmarks of his great accomplishment. But I would say they do not invalidate the achievement of Gadamer. Rather, Habermas scholars need to read Gadamer.

Let me suggest a few places where I think Gadamer writing on the same topics complements and offers an alternative that does not necessarily contradict Habermas. These have to do with not basing hermeneutics on a scientific theory of communicative rationality, with the value of grounding practical philosophy in Aristotelian *phronesis*, and with Gadamer's accounts of the encounter with works of art and poetry.

First, Gadamer offers a dialogical hermeneutics not based on communicative rationality. While the theory of communicative action serves well as a new methodological basis for social and political theory, this knowledge-guiding interest has shaped its dimensions from the beginning toward forms of knowledge that can be rationally legitimated as acceptable arguments for a theory. Here one thinks of Dilthey's dream of a methodological basis for the *Geisteswissenschaften* (human sciences) and the quest for general validity (*Allgemeingültigkeit*). But this means that in keeping with this "knowledge-guiding interest" Habermas sets preconditions on dialogical openness. His rationality is a peculiarly Western rationality, so that when the dialogical interaction is with non-Western countries and non-Western religions, I agree with Jay Goulding that the philosophical hermeneutics of Gadamer, with its Heideggerian openness to the non-Western other, has much to offer.[10] Gadamer's dialogical hermeneutics is willing to place its own perspective at risk, assuming with Socrates that the other partner could be right. It would seem to be more liberal and open in this respect than the approach of Habermas, who argues for liberal democracy on the basis of communicative competence. In his recent book, *The Inclusion of the Other: Studies in Political Theory* (1996, trans. 1998), the "other" is not the Eastern other, nor even the other in the Southern Hemisphere, but the other within European nation-states (which is still a hermeneutical problem, of course). The argument in the book remains dedicated to a more democratic Europe. Thomas McCarthy notes prophetically in 1978 in his *The Critical Theory of Jürgen Habermas* that as Habermas becomes more theoretical and universal in his later works, they become less hermeneutical and situational, although McCarthy still hastens to add that "Habermas maintains that at least the analysis of contemporary society has an irreducible practical dimension" (378). It seems to me that a strength of Habermas's social theory over against philosophical hermeneutics is his Critical Theorist's passion for the disenfranchized exploited other in developing countries, for the Nicaraguan peasant worker and the working poor in developing countries around the world who have to suffer under the "structural adjustment" policies of the International Monetary Fund and the World Bank. Yet on the theoretical level of *The Inclusion of the Other* and its concern with Europe, these are never mentioned. In that volume they remain the excluded other. Here I value Habermas's earlier Marxist base in Critical Theory's critique of late capitalism. His theory of communicative action is well suited to focus on the covert violence and the distorted communication with which the giant corporate institutions of late capitalism in the United States and Europe are raping the environment and exploiting the natural and human resources in the Third World. Perhaps

my reading of Habermas has not been extensive enough to know of his dealing with these other "others."

Admittedly, the Heideggerian and Gadamerian critiques of technological rationality also offer little as an alternative in terms of a social/political theory. Indeed, Heidegger's remark in 1966 that "Only a god can save us now!"[11] seems rather pathetic. Still, I think Gadamer's philosophical hermeneutics makes one aware of the limits of Kantian universal moral norms and even of communicative rationality. Both tend to presuppose a Western version of rationality as the basis for communication. Here, Gadamer's dialogical openness recommends itself as a basis for communication with non-Western cultures.

Another lasting contribution of Gadamer, I think, which we see in his book, *Reason in the Age of Science*, is his explication of a practical philosophy based on what Aristotle called *phronesis*. This is neither an Enlightenment rationality that overcomes dogma, nor a pragmatic rationality of costs and benefits, but a practical wisdom based on experience, tradition, and a sense of rightness. It is a wisdom not easily carried away by technological feasibility, a wisdom that distinguishes between what is available to calculative reason and what is not. *Phronesis* is closer to a dialogical reasoning together than to the solitary expert reasoning instrumentally about something. It works with the speech situation as it is rather than what it ought to be. I am not suggesting that Gadamer's theorizing of *phronesis* and dialogical openness can or should replace what is made available by Habermas in his theory of communicative action in the light of what communication should be ideally, but that it might be able to supplement it with a little philosophical wisdom from antiquity. Tom McCarthy notes that Habermas as Critical Theorist and Gadamer as hermeneutical theorist are both critical of a shallow scientism and technological rationality that leaves out history: "For Habermas, as for Gadamer, the ideas of a society freed from history and for a technical mastery of its future, of a history that has been disempowered as *Wirkungsgeschichte*, and of a posthistorical social science freed from context-bound interpretation of its historical situation *are equally illusory*" (178, emphasis added). Gadamer and Habermas undeniably have a great deal in common.

Indeed, it should be remembered that the theory of communicative action is a further development of the hermeneutical insight that dialogue is not something subjective but a reasoning together about a *Sache*, a subject-matter. Also, to see language functionally, to see it as behaviorally embedded and happening in a situation, is also consistent with and not contradictory to Gadamerian hermeneutics. In fact, to describe hermeneutics, as McCarthy occasionally does, as almost exclusively focussed

Sinnverstehen, the understanding of meaning, refers us to a Diltheyan version of hermeneutics and not the Gadamerian hermeneutics of dialogue and the play of language. In his encounter with Derrida, Gadamer emphasizes that his thinking focuses on living language and the concrete speech situation, not on writing.[12] In this and many other respects, Gadamer is closer to Habermas than to Derrida.

Finally, in addition to the way in which Gadamer reaps the conceptual riches of ancient philosophy, for example, of *phronesis*, there is his openness to the "truth" of art and poetry. Gadamer devotes a good deal of attention to the encounter with art. Three of the ten volumes of his collected works are devoted to ancient philosophy, while another two are devoted to art and poetry. Together these constitute half of his scholarly output. These are two areas about which Habermas has written very little. Of the other five volumes of Gadamer's collected works, three are on hermeneutics and the other two are about modern philosophy. Gadamer has written relatively little on social and political theory, while Habermas has recently written on law and democracy (*Between Facts and Norms*, trans.1996), for instance, and political theory (*The Inclusion of the Other*, 1996, trans. 1998). My point is that their contributions, in this sense, complement and supplement each other rather than contradict each other.

Gadamer offers an alternative description of the communicative situation. His description follows Heidegger in situating the existing interpreter in the midst of a concrete pragmatic situation. The concretely situated interpreter understands the present and has hopes for his or her future by virtue of a pre-understanding shaped by the past, by praxis, by tradition. History is at work in every act of understanding and decision. But since language is the medium in which understanding and interpretation take place, the existential-historical interpretive situation becomes an existentially-historically-linguistically conditioned communicative situation. To avoid a metaphysics of consciousness and object, Gadamer describes the situation in terms of a game in which one participates through dialogue with others in understanding a given *Sache*. The encounter with an artwork as an experience of the disclosure of truth, a Heideggerian notion, offered Gadamer an alternative to scientific definitions of truth and an argument for according more respect to experiences in the humanities and social sciences. Admittedly this does not provide a theoretical basis for social or political theory, but it helps appreciate the power and validity of art, which is hard for any scientific theory.

It is because understanding is a basic process that occurs in virtually every living moment of human existence, no matter what kind, that Gadamer claimed his ontology of understanding was "universal." It was universal in the sense that it articulated the conditions for the possibility

of any understanding whatsoever: it was spatio-temporally situated, it required a reference reservoir of historical experience and conceptualites, it stood in a horizon of expectations, and it was articulated in language. Habermas agreed with much of this and took it up into his own theory of communicative action, but he felt that Gadamer omitted any methodologically useful basis for social critique. Furthermore, logic seemed to stand outside such conditioning. He argued that Gadamer uncritically accepted traditional understandings and pre-understandings as authoritative and legitimate, whereas an adequate account of the communicative situation must set standards for measuring the legitimacy of one's pre-understanding as passed on by tradition. Gadamer would reply that one's standards for critique also come from tradition. Also, it seemed to Habermas that Gadamer was not sensitive to the distortions in communication and did not offer a standard or theoretical basis for eliminating them. The special significance of Habermas's proposal of the ideal speech situation of undistorted communication was that in it he was putting forward a theoretical basis for standards in social and political theory. It would seem that Dilthey's dream of a methodological basis for the *Geisteswissenschaften*, a basis for legitimation and for developing a fair and just society, has been realized in Habermas's social and political theory.

In conclusion, the two thinkers were doing two different and justifiable things. The famous debate misled many into seeing a radical dichotomy between Gadamer's hermeneutics and Habermas's theory of communicative action when in fact Habermas builds on Gadamer's hermeneutics and does what is necessary to apply it to social theory. For Gadamer's ontology of understanding, the erecting of a counterfactual ideal speech situation was not necessary, but for Habermas's project of social critique the ideal speech situation formed a basis for legitimate standards of social and political evaluation. Since their knowledge-guiding interests were quite different, their accomplishments were different and both remain important in their own way. The theory of communicative action clearly provides a promising theoretical foundation for social and political thinking, a thinking oriented to bringing about meaningful improvements in our culture. But it does not negate or supersede philosophical hermeneutics; it criticizes aspects of it, such as the fruitfulness of prejudice and respect for authority.

I would argue that Gadamer's dialogical openness to the other in a living speech situation, his appeal to practical wisdom as a factual reality described by Aristotle, and his account of the experience of art as having a claim to truth, also have something to offer. Unhampered by a special theory of communicative rationality, a suspicious presumption of distorted communication, or an advance vision of an ideal society and an ideal

speech situation, but not denying that these have their place, Gadamer's philosophical hermeneutics still offers an account of understanding luminous with insights that continue to merit our attention.

RICHARD E. PALMER

MACMURRAY COLLEGE
JANUARY 2000

I wish to thank my colleagues in the Central Illinois Philosophers Colloquium, especially Larry Shiner, Berndt Estabrook, and Meredith Cargill, for valuable suggestions which led to important modifications and corrections of this paper.

NOTES

1. My encounter with the writings of Habermas goes back to the late 1960s with his *Zur Logik der Sozialwissenschaften,* in which he called upon Gadamer and hermeneutics as an ally, and with his important book, *Erkenntnis und Interesse,* which distinguished three knowledge-guiding interests in its appendix, and his important collection of *Nietzsches Erkenntnistheoretische Schriften,* which related directly to his own theory of knowledge. It was at this time that the famous "debate," a series of essays back and forth, transpired and was published in 1971 (*Hermeneutik und Ideologiekritik*). In 1970, I had the honor of translating a major Gadamer contribution to that debate for a special Habermas-centered issue of *Continuum* magazine: "Rhetoric, Hermeneutik und Ideologiekritik," vol. 8, nos. 1–2 (Spring and Summer, 1970): 77–95. I first heard Professor Habermas in person at a seminar for Philosophical Faculty and hundreds of students at Heidelberg in 1971, and I have been privileged to hear him twice more in America (after one talk in the 1980s he sent me as promised an enscribed copy of *Postmetaphysisches Denken,* which I treasure), and on two occasions during the nineties in Heidelberg, when he received the prestigious Jaspers Prize and an honorary doctorate from the University of Heidelberg.

2. Demetrius Teigas, *Knowledge and Hermeneutic Understanding: The Habermas-Gadamer Debate* (Bucknell University Press, 1995) and Alan R. How, *The Habermas-Gadamer Debate and the Nature of the Social: Back to Bedrock* (Brookfield, Vt.: Avebury Press, 1995), among others, but see also substantial chapters in Thomas McCarthy, *The Critical Theory of Jürgen Habermas* (Cambridge: MIT Press, 1978), Robert C. Holub, *Jürgen Habermas: Critic in the Public Sphere* (London: Routledge, 1991), and Maurizio Ferraris, *History of Hermeneutics,* translated by Luca Somigli (Atlantic Highlands, N.J.: Humanities Press, 1996), esp. pp. 255–72. The book on Gadamer and Habermas by Scott Cameron is in progress, but see also his article, "On Communicative Actors Talking

Past One Another: The Gadamer-Habermas Debate," in *Philosophy Today* (Spring 1966): 160–68.

3. For a chronology of Gadamer's life and works, see the "Chronik" in Jean Grondin, *Hans-Georg Gadamer: Eine Biographie* (Tübingen: Mohr Siebeck, 1999), pp. 373–89.

4. *Der Anfang der Philosophie* [on Parmenides] (Stuttgart: Reklam, 1996; *The Beginning of Philosophy*, 1998) and *Der Anfang des Wissens* [on Heraclitus] (Stuttgart: Reklam, 1999).

5. In the present volume, I did not think it necessary to provide full bibliographical data on publications by Habermas.

6. Most of his books in German (more than two dozen) are now available in Suhrkamp paperbacks and a dozen English translations of these have been published by MIT Press.

7. See Gadamer, *Hermeneutik II: Wahrheit und Methode*, vol. 2 of the *Gesammelte Werke* (Tübingen: J.C.B. Mohr, 1986) for all the appendices and many articles on hermeneutics published over the years.

8. See his *Freud and Philosophy* (New Haven: Yale University Press, 1970), 32ff.

9. "On Communicative Actors Talking Past One Another: The Gadamer-Habermas Debate," *Philosophy Today* (Spring 1996): 160.

10. See his *Orbisiconography and the East Asian Communicative Body*, forthcoming as of this writing. I have only the prepublication draft of this substantial volume.

11. "Nur noch ein Gott kann uns retten," *Der Spiegel* (31 May 1966), translated by David Schendler as "Only a God Can Save Us Now," *Graduate Faculty Philosophy Journal* 6, no. 1 (1977): 5–27.

12. Hans-Georg Gadamer, "Reply to Jacques Derrida," in *Dialogue and Deconstruction: The Gadamer-Derrida Encounter,* ed. Diane P. Michelfelder and Richard E. Palmer (Albany: SUNY Press, 1989), pp. 55–57.

25

Larry A. Hickman

Habermas's Unresolved Dualism: *Zweckrationalität* as *Idée Fixe*

[T]he thing set down in words is not affirmed. It must affirm itself or no form of grammar and no verisimilitude can give it evidence.[1]
—Ralph Waldo Emerson

The Federal Republic of Germany is fortunate to have in Jürgen Habermas a deeply engaged public philosopher. Since the 1960s he has been a social critic of undisputed stature who has brought to numerous public debates a profound understanding of the past and prospects of philosophy in particular, and of the human sciences, in general. Some would argue that the United States has lacked a public philosopher of comparable stature since the death of John Dewey in 1952.

Even a quick scan of Habermas's recent work reveals the breadth of his interests. In numerous interviews, essays, and books, he has applied his broad and incisive intelligence to issues as diverse as the reunification of divided post–World War II Germany, the Persian Gulf War of 1991, the neoconservative movement, and the complex relations between the Federal Republic's policies on immigration and the German sense of national identity.

Despite the broad swath that he has cut through public policy issues in Germany, however, Habermas is still best known in the United States for his theoretical work. His early criticism of Marcuse concerning the status and prospects of technology; the "paradigm shift" toward an intersubjective theory of communication that his work exhibited beginning with the

publication of *The Theory of Communicative Action*; his reconstruction and defense of discourse ethics; and more particularly his discussions of the origin and role of norms within human activity: these and other aspects of his thought have inspired an extensive literature of comment and criticism.

In the brief remarks that follow I will restrict my attention to one area of Habermas's thought which I believe to be both crucial to his overall program and the locus of some continuing difficulty for it. This involves his characterization of the role of scientific technology as a type of human activity, and more particularly the persistent dualism that is explicit in his discussion of the forms of practice which he sometimes calls "technical activities" or "purposive-rational action"[2] on the one side, and "communicative action" or "symbolic interaction"[3] on the other. Since these matters turn out to be particularly problematic for those of his readers who approach his work from the tradition of American pragmatism, I shall address them from that perspective.

The terms "science" and "technology" appear only rarely in the indices of Habermas's major works from the publication of *The Theory of Communicative Action* to the present. In his early work, however, it is easy enough to follow his attempts to carve out a middle position between two competing visions of scientific technology, both of which took it as their task to avoid dogmatism. On the one hand, there was what Habermas termed the "decisionism" of the scientizing positivists, whom he correctly and eloquently charged with attempting to remove from the "mainstream of rationality the pollutants, the sewage of emotionality," which are "filtered off and locked away hygienically in a storage basin—an imposing mass of subjective value qualities."[4]

On the other hand there was Marcuse, who was singled out for special criticism because of his claims that all science is tinged with political considerations and that there might consequently be a post-revolutionary scientific technology that was new in kind. It was Marcuse's view that if the "fatal link" within scientific technology between what he took to be the tandem projects of the domination of nature and the domination of human beings could be severed, and if human beings (and the human sciences) could be politically liberated, then "science would arrive at essentially different concepts of nature and establish essentially different facts."[5] In short, Marcuse was proposing that if the human sciences were split off from the natural sciences and politically reformed, then the reform of technology would probably not be far behind.

To this suggestion Habermas replied that scientific technology (whose methods he identified as *Zweckrationalität*—what some have called "instrumental rationality" or "straight-line instrumentalism") is what it is for reasons that are rooted not so much in cultural or political practice as in the origins and development of the human species itself. Work and the

domination of nature, which necessarily rely on the establishment and pursuit of inflexible goals (straight-line instrumentalism), are not merely ubiquitous expressions of human life: they are among its very conditions. The alternatives that Marcuse envisioned, therefore (but, it should be recalled, that he never fully developed), were and remain in Habermas's view not true alternatives after all. If scientific technology is a project at all, as Marcuse thought it to be, then it is a project "of the human species *as a whole*, and not . . . one that could be historically surpassed."[6] In other words, Habermas didn't object to the split between scientific technology and the human sciences that Marcuse had thought necessary to the reform of both, but he did object strenuously to the suggestion that scientific technology might be reformed in ways that would substantially contribute to the advancement of the methods of the human sciences.

One of the reasons Habermas rejected the possibility of such reform was his contention that scientific technology can never be concerned with questions of practical reason, which takes as its task the interpretation and liberation of meanings. In order to do its work, scientific technology must dismiss such concerns as subjective. "The glory of the sciences," Habermas wrote, "is their unswerving application of their methods without reflecting on knowledge-constitutive interests."[7] It is not that scientific technology does not intervene in the conduct of life, but just that its methods disallow the self-conscious analysis of the ways in which this occurs.[8] Since Habermas holds that scientific technology is essentially linked to straight-line instrumentalism, it is left to the hermeneutic sciences to address such matters. This is because the hermeneutic sciences operate in terms of a wholly different methodology—one which not only does not assume the necessity of control and domination, but actively seeks to avoid such methods and ideals. In all this it is not so much that the methods and ideals of scientific technology are infelicitous or wrongheaded *for* scientific technology itself which is concerned with "facts," but just that they are inappropriate at best, and destructive at worst, when applied to or within the human sciences, which are concerned with "values."

Of course Habermas's attempt to construct a middle position between the disparate visions of scientific technology advanced by the positivist right and the Marcusean left is in some ways quite appealing. Especially given the highly positivized philosophical climate of the 1950s and 1960s, his attempt to retain what was good in enlightenment science without yielding to scientism, and at the same time to open up more space for the human sciences, can only be applauded as farsighted. From the standpoint of a Deweyan style pragmatism, however, his project appears to suffer from several difficulties.

First, a Deweyan pragmatist would certainly find a bit quaint Habermas's characterization of scientific technology as inherently monological, subject-

object oriented, and preoccupied with control or domination. In her view, to identify the essence of scientific technology with the excesses of *Zweckrationalität* would be similar to identifying the essence of religion with the excesses of the Inquisition. She would therefore regard Habermas's treatment of scientific technology—as methodologically, if not ontologically,[9] irreconcilable with the inherently dialogical project of communicative action—as tantamount to opening up an unnecessary and ultimately debilitating chasm within the domain of human inquiry. She would suggest that Habermas's unwillingness to envision scientific technology in terms of management or adjustment (which must also be operative within communicative action), rather than domination or control (which is the *leit motif* of straight-line instrumentalism), or to envision scientific technology *and* communicative action as continuous with one another and as features of a larger inquirential project, leaves Habermas with an underlying dualism from which his project continues to suffer.

Nor would her concern be just an arcane one that involves nothing more than Habermas's "pre-paradigm shift" work of the 1970s. Even after the "paradigm shift" of *The Theory of Communicative Action*, this split remains very much in evidence. In his essay "Reconstruction and Interpretation in the Social Sciences," for example, published in *Moral Consciousness and Communicative Action* (in German in 1983 and in English translation in 1990), Habermas was still contrasting the attitude of the scientist (as "someone who simply says how things stand") with the attitude of the interpreter (as "the performative attitude of someone who tries to understand what is said to him").[10]

From *The Theory of Communicative Action* to the present, then, Habermas seems just to accept the necessity of this dualism of scientific technology versus the human sciences and then to go forward to attempt to develop means by which to ground and enlarge one of its sides at the expense of the other. Instead of attempting to overcome the breach by the *reformation* first of politics and then of scientific technology as Marcuse would have had it, he seems to want to make of communicative action (as the central method of the human sciences) a *bulwark* against the "colonization of the lifeworld" by the strategic action of scientific technology, and to *expand* the domain of communicative action by mounting an inquiry into the grounds of its possibility. This latter project, the expansion of the domain of communicative action (just "pushing back" the scientific technologies without explicitly relating them to the ever growing domain of the human sciences) has led one of Habermas's pragmatist critics to complain that he "has not really attempted, from the standpoint of the theory of action, to do justice to the diversity of kinds of action, and accordingly has delivered only communication as such as the jam-packed residual category of non-instrumental action."[11]

The study of communicative action has thus become for Habermas *the* crucial science, since it performs the two functions just mentioned, namely acting as bulwark against scientific technology, on the one hand, and expanding into its domain, on the other. Put in terms of the three areas of human interest that Habermas laid out in *Knowledge and Human Interests*, the study of communicative action that arises from practical-hermeneutic interests performs just this double function. On the one hand it limits and counteracts *technical* interests (the bulwark effect), which seek to control objectivized processes. On the other, it informs and marshals the energies of *emancipatory* interests (the expansion effect) which are concerned with the criticism of asymmetrical power relations.

But surely there must be some way to preserve the middle ground that Habermas attempts to establish between scientism and relativism without paying the price of an unresolved and debilitating dualism that writes off scientific technology as irrevocably coupled to straight-line instrumentalism and thereby committed to "domination." And surely there must be a way to both preserve a reasonable understanding of the objectivity of science and reject the relativism of those such as Richard Rorty (who would reduce scientific technology to a type of literature) without insisting that there is an unbridgeable divide between scientific technology and the human sciences. If Habermas is correct in holding that no such way can be found, or that none is necessary, then the only contribution that scientific technology can make to the human sciences seems to be to supply them with "facts," which then serve as raw materials for their interpretation of "values" or meanings.

American pragmatism, and especially the work of John Dewey, provides a potentially fruitful perspective from which to view Habermas's account of these matters. Although Habermas has appropriated some aspects of the work of G. H. Mead and C. S. Peirce, some of his readers have found it curious that he has not so far demonstrated much interest in Dewey. A few cursory remarks about Dewey appear in Habermas's early work, but most of those seem either perfunctory or wide of the mark. This situation is especially surprising given the view, widely held among Habermas's critics, that the two philosophers have so much in common. Given the fact that the work of both Dewey and Habermas is concerned with the ways in which communication functions within industrial democracies, it is probably fair to say that Habermas's readers would like to see him engage Dewey's work at least to the extent that he has the work of Dewey's colleague G. H. Mead.

Of course, I am hardly the first to suggest that there are similarities between Dewey and Habermas. Alan Ryan has gone so far as to call Habermas "the most 'Deweyan'" of contemporary social theorists,[12] and his assessment is not without its basis. Dewey would certainly have applauded Habermas's rejection of hard line scientific realism (although he would have probably suggested that Habermas has not gone far enough in this regard).

Like Habermas, Dewey held that the natural sciences are not involved in an investigation of reality "as such" but only that part of reality that needs to be engaged with respect to certain human interests. Nor would Dewey have found much fault with Habermas's characterization of the empirical sciences as disclosing "reality subject to the constitutive interest in the possible securing and expansion, through information, of feedback-monitored action,"[13] although he would have interpreted the matter more positively than has Habermas. In other words, both Dewey and Habermas reject scientific realism on the grounds that knowing is perspectival and fallible, and they both retain a limited but healthy notion of scientific objectivity on operational grounds.

But there are also important differences between their respective positions. Dewey clearly rejected Habermas's view that the human sciences proceed on the basis of a *wholly different method* than do the scientific technologies, that is, that the two methods are at bottom irreconcilable.[14] The methods of the human sciences are not observational, according to Habermas, and they are not particularly interested in the outcome of experimental operations. "Access to the facts," he writes, "is provided by the understanding of meaning, not observation."[15] The human sciences are hermeneutic in the sense that they involve the interpenetration of traditional and cultural meaning and the meanings of those who communicate with the interpreter. It is the self-reflective aspect of the human sciences, according to Habermas, that takes them beyond a concern with producing nomological knowledge to an engagement with an "emancipatory cognitive interest."[16]

A pragmatist critic of Habermas would argue that scientific technology is far richer than Habermas's persistent characterization of it as narrowly instrumental, that is, as occupied with intransigent goals and oriented solely, or even principally, toward "facts" and "domination." Dewey developed a "thick" notion of scientific technology that located it, along with other forms of productive communication, within the context of a naturally occurring (and continually evolving) type of human behavior he called "inquiry."

In one sense, Deweyan inquiry is an analogue of Habermasian communicative action. Both inquiry and communicative action involve the clarification, extension, and enrichment of meanings. For Dewey, however, inquiry is more than just hermeneutical: it is experimental, and it includes the activities of both scientific technology and the human sciences (as well as the arts, historiography, and jurisprudence, to name but a few). Dewey's notion of inquiry is sufficiently rich to allow him to specify ways, for example, in which natural and human sciences can and do cooperate in the solution of pressing human social problems. In his view these and other disciplines interact with one another as they pursue their respective goals, and they also contribute to and borrow from a more general, overarching, and constantly evolving pattern of inquiry that he calls "the general method

of intelligence." For Dewey, properly conducted inquiry aims not at *control* or *domination* but at *management* or *adjustment*. And although he did not deny the existence of straight-line instrumentalist attempts at problem-solving, historically or in the present, he did deny that such attempts had ever achieved much success and he insisted that they had no legitimate place among the methods of scientific technology.

Habermas's pragmatist critic would thus argue that Dewey's naturalistic approach to inquiry is ultimately more productive than Habermas's quasi-transcendental approach to communicative action because it interrelates and *integrates* each of the interests that Habermas develops in *Knowledge and Human Interests*—the empirical sciences, the historical hermeneutical sciences, and the critical sciences, *within a general account of inquiry*. Consequently, it bridges the dualism exhibited by Habermas's project (or more accurately, it does not allow it in the first place). As I have already indicated, one of the ways Dewey achieved this was by emphasizing the ways in which the various disciplines interact with one another, both contributing to and borrowing from a more general notion of inquiry. Even more important, however, Dewey argued that each of the interests that Habermas characterizes as separate, and each of the methods to which those interests give rise, constitutes a *phase* within successful inquiry in its generic sense.

TECHNICAL INTERESTS

From the standpoint of history, the analytical feature of subject-object distinctions displayed by what Habermas calls *technical* interest provided one of the keys to the successes of the revolution in seventeenth-century science. And from the standpoint of present-day scientific technology (or even of inquiry in general), technical interest is not for the Deweyan pragmatist false or to be rejected *überhaupt*, but only if taken reductively as the ontological ground for inquiry or as a sole method of inquiry. In inquiry of all types, including the human sciences, it is often necessary to make such objectifying distinctions (arising out of what Habermas calls "third person" stances), but only as a part of the *analytical* or *solvent* phase of a particular sequence of inquiry.

Another way of putting this is that the Deweyan pragmatist does not totally reject the objectification of essences, but tempers such objectification by functionalizing or operationalizing what is objectified. Objectification as posited *within* and *as a part of* inquiry is therefore for the Deweyan pragmatist among the most important tools that inquiry has at its disposal. The difficulty comes when, as Dewey put it, the inquirer commits the "philosopher's fallacy" of "hard" reification or objectification—that is, the

taking of something that is the *result* of inquiry as if it had existed in its own right *prior to* inquiry.

This is a matter of enormous importance. The failure of "scientific" Marxism, as well as the failure of the "cold war technophilia" or excessive *Zweckrationalität* of the 1950s and 1960s in the United States exhibits just this type of objectification. Marcuse understood this well enough, and Habermas does too. For the Deweyan pragmatist, however, it would be a mistake to accept these phenomena as legitimate cases of scientific technology. She would regard their failure not as a failure of scientific technology, but as a failure of intelligence to resist the kind of gratuitous reification that leads to an ossified ideology. Put another way, scientific technology is experimental, and neither "scientific" Marxism nor American "cold war technophilia" was ever sufficiently so.

INTEREST IN INTERSUBJECTIVE UNDERSTANDING

The same is true with respect to the interest that Habermas terms intersubjective understanding. The Deweyan pragmatist would not view scientific-technical inquiry as excluding intersubjective understanding in principle, and she would argue that the positivists were wrong in their attempt to perform such a reduction. Seen in this light, and because of his systematic exclusion of intersubjective understanding from the "data gathering" activities of scientific technology (even if not from its metatheoretic activities), Habermas seems willing to give up a good deal more to the positivists than would a Deweyan pragmatist.

It should also be noted that Habermas's position in this regard leaves him wide open to the criticism of feminist philosophers of science who have enumerated in rich detail the ways in which "data gathering" does in fact change as a result of the enlarged role of women in the scientific technologies. This new situation, they correctly contend, has altered the interpersonal dimensions of those disciplines.

To put the matter somewhat differently, since the Deweyan pragmatist understands intersubjective interest as a *phase* in inquiry, she is obligated to reject Habermas's notion of a separate science or cluster of sciences which have a putatively proprietary claim to the methods of intersubjective understanding. Far from attempting an expansion of the intersubjective *phase* of inquiry to the point that it forms a bulwark against or exercises hegemony over other phases of inquiry, the Deweyan pragmatist views such action as only one phase within inquiry. The intersubjective phase of inquiry is, to be sure, the phase that sets up and institutes feedback relations between ends and means, and is therefore essential to the consensual objectivity that inquiry produces whenever it is successful. This is true both at the social

level and at the level of (derivative) inner dialogue. But the intersubjective phase of inquiry is not *all* of inquiry, and consensus is not *all* of objectivity. Objectivity demands not merely consensus, but consensus based on experimental results. Moreover, such experimental results are often non-linguistic.

<center>INTEREST IN THE CRITICAL SCIENCES</center>

What Habermas terms the interests and methods of the critical sciences, such as the critique of ideology, also play a part in Dewey's "thick" notion of inquiry, since a healthy skepticism about current modes of practice is not only a feature of the scientific temperament (and therefore a part of the scientific method) but also a feature of any inquiry that can be said to be productive. The Deweyan pragmatist would emphasize that this critical stance is an especially important feature of the social inquiry that occurs in primary and secondary education. It is for this reason that she would view both scientific technology and education as agents of the reform of social institutions. The enemies of social progress are for her not the "objectification" and "domination" that Habermas views as among the essential features of scientific technology, since she thinks that they have been only accidentally associated with scientific technology in any case. The enemies of social progress are rather the "objectification" and "domination" that are present in any species of deliberation that relies on what is reductive and intransigent, and that therefore resists the application of the methods (and the appropriation of the promises) of experimental inquiry in its various manifestations.

The Deweyan pragmatist would not deny that greed, class interest, and uncriticized tradition often work to prevent the enlargement of the meanings of human existence (a rough analogue of Habermas's "colonization of the lifeworld"). She would insist, however, that where meaning is diminished or eclipsed, scientific technology is not the culprit. In her view, if men and women are not free then it is not the fault of too much, but too little scientific technology (understanding scientific technology as the intelligent use of tools to solve perceived problems). And if there are problems in the public sphere, it is not the fault of too much, but too little democracy (understanding democracy as "belief in the ability of human experience to generate the aims and methods by which further experience will grow in ordered richness").[17]

One of the crucial differences between Habermas and Dewey on these issues, then, seems to be that Dewey's notion of inquiry is much more complex and at the same time much more flexible than Habermas's notion of communicative action. This is because Dewey's account of inquiry does not rest on an untenable dualism. Further, because Dewey did not ground

communicative action on quasi-transcendental norms, but instead on the historical-cultural-existential situatedness of a human organism that adjusts by means of the experimental use of tools of many different sorts, his theory of inquiry was much more open-ended and evolutionary in terms of its prospects. To put this another way, because Dewey emphasizes the situatedness and the prospects of inquiry, he does not need to make the covert foundational move that Habermas does when he, Habermas, writes that "the use of language with an orientation to reaching understanding is the *original mode* of language use, upon which indirect understanding, giving something to understand or letting something be understood, and the instrumental use of language in general, are parasitic."[18]

Like the dualism of which it is a feature, then, Habermas's quasi-transcendentalism continues to worry his larger project. In *The Past as Future*,[19] he seeks to distance himself from what he regards as the apriorism of Rawls and Nozick, who he thinks "design the basic norms of a 'well-ordered' society on the drafting table."[20] For Habermas, norms are not given by theorists or technocrats: they are instead "*encountered* in practice."[21] Dewey, too, thought that norms emerge from the practical phase of inquiry. But when one gets down to the details of how such norms emerge, the two thinkers reach very different conclusions. (This may be a result of Habermas's close association with Karl Otto Apel, who reads American pragmatism in terms of what some have described as an overly "transcendentalized" C. S. Peirce.)

Habermas thinks that norms "have to proceed from particular pragmatic presuppositions, in which something like communicative reason emerges."[22] In brief, norms seem to emerge out of communicative action in two ways. They emerge as parties to unhindered communication come to consensus, to be sure. Most often, however, they seem to emerge as such communication reveals the *grounds and conditions of its own possibility*.

For Dewey, by way of contrast, norms emerge as the *byproducts* of *experimental* inquiry, in which unhindered communication that eventuates in consensus plays a part, but does not constitute the whole of inquiry. Because of his rich notions of technology and science, Dewey thought that experimental *tests* are essential to the construction of norms, that the ability to perform such tests is gained through education in techniques of inquiry, and that there is a continuity between inquiry of a quotidian variety and inquiry in the sciences.[23] This is precisely Dewey's argument in the first chapter of his 1903 *Studies in Logical Theory*.[24] After a discussion of the ways in which an "undefined range of possible materials becomes specific through reference to an end," Dewey continues with the claim that, "In all this, there is no difference of kind between the methods of science and those of the plain man [Dewey's analogue of Habermas's lifeworld]. The difference is the greater control by science of the statement of the problem,

and of the selection and use of relevant material, *both sensible and conceptual* [emphasis added]."[25]

In this essay I have suggested that Habermas's project rests on an unstable dualism of strategic action versus communicative action that was developed in his early work and continues to the present. Habermas's pragmatist critics have suggested that his project places too much weight on the non-instrumental side of the breach, that it consequently fails to give experimentation its proper weight[26] and that it also sells short the historicist (adjustive) aspect of the human situation situatedness.[27] I have attempted to flesh out some of these criticisms and to suggest some of the ways in which Dewey's project, because it is both richer and more flexible than that of Habermas, avoids the pitfalls of the latter by avoiding its explicit dualism, as well as the quasi-transcendentalism that is nested within that dualism. I have also offered the modest proposal that, given the great similarities between the work of the two philosophers and the positive contributions already made to Habermas's work by the two American pragmatists C. S. Peirce and G. H. Mead, Habermas's readers would be greatly rewarded if he were to engage Dewey's work more systematically.

LARRY A. HICKMAN

THE CENTER FOR DEWEY STUDIES
SOUTHERN ILLINOIS UNIVERSITY AT CARBONDALE
MAY 1996

NOTES

1. Quoted in Robert D. Richardson, Jr. *Emerson: The Mind on Fire* (Berkeley: University of California Press, 1995), p. 131. The remark is from Emerson's notebooks. See *The Journals and Miscellaneous Notebooks of Ralph Waldo Emerson*, ed. William H. Gilman et al. 16 vols. (Cambridge: Harvard University Press, 1960–1982), 4:106.

2. Jürgen Habermas, *Toward a Rational Society*, trans. Jeremy J. Shapiro (Boston: Beacon Press, 1970), p. 91.

3. Ibid., p. 92.

4. Jürgen Habermas, *Theory and Practice*, trans. John Viertel (Boston, Beacon Press, 1973), p. 265.

5. Habermas, *Toward a Rational Society*, p. 86.

6. Ibid., p. 87.

7. Jürgen Habermas, *Knowledge and Human Interests*, trans. Jeremy J. Shapiro (Boston: Beacon Press, 1971), p. 315.

8. Ibid., p. 316.

9. Habermas sometimes seems to sense that he may have gone a bit too far in championing this breach between scientific technology and the human sciences. He attempts to backpedal in a footnote to his essay "Reconstruction and Interpretation in the Social Sciences." "I should add," he writes, "that by distinguishing sciences based on hermeneutic procedures from those that are not, I am not advocating an ontological dualism between specific domains of reality (e.g., culture versus nature, values versus facts, or similar neo-Kantian dichotomies introduced chiefly by Windelband, Rickert, and Cassirer). What I do advocate is a *methodological* distinction between sciences that gain access to their object domain by understanding what is said to someone and those which do not. All sciences have to address problems of interpretation at the *metatheoretical level*. . . . Yet only those with a hermeneutic dimension of research face problems of interpretation already at the level of *data generation* [emphasis in original]." Jürgen Habermas, "Reconstruction and Interpretation in the Social Sciences," in *Moral Consciousness and Communicative Action*, trans. Christian Lenhardt and Shierry Weber Nicholsen (Cambridge, Mass.: MIT Press, 1990), pp. 41–42. Habermas thus seems to want to avoid a dualism of fact and value by replacing it with a dualism of theory and metatheory.

10. Ibid., p. 26.

11. Hans Joas, "The Unhappy Marriage of Hermeneutics and Functionalism" in *Communicative Action*, ed. Axel Honneth and Hans Joas, trans. Jeremy Gaines and Doris L. Jones (Cambridge, Mass.: MIT Press, 1991), p. 101.

12. Alan Ryan, *John Dewey and the High Tide of American Liberalism,* (New York: W. W. Norton, 1995), p. 357.

13. Habermas, *Knowledge and Human Interests*, p. 309.

14. Robert J. Antonio and Douglas Kellner, "Communication, Modernity, and Democracy in Habermas and Dewey," *Symbolic Interaction* 15 (1992): 277–97. See especially their comments on p. 284. "In contrast to Habermas's sharp division between 'labor' and 'interaction,' Dewey treated technical and communicative activities as continuous, entwined spheres." And further, "Contrary to Habermas, Dewey's antidualistic naturalism opposes any effort to set off communication from other forms of understanding."

15. Habermas, *Knowledge and Human Interests*, p. 309.

16. Ibid., p. 310.

17. John Dewey, *The Collected Works of John Dewey. The Later Works*, vol. 14, ed. Jo Ann Boydston. (Carbondale and Edwardsville: Southern Illinois University Press, 1988), p. 229.

18. Jürgen Habermas, *The Theory of Communicative Action*, vol. 1, trans. Thomas McCarthy (Boston: Beacon Press, 1984), p. 288.

19. Jürgen Habermas, *The Past as Future*, ed. and trans. Max Pensky (Lincoln, Neb.: University of Nebraska Press, 1994).

20. Habermas, *The Past as Future*, p. 101.

21. Ibid., p. 102.

22. Ibid., pp. 101–2.

23. Hilary Putnam and Ruth Anna Putnam have also noted the fact that experimentation does not seem to play much of a role in Habermas's account of communicative action. See Hilary Putnam and Ruth Anna Putnam, "Education for Democracy," *Educational Theory* 43, no. 4 (Fall 1993): 371; "although Habermas does not actually deny the need for experiment in the establishment of norms, he rarely mentions it. His picture is one in which communities arrive at norms by mere discussion, while they arrive at 'facts' by experimentation. Moreover, (although Habermas has been moving away from this of late), the methodology that is supposed to guide the norm-producing discussion is itself derived *a priori*, via a 'transcendental pragmatics.' Dewey, we believe, would welcome Habermas's notion of an 'emancipatory interest,' but he would wish to break down all of the dualisms and reject all of the apriorism implicit in Habermas's scheme."

24. Dewey, *The Middle Works*, vol. 2, pp. 298–315.

25. Ibid., p. 305.

26. Hilary Putnam and Ruth Anna Putnam, "Education for Democracy," *Educational Theory* 43, no.4 (Fall 1993): 361–76.

27. Antonio and Kellner, p. 280. "[Habermas's] pragmatism is partial and contradictory, because of his nonhistorical standard of communicative rationality."

26

David Detmer

Habermas and Husserl on Positivism and the Philosophy of Science

Jürgen Habermas's engagement with the philosophy of science is confined primarily to his early works, written when positivism was still ascendant.[1] Accordingly, he expends considerable effort in attempting to refute positivism, and explains and defends his own position primarily by means of contrasting it with that then-hegemonic alternative. But since positivism is now moribund, both in the philosophy of science and in philosophy generally, the question arises as to whether or not Habermas's work in this vein is sufficiently relevant to contemporary concerns as to be worth our attention today.

For at least two reasons, I am inclined to answer this question in the affirmative. First, as most teachers of ethics could surely testify, positivism has not been dethroned among the general public. I find that I cannot engage my students for long in a consideration of ethical issues before one of them steps forward to assert that ethics is meaningless (or subjective, or relative, or noncognitive, or some such thing) because it is non-empirical and non-scientific. At my campus I have heard similar arguments offered by many faculty members in response to a proposal to make ethics a part of the university's required general education curriculum for undergraduates. So positivism still reigns in the hearts and minds of many. Thus, (and here it will be obvious that I sympathize with Habermas's rejection of positivism) there is still a need to kill it off. There may still be some point, therefore, in continuing to put the arguments against positivism before the public, even if these arguments are by now quite old and familiar in some circles.

A second, and much more important, reason for continuing to engage with Habermas's critique of positivism is that there is no consensus—indeed, there is great controversy—regarding the issue of *how* one should go about transcending positivism. And the debate is even more intense concerning

what should come in its place. In this paper I will explore a small corner of the terrain that one would have to traverse in order to deal with these questions adequately. I will contrast Habermas's alternative to positivism with that of Edmund Husserl, one of the allies whom he cites in his argument against positivism and then criticizes on the road to sketching his own approach to the philosophy of science.

I. HABERMAS'S CRITIQUE OF POSITIVISM

Habermas's critique of positivism can be succinctly summarized by saying that he objects to positivism's "scientism," "decisionism," and "objectivism." He defines "scientism" as follows: "'Scientism' means science's belief in itself: that is, the conviction that we can no longer understand science as *one* form of possible knowledge, but rather must identify knowledge with science."[2] Similarly, Habermas calls "the principle of scientism" the idea that "the meaning of knowledge is defined by what the sciences do and can thus be adequately explicated through the methodological analysis of scientific procedures."[3]

Perhaps Habermas's principal objection to scientism is that it is intolerably reductionistic. That is, scientism reduces all sorts of knowledge claims to one sort, the kind that is appropriately dealt with on the empiricist model. But the knowledge of persons, for example, requires interpretation, and thus in this domain empiricism must give way to hermeneutics.

Another objection is that scientism, in adopting the empiricist principle that all genuine knowledge must be based on sensory experience,[4] appears to contradict itself. That is, while it claims to know that all genuine knowledge is scientific in character, this claim itself is clearly not empirical or scientific, and thus, on its own terms, cannot be an instance of knowledge.[5]

Even more disastrous than scientism, however, is its logical consequence, "decisionism," which may be characterized as the idea that since value judgments fall outside the purview of science, they are irrational. On this view, value judgments are simply the expressions of arbitrary personal decisions. This is the notorious doctrine of "value freedom," which threatens to cut off from inquiry any moral or evaluative investigations. Thus, as Habermas puts it, "[w]hat was once supposed to comprise the practical efficacy of theory has now fallen prey to methodological prohibitions."[6] Indeed,

> the result of [positivism's] labors is monstrous enough: from the mainstream of rationality the pollutants, the sewage of emotionality, are filtered off and locked away hygienically in a storage basin—an imposing mass of subjective value qualities. Every single value appears as a meaningless agglomeration of

meaning, stamped solely with the stigma of irrationality, so that the priority of one value over the other—thus the persuasiveness which a value claims with respect to action—simply cannot be rationally justified. . . . The price paid for economy in the selection of means is a decisionism set wholly free in the selection of the highest level goals.[7]

It is easy to understand why Habermas would find this result so unpalatable. Surely if any area of human life is in need of the employment of procedures of rational justification, it is the domain of the values by which we choose our goals, set our priorities, and, in short, live our lives. Still, since there are some unpalatable findings which we simply must accept, on the grounds, quite simply, that they are true (the fact that everyone dies is an obvious example), it follows that the "monstrous" quality of positivism's implications are insufficient to warrant its rejection. But fortunately decisionism is unsupportable apart from the irrationally reductionistic and self-contradictory scientism on which it is based, and thus Habermas can legitimately claim justification for jettisoning it.[8]

We turn now to Habermas's third criticism of positivism, the one concerning its "objectivism":

With Husserl we shall designate as objectivistic an attitude that naively correlates theoretical propositions with matters of fact. This attitude presumes that the relations between empirical variables represented in theoretical propositions are self-existent. At the same time, it suppresses the transcendental framework that is the precondition of the meaning of the validity of such propositions. As soon as these statements are understood in relation to the prior frame of reference to which they are affixed, the objectivist illusion dissolves and makes visible a knowledge-constitutive interest.

There are three categories of processes of inquiry for which a specific connection between logical-methodological rules and knowledge-constitutive interests can be demonstrated. This demonstration is the task of a critical philosophy of science that escapes the snares of positivism. The approach of the empirical-analytic sciences incorporates a *technical* cognitive interest; that of the historical-hermeneutic sciences incorporates a *practical* one; and the approach of the critically oriented sciences incorporates the *emancipatory* cognitive interest that, as we saw, was at the root of traditional theories.[9]

II. HABERMAS'S ALTERNATIVE TO POSITIVISM

We are now in a position to see how Habermas's theory of knowledge-constitutive interests is designed to overcome the three generic weaknesses of positivism outlined above. As against scientism, Habermas insists that there are three kinds of knowledge, not just one. As against decisionism, he claims that two of these three kinds of knowledge (the historical-hermeneutic

sciences and the critically oriented sciences) are constituted by value-laden cognitive interests (practical and emancipatory, respectively). And as against what he takes to be positivism's naïve objectivism, Habermas asserts that each kind of knowledge is constituted by a specific human interest which determines its object domain and lays down the criteria by which claims within that domain are to be evaluated.

In part for this reason, he also rejects the correspondence theory of truth in favor of a consensus theory, according to which truth is to be understood in terms of agreement under certain conditions. On this view truth just is agreement under an "ideal speech situation," in which all have an equal chance to participate in unforced, undistorted communication, so that the only power that anyone wields is the power of rational persuasion. A consequence of this view is that value inquiry is elevated to the same epistemological status as the physical sciences, since the former is just as capable as the latter of generating truth in this Habermasian sense, and the latter is no longer seen as having access to something denied to the former, namely, a reality as it is in itself, apart from human subjectivity.

Finally, it should be noted that while Habermas has not addressed at length the recent postmodernist criticism of science, it is reasonably clear how it would fare from the standpoint of the position just sketched. Whereas positivism errs by reducing the historical-hermeneutic and critically oriented sciences to the logic and methodology of the empirical-analytic sciences (when it does not simply dismiss them outright as meaningless), many postmodernists err in the opposite direction—by attempting to assimilate the physical sciences to, for example, sociology, history, or critical theory. Similarly, while Habermas would concur with postmodernist complaints about the horrible uses to which modern science has been put, he would disagree with any attempt to make of this an indictment of science *per se*, as opposed to a criticism of the role science has played in a culture suffering from a scientistic self-misunderstanding. On Habermas's view, science need not be rejected, but rather kept in its place, working alongside of, rather than dominating, the other kinds of knowledge.

III. HUSSERL AND HABERMAS

It is noteworthy that in Habermas's "Knowledge and Human Interests: A General Perspective," a 1965 address in which he "first expound[s] the systematic perspectives guiding"[10] his early masterwork, *Knowledge and Human Interests*, he adopts as his starting point Husserl's *The Crisis of European Sciences and Transcendental Phenomenology*.[11] It seems fitting that he should do so, since in that work Husserl anticipates many of the

arguments against positivism that Habermas would later make. We have already seen, for example, that Habermas invokes Husserl in advancing his own refutation of objectivism. Similarly, while Husserl does not use the same vocabulary that Habermas employs in criticizing scientism and decisionism, the sentiment is strikingly similar:

> Merely fact-minded sciences make merely fact-minded people. . . . In our vital need—so we are told—this science has nothing to say to us. It excludes in principle precisely the questions which man, given over in our unhappy times to the most portentous upheavals, finds the most burning: questions of the meaning or meaninglessness of the whole of this human existence. Do not these questions, universal and necessary for all men, demand universal reflections and answers based on rational insight? In the final analysis they concern man as a free, self-determining being in his behavior toward the human and extrahuman surrounding world and free in regard to his capacities for rationally shaping himself and his surrounding world. What does science have to say about reason and unreason or about us men as subjects of this freedom? The mere science of bodies clearly has nothing to say; it abstracts from everything subjective. As for the humanistic sciences, on the other hand, . . . their rigorous scientific character requires, we are told, that the scholar carefully exclude all valuative positions, all questions of the reason or unreason of their human subject matter and its cultural configurations. Scientific, objective truth is exclusively a matter of establishing what the world, the physical as well as the spiritual world, is in fact. But can the world, and human existence in it, truthfully have a meaning if the sciences recognize as true only what is objectively established in this fashion . . . ?[12]

Or again:

> [Positivism] has dropped . . . all questions vaguely termed "ultimate and highest." Examined closely, these . . . excluded questions have their inseparable unity in the fact that they contain . . . *the problems of reason* —reason in all its particular forms. Reason is the explicit theme in the disciplines concerning knowledge (i.e., of true and genuine, rational knowledge), of true and genuine valuation (genuine values as values of reason), of ethical action (truly good acting, acting from practical reason) . . . All these "metaphysical" questions, taken broadly —commonly called specifically philosophical questions—surpass the world understood as the universe of mere facts. They surpass it precisely as being questions with the idea of reason in mind. And they all claim a higher dignity than questions of fact, which are subordinated to them even in the order of inquiry. Positivism, in a manner of speaking, decapitates philosophy.[13]

So the "crisis" to which Husserl refers in the title of his book is a crisis of reason. As modern Westerners increasingly come to equate reason with science, only to find that science does not deal with questions of value and meaning, the result is a hostility, not merely to science, but also to reason itself. Moreover, insofar as human beings are themselves rational beings, the result

is a kind of self-betrayal and alienation from self, which in turn culminates in the irrationalistic and anti-intellectualistic strains of thought so prevalent in Husserl's time and our own.

To put the point another way, the problem is that there is a tendency to confuse one specific historical form of rationalism, that which is implicit in modern (post-renaissance) science, with the generic idea of rationality itself, so that good reasons for rejecting the former are, in turn, confused with good reasons for abandoning the latter.

But what, precisely, is wrong with the rationalism of modern science? Husserl's answer, in part, is that it ignores the "lifeworld" of pre-scientific experience. Instead, it posits as ultimately real an abstract world of unexperienced mathematicized entities, and consigns to the refuse heap all of the clear givens of experience which fail to conform to this abstract, mathematical model. One of the results, to return to Habermas's terminology, is a decisionism about values.

Without mentioning Husserl by name, Habermas develops this theme of the scientific neglect of the lifeworld in his essay "Technical Progress and the Social Life-World."[14] There (pp. 50–51) he quotes from Aldous Huxley, who makes the point most effectively by contrasting science with literature:

> The world with which literature deals is the world in which human beings are born and live and finally die; the world in which they love and hate, in which they experience triumph and humiliation, hope and despair; the world of sufferings and enjoyments, of madness and common sense, of silliness, cunning and wisdom; the world of social pressures and individual impulses, of reason against passion, of instincts and conventions, of shared language and unsharable feelings and sensations . . . [15]

Thus, Habermas characterizes the lifeworld as being "culture-bound, ego-centered, and pre-interpreted in the ordinary language of social groups and socialized individuals."[16] Nonetheless, the sciences seem not to be concerned with the lifeworld at all, despite its primacy in human experience, as Huxley explains:

> As a professional chemist, say, a professional physicist or physiologist, [the scientist] is the inhabitant of a radically different universe—not the universe of given appearances, but the world of inferred fine structures, not the experienced world of unique events and diverse qualities, but the world of quantified regularities.[17]

Among the many Husserlian/Habermasian objections that might be raised against this modern scientific equation of the real and the objective with the physical/corporeal, two are of special significance. First, such a reduction is clearly not appropriate for all regions of inquiry. Indeed, in addition to ethics,

which we have already discussed in connection with decisionism, one need only think of logic in order to grasp this point.

Secondly, the modern scientific world view invites us to lose sight of all of the vexing issues concerning the transformation (via abstraction, generalization, and idealization) from what is primarily given in experience to the idea of independently existing physical bodies. Such forgetting, in turn, gives rise to a mistaken idea of objectivity according to which human minds can act simply as mirrors and recorders of reality. This then sets up a false dilemma—either reality is what it is utterly apart from any consideration of the constituting activities of consciousness, or else it is all a social construct (or relative, or subjective). Thus, postmodernism is positivism inverted. For example, while it undoubtedly requires creative effort to construct a historical narrative, or to advance a scientific hypothesis, to conclude from this that we are trapped with "telling stories," which can have only subjective, or relative, or contingent (not objective) validity is to rely unwittingly on the very positivist conception of knowledge that one is simultaneously attempting to undermine.

Another way of putting the false dilemma is this: either something is what it is quite apart from any experience of any kind—events are construed purely in positive terms, in categories of physical stuff and physical cause and effect, for example (objectivity), or it is what it is because of our reactions and point of view (subjectivity). But this leaves out a third category—that which is given in experience. Indeed, perhaps the main point of Husserl's project of phenomenology is to return our attention to this forgotten category, which is more primitive than, and foundational to, the other two just mentioned. Phenomenologist and Husserl scholar Erazim Kohák shows its importance by remarking that aggravated assault with a deadly weapon, "objectively considered,"

> quickly reduces to no more than a series of morally neutral events, each in its turn fully explained by antecedent causal conditions. To preserve the moral point of view, we shift to explaining why we, as victims, happen to consider such an act as evil. But this again misses the point that certain acts, though morally neutral "objectively," are not simply "considered evil" but, *as experience*, are intrinsically so. . . . [We must recognize] the crucial distinction between the necessary structure of subjectivity and individual subjective preference. . . . A genuine [social] science must do more than simply accumulate statistics about individual likes and dislikes, the way natural science accumulates statistics about what is in fact the case. As *scientia*, a social or a human science needs to turn to the intrinsic structure of experience as such.[18]

And in order to do this, the science in question will need to take into account, not only the lifeworld, but also "intentionality," Husserl's term for the act-character of consciousness. Indeed, according to Husserl, objects of all

kinds, including scientific objects, are correlative to and constituted by meaning-conferring acts of consciousness. It is precisely through his insistence on this point, moreover, that Husserl attempts to overcome what he, and Habermas as well, condemn as objectivism.

The rationale underlying Husserl's insistence is well explained by Kohák:

> [W]hat is, is intelligible only for the subject. Quite simply, what I describe as hail beating down prairie grass is nothing and means nothing in a world devoid of subjects. Only for a subject does it become experience. . . .
>
> [Consider, for example] the perception of a prairie Indian who depends on the prairie grasses for his livelihood. The reality he sees is a meaningful whole, a destruction of food which spells a hungry winter. His perception is clearly intentional, partaking of an act-character. . . . The presence of the Indian, not his preferences, not what he thinks or "feels," but his very presence, constitutes the experience as a meaningful whole.[19]

Kohák is equally incisive regarding the contrast between this Husserlian understanding of reality and that of modern science. (Note also the Habermasian points about the dangerous social consequences of a situation in which scientific knowledge is not checked by other kinds of knowledge):

> Husserl's recognition of the constitutive function of intentional consciousness explains . . . the ultimately teleological structure of intelligibility. In effect, it inverts the basic assumption of modern science, that the subject introduces a note of private purpose into a reality structured by efficient causality. Rather, it is the scientist who (incidentally, for good reason and to good effect)[20] introduces efficient causal explanation into what is essentially and primordially a teleologically ordered reality.
>
> That assumption itself needs to be understood teleologically, as defining a model of intelligibility. For a series of reasons—not causes, note, but reasons—Western science in recent centuries has defined its task as one of providing a causal description of a material universe. From this definition follow conceptions of what is to be regarded as real and what as derivative, what as good and what as bad, what as true and what as false, and, finally, what as successful and what as unsuccessful. The alleged success of modern science is success in terms of its own criteria. But we might legitimately ask whether there is not something strange about a group of flammable human beings who learn how to construct nuclear weapons while remaining entirely at a loss as to when and where to detonate them—and call it "success."
>
> The assumption that the first ability falls within the purview of science and so constitutes progress, while the second represents a purely private, subjective concern, is not a "scientific" conclusion but rather one particular ordering of human priorities, and a rather questionable one at that. Before we progress to the point of incinerating ourselves, we need to reopen the question of our priorities—of the basic principles in which we constitute the reality which our sciences so efficiently describe.[21]

IV. CRITICAL DISCUSSION

As we have seen, Husserl and Habermas share much in common in their criticisms of positivism and in their approaches to science more generally. Indeed, Husserl anticipates all three of Habermas's major objections to positivism, and Habermas acknowledges his indebtedness to Husserl. Still, Habermas does offer one objection against Husserl, and uses that very criticism as a launching pad for his own alternative human interest theory of knowledge and science. Moreover, the two thinkers differ in that Husserl does not hold, and undoubtedly would reject, Habermas's scheme of three knowledge-constitutive interests as well as his consensus theory of truth. Let us turn, then, to these three points of difference.

Habermas's criticism of Husserl is that the latter thinker allegedly fails to overcome objectivism. As Habermas puts it, Husserl

> errs because he does not discern the connection of positivism, which he justifiably criticizes, with the ontology from which he unconsciously borrows the traditional concept of theory. . . . While criticizing the objectivist self-understanding of the sciences, Husserl succumbs to another objectivism, which was always attached to the traditional concept of theory.[22]

Or again: "Contrary to Husserl's expectations, objectivism is eliminated not through the power of *theoria* but through demonstrating what it conceals: the connection of knowledge and interest."[23] With this last remark, one can readily discern Habermas's own project looming on the horizon.

To understand this criticism, we need to know what Habermas means by "the traditional concept of theory" (as he puts it in the first quotation in the immediately preceding paragraph) or "*theoria*" (as he puts it in the second). He defines it as holding that

> [w]hen the philosopher views the immortal order, he cannot help bringing himself into accord with the proportions of the cosmos and reproducing them internally. He manifests these proportions, which he sees in the motions of nature and the harmonic series of music, within himself; he forms himself through mimesis. Through the soul's likening itself to the ordered motion of the cosmos, theory enters the conduct of life. In *ethos* theory molds life to its form and is reflected in the conduct of those who subject themselves to its discipline.[24]

Returning now to Habermas's criticism, it seems to be based on an insufficient appreciation of the extent to which Husserl's project of transcendental phenomenology represents something new, and something radical, on the philosophical horizon. To be sure, Husserl does make some rhetorical appeals to *theoria* in his work, but these can be jettisoned entirely without effecting his overall argument, or any of the specific points noted in the

previous section, one iota. Habermas's procedure here seems to me on a par with an effort to reject Husserlian phenomenology by linking it to some defect in the philosophy of Descartes, on the grounds that Husserl once chose to introduce his ideas to a French audience by pointing out similarities between his own views and those of his great French predecessor.[25] To put the point another way, yes, *theoria* falls prey to objectivism, and Cartesianism is open to any number of powerful objections, and yes, Husserl's project of phenomenology shares much common ground with both of these two other ideas, but the question is, given that Husserl's project also breaks from these two predecessors, and often quite sharply, is it also vulnerable to these same objections? Is Husserlian phenomenology an objectivism?

Given Husserl's concept of, and emphasis on, intentionality, it seems to me that this question must be answered in the negative. Indeed, Husserl repeatedly calls attention to the importance, indeed the necessity, of the subjective in the constitution of all meaning, and heralds this move as something new in the history of philosophy, and hence a break with the tradition of *theoria*. Here is one representative passage:

> Let us direct our attention to the fact that in general the world, or, rather, objects are not merely pregiven to us all in such a way that we simply have them as substrates of their properties but that we become conscious of them . . . through subjective manners of appearance, or manners of givenness, without noticing it in particular; in fact we are for the most part not even aware of it at all. Let us now shape this into a new universal direction of interest; let us establish a consistent universal interest in the "how" of the manners of givenness . . . that is, with our interest exclusively and constantly directed toward *how*, throughout the alteration of relative validities, subjective appearances, and opinions, the coherent, universal validity *world* —the world—comes into being for us.[26]

Or again, Husserl speaks of phenomenology as carrying out a "new universal direction of interest," and asserts that a "coherent theoretical interest shall now be directed . . . toward the universe of the subjective."[27] It seems to me that this is, indeed, the heart of phenomenology, and that it cannot legitimately be charged with objectivism. In any case, Habermas, in charging Husserl with objectivism, ignores all of the new and distinctive features of his thought, focusing exclusively instead on his rhetorical nods in the direction of *theoria*. But surely this is insufficient to make the criticism stick.

The second point of disagreement between Habermas and Husserl concerns the former's insistence that there are precisely three knowledge-constitutive interests. While this tripartite division, if taken in a rough-and-ready sense, might well be useful in approaching a good many issues, questions arise as soon as one insists upon construing it in Habermas's precise and rigid sense. Why recognize only three such interests, when it seems that

many more might usefully be distinguished? Why *these* exact three? How do we *know* that these are the right ones? What is the *status* of the claim (for example, transcendental deduction? empirical generalization? general agreement?, and so on) that they are the right ones?[28] Why must these three be understood as reflecting hard and fast distinctions, allowing no mutual interpenetration, as opposed to being seen as points on a continuum?[29]

In any case, it is clear what Husserl would think of Habermas's scheme. Intentionality, as Husserl understands it, applies to all acts of consciousness, and includes all interests and all manners of having objects, in all of their rich diversity. To subsume all of these under just three headings may well have its uses for certain projects in certain situations, but I should think Husserl would find it unwise in the extreme to attempt to make of such a theoretical construct something harder and more durable than that.

Moreover, because intentional acts of consciousness as a matter of fact do not respect Habermas's categorial distinctions, it would seem that any philosophy which places the former at its center would have to reject the latter, and it seems that Husserl does. For example, as opposed to Habermas, who frequently employs as an instrument of criticism the observation that a given claim or theory illegitimately attempts to transcend its categorial boundaries, a major theme of the *Crisis* is an attack on the increasing movement toward specialization, which he attributes to the rise of modern science, and which he suggests gives to such prohibitions against boundary-crossing their spurious credibility.[30]

Such boundary-crossing does, indeed, seem necessary if one is to confront real problems in the world. Consider the environmental crisis, for example. Surely its solution involves inquiries into questions which, if they were to be categorized by discipline, would have to include questions of chemistry, biology, engineering, politics, ethics, and economics, to name just a few. On a boundary-respecting scheme, this means that our only hope is that work done in these different spheres will somehow end up being coordinated in such a way as to result in effective action. But if one abandons disciplinary concerns and disregards prohibitions against boundary-crossings, and constitutes the object of one's inquiry as that of solving or ameliorating the environmental problem, then all of these questions instantly and effortlessly are cast in a new light, and take their proper place alongside one another (and interpenetrate one another) as dictated by the logic of that inquiry. Thus, on both theoretical and practical grounds, I would argue that Husserl's idea of object-constitution by means of the almost infinite variety of meaning-conferring acts of consciousness makes more sense than does Habermas's ungrounded, rather artificial, and overly rigid scheme of precisely three knowledge-constitutive interests.

Finally, we turn to the issue of truth. Habermas's qualified consensus theory, while undoubtedly an improvement over a consensus theory which

would take no notice of how the consensus was achieved (and which would therefore have to count as "true" beliefs that had been won by bribery or coercion, for example), still faces most of the powerful objections that have historically been raised against theories which would reduce truth to agreement. For example, if agreement is understood as a *criterion* of (rather than as a definition of or as constitutive of) truth, then it confronts the simple problem that it is both logically possible and indeed highly likely in fact that agreements arrived at even by the best of means and in the best circumstances might still, due simply to human fallibility, often go awry. Furthermore, such agreement cannot be reasonably taken for a criterion of truth without some independent way of verifying that what is agreed to is indeed true.[31]

Moreover, as Longino argues,

> [m]atters are not improved by taking consensus to be a definition rather than a criterion of truth. What are we to say about changes in consensus over time? Has the truth of statements changed correspondingly? Just as problematic for a criterion or a definition is the possibility that there be no consensus regarding a particular question. Why should we suppose that we would all eventually come to agree that a particular theory is correct? And does it follow from a lack of consensus that there is no truth of a matter?[32]

As if this were not enough, the theory also seems to give rise to many paradoxes, of which I will mention two. First, if consensus, whether actual or ideal, is to serve as a criterion of or definition of truth, then we will need to know in any specific case what that consensus is (or ideally would be) before we can know what is true. Thus, before we can know what the truth is about X, we must first learn what the truth is about the consensus (whether actual or ideal) concerning X. But if truth is indeed determined by consensus, then the way to find out what the truth is about the consensus concerning X, is to learn what the consensus is regarding that consensus. And this, in turn, depends upon what the consensus is concerning the consensus regarding the consensus concerning X, and so on. If, in order to get out of this infinite regress, it is asserted that the nature of a consensus can be determined in some way other than by consensus, this opens the door to inquiries concerning both the nature of this other way and the reasons why it cannot be applied to anything other than the issue of the nature of consensuses.

The second paradox is this. If consensus just is truth, then, prior to consensus, we can have no motivation to advocate one view or another as true. If there already is a consensus, then discussion is needless. If there is no consensus, then discussion is groundless. But if discussion is needed and not groundless, then truth must be something other than consensus.

Husserl gets around these and related problems by calling for a "return to the things themselves," by which he means a return to a critical scrutiny of the

objects of experience, just as they give themselves in experience. This is not an objectivism, because these objects are seen as constituted by, and correlative to, the intentional acts of consciousness. Nor is it a scientism, because the objects of conscious experience, in all of their rich diversity, include far more than are dealt with by modern science. Nor, finally, is it a decisionism, since it includes values of all kinds, and asserts that these can be investigated with all the rigor of investigations of other kinds of objects. Thus, Husserl's position, whatever objections it may legitimately face, does seem able to move beyond positivism (and to do so with respect to precisely those aspects of positivism against which Habermas quite correctly warns us), without, however, entangling itself in the many difficulties, discussed above, confronting Habermas's early project of knowledge-constitutive interests.[33]

DAVID DETMER

PURDUE UNIVERSITY CALUMET
MAY 2000

NOTES

1. Indeed, in "A Reply to My Critics" (in John B. Thompson and David Held, eds., *Habermas: Critical Debates* [Cambridge, Mass.: MIT Press, 1982], p. 274), Habermas remarks that he had not kept up to date over the previous decade with new developments in the philosophy of science. Still, while Habermas has not addressed more recent work in the philosophy of science in depth, it is clear what he would think of it. He would approve of its attacks on positivism, but disapprove of its relativistic, anti-Enlightenment thrust. (See, in this connection, Habermas's *Philosophical Discourse of Modernity*, trans. Frederick G. Lawrence [Cambridge, Mass.: MIT Press, 1987].) For example, in response to the school of thought which views science as non-progressive, and as shot through with discontinuities and incommensurabilities, Thomas McCarthy remarks, much in the spirit of Habermas, that "[w]ell-established empirical regularities may be repeatedly refined and reconceptualized, but they are not simply dropped; we do not dismantle bridges or bombs when theories change" (*The Critical Theory of Jürgen Habermas* [Cambridge, Mass.: MIT Press, 1981], p. 61).

2. Habermas, *Knowledge and Human Interests*, trans. Jeremy J. Shapiro (Boston: Beacon Press, 1972), p. 4.

3. Ibid., p. 67. To give just one more formulation, Habermas also calls scientism "the pseudo-scientific propagation of the cognitive monopoly of science," according to which "legitimate knowledge is possible only in the system of the empirical sciences . . ." (Ibid., p. 71).

4. See Ibid., p. 74.

5. Habermas makes this point in many places. See, for example, ibid., p. 80, and again on p. 88.

6. Ibid., p. 304. See also Habermas's essays "The Analytical Theory of Science

and Dialectics," especially, pp. 158–62, and "A Positivistically Bisected Rationalism," especially pp. 215–20, both in Theodor W. Adorno et al, *The Positivist Dispute in German Sociology*, trans. Glyn Adey and David Frisby (Brookfield. Mass.: Avebury, 1994).

7. Habermas, "Dogmatism, Reason, and Decision: On Theory and Praxis in our Scientific Civilization," in *Theory and Practice*, trans. John Viertel (Boston: Beacon Press, 1973), p. 265.

8. Additional justification might come from reflecting on the value-laden nature of science itself. John D. Mullen (in *Hard Thinking* [Lanham, Md.: Rowman & Littlefield, 1995], p. 89) explains this clearly:

[I]t is often claimed that . . . science is *value free*. To be value free is depicted as "sticking to the facts as they are," rather than getting entangled in value questions that are claimed to deal with how we *feel*. This claim is mistaken in a number of ways. First, value questions are not about how we feel, but are about judgments of good, bad, better, or worse, based upon relevant criteria. . . [Moreover,] it is false to claim that science is value free. Values enter science . . . as an absolutely necessary element, without which there could be no science. . . If scientists were to refuse to make value judgments about what is good, bad, better, or worse, then there could be no such thing as science . . . [W]ithout the ability to distinguish good from bad science, sloppy from elegant research design, adequate from inadequate margins of error, honest from fraudulent mistakes, sufficient from insufficient data, clearly formulated from vague theoretical constructions, interesting from uninteresting problems, and much more, science as we understand it could not take place. Yet all these are value judgments.

9. Habermas, *Knowledge and Human Interests*, op. cit., pp. 307–8.

10. Ibid., p. vii.

11. Husserl, *The Crisis of European Sciences and Transcendental Phenomenology*, trans. David Carr (Evanston, Ill.: Northwestern University Press, 1970). Habermas's discussion of this work can be found in his "Knowledge and Human Interests: A General Perspective," a lecture published as an appendix to *Knowledge and Human Interests*, op. cit., pp. 301–17.

12. Husserl, op. cit., § 2, pp. 6–7.

13. Ibid., § 3, p. 9.

14. In Habermas, *Toward a Rational Society*, trans. Jeremy J. Shapiro (Boston: Beacon Press, 1971).

15. Huxley, *Literature and Science* (New York: Harper and Row, 1963), p. 8.

16. Habermas, *Toward a Rational Society*, op. cit., p. 51.

17. Huxley, op. cit., p. 8.

18. Kohák, *Idea & Experience* (Chicago: University of Chicago Press, 1978), p. 93.

19. Ibid., p. 123.

20. It is clear that Husserl, who began his intellectual career as a mathematician and was well-educated in the physical sciences, would agree with this praise of modern science. His aim is not to reject science, but rather to deepen and strengthen it, and to keep it in proper balance with other kinds of knowledge not currently regarded as scientific. This latter aim, of course, he shares with Habermas.

21. Kohák, op. cit., p. 124.

22. Habermas, *Knowledge and Human Interests*, op. cit., pp. 305–6.

23. Ibid., pp. 316–17.
24. Ibid., pp. 301–2.
25. I refer here to Husserl's *Cartesian Meditations*, trans. Dorion Cairns (The Hague: Martinus Nijhoff, 1977).
26. Husserl, *The Crisis of European Sciences and Transcendental Phenomenology*, op. cit., § 38, p. 144.
27. Ibid., § 38, p. 146. It is worth noting that Husserl certainly does not claim to be the first thinker to call attention to subjectivity. To the contrary, "that each person sees things and the world in general as they appear to him" is, he insists, a "fact which is naïvely taken for granted." But this fact, he continues,

> concealed, as we now realize, a great horizon of remarkable truths whose uniqueness and systematic interconnection never entered the philosophical purview. The correlation between world . . . and its subjective manners of givenness never evoked philosophical wonder . . . in spite of the fact that it had made itself felt even in pre-Socratic philosophy and among the Sophists—though here only as a motive for sceptical argumentation. This correlation never aroused a philosophical interest of its own which could have made it the object of an appropriate scientific attitude. Philosophers were confined by what was taken for granted, i.e., that each thing appeared differently in each case to each person. (Ibid., § 48, p. 165)

Note that here, once again, Husserl claims originality for his own position and explicitly distances it from the tradition of ancient Greek thought—the very tradition that he invokes when speaking of *theoria*. It is also significant that in rejecting objectivism, Husserl makes it clear here that he is not sliding into a facile subjectivism that would amount to a relativism or skepticism. Rather, once again (recall in this connection Kohák's example of aggravated assault with a deadly weapon), he tries to forge a new and different path, that of transcendental phenomenology.

28. In answering this question, Habermas tries to chart a middle course between claiming that his scheme of knowledge-constitutive interests is derived by transcendental deduction and affirming it merely as an empirical generalization. Thus, he coins the term "quasi-transcendental," as a kind of stopgap. Habermas has the intellectual integrity to admit, however, that "[t]he formula 'quasi-transcendental' is a product of an embarrassment which points to more problems than it solves" ("Introduction" to *Theory and Practice*, op. cit., p. 14). For example, as Helen E. Longino (*Science as Social Knowledge* [Princeton, N.J.: Princeton University Press, 1990], p. 198) points out, Habermas leaves it unclear as to whether or not his list of interests is subject to historical change, and if so, how. It is both understandable and significant, then, that Habermas drops this 'quasi-transcendental' formula in later work, and modifies much of the program of *Knowledge and Human Interests*.

29. On this point Longino (ibid., p. 200), offers a

> challenge to Habermas's view that the domains of knowledge marked out by the several knowledge-constitutive, or cognitive, interests are independent. One could argue that the very possibility of hermeneutic understanding requires that one rather than another biological model be adopted, that is, the one within which it makes sense to ascribe intention and effective subjectivity to oneself and other human beings. This line of argument clearly dissolves the

boundaries between technical and practical knowledge. The incursion, however, is not the familiar scientistic appropriation of the practical domain of human interaction but the reverse.

30. See, for example, Husserl, *The Crisis of European Sciences and Transcendental Phenomenology*, op. cit., § 11, pp. 61–65.

31. Discussions of such objections in connection with Habermas's theory can be found in Mary Hesse, *Revolutions and Reconstructions in the Philosophy of Science* (Bloomington, Ind.: Indiana University Press, 1980), pp. 206–31; in McCarthy, op. cit., pp. 303–10; and in Longino, op. cit., pp. 200–1.

32. Longino, op. cit., p. 201.

33. Surprisingly, however, in one remarkable passage Husserl declares that his position is a kind of "positivism," after all:

> If "*positivism*" is tantamount to an absolutely unprejudiced grounding of all sciences on the "positive," that is to say, on what can be seized upon originaliter, then *we* are the genuine positivists. In fact, we allow *no* authority to curtail our right to accept all kinds of intuition as equally valuable legitimating sources of cognition—not even the authority of "modern natural science." When it is actually natural science that speaks, we listen gladly and as disciples. But it is not always natural science that speaks when natural scientists are speaking . . . (Husserl, *Ideas Pertaining to a Pure Phenomenology and to a Phenomenological Philosophy, First Book*, trans. F. Kersten [Boston: Martinus Nijhoff, 1983], § 20, p. 39).

Husserl's main point here is that there is nothing wrong with positivism's attempt to ground knowledge in the experience of objects; rather, the problem lies in its overly restrictive conception of what can count as experience and of objects. For, example, in addition to excluding ethical objects and the experiences by which they are disclosed, the positivists also are guilty of attempting to reduce to "expressions of experiential matters of fact" what "we know with full insight" to be propositions that "give explicative expression to data of eidetic intuition." As examples of these, Husserl offers "'a + 1 = 1 + a,' 'a judgment cannot be colored,' 'of only two qualitatively different tones, one is lower and the other higher,' [and] 'a perception is, in itself, a perception of something'" (ibid.).

27

Robert Young

Habermas and Education

Jürgen Habermas has written relatively little directly on education, and most of what he has written has been in the form of occasional pieces, such as commencement addresses (Habermas, 1961; 1987b), yet the idea of learning and the possibility of the achievement of higher learning levels plays a quite central role in his work.

Because of this, and in order to understand the educational relevance of his work, I have not chosen the path of collecting and summarising Habermas's many passing references to education, schooling, or other specific educational forms, such as universities, but instead have taken the riskier path of attempting to identify central, educationally relevant features of his work and in the space available, to essay a necessarily simplified sketch of the implication of these for a critical theory of education. It is hoped that this broad treatment will serve as an at least partial corrective to the many occasions on which educators have appropriated fragments of Habermas's thought and sometimes distorted it beyond any possibility of the claim to even a felicitous misreading of it. This strategy has the additional advantage that it relates educational questions more closely to the problematic of critical theory than to particular stages in the development of the corpus of Habermas's work or to the sort of surface or specific features of it, such as the notion of the ideal speech situation, or the concept of "emancipation," which have proven so attractive to educators in the past.

THREE EDUCATIONAL INSIGHTS IN HABERMAS

1. History

The first educationally relevant starting point might be identified as a vision of human history in which the possibility of learning is viewed not only as

biographical but also as a social-historical process:

> Since (the 18th C), theory [or learning: RY] . . . deals with the objective, overall
> complex of development of a human species which produces itself. . . . The
> realisation of the good, happy and rational life has been stretched out along the
> vertical axis of world-history; praxis has been extended to cover stages of
> emancipation. (Habermas, 1974: 253)

As McCarthy (McCarthy, 1978: 126) put it, Habermas's conception of
critical theory has undergone considerable development since he first (1957)
labelled it an "empirical philosophy of history with practical intent." Yet
there remains a broad orientation to an empirical study which is nonetheless
not empirical-analytic, to a study in which philosophy's role complements
and interacts with that of social science, (Habermas, 1991b: ch. 1) to a study
in which there is historical acknowledgment of the specific institutional and
developmental conditions of present society without historicism, and in
which a practical-critical intent directs theory to the exploration of the
possibilities of emancipatory learning.

Developments in his work since the late 1970s have seen what Habermas
himself has called a paradigm shift (Habermas, 1982: 386–99) from philos-
ophy of consciousness and immanent critique of epistemology to a social,
communicative reconstruction of the human species' learning competence,
but the remarks McCarthy made in 1978 remain broadly valid. Even after
Habermas's linguistic and communicative turn, and new clarity about the
role of critical philosophy as a "place holder" for social science and as an
"interpreter" mediating between expert cultures and the lifeworld (1991b)
the concrete, historically-immanent Hegelianism which Habermas takes, in
part, from the early Marx, remains a fundamental part of the structure of his
thought. This insight could be summarised by saying that historically-
immanent critique is the form in which we hope. Education is one of the
sources of this hope.

2. Reason

The second starting point for the theory of education is Habermas's
unswerving commitment to an account of theory based on a modest
rationality. If historical institutionalisation of more and more emancipated
social forms is the end, reason is the means. He argues that "people like me
stubbornly cling to the notion that philosophy is the guardian of rationality"
(Habermas, 1991b: 20), because social practices of justification and
grounding—that is, of reasoning—about moral and existential questions are
the only alternative to more or less coercive practices, and because discursive
exploration of validity questions arising from the context of a disturbed

consensus and commitment can also terminate in a new consensus and commitment (Habermas, 1991b: 103, 204) which becomes the new identity and culture, the new social reality. Thus it could be said that reason is the way we learn. If we add Dewey's insight into the internal connection between philosophy, education, and inquiry (Dewey, 1916), we can see that there is a continuity of rational forms of learning.

3. Critique

This leads us to the third point at which a theory of education might be anchored—it is what might be called the "ontogenetic" dimension in Habermas's thought. In this, Habermas implicitly links a theory of the ontogeny of individual and social learning levels by using the same structurational model:

> Piaget conceives 'reflective abstraction' as that learning mechanism which explains the transition between cognitive stages in ontogenetic development. The end point of this understanding is a decentred understanding of the world. Reflective abstraction is similar to transcendental reflection [for example, in Kant: RY] in that it brings out the formal elements hidden in the cognitive content, identifies them as the schemata that underlie the knowing subject's action [cf: reconstructive science: RY], differentiates them, and reconstructs them at the next highest stage of reflection. Seen from a different perspective, the same learning mechanism has a function similar to Hegel's power of negation, which dialectically supersedes self-contradictory forms of consciousness. (Habermas, 1991b: 8)

It is *moral* ontogeny that is most crucial to Habermas's thesis, and he treats this in terms of Kohlberg's theory. In his discussion of Kohlberg, Habermas acknowledges the force of many of Gilligan's criticisms, but he points out that Gilligan fails to distinguish adequately between "the *cognitive problem* of application and the *motivational problem* of the [lifeworld] anchoring of moral insights" (1991b: 179). She makes "the distinction between postconventional formalism [of justice, negotiated rights, and the like] and the postconventional contextualism [which she sees as a stage beyond Kohlberg's stage 5] in terms of the distinction between hypothetical and actual situations" (1991b: 179). But what I ought to do becomes what I would do through motivation; this is not the same issue as the cognitive issue of applying a principle in a complex context—of working out how to act in accordance with an "ought" in a given context—and so does not imply an addition to Kohlberg's stages.

Further, he argues, Gilligan "fails to see that the two problems arise only after morality has been abstracted from ethical life and the basic moral-philosophical question of the justifiability of norms has been answered in

terms of a cognitivist ethics" (1991b: 179). The problems are the problems of application of a cognitivist ethics.

In addition, Gilligan's parallelling of, on the one hand, postconventional formalism and justice, and on the other, her stage of postconventional contextualism and caring and responsibility [with a hypothesized sexual difference] is weakened because of a misunderstanding of the issues. What is at stake is not an issue of further stages of cognitive judgement, but contextual sensitivity and autonomy—development of the whole person. But these are precisely issues of character or virtue and the motivation not only to act well but to learn to act better which raises the issue of the role of virtues in the complex processes of application of moral principles to and in circumstances and of the role of education in the circumstantial formation of relatively stable dispositions to act well and to learn.

The problems of contextual sensitivity and caring do not require a supplementation of Kohlberg's stages with an additional, higher stage, but a distinction between moral development and ego development. What corresponds to the cognitive capacity for moral judgement "are behavioural controls, or superego structures" (1991b: 182).

The transition to this postconventional moral sensitivity typically occurs or fails to occur during adolescence. A precondition for it is a departure from a taken-for-granted conventionalism and a capacity to reason hypothetically about moral issues. However, if this is not followed by an attempt to preserve and reconstitute what it means for norms to have validity, there is a real possibility of the adolescent being stabilised at what Kolhberg called stage four and a half, a relativist position on ethical issues not unlike that expounded by A. J. Ayer or Stevenson (1991b: 187) or some forms of post-structuralism.

But while the role of theory, including ethical theory, at whatever stage it finds itself along the "vertical axis of world-history," is identified with the role of "reflective abstraction," it is not identified as a process of purely individual reflection, for "pragmatism and hermeneutics oust the traditional notion of the solitary subject . . ." (Habermas, 1991b: 9), replacing the individual consciousness in its autogenetic process with "the community of those who cooperate and speak with one another" (Habermas, 1991b: 19). But this speech is not merely contemplative: "the results of the interplay between inner-worldly learning processes and world-disclosing innovations become sedimented [in social reality]" (Habermas, 1993: 165; McCarthy, in Habermas, 1982: xx). In this way, Habermas is able to give an answer to those who would argue that the concept of reflection is overburdened in critical theory. It could be said that mature articulateness in communicative action is the way we can intelligently become. This raises questions concerning the teacher-student relationship and the nature of critical pedagogy.

THEORY, LEARNING, AND PRACTICE

Readers may have noticed close to the beginning of this discussion that I somewhat provocatively glossed "theory" as "learning," but learning is really changed practice as well as changed appraisal of it. There is a distance between theory and practice (Cronin, C. in Habermas, 1993: xi), just as there is between cognitive or theoretical learning and changed practice. Strictly speaking, learning is an *intelligent change in behaviour*. The gap between thought and deed is bridged by concrete biographical and social-historical realisations of that which theory glimpses.

The way Habermas deals with this in the domain of moral learning is instructive. In his discussion of Kohlberg's stage theory of moral development, Habermas points out that what he calls "ethical" questions (that is, *re Sittlichkeit*) remain within the horizon of the lifeworld and retain their connection with the action-motivating potential of the concrete forms of life which are their origin and context, that is, there is no ontological gap between knowing what you ought to do and doing it. But thought about potentially universalizable questions of a moral kind, such as questions of justice, at the postconventional stage of development, needs to be reconnected with specific situations and the motivations/purposes of situated actors, because it is produced by a process of formalisation and abstraction. The gap between developed moral thought and concrete social life "needs to be compensated for by a system of internal behaviour controls" (Habermas, 1991: 183). The resolution of the adolescent crisis in favour of mature superego structures or "ego autonomy" can provide these controls. Much the same points can be made about motivation to learn in general.

But because "an autonomous ego and an emancipated society reciprocally require one another . . ." (Habermas, 1979: 71), the connection of cognitive processes with behavioural ones, of *theoria* with *praxis*, is problematic and uncertain at a social level, too:

> No one can construct an identity independently of the identifications others make of him. . . . But the ego does not accomplish its self-identification in a propositional attitude. It presents itself to itself as a practical ego in the performance of communicative actions; and in communicative action the participants must reciprocally suppose that the distinguishing-oneself-from-others is recognized by those others. Thus the basis for the assertion of one's own identity is not really self-identification, but intersubjectively recognized self-identification. (Habermas, 1979: 107)

This identity learning "takes place and is organized within the framework of ordinary language communication" (Habermas, 1972: 12), in homes, schools, and peer group association and, in turn, the structured opportunities for ordinary language communication are constrained because "relations of

power [are] surreptitiously incorporated in the symbolic structures and systems of speech and action" (Habermas, 1972: 12).

Nevertheless, Habermas's historical judgement is that the learning level of representative parliamentary democracies (Habermas, 1993: 159), "half-democracies" as Adorno called them, is such that it permits some degree of discursive exploration of the claims of power. Social movements, such as the Women's Movement, too, have given some degree of effective voice to various groups who hitherto have been relatively excluded from the public sphere of societal self-formation in such democracies.

Modern schooling systems are potentially part of this process of institutionalised learning. Indeed, they must assist in the formation of post-conventional ego identity if the forms of subjectivity necessary to emancipatory social development are to be developed:

> Today the traditional patterns of socialization, which till now were ensconced as natural in the cultural tradition, are set free by the psychologizing of children's education and the planning of school curricula according to cultural policy, and rendered accessible to general practical [that is, potentially critical: RY] discourse. (Habermas, 1974: 26)

Of course, such phenomena of institutionalised learning in bourgeois democracy are often highly equivocal and compromised—but the institutional potential for learning is there.

> The educational history of humanity develops in the same way or that of society . . . at a given developmental state of civilization, in the manner of a reproduction of a model of experience that is constitutive of it. (Habermas, 1961: 256, my translation)

One of the problems of such learning is the problem of cognitive and theoretical asymmetry. Normally, critique or critical hypothesising is expected to be confirmed in the process of historical-pragmatic feedback from collective actions based on it, or, initially in symmetrical responses from other participants, based on their interests and experience, prior to agreed action. But in situations of asymmetry "genuine confirmation of critique remains unattainable . . ." unless we enter into "communication of the type of therapeutic 'discourse'," that is, precisely in "successful processes of education [*Bildung*] voluntarily agreed to by the recipients themselves," (Habermas, 1972: 31) and in which each learning level is confirmed in the individual's own experience, after the model of psychoanalytic therapy.[1] In this sense, at its best education not only constitutes the contemporary model of experience, but like critique itself, sows the seeds of its transcendence. Of course, in the above remarks, Habermas was writing about the role of critical intellectuals vis-à-vis those whose situations they theorized. But there is a

further homology between political-therapeutic discourses of critical intellectuals and the hybrid therapeutic-formative discourses of the schooling process in contexts of critical education. When Habermas argues that "the identity of socialized individuals forms itself simultaneously in the medium of coming to an understanding with others in language and in the medium of coming to a life-historical and *intra*subjective understanding with oneself" (Habermas, 1992: 153), and simultaneously theorizes that coming to an understanding with oneself is truncated for most members of modern society because of a failure satisfactorily to resolve the adolescent identity crisis, he is clearly locating one of the preconditions for institutionalisation of higher social learning levels at a time of life and in a domain of activity where *schools* may have some influence.

While schools may have goals other than educational ones, and while it would be mistaken to load them with too great a responsibility for societal learning it is clear that they can play a role in the process of identity formation and thus in the development of the "historical, psychological, social and cultural preconditions of institutional(ising) moral-political discourse" (McCarthy, in Habermas, 1991b: xiii).

The question for educational critical theory is this: How do schools and other forms of formal education play an historically emancipatory role, relative to the existing social learning level? To answer this question we must first recognize that whatever answers we may give at the level of policy, curriculum, and organization, the answers must be such as to enable appropriate structures and processes of communicative educational action at the pedagogical level and in the formation of subjectivity. And to provide such answers we must first recognise that the educational situation presents a particular difficulty for critical theory because it partakes of a more radical asymmetry than the problematic situation of the party vis-à-vis the unenlightened proletariat it claimed to lead (Habermas, 1972: 33–36), since pedagogical asymmetry typically encompasses asymmetry of ego-maturity, institutional power, *and* theoretical asymmetry and because control over public education is not clearly mediated by discursive democratic involvement, in part due to the decline of the public sphere (1991a) which coincided with the rise of mass education. There is a need for a theory of critical leadership to supersede that of party leadership.

THREE FOCI OF EDUCATIONAL COMMUNICATIVE ACTION

1. Education and History

Writing of Peirce's view of the general forms of scientific inquiry, Habermas argues that

> The learning processes of the unlimited communication community [Peirce's procedural replacement for an unlimited concept of truth: RY] should form an arch *in* time bridging all temporal distances, and *in* the world they should realise the conditions whose fulfilment is a necessary presupposition of the uncondi-tionality of context-transcending validity claims. . . . While it is introduced in the context of a theory of truth, this notion also structures a concept of society grounded in communicative action. . . . (Habermas, 1993: 165)

But that society is not static. It must cope with endogenous and exogenous change.

However, Habermas argues, the undistorted reproduction (or, rather, developmental stabilisation) of the lifeworld requires processes of (1) cultural production and reproduction, so that newly arising situations "can be connected up with existing conditions in the world" (Habermas, 1987a: 344); (2) social integration, so that coordination of action and group membership may continue on the face of adaptive requirements of new situations; and (3) socialization, so that the generalized capacity for action of future generations and harmonization of biography and collective forms of life may be maintained and developed.

But in modern, differentiated, and increasingly instrumentally rational-ised societies, the possibility of undistorted reproduction of the lifeworld cannot be guaranteed by traditional means in the face of the colonisation of the lifeworld by media of power and money and the narrowly instrumental rationalisation of more and more areas formerly reproduced by traditional means. The alternative, critical possibility is the securing of forms of reproduction that are open to learning and more or less successful adaptation by the risky search for consensus through communicative action:

> the increasing reflexivity of culture, the generalization of values and norms, and the heightened introduction of socialized subjects, the enhancement of critical consciousness, autonomous will-formation and individuation—that is, the strong theory of the moments of rationality once attributed to the practice of subjects takes place under conditions of an ever more extensive and ever more finely woven net of linguistically generated intersubjectivity. (Habermas, 1987a: 345–46)

In the formation of the individuated subject, Habermas argues, G. H. Mead offers us guidance about the dynamics of the formation of the self in the transition to the postconventional type of identity required to resolve the crises of modernity: "A postconventional ego-identity can only stabilize itself in the anticipation of symmetrical relations of unforced reciprocal recognition" (Habermas, 1992: 188).

It is this identity form, hitherto produced relatively rarely, but now demanded by the modern condition, that provides the "radically democratic perspectives of Mead and Dewey [with] their own internal consistency"

(Habermas, 1992: 188). Adaptive ontogeny requires institutionalisation of discourse. Democracy is such an institutionalisation:

> Democracy rests on the will-formation of each individual who comes together with others in the institution of the election of representatives. If an irrational event is not to occur it demands the capability and courage [that is, ego maturity: RY] of each individual to follow his or her understanding. (Adorno, 1970: 133; my translation)

And if we can accept, with Dewey, that the general education system in a democracy, among its other functions, has a role that is continuous with wider forms of inquiry in scientific and intellectual life, and in the discursive exploration of values which is the role of publics, citizens, and parliaments, then one of the functions of schooling should be to prepare the new generation to not only participate in inquiry at the present learning level of society but potentially to be able to participate in the transcendence of that learning level. In this, the schooling system (*pace* Peters, 1963) must itself sometimes anticipate "symmetrical relations of unforced reciprocal recognition" *within* the overall structure of authority and trust that characterizes the educational relationship, if students are to be allowed to practise and so develop the necessary personal qualities for mature, democratic citizenship (see Young, 1990; Habermas, 1996).

At a time when the very possibility of *social* justice is questioned, and in which the value of the common good is either denied or greatly restricted, we need a robust theory of democracy in which the public domain and the role of the state in supporting the common good may be effectively defended, while avoiding the mere reproduction of the good of the ruling group in society. This theory will not be the old theory of the welfare state, because that has proven vulnerable to radicalisations of liberal theory. What is required is a theory which can connect cognitive analyses of social justice with motivation and self-representation and give this organisational expression. Such a theory calls out for addressees. Unlike Marx's intellectuals, who are depicted as bystanders, doing science in their minds as they await impatiently the precipitate action of historical forces, we require intellectuals, indeed citizens, whose virtues are comprised of both principle and action. Indeed, it is entirely reasonable and in accord with past usage to deny the title "social theory" to any theory which is not open to the development of practical strategic relevance. On this basis, much that currently passes for theory would be denied the title. We are talking here about the kind of subjectivity that should parallel effective theorising and that should be found in the effective theorist.

And the continuity between democratic participation and inquiry in general, provides us with a basis on which we can recognize that the education of citizens and technical professionals is not something that

belongs in separate parts of the curriculum, nor is the development of the character of the citizen something that can be recognized in one lesson and denied in all the rest.

Mature articulateness involves a group of virtues, not the least among them courage, prudence, and compassion. These appear in a specifically social or hermeneutic form because hermeneutics is not simply a cognitive understanding but a response of the whole person. As in classical Aristotelian theory, the appropriate form of these virtues, between self-representation and other-representation (self-abnegation), is a median form. The communicative practices of teachers functioning as "transformative intellectuals" (Giroux, 1985) must escape Ellsworth's (1989) criticism that they are not really transformative but just practitioners of a form of strategic action in the name of liberation. The difficult art of *developmental* transformation is difficult precisely because students are at best ambivalently capable of mature articulateness in its zone of proximal development and, simultaneously, schools are only ambivalently capable of allowing students room (*schönraum*) to learn to be articulate fellow-inquirers.

2. Critical Reason at the Present Learning Level

The de-traditionalization of the lifeworld burdens individuals with conflicting behavioural expectations and an increasing need for "individually processed decisions" (Habermas, 1992: 195). There are two options for responding to this situation, that of a truncated strategic rationalism, represented and mediated by the forces of the bureaucracy and the market (power and money) and represented educationally by an increasingly economically-instrumentalised curriculum, or a reconstitution of the lifeworld at a posttraditional or postconventional level through critical reason expressed in communicative action:

'As a member of organizations' and as a participant in systems, the individual who is seized by inclusion [Parsons' term for integration of individuals into organized systems: RY] is simply subjected to another kind of dependence [than traditional dependence]. One who is integrated must orient himself toward steering media such as money and administrative power. These media exercise a behavioural control that, on the one hand, *individualizes* because it is tailored to choices of the individual that are steered by preferences, but on the other hand it also *standardizes* because it allows only options in prestructured dimensions. . . . (Habermas, 1992: 196)

The schooling system is one of the few society-wide organizational processes which is available for the purpose of opposing forms of system integration that foster dependent and regressive resolution of the adolescent identity crisis, and it can do this through communicatively and

intersubjectively recognized self-identifications of a mature kind. While schooling involves relations of power, it also contains possibilities for restraint of power ("*Karenz*") (See Brumlik, 1985) and for creating islands of cognitive or reflective abstraction relatively free from the influence of power or money. Schooling can provide the conditions for a dialogic (rather than individual) "learning mechanism" which allows stage-transcending learning, providing the curriculum and the pedagogy provide space and time, and forms of communication within them that recognize and acknowledge the developmental needs of students. The relations of teachers and students must partake, at least at times, and in constrained but expanding scopes, of the qualities of unforced reciprocal recognition of students-as-fellow-inquirers, if students are to be readily able to anticipate such relationships in their maturity and so be able to develop the postconventional ego-identities so necessary in multicultural societies.

From time to time objections to this line of argument have been put forward. Oelkers (1983) has argued that the dependency of the student precludes the necessary practice in autonomy, but Brumlik (1985) has replied that possession of power does not preclude restraint in its exercise. I have argued elsewhere that it is possible for teachers to exercise their authority methodologically rather than substantively, and in creating and sustaining coercion-free debate *among students*, debate, at least, that is free of coercion as to its content outcomes (Young, 1992).

Spaemann (1975) has argued that students must first master a body of expertise before they can criticize it, but as I have argued, there is good reason to believe, in a Piagetian or post-Piagetian model of learning, that criticism is not subsequent to mastery of a body of thought but to an extent a precondition of it. Observational work by Max Miller (1986a,b) and others confirms this view, showing that dissident students in group discussion accelerate the stage-transcending learning of the whole group through their critique (see Young, 1992).

Yet the problem of the paradox of the framework (which is also the paradox of education) remains. It is not possible to totalize critique to the whole framework or across the whole lifeworld, and any idea of autonomy that does not see it as emergent from tradition, and consequently any idea of "emancipation" that views it as a "stepping outside" historically-provided cultural resources, is completely unrealistic. Critique always operates in a piecemeal way at the margins of the lifeworld and in the liminal zone between lifeworld and system, never totally or in a utopian fashion. It is emergent and so there is no necessary contradiction between critique and restrained educational authority.

One of the problems of much English-speaking and some German "critical theory of education" has been a failure to recognize that the content

agenda of left intellectuals, however validly achieved in *their* communication community, when imposed on students, can negate the reciprocal relationships of genuinely critical pedagogy and produce the strategic postconventional relativism of the so-called stage four and a half, a kind of simultaneously preconventional and "postmodern" moral and cognitive relativism that is unlikely to be able to function as a way of renewing diminished traditional motivational resources (Habermas, 1991b: 184–85) and which cannot serve as a satisfactory resolution of the adolescent identity crisis, resulting instead in a form of "narcissistically overinflated autonomy" (Habermas, 1987a: 315) characteristic of the anti-communal moral world inhabited by some forms of poststructuralism. An emerging body of critical-pragmatic (cf.: Shalin, 1992) educational thought promises to overcome these difficulties (Young, 1990, 1992, 1996a; Cherryholmes, 1988; Biesta, 1994; Miedema, 1995).

3. Educational Reason's Ontogenetic-Communicative Form

A critical theory of education is also a theory of critical pedagogical communicative-ontogenetic action—of educational pragmatics.

The developmental process of the formation of mature, articulate citizens (citizens with "*Mündigkeit*") is also a development of communicative competence. Understood in the round, communicative competence is also ontogenetic competence and "*Mündigkeit*" is the capacity to speak up, to effectively represent one's own interests, but also to take responsibility, and through such binding speaking, to participate in the formation of human affairs, particularly through rational inquiry in ethical, moral, existential, and aesthetic domains. In many countries, the cognitive, subject-based curriculum of the secondary schools, particularly as it has retreated from any claim to the formation of "character," towards instrumental, career-oriented goals, is imbued with a much narrower conception of education than a critical-pragmatic one. Equally, the so-called "subversive" curriculum provides no clear sense of the possibility of taking responsibility.

The form of communicative action in critical pedagogy becomes clearer if we examine it from the standpoint of the theory of (a) meaning in (b) inquiry and (c) conversational action.

(a) Meaning. As Cleo Cherryholmes pointed out, in a pioneering analysis, influenced by Habermas's work: "A perusal of the educational literature does not reveal much in the way of accounts, discussions, or theories . . . of meaning. The logical status of meaning [in the educational literature] is that of a primitive and undefined term . . ." (Cherryholmes, 1988: 1).

This remains the case today, and it remains inexplicable. Whatever else

teaching and learning is about, it is clearly something that is mediated by communication of meanings in talk and writing. Much the same can be said about theories of talk, and the nature of inquiry and learning, insofar as they are linked with communication.

Cherryholmes draws our attention to Habermas's social-critical adaptation of theory of meaning and the relationship between meaning and discourse. It is possible to identify and discard two common theories of meaning: referential and simple truth semantic. Words do not correspond to their objects in a relation of simple identity or mimesis, taking their meaning from the objective world and our relationship to it. However intuitively appealing, this theory of meaning has been decisively rejected by logicians, linguists, and sociolinguists since the beginning of the century. It is a view which leads to a tangle of contradictions (Cherryholmes, 1988: 1–4). Truth-conditional semantics was the logicians' answer to the naive referential view. Generally speaking, truth-conditional semantics is constituted by the idea that we know what an expression means when we understand the conditions under which we could hold it to be true.

But the truth-conditional view needs to be developed in two directions if it is to provide a theory of truth useful to social science, a pragmatic direction and a social direction. Pragmatist theorists, such as Davidson (1984), moved towards a view in which meaning could be analysed at two levels. At the first, formal or semantic level, the meaning in question is the "dictionary" meaning of the sentences in an utterance. Some of the meanings of such sentences are the traditional "propositions" beloved of philosophers. But from a linguistic pragmatic and/or pragmatist point of view, there is another level of meaning. This has been called the meaning of uttering a sentence containing, say, a proposition. In *How to do Things with Words*, Austin (1972) makes a similar point. Language has a performatory dimension as well as a logical one. This has also been called "occasioned" meaning. Uttering the most abstract propositions is still done by someone, for or to someone, for some purpose—all of this creates a context which the hearer takes into account in understanding what the utterer meant.

But linguists tell us that in actual *social* use every utterance is multifunctional. Its meanings are never merely propositional. Of course, this is much clearer when we turn to uses of language other than statements: warnings, promises, agreements, and so on. But let us stick to statements for a moment. The meaning of uttering a statement includes the meaning of uttering it to the persons it is uttered to: Why are you telling *me* this? It also includes the indications of the utterer's own attitude towards the statement—it is said vehemently, doubtfully, and so on. Broadly speaking, in addition to constative meanings we can identify personal expressive meanings, which indicate the speaker's attitudes (often conveyed extra-linguistically in tone of voice, posture, gesture, and so on), and interpersonal,

social, normative meanings, although different analysts divide up this list of functions slightly differently.

For a theory of natural, socially-imbedded language rather than "well-formed" language, and for a theory of language which deals with all language functions rather than simply conveying propositional meanings in the socially decontextualised situation of the pages of philosophy textbooks, we need an extension of truth-conditional semantics to include forms of judgements of validity other than those associated with propositional truth and a theory of forms of language other than propositional language. Habermas's (1982, 1984) view of meaning develops in just this direction.

Habermas's key point is that the insight of truth-conditional semantics remains valid—we understand what a competent utterance means when we understand the conditions under which we would regard:

(1) the propositional implications to be true,
(2) the interpersonal, normative implications to be justified, and
(3) the personal, expressive implications to be sincere or authentic.

If those conditions apply in the world we experience (including the social world) we ordinarily do not have a problem with the utterance. If, however, the conditions do not apply, we do have a problem—which we can ignore, defer, or engage with.

But it should also be remembered that we ordinarily utter our utterances within the institutionalised settings of our way of life. These form the conditions under which we judge the claims present in utterances. They have meanings in terms of the contexts of socially recognized situations and the socially allocated roles of communicators in them. In turn, these roles involve pre-existing commitments and identities anchored in meanings. Semantic meaning may suffice to discuss ideal examples of utterances, but a wider theory of meaning is necessary for analysing actual talk.

Ordinarily, interpretation is ampliative (it goes beyond "dictionary" meanings) and inferential (it is a fallible, actively constructed, although not usually consciously constructed, product of "theorising" by interpreters, who take into account and give varying weight to the data of memory, experience, words spoken, social and cultural convention, and the way they feel at the time).

As Habermas argues, we need to go beyond language act theory and a generalized "universal pragmatics" to an empirical pragmatics if we are to deal with the typically "poorly formed" texts of everyday talk. Language act theory is somewhat "atomistic." It provides classifications for well-formed (that is, grammatically explicit and complete) sentences and parts of sentences, but we typically encounter indexical, fragmentary, interactive, and complex linguistic forms: conversations, lectures, speeches, stories, lessons,

arguments, and so on. Systemic linguistics (and other action-oriented linguistic theories) can deal with the fragmented, elliptical, and interactively complex aspects of language much more adequately than language act theory (for example, Halliday and Hasan, 1985). In particular, it can deal with larger and longer linguistic "episodes," in which language takes on meaning in the context of socially recognized communicative structures, signalled in this theory by the use of the term "genre." Broadly speaking, genres are expected textual structures which reflect conventional ways production of talk (or writing) accomplishes a socially recognized task, such as getting married, teaching a lesson, or making a telephone call. Meaning is not simply an atomistic inference from a single utterance but the meaning of that utterance as a particular functional step in a socially recognized purposive talk sequence, through which the actions of different categories of social person, such as teachers, and learners, is coordinated and brought to a purposed, sometimes contested, conclusion (see Young, 1990, 1992; Masschelein, 1991; Miedema, 1995).

(b) Inquiry. The crucial issue in theories of inquiry, since the linguistic turn in social theory, is the fact that it is a cooperative, dialogic activity. Classically, epistemological questions have been at the heart of theories of inquiry. Epistemological questions concern the way the truth of propositions are warranted. They deal with methodological questions. A typical epistemological question is: "How can I be sure this statement is true?" However, since the linguistic turn, it has been widely recognised that there is a cognate, possibly logically prior, set of questions. These concern the way a community can come to inquire, and the way the practices of an inquiring community can condition the questions which are recognized within it and the answers that are accepted in that community. A typical communicative question is: "How does a community of inquiry come to an agreement that some methodology for deciding the truth or otherwise of a statement is valid?" This move does not exclude epistemological questions, but it can make their answers relative to a social, communicative process.

Because the focus has shifted from the individual looking at questions of consciousness, perception, and method, to communities understanding themselves as collectivities of inquirers, their culture, its field of focus, and the formation and change of inquiry practices, this change of perspective has been described as a shift from the "philosophy of consciousness" and "first philosophy" (that is, epistemology) to "communicative philosophy" and "postmetaphysical" philosophy. For the most part, school curricula are still dominated by a metaphysical and epistemological emphasis.

However, as argued earlier, the paradox of education is that it is not possible to learn something new without first developing a schema in which it can make sense as something intelligibly new. The paradox of schooling

as an apprenticeship to participation in a rational (modernist) culture is that in order to creatively participate in adaptive change, it is first necessary to be indoctrinated into a pre-existing culture in which the problem requiring an adaptive response is defined and in a sense created. It is only when we turn to the theory of pedagogical dialogue or conversation that we can begin to see a way of passing beyond this paradox.

(c) Conversation. Conversation, of which category classroom talk is but one example, mediates collective validity judgements, carries forward social tasks, negotiates meanings, and taken structurally as a set of practices, comprises at the same times the constraints on these processes. The crucial question for a theory of conversation is the question of newness of meanings. The bringing into existence of new meanings, albeit adaptively valid ones, is a necessary feature of inquiry, and, unproblematically at the biographical level, of schooling. It is a process essential to any account of what happens in classrooms. Analysis of classroom talk is only as good as the questions we ask of it. If these are educational questions, we will be concerned with the extent to which the meanings new to each student are also adaptive. Of course, here "adaptive" cannot mean merely adaptive to perennial problems of a student's stage of life, because the culture at large is also changing. And that not only opens up the question of the extent to which the content of the curriculum is "up to date" but the extent to which the manner in which *any* content is learned *enables* the student to join in the wider adaptive process of the species. For if the linguistic turn in social theory means anything it means that we utter our own becoming through the ontogenetic (reality-creating) character of the conversation of inquiry. Arguments matter, validity judgements matter. They are not just "academic," but definitive and constitutive of our (ephemeral) moving cultural and personal reality/identity (Young, 1996a).

It is not really the production of new meaning itself that is problematic. If meaning is pragmatically conceived as a product of inferences that take contextual data into account as well as the form of utterances, and we concede that circumstances are constantly changing, socially and autobiographically, it is clear that we can never put our interpretive foot into the same river of meaning twice. The river of life will have moved on. Uttering the same words next week will not mean the same as uttering them now. The theoretical question concerns not how new meaning is possible, but how it is possible to make sense of meaning when it is always on the move and deferred (Derrida), and how, *pace* Derrida, we can make better meanings.

But Habermas's Kohlbergian theory faces an additional hurdle, albeit one common to all dispositional or capacity-based theories—the gap between competence and performance. In a theory that acknowledges the emergence

óf new meanings, this gap takes on a temporal and ontogenetic as well as a motivational dimension. As Habermas points out, (1991b:187–88) competencies or dispositions can only be recognized in performances. And factors which determine performance are difficult to isolate from factors determining competence. Very roughly, it is useful to think of moral judgement as an indicator of competence and moral action as, relative to that competence, a matter of performance. The motivational anchoring of postconventional moral judgement in the personality is necessary if such judgements are to be effective in practice, but inhibiting factors can block this connection. Foremost among these is an incapacity to distinguish between strategic and communicative action. The general theory of defence mechanisms involves a process in which "barriers to communication are set up in the psyche, separating the [unconscious] strategic aspect of action [which serves the gratification of unconscious desires] from the manifest intentional action that aims at reaching understanding" (Habermas 1991b: 188). This may result in distorted self-talk as well as systematically distorted interpersonal communication.

As I have shown in analyses of a large corpus of classroom communication, just such a systematically distorted communication process characterises the overwhelming majority of classrooms (Young, 1992). When epistemological curricula are coupled with communication which is not open to dialogic emergence of meanings (that is, instructionally perlocutionary or strategic communication, often enough in the guise of illocutionary talk), students are denied developmentally necessary educative experience.

EDUCATION'S HERMENEUTIC AUTONOMY

The three educationally relevant insights in Habermas's work can be related to three general "existential problems" of interpretation and meaning (sometimes called hermeneutic aporiae) (Gallagher, 1992; Young, 1996b).

If a possibility of human achievement of the good life exists, it is "stretched out along the vertical axis of world-history" (Habermas, 1972: 253). But human life, good or not, is mediated by meanings and its attainment over time, as Habermas points out in his discussion of the world-disclosing function of signs (Habermas, 1992: 106) (contra Peirce), requires "*new* vocabulary . . . and an interplay between . . . linguistic world-constitution and inner-worldly problem-solving" in inquiry and universalising learning processes (Habermas, 1992: 106). So, as stated above, meaning is always in movement. The hermeneutic problem and the historical problem of emancipation are not that of the transmission of meaning but that of

participation in shaping its flow. We speak into new situations and the interpretive process always inferentially exceeds sedimented semantic meanings because it takes the changed circumstances of utterance of old words into account. But the perennial circumstance of schooling is that the "old" are teaching the young. However, each new generation carries with it some form of awareness of succession (see Arendt, 1958). For this reason, the curriculum is inevitably open in principle. This has been called the aporia of reproduction of meaning, but it is more appropriately labelled the aporia of difference or newness.

The response of power to this Heraclitean character of meaning is to try to employ authority (rather than reason) in distortion of communication through strategic management of communicative opportunity. This has been called the hermeneutic aporia of authority (Gallagher, 1992). Elsewhere, I have called it, the aporia of desire and the education of eros (1996b). In modern education systems, strategic or "prescribed" curricula (whether with traditional content or propaganda of the new orthodoxies of social justice) often masquerade as opportunities for personal decision and choice while creating further dependence by allowing only "options in prestructured dimensions . . ." of choice (Habermas, 1992: 196). Reason, in the sense of the outcome of autonomous communicative action which produces argument and refers to the evidence of experience, is the alternative to both traditional means of reproduction of meaning and to manufactured appearances of reason through "scripted" adoption from among the repertoire of "reasons" of power and money, even if the power concerned is only the product of a misunderstanding of the appropriate scope of the "emancipatory authority" (Giroux, 1985) of the teacher. Freire remains one of the best sources for an account of the kind of restraint that critical pedagogy requires (Freire and Shor, 1987).

The process of accepting or refining validity claims and the developed capacity to engage in discourse is a specific form of the dialogic or conversational potential—the hermeneutic aporia of dialectic or conversation. In the dialectal form of the learning mechanism of collective reflective abstraction, dialogue has a stage-transcending learning potential (that is, it is historically ontogenetic) because of its counterfactual commitment to the general validity of claims and commitments. This is sometimes undermined by an incomplete narcissistic resolution of the transition to stage 5 of the cognitive and moral development of adolescent students due to a relativising and totalising critique in the name of social justice, but in current circumstances the greater danger is clearly the economic instrumentalisation of the communicative dimension of the pedagogical process by mechanistic formulae defining predecided notions of "competency-based learning" and the like, as much as the instrumentalisation of the curriculum content itself.

However, it is inappropriate as has been done above to call these three dimensions of autonomy *aporiae*, since they are not gaps in theory but basic and perennial existential problems of the condition of a species that can constitute itself by recognizing the concrete immanence of "an ideal tension . . . imported into social reality itself, which comes to conscious awareness in participating subjects as a force that explodes the limits of the given context and transcends all merely provincial standards" (Habermas, 1993: 165), leading in contemporary social democracies to the possibility of reflexive critical learning.

The three existential problem areas are core sites for critique, resistance, and ideology and each relates to overlapping bodies of theorising within the overall process of educational theorising. Problems of history, reproduction, and shift of meanings relate primarily to curriculum theory; problems of reason versus authority relate to the study of structures of education roles such as teaching, and the biographical stages of student development in the context of the school, and problem of conversation, dialogue or dialectic to the theory of pedagogy as the facilitation of ontogenetic rather than merely legal *Mündigkeit*. Education, as contrasted with training, consists in forms of interaction and communicative action that allow that ideal tension referred to above to do its work—to allow hope for new and better meaning/understanding to flourish by assisting the formation of participants in the ontogenetic (biographical/societal) process.

Perhaps not surprisingly, educational thought has suffered a degree of marginalisation in the contemporary academy, whether because it has sometimes patently failed to take up its world-disclosing responsibility due to a fashionable postmodern "radicalism," or more often because when it has actually achieved some critical success, it has so clearly threatened the futile yet ever-renewed conservative attempt to halt the movement of meaning in the direction of greater emancipation.

Sometimes, educational thought has been colonised by either a potentially bureaucratic, sometimes leftist, form of cultural control which attempts to destroy old meanings and inculcate supposedly progressive new ones, but more frequently, particularly in societies of European origin, it has been colonised by the market, in an attempt to create a free exchange of otherwise incommensurate values and to employ that mechanism in place of reason.

But education's current role on the vertical axis of world history is to support the radicalisation of democratic processes within social democracies and to increase the numbers of ego autonomous citizens communicatively involved in reason.

The potential paradox of a fully enlightened society is that it could not simply impose its enlightenment on the coming generation. But in real, historical societies, this paradox cannot arise, because present institutions

and roles are the starting point of an enlightenment process that always proceeds immanently, both cognitively and in terms of social relationships of learning. Learners will only transcend the present individual and societal learning level if there is room, within and among any necessarily present-oriented or backward-looking components of curriculum, for them to engage with the paradoxical immanence of the transcendent possibilities of communicative action in their classrooms.

<div align="right">ROBERT YOUNG</div>

DEPARTMENT OF SOCIAL AND POLITICAL STUDIES
UNIVERSITY OF SYDNEY
JUNE 1997

NOTES

1. Setting aside the special problems which may arise from the dependent relationship of children with respect to adults, and focusing solely on the issue of critique, it appears to be Habermas's view that "one might point out today that in advanced capitalism changing the structure of the general system of education [*Bildungssystem*] might possibly be more important for the organisation of enlightenment than the ineffectual training of cadres or the building of impotent parties" (Habermas, 1974: 31–32). That is, educational processes can be a signifi-cant source of historical learning and practical social development, but, of course, there are acknowledged problems with the employment of the psychoanalytic model outside its appropriate context. It nevertheless serves as an indicator of a possible methodology.

REFERENCES

Adorno, T. *Erziehung zur Mündigkeit* (Education for Mature Articulateness). Suhrkamp: Frankfurt, 1970.
Arendt, H. *The Human Condition*. Chicago: University of Chicago Press, 1958.
Austin, J. *How to Do Things with Words*. Oxford: The Clarendon Press, 1972.
Biesta, G. "Education as Practical Intersubjectivity: Towards a Critical-Pragmatic Understanding of Education." *Educational Theory* 44, no. 3 (1994): 121–30.
Brumlik, M. "Verstehen oder kolonisieren—Überlegungen zu einem aktuellen Thema," pp. 31–62 in S. Müller and H. U. Otto, eds. *Verstehen oder kolonisieren*. Bonn: DGE, 1985.
Cherryholmes, C. "An Exploration of Meaning and the Dialogue between Textbook and Teaching." *Journal of Curriculum Studies* 20, no. 1 (1988): 1–21.

Cronin, C. "Translator's Introduction," in Habermas, J., 1993, pp. xi–xxi.

Davidson, D. *Inquiries into Truth and Interpretation*. Oxford: The Clarendon Press, 1984.

Derrida, J. *Of Grammatology*. Baltimore: Johns Hopkins University Press, 1976.

Dewey, J. *Democracy and Education*. New York: The Free Press, 1916.

Ellsworth, E. "Why Doesn't This Feel Empowering? Working through the Repressive Myths of Critical Pedagogy." *Harvard Education Review* 59, no. 3 (1989): 241–49.

Foucault, M. *Power/Knowledge*. Brighton: Harvester, 1980.

Freire, P and Shor, I. *A Pedagogy for Liberation*. London: Macmillan, 1987.

Gallagher, S. *Hermeneutics and Education*. New York: State University of New York Press, 1992.

Giroux, H. "Teachers as Transformative Intellectuals." *Social Education*, May, 1985: 376–79.

Habermas, J. "Pädagogischer "Optimismus" vor Gericht einer pessimistischen Anthropologie." *Neue Sammlung* 1 (1961): 251–78.

———. *Knowledge and Human Interests*. London: Heinemann Educational Books, 1972.

———. *Theory and Practice*. London: Heinemann Educational Books, 1974.

———. *Communication and the Evolution of Society*. London: Heinemann Educational Books, 1979.

———. *The Theory of Communicative Action*. Vols. 1 & 2. London and Cambridge: Heinemann, and Polity Press, 1982, 1984.

———. *The Philosophical Discourse of Modernity*. Cambridge: Polity Press, 1987a.

———. "Die Idee der Universität: Lernprozesse." In Habermas, J. *Eine Art Neue Schadensabwicklung*. Frankfurt: Suhrkamp, 1987b.

———. *The Structural Transformation of the Public Sphere*. Cambridge, Mass.: MIT Press, 1991a.

———. *Moral Consciousness and Communicative Action*. Cambridge, Mass.: MIT Press, 1991b.

———. "Introduction." 1991b, pp. vii–xii.

———. *Postmetaphysical Thinking*. Cambridge, Mass.: MIT Press, 1992.

———. *Justification and Application*. Cambridge, Mass.: MIT Press, 1993.

———. *Between Facts and Norms*. Cambridge: Polity Press, 1996.

Halliday, M and Hasan, R. *Language, Context and Text*. Geelong: Deakin University Press, 1985.

Masschelein, J. *Kommunikatives Handeln und pädagogisches Handeln*. Weinheim: Deutscher Studien Verlag, 1991.

Miedema, S. "The Relevance for Pedagogy of Habermas's Theory of Communicative Action." *Interchange* 25, no. 2 (1994).

Miller, M. "Learning How to Contradict and still Pursue a Common End: The Ontogenesis of Moral Argumentation." In J. Cook-Gumperz, W. Corsaro and J. Streeck, eds. *Children's Worlds and Children's Language*. Bethin: Mouton de Gruyter, 1986; and *Kollektive Lernprozesse*, Frankfurt: Suhrkamp, 1986.

McCarthy, T. *The Critical Theory of Jürgen Habermas*. London: Hutchison, 1978.

Oelkers, J. "Pädagogische Anmerkungen zu Habermas Theorie kommunikativen Handelns." *Zeitschrift für Pädagogik* 30, no. 2 (1983): 271–80.

Peters, R. "Reason and Habit: The Paradox of Moral Education." In W. Niblett, ed. *Moral Education in a Changing Society.* London: Faber and Faber, 1963.

Shalin, D. "Critical Theory and the Pragmatist Challenge." *American Journal of Sociology* 98, no. 2 (1992): 237–79.

Spaemann, R. "Emanzipation: ein Bildungziel?" *Merkur* 29 (320), 1975: 11–24.

Young, R. "Habermas's Ontology of Learning: Reconstructing Dewey." *Educational Theory* 40, no. 4 (1990): 471–82.

————. *Critical Theory and Classroom Talk.* Philadelphia: Multilingual Matters, 1992.

————. *Intercultural Communication: Pragmatics, Genealogy, Deconstruction.* Philadelphia: Multilingual Matters. 1996a.

————. "Decolonising Education: The Scope of Educational Thought." *Studies in Philosophy and Education* 15, no. 4 (1996b): 309–22.

PART FIVE

THE FUTURE OF
CRITICAL THEORY

28

James L. Marsh

What's Critical about Critical Theory?

I'm grateful to the Society for Phenomenology and Existential Philosophy (SPEP) for sponsoring a session on my book, *Critique, Action, and Liberation* (CAL) at its annual meeting in October 1995, and I am also grateful to Martin Matuštík for his insightful, challenging commentary on my book. My procedure in this response will be to present a few introductory remarks, which I am doing now, and then reflect on the status of critical theory, modern and postmodern. In so doing, I will be reflecting not only on where critical theory is today, as present in my book and Martin's commentary, but on where it is going and where it should go. On the future as well as the present and recent past of critical theory.[1]

In the last part I will argue for a far more radical critique of late capitalism than seems to be present in Habermasian critical theory, for a more adequate appropriation of Marx, earlier Western Marxism and critical theory, and postmodernism, and for the necessity of an interpretation and critique of neo-imperialism if critical theory is to avoid being Eurocentric and insufficiently open to the excluded, oppressed, marginalized other. In these remarks I will be commenting on ideas and themes present for the most part in *Critique, Action, and Liberation* (CAL) and will be discussing my implicit and explicit disagreement with Habermas in that book, which was present but without the rhetorical edge present in my critique of post modernism, after capitalism the major critical target of CAL. In this response more of a rhetorical edge is present in my critique of Habermas. So forewarned is forearmed.

By way of introduction, I wish to say that I am in sympathy with and am following up on the suggestion of Matuštík's that in the 1990s there are alliances and affinities between and among various groups in modern and postmodern theory on the issue of radical versus neo-liberal democracy. I will also be raising a question about the status of Habermasian critical theory today. Is it sufficiently radical, critical, and devoted to social transformation? In such remarks I shall be implicitly and explicitly self-critical, since I have

been an enthusiastic supporter of Habermasian critical theory for many years, as well as mention ways in which CAL is an initial, partial attempt to respond to such criticisms and self-criticisms. In so doing, I do not intend any disrespect to Habermas; his contribution and my debt to him is enormous. But more, I think, needs to be done.

Now I would like to turn to the second and main part of my response concerning the present and future of critical theory, modernist and postmodernist, and in doing so will be drawing on and following up positively on some of Matuštík's suggestions. First, I should like to suggest that the modernist-postmodernist debate is or should be over, for at least four reasons. First, it seems to me that we have learned what we can from it. Second, modernist rationality, "critical modernism" as I have called it, if it has not won the day, at least has plausibly and adequately answered the main postmodern criticisms of it. Here I accept the letter and spirit of Matuštík's remarks that a "critical modernist is not implicated by postmodern critiques of instrumental modernity," that "a critical theorist can offer a differentiated account of communicative reason, fallibilistic normativity, egalitarian praxis, ethics of freedom and justice, and a post-1989 project of democratic socialism." Thank you, Martin Matuštík.

My third reason for saying that the modernism-postmodernism debate is over is that modernism in the latest phase of the debate has mounted a nuanced, sophisticated critique of postmodernism that has yet to receive much significant response. That debate has gone through three phases. We had, first, the modernist thesis present in strong versions of rationality in thinkers like Kant, Hegel, and Husserl. Next, the postmodernist antithesis in thinkers like the late Heidegger, Derrida, Foucault, and Rorty; and, starting with Habermas's *The Philosophical Discourse of Modernity* in the mid-1980s, a series of at least fifteen to twenty books that function as modernist rebuttal. In addition to my four books, we note books by authors such as Bernstein, Honneth, Fraser, McCarthy (2), Lash and Urry, Harvey, Kellner (2), Jameson, and Christopher Norris (3). Except for Hoy's response to McCarthy in *Critical Theory* and Caputo's response to me in *Modernity and Its Discontents*, to my knowledge there has been little or no postmodernist response to this critique. Hoy's and Caputo's efforts are insightful and challenging, but certainly do not constitute a response that is proportional to the modernist rebuttal. So far, then, it stands largely unanswered.[2]

Now my own version of that rebuttal articulated in CAL, which draws on much of the above work, has four levels, moving from abstract to concrete: the charges of self-referential inconsistency in the postmodernist critique of Western, modern reason; descriptive inadequacy in that the postmodern account of reason is de-differentiated, reductionistic, and misses the positive, dialogical forms of reason as we experience them; hermeneutical inadequacy

in the account of modernist rationality as it has developed historically, again reductionistic, de-differentiated, and identifying modern rationality with its pathological forms; and lack of ethical-political cogency. The last level has four sub-levels: lack of normative grounds for criticizing and transcending Western rationality and its pomps, no account of contradictions within Western institutions providing positive leverage points of transcendence, little or no indication of social groups or movements that would be carriers of such transcendence, and finally the ideological character of post modernism. It functions as a form of "French ideology," with German and American offshoots, reflecting, legitimating, and covering up late capitalism in its latest phase of flexible accumulation.[3]

Rather than rehearsing these debates and issues, therefore, I prefer to reflect on my fourth reason for saying that the modernism-postmodernism debate is over, namely that the reason or a reason or the post-reason argued for needs to get down to the job of social transformation. Reformulating Marx, who says that "philosophers have only interpreted the world in various ways; the point is to change it," we could say that philosophers have too long been trying to get clear about the rationality debate; the task is to use rationality to transform the world.[4]

Here I implicate myself in my critique and intend to do so throughout this discussion. In books such as *Modernity and Its Discontents* (MAD), co-authored by me, Westphal, and Caputo and contributed to by Mark Yount and Martin DeNys, and *Critical Theory* by McCarthy and Hoy, the impression can easily be given that all critical theory is about is the rationality debate, or at least, that that is its main task. To that extent, both postmodernist and modernist critical theory run the risk of being idealistic in a bad sense, that is, they give insufficient attention and energy to the task of interpreting, criticizing, and overcoming late capitalism in its racist, sexist, and classist aspects.[5]

I do not wish to be misunderstood here. Works such as the above are valid and significant. I do not back away one inch from anything I said in MAD, and I think that *Critical Theory* is a very good book from which I learned much. I wish to associate myself with the great work of articulating and defending modernist, communicative rationality undertaken by Habermas and continued in such people as McCarthy, Honneth, Baynes, Bohman, Ingram, Trey, Rasmussen, Matuštík, and others. That work becomes an essential, necessary condition for the radical social transformation that now seems necessary.

In the spirit of Marx's *German Ideology*, I have in CAL criticized postmodernism as being a form of French ideology, reflecting and legitimating the structures of late capitalism. To the extent that Habermas's critical theory remains primarily or dominantly, in its content, emphasis, and

implications, a theory of rationality and to the extent that it is content to become resigned before or accept the fact and dominance of a late capitalism that is becoming increasingly virulent nationally and internationally, it runs the risk of becoming a form of modernist ideology; we might say, referring to Marx again, that it can become a form of German rather than French ideology that blocks and inhibits the way toward social transformation.[6]

It is hard to say such things without sounding harsh and disrespectful and ungrateful; yet they must be said. Truth is more important than friendship here. Let me develop the point a bit. As I read Habermas, what his theory seems to amount to politically at best is that we are to resign ourselves to the fact of capitalism and to fight excessive colonization; his position is a form of welfare statism. The best we can do, Habermas seems to say, is a more or less democratic welfare state in which capitalist ownership and control of the means of production remains intact and the colonization of the lifeworld by system is minimized. Workplace democracy is rejected in favor of the public sphere as the locus of participatory democracy, even though Habermas expresses some reservations about capitalist labor markets and cultural class privilege. These claims are in tension with Habermas's claims about the contradiction between accumulation and legitimation in late capitalism and the injustice of the welfare state, based upon a pseudo-compromise between labor and capital. The critique of capitalism at best is understated and at worst counsels resignation.[7]

I find such a stance mystifying. Rather than a communicative action leading into radical social transformation, which I have argued for in CAL, Habermas cashes out communicative action very conservatively, and it is hard to say why. Is the reason the failure of Eastern European state socialism? But this misses the possibility of democratic socialism, which I have also argued for in CAL. Is it that bureaucratic and economic systems are seen as inevitable, irreversible, and indeed progressive in many respects if they remain within their own spheres? But this claim misses the possibility of representational, mediated, market socialism, which I have argued for in CAL. Is it that the welfare state, at least in Western Europe, is relatively benign and seems to be solving its problems? But this misses the contradiction between accumulation and legitimation pointed out by Habermas, the worsening condition of Western Europe after the fall of Berlin in 1989 and the increasing transnationalization of capital leading to a race to the bottom of wages in all Western capitalist countries, as capital forces workers in the North to compete against those in the South; and the claim also misses the damage wrought by the North on the South, a point to which I will return later.[8]

Following a hint given in *Legitimation Crisis*, we could say that the legitimation crisis could be resolved in two ways. We could repress the need

for democratic legitimation repressively, terroristically, and violently in moving toward a fascism or neo-fascism (and who can doubt which direction we are moving in in the U.S.), or we could resolve the legitimation crisis by removing the class domination of capitalism and moving toward full economic, political, and social democracy. It is this move that I argued for in CAL. If I am right, Habermas's own theory requires radical social transformation as its proper extension and completion.[9]

To state the same issue differently, has Habermas's critique of postmodernism and defense of modernism inclined him to understate the pathology of a bad capitalist present, forgetting or not following through on the claim that modernity and capitalist modernity are contradictory, good aspects like communicative rationality in tension with bad aspects like colonization? Here, as I will suggest and develop later, Marx is a good corrective; his recognition of the good aspects of capitalist modernity, its productivity, for example, does not cause him to minimize or deny its bad aspects, its exploitativeness, for example, or to back away from revolutionary transformation as the proper solution to the contradictions of capitalist modernity. It seems to me that Marx, against Habermas, is still correct. Habermas, if he were to remain faithful to his own theory, should be a socialist.

It is for the above reasons that I think critical theory needs far more of a positive appropriation of Marx, earlier Western Marxism, and critical theory, and of postmodernism than occurs in Habermas. If capitalism is deeply pathological and unjust, as I think it is and as I argued in CAL, then we need the resources of what still remains the deepest and most comprehensive critique of capitalist political economy, that which occurs in the late Marx in the pages of the *Grundrisse*, *Capital*, and *The Theories of Surplus Value*, seven volumes that are more relevant than ever. For these reasons I draw in CAL on Marx's theory of exploited labor in the workplace, his theory of tyranny, in which the economy and money impinge on non-economic aspects of the lifeworld in a way that is absurd, his theory of a marginalized industrial reserve army, his theory of value and surplus value, and his account of a substantive socialism. Capitalist pathology is not just colonization of lifeworld by system, although that is certainly an important part of such pathology, but includes exploitation, tyranny, and marginalization as well.[10]

Habermasian critical theory, we could say, to too great an extent, is a critical theory without Marx and is thus a critical theory that is insufficiently critical. This claim requires nuance and qualification, of course, and is made in spite of the fact that Habermas refers to himself as "the last Marxist." But it remains true that his appropriation and positive use of Marx, although present somewhat, is insufficient. If capitalism is deeply unjust and

pathological in a way that is now world-wide, then we need the resources of its first and still foremost critic. Rather than being irrelevant as some even on the left contend, Marx is more relevant than ever.[11]

The appropriation has to be nuanced and selective and critical, of course, and blended with other post-Marxist insights and methodologies, including those of Habermas himself. What I did in CAL was to blend a radical Marxian hermeneutic of late capitalism with a communicative ethic and morality, which is expanded into a substantive morality and theory of justice. If I am Habermasian, as some have said even though I am speaking in my own voice, then it is a Habermasianism of the left, a left-wing Habermasianism.

Here, drawing on Matuštík's suggestion, we receive aid and comfort from some of our postmodern friends, for in a recent book, *Specters of Marx*, Jacques Derrida has spoken of the heritage of Marx. "Whether they wish it or know it or not, all men and women, all over the earth, are today to a certain extent the heirs of Marx and Marxism."[12] Elsewhere in the same book Derrida says that "there is no future without Marx."[13] We in critical theory, to the extent that we are tempted to minimize or play down or ignore Marx, need to heed such words.

We could put the above point in still another way. Ernst Bloch talks about the coexistence within Marxism of a rational scientific, "cool" stream and a radical, prophetic, "hot" stream. Habermas, we could say, in an invaluable way has developed the rational, scientific side to a preeminent degree; he has put critical theory on new, much more solid rational and moral foundations. What needs to be reappropriated and linked to this new foundation is the radical, prophetic side, drawing on Derrida, the spirit of questioning rooted in a sense of justice and in an outrage over the devastation wrought upon the victims of capitalist injustice. It is this that I have done, or tried to do or begun to do in CAL, in the ways already mentioned.[14]

Habermasian critical theory has so developed the rational, "scientific" side of Marxism that it, Habermasian critical theory, is now a part of mainstream academic discourse; no major graduate program in the U.S. can now afford to be without at least one critical theorist. Such acceptance is an achievement that should not be gainsaid, but it is an ambiguous achievement. Critical theory runs the risk and suffers the temptation of being tamed, "academicized," "bourgeoisified." Is the price of such acceptance the giving up or softening of the critique of capitalism? Are we being asked and being pressured to be "scientific" and "rational" while giving up the "unreasonable" and "utopian" critiques not only of Marx himself but of Gramsci, Bloch, Marcuse, and Adorno? Is the academic establishment

breathing a collective sigh of relief as critical theory is finally becoming "responsible" and "sober" and gives up on that wild man Marx? The specter of Marx is, or seems to be, thoroughly banished, and the academic establishment can get on with business as usual while the capitalist wasteland grows.

Not only do we need a more adequate and positive appropriation of Marx, but of earlier texts in Western Marxism and postmodernism as well, especially those texts that serve the needs of radical, critical, utopian social theory and that shine a penetrating light on the depths of late capitalist pathology. Accordingly, what I did in CAL was to use in a positive way Derrida's notion of deconstruction and *differance*, Foucault's account of the disciplinary society, Baudrillard's interpretation of media, and Deleuze-Guattari's postmodern synthesis of Marx and Freud, as well as Marcuse's critique of one-dimensionality and notion of erotic reason, Bloch's conception of process and utopia, the late Sartre's notions of the fused group and singular individual, Gramsci's notion of hegemony, "people," and the Modern Prince, and Adorno's and Benjamin's accounts of the consciousness industry in relation to late capitalism. I am more and more impressed by how positively revealing and insightful such texts are, and I say this without conceding one iota of my critique of postmodernism on the rationality issue. Has Habermas, have we, have I been too dismissive of postmodernism on such issues? In articulating and defending rationality as we must, have we critical theorists missed positive sources of insight and truth in postmodern texts?[15]

Now all or nearly all of what I have said so far is what is present implicitly or explicitly in the pages of CAL. What I wish to discuss now is a new question, which I am currently working on, that of neo-imperialism. We desperately need a critical theory of neo-imperialism. Neo-imperialism is simply capitalism transplanted abroad in search of markets, raw materials, cheap or cheaper labor, indulgent, supportive governments, and lower taxes. The New World Order (NWO) is a neo-imperial system with linked, internally related aspects: multinational corporations, U.S. military might as an enforcer of last resort to insure that what we say goes, international organizations like the International Monetary Fund (IMF) and World Bank functioning to keep the Third World in thrall to First World capital, corrupt local monarchies and oligarchies like those currently running Guatemala and Colombia kept in power by and supportive of U.S. aims against the interests of their own people, rich landowning and capitalist classes in the Third World that exploit and oppress the poor, and police and military officers trained by the U.S. in the latest techniques of repression, terror, and torture in places like Fort Benning, Georgia's School of the Americas, nicknamed

by its victims in Central and Latin America "The School of Assassins." Many of the officers participating in the Haiti coup and subsequent repressive rule, the assassination of Romero in El Salvador, and the El Mezote massacre in El Salvador are star pupils and graduates of this school.[16]

The basic point or goal of this imperial structure, we could say, using and drawing on Chomsky, is the Fifth Freedom: the right of U.S., Japanese, and European corporations to rob, kill, repress, and exploit indigenous peoples with impunity. Other freedoms, as our sponsoring intervention after intervention against democratic governments in Guatemala (1954), the Dominican Republic (1966), Chile (1973), Nicaragua (1980s), and Haiti (1991) indicates, we are quite ready to jettison when they do not serve or when they endanger the Fifth Freedom. Indeed Chomsky and Herman in another work have shown an empirical correlation between increasing terror and denial of democracy in Third World countries and increasing U.S. aid. As terror in Colombia rapidly increased in the last few years, U.S. aid shot up dramatically.[17]

Dussel, using Marx, states that the goal of the NWO is the international transfer from South to North of surplus value, labor time for which labor is not paid. The goal of capitalism in general as private ownership and control of the means of production is to produce and extract such surplus value. Hundreds of billions of dollars per year are transferred from Third World to First World countries, while the poor majorities in those countries starve. Such transfers occur through such mechanisms as debt payments to U.S. banks, World Bank, and the IMF.[18]

What about, someone might ask in objection, the supposed "economic miracles" that have occurred in Central and Latin America in the last fifteen to twenty years? Do not the people in those countries benefit? The general answer to this objection is that the top one or two percent of the wealthy in these countries benefit, but that the fortunes of the poor majorities in those countries have not only not been helped but have worsened. During the 1980s U.S. investments in Latin America were heavy; the result was 230 billion transferred to the U.S. through debt service, dividends, and profits. The results for most Latin Americans have been disastrous. Over half the population, 222 million people, now live in poverty, 70 million more than in 1980.[19]

On this issue, Derrida offers surprising support. Let me quote him.

A "new international" is being sought through these crises of international law; it already denounces the limits of a discourse on human rights that will remain inadequate, sometimes hypocritical, and in any case formalistic and inconsistent with itself as long as the law of the market, the "foreign debt", the inequality of

techno-scientific, military, and economic development maintain an effective inequality as monstrous as that which prevails today, to a greater extent than ever in the history of humanity. For it must be cried out, at a time some have the audacity to neo-evangelize in the name of the ideal of a liberal democracy that has finally realized itself as the ideal of human history: never have violence, inequality, exclusion, famine, and thus economic oppression affected as many human beings in the history of the earth and of humanity. Instead of singing the advent of the ideal democracy and of the capitalist market in the euphoria of the end of history, instead of celebrating the "end of ideologies" and the end of the great emancipatory discourses, let us never neglect this obvious macroscopic fact, made up of innumerable singular sites of suffering: no degree of progress allows one to ignore that never before, in absolute figures, never have so many men, women, and children been subjugated, starved, or exterminated on the earth.[20]

These, I think, are some of the most important sentences written in the last ten to fifteen years in philosophy and social theory, and they should cause grave discomfort to a merely reformist, liberal democratic, formalist critical theory. Confirming figures that I have seen indicate that over 20 million people die per year as direct or indirect victims of the empire through starvation, torture, terror, war, hunger, homelessness, and disease.[21]

Derrida goes on to develop and spell out this claim more specifically and evidentially by listing ten different instances of capitalist induced suffering and injustice: massive unemployment; exclusion of the homeless from participation in the government of the country, and exclusion of immigrants; economic war without ceasing among European countries themselves and among them, the U.S. and Japan; contradiction between actual protectionism and the proclamation of a free market, leaving workers in all of those countries very vulnerable to capital flight and various kinds of exploitation; Third World debt to the First World, a debt that starves and otherwise grinds down a high percentage of suffering humanity in Third World nations; an arms trade that is first in the world, even over drugs; the spread of atomic armaments that does not fall under state or market control; inter-ethnic wars in places like Bosnia, Somalia, Rwanda; phantom states of mafia and drug consortiums operative nationally and internationally; an excessively formal international law that does not contain or inhibit international predators and is used by powerful national states to justify illegitimate interventions.[22]

Now what does Habermas have to say about all of this? Unfortunately very little, except to support the empire occasionally in some of its worst aspects and interventions. One of Habermas's noteworthy acts was to support the Gulf War; one of the main reasons for this support seemed to be that it was a U.N. action. This justification misses, I think, the fact that the U.S. bribed or threatened almost every member of the Security Council to

go along with its aims. The U.N. resolution to intervene was almost a perfect example of strategic action, not communicative action; and it occurred within an imperial structure that is asymmetrical in involving enormous differences of economic, political, and social power between North and South, regular use of manipulation, terror, violence, and military interventions, subversion of democracy, and so on. The NWO as imperial structure is a regular, day-in and day-out violation of communicative action and morality. Yet Habermasian critical theory has had little or nothing to say so far about this state of affairs, and Derrida has and in so doing criticizes in a telling way the limits of a merely formal concern for human rights and democracy that leaves unthematized enormous inequities in political, economic, and social power rendering communicative action null and void or ineffective. Habermasian rationality, I think, needs Derridean prophecy and critique. Of course, Derrida, as McCarthy, Bernstein, and others remind us, needs Habermasian rationality. Communicative rationality and prophetic critique go together or not at all, and taken most adequately together can be used to develop a critique of neo-imperialism.[23]

It is not an adequate defense of Habermas to say that this stance on the Gulf War is just a personal, political position that does not affect the validity of his theoretical stance. On the contrary, using Derridean resources again, I would argue that something apparently external, accidental, supplemental ("the logic of the supplement"), reveals something deeply problematic about the theory itself. Indeed, I would argue that Habermasian critical theory, unless it begins to undertake an interpretation and critique of neo-imperialism, becomes in fact and reality, even if in principle and intention it is not so, Eurocentric. Indeed Enrique Dussel has argued precisely this point in a recent book. In excluding the South or Third World from his account of modernity, Habermas, according to Dussel, gives in to a triumphalistic myth of modernity that is factually Eurocentric in that it ignores the role of the Third World in contributing to the development of Europe in the phase of primitive accumulation, during which transfer of precious metals and slaves from South to North played an enormous role in the stage of imperialism from 1850 to 1950, in which firms from the North moved abroad to sell their products in Third World countries, and in the late capitalist neo-imperialism which we now have, in which multinational corporations and banks from the North strike down roots in the Third World, withdraw hundreds of billions yearly, and leave the poor majorities in those countries worse off than they were before. Habermasian critical theory, then, to the extent that it leaves the Third World out of its hermeneutical account of modernity and refuses to criticize neo-imperialism ethically, becomes factually Eurocentric. A contradiction emerges between a theory that is in principle and intention universal but which in fact becomes Eurocentric.[24]

The irony, therefore, is this: a communicative ethics and praxis that is in principle open to the marginalized other, and I have argued this point in CAL, becomes in fact closed to that other.[25] The postmodern critique of Habermas on this score, in principle answerable and refutable, on a concrete, factual, political, economic level becomes true and valid. It is somewhat of a hollow victory to win the debate theoretically and lose it practically. At the very least, postmodern critiques of Western rationality need to be heeded and taken seriously, lest modern, Western rationality not live up to and indeed violate its own best intentions. Derrida, and others as well, may be necessary to save Habermas from himself.

To conclude, finally, in my writing of CAL and my reflections afterwards, I have had to confront what strikes me as the ambiguous legacy of Habermas, simultaneously enabling and inhibiting. Enabling in the sense that the theory of rationality, morality, modernity, and late capitalism is an enormous step forward, upon which any critical theory must stand today and below which it cannot afford to fall. Inhibiting in the sense that it can block the emergence of a more fundamental and radical critique of capitalism and neo-imperialism and a more thoroughgoing appropriation of Marx, earlier Western Marxism, and postmodernism. It is this task that I began in CAL and am continuing in present, ongoing work.

It is tempting for me to compare Habermas in this simultaneously enabling and inhibiting role at the end of the twentieth century with Hegel at the beginning of the nineteenth century; I mean that comparison seriously; Habermas is that important or almost that important. He is comparable to Hegel not only because of his enormous, positive, intellectual achievement, but also because of his tendencies, in tension with the best impulses of his theory, to identify the rational with an ethically deficient actual, to separate realism from utopia, to develop contradictions demanding a more radical, genuinely universalistic social theory, and to counsel reformism and/or resignation before a deeply corrupt, pathological status quo rather than its transformation and overcoming. Even the recent book in philosophy of law, *Between Facts and Norms*, is comparable to Hegel's *Philosophy of Right* because of the book's importance in itself and in its relation to his masterpiece, *The Theory of Communicative Action*, and in its tendency to legitimize a bad actual. And here I end with a question that is more than rhetorical. Who will be the young or middle-aged or old Habermasian who will write the critique of Habermas's philosophy of law?

JAMES L. MARSH

FORDHAM UNIVERSITY
DEPARTMENT OF PHILOSOPHY
FEBRUARY 1997

NOTES

1. Matuštík's commentary is entitled "Critical and Postmodern Social Theory at the Crossroads." This commentary was developed as part of a discussion of CAL at the Annual Meeting of the Society for Phenomenology and Existential Philosophy, October, 1995; the full reference for CAL is *Critique, Action, and Liberation* (Albany: SUNY Press, 1994).

2. In addition to CAL and *Modernity and Its Discontents* (New York: Fordham University Press, 1992), my other works include *Post-Cartesian Meditations* (New York: Fordham University Press, 1988); and *Radical Fragments* (New York: Peter Lang, 1992). Works by the other authors mentioned include Douglas Kellner, *Jean Baudrillard: From Marxism to Postmodernism and Beyond* (Stanford: Stanford University Press, 1989); and, with Steven Best, *Postmodern Theory* (New York: Guilford Press, 1991); David Harvey, *The Condition of Post-Modernity* (Cambridge: Basil Blackwell, 1989); Scott Lash and John Urry, *The End of Organized Capitalism* (Madison, Wisc.: The University of Wisconsin Press, 1987); Nancy Fraser, *Unruly Practices* (Minneapolis: University of Minnesota Press, 1989); Richard Bernstein, *The New Constellation* (Cambridge, Mass.: MIT Press, 1992); Thomas McCarthy, *Ideals and Illusions* (Cambridge, Mass.: MIT Press, 1991); co-authored with David Hoy, *Critical Theory* (Oxford; Cambridge, Mass.: Blackwell, 1994); Axel Honneth, *The Critique of Power*, trans. Kenneth Baynes (Cambridge, Mass.: MIT Press, 1991); Christopher Norris, *What's Wrong with Post-Modernism: Critical Theory and the Ends of Philosophy* (Baltimore: Johns Hopkins Press, 1990); *Uncritical Theory: Postmodernism, Intellectuals, and the Gulf War* (Amherst: University of Massachusetts Press, 1992); and *The Truth about Post-modernism* (Cambridge, Mass.: Blackwell, 1993); Peter Daws, *Logics of Disintegration* (New York: Verso Books, 1987); and David Ingram, *Reason, History, and Politics: The Communitarian Grounds of Legitimation in the Modern Age* (Albany: SUNY Press, 1995).

3. CAL, pp. 61–64, 75–86, 222–25, 234, 291–312.

4. Karl Marx, *Selected Writings*, ed. David McLellan (New York: Oxford University Press, 1977), p. 158.

5. Marsh, Caputo, Westphal, *Modernity and Its Discontents*. McCarthy and Hoy, *Critical Theory*.

6. CAL, pp. 291–312.

7. Jürgen Habermas, *The Theory of Communicative Action*, II: *Lifeworld and System: The Critique of Functionalist Reason*, trans. Thomas McCarthy (Boston: Beacon Press, 1987). *Legitimation Crisis*, trans. Thomas McCarthy (Boston: Beacon Press, 1975), pp. 68–75, 111–17. Thomas McCarthy, "Complexity and Democracy or the Seducements of Systems Theory," in *Habermas: Autonomy and Communicative Action*, ed. Axel Honneth and Hans Joas, trans. Jeremy Gaines and Doris L. Jones, pp. 119–39. *Habermas and the Public Sphere*, ed. Craig Calhoun

(Cambridge, Mass: MIT Press, 1992), pp. 468–69. David Ingram, *Reason, History, and Ethics* (Albany: SUNY Press, 1995), pp. 236–38.

8. CAL, pp. 166–67, 313–55.

9. Habermas, *Legitimation Crisis*, pp. 92–94.

10. CAL, pp. 173–74, 265–89.

11. *Habermas and the Public Sphere*, p. 469.

12. Jacques Derrida, *Specters of Marx*, trans. Peggy Kamuf (New York: Routledge, 1994), p. 91.

13. Ibid., p. 13.

14. Ernst Bloch, *The Principle of Hope*, I, trans. Neville Plaice, Stephen Plaice, and Paul Knight (Cambridge, Mass: MIT Press, 1986), pp. 205–10.

15. CAL, notes 51–52, pp. 376–79, note 40, pp. 389–90; 75–86, 87–93, 261–62, 305–06, 292–93, 294–97, 331–53, 342–43, 348–53. Thinkers like Doug Kellner have done some of this work of reaffirming Western Marxism and critical theory. See his *Herbert Marcuse and the Crisis of Marxism* (Berkeley: University of California Press, 1984), *Critical Theory, Marxism, and Modernity* (Baltimore: Johns Hopkins University Press, 1989).

16. Roy Bourgeois, "School of Assassins," *Z Magazine* 7 (Sept. 1994): 14–16.

17. Noam Chomsky, *Turning the Tide* (Boston: South End Press, 1985), pp. 158–59.

18. Enrique Dussel, *Ethics and Community* (Maryknoll, N.Y.: Orbis, 1988), pp. 146–69.

19. Larry Everest, "The Selling of Peru," *Z Magazine* 7 (Sept. 1994): 35–36.

20. Derrida, *Specters of Marx*, p. 85.

21. Jack Nelson Pallmeyer, *Brave New World Order* (Maryknoll, N.Y.: Orbis Books, 1992), pp. 4–5.

22. Derrida, *Specters of Marx*, pp. 81–83.

23. Jürgen Habermas, *The Past as Future*, trans. Max Pensky (Lincoln: University of Nebraska Press, 1994), pp. 5–31. Nelson-Pallmeyer, *Brave New World Order*, p. 80.

24. Jacques Derrida, *Of Grammatology*, trans. Gayatri Chakrovorty Spivak (Baltimore: Johns Hopkins University Press, 1976), pp. 269–316. Enrique Dussel, *The Invention of the Americas: Eclipse of "the Other" and the Myth of Modernity*, trans. Michael Barber (New York: Continuum, 1995).

25. CAL, pp. 126–33, 175–76.

INDEX

inter-humanity, 203
Internet, and democracy, 278, 280
interpretation, and meaning, 162
interpretive economics, 477, 478–79
"invaders," 400

Jameson, Fredric, 556
Jaspers, Karl, 351, 354
Jefferson, Thomas, 139
Joas, Hans, 377
Johnston, R., 390–91, 392, 395
Jove, 83, 85
judgment
 active, 165
 assertive, 165
 exhibitive, 165–67, 168, 170
 nonlinguistic forms of, 166
Jung, Carl, 103
Juno, 85
justification, and application, connection
 between, 197–98

Kant, Immanuel, 17, 141, 143, 146, 178,
 179, 185, 189, 195, 197, 247,
 417, 419, 491, 493
 categorical imperative of, 212–13
 as modernist, 556
 and moral theory, 177, 292
 on perfect duties, 296
 as reconstructive, 197
 as subjectivist, 145
 thing-in-itself, 237
 two-level theory of, 200
 and universalization, 180
Kellner, Douglas, 556
 Television and the Crisis of
 Democracy, 274
Kelly, Michael, 472
Kemmis, Daniel, 397, 401, 403, 405
 Community and the Politics of Place,
 400
Kierkegaard, Søren, 104, 132, 351, 356
 Either/Or, 355
Kirby, John, 108
Kirchheimer, O., 289
Kissinger, Henry, 435
Kluge, Alexander, 267
Knight, Frank H., 478
Kohák, Erazim, 521, 522
Kohl, Helmut, 351
Kohlberg, Lawrence, 131, 176, 247, 452,
 491, 533, 534, 535
Koselleck, Reinhart, 131

Lacan, Jacques, 147
Lamers, Karl, 427
La Mettrie, Julien Offray de, 143
language
 and communication, difference
 between, 32, 34–35
 poststructuralism of, 271–72
 theory of, 544
 universal claims of validity of, 52
language act theory, 544–45
Lanzmann, Claude, 343, 346, 350
Larmore, Charles, 295
Lash, Christopher, 556
law
 and critical theory, 381–21
 and inequalities, 318
 and rights, 318
Lawrence, Elizabeth
 Rodeo, 387
learning, 535
 cross-cultural, 335
 institutionalized, 536–37
Lefort, Claude, 469
legitimation crisis, 558–59
Lenhardt, Christian, 348
Levinas, Emmanuel, 246
Lévi-Strauss, Claude, 97, 100, 103, 109
Lévy, Benny, 430
Lévy-Bruhl, Claude, 76
li, 207–8, 209, 221
li_2, 220–21, 222
liberalism, 323, 378
 and communitarianism
 conflict between, 289–90
 resolving differences between,
 227–28
liberal state, 314
libertarianism, 297
 and democracy, 298
 and impartiality, 297
 and rule of law, 298
lifeworld, as subject-subject relations, 37
Lincoln, Abraham, 276
linguistics, object domain for, 33, 34
Locke, John, 143, 290–91
Longino, Helen E., 526
Love, Nancy S., 431, 434
 "What's Left of Marx?" 430
Luhmann, Nicholas, 131, 132, 142, 428,
 491, 492
Lukács, Georg, 429

MacIntyre, Alasdair, 229, 240, 328